Art Law and the Business of Art

Elgar Practical Guides

Rich in practical advice, *Elgar Practical Guides* are handy, concise guides to a range of legal practice areas.

Combining practical insight and step-by-step guidance with the relevant substantive law and procedural rules, the books in this series focus on understanding and navigating the issues that are likely to be encountered in practice. This is facilitated by a range of structural tools including checklists, glossaries, sample documentation and recommended actions.

Elgar Practical Guides are indispensable resources for the busy practitioner and for the non-specialist who requires a first introduction or a reliable turn-to reference book.

Titles in the series include:

Start-up Law
Edited by Alexandra Andhov

Copyright in the Music Industry
A Practical Guide to Exploiting and Enforcing Rights
Hayleigh Bosher

The Law and Practice of Fine Art, Jewellery and Specie Insurance
David Scully

Financial Regulation and Technology
A Legal and Compliance Guide
Iain Sheridan

Intellectual Property Strategies for Start-ups
A Practical Guide
Edited by Stefan Golkowsky

Art Law and the Business of Art
Second Edition
Martin Wilson

Art Law and the Business of Art

SECOND EDITION

MARTIN WILSON
 *Chief General Counsel and Head of Fiduciary Services, Phillips
 Auctioneers, previously Co-Head Legal and Compliance, Christie's
 Auctioneers*

Elgar Practical Guides

Cheltenham, UK • Northampton, MA, USA

Published by
Edward Elgar Publishing Limited
The Lypiatts
15 Lansdown Road
Cheltenham
Glos GL50 2JA
UK

Edward Elgar Publishing, Inc.
William Pratt House
9 Dewey Court
Northampton
Massachusetts 01060
USA

A catalogue record for this book
is available from the British Library

Library of Congress Control Number: 2022946674

This book is available electronically in the **Elgar**online
Law subject collection
http://dx.doi.org/10.4337/9781800885783

ISBN 978 1 80088 576 9 (cased)
ISBN 978 1 80088 578 3 (eBook)
ISBN 978 1 80088 577 6 (paperback)

Printed and bound by CPI Group (UK) Ltd, Croydon, CR0 4YY

Content overview

Table of contents

Preface

My first taste of the art world was in 1998, when I joined the legal department of Christie's auction house. The concept of an 'art lawyer' did not exist at that time. I was simply a commercial lawyer working at a business which happened to sell art. I had been recruited to the three-person legal team in London because Christie's had begun to see more disputes and some contracts for the sale of property were being negotiated rather than concluded on standard terms. This was a novelty because at that time transactions in the art world were largely conducted on the basis of a handshake or an invoice. Usually the only area of negotiation was price. When disputes arose they were rarely resolved through the courts. As a result, legal advice was not usually required.

Over the following 20 years, however, all of that was to change. By the time I left Christie's in 2017 the legal department numbered 40 employees, and many lawyers – both established and newly qualified – now aspire to become art lawyers.

The change was driven in part by the awareness of the importance of compliance and oversight which has affected all businesses. However, in the art business the growth in the need for legal advice and an understanding of the legal framework has also been necessitated by the legal risks inherent in the very unique characteristics of the world of art transactions. The value of any artwork depends upon its authorship (a matter of expert opinion where the author died long ago), its authenticity (again, often a question of opinion), its provenance (a question of research and detective work), the right and ability of the owner to sell the work (a question of law) and the condition of the work (defects are sometimes obvious, sometimes hidden). The decisions to purchase an artwork and of the price at which it is acquired are also a complex mix of emotion and judgement – often made without the kind of due diligence investigation which would accompany the purchase of a company or real estate. Finally, artists and their representatives have a continuing interest in their works of art, and often strong opinions about how they are sold. This combination of factors is in itself fertile ground for legal complexities. However, there are also other factors which have specifically emerged over the past 20 years.

The first of these was the explosion, in the late 1990s, of claims for restitution of art looted from Holocaust victims during the Second World War. The validity of many transactions which had taken place since the war was questioned by claimants and it became vital for those selling art that the history of the works they were offering for sale was checked to ensure that the work had not been looted during the war.

The second major event was the antitrust litigation and prosecutions resulting from Christie's and Sotheby's colluding with each other to fix commission charges. This traumatic process heralded the strengthening of legal departments and the establishment in major auction houses of compliance departments tasked with ensuring that such activities could never again happen.

Perhaps the single biggest driver of legal complexity has been the growth in the past two decades of complex financial transactions surrounding art, and the growth in value of the art sold. Whereas in 1998 the role of the auction house or dealer was simply to sell the artwork, the consignment of valuable artworks is now usually the subject of complex negotiations involving minimum price guarantees, advances and loans. Such transactions are commercially and legally complex and involve a significant degree of financial and legal risk. Further, the complexity of these arrangements, combined with the art market's culture of confidentiality, has led to concerns, from the buyer's perspective, of a lack of transparency and worries over conflicts of interest.

There has also been growth in the ethical and public policy considerations around the sale of certain types of artwork. The concept of individuals, cultures and States having a claim to restitution of artworks has been steadily growing. That issue first came to prominence with claims for restitution of artworks looted during the Second World War and has more recently been brought into even sharper focus by the destruction and theft by ISIS of artworks on ancient sites in Iraq and Syria. Artworks incorporating ivory and other rare animal products are also controversial. With the development of contemporary 'shock art', which uses controversial sexual or violent imagery, the limits of free speech are also often tested.

Finally, and more recently, in response to concerns about the opacity of the art market, there has been a move in many countries to subject the art market to anti-money laundering regulation similar to those applicable to banks. While anti-money laundering regulation may appear to be simply an administrative burden it represents, in practice, a huge change to the way in which the art market operates.

These are all unusual legal issues. To be able to navigate them requires not just an understanding of the law, but – perhaps even more importantly – an appreciation of how the art business operates in practice. What I am hoping to achieve in this

book is to put the law firmly in the context of the business. It is not intended purely as a law book for lawyers. Rather I hope that it will serve as a practical handbook for those who collect or work in the art business, as well as for lawyers. Above all, I hope that the book will convey the enthusiasm and excitement I have experienced over the years working in this fascinating field.

I would like to thank the many colleagues and experts in this field who have helped me along the way with advice and suggestions. One of the great joys of working in this field is the interesting and very learned people who populate it. In particular, thank you to all of my colleagues and friends who encouraged me to write this work and who devoted their time to making sure it is accurate. These include Frances Wilson of the Arts Council, Anthony Browne of the British Art Market Federation, Roland Foord of Stephenson Harwood, Andrew Kitt of Phillips, Ruth Cornett of Christie's, Susan Johnson of BDP Pitmans, Aaron Taylor of Fountain Court, Freya Stewart of the Fine Art Fund, Richard Aydon and my brother Alex Wilson. It has been a privilege working with you over the years and in the context of this book.

We have also recently lost two brilliant art lawyers who passed away in 2020 and 2021, respectively – Richard Edwards QC and Ludovic de Walden. They both in their different ways exemplified the sheer enjoyment of practising in art law and will be missed, by me and also by the art law community.

I would also like to thank the wonderful art world professionals who, over the years, have made working in this industry so fascinating and enjoyable. It has been a pleasure to share their passion for art and for the commercial art world. There are too many to list here but Noel Annesley, Ed Dolman, Jussi Pylkkanen, Francois Curiel, Stephen Brooks, Lisa King, Thomas Seydoux, Sophie Carter and Lord Hindlip have all played a huge part in shaping the modern commercial art world and it has been a privilege to work with them.

I am dedicating this edition to my late father, who knew a few things about words.

Thank you also to my wife, Alison, who first encouraged me to enter the art world and who has since been a constant source of inspiration and guidance to me.

Notes

This second edition of *Art Law and the Business of Art* has been required sooner than might usually be the case because of some important and far-reaching developments which have occurred since the publication of the first edition. The most obvious of these is Brexit, which has had a significant impact on the United Kingdom art market and its practical operation, and is likely to continue to do so. The second major development is the regulation, for anti-money laundering purposes, of the art market. The transparency required by the new regulatory regime has presented a significant challenge to the culture of confidentiality which has until now been a central aspect of the art market. The increasing focus on online sales as a result of the COVID crisis and the NFT phenomenon have also led to significant changes in how art is sold. This edition seeks to describe the new legal and commercial landscape of the art market in the light of these major changes. I have of course also taken the opportunity to incorporate details of many new legal developments and caselaw. I have also expanded my exploration of forgery.

While the art market is international, this book is firmly focused on the law and practice in the United Kingdom. In the interests of clarity, the laws and practices of other countries are not usually considered in this book – other than for comparative purposes.

In an effort to provide a complete overview, I have sought to tackle some subjects, laws and regulations which tend to be avoided by other authors because of their propensity for frequent change. An example of this is tax and export controls. While the information in this book is correct at the date of publication, there is – as always – talk of new laws and regulations affecting the art market. Care should therefore be taken to check the up to date position in these areas.

The sale of art takes place though a variety of channels, through a variety of intermediaries and at all value levels. The concerns and practices are different in each case. I have sought to cover all aspects but readers may be conscious that what I write is principally informed by my experience in a large international auction house, which may be very different to the experiences of other market players.

From time to time in this book I have expressed opinions and views. I should emphasise that those opinions and views are my own and not those of my employers, Christie's and Phillips.

Finally, this book is intended to provide a practical and, at times, general overview. It is not a substitute for taking legal advice yourself, and each set of circumstances is different. As a result, it is important that you seek independent advice before acting on anything you read in it.

Glossary of art terms

	
Advance	A sum of money loaned to the seller by the auction house prior to the sale, secured upon the lot which has been entrusted to the auction house by the seller for sale
Aftersale	A postauction private sale of a lot which was unsold during the auction
All-in	A seller's commission which has been negotiated between the auction house and the seller to include all costs and expenses
Appraisal	A valuation of an artwork
Art agent/Art adviser	A person or business offering advisory services to buyers or sellers of art, often acting as intermediary or agent
Artist's resale royalty	A royalty paid to the original artist on resale of his or her artwork based on the resale price
As is	A term used to describe the fact that works at auction are offered for sale in whatever condition they are in at the time of the sale. It is the buyer's responsibility to ascertain the condition
Attribution	Identifying the author of an artwork
Authenticity Certificate	A written statement from the artist, a scholar, an expert or a qualified body attesting to the authenticity of an artwork
Autograph work	A work considered to be by a named artist
Bid	The signal given to the auctioneer by a prospective buyer indicating the amount the bidder is prepared to pay for the lot being offered for sale
Bid increment	The amount by which the auctioneer raises the bidding price after each bid

Bidding in the room	Bidding taking place by bidders attending the auction sale in person
Bought in	The phrase used to describe a lot which is unsold at auction
Burnt	A lot which has been unsuccessfully offered for sale publicly and is now difficult to sell as a result
Buyer's premium	The fee paid by the buyer to the auction house in addition to the hammer price. Generally calculated as a percentage of the hammer price
Buying bid	A bid which is over the seller's reserve
Catalogue raisonné	A complete written record of an artist's known works
Condition report	A report made available to potential bidders on the physical condition of a lot
Consignor	The seller of the work being sold by the auction house, and the person for whom the auction house is acting as agent
Cover lot	The lot which is illustrated on the front cover of the auction catalogue – usually the star lot
Chandelier bidding/ Bidding on behalf of the seller / Consecutive bidding	Bids taken by the auctioneer up to the reserve on behalf of the seller of the lot
Credit terms	An agreement with the buyer to accept payment by instalments and/or at a later date than provided for in the standard terms of sale
Dealer/Trader	A person or business engaged in the business of buying and selling art
Estimate	The price or range of prices that the auctioneer believes that a lot is likely to sell for. Printed in the catalogue and usually expressed as a range
Evening sale	A sale held in the evening, in which the auction house offers the most popular and valuable lots for sale
Fair warning	The phrase used by the auctioneer to warn bidders that he is on the point of bringing the hammer down and closing the bidding on a lot
Fake	An artwork which has been deliberately made to deceive either as to authorship, period or origin

Flipping	The practice of purchasing an artwork and reselling it shortly afterwards at a profit
Guarantee / Minimum price guarantee	A contractual commitment made by the auction house to the seller before the auction that the auction house will pay the seller a minimum amount of money regardless of the outcome of the sale
Hammer/Gavel	The object held by the auctioneer during the sale which is physically brought down to strike the auctioneer's podium to indicate the sale of the lot to the highest bid
Hammer price	The bid at which the sale is concluded, indicated by the auctioneer's hammer being brought down to strike the auctioneer's podium
Introductory commission/IC	A payment made to a party who introduces a seller, buyer or intermediary to an opportunity to transact
Irrevocable bid	An irrevocable commitment made by a bidder prior to the auction to bid for a lot up to a certain amount. This is usually offered by a third party as part of a third party guarantee
Knocked down / Hammered	Sold at auction
Low estimate	The low end of the range of estimates provided by the auction house prior to the auction sale
Medium	A description of the material used to create the artwork
Mid-estimate	The mid-point between the high estimate and the low estimate
Misattribution	The incorrect identification of an artist as the author of an artwork
Not right	Words used to describe a work which is believed not to be authentic
NFT	An NFT (a non-fungible token) is a unique item of data recorded on a blockchain which is usually associated with a digital file such as a particular digital artwork, a photograph, a video or an audio file
Oeuvre	An artist's body of work
Paddle	A numbered panel given to bidders upon registration, to be used to indicate a bid to the auctioneer and allow the auctioneer to identify the winning bidder

Pass/Bought in	The phrase used by the auctioneer to announce that a lot has failed to sell due to the bids not having reached the seller's reserve price
Pledge	A legal construct which allows a lender to retain physical possession of an artwork or other chattel belonging to a debtor as security for a debt
Payment guarantee	A commitment to the seller made by the auction house that it will underwrite nonpayment or late payment by the successful bidder
Percentage sold	The percentage of lots successfully sold in an auction – expressed as either a percentage of the number of lots in the sale or a percentage of the total value of the lots in the sale
Primary market	A market in which artworks are sold for the first time, usually by or on behalf of the artist
Private sale	A sale of an artwork concluded otherwise than by auction between a buyer and a seller at an agreed price
Provenance	The ownership history of the lot
Reserve	The confidential minimum price below which the seller is not prepared to sell his or her lot
Ring	An illegal agreement between bidders to abstain from bidding in order to secure a lot at a lower price
Rostrum	The raised podium where the auctioneer stands
Saleroom announcement	An announcement made by the auctioneer relating to a lot or lots, usually correcting or supplementing the catalogue information
Scholar/Art expert	An individual or body generally acknowledged to be a leading source of scholarship and expertise in the body of work of an artist or period
Secondary market	A market for artworks which have previously been sold
Selection for sale	A valuation of a collection of artworks prepared by a dealer or auction house with a view to sale
Seller's commission	The fee paid by the seller to the auction house. Generally calculated as a percentage of the hammer price
Specialist	An auction house employee involved in the attribution and valuation of artworks
Starting price	The point at which the auctioneer starts the bidding on a lot

Stock/Stock lot	A lot which is owned by the auction house or dealer offering the lot for sale
Telephone bidding	Bidding taking place by telephone via an auction house employee, who is based in the auction sale room and relays the bids to the auctioneer. This happens where the bidder is unable or unwilling, usually for reasons of confidentiality, to attend the sale in person
Third party guarantee	An agreement between the auction house and a third party to share the profit and loss resulting from a minimum price guarantee
Title/Good title	Legal ownership
Underbidder	A person who bid below the successful buyer's winning bid
Unsold lot fee	The fee payable by the seller to cover the auction house's administrative costs in the event that the seller's lot fails to sell
Upside	In the case of a lot which is the subject of a minimum price guarantee, the amount, if any, by which the hammer price of a lot exceeds the guaranteed minimum amount
View	The public exhibition of the lots to be sold at auction
White glove sale	An auction in which every lot is sold and no lots are unsold
With you / Not with you	Words sometimes used by auctioneer to indicate to a bidder that he or she is or is not currently the high bidder
With the hammer	An expression used by the auctioneer to indicate that he or she is exercising the auctioneer's discretion to accept a bid which was made simultaneously with the fall of the hammer and is therefore reopening and continuing the bidding
Withdrawn	A lot which was scheduled for sale at auction, but which has since been withdrawn from the auction and is not offered for sale
Written bid / Absentee bid / Commission bid	A written instruction to the auction house from a bidder to bid on his or her behalf for a lot up to a specified maximum amount

Commonly used catalogue terms related to attribution

There is a surprisingly extensive – and, some would argue, confusing – set of terms used to describe the various gradations of authenticity. These terms are a form of code or language best understood by those with experience of the art business. While there is undoubtedly a need to describe the gradations of authenticity accurately, some of the terms used have the potential to be confusing for the unwary or those unfamiliar with their meaning or significance. This is very significant where authenticity is the most important factor when determining value. A work which is by the hand of a famous artist will of course have a far greater value than a work by a pupil of the artist or a work by someone unrelated to the artist who copies the artist's style. It follows, then, that this is an area where dealers and auction houses should be crystal clear. With the emphasis on transparency and clarity where consumers are concerned, it can only be a matter of time before these terms are replaced by more descriptions which are less euphemistic. In the meantime, we set out below some of the most commonly used terms, and their meanings.

After	A copy (of any date) of a work of the named artist
Attributed to	Probably a work in whole or in part by the named artist
Circle of	A work of the period of the named artist and showing the artist's influence
Follower of	A work executed in the style of the named artist but not necessarily by a pupil of the artist
Manner of	A work executed in the style of the named artist but of a later date
Signed / Dated / Inscribed	A work which has been signed/dated/inscribed by the named artist
Studio of / Workshop of	A work executed in the studio or workshop of the named artist, possibly under the artist's supervision
With signature / With date / With inscription	Signature/date/inscription appears to have been added by someone other than the artist

Table of cases

Table of legislation

Statutory Instruments

EUROPEAN UNION

NATIONAL LEGISLATION

Turkey

United States of America

CONVENTIONS

OTHER INTERNATIONAL INSTRUMENTS

CODES OF PRACTICE, GUIDANCE

1 The artist and the artwork

When an artist produces a work he or she creates something unique – a combination of the artist's imagination and a tangible way of expressing that imaginative idea. The artist also invests labour and time in the work. Just as an inventor of a new technology needs legal protection to prevent others copying and making use of his new invention, so too an artist needs legal protection to allow him or her to control the use by others of the fruits of his or her own creativity. This has never been more important than in the internet age, where reproduction, editing and distribution of images is so easy and widespread.

The argument in favour of legal protection of artistic works is that without legal protection and control over the exploitation of the work there would be less incentive for musicians, writers or artists to invest time and effort in creative work. Protection of the rights of the artist is therefore automatically provided by United Kingdom law, without the need for any formality or process, in three ways:

- Copyright law prevents the artist's work being copied or reproduced without the consent of the artist.
- Moral rights allow the artist to prevent the use or reproduction of the work in ways that the artist does not approve of.
- The artist's resale right allows the artist to be paid a percentage of the sale price of the artwork each time it is resold.

We will examine each of these in turn.

1.1 Copyright

Copyright is the legal protection given to artists, to protect their economic and moral rights in the artworks they produce. Copyright is part of a group of intellectual property rights that comprise patents, industrial designs and trademarks. These are legal rights given to the creator of a creative work over their creation.

Copyright requires no formality to be enforceable, unlike patents, registered industrial designs and trademarks, which require formal registration. Copyright protection applies automatically to any creative work that satisfies certain criteria regardless of the identity and creative credentials of the person who produced the

creative work. There is no need to apply for copyright protection, register the work or even label it as being copyright.

Copyright is also a distinct right from the ownership right in a creative work. A person buying a painting at auction which is protected by copyright will become the owner of the painting but will, unless the copyright is transferred to him or her, usually need the permission of the copyright owner to make copies of the artwork. Equally, a buyer of an unreleased 'bootleg' recording of the Beatles practising in the recording studio is the owner of the recording and may listen to it, but may not broadcast or make copies of it without the permission of the copyright owner.

Copyright law in the United Kingdom and the United States has traditionally started from the economic model – the idea that an artist should be able to have continuing financial enjoyment of the benefits of his or her creation. This is achieved by giving the artist the ability, through licensing, to control acts such as copying, renting, lending, adaptation or communication to the public of his or her artwork. These economic rights of the artist can also be assigned or sold to others. This approach, which focuses on the economic value of the work, is in contrast to many European legal systems which have adopted a slightly different starting point – the fundamental moral right of the artist to prevent the treatment of the artwork in ways of which the artist does not approve. These moral 'policing' rights – originally conceived in continental Europe but now also enshrined in UK law – include the right to be identified as the author of the artwork and the right to object to derogatory treatment of the artwork. Unlike the economic model, moral rights are not assigned or licensed. They are instead vested in the artist and the artist's estate. Gradually the economic model has been diluted by the continental European approach through European legislation and case law, so that now there is considerable harmonisation across Europe in many aspects of copyright law.

In the United Kingdom, modern copyright law is enshrined in the Copyright, Designs and Patents Act 1988 (CDPA 1998). The CDPA 1988 seeks to incorporate both the economic rights and the moral rights of the artist. Where copyright exists in an artwork, the copyright owner has the exclusive right to copy the work (s 17), issue copies of the artwork to the public (s 18) or make an adaptation of the artwork (s 21). The copyright owner is also entitled to prevent unauthorised persons doing any of these things in relation to the artwork. That right relates not just to the artwork as a whole but to any substantial part of the artwork (s 16(3)).

1.1.1 What types of artwork are protected by copyright?

The starting point for determining whether a creative work is protected by copyright is to look at whether it is of a kind which can be protected by copyright. CDPA 1988, s 1(1)(a) states that copyright shall subsist in 'original literary, dra-

matic, musical or artistic works'. Section 4 goes on to define which types of 'artistic works' are capable of being protected by copyright. These include:

(a) a graphic work, photograph, sculpture or collage, irrespective of artistic quality
(b) a work of architecture being a building or model for a building, or
(c) a work of artistic craftsmanship.

Leaving aside, for the time being, the requirement of originality and the question of artistic quality, it will be noticed that the types of artwork protected by the CDPA 1988 are wide ranging.

1.1.1.1 Graphic works: paintings, drawings and engravings

The term 'graphic work' includes (a) any painting, drawing, diagram, map, chart or plan and (b) any etching, lithograph, woodcut or similar work (s 4(2)(b)).

In determining whether a work is a painting or a drawing for the purposes of copyright law, the ordinary meaning should be given to the words painting and drawing. It is important to remember that no regard should be given to whether or not the work has artistic merit. A drawing or painting can be extremely simple and yet be protected. However, the more simple the work is, the more exact the reproduction will need to be in order to amount to an infringement of copyright.

1.1.1.2 Photographs

A photograph for the purposes of the CDPA 1988 is defined as 'a recording of light or other radiation on any medium on which an image is produced or from which an image may by any means be produced, and which is not part of a film' (s 4(2) (b)). A photograph can therefore be a light recording captured on light sensitive film, paper or digital sensor.

1.1.1.3 Sculpture

The CDPA 1988 makes it clear that sculpture includes 'any cast or model made for the purposes of sculpture' (s 4(2)(b)) with the result that the sculpture as well as the cast used to make it is protected. However, it does not provide any more guidance on what constitutes a sculpture for the purposes of copyright protection. That question was addressed in Lucasfilm Ltd v Ainsworth,[1] where the issue before the court was whether the Imperial Stormtroopers' helmets used in the Star Wars film were sculptures within the meaning of the CDPA 1988 and were therefore pro-

[1] [2011] UKSC 39.

tected by copyright, rather than the law of registered or unregistered design which protects more utilitarian three dimensional designs. The court decided that the helmets were not 'sculptures' within the meaning of the CDPA 1988. Specifically, it held that the ordinary meaning of the term 'sculpture' should not extend to a helmet used in the making of a film, even where the helmet contributed to the artistic effect of the overall film. The court therefore considered that the helmet was utilitarian rather than a work of art, and was not protected by copyright law as a sculpture. In reaching its conclusions the court endorsed a list of guidelines to be used in determining whether a work is a sculpture within the meaning of the CDPA 1988:

(i) Some regard has to be had to the normal use of the word.
(ii) Nevertheless, the concept can be applicable to things going beyond what one would normally expect to be art in the sense of the sort of things that one would expect to find in art galleries.
(iii) It is inappropriate to stray too far from what would normally be regarded as sculpture.
(iv) No judgement is to be made about artistic worth.
(v) Not every three dimensional representation of a concept can be regarded as a sculpture. Otherwise every three dimensional construction or fabrication would be a sculpture, and that cannot be right.
(vi) It is of the essence of a sculpture that it should have, as part of its purpose, a visual appeal in the sense that it might be enjoyed for that purpose alone, whether or not it might have another purpose as well …
(vii) The fact that the object has some other use does not necessarily disqualify it from being a sculpture, but it still has to have the intrinsic quality of being intended to be enjoyed as a visual thing …
(viii) The process of fabrication is relevant but not determinative.

The forms of art known as readymade, objets trouvés, installations or assemblages are works where the artist will take an object or group of objects which are utilitarian or ordinary, often seeking to use them to challenge the idea of the nature of art. Examples of such art are the works of Marcel Duchamp, Tony Cragg, Pablo Picasso and Michael Landy. Such works will usually fall within the definition of sculpture for the purposes of copyright law.

Example

• Marcel Duchamp's 1917 work *Fountain* is an example of readymade art, where the artist conscripts an ordinary manufactured item and displays it as a work of art. In this case the item was a porcelain urinal purchased from a plumbing supplier. Duchamp arranged it lying on its back and signed it with the inscription 'R.Mutt 1917'. R stood for a French slang word for moneybags and Mutt

was a nod to the company who had sold the urinal to Duchamp. Fountain is a sculpture for the purposes of copyright protection under United Kingdom copyright law because, taking account of the principles in *Lucasfilm Ltd v Ainsworth* (see above), it has as its purpose a visual appeal and is intended to be enjoyed for that purpose alone, regardless of the fact that the urinal has another purpose as well. That purpose was a challenge to his audience to question the concept of what is or is not art.

It is also worth noting that even if an artwork is a sculpture for the purposes of copyright law, an unusual exception to copyright protection applies in the United Kingdom to sculptures and works of artistic craftsmanship which are on permanent display to the public or in premises open to the public. In the case of such work there will be no infringement by making a graphic work (such as a painting or drawing), a photograph or a film representing it (s 62).

1.1.1.4 *Collages*

Collages are artworks created by assembling images. The technique became widely used as an art form by early twentieth-century artists such as Braque and Picasso, who incorporated cuttings from newspapers and magazines into their canvases to provide a contemporary context to the artworks. The technique was widely adopted and developed by artists such as Man Ray and Nancy Spero, often involving quotes, photographs and images taken from other sources and incorporated into a single artwork. A collage of these items may be a copyright work in its own right but the individual images and text from which the collage is comprised may themselves also be protected by copyright and therefore require the copyright holder's consent to be used in the collage if a substantial part of the copyright holder's work is reproduced. The question of what is substantial is often relevant because collages frequently incorporate small parts or sections of other images. As a rule of thumb the use is likely to be considered substantial if it is particularly recognisable and an integral part of the collage work. Care also needs to be taken not to infringe the copyright owner's moral rights (see section 1.2.2.2, 'The right of integrity') when using a cut-down version of the original image.

1.1.1.5 *Works of artistic craftsmanship*

'Works of artistic craftsmanship' is intended to cover works such as painted tiles, pottery, book bindings, wrought iron gates, cutlery, needlework and stained glass, jewellery and twentieth-century furniture. The difficulty here is to distinguish between works which are utilitarian and those which are works of art, and therefore qualify for copyright protection. The reason this has been a live issue is that the authors of design prototypes or other works of craftsmanship which might usually be protected as registered designs have sometimes sought to claim copyright protection as works of artistic craftsmanship, which can be more advan-

tageous. However, in order to benefit from such protection, the author needs to demonstrate not only that it is a work of craftsmanship, but that it is an artistic work. The courts have sought, without success, to establish a clear test for determining whether or not a work is a work of artistic craftsmanship. The leading case on this issue is George Hensher Ltd v Restawile Upholstery (Lancs) Ltd,[2] which involved a dispute over the copying of prototype furniture design. The judges' speeches in that case sought to set out the following principles to be borne in mind:

(1) A work is artistic if it is genuinely admired by a section of the community by reason of the emotional or intellectual satisfaction its appearance gives.

(2) That the author was not consciously concerned to create a work of art is not determinative.

(3) Whether something is or is not artistic is a question of fact, to be decided in the light of evidence, and it is pointless to try to expound the meaning of the word.

(4) 'Work of artistic craftsmanship' is a composite phrase, to be construed as a whole, and it is a mistake to consider the terms 'craftsmanship' and 'artistic' in isolation from one another.

(5) The word 'artistic' is for the court to interpret, not witnesses. The true test is whether the author has been consciously concerned to produce a work of art.

However, the tests set down in George Hensher Ltd v Restawile Upholstery (Lancs) Ltd were criticised in Laddie, Prescott & Vitoria as being inconsistent and unhelpful.[3] Laddie proposes an alternative test, which carefully avoids a situation where the judge is asked to be the arbiter of whether or not the work is a work of art. Instead it proposes a test in which the reaction to the work of members of the public is objectively assessed:

> In the case of a work of artistic craftsmanship the medium is the working of materials by manual dexterity (craftsmanship); and the visual appearance is significant if it would cause at least some members of the public to wish to acquire and retain the object on especial account thereof: an objective fact, capable of ascertainment. Whether this public is or is not well advised is a matter of absolutely no concern to the court; the other ingredients of the question are well within its sphere of competence of adjudication.[4]

This latter test does appear to be the better one. It is certainly preferable to base the test on an analysis of public reaction to a work than to burden the judge with the responsibility of assessing artistic merit.

[2] [1976] AC 64.

[3] Laddie, Prescott & Vitoria, *The Modern Law of Copyright and Designs* (5th edn, LexisNexis, 2018), para 4.37.

[4] Lord Reid in *Hensher v Restawile Upholstery (Lancs) Ltd* [1976] AC 64.

1.1.2 The requirement of originality

1.1.2.1 Originality

As we have seen, s 1(1) of the CDPA 1988 requires not only that the work be an artistic work, but that it be 'original'. It is therefore a fundamental requirement for copyright protection of an artistic work that the work be original.[5] Having established that the work is of a type which is capable of copyright protection as an artistic work, the second step is to determine whether or not it is original. If it is not original it will not benefit from copyright protection. The concept is not defined in statute, but has been considered extensively by the courts. In University of London Press Limited v University Tutorial Press Limited,[6] the court concluded that the threshold for originality was low and that it is not necessary that the idea behind the work should be original. Few ideas are wholly original and artists take their inspiration and ideas from others and from tradition. Rather, the originality required is the originality of expression of the idea. However, even the expression of the idea does not need to be novel to be original. It is sufficient that it should originate from the author and must not be copied from another work. It is also accepted that some degree of skill and labour on the part of the author is required for the work to be original – but that degree of skill and effort can be minimal.[7]

A striking illustration of just how low the threshold for originality is can be seen by the protection given to photographs. Whereas a photocopy of an image is unlikely to involve sufficient skill and labour to attract copyright protection, a photograph of an object or image is protected by copyright even though the originality and creativity involved in taking the photograph can amount to no more than pointing and clicking. This means that a photograph of a painting is itself capable of being a copyright work distinct from the painting which is the subject of the photograph.

Example

- When an auction house photographs a work of contemporary art by Damien Hirst for its sale catalogue, the photograph itself becomes a copyright work owned by the auction house. Anyone wishing to reproduce the photograph will need to obtain the consent of Damien Hirst to reproduce the image of the artwork, but also the consent of the auction house to reproduce the photo-graph of the artwork.[8]

5 CDPA, s 1(1)(a).

6 [1916] 2 Ch 601.

7 Interlego v Tyco [1989] AC 217, at 262H.

8 See Laddie, Prescott & Vitoria: The Modern Law of Copyright and Designs (5th edn, LexisNexis, 2018) at para 4.37 for more detail regarding cover photographs and originality.

There remains however some debate over the point at which, under UK law, a photograph of an existing copyright work creates a new work which benefits from its own copyright protection. In 1869, *Grave's Case* [4 LRQB 715] held that a photograph of an engraving enjoyed copyright. That is still the position under UK law. However, the *obiter* comments in *Interlego v Tyco* [1989] AC 217 suggest that the position may be more nuanced – particularly where the reproduction of the original copyright work requires no creative input, skill or judgment, such as a photocopy or digitisation:

> It takes great skill, judgment and labour to produce a good copy by painting or to produce an enlarged photograph from a positive print, but no one would reasonably contend that the copy painting or enlargement was an 'original' artistic work in which the copier is entitled to claim copyright. Skill, labour or judgment merely in the process of copying cannot confer originality.

In my view, while the originality threshold is low, it is unlikely that someone who photocopies a copyright work could be said to be producing a new copyright work. The same would apply to an image of a copyright work copied digitally from a website. However, that seems to me to be different from the position where a photographer produces a photograph of a copyright painting hanging on display, making the necessary adjustments for exposure, depth of field and lighting. In this case it seems to me that the photograph has satisfied the skill, judgement and labour requirements to acquire its own copyright protection.

The requirement of originality is often discussed and illustrated in the context of contemporary artworks, which frequently celebrate ordinary objects. Think for instance of Andy Warhol's soup cans. Andy Warhol's images are typical of what is sometimes known as the art of appropriation. This form of art takes brands, images and objects which are part of our culture and incorporates them into artwork. We have seen that it is not a requirement that the artistic work should be an original, novel or inventive idea or thought. So once again, the fact that the soup can design already existed and is illustrated elsewhere plays no part in deciding whether or not it is original. Equally, in the context of installations and objets trouvés, the originality lies not in the object but the fact that it has been taken out of its context and placed in an artistic context.

The question is, then: is the expression of Andy Warhol, in the depiction of the soup can as a screen print, an original expression? The starting point for determining this question is that the artwork must be different from other versions of the image. It must not be copied from another work. Second, it should originate from the author. Finally, to be original the artwork must involve an exercise by the artist of skill, labour and judgement. In this case Warhol was not simply copying the can label – he expanded it and reproduced it as a screen print using skill and labour. The work therefore did satisfy the requirement of originality of expression.

However, an exact copy of the Warhol screen print by another artist would not be an original work because it is neither an original expression of the idea nor involves skill, labour and judgement. An artwork copied from another work will not enjoy copyright protection in its own right if it is simply an exact copy of the work of another artist. However, if there is an element of embellishment or alteration, it may be protected.

It is also worth bearing in mind, though, that while the Andy Warhol soup can screen print and canvases may pass the originality test and therefore be protected by copyright as an original artwork, the Campbell soup company also has intellectual property rights in the copying of its logo, including copyright. So the reproduction of the Campbell logo in the artwork would require the consent of the Campbell soup company. In practice, however, this issue never arose, as the Campbell soup company was quick to recognise the advertising value it gained from the Warhol soup cans and did nothing to prevent or restrict Warhol's use of the logo. It is said that they even sent him a couple of cases of tomato soup as a thank you.

1.1.2.2 Originality and photographs

Photographs are different from many other artworks in that a photograph is in itself a form of reproduction which can require little originality or labour beyond the pressing of the camera button. For this reason it is worth considering the status of photographs in the context of copyright. The question of copyright in photographs is increasingly important given the advent of smartphones, which allow us to create, alter and distribute many thousands of photographs. Social media also encourages us all to be creative and share images, making us all amateur photographers. We have also seen that under United Kingdom law the threshold for originality is very low. As a result, provided that there is some judgement involved in choice of angle, exposure or timing, even a snapshot of a subject photographed by many others, or a snapshot of a building, object or scene, will benefit from its own distinct copyright protection. It is for this reason that, as we have seen above, a photograph taken by an auction house or dealer of a painting for the sale catalogue will be a copyright work in its own right. This is because, just like a snapshot by a tourist, a photograph for cataloguing purposes will require some degree of originality in choice of lighting and exposure. On the other hand, a photocopy of an image will not be protected by copyright as the placing of the image on the photocopier glass and pressing the copy button requires no originality or labour. This low originality threshold requirement has been exploited by artists such as Richard Prince. Prince's art involves the 're-photographing' of photographs taken from magazines, posters and advertisements, but reproducing them with often very subtle changes. As a part of the Frieze Art Fair in New York in 2015, Prince displayed significantly enlarged screenshots of Instagram posts which he had

come across on the internet. He believes he was able to do this without infringing the copyright of the people who posted the images on Instagram because he enlarged the image and modified the captions accompanying the photograph in each case. His argument is based upon a previous case brought against him in the US courts by photographer Patrick Cariou, in which the United States Court of Appeals for the Second Circuit ruled that Prince's appropriation art could constitute fair use under US law and that a number of his works were transformative fair uses of Cariou's photographs.[9] At the time of writing this position is now due to be tested in court, as Richard Prince is the subject of a further lawsuit over one of the Instagram images, 'Rastafarian smoking a joint' in the 2015 Frieze Art Fair, brought by photographer Donald Graham.[10] While at the time of writing the case has not yet been finally decided, the Court has given an interim ruling in response to a motion to dismiss by Prince. The Court refused the motion ruling that because Prince's reproduction of the original Instagram post 'Rastafarian smoking a joint', renamed 'Untitled', did not contain significant aesthetic alterations it is not, as a matter of US law, transformative. This shows that even in the US, where the notion of 'fair use' is much broader than in the UK, much will depend upon the facts.

1.1.3 Duration of protection

Even where an artwork is protected by copyright law, that protection is limited in time. After the expiry of the copyright protection period, the consent of the copyright owner is no longer required for reproduction or distribution of the artwork.

Since 1996, copyright protection has expired 70 years after the death of the artist.[11] So, for example, Picasso died on 8 April 1973, so copyright in works by Picasso will continue until 70 years from 31 December 1973, which is 31 December 2043.

Prior to 1996, the period of copyright protection was the lifetime of the artist plus 50 years. Extending the copyright period from 50 to 70 years had the effect of bringing back into copyright works where copyright had previously expired. So, for example, in 1995 the works of an artist such as Paul Klee, who died in 1940, were no longer protected by copyright and could be freely copied. But one year later the 70 year rule extended copyright, so that the artist's work came back into copyright until 2010.

9 *Cariou v Prince*, 714 F. 3d 694 (2d Cir. 2013).
10 *Donald Graham v Richard Prince and Ors Southern District Court of New York* 15-Cv-10160.
11 CDPA 1988, s 12(2), as amended by the Duration of Copyright and Rights of Performances Regulations 1995 (SI 1995/3297).

1.1.4 Ownership of copyright

Purchasers of artworks frequently have the misconception that they own the copyright in the artwork they have purchased. In fact they have almost always purchased only the object itself, and the copyright remains with the copyright owner – usually the artist. What this means is that while the proud owner of the work can hang his or her new painting wherever he or she wishes, he or she cannot make or sell reproductions of the work without the consent of the copyright owner. It is of course possible for the artist to assign copyright to the buyer on sale of the work, but this is very unusual.

1.1.4.1 Artworks created in the course of employment

The usual rule is that the author of an artwork is the first owner of copyright in the work (CDPA 1988, s 11(1)). However, where an artwork or photograph is created in the course of employment after 31 July 1989 (the date the CDPA 1988 came into force), the first owner of the copyright in the work will be the employer, unless there is an agreement to the contrary (s 11(2)). For works which were created by employees in the course of their employment on or prior to 31 July 1989, the Copyright Act 1956 provides that the owner of the copyright will be the employer, except where the employer is the proprietor of a newspaper or magazine. Where the employer is a newspaper or magazine proprietor, the employer shall have the right to the copyright in the artwork and the right to reproduce the artwork only in so far as is related to the publication in the magazine or newspaper. All other copyright remains with the employee (Copyright Act 1956, s 4(2)).

1.1.4.2 Commissioned artworks

A similar presumption applies in relation to commissioned artworks. Section 4(4) of the Copyright Act 1956 provides that where, after 1 June 1957 but before 1 August 1989, an artist was commissioned by a person to take a photograph, draw or paint a portrait or make an engraving or sound recording and the artist was remunerated in money or money's worth, the person who commissioned the artwork rather than the artist would be the first owner of the copyright unless there was an agreement to the contrary.

No express provision is made in the CDPA for artworks commissioned on or after 1 August 1989. As a result, copyright in such works will remain with the artist who created the work, unless there is an agreement to the contrary in which the artist assigns the copyright in the artwork to the commissioner. For this reason it is important for commissioners of works of art to set out in a written agreement the intended ownership of the copyright in the commissioned work.

1.1.4.3 Joint artworks

Where an artwork has been created jointly or where the copyright in the work has been assigned so that it is owned jointly, the copyright may be owned by more than one person. In such circumstances, the first question is whether the joint owners own the copyright as tenants in common – so that each owns a percentage interest – or as joint tenants, where the interest is jointly held by both authors and each have equal rights over the whole artwork. In the latter case the ownership of the copyright passes to the surviving joint owner on the death of a joint owner. In the former case it does not, and the deceased joint owner's interest can be passed on to a third party in a will. Either form of joint ownership is possible and will depend on the circumstances or upon the agreement between the joint owners.

In either case, no part owner may deal with the copyright in the work without the consent of the coowner.

1.1.4.4 Artworks not created by a human

In 2011 in the Indonesian jungle, a macaque monkey used a camera belonging to photographer David Slater to take a 'selfie' photograph. An online platform, Wikimedia, hosted the image and was accused by David Slater of copyright infringement on the basis that he owned the copyright.

Separately, Slater himself was sued in the US by PETA (The Society for Ethical Treatment of Animals). PETA argued that as the macaque monkey had physically triggered the camera shutter, the monkey owned the copyright in the resulting image. The US Court dismissed PETA's claim on the grounds that the US Copyright Office had issued an opinion in 2014 that artworks 'produced by nature, animals, or plants' cannot be granted copyright protection. Accordingly, the macaque was incapable of owning the copyright in the photograph.

Slater's infringement claim against the online platform was never litigated. The question of whether or not Slater owned the copyright in the image turns, in my view, on the question of the extent of his contribution. Slater said that he had set the camera up, framed the shot and set the exposure. He argued that he had therefore created the photograph regardless of the fact that the shutter was mechanically triggered by the macaque. Had the issue been litigated, I suspect that the courts in the US or the UK would probably have agreed with Slater on this.

1.1.5 Copyright infringement

So what protection does copyright provide? Once covered by copyright, the agreement of the copyright owner will be required to:

(a) reproduce the work in any material form (CDPA, s 17);

(b) issue copies of the work to the public (CDPA, s 18);
(c) rent or lend the work to the public (CDPA, s 18A);
(d) communicate the work to the public (CDPA, s 20).

A failure to obtain permission for any of these acts will constitute an infringement of copyright, which may entitle the copyright owner to damages and/or a court order preventing further infringements and/or requiring the destruction of infringing copies.

1.1.5.1 Liability for infringement

Each person who commits an infringing act is of course liable for the infringement, but the Act also extends potential liability to others. A person who imports into the United Kingdom an infringing copy of an artwork may be liable for infringement (CDPA 1988, s 22). Equally, a person who possesses an infringing copy in the course of a business (s 23(a)); sells, hires out or exhibits an infringing copy for sale or hire (s 23(b)); or exhibits in public or distributes an infringing copy (s 23(c)) may also be liable as a secondary infringer. Knowingly providing the equipment necessary for making infringing copies is also an act of infringement (s 24).

1.1.5.2 Reproduction or copying

Reproducing a copyright work in any material form means producing a copy of the work. In its simplest form this will mean the making of a facsimile copy such as a photocopy of the work. It will, however, also include the creation of an electronic copy of a copyright work stored on a computer or disc. It will also include making a two dimensional reproduction of a three dimensional object, such as a sculpture – or, indeed, a three dimensional reproduction of a two dimensional work (s 17(3)). There is no numerical minimum on the extent of the reproduction. Making a single unauthorised copy of a copyright artwork is an infringing act.

1.1.5.3 Issuing and communicating copies to the public

The issuing of copies to the public means putting copies of the artwork into circulation. Traditionally this would have been done through publication of the work in a book or magazine. Today publication is, however, just as likely – indeed, more likely – to occur through circulation on the internet, for example on social media or on a website. Such acts are also covered by the infringement of communicating the work to the public.

1.1.5.4 Rental or lending

As noted above, the rental or lending of copies of a copyright artistic work – or the original work itself – to the public is a restricted act under s 18 of the CDPA

1988. It does not, however, apply to works of applied art. Applied art for these purposes is the application of design and decoration to everyday objects to make them aesthetically pleasing, as opposed to traditional forms of art such as drawing and painting. However, the terms 'rental' and 'lending' do not include public performances, exhibiting or showing in public (s 18(3)(a) and (b)). Nor does s 18 apply where copies of works or the works themselves are made available between establishments which are accessible to the public.

1.1.6 Substantial part

We have seen above that copyright protection may extend not only to the whole of the artwork, but also to substantial parts of it (s 16(3)). Where the artwork or an element of the artwork has been copied not in whole but in part, the question arises whether the part copied is sufficiently substantial to be considered protected by copyright. It has been established that the substantiality test should be about the quality of the part reproduced rather than the quantity.[12] It follows that the part will be considered substantial if the part reproduced expresses the artist's intellectual creation. That can only be determined on a case by case basis, looking at the artwork and taking account of the overall impression of the reproduction.

1.1.7 Inexact copies and imitation

In some circumstances the issue is not the substantiality of the part of an artwork reproduced but the proximity of the reproduction to the original copyright protected artwork. Where an artwork has been imitated rather than slavishly reproduced, whether or not the imitation amounts to copyright infringement can only be determined on a case by case basis. In doing so it is important to remember that the protection afforded by copyright law does not extend to an idea, but to the expression of an idea. So, what is required is an analysis of what elements of the artist's artwork were copied. If the sum of those elements is sufficiently original as an expression of an idea, then the imitation or inexact copy may not amount to an infringement of copyright.

1.1.8 Fair dealing

There are certain limited circumstances where a copyright work can be repro-duced in the United Kingdom without the consent of the copyright owner. This is loosely known as 'fair dealing'. The term should not be confused with the US concept of fair use, which is less specific and of potentially broader ambit. The US has a fluid approach to permitting reproduction on grounds of fair use which is

[12] *Ladbroke (Football) Ltd v William Hill (Football) Ltd* [1964] 1 All ER 465, [1964] 1 WLR 273, HL.

designed to encourage innovation. This is in contrast to the European approach, which requires the use to fall within a clear set of exceptions.

1.1.8.1 Private use

Section 28B of the CDPA 1988 permits the making of a copy of a copyright work by an individual provided the copy is of the individual's own copy of the work. However, it must be for the individual's private use and made for noncommercial purposes. It will also become an infringing act if the copy is passed on to a third party.

1.1.8.2 Research purposes

Section 29(1) of the CDPA 1988 specifically permits the reproduction of copyright material for the purposes of research for a noncommercial purpose provided that it is accompanied by a sufficient acknowledgement. Fair dealing for the purposes of private study also does not infringe copyright (CDPA 1988, s 29(1C)). For example, a student photocopying images of an artwork in the course of research for a thesis would not need to seek the consent of the copyright owner.

1.1.8.3 Criticism or review

Section 30 of the CDPA 1988 similarly allows the copying of copyright material for the purposes of criticism or review, provided once again that the reproduction is accompanied by a sufficient acknowledgement and provided that the work in question has been made available to the public.

1.1.8.4 News reporting

The reproduction of a copyright work for the purposes of news reporting is also permitted as fair dealing under the CDPA 1988, s 30, although the author must be acknowledged. It is also important to note that the reproduction of photographs in the context of news reporting is excluded from this exemption. A newspaper is therefore able to publish a reproduction of a copyright artwork which has recently been sold at auction on the grounds that this is 'fair dealing' for the purposes of s 30 of the CDPA 1988. However, where the newspaper is seeking to reproduce a photograph of the copyright artwork taken by a photographer, the consent of the photographer, as the copyright owner of the photograph, will need to be obtained.

1.1.8.5 Caricature, parody and pastiche

Section 30A of the CDPA 1988 permits the reproduction of a copyright work for the purposes of caricature, parody or pastiche. It is sometimes the case that well

known artworks are parodied in a way which involves taking some recognisable part of the original copyright work. While this sort of parody is permitted under the CDPA 1988, it is only permitted to the extent that it can be considered as 'fair dealing'. This is a question of degree which must be assessed by the court in each case. A cartoonist could, for instance, include as part of a cartoon a well known work by the graffiti artist Banksy. That would not amount to an infringement. However, a facsimile reproduction of the Banksy artwork with a funny caption underneath would probably not amount to fair dealing. Equally, a parody which causes or is likely to cause economic damage to the copyright holder may not be considered 'fair dealing'.

The Court of Justice of the European Union provided some guidance on the parody exception in the *Deckmyn and another v Vandersteen and others*[13] case. The court indicated that to qualify as a parody, the parody should evoke an existing work while being *different from it*. The parody should also constitute an *expression of humour or mockery*. The overriding requirement, however, was that a balance should be struck between the rights of the copyright holder and the rights of freedom of expression of the creator of the parody work.

In France, Franck Davidovici, the creator of a photograph used in an advertising campaign for the brand Naf Naf, sued the artist Jeff Koons for copyright infringement on the grounds that a porcelain sculpture by Koons, *Fait d'hiver*, was an unauthorised reproduction of Davidovici's photograph. Davidovici's work featured a woman lying in the snow next to a pig wearing a barrel around its neck. The Koons sculpture featured a woman with the same face and hair as the model in the Davidovici photograph lying in the snow next to a pig wearing a ring of roses and a barrel around its neck, but with the woman wearing a revealing top and the addition of two penguins. Koons argued that his artwork was a parody and therefore permitted under the French equivalent of Section 30A of the CDPA 1988. In December 2021 the French court of appeal issued its judgment, rejecting Koons' argument on the grounds that the Koons work was simply a reproduction and did not amount to humour or mockery. The court noted also that Koons did not make any reference to the original Davidovici work, which the Court considered to be essential in order to qualify as a parody.

1.1.8.6 *Advertisement of a copyright artwork for sale*

A further important exception is the right under s 63 of the CDPA 1988 to reproduce an artwork for advertising purposes for the sale of the artwork. This means that copyright consent is not required for the illustration in an auction house sale catalogue of an artwork being offered for sale. Nor is it required for an artwork

[13] [2014] All ER (D) 30 (Sep).

illustrated on a website or Instagram feed as being for sale. It will, however, be required where other similar works, which are being offered for sale, are illustrated in the catalogue by way of comparison and context. Also, once the work has been sold the exemption no longer applies, so care needs to be taken following the sale to obtain copyright consent for any further commercial use of the image of the sold work.

1.1.9 Implied licences

In addition to the statutory exceptions where copyright consent is not required, the law recognises certain circumstances where, even in the absence of actual express consent from the author, consent to the use of the copyright work by a third party can be implied. The courts are however very cautious about implying such terms and will only do to the minimum extent necessary – and usually only in the context of a contractual relationship between the copyright holder and the third party. In *BP Refinery (Westernport) Pty Ltd v The President, Councillors and Ratepayers of the Shire of Hastings* [(1978) 52 ALJR 20] the UK courts' approach to implied terms in contracts was summarised as follows:

> […] for a term to be implied, the following conditions (which may overlap) must be satisfied: (1) it must be reasonable and equitable; (2) it must be necessary to give business efficacy to the contract, so that no term will be implied if the contract is effective without it; (3) it must be so obvious that 'it goes without saying'; (4) it must be capable of clear expression; (5) it must not contradict any express term of the contract.

It can therefore be seen that the cases in which the courts are likely to find that the copyright holder has granted an implied licence in a contractual relationship are limited to cases where the existence of the licence – even if not expressly referred to in the contract – is critical to the purpose of the contract.

In my view it is unlikely, outside of contractual relationships, that the courts will find that a copyright holder has granted an implied licence to another party or the public at large. Certainly, by publishing a work on the internet the copyright owner is unlikely to be found to have impliedly authorised reproduction by others. However, anyone publishing images in this way would be well advised to put the matter beyond doubt by including a statement on the website making it clear that the image is copyright and that reproduction or use of the image requires consent.

1.1.10 The Internet

The internet presents a practical challenge to the notion of copyright. The challenge it raises is not so much whether an artist's rights are protected on the internet, but whether those rights are capable of being policed and enforced.

1.1.10.1 A haven for copyright infringement?

As we photograph and record our surroundings on our smartphones and post those images to the internet on social media, very few of us give thought to the notion of copyright infringement. The internet is sometimes treated as a copyright-free area. That is certainly incorrect from a legal perspective. The reproduction and distribution of a copyright protected work on the internet is no different from a reproduction and distribution of the work on paper. A copyright owner has every right to prevent the unlicensed reproduction of his or her work on the internet. However, the difficulty lies in the ability to enforce that right. First, there is the challenge of identifying the infringer, who can be located anywhere in the world. Then there are the often prohibitive costs of asking the courts to recognise those rights. Finally, armed with a court decision in his or her favour, the copyright owner will need to enforce those rights – often only to find that the infringer has disappeared or has no assets. All of these factors make it difficult for copyright owners to seek to assert their rights in most cases of infringement, and it is only worthwhile to do so in major cases of infringement.

1.1.10.2 Social media

Given the fact that even everyday photographs benefit from copyright protection, users of Facebook, Instagram, Twitter and other social media applications may be concerned about the copyright status of images that they post on social media sites. At the time of publication, sites do not seek to acquire ownership in works posted on their sites, but those who use their services are deemed to have agreed to give the social media site a royalty-free unlimited licence to use the images. This, it could be argued, is little different in effect to an assignment of the copyright. The copyright owner loses control over the image. So, if you are an artist or if you are concerned about guarding the copyright in your images, thought should be given to the consequences of posting images on social media.

Instagram is typical in this regard. Its terms and conditions of use provide:

> We do not claim ownership of your content, but you grant us a license to use it.
> Nothing is changing about your rights in your content. We do not claim ownership of your content that you post on or through the Service and you are free to share your content with anyone else, wherever you want. However, we need certain legal permissions from you (known as a 'license') to provide the Service. When you share, post, or upload content that is covered by intellectual property rights (like photos or videos) on or in connection with our Service, you hereby grant to us a non-exclusive, royalty-free, transferable, sub-licensable, worldwide license to host, use, distribute, modify, run, copy, publicly perform or display, translate, and create derivative works of your content (consistent with your privacy and application settings). This license will end when your content is deleted from our systems.

Facebook similarly provides: 'when you share, post, or upload content that is covered by intellectual property rights on or in connection with our Products, you grant us a non-exclusive, transferable, sub-licensable, royalty-free, and worldwide license to host, use, distribute, modify, run, copy, publicly perform or display, translate, and create derivative works of your content.'

1.1.10.3 Web crawling and website scraping

In recent years there has been a rise in the number of companies and software products which gather data and images from third party websites. This practice, known as 'scraping' is estimated to account for up to 52% of website traffic, reflecting the growing importance to businesses of amassing data and images. There is no specific law in the UK which prevents such scraping but there is some guidance on how the courts will approach such activities.

In *Ryanair Ltd v PR Aviation BV* [2015] the Court of Justice of the European Union found in favour of the company which had scraped Ryanair's database of flight times and prices. This is because it found that the database did not satisfy the requirement of originality in order to be protected by copyright. As the database was not copyright protected, the scraper was entitled to extract and reproduce the information. In the UK Supreme Court case of *NLA v Meltwater* [2013], however, the subject of the scraping was news headlines. In this case the Court found that the news headlines did satisfy the requirement of originality and were therefore protected from reproduction by the defendant Meltwater.

It therefore seems that scraping is permitted provided that the data being scraped is not copyright protected. However, the *Ryanair Ltd v PR Aviation BV* case also made it clear that even where the data is not protected by copyright, the website owner can legally prevent scraping by including terms and conditions of use on the site which prohibit users from scraping. This prohibition can be enforced by means of contract law rather than through copyright law.

1.1.10.4 Online art sales databases

The growth of the internet has led to the establishment of a number of online databases listing art sales data, including images of the artworks. In those cases the images themselves may require copyright consent. In addition, where the images of the works are taken from an auction house or dealer's online catalogue, the consent of the auction house or dealer – as the owner of the copyright in the photograph – may be required.

1.1.10.5 Artworks created by artificial intelligence

In 2018 Christie's caused a sensation by selling Portrait of Redmond Belamy, created by artificial intelligence, for US$432,500, nearly 45 times its published estimate. Portrait of Redmond Belamy depicted a man dressed in a frock coat with a white collar showing. The appearance of the work was as though it was unfinished, with the facial features of the man blurred and indistinct. The areas of canvas surrounding the portrait are also left blank. The work had been signed using the mathematical formula of the algorithms used to create it.

The work was the brainchild of a Paris-based collective called Obvious. It was created using a technology called the Generative Adversarial Network algorithm (GAN). Composed of a two part algorithm – the generator and the discriminator – the system was fed a data set of 15,000 portraits painted between the fourteenth and twentieth centuries. The generator created new images based on this set, while the discriminator reviewed all outputs, comparing the product of the algorithm with the pieces painted by human hands until it couldn't tell the two apart. Once the computer algorithm had generated the image, this was then printed in ink on canvas. The objective of Obvious was to show that machines can be creative, just like humans.

The question, then, is whether a work which is generated by artificial intelligence is capable of being protected by United Kingdom copyright law. As we have seen, there is a requirement under United Kingdom law for the work to be 'original'. While the level of originality required is low, a human author must be involved. Section 9(3) of the CDPA 1988 does however explicitly allow for the possibility that copyright works can be computer generated in the sense that they are 'generated by a computer in circumstances such that there is no human author of the work' (CDPA 1988, s 178). In these circumstances s 9(3) of the CDPA 1988 deems the author to be the person by whom the arrangements necessary for the creation of the work are undertaken. In the case of the painting sold by Christie's, then, it will be the human user or programmer of the GAN tool.

If in the future artworks are able to be created fully autonomously, with no human intervention of any sort, then such works will not benefit from copyright protection.

1.2 Moral rights

1.2.1 Introduction

Moral rights are a series of rights given to artists by the CDPA 1988 Ch IV (ss 77–89) to ensure that the artist is given due recognition for creating the artwork

and that the work is not used or reproduced in a way of which the artist does not approve.

Moral rights are a concept which originated in non-common law countries such as France, where the artist and his or her descendants are seen as the guardians of artwork and the artist's oeuvre. Common law countries such as the United Kingdom have tended to use as the starting point the licensed owner of the copyright – which may or may not be the artist. It is perhaps for this reason that common law countries refer to 'copyright' and 'intellectual property', while in France the law is referred to as the 'Droits d'Auteur' (Author's Rights). Until the CDPA 1988 there was no express provision in UK copyright law protecting the paternity and integrity rights of the artist or author of a work. However, with the introduction of the CDPA 1988 the United Kingdom adopted the concept of moral rights in line with the 1928 Berne Convention for the Protection of Literary and Artistic Works.

It is important to bear in mind that a moral right can only exist where the work in question is protected by copyright. Also, because these rights were first introduced in the CDPA 1988, the protection of paternity and integrity rights do not apply to any act which occurred before August 1989.[14]

These moral rights have assumed greater importance to artists with the rise of digital communication, where images are copied, altered, incorporated into other images or contexts and distributed without credit or attribution with a few clicks of a mouse button. However, the extent and the ease with which this happens has meant that enforcing those rights has become extremely difficult. Communication on the internet through Facebook, Instagram, Snapchat and Tumblr is increasingly focused on images, and those images are routinely altered or doctored and are rarely attributed to the original author. This raises the wider question of whether, without a means of effective enforcement, the concept of moral rights can survive the advent of digital communication.

1.2.2 Moral rights

The moral rights, which apply to the whole work or any substantial part of it, are:

- The right of an artist to be clearly and reasonably prominently identified whenever the artist's work is commercially published, exhibited to the public or included in a broadcast or film. This is known as the Right of Paternity.

[14] CDPA 1988, Sch 1, para 22(1).

- The right of the artist to object to a reproduction or representation of the artwork in a way which the artist feels is derogatory. This is known as the Right of Integrity.
- The Right of False Attribution, which is the right not to be identified as the creator of a work created by someone else.
- The right of someone who has privately commissioned a photograph or film not to have copies of the work displayed or broadcast publicly. This is known as the Right to Privacy.

Under s 87 of the CDPA 1988 all of these rights can be waived by the person giving up the right, but the waiver must be in writing. The waiver may relate to a specific work, to works of a specified description or to works generally, and may relate to existing or future work. It may be conditional or unconditional and may be expressed to be subject to revocation. However, moral rights, unlike copyright, cannot be assigned, sold or given away to anyone else by the owner of the moral right (CDPA 1988, s 94).

When the owner of the moral right dies the right shall pass:

(a) By descent to whomever the deceased person has designated in his or her will; or

(b) if there is no provision in the will but the copyright in the work in question forms part of the deceased's estate, to whomever the estate passes, and

(c) if neither (a) nor (b) applies the decision as to who the moral rights shall pass to is for the deceased's personal representatives to make. (CDPA 1988, s 95)

1.2.2.1 Right of paternity

The right of an artist to be identified as the author of an artistic work applies where the work is published commercially or exhibited in public, or a visual image of the work is communicated to the public.

The right applies not only to artworks in the traditional sense, such as paintings, but also to sculpture, works of architecture, models of buildings, works of artistic craftsmanship more generally, and copies of graphic works or photographs which depict a work of art, where these are issued to the public.

The right also applies to films, and the director of a film has the right to be identified whenever a film is shown in public or copies of the film are made available to the public.

However, the artist needs to assert the right to paternity. In layman's terms this means that the artist needs to have laid claim to authorship of the work (CDPA

1988, s 78). This is usually done by the artist signing the work or subsequently notifying others of his authorship of the work.

As noted above, because the concept of moral rights was first introduced by the CDPA 1988, the right of paternity does not apply to artworks where the author died before 1 August 1989.

There are some works to which the right does not apply (CDPA 1988, s 79). The right does not apply to artworks which are a computer program, a typeface design or a computer generated work. Nor does it apply in connection with a reproduction of a work which has been specifically created for inclusion in a newspaper magazine or reference book and published with the author's consent. Nor does the right apply where the artwork is depicted in the course of reporting current events through a sound recording, film or broadcast.

1.2.2.2 The right of integrity

The right of integrity under s 80 of the CDPA 1988 protects artists from having their artworks subjected to derogatory treatment such as a 'distortion' or 'mutilation' of the original work or alteration in a way that harms the author's reputation or honour.

The right applies where the artwork or images of the artwork are published or broadcast commercially, where the artwork is exhibited publicly or where copies of the work are issued to the public (CDPA 1988, s 80(4)).

Derogatory treatment amounts to altering or adapting the work in a way which amounts to distortion or mutilation of the work or in a way which is otherwise prejudicial to the honour or reputation of the artist (CDPA 1988, s 80(2)(b)).

This fairly wide definition is generally considered to mean that artworks must be depicted or exhibited in full and without alteration. So, for instance, a magazine with an image of painting on its cover could be infringing the moral right of integrity of the artist if it were to depict only a detail or a part of the artwork, or if it were to reproduce the artwork in full with lettering across part of the image. As for the extent of the infringement, there is no requirement for the alteration or distortion to affect a substantial part of the artwork, so even a minor breach constitutes an infringement.

Perhaps surprisingly, s 80 of the CDPA 1988 does not envisage the destruction of the artist's work as amounting to derogatory treatment. There have been instances of the actual or threatened destruction of artists' works, and in such cases – under UK law, at least – the artists have been unable to intervene. Graham Sutherland's portrait of Sir Winston Churchill, commissioned by parliament, was famously

destroyed by Lady Churchill as she did not like it. The Japanese businessman Ryoei Saito, who bought Van Gogh's Portrait of Dr Gachet in 1990 for US$82.5m, is said to have threatened to have the painting cremated with him upon his death. More recently the graffiti artist Banksy destroyed one of his own works using a shredder incorporated into the artwork's frame. The shredder was triggered, for dramatic effect, immediately after the artwork was sold at a Sotheby's auction in October 2018. Of course, where the artist himself destroys the work, there can be no question of moral rights infringement.

Cases of deliberate attacks on artworks are also, sadly, not rare. In 1914 Mary Richardson slashed Diego Velázquez's *Rokeby Venus* at the National Gallery. In 1987 Leonardo da Vinci's *Virgin and Child with St Anne and St John the Baptist* was damaged by a shotgun attack. In 2012 a Polish artist, Vladimir Umanets, drew a 'tag' in black marker pen on the corner of Mark Rothko's *Black on Maroon* while it was on display at Tate Modern in London. Most recently, in 2020 Shakeel Ryan Massey was jailed after he pulled a Picasso painting on display at Tate Modern from the wall and threw it to the floor, punching a hole into it. While it is interesting from a legal perspective to consider whether these acts amount to infringements of the artist's moral rights, the law adopts a more straightforward approach of prosecuting on the grounds of criminal damage – sanctioning such acts with prison terms.

Another interesting question surrounds the context of the display and placement of artworks. Can an artist object if, for instance, his or her work is displayed along-side other works which the artists feels are demeaning, such as pornographic or religious works? Or can the artist object if his or her work is grouped with other works in a museum exhibition with a controversial title? The question has not yet been addressed by the courts.

An unusual situation arose in France in 2015 in connection with a sculpture by Anish Kapoor entitled Dirty Work. The work was exhibited in the grounds of the Palais de Versailles. The sculpture was vandalised when yellow paint was thrown over its interior. Kapoor asked that the paint be removed. The artwork was then once again vandalised, but on this occasion with antisemitic graffiti. Kapoor decided that the artwork should remain in its vandalised state as he did not want to allow the act of violence and intolerance to be erased. In France moral rights are more extensive than in the United Kingdom, giving artists the right to insist on the completion of a commissioned work, the right to withdraw an artwork and the right to prevent its destruction. It might be thought that Kapoor's insistence that the sculpture remain in its vandalised state would be respected as an expression of his moral rights. However, a local Versailles councillor disagreed and filed a complaint with the French courts demanding that the graffiti or the sculpture be removed on the grounds that leaving it in its present state incited racial hatred. The French court agreed and ordered the removal of the graffiti.

1.2.2.3 The right of false attribution

Under s 84(a) of the CDPA 1988 a person has the right not to have a literary, dramatic, musical or artistic work falsely attributed to him as author and, in the case of a film, not to have a film falsely attributed to him as director. An 'attribution' can be an express or implied statement as to who is the author of the work or the director of the film.

For there to be an infringement, the two elements must exist. First, there must be a false attribution; second, the person making the attribution must do so knowing it to be false.

Specifically, s 84(2) of CDPA 1988 requires that in order to constitute an infringement the work must be exhibited to the public or copies of the work must be issued to the public accompanied by a false attribution of authorship. And, as we have seen, the person doing so must know or have reason to believe that the attribution is false (CDPA 1988, s 84(4)). A person also infringes the right if, in the course of a business, he possesses or deals with a copy of a work in relation to which there is a false attribution if he knows or has reason to believe that there is such an attribution and that it is false (CDPA 1988, s 84(5)). An auction house or dealer knowingly handling a work which is falsely attributed to an artist is therefore at risk of action by the person to whom the work has been falsely attributed. In addition, a false representation that such a work is an adaptation of the work of a person is actionable in the above circumstances. This section will also apply where a copy of an artistic work is falsely represented as being a copy made by the author of the artistic work (CDPA 1988, s 84(6)(b)).

In contrast to the other moral rights listed above and below, which subsist for as long as copyright exists, the right of false attribution expires 20 years after the death of the person to whom the work is falsely attributed.

Most cases in which the right of false attribution has been an issue in the United Kingdom have centred upon literary works.[15] The right is, however, important for artists who want to protect their brand and in particular ensure that dishonest traders cannot use their name to sell works or copies of works which were not created by the artist.

The importance of protection of this kind for artists was emphasised in a bizarre US case in 2016. A former prison corrections officer, Robert Fletcher, and an art dealer, Peter Bartlow, tried to sell a work which they claimed was by the artist Peter Doig. Doig, however, refused to authenticate it on the grounds that he had

[15] See for instance *Clark v Associated Newspapers Ltd* 1988 1 All ER 959, in which the court held that the format of parodied diaries in the *Evening Standard* said to be by Alan Clark was deceptive.

not painted the work. Fletcher sued Doig for US$5,000,000 and a declaration of authorship, claiming that he had bought the work – a desert landscape – from Doig for US$100 while he was incarcerated at the Thunder Bay Correctional Centre, where Fletcher worked. Fletcher claimed he bought it to ensure that the painter, whom he said had been jailed on an LSD charge, would not go back to selling drugs. Doig was successful in proving that he was not the author of the work, and that he had never been incarcerated in Thunder Bay Correctional Centre on any charge. The claim therefore failed.

1.2.2.4 *The right to privacy in privately commissioned photographs and films*

Any person who, for private and domestic purposes, commissions the taking of a photograph or the making of a film on or after 1 August 1989 has the right under s 85(1) of the CDPA 1988 not to have copies of the work issued to the public, or the work itself exhibited or shown in public or communicated to the public. It is also an infringement of that right for anyone else to authorise others to do any of these things.

However, it is important to note (CDPA 1988, s 85) that the right is not infringed by an act which the CDPA 1988 deems to be an exception to copyright infringement. These include:

(a) s 31 (incidental inclusion of work in an artistic work, film or broadcast);
(b) s 45 (parliamentary and judicial proceedings);
(c) s 46 (Royal Commissions and statutory inquiries);
(d) s 50 (acts done under statutory authority);
(e) s 57 or 66A (acts permitted on expiry of copyright).

1.2.3 Application of moral rights

1.2.3.1 *Collaborative works and joint authorship*

In the case of a work of joint authorship, each author has his own separate right of paternity (CDPA 1988, s 88(1)) and right of integrity (CDPA 1988, s 88(1)). However, where the right of paternity is concerned, each of the coauthors must have independently asserted their rights of paternity.

1.2.3.2 *Duration of moral rights*

The right to be identified as author, the right to object to derogatory treatment and the right to privacy of certain photographs and films continue to subsist as long as copyright in the artwork subsists, this being the life of the artist plus 70 years. The right to object to false attribution however expires 20 years after the artist's death (CDPA 1988, s 86).

1.2.3.3 *Enforcement of moral rights*

There are a wide variety of remedies for breach of moral rights, such as injunctions preventing the exhibition or distribution of, or other prohibited acts relating to, the work in question. Damages are also available unless the defendant is able to prove that at the time of the infringement he or she did not know, and had no reason to believe, that copyright subsisted in the work to which the action relates (CDPA 1988, s 97). The court may also order that infringing copies of works should be delivered up to the claimant by the defendant (CDPA 1988, s 99).

The CDPA 1988 also authorises the holder of the right, in certain circumstances, to take the law into his or her own hands. Section 100 of the CDPA 1988 provides that where an infringing copy of a work is found on sale or exhibition, that work can be seized and detained by the copyright owner or by a person authorised by him. However, there are some fairly extensive conditions which limit the use of this right. Before anything is seized under this section, notice of the time and place of the proposed seizure must be given to a local police station. The right only extends to places where the public have access, but the right cannot be exercised where the object to be seized is to be found at a person's permanent or regular place of business, nor can any force be used to effect the seizure. When anything is seized under s 100 a notice must be left in a prescribed form containing details of the person by whom or on whose authority the seizure is made and the grounds on which it is made.

1.3 Artist's resale right

1.3.1 Introduction

French and German law have long incorporated the concept of the artist's right to be remunerated in relation to sales which occur subsequently to the first sale of the artwork. This was designed to address the concern that an impecunious artist who has sold his artworks for very little might later see his artworks changing hands for significant sums. The solution – a mechanism known in France as 'Droit de Suite' – was designed to ensure the artist and his estate would be entitled, for as long as the artwork was in copyright, to receive a proportion of the proceeds of sale each time his artwork is sold – similar to the royalty an author receives upon each sale of his book. Originally Droit de Suite applied only to auction sales but it has since been widened to apply to all forms of resale.

This concept did not exist in common law countries, and the proposal by the European Commission to incorporate the Droit de Suite into the laws of all European Union member countries was initially resisted by the United Kingdom. However, the measure was eventually pushed through, resulting in the European Parliament and Council Directive (EC) 2001/84 (OJ L272, 13.10.2001), p 32. Droit

de Suite was therefore incorporated into United Kingdom law through the Artist's Resale Right Regulations (ARR) 2006.[16] The 2021 EU–UK Trade and Cooperation Agreement contains an undertaking by the UK to operate an Artist's Resale Right scheme, despite Brexit. At the time of writing, therefore, the entitlement of artists to an Artist's Resale Right is expected to continue in the UK after Brexit.

It is important to note that the most significant art markets outside the European Union, including the United States and Hong Kong, do not levy an artist's royalty on resales. The absence of such a legal right has been one of the drivers, from the point of view of artists, for the popularity of NFT art. As we will see in section 1.6 below, it is possible to programme smart contracts so that each secondary sale of the NFT will automatically trigger a royalty payment to the artist.

1.3.2 Artist's resale royalty in the United Kingdom

1.3.2.1 Sectors of the art market are affected by the artist's resale royalty

Because the royalty is payable while the artist is living and for 70 years thereafter, the sectors of the art market which are primarily affected by the artist's resale right are sales of modern,[17] postwar, and contemporary art,[18] which account for approximately 75% of the UK fine art market by value.[19]

1.3.2.2 Types of artwork liable to artist's resale royalty

The ARR applies to graphic or plastic artworks which are protected by copyright, such as pictures, collages, paintings, drawings, photographs engravings, prints, lithographs, tapestries, ceramics or glassware (ARR 2006, reg 4(1)).

Posters of a graphic work which are authored by a named artist are covered by the ARR but commercial reproductions of artworks in the form of unlimited posters and prints do not qualify. This is because a copy of an artwork is not to be regarded as a work qualifying for the artist's resale royalty unless the copy is one of a limited number made by the artist or under the artist's authority (ARR 2006, reg 4(2)).

It is to be noted that the definition of works covered by the resale right in the ARR 2006 does not include furniture, silverware or jewellery.

[16] SI 2006 (ARR 2006).

[17] Modern is defined for these purposes as an artist born between 1975 and 1910.

[18] Postwar and contemporary is defined for these purposes as artists born after 1910.

[19] British Art Market Federation Report, *The British Art Market*, 2017.

1.3.2.3 The nationality of the artist

The artist must be a natural person who is a national of an EEA state,[20] or a national of one of the countries listed in Schedule 2 countries outside the EEA whose nationals may enjoy resale right.[21]

1.3.2.4 When is the artist's resale royalty payable?

The royalty is aimed at the 'secondary market' – transactions which take place after the first transfer of ownership of an artwork by the artist (ARR 2006, reg 3(1)). As a result, the royalty is not payable on the first transfer of ownership from the artist,[22] but is payable on each subsequent sale of the work.

1.3.2.5 What type of resale triggers the resale royalty entitlement?

'Sale' for the purposes of the ARR 2006 means a contract of sale under which the seller transfers or agrees to transfer the property in the artwork to the buyer for a money consideration, which is the price. The sale can be conditional or absolute.

To qualify, the resale must be by a buyer or seller or (if the sale takes place through an agent) an agent acting in the course of a business of dealing in works of art (ARR 2006, reg 12(3)(a)). The sale price of the artwork must also be no less than 1,000 EUR (ARR 2006, reg 12(3)(b)).

The sale will not qualify as a resale or trigger the royalty where, as we have seen above, the sale is a first sale by the artist or where (i) the seller acquired the artwork from the artist less than three years ago and (ii) the sale price is 10,000 EUR or less (ARR 2006, reg 12(4)). This provision is designed to ensure that where a dealer buys an artwork for 10,000 EUR or less direct from the artist for the purposes of resale, the dealer is not charged the artist's resale right on an onward sale to a customer within a reasonable period thereafter. However, where the dealer is unable to resell the artwork within the three year window and resells it thereafter, then the royalty will apply to the resale.

[20] Austria, Belgium, Bulgaria, Croatia, Republic of Cyprus, Czech Republic, Denmark, Estonia, Finland, France, Germany, Greece, Hungary, Ireland, Italy, Latvia, Lithuania, Luxembourg, Malta, Netherlands, Poland, Portugal, Romania, Slovakia, Slovenia, Spain, Sweden and the UK.

[21] Algeria, Brazil, Bulgaria, Burkina Faso, Chile, Congo, Costa Rica, Croatia, Ecuador, Guinea, Iraq, Ivory Coast, Laos, Madagascar, Mali, Monaco, Morocco, Peru, Philippines, Romania, Russian Federation, Senegal, Serbia and Montenegro, Tunisia, Turkey, Uruguay.

[22] A first transfer will include transfer of ownership from the from the artist by inheritance or by the artist's personal representatives for the purposes of the administration of his estate, and disposal of the work by an official receiver or a trustee in bankruptcy.

1.3.2.6 How much is payable?

The royalty is calculated as a percentage amount of the sale price, net of tax, but at the time of writing is capped so that the total amount of royalty payable on the sale of the artwork does not exceed 12,500 EUR.

The royalty is payable if the sale price of the artwork, net of tax, exceeds the pound sterling equivalent of 1,000 EUR. The royalty is calculated on a sliding scale.

4%[23]	Up to 50,000 EUR
3%	Between 50,000.01 and 200,000 EUR
1%	Between 200,000.01 and 350,000 EUR
0.5%	Between 350,000.01 and 500,000 EUR
0.25%	In excess of 500,000 EUR

The scale is cumulative so that the different percentages apply to each part of the sale price. For example, a work sold for 400,000 EUR will be charged at 4% on the first 50,000 EUR, 3% on the next 150,000 EUR, 1% on the next 150,000 EUR and 0.5% on the balance of 50,000 EUR. However, the total royalty will be capped at 12,500 EUR. No VAT is payable on the artist's resale royalty.

1.3.2.7 Who is entitled to the artist's resale royalty?

The artist is entitled to the royalty; following the death of the artist, the artist's entitlement passes to the artist's estate or successors in title (ARR 2006, reg 9). The royalty is payable for each sale as long as the artwork remains in copyright, which is usually the lifetime of the artist plus 70 years.

As we have seen, to qualify, the artist must be either (i) a national of a European Economic Area (EEA) country or (ii) a national of a state outside the EEA which permits resale right protection for authors from EEA states and their successors in title (ARR 2006, reg 10(3)).

The person whose name appears on the artwork is presumed to be the author of the work unless the contrary is proved (ARR 2006, reg 6(1)).

The right to the resale royalty cannot be shared by the artist with anyone else (ARR 2006 reg 8(1)), or assigned to anyone (ARR 2006, reg 7). However, where the artwork is a work of joint ownership, the resale right belongs to the joint owners in common – held in equal shares or such shares as shall be agreed between them in writing (ARR 2006, reg 5).

[23] Member States are entitled to charge up to 5% for sales up to 50,000 EUR if they so choose. The United Kingdom has opted to charge 4%.

Unusually, the resale right cannot be waived by the artist. A purported waiver of the right is deemed under reg 8 of ARR 2006 to be void.

1.3.2.8 The right to information

Any person entitled to the royalty, or their representative, has a right to such information as may be required to exercise the right. So an artist may require a dealer who has concluded a sale of one of the artist's works to disclose to the artist the sale price of the work. The person to whom the request is addressed is required do everything within his power to supply the information within 90 days of the receipt of the request. If not, the person making the request may apply to the county court for an order compelling the person to whom the request is made to provide the information.

1.3.2.9 Liability to pay the royalty

Regulation 13 of the ARR 2006 provides that the following persons shall be jointly and severally liable to pay the resale royalty:

(a) the seller; and
(b) one of the following:
 (i) the seller's agent; or
 (ii) if the seller does not have an agent, the buyer's agent; or
 (iii) where there are no agents, the buyer.

In other words, any and/or all of the above can be pursued by the artist for payment, either in full or in part, of the resale royalty.

There is a great deal of competition among auction houses to win major consignments from sellers. Auction houses have recognised that if the economic burden of the artist's resale royalty rests with the seller, then sellers of these consignments will be reluctant to sell works in countries where the artist's resale right applies. To address this concern they have therefore often adopted the practice of contractually shifting the financial burden onto the buyer. They have done this by charging buyers of qualifying artworks an additional sum equal to the amount of the artist's resale royalty. The auction house then remits that sum to the collecting society and the seller therefore receives no less in sale proceeds than he would have received had he sold his works in a non-EEA country. In the United Kingdom such an arrangement is permitted due to the overriding freedom of parties to contract and because there is nothing in the ARR 2006 which prevents it. The system was however challenged in France and has been the subject of a ruling from the European Court of Justice, which upheld the right under European law of auction houses to shift the contractual burden onto the buyer. In 2018 the French Cour de Cassation confirmed that view.

1.3.2.10 When is the royalty payable?

The royalty is payable on the completion of the sale. Anyone from whom the royalty is being demanded is entitled to withhold payment until evidence of entitlement to payment of the royalty is produced (ARR 2006, reg 12(2)).

1.3.2.11 Collection of the royalty

The artist cannot collect the resale royalty. That right may be exercised only through a collecting society (ARR 2006, reg 14) such as the Design and Artist's Copyright Society (DACS) and the Artist's Collecting Society (ACS) on the artist's behalf. The law also ensures that even where the artist has not appointed a collecting society to act on the artist's behalf, the collecting society is nevertheless deemed to be appointed to collect the royalty. This gives rise to an unusual situation where a collecting society which has never been asked by an artist to represent him is entitled to collect royalties on his behalf.

1.3.2.12 Problems with the artist's resale royalty

The principal difficulty with the artist's resale royalty is that it operates as a disincentive to sell qualifying artworks in the countries in which it is applied. A seller who does not wish to pay the artist's resale royalty can opt to sell in one of the many countries outside of the EEA that do not apply the artist's resale royalty. London, Paris and Berlin are therefore less attractive to sellers of qualifying artworks than other major venues such as the United States, Hong Kong and Switzerland, all of whom do not require payment of a royalty to the artist. The incentive to sell outside the EEA is even greater where the seller is selling a high value collection, where each work could trigger a 12,500 EUR royalty payment.

There are also legitimate questions to be asked about whether the artist's resale royalty has achieved its aim of benefiting poorer artists. Because the higher royalties are paid to the most established artists, the main beneficiaries of the artist's resale right have been wealthy artists and the large and wealthy artist's estates, such as the Picasso estate.

Difficulties also arise from the fact that it is triggered in full every time the work is resold. If a dealer purchases a high value qualifying work for resale then the resale right – which could be as high as 12,500 EUR – is payable. If the dealer sells it on to a buyer a week later, the full resale royalty is payable a second time. It could be argued that a more equitable way of dealing with this issue would be to charge the royalty as a percentage of the profit made on each transaction.

The dealer who purchases qualifying artworks direct from the artist to resell to the public can also run into problems if he does not sell the works on promptly.

While any resale within three years will not trigger the resale royalty, a sale after that time will do so.

It is also difficult to police. Private art sale transactions usually take place discreetly and out of the public view. Responsible art market players will account for transactions where the royalty falls due but there is a concern that an unscrupulous seller or agent could evade the royalty by simply not accounting for the transaction.

Because of these difficulties it is fair to say that, while broadly popular with collecting societies and many artists, the artist's resale right has been controversial in the United Kingdom art market.

1.4 Royalties and enforcement

1.4.1 Introduction

As we have seen, copyright law empowers the owner of the copyright – usually the artist or the artist's estate – to control or prohibit certain acts in relation to their copyright works. How the artist makes use of that power is a matter for the artist. They may either refuse to grant permission or grant permission subject to certain conditions, such as payment of royalties.

1.4.2 Royalties

While it is open to an artist not to consent to reproduction or distribution, most artists are happy to consent to the use of images of their works provided that it is done within certain parameters and provided that the artist is remunerated in the form of a royalty. The amount of the royalty and the terms of the use are a matter for negotiation in each case. Considering such requests, negotiating royalties and chasing payment is, however, an administrative burden, which many artists prefer to leave to collection agencies such as DACS.

The way in which this works is that the copyright owner will register with the collecting agency and enter into an agreement under which the agency is appointed on the copyright holder's behalf to administer the collection of royalties. The agency then regularly accounts to the copyright holder for any royalties collected. The agency will charge a fee for this service – usually around 20% of the royalties collected.

This centralisation of the approval and payment process is also helpful for those who are seeking consent for the use or reproduction of copyright images. Through the DACS website they can establish whether or not the copyright owner is repre-

sented by the collecting agency, and, if he or she is represented, seek consent from the agency.

1.4.3 Enforcement

Copyright in an artwork protected by copyright is infringed where it is reproduced or distributed without the permission of the copyright owner. Where this occurs the copyright owner will usually want to either prevent the infringement or obtain compensation for the unauthorised use.

Most such cases can be resolved by negotiation and without the need for court proceedings. However, where this is not possible the copyright holder may need to look to legal action for redress. The courts have wide powers to enforce a copyright holder's rights. These include an injunction to prevent an imminent or continuing infringement, the award of damages or an order for delivery up of infringing materials.

Sometimes the strict requirements for a work to qualify for copyright protection lead artists to explore other legal avenues which might offer similar enforcement options.

Example

- In order to enforce copyright it is of course necessary for the artist to identify him or herself as the author of the infringed artwork. In most cases this would not present the artist with any difficulty, but in the case of the street artist Banksy it caused the artist a very real problem. A central part of Banksy's brand is the fact that the public at large do not know the identity of the artist. While Banksy had often taken the position that he did not care about copyright, it was also the case that his work was being widely reproduced by others. A Banksy image of a protester hurling a bouquet of flowers was, for instance, used by a greeting card company, Full Colour Black. Banksy wanted to take action to prevent the use of this work but knew that doing so would mean having to publicly reveal his identity in the copyright infringement proceedings. His lawyers recommended that the company Pest Control Office Limited – which looks after Banksy's legal interests – register the image as a trade mark. In this way Pest Control Office Limited could, as the owner of the trade mark, take trade mark infringement action without Banksy being required to be involved or, crucially, to reveal his identity. Full Colour Black challenged the trade mark on the grounds that it was not being used by Pest Control Office Limited for trade purposes or for branding – a fundamental requirement for the validity of a trade mark. In order to show that it was being used for trading purposes, Pest Control Office Limited opened a pop-up shop called Gross Domestic Product

in South London. The shop sold merchandise created by Banksy, but rather than operating as a conventional retail outlet, it invited collectors to apply online to buy its stock. The European Union Intellectual Property Office was however unconvinced and ruled in favour of Full Colour Black. The decision concluded that the trademark had not in fact been used to commercialise goods, and that the Gross Domestic Product shop had been opened only after the legal challenge was made by Full Colour Black, and was established with the intention to circumvent the requirements of trademark law. Of particular interest is that the decision was influenced in large part by Banksy's unwillingness to avail himself of the protection afforded by copyright law.

1.4.3.1 Damages

The calculation of damages may be based upon the royalties which the copyright owner would have received had the infringer obtained consent for the infringing act. However, damages awards may also take account of other factors, such as the profits made by the infringer through the infringement or the financial or moral prejudice caused to the copyright owner through the infringement. In cases where the infringement is deliberate, s 97(2) of the CDPA 1988 also gives the court the ability to award additional damages for flagrant copyright infringement.

1.4.3.2 Injunctions

An injunction may be appropriate in cases where urgent action is needed to prevent an imminent infringement or the continuation of an existing infringement. A prohibitory injunction is an order issued by the court restraining a person from carrying out or continuing to carry out an act which infringes or may infringe the rights of another person. A mandatory injunction is a court order compelling a person to carry out a certain act, for example, to deliver up infringing copies of an artwork. Failure to comply with an injunction can have very serious consequences, including imprisonment. Injunctions are usually temporary measures, designed to preserve the status quo pending a hearing or trial of the issues. In most cases applications for injunctions are therefore made before legal proceedings have begun. In some cases the hearing will be inter partes, involving both the applicant and the defendant making submissions to the judge. However, in urgent cases the court will hear an application for an injunction on an ex parte basis. This means that the judge will make a decision based upon the submissions of the applicant only. In such cases, if the injunction is granted it will be served upon the defendant, who will then at a later date have an opportunity to make submissions to the court to get the injunction set aside or amended. If the defendant is unsuccessful the injunction will remain in place until the trial has taken place and the court has given judgment in the case. Injunctions are often considered to be the nuclear option of enforcement. This is because the grant of an

injunction can have a devastating effect upon the party subject to the injunction, regardless of the outcome of the trial. The risks for the applicant are also very high. Injunction applications are extremely expensive and the applicant can risk having to pay his own costs and those of the defendant if he or she loses at trial. The courts are therefore extremely careful to ensure that injunctions are granted only in cases where it is just and equitable to do so. Applicants for injunctions are also required to give undertakings, known as 'cross-undertakings in damages', to the court that in the event that the injunction turns out to have been incorrectly granted, the applicant will compensate the defendant for any loss suffered as a consequence of the injunction. The applicant will also be required to demonstrate that he or she has the financial means to honour that undertaking if called upon to do so.

The application for an injunction must be made with supporting evidence, setting out all the evidence on which the applicant relies. Where the application is made on an ex parte basis or on short notice there is an obligation to give full and frank disclosure including any material facts which do not support the applicant's case.

Applications for injunctions must be made without delay. Once the applicant becomes aware of the actual or threatened infringement he or she must act immediately by applying for an injunction. A delay in doing so will usually be fatal to the application. Certain requirements also need to be in place in order for the court to grant an injunction.[24] First, the court must be satisfied that there is a serious issue to be tried. In a copyright infringement case the applicant will need to demonstrate that an infringing act has been or is about to be committed, and that he or she has not consented to it. Second, the court will consider whether, if the injunction were not to be granted, an award of damages would adequately compensate the applicant in the event of an infringement. For instance, in a case where the copyright owner would, had he or she been approached in the first place, have licensed the reproduction of his artwork in return for a fee, the court will consider whether payment of damages equal to or greater than the royalty fee might be an adequate remedy, rather than an injunction. The answer in that case may be different to a case where an artist's work is being used in a context which he would not have consented to at any price. In such a case damages may not be an adequate remedy for an infringement. Third, the court will consider the balance of convenience. This involves taking a step back in order to determine whether the grant of an injunction is likely to unduly destabilise the affairs of one or the other party. Finally, the court can consider whether or not to take account of any special factors which are particular to the case.

It will be apparent from the tests above that the courts are extremely cautious about the grant of injunctions, and tend to prefer the option of a speedy trial

[24] *American Cyanamid Co. v Ethicon Ltd* [1975] 1 All ER 504.

where that is possible. From an applicant's point of view such applications are also fraught with risk. An unsuccessful application, or a successful application which is then followed by an unsuccessful claim at trial, can result in a very heavy financial costs burden.

1.4.3.3 Website blocking orders

The ease with which copyright can be infringed using the internet presents particular enforcement challenges for copyright owners. It is often difficult to identify and locate the owners of websites containing infringing material, let alone take enforcement action against them. As a result, many copyright owners seek to enforce their rights via the internet service provider (ISP) hosting the infringing site. The reason for this is that ISPs are easier to identify, and often within the jurisdiction of the copyright holder. While the ISP will usually not be liable for copyright infringement by third party websites which it hosts, it does have the power to block the website.

The ability of a UK court to order the ISP to block websites is to be found in s 97A of the CDPA 1988. For an application to the court for a blocking order to be successful, the following requirements must be met:[25]

• the defendant must be an ISP;
• the website in question must be infringing the claimant's copyright;
• the users or operators of the website must be making use of the ISP's services in order to infringe copyright;
• the ISP must be aware of another person using their platform or services to infringe copyright.

1.5 Graffiti and street art

The general public often consider graffiti and street art a form of antisocial behaviour. However, the success of artists such as Banksy has led to graffiti art or street art becoming more sophisticated and evolving into a recognised art form. The words 'graffiti' and 'street art' tend to be used interchangeably, but represent different, but related, art forms. Graffiti is associated with 'tags', which are symbols or signatures used to denote territory. Graffiti tends to be word or letter-based. Street art, on the other hand, is image-based art, although it may incorporate tags or words.

[25] *Twentieth Century Fox Film Corp v British Telecommunications (Newzbin2)* 2011 All ER (D) 275.

As we have seen, CDPA 1988, s 1(1)(a) states that copyright shall subsist in 'original [...] artistic works', which include graphic works and works of artistic craftsmanship including paintings and drawings. Graffiti and street art is likely to qualify for protection as a category of artistic work. And it is also important to remember that the protection exists for artistic works 'regardless of artistic quality'.[26] Graffiti and street art both also involve a level of creativity and skill, which will in most cases satisfy the requirement of originality. There is therefore no reason why graffiti and street art cannot qualify for copyright protection and therefore enjoy the intellectual property rights enjoyed by more traditional forms of artwork.

It is however necessary, for copyright protection to exist, that the author of the work is known. As much street art is created anonymously or under a pseudonym, this can be an issue. CDPA 1988 S9(5) states that the identity of an author shall be regarded as unknown if it is not possible for a person to ascertain his identity by reasonable inquiry. If the author is unknown, the artwork should be treated as an orphan work. Orphan works can licensed for exploitation but this requires a licence from the Intellectual Property Office.

One possible obstacle to copyright protection, however, could be where the creation of the artwork is an illegal act. While there is at the time of writing no caselaw on the point, it seems that there could be circumstances where enforcing the artist's intellectual property rights over the rights of the victim of a crime could fall within section CDPA S171(3), which provides an exception for the enforcement of copyright where to do so would be against a rule of law preventing or restricting the enforcement of copyright on grounds of public policy.

While street artists are likely to be more tolerant of acts of copying, overpainting and alteration than other artists, the popularity of this art form has drawn the attention of commercial organisations – and this is where graffiti artists may be more uncomfortable with breaches of their intellectual property rights.

1.5.1 Graffiti and street art as a recognised art form

A good example of the significant changes in public attitudes to street art and its acceptance as an art form is the US case of *Castillo v G&M Realty*, in which the court recognised street art as 'a major category of contemporary art'. The defendant in this case was Gerald Wolkoff, the owner of a Long Island 200,000 square foot warehouse known as 5Pointz, which had been used for the display of 45 authorised street art works created by a number of street artists over a period of ten years. Because of the display of the artwork the 5Pointz Property had over the

[26] CDPA 1988 S4(1)(a).

years become a well known landmark. The source of the dispute was the property owner's decision, without prior notice, to whitewash the artworks. The issue at the heart of the case was whether temporary artworks were of sufficient 'recognised stature' to qualify for protection against removal under the US Visual Artist's Rights Act 1990 (VARA). The court found that the 45 whitewashed works were indeed of recognised stature on the basis that they were of 'high quality, status or caliber that has been acknowledged as such by a relevant community, [which will] typically be the artistic community, comprising art historians, art critics, museum curators, gallerists, prominent artists and other experts'. The fact that the works were temporary in nature was no bar to them being accorded protection against removal under VARA. The court went on to conclude that Wolkoff had intentionally destroyed the works and that Wolkoff must therefore pay the artists who had created the works damages totalling 6.75 million dollars.

It is interesting to consider whether, in the United Kingdom, works of graffiti and street art could enjoy similar moral rights protection. One of the hallmarks of street art is that it is destined in most cases to disappear. This is a risk which most street artists are perfectly happy to accept – and, indeed, embrace.

Many street artists rely also upon the informal code of conduct which exists between street artists defining the circumstances in which a work can be placed over another work and the manner in which that can be done. These rules generally make it unacceptable to paint over another work completely. There are subjective exceptions to this rule based on the notion of mutual respect; for instance, where the artist doing the over-painting is more accomplished or can justifiably be said to be improving the original. An example, perhaps, of the latter was Banksy's reaction to the addition in 2020, to his image of a girl with a slingshot on a wall in Bristol. Someone had added words insulting Bristol County Council to the image. 'I'm kind of glad the piece in Barton Hill got vandalised," he wrote on Instagram. "The initial sketch was a lot better…' While these rules and conventions are not enforced by law, they are probably more effective at street level than invoking intellectual property law would be.

However, where the work has required a significant investment of effort and time, there may be increasing interest in the protection offered by the law. We have seen earlier in this chapter that the right of integrity under s 80 of the CDPA 1988 protects artists from having their artworks subjected to derogatory treatment such as a 'distortion' or 'mutilation' of the original work or alteration in a way that harms the author's reputation or honour. In principle there seems no reason why a street artist could not argue that s 80 of the CDPA 1988 should operate to prevent the destruction or mutilation of a graffiti artwork. Graffiti and street art are artistic works within the definition of the CDPA 1988 and the removal or overpainting of the work would seem to amount to 'distortion or mutilation of the work' and might be 'otherwise prejudicial to the honour or reputation of the author…'.

However, it is difficult, because of the inherent costs and time involved, to imagine a scenario where street artists might seek legal remedies against each other. If, on the other hand, the conflict arose between the street artist and the owner of the property on which the artwork appeared, it seems likely that a UK court would take into account a number of the factors identified in the 5Pointz case in order to strike a balance between the rights of the artist and the property owner. Some of the key issues, for instance, would be the question of whether the work was authorised or not, and the public interest in protecting the work.

Street art's insurgent image has made it a tempting subject for advertising campaigns seeking to appeal to a youthful audience. Street artists, often anxious to protect their image and avoid their work becoming mainstream, have in some cases taken action to prevent such use. One such case involved the Los Angeles artist Jason 'Revok' Williams, whose work – painted on the wall of a Brooklyn basketball court – was used as a backdrop in a television advertisement by the fashion brand H&M. When Revok served a 'cease and desist' notice on H&M, requiring the company to stop running the advertisement on grounds of copyright infringement, H&M responded by suing Revok, arguing that the artwork was the result of criminal conduct and therefore could not benefit from copyright protection. The case never came to court as the parties reached a settlement, with H&M withdrawing the lawsuit. This is not likely to be an isolated case. In 2021 the street artist Futura sued the clothing company North Face, alleging that the company had copied his signature 'atom design' motif for a range of its clothing. In response North Face announced that it would be phasing out the motif.

It is therefore in the context of advertising and merchandising that intellectual property rights are most likely to come into play for street artists. Street artists are likely to be justified in seeking to object, on copyright grounds, to the use of their works for the advertisement or promotion of products. They can also in many cases require an acknowledgement of their authorship. As we have seen, the moral right of paternity is intended to ensure that the artist is recognised as the author of their artwork. A book of street art or an advertising campaign depicting street art could, for instance, be required to identify the artists of the works of street art depicted. Artists who work using pseudonyms can avail themselves of these rights under section 71(A) of CDPA, which provides that 'if the author or director in asserting his right to be identified specifies a pseudonym, initials or some other particular form of identification, that form shall be used'. Street artists who work anonymously, however, cannot rely on the right of paternity unless and until they assert the right in writing.[27]

[27] CDPA 78(2)(b) and 78(3)(b).

1.5.2 Graffiti, street art and protection of third party property rights

To the extent that graffiti and street art is controversial, the controversy centres not so much upon the art as on the damage to the buildings and structures to which it is applied. Street artists need to be aware of the law in this regard.

The principal piece of legislation used relating to graffiti is s 1 of the Criminal Damage Act 1971. This Act provides that a person who without lawful excuse destroys or damages any property belonging to another, intending to destroy or damage any such property or being reckless as to whether any such property would be destroyed or damaged, is guilty of an offence.

The Criminal Damage Act 1971 provides for a fine of up to £5,000 or a community service order where the damage caused by the graffiti is £5,000 or less. The community service order is used principally in relation to young offenders. Where the damage caused exceeds £5,000 the case will be referred for trial to the Crown Court, which has more extensive sentencing powers, including imprisonment.

Whether or not an offence has been committed will depend upon the attitude of the owner of the property to which the graffiti has been applied. If the owner consented to the graffiti or does not regard it as being damage, no offence will have been committed. It is also a defence for a person charged with an offence under the Criminal Damage Act 1971 to argue that at the time of applying the graffiti he or she believed that the owner of the damaged property had consented to application of the graffiti, or would have so consented to it if he or they had known of it.

Police investigating criminal damage caused by graffiti art are also entitled, under the Criminal Damage Act 1971, to obtain a warrant to search a suspect's home and computer records in order to find evidence. It is also an offence under s 3 of the Criminal Damage Act 1971 to be found in possession of anything – which would include spray cans – with intent to destroy or damage property. However, there are no stop and search powers under the Criminal Damage Act 1971.

In addition to the Criminal Damage Act 1971, the Clean Neighbourhoods and Environment Act 2005 gives local authorities the power to issue a fixed penalty notice – usually £75 – for anyone caught applying graffiti. Provided the fixed penalty is paid within 14 days, no criminal proceedings can be brought against the person to whom the notice has been issued. The Clean Neighbourhoods and Environment Act 2005 also makes it illegal for retailers to sell spray paint to people under the age of 16. It is a defence for the retailer to prove that he or she took reasonable steps to confirm the age of the person buying it.

While graffiti and street art is usually controversial due to the damage it causes, the content of the artwork can, as with any artwork, also be problematic. Arguably,

the fact that graffiti is usually prominently and publicly displayed makes it even more exposed to charges where it uses images or words which incite racial hatred or religious hatred. Such images and works can amount to an offence under the Public Order Act 1986 and the Racial and Religious Hatred Act 2006 (see section 10.5.3, 'Art, religion and race').

The question of ownership of graffiti and street art also arises where it is applied to an object or building belonging to a third party. This issue was addressed in the case of Creative Foundation v Dreamland Leisure.[28] In 2014 the artist Banksy had applied graffiti to the wall of a building owned by a landlord, Stonefield Estates Ltd. Recognising that graffiti works by Banksy commanded significant prices in the art market, the tenant, Dreamland Leisure, removed the wall with the graffiti and sought to put it up for sale. It did so relying on a clause in its lease requiring it to remove or paint over graffiti. The court held that, notwithstanding the obligation to repair, the ownership in the wall – and therefore the artwork on it – remained with the landlord.

While this case dealt primarily with the question of ownership of the wall and the artwork, there is also the question of who owns the intellectual property rights in the artwork. Although this was not the primary issue in the Creative Foundation case, the judge confirmed obiter that copyright remains with the artist. The result is that graffiti has a double ownership structure. The building owner is the owner of the graffiti artist's 'canvas' whereas the image rights remain with the graffiti artist. This raises the interesting question of whether the artist can object to the sale of the work by the building owner. The likely answer is that he or she cannot, provided his or her moral rights are not infringed (see section 1.2.2, 'Moral rights'). However, he or she will in principle be entitled to artist's resale royalty on any resale and, as the owner of the copyright in the image, will be entitled to control over copying and reproductions of the artwork.

1.6 NFTs and digital art

Digital art tends to be thought of as a separate category of art, and this might suggest that it should be subject to different legal rules. Perhaps this is because its artistic value tends to be questioned in a similar way to street art, or perhaps it is because digital art is able to be so freely reproduced. In fact, while it is a relatively recent way in which to create artworks, digital art is treated, from a legal perspective, in very much the same way as a non-digital artwork.

28 [2015] EWHC 2556.

Specifically, digital art enjoys copyright protection provided it is an artistic work and satisfies the requirement of originality under the CDPA (see sections 1.1.1 and 1.1.2 earlier in this chapter). It also enjoys the protection of moral rights (see section 1.2 earlier in this chapter).

Certainly, digital art has come of age as a popular and recognised art form. The fact that it can be produced, sold and acquired in immediate online transactions has added to its appeal. The difficulty, however, with digital art is that the fact that any one digital artwork can be so readily copied and reproduced online means it often lacks the financial value which goes with scarcity and with owning a unique physical artwork.

1.6.1 What is a non-fungible token?

In 2021 the sale by Christie's of a digital artwork, *Everydays: The First 5000 Days* by the artist Beeple, for a staggering $69,000,000 caused a sensation in the traditional art world. The artwork was a digital collage of 5000 individual works, and this in itself caused some debate over the artistic merit and value of digital art. What was novel for the international art market, however, was not the artwork but the fact that this digital artwork was sold as a non-fungible token (NFT). The fact that an NFT could be sold for such a price caused a shockwave, which was followed by an art market-wide scramble to understand the phenomenon.

An NFT is a digital unit of computer code or data which is stored on the blockchain. The blockchain is best thought of as a kind of virtual record of ownership – a spreadsheet or ledger of transactions which is checked and counterchecked by a network of thousands of participating computers across the world who hold duplicates of the ledger. Because a change can only be made to the digital ledger with the agreement of all the computers in the network, the blockchain is considered to be difficult or impossible to change or hack.

Once it is registered on the blockchain the NFT can be traded or sold and, for instance in the case of *Everydays: The First 5000 Days*, the owner of the NFT will have access to the particular version of the digital artwork by Beeple that was sold by Christie's in 2021. While there are and will continue to be many identical versions of *Everydays: The First 5000 Days* displayed, exchanged and reproduced in cyberspace, the version which was sold at Christie's will be the only one which is linked to the NFT created by Beeple and sold at Christie's in 2021. NFTs are usually digitally linked to digital assets but it is also possible for an NFT act as an ownership record relating to a physical object. This is however less common due to the difficulty of creating a link between the virtual and physical world which binds or matches the NFT to the physical object.

1.6.2 Creating and selling a non-fungible token

Producing an NFT works like this: the creator of the NFT will 'mint' an NFT on the blockchain for an artwork. Minting an NFT creates a record on the blockchain of the creation of the NFT. It means in practice that the creator of the NFT creates a digital token which is registered on the blockchain and which can, from that point onwards, be traded. The token is the record of the NFT owner's ownership of the artwork. Where the subject of the NFT is a digital artwork, the NFT will also provide access to a digital video, audio or image file held on a remote server or website. The digital artwork may be held on a third party website, on a peer-to-peer network such as the Interplanetary File System (IPFS) or on the blockchain itself.

The next stage is the sale of the NFT. This is usually done using an online trading platform which is authorised to sell the NFT by executing a 'smart contract'. The smart contract is a piece of coding which automatically executes the transfer of ownership of the NFT once a set of pre-defined conditions have been satisfied. With the execution of the smart contract, the different elements of an art sale transaction which usually happen sequentially (invoicing, transfer of funds, delivery of the artwork, and so on) happen all at once and this is recorded in the blockchain. Because this occurs automatically, the element of trust required for traditional contractual relationships is not necessary. Transactions of this kind are also said to be transparent as the blockchain, which can be inspected by anyone, records the minting of the NFT followed by each subsequent transaction through the trading platform in which the NFT changes hands.

Where auction houses sell NFTs, the sales are often 'off-chain'. This means that, unlike on trading platforms, which usually sell 'on chain', the NFT and the artwork are not stored on the blockchain while the auction happens. The process of exchanging the NFT for the purchase price is carried out manually outside of the blockchain, as in a traditional auction. The NFT is held on a hard drive which is often not connected to the internet. Then, following the sale, the NFT is then placed on the blockchain.

1.6.3 Early NFT sales

The Christie's Beeple sale was followed shortly afterwards by a number of NFT ventures. In April 2021 Phillips sold an NFT for an artwork known as *Replicator* by the artist Mad Dog Jones for more than US$4 million. The smart contract for this NFT was designed to create a limited number of similar NFTs over the following 12 months, which the owner could choose to keep or trade onwards.

Damien Hirst then launched the project 'The Currency', which involved minting and selling NFTs connected to 10,000 dot paintings which were similar but unique

and stored in a vault in the United Kingdom. Each NFT cost US$2,000. However, 12 months after the purchase, those who had bought the NFT would be required to decide between keeping the digital token or keeping the physical artwork. Choosing to keep the NFT would result in the artwork being destroyed. Choosing to keep the artwork would result in the NFT being destroyed. It was reported that, a month after the launch of the project, the NFTs were changing hands at ten times the original price.

In September 2021 Sotheby's sold a bundle of 101 NFTs linked to avatars depicting cartoon apes, known as Bored Apes, for more than US$24 million. These avatars are unique cartoon images of apes with various subtly different traits and attributes, and can be attached as a profile image to the owner's social media accounts.

More spectacular and unusual NFT sales will no doubt follow in years to come. And with the speed of developments in this area, it is likely that the sale of digital art and NFTs will develop in ways at which, at the time of writing, we can only guess. There is no way of knowing, for the time being, whether art NFTs are a temporary phenomenon or a permanent fixture. Different players in the art market will adopt different strategies depending on their view. However, while NFTs remain a phenomenon, it is important to understand the opportunities and risks associated with them.

1.6.4 The advantages of NFTs

The use of NFTs in the sale of art has been an important development because it addresses a number of issues.

The first was that the blockchain had, despite initial enthusiasm, proved in practice to be of limited use in connection with the authentication and provenance recording of physical artworks. This was largely because of the difficulty of creating a unbreakable link between a blockchain record which exists in cyberspace and the physical object to which it relates. Digital art, on the other hand, does exist in cyberspace and can therefore be more easily linked to the blockchain record.

As we have seen, the problem with digital art is that it can be so easily reproduced that, in the absence of scarcity, the original work may not have financial value. The advantage of linking digital art to the blockchain using NFTs was that this would allow the creator of a digital artwork to designate a particular image or a series of images as the verified original versions of an artwork, even where identical images of that artwork are ubiquitous. This designation confers upon those designated copies of the image the cachet of authenticity and rarity. This in turn makes these blockchain-linked copies tradable assets.

The rise of NFTs was also seen as a means by which higher levels of transparency and trust could be brought to art transactions. The blockchain would ensure that artworks could be traced back to the artist and each subsequent transaction would also be available for inspection. In this way the blockchain would take the guess-work out of authenticity and provenance.

NFTs are extremely attractive to artists. Digital artists had difficulty monetising their artworks because, unlike physical artworks, they could be so readily repro-duced and shared. Because NFTs designate a single copy of the digital artwork as being the authentic version, the NFT creates value through scarcity and confers on the NFT owner a record of that ownership – both of which create value. Artists also sometimes see the traditional art world as a barrier between the artist and the public. NFTs are seen to be a way in which artists can offer their works for sale directly to the public without the need for dealers and auction houses. Further, by embedding a royalty payment requirement into the NFT smart contract, the artist could require a percentage of each subsequent transaction involving his or her art to be paid. This digital form of artist's resale royalty allows the artist to share immediately in the success of an artwork where the NFT is subsequently successfully traded.

1.6.5 Potential legal issues with NFTs

1.6.5.1 Link/access obsolescence

A major potential difficulty with NFTs is that, as we have seen above, the NFT is simply a link to the digital artwork which sits on a third party site. That link is effective only for so long as that site exists and for as long as the NFT is effective in providing access. What happens when, in years to come, the site ceases to exist? Or the link is corrupted or fails to work? Or technology moves on, rendering the link obsolete? This risk is greatest where the artwork is hosted on a third party website. A more secure way of guarding against link obsolescence is to place the artwork on the blockchain or to host the artwork on a peer-to-peer network such as IPFS, which allows participants to download mirrored versions of the information on a website from computers belonging to other participants. In this way, the inten-tion is that if the website ceases to work, its content will still be available elsewhere on the internet. None of these methods are, however, a guarantee of future-proof permanence.

1.6.5.2 Future replication

The uniqueness and cachet afforded to a digital artwork can be quickly eroded if the artist mints further NFTs relating to the same or similar artworks.

1.6.5.3 No intellectual property rights

It is also vital to bear in mind that by acquiring a digital artwork – just as with a physical artwork – the owner does not (unless otherwise agreed with the artist or copyright owner) come to own the copyright in the digital artwork. If the new owner wishes to reproduce a copyright digital artwork or circulate copies on the internet, that would require the consent of the copyright owner. This is not a problem for owners of physical art, who are usually content to display their artworks on the wall. But the display of digital artworks so often requires their circulation and reproduction. This does therefore raise the question of what the value of ownership of the digital work, beyond kudos, is. Some NFTs give the NFT owner limited rights, licensed by the copyright owner, to reproduce or share the image of the artwork for private and non-commercial purposes. This is for instance often the case where the artwork is an avatar which the NFT owner will want to display or share. But such licences are usually clear that ownership of the copyright remains with the copyright owner and that the limited licence granted to the NFT owner does not usually extend to commercialising the image.[29] In the absence of such a licence the default position is that the owner has no right to reproduce or share the artwork without the consent of the copyright holder. Some might ask whether, in the context of digital art, this undermines the value of ownership? Perhaps the answer is that ownership confers not just credibility but also membership of a community – that you understand and have invested in the artform. When you think about it like that, it shares many characteristics with the traditional art market.

1.6.5.4 Seller's right to sell

Anyone buying an NFT should also take care to ensure that the artwork or file to which the NFT relates is in fact owned by the person selling the NFT or, if not, that the NFT owner has the necessary permission to sell it. There have been cases already of artists complaining that their work has been tokenised without their permission. In 2021 the illustrator Derek Laufman claimed that someone had impersonated him in order to set up a verified account on an NFT trading platform and begun to sell Laufman's artwork as NFTs. The risk was further highlighted when a company called Global Art Museum began in 2021 to mint NFTs relating to open source images of physical artworks hanging in leading museums such as the Rijksmuseum in Amsterdam. This caused considerable controversy and Global Art Museum subsequently claimed that this was a 'social experiment'. It neatly illustrated, however, that the process of attributing or claiming ownership of digital works can in some cases not be straightforward. The Global Art Museum controversy did not however prevent museums venturing into the world of NFTs.

[29] An exception to this are the Bored Ape NFTs, which do grant the owner the right to make commercial use of the image associated with the NFT.

The British Museum, the State Hermitage Museum, the Uffizi Galleries and the Whitworth Art Gallery have all sold NFTs based on their collections. The NFTs are usually of public domain artworks – which are themselves not in copyright. But because the digital photograph which the museum has created of the artwork is subject to copyright (see section 1.1.2.1), the museum is able to issue editions of the museum's image described as limited editions. This approach, marketing limited-edition NFTs of public domain works, has been criticised by some as being a way 'to confect scarcity where none exists'.[30]

1.6.5.5 Blockchain manipulation

There is also a concern that the blockchain, seen as the incorruptible source of truth, is open to manipulation. While the blockchain may faithfully record each transaction, the data it holds may not be reliable or may be misleading. For instance, the identity of the owners of the digital wallets involved in the transaction is usually hidden to the public. So while it is true that transactions between wallets are recorded on the blockchain and can be examined by the public there is no obvious way for the owners of wallets to be identified. This leaves open the possibility that records of high value sales can be generated on the blockchain where the sale is in fact between two wallets owned by the same person – known as 'washing trading' – or that the transactors have a common interest in pushing up the price of the NFT. 'Flash loans', which provide instant uncollateralised cryptocurrency loans which are taken out and automatically repaid in one transaction using a smart contract, allow buyers to buy NFTs from themselves or related parties using borrowed money and repay the loan in the same transaction. This potentially could allow the NFT to be recorded on the blockchain as being sold in a high value transaction without putting their own funds at risk.

1.6.5.6 Environmental concerns

At the time of writing, NFTs are also problematic from an environmental point of view. Each time an NFT is minted or traded on the blockchain a huge amount of computing power is deployed. It is said that minting an NFT related to an artwork on the blockchain uses weeks, months and sometimes even years of an average person's energy consumption. This is an extremely unattractive and controversial aspect to NFTs.

1.6.5.7 Understanding what is being acquired

Perhaps the biggest question surrounding NFTs is the more fundamental issue of what the buyer believes himself or herself to be buying when buying an NFT.

[30] Should museums be dabbling in NFTs? *Apollo Magazine* 25 October 2021.

As we have seen, the buyer does not acquire the artwork or the copyright in the artwork; nor does he or she have the exclusive right to view or display it, as there are often many identical versions of the artwork in existence. Rather, the buyer is buying the right to say that he or she has access to a particular copy of an artwork which has been digitally designated or autographed by the artist. Critics of NFTs have described them as a mere 'electronic receipt that anyone can make pointing to anything'.[31] This, and the risks associated with NFTs must always be fully understood by buyers.

1.6.5.8 Financial and value risk

The underlying artistic value of much of the NFT art available has often been questioned. Certainly, the arrival of NFTs has sparked a great interest in digital art and, as with any art form, there are fans and detractors. However, to some extent this criticism misses the point. It is fair to say that one of the key attractions for collectors of NFT art is not the artistic value, but the ability to trade the artwork easily as an asset. Just as with cryptocurrency, both the artist and the collector hold an underlying hope that the NFT asset will gain in value – perhaps exponentially. There is some basis to this hope as it has happened on many occasions, most strikingly in the case of Beeple. There are many collectors who have seen the value of their NFTs rocket, and this may continue; or the NFT market may stabilise with more modest growth as NFTs find their price point. However, just as with investments in cryptocurrency, the likelihood of an NFT artwork appreciating in value or indeed maintaining its value is dependent on the popularity of NFTs generally, and the cachet of ownership of that particular NFT. If both are maintained, the value of the NFT could indeed continue rising. However, take either of these factors away and the value of the NFT may well diminish – perhaps even dramatically.

In December 2021 the Bank of England warned that the cryptocurrency Bitcoin could become worthless and people investing in digital currency should be prepared to lose everything.[32] That risk must also exist in the world of NFTs.

As digital assets, NFTs are also vulnerable to being stolen by hackers, and access to the NFT can be lost through corrupted files, phishing attacks or the loss of a password. NFTs have also shown themselves to be susceptible to scams and insider trading. Scams known as 'rug pulls', where a crowdfunder disappears with crowdfunded money, are becoming more common, as are 'pump and dump' schemes, where start-up NFT projects are abandoned after being promoted by generating large numbers of followers on Twitter to encourage investment. Washing trading,

[31] Ryan Cooper, The NFT craze has stopped being funny, *The Week* 4 January 2022.
[32] Bitcoin could become 'worthless', Bank of England warns, *The Guardian* 14 December 2021.

referred to above, is also a risk in the largely anonymous crypto world, where crypto assets are bought and sold through wallets owned or controlled by the same or related people in order to drive up the price.

At the time of writing it is difficult to say whether NFTs will remain an important part of the art world landscape. It is also impossible to predict whether the NFT works which have been sold for record prices will maintain their value in years to come. The two questions are perhaps inextricably linked. Whatever the future for NFTs, their arrival has undoubtedly sparked some important discussions about digital art and some novel legal and artistic questions.

1.6.6 Fractional ownership

A phenomenon associated with the rise in NFTs has been the concept of fractionalised ownership of art. The idea is that a series of NFTs are minted which give the owner a part share in a physical artwork. Those NFTs can then be registered on the blockchain and traded. The argument in favour of such an arrangement is that it makes the ownership of art accessible with a modest investment, and the costs of ownership are shared. At the time of writing, however, such schemes have not yet proved to be widespread. This is because in many countries – including the United States – this would be considered to be trading securities, which is a regulated activity and cannot be carried out by anyone other than accredited entities or persons who are supervised and regulated by the securities authorities.

One challenge for fractionalised ownership schemes is that even with a 'blue-chip' name, it cannot be assumed that art will increase in value. The asset which is the subject of the investment is unique and its performance as an investment will depend upon many factors beyond its authorship. Factors such as the period, the medium, the rarity, the quality of the work, its size and its 'wall-power' will all play a part. The extent to which those factors are understood by the person offering the fractionalised ownership shares, or by those who purchase them, will vary. Ultimately the success of any fractionalised art scheme is dependent on whether the sale of the fractionalised ownership artwork can generate the promised returns.

A form of fractionalised ownership is the use of crowdfunding by means of decentralised autonomous organisations (DAOs). A DAO is a virtual organisation with no central decision-making process. DAOs are used for crowdfunding where members invest in the DAO, and whose ownership is recorded on the blockchain. Members of the DAO are given voting rights on key decisions. The theory is that by eliminating the intermediary investment mistakes are eliminated or reduced. But DAOs, like intermediaries as susceptible to making questionable investment decisions too. In 2022 Spice DAO bought a rare art book by director Alejandro Jodorowsky containing storyboards and concept art relating to an unmade film adaptation of Frank Herbert's novel *Dune*. The book was sold at auction to Spice

DAO for £2,200,000 (more than 100 times the estimate). Spice DAO announced following the auction that it planned to convert the book into NFTs, burn the physical copy and adapt the story into an animated series. These plans were appeared however to be based on the assumption that by buying the physical book the DAO had also acquired the copyright in the work. As with any purchase of art at auction the buyer acquired the physical artwork but not the intellectual property rights necessary to commercialise it. Without the copyright license from the Frank Herbert estate and from Alejandro Jodorowsky, much of Spice DAO's plans to create derivative works such as an animated series could in practice not be implemented.

Auction sales: introduction

2.1 The popularity and psychology of the auction

In 2020 sales of art and antiques at auction worldwide reached a total of US$17.6 billion. Largely due to COVID, this was 30% less than the $25.2 billion total in 2019 but it remains a staggering figure.[1] Sales by auction remain hugely popular and are increasingly global, and, as a result of the internet, increasingly accessible. Indeed, the effect of the COVID lockdown was to dramatically increase the popularity of online auction sales, even for the most valuable of artworks. We will analyse the importance and legal issues surrounding online sales in greater detail in Chapter 7. The global art and antiques market by value of sales remains dominated by three countries: the United States (42%), China (20%) and the United Kingdom (20%). Sales in the United Kingdom in 2020 amounted to US$9.9 billion.[2] The purpose of this book is to illustrate how the law applies to the business of art. As a result, before analysing the legal rights and obligations involved in an auction, we will spend some time considering the mechanics and commercial drivers of auctions. Those readers who are already familiar with the functioning of the auction process may want to skip ahead to Chapter 3, where we cover the legal framework.

An auction is a sale, open to the public at large, in which property is offered for sale to the highest bidder. It is an ancient practice, known to have been used by the Greeks in 500 bc and then later by the Romans. At that time it was used primarily as a means of disposing of the spoils of war, but the auction was also used for slaves and even for daughters to be wives. Auctions saw a revival in Europe during the seventeenth century and in 1744, 1766 and 1796 respectively, the Sotheby's, Christie's and Phillips auction houses came into being. Today, while the international auction market continues to be dominated by those houses, there are many local and specialised auction houses holding regular sales throughout the United Kingdom.[3] While the arrival of the internet has made auction rooms more

[1] Dr Clare McAndrew, Art Basel and UBS report, The Art Market 2021.

[2] Dr Clare McAndrew, Art Basel and UBS report, The Art Market 2021.

[3] In this chapter I will tend to focus on practices which are applicable in international auction houses. Those practices may not be appropriate or may vary in local or national auction houses.

accessible, the underlying auction process and the reasons for its popularity are fundamentally the same today as they were 500 years ago.

How has such an ancient method of sale retained its popularity? And why is it as relevant today as it was in the seventeenth century? The principal reason is that disposal of property by auction is extremely efficient. It allows large quantities of property to be offered for sale and sold within a few hours. This is important where speed is of the essence. It is therefore no surprise that the consignments of property to auction houses have traditionally been triggered by one of the 'three Ds': debt, divorce and death.[4] All of these circumstances require the seller to raise cash speedily and efficiently while ensuring that the property is sold at market price.

However, speed and efficiency are not auctions' only attraction. The enduring popularity of auctions over ordinary sales privately negotiated between a buyer and a seller lies principally in the juxtaposition of expectations. Artworks are usually unique objects and the value of each artwork is determined by the appetite of buyers for that artwork at a particular moment in time. There is no better way to determine that value than offering it up for sale to the widest possible market of potential buyers. In doing so the seller hopes for a competitive battle between bidders, pushing the price upwards, beyond what could be achieved in an ordinary sale negotiation. The buyer, on the other hand, usually hopes to secure a coveted object, without paying over the odds and preferably at a bargain price. The auction itself is an accelerated negotiation in which emotion and adrenaline can often play significant parts – and it is the resulting unpredictability which allows both seller and buyer to dream. The role of the auctioneer is, through clever marketing and charisma, to generate and encourage that drama. It is not just the bidders who experience the excitement. The public nature of the spectacle makes the auction a spectator sport and a reoccurring news story.

Example

- A good, but perhaps extreme, illustration of the theatre of auctions can be seen in the 2017 auction sale by Christie's of Leonardo da Vinci's Salvatore Mundi. This work had been acquired, on a hunch, for $10,000 in 2005 by an American art dealer at an estate sale in New Orleans, who thought that the extensive overpainting might hide a work of greater quality. The work was then extensively restored in New York, revealing what was believed to be an autograph work by Leonardo da Vinci. The work was sold privately in 2013 to the Russian billionaire Dimitry Rybolovalev for US$127.5m. This was, at the time, a huge price for an artwork which was acknowledged to have major condition issues.

4 These are of course drivers of private sales as well as auctions.

The painting had been extensively restored and repainted, to the point that many experts questioned how much of the original work could now be seen. Rybolovalev also subsequently came to suspect that he had paid too much for the work. Four years later, however, Christie's approached Rybolovalev with a daring proposal. If Rybolovalev would consign the Leonardo to Christie's for sale at auction they would guarantee him a minimum price close to the price he had paid for it in 2013. Christie's were confident that, using the theatre of auction, they could achieve a price in excess of this amount. To achieve this, the marketing team embarked on an extraordinary campaign aimed at developing the mystique around the painting to such an extent that the auction would see an unprecedented level of excitement and anticipation. The cleverness of the campaign was that it was arguably less about the artwork and more about the cachet of owning the work. The artwork was advertised as the last Leonardo in private hands, emphasising its uniqueness. As if to highlight that the sale was about the right to own a masterpiece, a memorable part of the advertising campaign was a film of the awestruck faces of those viewing the artwork on display at Christie's. The painting was taken on tour to Hong Kong, San Francisco, London and New York and displayed alongside Andy Warhol's Sixty Last Suppers. The outcome was successful beyond anyone's expectations. The artwork sold for a staggering $450.3m after an adrenaline-charged bidding war between five bidders. Reporting on the sale, reporter Susan Moore of Apollo Magazine attributed that success in large part to an 'unabashedly manipulative promotional campaign'.[5] Whether or not that is right, the auction demonstrated the power of the drama at auction. This was simply not a price which could have been achievable in a private sale.

Those who take part in auctions relish the excitement and theatre which accompanies them. An auction is a networking opportunity for collectors and dealers. High end auctions are also social and spectator events. Indeed, it was only in the mid 1990s that the 'black tie' dress code for staff was relaxed at Christie's and Sotheby's flagship sales. The prestigious evening sales at the international auction houses are often packed, but in practice spectators usually heavily outnumber bidders. Entrance to the saleroom for major sales is often by invitation only, with reserved seating, and well-dressed bidders arrive knowing that they are very much part of the event. A great deal of thought goes into the seating arrangements, with some bidders preferring to be in prominent positions in front of the auctioneer and others seeking out more anonymous vantage points at the back of the room. Eyes are on fellow bidders every bit as much as on the auctioneer. The media is often also in attendance, with successes and failures at auction extensively reported in newspapers and on television. The shared drama and uncertainty inherent in an auction are a key part of its attraction. However, that drama and competition is

[5] Apollo Magazine, 16 November 2017.

not dependent on the value of the works on sale. It is just as evident in a local auction room as in the saleroom of an international auction house.

COVID restrictions in 2020 meant that international auction houses had to rapidly reinvent the live auction experience so that it moved from a physical and social experience to become an online streaming media event. In this new format the auctioneer conducts the auction in front of cameras which cut to and from auction house staff bidding on telephones, sometimes in different continents and time zones. The production values are similar to those in television studios, with multiple camera angles and visual effects designed to convey movement and drama to customers following the sale online.

Behind the scenes, the excitement can also extend to the presale preparations. At the top end, international auction houses compete with each other to offer more inventive and lucrative proposals to encourage sellers to consign their most valuable artworks for sale. That business-getting process for top artworks has in itself become something of an auction, with auction houses outbidding each other by offering minimum price guarantees, taking on significant financial risks – often simply a bet on the future performance of the art market and the outcome of the sale (see section 4.2, 'Guarantees and risk sharing arrangements'). Because such bets are often a crucial factor in persuading a vendor to sell with a particular auction house, the auction houses will often offer guarantees which are at the very highest level of what they expect the artwork to sell for. The auction house hopes that with clever marketing and a buoyant art market, the bidding will exceed the minimum price guarantee. When that happens, and the sale of the artwork out-performs the minimum price guarantee, the auction house can make a significant profit. Conversely, that bet can sometimes go badly wrong if the art market dips or if the auction house has overestimated its ability to find bidders for the artwork. This happened in dramatic fashion in 2008. Both Christie's and Sotheby's had guaranteed minimum prices for collections on the assumption that the art market would continue on its upward trajectory. That assumption proved to be a costly miscalculation when the Lehman Brothers bank collapse heralded a major and sudden economic downturn immediately prior to the auction houses' sales in October. The results for those sales were far worse than expected – 27% of the lots were unsold at Sotheby's, 45% unsold at Christie's and 46% unsold at Phillips de Pury. The result was that the auction houses had to pay out tens of millions of dollars to the sellers of unsold works for which they had offered minimum price guarantees. Minimum price guarantees continue to be an important feature of top sales and their existence adds yet another layer of drama to the auction process.

Auction houses have also become more adept at measuring the inherent risk of auctions. Successful auctions depend on momentum, which can be interrupted by a lot which is unsold. The aim is therefore to ensure that sales have as few unsold lots as possible. This involves knowing before the sale which lots bidders might be

interested in bidding for. Auction house staff therefore patrol the presale exhibition talking with potential bidders in order to gauge their interest.

At the larger international auction houses nothing is left to chance. In the days prior to the sale, auction house staff often meet repeatedly and at length to determine which of their clients are likely to bid on which lots and up to what level. The meetings identify how much presale interest has been shown in each of the lots, and specialists are encouraged to focus on lots which have less interest. This analysis has become increasingly sophisticated, to the point where, for instance, Phillips auction house designed its own software programme to map the ebb and flow of buyer interest in the days and hours before the sale. This allows the specialists to focus their efforts most effectively on those lots where an extra bid can make a difference. In the worst case scenario, where despite the efforts of the specialists there is no presale interest in a lot, sellers may be asked to consider withdrawing their lot from the sale rather than face the ignominy of it going unsold. In other cases, owners of lots where there is limited presale interest from bidders may be persuaded to lower their reserve in order to increase the chances of a sale. The aim for the auction house is to get as close as possible to all the lots being sold – known as a 'white glove sale'.

Even long before the auction, at the proposal stage, some sellers find yet further ways of injecting further excitement into the process. Famously, in 2005 a Japanese seller with a US$20m art collection found himself unable to choose between the competing proposals of Christie's or Sotheby's.[6] He therefore told the houses that the issue would be decided by the playground game of 'rock, paper, scissors'. Each auction house sent a representative to the seller's offices in Japan on the appointed day, and both were required to sit opposite each other. They were then asked to write one word in Japanese – 'rock', 'paper' or 'scissors' – on the paper. The winner was Christie's, which had prudently opted for 'scissors' on the advice of the 11-year-old child of one of the art specialists.

Auction sales are likely to remain a major feature of the art world as there can be few more exciting and efficient ways of selling or acquiring an artwork. But underlying the drama of the auction is a complex legal and commercial structure, which we will now analyse in detail.

2.2 The auction process

An auction is a method of sale administered by an auctioneer, who acts as the agent for the owner of the property, inviting bids for the purchase of the property

[6] 'Rock, Paper, Payoff: Child's Play Wins Auction House an Art Sale', New York Times, 29 April 2005.

and concluding a sale of the property to the highest bidder. Traditionally, the point at which the sale is concluded is signalled by the auctioneer bringing down his hammer, known as a gavel.

For performing this service, the auctioneer is usually paid a fee based upon the amount for which the property is sold. The fee can be paid by the seller and/or the buyer, depending on the charging structure.

Before looking at the detailed legal and commercial aspects of the auction it is useful to outline the auction process from beginning to end. Understanding the structure and mechanics of the auction is critical in order to understand how the law interacts with the process.

2.2.1 The decision to sell

The starting point for the auction process is the owner of the artwork's decision to sell. This can be at the initiative of the seller, but may also be with the encouragement of the auction house.

We have seen that the triggers for sales were known as the 'three Ds': death, debt and divorce. While it is true to say that these are important triggers, there are now other important incentives to opt for sale by auction. One crucial factor is investment opportunity. The market in contemporary art has seen meteoric rises in value, sometimes over very short periods of time. In 2021 the turnover of the contemporary art market increased by more than 1,370% on 2000 figures.[7] Such returns can tempt sellers to cash in their art assets and encourage speculation. Equally, the sale of a work by an artist at a 'breakout' or unusually high price will tempt the owners of similar works to sell while the artist's works are in demand. Auction houses are also becoming adept at generating excitement and interest around certain categories or themes of art by holding 'curated sales' featuring only the best works within that category or theme. We will deal with these in more detail below.

Buyers in the contemporary market are always on the lookout for artists whose works are experiencing a surge in interest. In 2020/21 the top contemporary artist by auction record was Jean-Michel Basquiat, an artist who might be described as established and 'blue-chip'. In second and third place, however, were the, until then, relatively unknown NFT artist Beeple and the Chinese/US artist Chen Danquin. Meanwhile, the top selling contemporary artists by volume in 2020/21 were Kaws, Murakami and Banksy, who together accounted for approximately 5,000 lots per year, representing 4.7% of the total number of contemporary art

[7] Artprice Contemporary Art Market Report 2021.

transactions. These three are accessible artists whose artwork and marketing strategies have the widest appeal. But, just as importantly, these artists have seen meteoric growth in the average value of their artworks over the years. A Banksy print worth $5,000 in 2010 had by 2020 increased in value tenfold, with an 85% year-on-year increase between 2019 and 2020. With increases in value of this magnitude, a buyer can often be persuaded by the auction house that it is time to sell.

2.2.2 Consignment of the property and the choice of auction house

Many artworks come to auction because the seller approaches the auction house, unprompted, having made the decision to sell. In such cases there is no pre-existing relationship and the choice of auction house is made by the seller, often based on location or convenience. This is by far the most common source of business for most local and national auction houses in the United Kingdom. In some other cases the choice of auction house is dictated by the specialism of the auction house. A collector of stamps, for instance, is likely to choose a specialised stamp auction house to sell his or her collection. However, in many cases the choice of auction house is made as a result of a significant investment of time and energy by the auction house in building a relationship with a potential seller. The importance of building personal relationships with potential sellers is understood by all auction houses (and dealers) regardless of the type and value of artwork sold. Larger auction houses are known to devote significant resources to encouraging loyalty. Their efforts might include invitations to exclusive auction house dinners and parties, free valuations, and offers to store and insure the client's artworks. However the auction house goes about it, the hope is that by the time the seller decides to sell, the relationship it has developed is one of trust, such that the seller will choose that auction house to sell his or her artwork.[8]

Despite these efforts to develop a close relationship, where the artwork is of very high value and the artwork is to be sold by one of the top international auction houses, many sellers opt to approach a number of auction houses to explore which of the houses will offer the best terms for sale. In these circumstances, auction houses vie with each other to offer special terms in order to secure the consignment of the artwork for sale. The major international auction houses are highly competitive and have developed teams and processes which are able to put together seductive and financially sophisticated presentations almost overnight. These presentations will typically include glossy hardback booklets featuring a mockup of the catalogue entry for the artwork, examples of prices achieved for similar works sold, a bespoke marketing campaign and details of any financial arrangements on offer, such as advances or minimum price guarantees. Auction houses will also offer tempting addons such as free travel to the auction sale and

[8] These techniques are of course also used by dealers and agents.

accommodation for the seller, the use of the auction house's banqueting room for the client to host a presale dinner or the commissioning of an identical replica of the work to be sold to take the place of the original in the client's home. The presentations are always carefully tailored to appeal, in every detail, to the client. Again, however, it is important to emphasise that this level of engagement is reserved for only the most valuable works of art being sold on the international art market. The vast majority of art sales in the United Kingdom are conducted at a local or national level and do not require these kinds of effort.

An artwork is said to be 'consigned' when the seller commits to entrust it to an auction house. The terms on which he or she agrees to do this are contained in the auction house's seller's agreement. Usually these agreements are on standard terms, but for high value works they can be the subject of extensive negotiation. Later on we will look in more detail at the contents of the seller's agreement. For the time being, though, it is sufficient to know that this is the legal document through which the seller appoints the auction house as his or her agent to market and sell his or her artwork at auction. The document essentially sets out:

- the appointment of the auction house as the seller's exclusive agent;
- confirmation from the seller that he or she has good title and the right to sell and that, if the property has been exported from another country, this has been done in accordance with that country's laws;
- an agreement that, once consigned, the artwork cannot be withdrawn from auction;
- the estimate and reserve (if agreed at that point);
- the terms on which the artwork is covered in the event of physical loss or damage;
- the date of the sale;
- the right of the auction house to offer the work for sale privately after the auction if it fails to be sold at auction;
- what happens if the sale is cancelled due to nonpayment by the buyer;
- what happens if the sale is cancelled due to doubt over the artwork's authenticity or attribution.

2.2.3 The seller's commission and costs

The auction house will usually charge the seller a commission known as the seller's commission. (This is not to be confused with the buyer's premium charged to the buyer: see section 2.2.16, 'Charges to the buyer'.) The seller's commission is calculated as a percentage of the price achieved by the lot if it is sold. It may be a fixed percentage or based on a sliding scale.

In addition, the seller may be charged for the costs associated with selling the lot. This can include photography, restoration, protection against physical damage

to the lot and in some cases an administration fee if the lot is unsold. However, in cases where the lot being offered is very high value these fees and the seller's commission are negotiable, and may even be waived by the auction house in order to win the consignment.

2.2.4 The sale calendar

Where an artwork is being sold on the international art market the timing and location of sales can be extremely important. The objective of the auction house is to ensure that the artwork is presented for sale to the maximum number of potential buyers. How best to do this will depend on the type of artwork and identifying when and where potential buyers are best targeted. As a result, when an artwork is consigned to an auction house for sale there will often be a discussion with the seller – particularly where international auction houses are concerned – over which sale and which saleroom the artwork should be sold in. This may be dictated simply by where the next auction is scheduled to take place or it may be that the artwork is of a type which is likely to sell better in one territory than in another.

Smaller auction houses often hold regular weekly sales of mixed categories such as furniture, paintings and silver. The larger auction houses devote sales to particular categories of art which are spaced out over the year. At the top level, the international auction houses schedule sale weeks in which they aim to attract collectors of particular categories of art to their salerooms in major sale sites at the same time. These major sales usually also coincide with art fairs and other cultural events intended to take advantage of the presence of many art buyers in town at the same time. One interesting effect of the COVID crisis in 2020/21, however, was that the traditional sale timetable which had become such a part of the art world calendar was disrupted. Auction sales were cancelled and rescheduled at short notice, often moving online – usually with no negative consequences. The result has been a reassessment by the auction houses of the perceived importance of the traditional auction calendar, and even the physical sale.

Traditional auction formats are also at risk of becoming outdated, based as they are on the days when the majority of buyers at auction were dealers seeking to purchase lots in particular categories on a regular basis for stock and resale to the public at a profit. Buyers today include a wide variety of collectors and occasional buyers as well as dealers. These nontrade buyers' interactions with auction houses are similar to their interactions with museums. They expect to be educated and intellectually stimulated, and increasingly do not focus on a single category of artworks. The auction houses have responded to this by staging curated crosscategory sales, often devoted to a theme. These sales are very popular and are often of museum standard. One of the first of these was Christie's If I live I'll see you on Tuesday sale of works by both established and emerging artists in May 2014. The sale's promotion by a video of a skateboarder skating through the exhibition

and Christie's offices successfully underlined its youth and cutting edge appeal. That was followed in 2015 by Looking Forward to the Past, a curated collection of postwar artworks around the theme of artistic innovation inspired by the past. This sale of 34 works raised US$705.9m. The themed sale is now an established feature of the auction market and further successful themed sales followed at Christie's in 2016, including The Artist's Muse, Bound to Fail and Defining British Art. The appeal of these sales is that they do not have the appearance of a simple disposal of property. Rather, they are a celebration of fashion and taste in art, presenting sellers with a one off opportunity to showcase their work alongside other works of similar calibre and interest. Buyers are attracted to the sales because they provide intellectual and aesthetic stimulation, putting the art into context. It would not be surprising to see curated auctions become an increasingly established feature of the auction calendar, possibly even at the expense of the regular single category sales.

2.2.5 Cataloguing

Once the work is in the hands of the auction house the departmental specialists will begin to catalogue the artwork. Cataloguing is the process of describing the nature, authorship and history of the artwork. This, in many ways, is the core of the auction house's job, and the area where it places its legal and professional responsibility on the line. The aim is to correctly identify the author and accurately describe the work. It is this description which forms the central basis of the bidder's decision to seek to buy the artwork and the amount he or she is prepared to bid for it. In some categories of artwork this is a relatively straightforward process. Artworks which were created recently, which are well known, and/or whose existence has been well documented are the most straightforward to catalogue. At the other end of the scale, however, are older artworks such as Old Master paintings, whose true authorship may be lost in the mists of time or hidden behind restoration, dirt and overpainting. Such works carry the very real risk of being sold without their true value being recognised. Equally, such works can be oversold when an ordinary work is wrongly attributed to a famous artist. Both situations can lead to the auction house suffering damage to its reputation, and legal liability. The job of the auction house is therefore to exercise the necessary care and skill to ensure that the description is accurate.

The cataloguing process starts with a physical inspection of the object by the auction house specialist. The specialist will look at previous sales records or, if available, an authenticity certificate or any other documents accompanying the work which might provide evidence of its authorship. If the specialist is in any doubt about the authenticity or the authorship he or she may consult with third party experts such as scholars, museum curators or artists' estates. He or she may also refer to a catalogue raisonné – a reference book detailing all the known works

by an artist. Then the specialist will search art historical records to identify any references to the work, such as scholarly publications, exhibitions or auction records. If the seller has any records of when and where it was acquired this will also be helpful. It is important to note that the auction house does not usually, unless it has a suspicion that doing so will reveal a more valuable work, carry out restoration or cleaning work, nor does it dismantle artworks. Buyers, on the other hand, can and often do carry out such work on their purchases. This can sometimes lead to surprising postsale discoveries.

In addition to describing the authorship of the artwork, the catalogue description will also, where the work is valuable or important, cover the history of the artwork and its art historical context. Details will also be provided of any exhibitions or publications in which it has featured.

Finally, the artwork will be photographed. This is one of the most important aspects of the catalogue entry as human reaction to artwork is usually predominantly visual. Great care is therefore given to photographing the artwork in a way which presents it at its best.

2.2.6 Provenance

The provenance of an artwork has a double meaning. Provenance may be a reference to the origin of the artwork or to its ownership history. As part of the cataloguing process, auction houses will devote time to researching the provenance of artworks. This is because both the origin and the ownership history of artworks have assumed far greater importance in recent years. There are a number of reasons for this. First, a recorded provenance often provides a great deal of comfort when confirming the authenticity of an object. Being able to show, for instance, that an artwork was purchased from the artist's studio will be a strong indicator of authenticity. Equally, the absence of any recorded provenance may in some circumstances raise questions about the authenticity of the work. Second, when in the late 1990s restitution claims began to be made by the families of the victims of wartime spoliation, it became extremely important to be able to account for the whereabouts of artworks in the period 1933–45. Here, the importance of ownership history rather than origin became important. There were also certain names which, if they appeared in the ownership history, could be a warning that the work was looted during this period. Third, provenance has also become more important in the field of antiquities. Here the double meaning of the word 'provenance' can raise complex issues. Critics of the sale of antiquities consider 'provenance' in the context of antiquities to mean 'origin'. They will argue that unless an antiquity cannot be traced back to the precise place where it was unearthed – and unless it can be shown that the unearthing was lawful – then the antiquity is without provenance. Provenance, in terms of origin, is important also to the art market but it attaches equal importance to ownership history. This is because an antiquity with

no recent ownership history may be unsaleable in the art market because it cannot be demonstrated that the antiquity has been in circulation in the art market and cannot therefore have been recently unearthed. For this reason a specialist in the antiquities department of an auction house will spend as much time researching the provenance of a work – both in terms of origin and of ownership history – as he or she spends on its authenticity.

Finally, an interesting or important provenance will often add to the appeal, and therefore the price, of the artwork. This is where provenance is used in the sense of celebrity ownership history rather than origin.

In 2011 Christie's held a sale of the jewellery of Elizabeth Taylor, much of which had been given to her by Richard Burton. While the sale had been expected to raise £13 million, the celebrity romance connection ensured that the sale total soared to nearly £75 million. Equally, Old Master paintings which can be traced back to the collection of King Charles I will command a premium because of the connection with the king's famous royal collection. At Christie's sale of Princess Margaret's estate in 2006 a cigarette holder with a presale estimate of £2,000 sold for £209,600. Sales which are devoted to the contents of a famous house or the collection of a major collector often achieve similarly full prices due to their history.

In theory, at least, provenance should provide buyers with a chain of title stretching from the date the artwork was created up to today. In practice, however, the chain of provenance is rarely complete. Where there are disputes over ownership an incomplete provenance is often viewed with suspicion out of a concern that an attempt has been made to hide the history of the artwork. While that is certainly possible, it is rarely the case. The reasons for incomplete provenance are usually rather more mundane. First, records and memories of ownership become lost over time as artworks change hands. This may seem surprising where the artwork is valuable, but it should be remembered that recognition of the importance and value of artworks often develops over time. As an artwork's importance grows, so too will the likelihood of its existence being recorded in ownership records, photographs, insurance valuations or publications. Another reason for incomplete provenance is the desire for discretion on the part of those who own art. That desire for discretion is often greatest among more recent owners. It may simply be motivated by a wish for privacy, or it may be necessary because the sale is triggered by unhappy circumstances such as financial difficulties which the owner does not want to broadcast.

The importance of provenance is perhaps best illustrated by the fact that forgery of provenance has become a crucial aspect of art forgery.

Example

- In the late 1980s a small time artist called John Myatt began to produce clever forgeries in the style of Braque, Matisse, Giacometti and Le Corbusier. Myatt teamed up with a man called John Drewe who masterminded a plan to pass off Myatt's works as authentic works by these artists. Drewe did this by creating a convincing provenance for the artworks. Drewe gained access to major art archives, such as those of the Victoria and Albert Museum and the Tate, and then altered the archives to create a lineage for Myatt's forgeries. He implanted the archives with false records such as receipts and certificates of authenticity that provided the pictures he then consigned for sale through auction houses with verifiable heritage. A similar technique was employed by the German forger Wolfgang Beltracchi, who, in the 2000s, together with his wife Helene, sold forged works purporting to be by Max Ernst, Heinrich Campendonk, Fernand Léger and Kees van Dongen. As with the Myatt/Drewe case, a key part of Beltracchi's success lay in the fact that for each forgery he created recorded provenance. He claimed that the works had formed part of two fictitious 1920s collections – the Knops Sammlung and Werner Jägers Sammlung. The paintings were marked with stamps from the collections and he created convincing black and white photographs featuring the painting and his wife, posing as her grandmother in period dress. The Beltracchi case and a number of other forgery cases which made use of provenance as a means of deception are analysed in more detail in Chapter 5.

For all these reasons, provenance research is a crucial part of the authentication and cataloguing process. There are aspects of provenance which will enhance the value of an artwork and aspects of provenance which may affect the value because they raise legal or ownership issues. For important works of art, auction houses will devote considerable resources to providing as full a provenance as possible in the catalogue. Doing so assists with authentication, increases the appeal to buyers and flushes out any potential problems with ownership or origin.

2.2.7 Estimates

The auction house specialist will then consider what he or she believes the artwork is likely to sell for. A starting point for that determination is researching comparables – the sale prices achieved by the same or similar artworks in the past. Previously this was done manually, using a set of books called the Art Sales Index, which listed, for each year, the results of artworks sold at auction. Searching for comparables has become considerably easier with the far greater availability of online art sales databases such as Artnet. These online databases contain historical records of the prices achieved by the artworks offered for public sale. This data

allows the auction house specialist to place a value on an artwork by comparing it with the prices achieved by other artworks by the same artist.

However, while the use of comparables is a starting point for the exercise, it is important to remember that each artwork is unique. Comparables do not take account of variables such as the physical condition of the artwork, its freshness to the market and its commercial appeal – which can depend on its subject matter, its colour or its size. This is where the specialist knowledge of the auction house or specialist comes into play when setting the right estimate.

The estimate is expressed as a range between a low and a high estimate. For instance, an estimate of $10,000–$15,000 means that the specialist believes that the hammer is likely to fall somewhere between $10,000 and $15,000.

The specialist needs to get the balance right when setting estimates. An ambitious estimate which is set at too high a level may deter potential bidders, which could mean that the artwork fails to sell. An estimate which is more conservative, on the other hand, may serve to encourage bids from bidders who will hope that the artwork can be acquired at a lower price. This can lead to more competitive bidding, resulting in a price at or above the high estimate. It can, however, often be difficult to persuade potential sellers of the merits of a conservative estimate. Sellers tend to respond better to ambitious estimates and so, in competitive situations, there can often be an 'auction of estimates' as auction houses vie with each other to go as high as they dare in order to win the seller's business. Winning the consignment on the basis of an overambitious estimate can, however, be a shortlived triumph if the lot subsequently fails to sell due to bidders being deterred by the high estimate.

The estimate is published in the catalogue as a guide for bidders of the price the artwork is expected to achieve at auction. In some cases, however, the estimate will not be published, and instead the words 'estimate on request' will be used. This is usually done in cases where the artwork is expected to achieve a very high price but the auction house does not want to commit, at the time the catalogue is published, to a prediction of what it expects to the artwork to sell for. Rather, it will wait to see how much interest there is in the artwork closer to the sale, and then pitch the estimate according to the interest expressed by potential bidders in the artwork.

One important point to note here is that the reserve – which is the confidential amount below which the auction house agrees with the seller that it will not sell the lot – cannot be above the low estimate. This is covered in more detail below in section 2.2.10, 'The reserve price'.

2.2.8 Condition reports

A key factor in the value of the artwork will be its condition. As most objects sold at auction are by their nature preowned, there will often be wear and tear, damage or restoration work. Auction houses are at pains to emphasise to bidders that the artworks they sell are sold 'as is', in the condition they are in at the time of the sale. It is therefore the responsibility of the bidder to inspect the condition of the artwork prior to the sale. While the auction house generally takes no legal responsibility for the condition of the artworks it sells, it does not entirely wash its hands of the question of condition. The auction house will often prepare a note describing the condition of the artwork, known as a condition report. The condition report will then be provided to any bidder who might be interested in bidding on the artwork, so that they have an indication of the condition of the artwork. However, it is worth noting that the auction house will usually supply these condition reports with numerous disclaimers warning the buyer that the condition report is based on a simple physical inspection, that it is not an exhaustive list of all defects, that the auction house does not warrant condition and that the buyer should satisfy him or herself of condition by physically inspecting the artwork. This is why many buyers – and sometimes auction houses – will now commission reports from independent art restorers to provide additional comfort before the sale. This has become even more important now that so many purchases are made online by buyers on the other side of the world, who are often unable to inspect the artworks themselves.

2.2.9 Catalogue and marketing

Having researched and priced the artwork, the auction house will then embark upon advertising the auction sale and the works which are to be offered for sale. Until recently the principal means by which this was done was through the publication and distribution of a physical sale catalogue, illustrating and describing each of the artworks in the auction. These catalogues were glossy and extremely expensive to produce and would be sent out by post to potentially interested clients of the auction house. As the auction industry and its clients have embraced the convenience of online sales, the number of physical catalogues produced has dropped dramatically. Catalogues are now routinely published online on the auction house website and the majority of buyers are comfortable with the convenience of being able to consult catalogues online. Online catalogues also allow dynamic interaction with the buyer. Condition reports can be requested, images can be zoomed in on and additional information can be provided in ways not possible with a physical catalogue. While often still popular with sellers and auction house specialists alike as a physical souvenir of sales, physical catalogues are now a rarity. In addition, the auction house may advertise the sale to the public at large. Here again, marketing strategy has changed dramatically in recent years. There has been a move from traditional print media to online and social media.

Instagram, Twitter, Facebook and corporate websites are all heavily used by the auction houses and their staff to engage with potential sellers and buyers and to promote their sales and achievements. In the case of international auctions artworks may, prior to the auction, be toured around the world and exhibited at different locations in order to generate interest. Exhibitions may also be accompanied by events and parties to which potentially interested bidders are invited.

Environmental considerations are, however, increasingly affecting the marketing programmes and business-getting activities of auction houses. The publication and distribution throughout the world of paper catalogues, the global touring and associated shipping of artworks, the seasonal auction and art fair gatherings and the travel-intensive lifestyles of business-getters mean that the art industry can be rightly criticised for having a significant environmental footprint. There is pressure, internally and externally, on international auction houses to reduce the environmental impact of their activities, and the move into the online world will be a key factor in that strategy.

2.2.10 The reserve price

At some point prior to the sale, the seller will be asked to set a reserve price. This is the confidential amount below which the auction house agrees that it may not sell the lot.[9] So, for instance, if the reserve price agreed is £1,000, the auctioneer cannot conclude a sale unless he or she receives a bid at or above £1,000. As we have seen above, in the United Kingdom and most other jurisdictions, the reserve may not be above the low estimate.

The reserve is kept confidential from bidders, who bid not knowing in advance whether their bid is a 'buying bid' or whether it falls below the reserve and is not therefore capable of resulting in a sale. The need for confidentiality of reserves is from time to time a matter of debate. There are those who argue that it would increase transparency if auction houses were to make it clear to bidders in each case what the minimum bid is that the seller will accept. The counterargument is that this would mean the bidding could only start at the reserve, increasing the risk of the lot being unsold due to lack of bidding momentum. Publicising the reserve, it is argued, is the equivalent of starting a negotiation with your best offer. This is important because, at the risk of generalising, sellers tend to have less experience of auctions than buyers. A seller may use an auction house only once in his or her life, whereas many buyers are regulars in the salerooms. This potential imbalance of experience means that the seller should have the protection of not being required to reveal his minimum price as this could tempt bidders to use tactics to artificially depress the bidding beyond the minimum price (known as 'ringing': see

[9] But see below on selling below the reserve.

section 6.2, 'Bidding agreements'). The consensus, and practice, therefore is that reserves should be kept confidential as between the seller and the auction house.

Many auction houses, however, agree an arrangement with the seller which allows the auction house to sell the lot to a bidder despite the bid being below the reserve, provided the seller is paid the same amount as he or she would have received had the lot been sold at the reserve. In other words, the auction house makes up the difference out of its own pocket. To understand this arrangement, it is important to bear in mind that the auction house makes no money if the lot is unsold. So, if the bidding is close to the reserve, it can make financial sense to the auction house to sell – even if it makes less out of the transaction that it might have done had the lot sold at the reserve. Sellers are usually content with the arrangement as it means they are financially no worse off than if the lot had sold at the reserve.

2.2.11 Viewing

In the days immediately prior to the sale, the auction house will put the items in the auction on display for viewing and physical inspection by prospective bidders. This is sometimes known as the 'view'. The view is an opportunity for buyers to physically inspect the lots on sale and discuss them with the auction house specialists. The auction house specialist's job at this point is to 'sell' the sale. They will accompany potential bidders around the viewing, answering questions and providing encouragement. The specialists will be alert during the viewing to any signs of interest in particular lots by bidders. Identifying lots which are likely to do well and lots which are struggling to attract bidding interest allows the auction house to deploy its sales team in a targeted way during the runup to the sale.

2.2.12 Saleroom announcements

Sometimes new information about a lot comes to light after publication of the catalogue. Where that information is material or may be relevant to prospective bidders, the auction house will make a saleroom announcement. This can take the form of a written notice pinned to the wall next to the lot at the viewing and/or a verbal announcement by the auctioneer before the lot is offered for sale.

Saleroom announcements are also made in connection with the increasingly complex financial arrangements surrounding top end sales in international auction houses. These are necessary to ensure that bidders are aware of competing financial interests in lots. Often such interests are drawn to bidders' attention in the catalogue, but sometimes the financial arrangements are put into place after

the catalogue is published, necessitating a saleroom announcement. The following are announcements which are commonly seen in this context:

- where the lots being sold are from a deceased person's estate, that the beneficiaries of the estate may be bidding on certain lots;
- where the auction house owns, part owns or has a financial interest in the lot;
- where the lot is the subject of a third party guarantee (see section 4.2, 'Guarantees and risk sharing arrangements') that the third party guarantor, who has an interest in the outcome of the sale, may be bidding on the lot.
- Saleroom announcements are avoided wherever possible as they risk disrupting the momentum of the sale and can introduce an element of last minute confusion or uncertainty which risks putting bidders off bidding.

2.2.13 Buyer registration

Anyone intending to bid at the auction held by one of the major auction houses will need to register as a bidder and will be issued with a bidder registration number.[10] If the bidder is bidding in the saleroom in person, he or she will be issued with a bidding paddle, which is a card or a table tennis racquet shaped object with the bidder's registration number printed on it. The registration process will involve a basic identity or 'know your client' check, anti-money laundering checks and credit checks. In some high value sales a deposit may be required as a condition of bidding.

As we will see, the receipt of payment by the seller is dependent on the buyer paying the auction house. As a result the question of presale credit checks may be raised by buyers in circumstances where the buyer has not paid. Most auction houses make it clear in their agreements with sellers that they accept no liability for nonpayment by the buyer. That is because it is in the seller's and the auction house's interests to allow potential bidders to participate in the sale unless there are strong reasons for not doing so. Doing otherwise could limit the pool of bidders and reduce the sale prospects of the lot. Such exclusions are therefore likely to be effective, except perhaps in cases where the seller can show that the auction house had actual knowledge that the bidder would not pay and nevertheless negligently allowed the bidder to participate in the sale.[11]

2.2.14 Bidding

The traditional method of bidding is to attend the sale in person and bid on the lots. This is certainly the method preferred by the auction house as a room full of

[10] Presale registration may not always be required in smaller auction houses.
[11] See also Fordham v Christie Manson & Woods Limited (1977) 121 Sol Jo 529, [1977] 2 EGLR 9, 244 Estates Gazette 21.

bidders generates a sense of excitement and competition which is, in turn, likely to result in successful sales. There are, however, other methods of bidding for those who cannot attend the auction in person or who do not wish to be seen to be bidding. The first of these is the written bid, also known as the absentee bid. This is an instruction from the bidder to the auction house to bid on his or her behalf up to a maximum amount. This is convenient but some bidders, sometimes out of a concern for confidentiality or not showing their hand before the auction, prefer to make use of the telephone bidding facility, which is used by bidders who wish to be contacted by telephone by an auction house representative when the lot they are interested in comes up for sale. The bidder then instructs the auction house representative, who is seated near the auctioneer in the saleroom, to communicate bids on the bidder's behalf to the auctioneer. This has become a popular way of bidding because it preserves the anonymity of the bidder. It also allows bidders to experience the dynamics and atmosphere of the competition in the saleroom without having to attend the auction. As a result the salerooms of the major international auction houses have a long line of staff manning telephones and bidding on behalf of telephone bidders to the side of the auctioneer. Finally, and most recently, auction houses now also usually permit bidders to bid live via the internet. Bids over the internet are displayed on a screen to the auctioneer and internet bidders can follow the auction onscreen via a live internet video feed. Internet bidding has opened the saleroom up to a huge audience of potential bidders in different countries and timezones. As a result it is fast becoming one of the most popular ways of bidding.

The auctioneer will start the bidding below the reserve price and invite bids moving upwards in increments. The size of the increments is a matter for the auctioneer. As a rule the increments become larger as the bids go higher. Even when the auctioneer invites bids at a certain increment over the last bid, bidders can counteroffer with a bid at a lesser increment. This is known as splitting bids and the auctioneer has a choice: he or she can either accept a bid at the lesser amount, or reject it if the auctioneer believes he or she is likely to be able to secure a bid at the full increment.

Bidding increments will vary depending on the auction house and the value of the lots being sold. As an example, however, the bidding increments might usually be as follows:

£0 to £100	by £5s
£100 to £200	by £10s
£200 to £500	by £20s
£50 to £1,000	by £50s
£1,000 to £2,000	by £100s
£2,000 to £3,000	by £200s
£3,000 to £5,000	by £200, £500 or £800
£5,000 to £10,000	by £500s
£10,000 to £20,000	by £1,000s
£20,000 to £30,000	by £2,000s
£30,000 to £50,000	by £2,000, £5,000 or £8,000
£50,000 to £100,000	by £5,000s
£100,000 to £200,000	by £10,000s
Above £200,000	Auctioneer's discretion

The auctioneer may signal that a bidder is currently the highest bidder by saying 'it's with you' or, if the bidder has been outbid, 'it's not with you'.

When the bids are below the reserve, most auctioneers reserve the legal right to bid on behalf of the seller below the reserve. This practice, which is considered by some to be controversial, is known as 'consecutive bidding'.[12] It means that provided the bidding remains below the reserve, the auctioneer will accept a bid from a bidder in the room and then counter it with a bid at a higher increment on behalf of the seller. As a result a bidder can, until the reserve has been reached, be the only person actually bidding on a lot and yet find the bids rising by a further increment each time he or she bids. The reason why this is done – and legally permitted – is because the bidder is not prejudiced by the consecutive bidding on behalf of the seller. This is because the bidder cannot acquire the lot until the bidding reaches the reserve. Consecutive bidding on behalf of the seller is only permitted up to that point, and if the bidder bids against the seller up to the reserve the bidder will still acquire the lot at the lowest price possible. Because consecutive bids are not permitted beyond that point the bidder can only be pushed over the reserve by competing bids from other potential buyers bidding in the sale.

If this practice were not possible, a single bidder below the reserve would be stranded, unable to move his bid up to the reserve, which is the point where he or she is able to purchase the lot. To overcome this the auctioneer would have to start the bidding at the reserve. This is also problematic for two reasons. First, as

[12] Also known as 'chandelier bidding'.

we have seen above, the reserve is confidential and unknown to bidders. Having to start the bidding at the reserve would amount to disclosing the reserve to bidders. Second, inviting bids at the reserve would mean a 'cold start' to the bidding close to the estimate – which could discourage bidders and result in an absence of momentum. This in turn would lead to a greater number of unsold lots.

Once the bidding reaches the reserve (see above) the auctioneer will signal to the bidders that he is now authorised to sell the lot by words such as 'I'm now selling' or 'it's yours at …'.

We have seen above that the increments by which an auctioneer advances the bidding tend to follow a pattern, but may vary depending on the auctioneer's discretion or whether the bids offered to him are 'split' and therefore not in the standard increments. When departing from the standard increments the auctioneer needs to be careful not to 'land on the wrong foot'. This happens when the last live bid in the room is below the reserve, but not a full increment below. This is awkward but is usually overcome by the auctioneer inviting a bid at the reserve even though it is less than a full increment, and then – if no bid is received – bringing the hammer down to declare the lot unsold.

One area where questions can sometimes arise is the manner in which consecutive bids are executed. The auctioneer may simply announce the consecutive bid while gazing out into the saleroom or towards the bank of telephone bidders at nobody in particular. That is certainly acceptable. What is more difficult is where the auctioneer says or does something to suggest that a particular person is registering an actual bid when they are not. An example would be calling out the name of an auction house employee who is on the telephone or taking a bid 'from the gentleman at the back of the room'. There is no caselaw or legislation which addresses this point directly. Perhaps this is because bidders are not prejudiced as the consecutive bidding takes place below the reserve – and therefore at a level where the lot cannot be sold anyway. However, our view is that as a matter of good practice auctioneers should not put in place arrangements designed to proactively suggest that a bid on behalf of a seller is a real bid on behalf of a potential buyer.

2.2.15 The hammer

The striking of the hammer on the rostrum by the auctioneer is the sign that the highest bid has been accepted and a binding contract of sale has been entered into between the buyer and the seller. The auctioneer will signal a sale by saying 'sold' and then reading out the paddle number of the bidder. The winning bid at which the hammer falls is called the 'hammer price'. The terms of the sale are those set out in the conditions of sale in the sale catalogue.

If, however, the bidding has not reached the reserve price, the auctioneer will signal the fact that the lot is unsold by saying 'unsold', 'pass' or 'bought in', sometimes accompanied by the striking of the hammer. The challenge for the auctioneer is to make the announcement as briskly as possible and move on without interrupting the momentum of the sale. Above all, the auctioneer must not show disappointment in the result. This may seem trivial but is in fact important because the auctioneer's role is to project excitement, momentum and positivity. A high profile lot which is unsold, or a sequence of unsold lots, has the potential to have a negative effect on bidding throughout the sale. A skilled auctioneer can counter that effect to some extent, however, with a display of confidence and energy. Jussi Pylkkanen, Christie's lead auctioneer, was well known for being unfailingly positive and injecting the same enthusiasm and dynamism into a sale littered with unsold lots as into one where the lots were all sold.

2.2.16 Charges to the buyer

The price charged to the successful buyer is the hammer price plus the auctioneer's charge to the buyer, known as the buyer's premium. The buyer's premium was first introduced by Christie's and Sotheby's in 1975. It is imposed under the terms of the sale contract. Buyer's premium rates vary from auction house to auction house. The buyer's premium rates charged are usually more than the rates charged as vendor's commission to the seller. To provide an idea of typical buyer's premium rates, at the time of writing, the buyer's premium at Christie's is:

> 26% of the hammer price up to £700,000
> 20% of the hammer price between £700,001 and £4,500,000
> 14.5% of the hammer price over £4,500,000

Local auction houses also charge a buyer's premium, either at a flat rate of around 20–25% of the hammer price or on a falling scale of between 15 and 25% depending on the point at which the hammer falls.

In addition to the buyer's premium, VAT may also be payable (see Chapter 11) – usually on the buyer's premium, but sometimes on the hammer price – together with a sum in respect of any artist's resale royalty (see section 1.3.2).

2.2.17 Payment and proceeds of sale

The buyer is usually required to pay the purchase price within 30 days or less after the auction. The lot will not usually be released to the buyer by the auction house until payment is made.

As previously mentioned, it is important to remember that the seller is paid only when the buyer pays the auction house. In other words, the risk of nonpayment is

borne by the seller. Auction houses will usually have language in their agreements which disclaims any liability to the seller where a buyer is late paying or fails to pay altogether.

When the buyer pays the purchase price (hammer price plus any applicable VAT), the auction house will deduct from the purchase price:

- the buyer's premium;
- any VAT charged on the buyer's premium;
- any marketing, photography or other costs which the seller agreed to pay;
- any seller's commission;
- any VAT charged on the seller's commission.

The remaining balance will be forwarded to the seller, usually within five days of receipt of payment in full.

2.2.18 Collection

Once the buyer has made payment in full to the auction house the ownership in the lot transfers to the buyer, and he or she is free to collect it or arrange to have it collected from the auction house.

Having covered the mechanics of the auction process, we will turn next to the legal relationships between the parties.

3 Auctions: the auction house

3.1 The auction house and the seller

The following chapter is devoted to an analysis of the legal framework of auction
sales. That framework is not straightforward because it involves a balancing act
of the rights and obligations of a number of parties: the seller, the auctioneer, the
bidders and the buyer. Those rights and obligations arise mainly as a result of the
contractual relationships between those parties, but also under the law of tort and
under consumer law. Understanding the framework is not merely an academic
exercise. In practice, it allows us to determine, for example, what remedies a seller
has when an auction house mistakenly sells an artwork for less than its true value,
or what rights a buyer has when he or she purchases an artwork which turns out
not to be authentic.

It is a common misconception that the auction house is the owner or seller of the
lots in its auction. With rare exceptions (see guarantees and stock lots in section
4.2, 'Guarantees and risk sharing arrangements'), that is not the case. Rather, the
auction house acts as agent for the seller of the lot.

An agency is the term used to describe a situation where a person – the principal
– gives another person – the agent – the authority to create legal relations between
the principal and third parties. So, in the case of an auction the seller is the princi-
pal, instructing the auction house as agent, to conclude a sale contract with a third
party, the buyer. The sale contract is concluded between the buyer and the seller
through the intermediary of the auction house. As a result, unlike in a sale contract
which has two parties, the contractual structure in an auction is tripartite.

While the auctioneer is not a party to the sale contract, other than as agent for the
seller, the auctioneer does have legal rights and duties, both in relation to the seller
and to the buyer. Some of these rights and duties arise as a result of the contractual
relationships between the auctioneer and the seller, and between the auctioneer
and the buyer. Others are implied or imposed by law.

The appointment by the seller of the auctioneer as agent takes the form of con-
tractual agreement – known as an agency agreement – between the auctioneer

and the seller. This agreement is known, variously, as the seller's agreement, the consignment agreement or the agency agreement. In this book we shall call it the agency agreement. The principal purpose of the agency agreement is to set out what the auction house is authorised by the seller to do and what the limits of that authorisation are. The rights and obligations of both the seller and the auctioneer are set out in the agency agreement and determining whether or not the auctioneer has discharged his duties to the seller can usually be done by referring to the contractual commitments set out in the agency agreement. Each auctioneer will have a standard agency agreement which the seller will be asked to sign, appointing the auctioneer as the seller's agent. The most common areas of disagreement tend to be anticipated and addressed in this agreement between the auctioneer and the seller, and later in this chapter we will cover the manner in which that tends to happen.

However, before analysing the contractual arrangements set out in the agency agreement it is important also to consider the overarching duties which, leaving aside any contract, are implied by the law and imposed upon the auctioneer.

3.1.1 Fiduciary duties

Equity imposes a number of obligations upon the auctioneer in relation to the seller. These are fiduciary obligations, the duty to care for the seller's property and the duty to act with skill and care. In addition, where the seller is a consumer he or she may be entitled to certain cancellation and information rights. We will cover each of these duties in turn.

As agent for the seller, the auctioneer owes the seller what is known as a fiduciary duty – a duty to act in good faith without placing his own or anyone else's interests in conflict with or above those of his principal, the seller.[1] A fiduciary relationship is seen by the law as a relationship of utmost trust and confidence, which imposes on the agent a duty of the greatest transparency and ethical propriety. Other examples where fiduciary relationships arise are, for instance, the relationship between trustees and beneficiaries, or that between a solicitor and his or her client. Because the fiduciary duty is such a cornerstone of the relationship between the seller and the auctioneer, it is thankfully rare that circumstances arise where there is a breach by the auctioneer of fiduciary obligations. However, there are aspects of the art market – such as the culture of confidentiality, payments of commissions and the concern of the auctioneer to maintain strong relationships with buyers – which can give rise to real or perceived concerns over conflicts of interest. Those conflicts of interest can lead to breaches of fiduciary duty, and where such breaches are found to have occurred, the consequences can be serious.

[1] Parker v McKenna (1874) 10 Ch App 96.

The fundamental principle which should guide the auctioneer – as with any other professional in a fiduciary relationship – is the need to place his principal's interests above the interests of all other persons, including those of the auctioneer himself. Not only is it vital to avoid an actual conflict of interest of this kind, but it is also important to avoid situations which could give rise to a perception of conflict of interest. There are some instances in particular where this issue can arise in the context of auctions.

(1) No Secret Profit: Where a fiduciary relationship exists, the agent may not make a secret profit – deducting or earning money as a result of the agency which is not disclosed to the principal, the seller. This is the case even where the principal does not suffer any loss as a result of the secret profit being taken by the agent. In Parker v McKenna, James LJ said:

> I do not think it is necessary, but it appears to me very important, that we should concur in laying down the general principle that in this court no agent in the course of his agency, in the matter of his agency, can be allowed to make any profit without the knowledge and consent of his principal; that the rule is an inflexible rule, and must be applied inexorably by this court, which is not entitled, in my judgment, to receive evidence, or suggestion, or argument as to whether the principal did or did not suffer any injury in fact by reason of the dealing of the agent.

In Hippisley v Knee Bros,[2] the auctioneer agreed with the principal that he would be paid a seller's commission plus any out of pocket expenses relating to the marketing. The auctioneer was invoiced by the printer of the sale catalogues at standard rates but was given a 10% discount. The auctioneer charged the seller for the sale catalogues at the full rate without disclosing the existence of the 10% discount. The auctioneer was required to repay the 10% discount to the seller as this was held to be a secret profit. Because auction sale transactions are conducted on standard published terms and the hammer price is public knowledge, the scope for an auction house taking secret profits out of the proceeds of sale are limited. However, private sale transactions can be more opaque and/or involve a greater number of parties, making them much more open to the risk of secret profits being taken by the agent. We will cover this in more detail in Chapter 9.

The Court of Appeal case of *Prince Eze v Conway*[3] related to commissions claimed by an intermediary in connection with real estate, but the Court's findings in the case are nevertheless of relevance to the art market. One of the difficulties with intermediary relationships is that they can develop and change during the course of the transaction. A relationship which may not have imposed fiduciary responsibilities at the outset may develop into one which does. One of the difficulties

2 [1905] 1 KB 1.
3 *Conway and Another v Prince Arthur Ikpechukwu Eze* [2018] EWHC 29 (Ch).

for agents is being aware of the point at which such responsibilities arise. In this case a property agent, Mr Obahor, told Mr and Mrs Conway, who were selling their house, that he was acting on behalf of a purchaser. A finder's fee was agreed with the Conways of 1.5% of the purchase price if a sale could be agreed. Having agreed the finder's fee, Obahor then negotiated a reduction in the advertised sale price of the Conway's property. It was only having done so that Obahor found a potential purchaser for the property – Prince Eze. Obahor sought a fee of 3% of the purchase price from Prince Eze in return for locating the property. Prince Eze paid a deposit but failed to complete the purchase of the Conways' property. The Conways sued Prince Eze for breach of contract and during the proceedings the question of Obahor's role and the commissions came into sharp relief. This was because Prince Eze argued that Obahor was his agent and that the commission agreed between Obahor and the Conways was a secret commission – and therefore a breach of fiduciary duty, which rendered the purchase contract with the Conways for the purchase of the property voidable. The court found that, having examined the facts, Obahor was not acting as agent for Prince Eze – he was simply acting as an introducer, introducing the Conways to a purchaser and the purchaser to the Conways and the property. Obahor had at a later stage in the transaction been given authority by Prince Eze to give instructions to Prince Eze's solicitors but the Court found that this was a limited form of agency and did not give rise to a fiduciary relationship. As a result, given his status as an introducer, the court found it acceptable that Obahor should be paid a commission by both sides of the transaction. Neither payment constituted a breach of fiduciary duty. The case illustrates that the imposition of very onerous fiduciary duties will in each case depend on the facts, and that the line between owing such duties and not owing them is a fine one which is capable of being misunderstood by the parties to a transaction.

(2) Introductory Commission: As illustrated by the *Prince Eze* case, an area of high risk in the context of the fiduciary relationship is that of introductory commission payments. It has long been common in the art industry for payments to be made by auction houses (and dealers) to individuals or companies in return for introductions to sellers. Typically the introducer will be paid a percentage of the auction house's revenue from any sale which results from the introduction. Where this occurs, a failure to disclose to the seller the existence of the introductory commission can amount to a breach of fiduciary duty on the part of the auction house.

Example

- Having negotiated an agency agreement between his client and an auction house to sell his client's Picasso, the lawyer requests a fee from the auction house. As the agent for the seller, the auction house is in a fiduciary relationship with the seller. If the auction house agrees to pay the fee to the lawyer

without the seller being aware of the arrangement, the auction house will be in breach of its fiduciary obligations. The rationale behind this is twofold. First, the seller has lost out financially. Had the seller known of the arrangement he might have negotiated a more profitable deal or gone elsewhere. The money which was used to pay the introductory commission to the lawyer could, for instance, have been credited to the seller as part of the deal. Second, the seller is expecting impartial advice from the lawyer. A secret transaction where the lawyer is paid a fee by the auction house could be seen as an attempt by the auction house to influence the lawyer's duty to the seller to give impartial advice. That could be a breach of its fiduciary obligations to the seller. The auction house is not the only person at risk in such cases. Where, as in this example, the introducer who has been paid the undisclosed introductory commission is a lawyer or other professional acting for the seller, then the professional may also be in breach of his or her fiduciary duty to the client by soliciting or accepting the payment. Even more seriously, an undisclosed payment to the introducer may amount to a criminal offence under the Bribery Act 2010. We will cover this issue in more detail in Chapter 19.

• It is important to remember, however, that the ethical and legal objection is not to the payment of the introductory fee, but to the secrecy of the arrangement. Disclosure of the arrangement means that the seller has a full view of the money that is changing hands in connection with the transaction and is able to assess for him or herself the value of the transaction and the motivations of the parties involved.

(3) Purchasing the principal's property: A fiduciary may also not profit personally from his or her position unless the principal consents. Because of the potential conflict of interest, the auctioneer may not purchase the seller's property. The only exceptions to this rule are: (i) where the auctioneer has obtained the consent of the seller, having made complete disclosure to the seller of all relevant facts, or (ii) where the auctioneer's agency has ended. Any purchase by the auctioneer in breach of these rules will enable the principal to apply to set aside the sale. Further, where, in breach of his obligations, a fiduciary has profited personally, the law requires the fiduciary to account to his or her principal and hand over that profit. This will be the case regardless of whether or not the principal has suffered loss and regardless of the motives of the fiduciary. FHR European Ventures v Cedar Capital Partners confirmed,[4] for instance, that a bribe or secret commission accepted by an agent is held on trust for his principal. Therefore the auctioneer who purchases his principal's property in breach of his fiduciary obligations will be obliged to account to and reimburse the principal for any profit and/or commission made as a result of the transaction.

[4] [2014] UKSC 45.

(4) Misuse of information obtained as a result of the agency: In the course of the agency arrangement the agent may be provided with information in order to permit him or her to carry out his or her duties. The law requires that the agent should use such information only for the purposes of carrying out his duties as agent. Specifically, whether or not the agency has come to an end, the agent is not permitted to share confidential information obtained during the agency with third parties,[5] or use the information himself or herself for his or her own benefit in competition with the principal.[6] So, for instance, if an auctioneer has learned, in the course of a confidential valuation, that a collector owns a particular artwork, the auctioneer cannot then use that information in a separate transaction in which the auctioneer stands to benefit. He cannot, for instance, tip off a dealer about the whereabouts of the artwork in return for a secret introductory commission.

(5) Best advice: It is axiomatic that a professional in a fiduciary relationship must seek to provide his or her principal with impartial advice which is designed to be in the best interests of the principal. The auction business has become far more complex in the past 20 years and we will see later in this chapter that sellers are sometimes able to agree special arrangements with the auctioneer, such as minimum price guarantees, in which the auctioneer agrees to shoulder some or all of the risks associated with the auction sale in return for a larger fee. Sometimes these arrangements are agreed at the outset, and sometimes they are agreed immediately prior to the auction. In the latter case, where the auction house has been retained and is proposing that the seller agrees to alter the terms of the relationship to an arrangement which could result in a larger fee being paid to the auctioneer, the auction house needs to be extremely careful not to be placed in a position of actual or perceived conflict of interest. In such circumstances care should be taken to ensure that the advice being given is balanced, is in the seller's interests and is not motivated simply by a desire by the auction house to increase its profit. A similar question can arise in the context of advising sellers on whether sale by auction or sale by private sale is most appropriate. Once again auctioneers need to ensure that the advice they provide is balanced, suited to the seller's needs and not driven in any way by the auction house's own interests, such as its remuneration.

(6) Duty to account: A key part of the auctioneer's role is to receive the proceeds of sale of the seller's property and to account to the seller for those proceeds of sale. The law imposes a number of duties upon agents handling a principal's money. The agent is obliged to keep accurate accounts of all his or her transactions,[7] and to produce those accounts to the principal on demand.[8] The seller also has a legal

5 Merryweather v Moore [1892] 2 Ch 518.
6 Robb v Green [1895] 2 QB 315, CA.
7 Gray v Haig (1855) 20 Beav 21.
8 Pearse v Green (1819) 1 Jac & W 135.

right to be informed of the state of any sale which the auction house has concluded or is seeking to conclude on his or her behalf. The duty to provide accounts is a continuing duty and endures despite the agency coming to an end.[9]

The law does not impose upon the auctioneer a duty to keep money belonging to the seller separately from the auctioneer's own funds. As a rule, for cashflow reasons, the mixing of funds is seen by most auctioneers as essential to the auctioneer's business. Individual agreements between the seller and the auctioneer can of course provide otherwise, but this is rare, as such one off arrangements are expensive and can be complex to set up.

3.1.2 Duty to care for the principal's property

The seller entrusts the auctioneer with his property and the auctioneer is therefore expected to treat the property with the same care as if it were his or her own. The legal term for this is bailment. The seller is known as the bailor whereas the auctioneer is the bailee. The agency agreement between the seller and the auction house will usually include detailed provisions on the nature and extent of the auction house's liability to the seller for any loss or damage to the artwork, the insurance arrangements and the rights of the auctioneer to deal with the property. Overall, however, the principle is that the auction house, as bailee, is under a duty to take all reasonable care of goods,[10] and to handle them in accordance with any express instructions given by the bailor. The auctioneer will, subject to the terms of the agency agreement, be liable for any damage to or loss of the property caused by a failure to take reasonable care of the property or by handling the property in a way which is not consistent with the instructions given to him or her by the bailor.

The question of whether the auctioneer has taken reasonable care of an object will depend in each case on the facts, including the manner in which the loss or damage occurred and the terms of any agreement between the auctioneer and principal. For instance, the auctioneer may escape liability if he or she is able to show that loss or damage occurred without any failure on his or her part to take reasonable care. The agency agreement between the auctioneer and the seller may also exclude liability for physical loss and damage in certain circumstances. Whether or not such a clause is enforceable will depend in each case on whether the court considers the exclusion to be reasonable.

[9] Yasuda Fire and Marine Insurance of Europe Ltd v Orion Marine Insurance Underwriting Agency Ltd [1995] QB 174, [1995] 3 All ER 211.

[10] Matrix Europe Ltd v Uniserve Holdings Ltd [2008] EWHC 11 (QB), [2008] All ER (D) 359 (Jul) (2008 Abr para 614).

In Spriggs v Sotheby's Parke Bernet & Co.[11] a diamond valued at £22,000 was stolen during a Sotheby's presale viewing. The court found that the auctioneer owed a duty of care as bailee of the property to take reasonable care of the diamond. The court held that, having established such a duty, the onus was on the auctioneer to show that the loss or damage did not occur as a result of its neglect or that of its employees. The auctioneer needed in this case to demonstrate that it had in place a safe system of security and that it had operated that system diligently. While the court held that the auctioneer had not satisfied these two tests, Sotheby's was not held liable because of an exclusion clause in the contract between the seller and the auctioneer which excluded 'liability for loss and damage whether caused by negligence or otherwise'.

At the end of the bailment a refusal, without legal justification, by the auctioneer to return the artwork to the bailor will make the auctioneer liable for damages in the tort of conversion (see section 5.1.2, 'Conversion'). A legal justification could, for instance, be where the terms of the agency agreement expressly permit the retention of the artwork or where the auctioneer is exercising a lien over the artwork. Typically such rights will be found in the agency agreement between the seller and the auction house, which will usually include a provision that if the auctioneer's costs and charges are not paid then the auctioneer shall be entitled to exercise a lien by retaining the seller's property.

In Hammonds v Barclays,[12] a lien was described as 'a right in one man to retain that which is in his possession belonging to another until certain demands of him, the person in possession are satisfied'. In common law the auctioneer has such a lien over the principal's property as a form of security for payment of the auction house's charges and expenses.[13] This right is exercisable not only against his principal but also as against a third party – even the successful purchaser of the property. However, for this right to be exercised, the auctioneer must remain in possession of the artwork. If the auctioneer releases the artwork to the purchaser, the right of lien over the artwork is lost. However, where the purchaser has paid the purchase price to secure the release of the artwork the auctioneer will instead be entitled to exercise his or her right of lien over the seller's proceeds of sale rather than the artwork. It is important to note that the right of lien is simply a right to retain the artwork. It does not, in the absence of an agreement to the contrary, empower the auctioneer to sell the artwork to satisfy the debt.[14] In such circumstances, if the auctioneer wants to sell the property, the consent of the court is required.[15]

[11] (1986) 1 Lloyds Rep 487.
[12] (1802) 2 East 227.
[13] Williams v Millington (1788) 126 ER 49, [1775–1802] All ER 124.
[14] Bartholomew v Freeman (1877) 3 CPD 316, 38 LT 814.
[15] Larner v Fawcett (1950) 2 All ER 727 CA.

Because the common law right to exercise a lien over the artwork does not include the automatic power to sell the artwork, the auctioneer will usually reserve contractual rights under the agency agreement to do so. By doing this the auctioneer will be entitled not only to retain the artwork, but also to sell it. Typically, the agency agreement with the seller will contain a provision which allows the auctioneer to retain any property or money belonging to the seller as security for the seller's debts, including an express right of sale of the property to satisfy the debts. The auctioneer may also reserve the right to retain property where there are competing claims to ownership over the property.

3.1.3 Duty to act with skill and care

As is the case with any professional, the auctioneer is required to act with a degree of skill and care in going about the exercise of his profession.[16] The seller is entitled to expect that the auctioneer will not act negligently.

Before examining that requirement, it is worth saying a few words about negligence and authenticity. The question of negligence arises most frequently in the art world in the context of attribution and authenticity. The classic situation is where, subsequent to a sale, it is alleged that the professional handling the sale has failed to correctly identify the authorship of an artwork. As a result, the artwork is either sold for less than its true value, or for more than its true value – causing loss to the seller in the former case or to the buyer in the latter case. It might be thought in such circumstances that the question of whether or not the professional was negligent will hinge upon the binary question of whether or not a forensic investigation can determine whether or not the artwork was in fact correctly described. As a result, much time and energy is devoted in such cases to the fascinating exercise of using expert evidence and science to determine whether or not an artwork is by a famous artist or is not. In fact, from a legal perspective this is in some senses a secondary issue. The real issue of substance is determining whether, regardless of what we now know about the artwork, the professional was negligent in reaching the conclusion that he or she reached at the time of the sale. To answer that question, the starting point is determining what the standard of care is required of the professional. That standard is not established in a vacuum – it is determined by reference to the professional's peers. The second part of the exercise is then to determine whether he or she fell below that standard in reaching the conclusion that he or she did. Even in the second part of this test there is an element of peer review. Was the professional's judgement and methodology in line with the judgements and methodology of his or her peers at the time?

[16] Supply of Goods and Services Act 1982, s 13.

When considering the auctioneer's duty of care to the seller, the standard of care expected is that of the auctioneer's peer – a reasonably competent professional auctioneer. While this might appear to be a straightforward test, it is complicated by the different levels of specialism, expertise and resources within the auction industry. In deciding what the standard of a reasonably competent auctioneer is, account will be taken of the level of knowledge and expertise to be expected of the category of auctioneer in question. For instance, international auction houses with large departments of experts specialising in different artists, categories of art or historical periods may be held to a different standard than a local auctioneer, whose experts are likely to have more general rather than specialist expertise.[17] In Thomson v Christie Manson & Woods Limited and others,[18] the dispute revolved around the accuracy of the cataloguing of a pair of vases bought by the claimant. The court applied the Luxmoore-May test, asking whether 'in cataloguing the vases, Christie's exercised the skill reasonably to be expected of an international auction house of their standing'.

Turning to the question of whether the auctioneer fell below the standard to be expected, it is important to bear in mind that many aspects of the auctioneer's work involve the exercise of judgement. To be negligent, it is not enough for the claimant to demonstrate that another auctioneer – or even many auctioneers – would have exercised their judgement in a different way. The test for negligence is that the auctioneer must have exercised his judgement in a way that no reasonably competent auctioneer would have done (Luxmoore-May v Messenger May Baverstock[19]). This is important because, as we have seen above, the question of whether or not the judgement is correct is a very different one from whether or not the judgement was negligent. An auctioneer may very well reach an incorrect conclusion and yet do so without being negligent. In Luxmoore-May v Messenger May Baverstock, Slade LJ said:

> [the] valuation of pictures of which the artist is unknown, pre-eminently involves an exercise of opinion and judgment, most particularly in deciding whether an attribution to any particular artist should be made. Since it is not an exact science, the judgment in the very nature of things may be fallible, and may turn out to be wrong. Accordingly, provided that the valuer has done his job honestly and with due diligence, I think that the court should be cautious before convicting him of professional negligence merely because he has failed to be the first to spot a 'sleeper' or the potentiality of a 'sleeper'.

In Thomson v Christie Manson & Woods Limited and others, Christie's was sued by Taylor Thomson, the buyer of a pair of vases known as the Houghton urns. The crux of the dispute was Taylor Thomson's allegation that the urns were not

17 Luxmoore-May v Messenger May Baverstock [1990] All ER 1067, CA.

18 [2005] All ER (D) 176.

19 [1990] All ER 1067, CA.

eighteenth-century vases, as described in the Christie's catalogue, and were in fact made more recently. Ms Thomson contended that Christie's was negligent in cataloguing the urns as being eighteenth-century vases. While that case revolved around the question of the auctioneer's duties to the buyer rather than the seller (duties to the buyer are dealt with later in this chapter), it is worth considering its wider implications as regards the exercise of judgement by the auctioneer. The judge at first instance, Mr Justice Jack, found that it was reasonable of Christie's to catalogue the urns as being eighteenth-century vases. However, he then placed himself in the position of an art expert, concluding that in his view, having heard the expert evidence, the factors in favour of an eighteenth-century date outweighed those which were against it. He said:

> I cannot be certain that the Houghton urns were made around 1760 to 1765, but I think that it is likely. The evidence establishes the position somewhere between certainty and more likely than not. If a figure must be placed on it, I would put it in the region of 70%. I am of this view after having reviewed and reconsidered all the evidence and submissions which I have heard.

In doing this, Mr Justice Jack had given in to the understandable temptation, having heard the expert evidence, to make a determination himself on the authenticity of the urns. While such an exercise was a relevant, and possibly a necessary, part of the court's examination of the urns, it diverted the court from the central issue – which was Mr Justice Jack's finding that it was reasonable at the time of the sale for Christie's to catalogue the urns as being eighteenth-century. Against the background of that finding, the determination of whether their judgement was ultimately right or not was of interest but not directly relevant to the question of negligence. Instead the judge used his findings on the likelihood of the urns being eighteenth-century as a basis for ruling that Christie's was negligent because it had not made clear to Ms Thomson that there was a lack of certainty surrounding the dating of the vases.

The ruling at first instance was appealed by Christie's. Having heard the appeal, the Court of Appeal disagreed with Mr Justice Jack's conclusion that Christie's was in breach of its duty to Ms Thomson. The Court concluded that if – as Mr Justice Jack had found – it was reasonable for Christie's to catalogue the vases as eighteenth-century, then it followed that the auction house could not be negligent by failing to qualify that opinion. If at the time of the sale Christie's reasonably held a certain and definite opinion that the vases were eighteenth-century, the Court of Appeal said, it was difficult to see how Christie's was obliged to express anything other than confidence to Ms Thomson. It would, the court said, by definition have been expressing fanciful, unreal doubt about the age of the vases, when it had no real doubt. That conclusion was unaffected even if, after an examination by the court – and with the benefit of hindsight – the vases were in fact found not to be eighteenth-century. The Court of Appeal concluded therefore that there was

no duty on auctioneers who held on reasonable grounds a certain and definite opinion as to the provenance of an item offered for sale to qualify a description in the catalogue.

In Fordham v Christie Manson & Woods Limited,[20] the principle that the auctioneer owes the seller a duty to use reasonable skill and care was reasserted with some examples of other instances in which an auctioneer might be considered to be negligent:

> In my view an auctioneer, like any other professional man, is under an obligation to his client to use reasonable care and skill in and about his calling as an auctioneer and to act in accordance with the terms of his contract with his client, the intending vendor. He must, for instance, obtain the best possible price for the property being auctioned. He must not negligently miss the nod of the head, or the wink of the eye or the raise of the hand in the auction room, indicating a higher bid. He must take reasonable care to ensure that he obtains a binding contract with the purchaser for his client, the vendor. In the ordinary auction of anything other than real property, the binding contract is made by the fall of the hammer. In effecting that contract the auctioneer must take reasonable care that there is no uncertainty in the mind of either the man on the rostrum or the person bidding about what the one is offering and for what the other is bidding. Nor must there be any lack of reasonable care in ascertaining the amount of the final bid for which the property is knocked down. I think also that there is a clear duty on an auctioneer selling in these circumstances.

While the Fordham v Christie Manson & Woods Limited case provided a list of a number of areas where an auctioneer might be expected to exercise skill and care, the principal question in that case was whether the auctioneer owed the seller a duty to pursue the buyer for the purchase price. The court found that there was no such duty:

> I]n my judgment auctioneers are in general under no duty to take active steps to get in the purchase money from buyers. They have to receive it: having received it they must then account for it with due care to the vendor, deducting their commission and whatever else their contract may permit or require, for instance VAT or whatever it may be.

Having identified the areas where an auctioneer owes a duty to the seller in common law, it is however important to note that the contract between the seller and the auctioneer will almost always place some limits and exclusions on the extent to which the auctioneer may be held liable for negligence – in particular, in the taking of bids. Typically, the agreement between the seller and the auctioneer will provide that the auctioneer has absolute discretion in the taking or rejection of bids.

[20] (1977) 244 EG.

3.1.4 Auctioneer's obligations to the seller imposed by consumer law

3.1.4.1 Seller's cancellation rights

In certain limited circumstances sellers who are deemed to be consumers may, after entering into an agency agreement with the auction house, have a right to withdraw from the agreement. The Consumer Contracts (Information, Cancellation and Additional Charges) Regulations 2013 (CCR) provide, under regs 29 and 30, a right for consumers to cancel a service contract within 14 days of entering into the contract. A consumer means 'an individual acting for purposes which are wholly or mainly outside that individual's trade, business, craft or profession' (reg 4 of the CCR). However, even where the seller qualifies as a consumer, the right to cancel applies only in certain specified circumstances – where the contract is either a distance or off-premises contract.

Distance contracts are (reg 5 of the CCR) contracts which are concluded without the trader and the consumer being in each other's physical presence at any point up until the contract is concluded. Distance contracts are defined by the CCR as negotiated and agreed by the use of one or more organised means of distance communication – for example, by phone, by post or over the internet. The phrase 'organised means of distance communication' is not defined but appears to be intended to describe a fixed process designed for sales in which there is no physical contact between the consumer and the trader, involving template letters and forms sent out in sequence by post, telephone or internet leading to the conclusion of a binding agreement for services. This interpretation is supported by the fact that, in relation to the Consumer Protection (Distance Selling) Regulations 2000, the Office of Fair Trading took the view that an organised distance sales or service provision was likely to exist where standard letters, emails or faxes were sent to potential customers who ordered services or goods by returning them by post, email or fax. That would appear not to be the same as a business such as that of auction houses, which is usually designed to be a personal process. The auction process will usually involve discussion, negotiation and face to face contact with the consumer – even where telephone, email or post is used as an incidental part of the exercise. It is also worth noting the requirement that the contract should be exclusively negotiated and agreed by phone, by post or over the internet. This would suggest again that to be an organised distance sales scheme, the business needs to have designed a work flow process in a manner intended to conclude contracts entirely online, by phone or by post without personal interaction up to the point of signature of the contract. An example might be an order placed online by a consumer for a monthly service such as shirt ironing. The consumer might fill out a form online with his name and address, the service required and payment details. When submitting the completed form online the consumer would be required to click on a box to confirm acceptance of the laundry service's terms and conditions. On receipt of the form a computer program designed by the laundry

service might automatically respond with an email to the consumer confirming acceptance of the order, attaching an automatically generated email. As an organised means of distance communication this process would repeat itself with each consumer customer in an identical way. Because this is not usually the model used by auction houses to conclude contracts with sellers, it is unlikely that many such contracts would usually qualify under the CCR as distance contracts.

Off premises contracts (reg 5 of the CCR) are (i) contracts concluded in the physical presence of both the trader and the consumer, but not on the trader's premises; or (ii) where the consumer makes an offer to the trader to enter into an agency agreement, but not on the trader's premises; or (iii) where the consumer is approached by the trader outside the trader's premises and then the agreement is signed immediately thereafter on the trader's premises; or (iv) where the agreement is signed during an excursion organised by the trader with the aim of selling its services to the consumer.

In so far as it relates to off premises commercial dealings, the CCR was not of course primarily enacted to address relationships such as that of the auction house and seller. Rather, it was designed to address the problems of high pressure sales techniques and doorstepping. In such cases the balance of power is in favour of the trader and the CCR seeks to redress the balance by giving the consumer time to reflect and back out of an agreement signed in haste and under pressure, having been cornered by a pushy salesman. This is different from the relationship between a potential seller and the auction house, where the balance of power is arguably reversed. The seller has the stronger hand and decisions to consign are not taken on the doorstep. However, the broad nature of the legislation means that agency agreements between the seller and the auction house involving the consignment for sale of art can potentially fall within the ambit of the Regulations, giving rise to a right on the part of the consumer to cancellation of the agency agreement. Whether it does or not will depend upon whether the seller is a consumer and where and how agency agreements are signed.

It is important not to assume that the regulations do not apply to agency agreements. An agency agreement between the seller and the auction house can be classified as a distance contract or an off premises contract if the particular circumstances of the negotiation allow it to be so. If that happens and the consumer has not been given the necessary cancellation rights in the prescribed format, reg 19 of the CCR provides that an offence will have been committed, punishable by a fine.

As we have seen, the process of trying to convince sellers to consign property is highly competitive and client relationships are usually built up over a long time. The auction houses have therefore often taken steps to minimise the risk of cancellation rights arising inadvertently. Examples of this are ensuring that internal

systems and training are designed to promote personal contact between the seller and the auction house representatives, thus avoiding the resulting agency being classed as a distance selling contract. Equally, auction houses often avoid signature of agency agreements away from the auction house, and where this is unavoidable they seek to ensure that it does not happen in the simultaneous physical presence of both the auctioneer and the seller. Another sensible approach is to ensure that there is always a reasonable hiatus and further discussion or negotiation between a visit to the seller and the signature of the agency agreement.

3.1.4.2 *Seller's information rights*

The Consumer Contracts (Information, Cancellation and Additional Charges) Regulations 2013 also provide for certain information to be provided to consumers by the trader, depending on the nature of the contract.[21] A failure to provide the information can lead to the agreement being unenforceable against the consumer.

The information must be provided on paper or (with the consumer's agreement) on another durable medium. The information requirements are slightly different depending upon whether the contract is an on premises contract (that is, a contract which does not fall within the definition of off premises contracts: see section 3.1.4.1, 'Seller's cancellation rights') or an off premises contract. The information required is of a kind which would usually be expected to be provided in agency agreement and includes, in particular, the following relevant to agency agreements:

(a) the main characteristics of the goods or services;

(b) the identity of the trader, the geographical address at which the trader is established and the trader's telephone number;

(c) the total price of the services inclusive of taxes, or, where the nature of the goods or services is such that the price cannot reasonably be calculated in advance, the manner in which the price is to be calculated;

(d) information relating to additional delivery charges;

(e) the arrangements and timing for payment, delivery, performance of the services;

(f) where applicable, the trader's complaint handling policy;

(g) the existence and the conditions of aftersales services and commercial guarantees;

(h) the duration of the contract and the conditions for terminating the contract.

[21] Schedules 1 and 2 of the Consumer Contracts (Information, Cancellation and Additional Charges) Regulations 2013.

3.1.5 Auctioneer's contractual rights and obligations in relation to the seller under the agency agreement

In addition to the duties implied by common law and consumer legislation, the relationship between the seller and the auctioneer will be principally defined by the contract between the seller and the auction house, which, as we have seen, is the agreement appointing the auctioneer to act as the seller's agent. This document – the agency agreement – sets out the rights and obligations of the auctioneer and the seller with regard to the auction sale. Put another way, this document sets out the limits of the auctioneer's authority. The auctioneer has a duty to act within those limits as a failure to do so will result in liability in damages to the seller for any loss flowing from the breach of contract.

The most common areas of disagreement between the seller and the auctioneer tend to be addressed in the agency agreement. These are:

• the timing or venue of the sale;
• the marketing of the sale;
• loss or damage to the artwork while in the auctioneer's care;
• the conduct of the auction and bidding;
• the collection of the purchase price;
• the circumstances in which the auctioneer is entitled to retain the artwork or proceeds of sale;
• cancellation of the sale.

With these issues in mind we will consider the matters commonly addressed in the agreement with the seller.

3.1.5.1 The identity of the seller

The identity of the seller is primarily important because it is the seller who is concluding a contract of sale with the buyer. To be able to do this the seller must be the owner of the property being sold, or, if not, must be authorised to sell as agent for the owner of the property. Care therefore needs to be taken to ensure that the seller has the right to sell and that this is reflected in the agreement between the auctioneer and the seller. This is not as straightforward as it may appear, given that, unlike real estate or vehicles, there is in the United Kingdom no official register of ownership of artworks. Artworks can be owned by trusts, corporate vehicles and/ or multiple owners. Because records of purchases, gifts and inheritance often do not survive the passage of time, the due diligence an auction house can carry out with regard to ownership is limited. A great deal of reliance is necessarily placed upon the guarantees given by the seller that he or she is the owner of the property and has the right to sell it. This reliance by auction houses on the assurances of the seller in relation to ownership often comes as a surprise to buyers. However, the reality is that the auction house is seldom in a position to verify the circumstances

in which artworks have changed hands in the past and, even if it did, would not have the legal expertise or detailed factual knowledge of those transactions to analyse the legal chain of title or ownership. However, the auction house cannot close its eyes if there are facts which are known to it which raise questions over ownership or which require steps to ensure that the transaction is not being used for money laundering. In such circumstances more due diligence is required to enable the auction house to proceed with the transaction.

It is worth analysing the position of agents in this context. It is sometimes the case that the person contracting with the auction house is not in fact the owner of the artwork, but an agent acting for the owner. That fact may be hidden from the auction house, or it may be disclosed to it. In the latter case the agent may simply disclose the fact that he or she is an agent without revealing the identity of the owner, or he or she may disclose the agency and the identity of the owner.

If the existence of the agency is not disclosed, the agent will be treated as the owner and will be liable under the contract of sale and the agreement with the auction house as if he or she was the seller.[22]

If the agency is disclosed but the identity of the owner is not revealed then the agent will not usually be treated as liable unless the provisions of the contract expressly impose such liability upon him or her.[23] In such cases the auction house will need to look to the agent's principal for performance of the contract. In order to do this it will need to persuade the agent to disclose the identity of the principal or, failing that, obtain a court order requiring the agent to do so.

Similarly, if both the agency and the identity of the owner are disclosed then the agency will not be personally liable except to the extent expressly provided in the contract. Again, the auction house will need to look to the agent's principal for performance of the contract.

3.1.5.2 *The property to be sold*

The property to be sold must of course be clearly identified in the agency agreement. Care must be taken to identify the property in appropriate detail to avoid any misunderstanding. The description will typically include the artist or period, followed by the title of the artwork, the medium (such as oil on canvas) and the date of the work.

[22] Saxon v Blake (1861) 29 Beav 438.
[23] Gadd v Houghton (1876) 1 ExD 357, CA.

3.1.5.3 *The date and location of the auction sale*

The date and location of the sale in which the property is to be offered for sale is often specified in the agreement. The date is usually of importance to the seller because it determines when the payment is likely to be forthcoming. Auction houses will often include a right to postpone the auction, either generally or in the case of events beyond the auction house's control.

3.1.5.4 *The agency*

The contract will usually confer upon the auction house the status of exclusive agent for the sale of the seller's property. While nonexclusive multiple agency arrangements are a possibility in agency contracts, the sale of art by auction does not usually lend itself to anything other than an exclusive agency arrangement.

The agreement will also frequently provide that, during the period of agency, the seller shall not market the artwork him or herself and shall refer all enquiries about the artwork to the auction house.

These exclusivity provisions have a number of objectives. They are designed to ensure that the auction house has complete control of the marketing effort. This ensures that the artwork is presented to the market in a professional and coordinated manner. In particular, it avoids the possibility of the same potential buyers being approached from multiple sources. Most importantly from the auction house's perspective, it is intended to exclude the possibility of the auction house being deprived of the opportunity to auction the artwork as a result of another auction house being instructed to sell the work or a private sale being concluded prior to the auction by the seller or by a third party.

Once a seller has appointed an exclusive agent for the sale of an artwork, any attempt by third parties to encourage the seller to act in breach of the exclusivity commitment may give rise to an action for damages for breach of contract against the seller and an action against the third party for inducement to breach contract. For such an action to be successful, the third party must have intentionally induced (or procured someone else to induce) the seller to breach the agency agreement between the seller and the agent.[24] The agent must also have suffered loss as a result of that breach.[25] The claim can, however, only succeed against the third party if the third party had actual knowledge of the existence of the contract between the seller and the agent and intended to procure its breach.[26] Full knowledge of its terms is

[24] White v Riley [1921] 1 Ch 1 at 16, CA.

[25] National Phonograph Co Ltd v Edison-Bell Consolidated Phonograph Co Ltd [1908] 1 Ch 335 at 369–70.

[26] Swiss Bank Corpn v Lloyds Bank Ltd [1979] Ch 548 at 572, [1979] 2 All ER 853 at 871 per Browne-Wilkinson J.

not necessary.[27] However, the third party cannot escape liability by simply turning a blind eye to the existence of the contract.[28] In practice this means that if a seller wishes to extricate him or herself from an exclusive agency agreement – with or without the encouragement of a third party – the safest way of doing so will usually be to negotiate a financial deal with the agent where the agent is compensated in some way for relinquishing his or her exclusive rights to sell the artwork.

3.1.5.5 How the auctioneer will publicise and market the auction

The marketing and publicising of the sale is one of the key factors used by auction houses to distinguish themselves from the competition. In most auction houses this will be a question of featuring the lot in advertisements, social media campaigns or on the auction house website. In international auction houses, where the property to be offered for sale is very valuable, auction houses may suggest inventive and extravagant marketing, touring, social media and publicity strategies designed to encourage potential bidders and appeal to sellers who want to see their artwork centre stage. The effectiveness of these strategies depends in each case on the nature and value of the artwork and the particular circumstances of the sale. It can include special standalone catalogues, tours to various countries, special events, email, social media and advertising campaigns. Auctioneers feel that the marketing and publicity campaign is part of the exercise of their professional judgement. They will also be concerned to retain a degree of flexibility over marketing opportunities. The contract will therefore usually provide that, regardless of any ideas or proposals discussed with the seller, the auction house will have absolute discretion over how to market the artwork. Sellers, however, tend to place great store by such proposals and may insist in some cases that the contract should include contractual commitments to all or some aspects of the marketing proposals made by the auction house as part of the pitch to their seller.

The agreement will also usually provide that the auctioneer will have complete discretion as to the written materials produced in connection with the sale. This will include the description of the artwork in the sale catalogue and the content of any saleroom announcements and condition reports. The purpose of these materials is of course to sell the artwork, and the auction house will endeavour to present the artwork in the most attractive way possible. However, this provision is designed to ensure that the auction house is free to describe the artwork accurately to buyers without pressure from the seller to omit from the description facts and matters which might be relevant considerations for buyers – or indeed to 'gild the lily' by exaggerating its qualities.

[27] JT Stratford & Son Ltd v Lindley [1965] AC 269, [1964] 3 All ER 102.
[28] Emerald Construction Co Ltd v Lowthian [1966] 1 All ER 1013 at 1017, [1966] 1 WLR 691 at 701, CA, per Lord Denning MR.

3.1.5.6 *The warranties and guarantees which the seller gives in relation to the property to be sold*

There are certain fundamental aspects of the sale transaction – usually matters of fact – in relation to which any buyer needs reassurance. That reassurance is provided in the form of warranties and guarantees. The seller will usually be required to provide those guarantees and warranties to the auction house in the agency agreement so that they can, in turn, be passed on by the auction house to the buyer in the contract of sale. The most common warranties of this kind provided by the seller are:

• A warranty that the seller is the owner of the artwork or that he or she has the authority of the owner to sell the artwork.
• A warranty that the seller has the right to sell the artwork free of any claims by third parties.
• A warranty that the seller has complied with all export obligations.
• A warranty that the seller has disclosed details of all restoration work to the artwork and any doubts expressed about the authenticity of the artwork.
• A warranty that the seller has disclosed all details of the ownership history, or provenance, of the artwork.

It is worth emphasising that these are warranties provided to the buyer, via the auctioneer, by the seller. This is because the matters covered by these warranties are factual matters relating to the history and ownership of the artwork which the seller, rather than the auction house, is in the best position to confirm. The auction house, on the other hand, is often in a better position than the seller to provide comfort to the buyer in relation to the authenticity and authorship of the artwork. For this reason, warranties and guarantees in relation to the authorship and authenticity of the artwork can and often are provided by the auction house to the buyer in the sale contract to supplement those warranties on ownership and history provided by the seller.

The warranties provided by the seller in the agency agreement in relation to the artwork to be sold are for the benefit of both the auction house and the buyer. The auction house will usually include in the agreement a provision that if any of the seller's warranties prove to be incorrect, the auction house will be entitled to be indemnified against any loss or costs which it incurs as a result of the breach of warranty. A breach of the seller's warranties may also be grounds, under the terms of the agency agreement, for the auction house to unilaterally rescind or cancel the sale.

3.1.5.7 *The estimates to be published in the sale catalogue*

Artworks offered for sale at auction will usually be accompanied by a presale estimate which is agreed between the seller and the auction house prior to the auction.

The estimate is expressed as a range, with the lower end of the range known as the low estimate and the upper end known as the high estimate. The estimate is published in the sale catalogue, providing potential bidders with an indication of the expected sale price of the artwork. The correct calibration of the estimate is often crucial to the successful sale of the artwork. (See also section 2.2.7, 'Estimates'.)

As we have seen, the auction house will prefer an estimate which is conservative and/or realistic. The theory is that this will encourage bidders to bid in the hope of a bargain, creating competitive bidding and momentum which might then push the price up to the high estimate or beyond.

Sellers, on the other hand, are often concerned that their artwork should not be undervalued and are worried that a conservative estimate will result in a conservative sale price. They frequently therefore prefer a more ambitious estimate, in the hope that this will set bidders' expectations at a higher level, resulting in a higher sale price. The danger with this approach is that if the estimate is too high, bidders may be put off bidding and the artwork will fail to sell.

For these reasons the setting of the estimate is a matter for careful negotiation between the auction house and the seller. In situations where rival auction houses are competing with each other to win the right to sell an artwork, it is often the estimate suggested for the artwork by the auction house which can win or lose a deal.

Usually the estimate is agreed at the time the artwork is consigned to the auction house. Sometimes, however, the contract provides that the estimate will be agreed between the auction house and the seller closer to the time of the auction when the catalogue is published. It is possible for the seller and the auction house to change an estimate prior to the auction even after it has been published in the catalogue, but postcatalogue changes are extremely rare, as to do so requires a saleroom announcement by the auctioneer – which runs the risk of putting off bidders.

Where an artwork is particularly valuable or unique, or where there is some uncertainty as to the likely interest in an artwork, the catalogue entry may not provide an estimate at all. Instead it will state 'estimate on request', inviting bidders to contact the auction house for confirmation of the estimate. This approach signals to buyers that the work is of high value. It also allows a certain degree of flexibility, depending on the level of interest shown by bidders in the artwork as the auction approaches. It is far easier to adjust an estimate upwards or downwards when it has not been published in the catalogue.

3.1.5.8 The reserve to be applied to the property

The setting of the reserve is a crucial part of the agreement between the seller and the auction house (see also section 2.2.10, 'The reserve price'). The reserve is a confidential minimum amount below which the auctioneer is not authorised by the seller to sell the artwork. This is critical to the seller because, while most sellers are willing to take the risk of the possibility of a lower sale price in exchange for the possibility of a higher price, most have a threshold in mind below which they would prefer the sale not to go ahead, and instead to remain owner of the artwork. For this reason the auctioneer is instructed that he or she may not sell the artwork until the bidding reaches a predetermined point, known as the reserve. The reserve is a matter for agreement between the auction house and the seller.

One important aspect of the auction process is that the reserve cannot be above the low estimate published in the catalogue. While there appears to be no caselaw to support this prohibition it is a matter of established practice, and for good reason. To allow the reserve to sit higher than the low estimate would be misleading to potential bidders, who take part in the bidding on the understanding that the artwork can be purchased within or above the estimate range. As a result, once the estimate is published, it is not open to the seller to place a reserve on the artwork which exceeds the low estimate. The only way this can be done is by adjusting the published estimate upwards – which will necessitate a saleroom announcement.

As mentioned earlier, the fact that a reserve is set does not always mean that the lot cannot be sold by the auctioneer below the reserve. The agency agreement often allows for a mechanism which permits the auction house to sell the lot to a bidder despite the bid being below the reserve, provided the seller is paid the same amount as he or she would have received had the lot been sold at the reserve. In other words, the auction house makes up the difference out of the buyer's premium it receives from the sale. This is done to ensure that if the bidding ends close to the reserve, the auction house can still opt, rather than allowing the artwork to be unsold, to sell the artwork. Selling below the reserve in this way results in less revenue for the auction house than it would have made had the lot sold at the reserve, but that is preferable to an unsold lot which results in no revenue. In their pursuit of sales with the highest possible sold percentage rates, the ability to sell below the reserve has become an important strategy for auctions houses. Prior to the auction the auctioneer will often work out which lots can be sold below the reserve, and at how much below the reserve. Sellers are usually content with the arrangement as it means they are financially no worse off than if the lot had sold at the reserve.

It is also possible for the seller and the auction house to agree that no reserve shall be applied to the sale. In other words, the sale will be a sale 'without reserve'. Such an agreement means that the auctioneer will sell the artwork to the highest

bidder regardless of the level of the bid. The advantage of such an arrangement is that a sale without reserve usually generates a great deal of interest and bids from bidders who are hoping for a bargain. More competitive bidding can often push prices higher. It also guarantees to the seller that the artwork will be sold. If a sale is expressed to be a sale without reserve, however, the auction house is bound to accept the highest bid, even where that bid falls below the seller's and the auction house's expectations. A refusal or failure to do so can result in a claim for damages by the highest bidder against the auction house (Barry v Davies 2000 1 WLR 1962).

3.1.5.9 *The costs and commission to be paid by the seller in relation to the sale*

Sellers will usually be required to pay the auction house a commission, which is deducted from the proceeds of sale of the artwork. The commission is typically on a sliding scale, calculated by reference to the hammer price of the lot.

In addition, the auction house may charge the seller for out of pocket costs and expenses incurred in preparing the artwork for sale, whether or not the artwork is sold. This may include such items as catalogue costs, photography costs, insurance costs, shipping costs, and so on.

Finally, some agency agreements provide for an unsold lot fee, which is designed to cover the auction house's administrative costs in the event that an artwork fails to sell.

3.1.5.10 *The terms on which the property will be insured while in the hands of the auctioneer*

Sellers are usually understandably concerned to ensure that their artwork is covered in the event that it is damaged, lost or stolen. The agency agreement will provide confirmation of the arrangements in place in the event of such an incident. The most obvious is a provision confirming that the artwork will be insured under an insurance policy from the moment it is in the hands of the auction house until the moment it is collected by the buyer or returned to the seller. Another approach is for the auction house to provide cover as though it was itself an insurer. In this latter case the auction house simply assumes liability for any loss or damage.

In either case the cover provided will be subject to conditions, exclusions and limits. The more common such exclusions are covered in Chapter 12.

3.1.5.11 *Withdrawal*

In committing to offer an artwork for sale the auction house is agreeing to invest in the sale by committing its resources to publicising the sale by advertising, publication and distribution of sales material as well as exhibiting the artwork. That

investment is made in the hope that the artwork will sell successfully, resulting in revenue for the auction house and reputational success. To protect the auction house's investment, the seller will usually be required by the auction house to commit irrevocably to the sale. This avoids the possibility of the seller changing his or her mind and either deciding not to sell the artwork at all or deciding to sell the artwork otherwise than through the auction house. Many agency agreements provide that once the agency agreement is signed the seller may not withdraw the artwork from sale at all, or that the seller may do so only with the consent of the auction house. In the latter case a condition for such consent being given will usually be payment of the auction house's costs together with a withdrawal fee equal to the revenue the auction house would have made had the artwork sold at auction – ordinarily at the mid-estimate, halfway between the low and the high estimate.

3.1.5.12 Conduct of the auction

The agreement between the auction house and the seller will usually contain a term which gives the auctioneer complete discretion as to the conduct of the auction, and in particular which bids to accept or reject and how to deal with errors or disputes in the saleroom.

3.1.5.13 Force majeure

Auction contracts have long incorporated a *force majeure* clause designed to excuse a party's non-performance in case of an unexpected natural disaster or an event which was outside the control of the contracting parties. The clauses were generally inserted to allow the auction house to cancel or postpone an auction sale in the event of a fire, a flood or public disorder. In truth these clauses attracted little attention and were seen as 'boilerplate clauses' which were rarely negotiated. The sudden emergence in 2020 of COVID-19 and its dramatic effects changed all of that. When, in early 2020, governments across the world banned auction houses from holding physical auctions the auction houses successfully invoked their rights under force majeure clauses to justify the cancellation or postponement of their obligations.[29] As a result the *force majeure* clause is today the subject of considerable focus in contract negotiations, in particular where the timing of the sale and payment are important to the seller. The main focus of the discussions is

[29] In JN Contemporary Art, *LLC v Phillips Auctioneers LLC* (2020 WL 7405262 (SDNY Dec. 16 2020)), the United States District Court for the Southern District of New York was asked by the consignor to rule on whether or not the COVID-19 pandemic constituted a 'natural disaster' and fell within the scope of Phillips' force majeure clause. The Court held that it was a natural disaster and that Phillips was excused from offering the work for sale with a US$5,000,000 minimum price guarantee.

usually upon the types of events which trigger the clause and whether the trigger entitles the parties to walk away from the contract altogether or to postpone it.

3.1.5.14 Payment

In auctions, just as in any other form of sale, the sale can only be said to have been concluded once the buyer has paid in full for his or her purchase. While failure to pay remains a rare occurrence, there is always a risk that, following the auction, buyers are unwilling or unable to complete the sale. Where that happens, the agreement between the auction house and the seller will usually make it clear that in case of delay or default by the buyer the auction house is not liable to the seller for the purchase price. The auction house will, however, pursue defaulting buyers for payment on behalf of the seller.

Because the release of the artwork to the buyer and the transfer of ownership to the buyer are both dependent upon payment in full being received, in the event of nonpayment or slow payment the artwork will almost always still be in the hands of the auction house and ownership will not have passed to the buyer. This provides significant protection to the seller. Even if the buyer fails to pay altogether, the seller will still have the artwork and can reoffer it for sale. In some rare cases, however, the auction house may release the artwork to the buyer before payment in full has been received. In such cases, unless otherwise agreed with the seller, the auction house will, in doing so, have taken on the risk of nonpayment and will be liable to the seller for payment as if the auction house was the buyer. While sellers may be instinctively uncomfortable with the prospect of their artwork being released before payment is received, the advantage for them is that they are effectively guaranteed payment by the auction house on the due date.

The question will therefore be how best to encourage the buyer to pay. The agency agreement between the auction house and the seller will usually be unspecific about what steps will be taken by the auction house in the event of a failure to pay by the buyer. It will also make it clear that the manner in which the debt is pursued is a matter for the auction house's discretion. This is deliberate because there are a range of options and the strategy most likely to secure the desired outcome will vary greatly depending upon the identity and location of the buyer, the amount of money at stake and the reason for the delay or nonpayment. The concern of the auction house and the seller will usually be to enforce the sale. This can be done through an escalating series of measures ranging in severity from oral and written reminders through to court action. Sellers often encourage auction houses to take court action against buyers at an early stage. Certainly, in some cases the threat or issue of court proceedings will elicit payment. However, in other cases such an approach will result in greater determination on the part of the buyer not to pay. If the buyer is known to the auction house then the auction house will be best placed

100 ART LAW AND THE BUSINESS OF ART

to make that judgement. There are also other considerations to be taken account of beyond the personality of the buyer. There is, for instance, little point in going to the trouble and expense of obtaining judgment against the buyer if the buyer does not have the means to pay and/or does not have any assets against which the judgment can be enforced. In these cases a more cost effective option may be to cancel the sale altogether on ground of nonpayment and seek to sell the artwork privately to another buyer – such as the underbidder in the auction.

Where a lot is very high value, the consequences of a payment default can be significant. We have seen that the price achieved by lots can have much to do with their rarity and freshness. A work which has to be reoffered for sale, privately or by auction, due to a failure by the original buyer to make payment may well not achieve the same price as it did when first offered. For this reason auction houses are careful to satisfy themselves that potential bidders for high value lots are not likely to default on payment. Beyond the credit checks and bank references some auction houses require a substantial deposit from bidders intending to bid on high value lots. The deposit is refundable if the bidder is unsuccessful, but if he or she is successful the deposit is applied to the purchase price and may be forfeited in the event of a default.

3.1.5.15 Cancellation and rescission of the sale

Most auction houses provide buyers with a form of money back guarantee in the event that an artwork turns out after the sale to be a forgery, or is not by the artist it was held out to be by. Later we will cover how those guarantees operate (see section 5.2, 'Authenticity and attribution'). Many agreements between auction houses and sellers provide for a clawback arrangement against the seller where the auction house is required to refund the buyer on grounds of inauthenticity or misattribution. This may seem odd at first blush, given that the description of the artwork in the catalogue and confirmation of authenticity might be said to be within the professional responsibilities of the auctioneer rather than those of the seller. However, it is important to remember that the purpose of cancellation and rescission is to place all the parties in the same position they were in prior to the sale. So, the auction house must return its fees to the buyer and the seller. The seller must in turn return the purchase price to the buyer. The buyer must return the artwork to the seller. The seller might argue that the auction house was negligent in failing to identify the artwork as a forgery or by wrongly attributing the artwork to a famous artist. That, however, is a separate question. The seller in such a case is free to sue the auction house for any loss he or she may have incurred as a result of the negligence. However, even if the auction house was negligent, establishing a loss in such circumstances is more difficult than it might seem. Had the auction house not been negligent – and had it identified the artwork as being a forgery – the seller would have been the owner of a worthless forgery and there-

fore in no worse a position than he or she would be in following the cancellation of the sale due to the negligence of the auction house. What the seller cannot claim is to be entitled to a sum of money equal to the value of an authentic version of his or her forgery.

The case of *Sotheby's v Mark Weiss Ltd, Fairlight Art Ventures Ltd and Mark Weiss* [2019] EWHC 3416 was an example of a seller questioning the obligation to repay the proceeds of sale when a sale to a buyer was cancelled due to the artwork being a forgery. The artwork in that case was a painting sold privately by Sotheby's for US$11,000,000 on behalf of the seller as being by Frans Hals. A tip-off by the French authorities investigating forged old master paintings led the buyer of the painting to return it to Sotheby's for scientific testing. An analysis of the paint revealed the presence of a pigment which did not exist at the time that Frans Hals was active. The painting was therefore a forgery and Sotheby's refunded the US$11,000,000 to the buyer. Sotheby's then demanded that that seller return the proceeds of sale. Sotheby's relied upon a clause in the Seller's agreement which stated that 'in the event Sotheby's determines that [the artwork] is "counterfeit", you [the seller] agree to a recission of the sale and will return to the buyer the purchase price received by you for [the artwork]'. The seller refused to refund the proceeds of sale, claiming that in refunding the buyer Sotheby's had acted 'unreasonably, irrationally, arbitrarily, capriciously and without good faith'. Sotheby's sued the seller and the judge upheld its entitlement to a return of the proceeds of sale from the seller.

3.1.5.16 *Exclusions and limitations of liability*

The agency agreement with the Seller will also include limits and exclusions on the liability of the auction house. The effectiveness of such provisions is covered below in section 3.2.3.2.

3.2 The auction house and the buyer

As we have seen above, the auctioneer acts as agent for the seller. The auctioneer's fiduciary duty to the seller therefore precludes the possibility of the auctioneer acting also for the buyer. To do so would raise a clear conflict of interest. In addition, the sale contract is between the seller and the buyer. The auctioneer is not a party to that contract. While this is the legal position, the relationship between the auctioneer and the bidder and buyer is nevertheless a complex one.

Auction sales catalogues provide significant art historical and other details which are designed to inform the potential buyer about the artworks on offer. Auction house specialists regularly visit important collectors to discuss their collections

and make curatorial suggestions. Auction house presale viewings are staffed by specialists ready to escort potential buyers around the exhibition discussing the merits of the artworks. At the auction, auction house staff guide their telephone bidders through the bidding process, relaying information about the bidding in the saleroom. All of this can leave the bidder with the impression that the auction house is acting as his or her adviser. However, while there is no doubt that auction houses are seeking to provide the best information and client care possible to the buyer, the legal reality is that they are doing so as the agent for the seller.

The fact that the auctioneer is not acting as agent for the bidder or buyer and is not a party to the contract of sale does not, however, mean that the auctioneer has no liability to these parties. Despite not being their agent, the auctioneer may be liable in contract to those who bid and buy in the room in other ways.

3.2.1 The auctioneer's liability to the buyer

3.2.1.1 *The auctioneer's implied warranty of authority*

As the agent for the seller, seeking to conclude a contract of sale on behalf of the seller, the auctioneer gives an implied warranty to buyers that the auctioneer has the seller's authority to sell the artwork. If the auctioneer does not in fact have any authority from the seller to offer the artwork for sale, the seller will not be bound by the contract of sale and the auctioneer may be liable to the buyer for breach of his warranty of authority and any loss suffered by the buyer as a result.[30]

A more difficult question arises where the auctioneer has authority from the seller, but exceeds or acts outside of that authority. In principle, where the auctioneer has been duly appointed as the seller's agent, the seller will be bound by the acts of the auctioneer. This is because by appointing the auctioneer as agent the seller has given buyers the impression that the auctioneer is acting with authority. It is not for the buyer to know what the limits of that authority are. This is known as 'apparent' or 'ostensible' authority. If the buyer has, in good faith, relied upon that impression in entering into a contract of sale then the contract is binding. However, if the buyer has been made aware of the limits of the auctioneer's authority then a contract which exceeds those limits will not be binding.

The obvious situation where this can arise in the context of an auction is where an auctioneer has been instructed by a seller to sell an artwork, but subject to a reserve below which the auctioneer has no authority to sell. What is the position if, in breach of his instructions, the auctioneer sells the artwork to a buyer below the reserve? In McManus v Fortescue it was held that:[31] (i) where the buyer had

[30] Anderson v John Croall & Sons Ltd 1903 6 F (Ct of Sess) 153, 41 Sc LR 95.

[31] [1907] 2 KB 1, 76 LJ KB 393 CA.

notice, from the auctioneer's terms and conditions, that the artwork was or may be subject to a reserve, then he or she is deemed to have had actual or constructive notice that the auctioneer's authority was limited and cannot therefore sue the auctioneer for breach of warranty of authority, even if the precise limits on the auctioneer's authority – in other words, the level of the reserve – were not known to the seller; (ii) because the sale was stated to be subject to a reserve, the sale was conditional upon the reserve price having been reached.

It is important to note, however, that McManus & Fortescue was decided at a time when a sale by auction was not, as it usually is today, completed on the fall of the hammer. A further step was required, namely, the signature of a memorandum of sale by the auctioneer. That step had not been completed and the suggestion in McManus v Fortescue was that, because that final step had not been taken, in the absence of a completed sale no binding contractual warranty had come into existence. It followed therefore that there could be no breach of warranty of authority. At most auction sales today the sale is completed on the fall of the hammer, so the realisation that the lot has been sold below the reserve will occur only after the sale has been completed – when the warranty of authority is in place. Further, if there is a provision in the auctioneer's terms and conditions notifying bidders that lots are offered subject to a reserve, then bidders will indeed be on notice of the existence of a reserve. However, because the reserve is confidential, they have no way of knowing or finding out prior to the fall of the hammer at what level the reserve has been set. The bidder must, in my view, be permitted to rely upon the professionalism of the auctioneer in such circumstances – and where the auctioneer incorrectly sells below the reserve, while the contract of sale cannot be enforced against the seller, it should be open to the buyer – even if he is unable to enforce the sale against the seller – to sue the auctioneer for breach of his warranty of authority.

3.2.1.2 Auctioneer's liability on the contract of sale

A crucial and often misunderstood aspect of the structure of an auction is the liability of the auctioneer under the contract of sale. The contract of sale, usually incorporated into the conditions of sale at the back of the auction catalogue, is an agreement between the seller and the buyer. The contract is concluded by the auctioneer as agent for – and on behalf of – the seller. As we have seen, the auctioneer is not, however, a party to the contract of sale. The auction house and the buyer may be bound to each other contractually by other provisions under the conditions of sale – but not under the contract of sale, which is exclusively between the seller and the buyer.

However, where the auctioneer holds himself or herself out as being the seller, and does not reveal to bidders that he or she is in fact acting as agent for a third party

seller, then, because the bidder thought he or she was buying from the auctioneer, the auctioneer will be liable as if he or she was the seller.[32]

A more difficult case is where the auctioneer reveals that he or she is acting as agent for the seller, but does not reveal the name of the seller. This is the position in most sales by auction. In these circumstances, unless there is a contrary intention, the law requires that the agent will in principle be liable under the contract of sale.[33] However, the position will be different if there is a contrary intention. That contrary intention is usually present because in most cases the auctioneer's conditions of sale will make it clear to the buyer that the auctioneer is not the principal and is acting merely as agent. The contrary intention can also be inferred from the circumstances of the sale. In Benton v Campbell Parker & Co a distinction was drawn between a situation where the goods being sold were unascertained generic goods, such as three sacks of flour, which could be procured from another source, and a situation where the item being sold was specific and ascertained, such as an artwork. In the case of unascertained generic goods it would be reasonable for a buyer to expect the agent to source the goods from elsewhere if the principal was unable to transfer title to the buyer. However, where the agency is an agency for the sale of a specific object, which the buyer knows is not the property of the agent, Salter J said:

> [I]t seems to me impossible to presume that the buyer, who contracts to buy that chattel from the principal, would stipulate that the agent, if called on, shall himself sell the chattel to the buyer and shall himself warrant his own title to a thing which the buyer knows is not his. It is impossible to presume that the agent would agree to undertake such a liability.

Most, if not all, art auctions will involve the sale of an ascertained object in circumstances where the auction house has made it clear that it is acting as agent for the seller. As a result, it is unlikely the auctioneer will be liable under the contract of sale. Even where the auction house is liable under the contract of sale, the extent of the auctioneer's liability under the contract of sale in these circumstances is likely to be limited. While the auctioneer may have liability under the contract of sale to procure the delivery up of the artwork which has been purchased, the auctioneer is unlikely to be liable beyond nondelivery.

This kind of analysis may however be less important in practice, as a disappointed buyer will in most cases tend to sue the auctioneer under the contract of sale. This is in part because the buyer does not usually know the identity of the seller, as in most auction sales the buyer's identity has been kept confidential by the auction-

[32] Saxon v Blake (1861) 29 Beav 438.
[33] Benton v Campbell Parker & Co [1925] 2 KB 410 at 417.

eer. Suing the auctioneer encourages the auctioneer to reveal the identity of the seller and/or put pressure on the seller.

3.2.1.3 Auctioneer's collateral contractual liability to the buyer

We have seen that in most cases the auction house as agent will not be liable under the contract of sale, which is between the seller and the buyer. This does not however mean that the auction house has no contractual liability to the buyer. The conditions of sale at the back of the catalogue include the contract of sale, but also include contractual provisions which are designed to govern the relationship between the auction house and the buyer. We will cover these below in section 3.2.2.1 on express terms in the conditions of sale. In addition there are some situations where, while acting as agent for the seller, the auctioneer will nevertheless be deemed to have a collateral contractual relationship with the buyer which renders the auctioneer primarily liable. In De Balkanay v Christie Manson & Woods,[34] for instance, the auctioneers were found to have entered into a separate contractual commitment with the buyer to 'repurchase' the artwork if it turned out to be a forgery. The consideration for this commitment was deemed to be the payment by the buyer of the buyer's premium.

It is perhaps worth examining the facts of this case, which are also important from a more general perspective when analysing the courts' approach to the contractual duties of auction houses. In this case a painting was consigned by the seller to Christie's, which was attributed by the auction house to the artist Egon Schiele and was described in the sale catalogue entry as signed by Schiele, following an inspection using an ultraviolet lamp and a magnifying glass. The buyer, Mme de Balkany, bought the painting for the £500,000 reserve price at the auction in June 1987 and paid the hammer price together with the buyer's premium. In March 1991 the buyer contacted Christie's, alleging the painting was a forgery within Christie's terms and conditions of sale and claiming a refund.

Christie's terms and conditions of the sale excluded liability in relation to any statement made as to authorship, origin, date, age, attribution, genuineness or provenance or any other errors of description, or for any faults or defects in any lot. (We will cover the effectiveness of this exclusion below in section 3.2.1.4, 'Auctioneer's liability to the buyer in tort'.) However, the conditions of sale did, subject to certain conditions, provide the buyer with a contractual right to cancel the sale and obtain a refund where the lot was a forgery. A forgery, for these purposes, was defined as an artwork created with an 'intention to deceive as to authorship, origin, date, age, period, culture or source'. However, even where a lot

[34] [1995] Independent Law Reports, 19 January 1995.

was found to be a forgery there was no right of refund under the conditions of sale if Christie's opinion at the time of the sale was in line with the state of scholarship.

Christie's claimed that it owed no duty of care to the buyer, that the painting was sold 'as is' and that it was correctly described. Further, Christie's took the position that the buyer was not entitled to a refund under the conditions of sale on the grounds that (i) the painting was by Egon Schiele and had not been created with an intention to deceive as to authorship, and (ii) Christie's opinion was in line with the state of scholarship at the time of the sale.

The judge found that while the painting was, on the balance of probabilities, likely to be by Egon Schiele, it had at some stage been extensively overpainted. Of the total surface area of the painting visible to the naked eye, 94% had been painted by someone other than Schiele. The initials 'E' and 'S' had also been added as part of the overpainting and a monogram on the original work had been deliberately obscured by the overpainting. This was not disputed by Christie's, but its position was that no amount of overpainting could make the painting a forgery. The judge disagreed, saying that what the buyer bought was a painting which was almost wholly made by an unknown person. What was visible was a picture painted by such person, although it may well follow a composition by Schiele and reproduce reasonably closely (but not exactly) the colours of the painting over which the painting was made. The judge went on to find that the overpainter must have intended to deceive the viewer into believing that the initials were painted by Schiele because the evidence had shown that he had overpainted the original monogram. The overpainter had, the judge concluded, intended to deceive as to authorship and the date and age of what is visible on the painting. Further, the judge found that regardless of the state of scholarship, a careful inspection should have revealed to Christie's that the painting as seen was largely the work of an overpainter who had forged Egon Schiele's initials, and accordingly Christie's was not entitled to escape liability on the grounds that its opinion at the time of the sale was in line with the state of scholarship.

3.2.1.4 Auctioneer's liability to the buyer in tort

In De Balkanay v Christie Manson & Woods,[35] the judge discussed the question of the liability of Christie's to buyers in tort and the effectiveness of its contractual disclaimers of liability. The judge found that because Christie's took responsibility for the catalogue description and because the buyer pays a buyer's premium, there was an assumption of responsibility such that Christie's became liable to a buyer for negligent misstatement in the catalogue entries. However, he went on to conclude, reluctantly, that Christie's had made it reasonably clear in its conditions of

[35] [1995] Independent Law Reports, 19 January 1995.

sale that it had not assumed any responsibility to the buyer for the way in which the statements in the catalogue are prepared.

Following the De Balkany case, and in part because of the usually very limited liability that the auction house usually has to the buyer under the contract of sale, attempts have been made by buyers to sue auction houses in tort for negligence – particularly in cases where a work is alleged to be a forgery or misattributed. However, to date those attempts have tended to be unsuccessful. It is likely that this is because the courts have recognised the difficulty of auction houses owing on the one hand a fiduciary duty to the seller, and on the other a duty of care to the buyer. It is also likely that the courts are reluctant to go behind the contractual remedies available to the buyer under the auction house's conditions of sale.[36] It may also be an acknowledgement by the courts of the inherently subjective nature of attribution.

In some cases, however, there may be certain special circumstances where a duty of care in tort does arise. In Thomson v Christie Manson & Woods Limited,[37] it was established that where an auction house set up an advisory service designed to provide technical advice to a small number of high net worth buyers, this could give rise to a special duty of care which was more extensive than the general duty it owed to bidders to take reasonable care with cataloguing. This follows the principles outlined in Hedley Byrne & Co Ltd v Heller & Partners Ltd,[38] which established that when a party seeks information or advice from another – possessing a special skill – and trusts him to exercise due care, and that party knew or ought to have known that the first party was relying on his skill and judgement, then a duty of care will be implied.

It is a reality that, while acting for the seller, auctioneers routinely seek to encourage buyers and develop relationships with buyers by providing assistance and guidance on their purchases. Buyers certainly see themselves as clients of auction houses, expecting, and indeed often receiving, the same level of attention, guidance and assistance as that enjoyed by sellers. However, despite any appearance to the contrary, it is the seller for whom the auction house is acting. Auction houses need to keep this in mind at all times and must take care to ensure that assistance of this kind does not amount to the provision of specialist professional advice to the buyer – which carries with it the double risk of liability and a potential conflict of interest.

[36] See also Avrora v Christie Manson & Woods Ltd [2012] EWHC 2198 (Ch).
[37] [2004] EWHC (QB), [2004] All ER (D) 267.
[38] (1964) AC 465 (HL).

3.2.2 The rights and obligations of the buyer

3.2.2.1 *Express terms in the conditions of sale*

The terms on which the sale is concluded are usually set out in the back of the auction sale catalogue and may also be displayed on the auctioneer's website or be displayed or available at the saleroom. These terms govern not only the relationship between the buyer and the seller (that is, the contract of sale), but also certain aspects of the relationship between the auction house and the buyer and between the auction house and bidder.

While the contract between the seller and the auction house is often the subject of negotiation, the terms and conditions of sale printed in the catalogue are standard terms of business which apply to all buyers and bidders. They are not usually open to variation or negotiation, because to do so would affect the chief attraction of an auction, which is that all bidders compete with each other on the same terms.

The conditions of sale at the back of the catalogue embody the terms on which the artworks in the auction are sold. They therefore incorporate the contract of sale, the manner in which the auction will be conducted and the rights and obligations of the buyer. The conditions of sale are standard conditions applying to all bidders in the saleroom and are not negotiable. They will usually include a term that by participating in the auction bidders are confirming their acceptance of the conditions of sale. Because the conditions of sale are central to the conduct of the auction it is important that they should be drawn to the attention of the bidder before the sale is concluded. The most obvious way this is done is by incorporating them into the sale catalogue. However, as auction houses seek to save costs by encouraging buyers to rely on virtual catalogues on their websites or short viewing guides, the question of whether the conditions of sale have been drawn to the attention of the bidder becomes more critical. Auction houses have taken to displaying copies of their conditions of sale on the saleroom wall, making them available at the time of bidder registration or requiring a clickthrough acceptance for online catalogue viewing. The more effort the auction house puts into making its conditions of sale easily available, the more difficult it is for a buyer to assert that he was not aware of the conditions of sale and is therefore not bound by them. Indeed, it is difficult to imagine many scenarios where a bidder – and in particular an experienced bidder – could plausibly claim to have been unaware of conditions of sale.

Before examining in detail what express terms are usually found in the conditions of sale, it is worth considering their function, in a wider sense. Auction houses are selling valuable objects which have passed through many hands, are rarely in their original condition, have sometimes been repaired and restored, and the authorship of which is often the subject of informed opinion rather than fact. Bidders appreciate and accept many of the risks inherent in these circumstances, knowing

the uncertainty can also work in their favour. However, because of these factors the likelihood of a claim by a disappointed buyer is potentially very wide. As a result, it is important to be clear about which aspects of the artwork are the subject of guarantees given by the auction house and/or the seller, and which aspects are at the buyer's risk. In addition, it is important to bear in mind that the purpose of the auction is very different from that of a retail transaction. The auction process is intended to establish the value of an object by giving bidders the opportunity to compete between each other for it, having all been given an opportunity to assess the value of the object for themselves through a visual inspection. For this process to be effective, however, the buyer cannot be permitted to walk away from his or her purchase other than on the limited basis of a fundamental problem with the artwork which he or she could not have been expected to know about at the time of the sale, or in relation to which he or she was substantially misled. Defining those limited circumstances in which the buyer can cancel a sale is the primary function of the conditions of sale and also the reason why the buyer's remedies under the conditions of sale can appear limited.

As a rule, auction houses expect to be viewed as experts on attribution. In other words, the expertise of the specialists in the auction house lies in correctly identifying the creator or the period or territory from which an artwork came. It does this using its in-house expertise or by seeking the views of scholars. (Even this is not risk free, as the state of scholarship can change and attributions which were accepted at one point in time may change as a result of new evidence or a new body of opinion.) The conditions of sale usually recognise this expectation by making the auction house liable, subject to certain important conditions, if it gets the attribution wrong or sells a work as authentic which later transpires to be a forgery. On the other hand, there are certain aspects of the artwork which the auction house cannot know or is not equipped to express a view on. For instance, if an artwork has in the past changed hands through inheritance, as a gift, or through a marriage or a sale contract, the auction house is not in a position to check whether the will or the contract was legally effective, particularly if the event took place a long time ago. That is a legal question known only to the seller or his predecessors in title. As a result, under the conditions of sale it is the seller who warrants to the buyer that he or she is the legal owner of the artwork and has the right to sell it. Equally, the physical condition of artworks is an area which presents auction houses with some difficulty. While obvious blemishes or damage can be identified by inspection, the reality is that damage and wear and tear to works of art are frequently masked or hidden by restoration and repairs which can be identified only by trained conservators, by scientific techniques, by invasive cleaning or by stripping the artwork down. Added to that, the buyer has also been given the chance to inspect the artwork and ascertain for him or herself the condition of the artwork. There is therefore a reluctance on the part of auction houses or the seller to accept

responsibility for the condition of the works sold. For this reason the conditions of sale usually place risks around the condition of artworks at the door of the buyer.

With this in mind, we will now turn to the detail of the terms which are to be found in the auction house's conditions of sale. Of course, all conditions of sale are different and their format and content will vary from auction house to auction house, but what follows are some of the provisions commonly found in auction conditions of sale.

(1) Catalogue description: The conditions of sale will often make it clear that the description of the lots in the catalogue, including statements about the artwork's history, ownership, authorship, materials, period or dimensions, are expressions of opinion and not to be relied upon as statements of fact. While this may at first blush seem like a rather wide disclaimer, there is some basis to the statement. Many, if not most, works of art which appear in the catalogue were created long ago. Unless the auction house specialist was standing at the shoulder of the artist and watched him create the artwork, it cannot be said as a statement of fact that the work was by the hand of the artist. The auction house specialist can however bring to bear the knowledge that he or she and other scholars have of the artist's work and express an opinion that the work was by the hand of the artist. It is that opinion which appears as the catalogue description.

Most conditions of sale will also seek to narrow down which aspects of the catalogue description may be relied upon by the buyer as part of the contractual description and which may not. Typically, those parts of the description which are intended to form part of the contractual description will be highlighted in the catalogue in bold type or capitalised letters. Usually this will be restricted to the name of the artist. The conditions will then include a wide exclusion of liability for all other elements of the catalogue description. Typically, the auction house will make it clear that other than in relation to the elements of the catalogue description identified as being contractual in nature, the seller and auction house do not give any guarantee or warranty, or make any representation in relation to the description of the artwork. As a result, elements such as the ownership and exhibition history, artistic appraisal, condition and dimensions do not form part of the contractual description of the artwork.

It is important to note that there is no obligation under United Kingdom law on the auction house to provide full, or indeed any information in the catalogue entry in relation to the previous ownership of the artwork, known as 'provenance'. And most conditions of sale make it clear that provenance information may not be complete. This is a contentious issue as it is sometimes asserted by buyers that they would not have bought the artwork had they known about a particular aspect of its previous ownership history. Restitution claimants also sometimes suggest that provenance information may have been suppressed or omitted in order to hide

a problematic history. In practice, this is unlikely. Auction houses do not have a commercial interest in selling works which they know or suspect will later be identified as problematic. Doing so would be high-risk from a client relations and financial perspective. They therefore devote resources to ensuring that they know the ownership history of the artworks they sell provide as complete a provenance as they are able – even though they are under no legal obligation to do so. This is not only for their protection but also because a historic or full provenance usually makes works more saleable – and, in the case of antiquities, is almost essential. Provenance gaps often do exist, but these are more commonly the result of an absence of written records. Lack of such records is not surprising given that it is only relatively recently, as a result of cultural property and Holocaust restitution claims, that knowing where an artwork has come from has become so very important – particularly in certain categories of art. Recent provenance may sometimes be omitted, but usually only because its inclusion might reveal the seller's identity or the fact that the work was recently acquired by the seller.

Conditions of sale will also often include specific exclusions of liability for fitness for purpose of satisfactory quality under the Sale of Goods Act 1979. (See section 3.2.2.2, 'Terms implied by law'.)

(2) Condition: Auction house terms and conditions frequently seek to exclude or limit liability for defects in the condition of the lots. This is because artworks sold in the secondary market are, due to their age, rarely in perfect condition, and the onus is on the buyer to ascertain the condition for him or herself. Most conditions of sale include reminders that the buyer is responsible for inspecting lots before bidding on them and satisfying him or herself of their condition, taking independent advice if necessary. Indeed, this is the primary purpose of the presale viewing. The position is made more complicated by the fact that the condition of artworks can often be hidden by restoration and repairs which a lay person – or even a professional restorer – would be unable to spot. Condition issues can often emerge only after the sale, once the work is taken away by the buyer or sent for cleaning or restoration. This is why the terms often reinforce the fact that lots are sold 'as is', in the condition they are in at the time of the sale.

Most auction houses do however provide condition reports, detailing the condition of each lot in the sale. This might seem at odds with the principle that the buyer is responsible for checking the condition, but it is a reflection of the reality that many potential bidders considering bidding on a lot will want some indication of condition, even if ultimately it is their responsibility to satisfy themselves of condition. Where such condition reports are provided, the conditions of sale will often make it clear that the provision of the report is a service by the auction house, that the contents of the report are not exhaustive, that the report is no substitute for a physical inspection and that the supply of the condition report does not absolve the buyer of responsibility to inspect the lot him or herself.

(3) Seller's warranties: As we have seen, at the time of instructing the auction house to sell his or her artwork, the seller is required to give certain warranties. Some of these warranties may be passed on expressly in the conditions of sale to the buyer of the artwork. The most important of these are that the seller is the owner of the lot and has the right to sell it and pass good title to the buyer. This means that if it transpires that the seller did not own the artwork and did not have the right to pass good title on to the buyer, the buyer will be entitled to sue the seller for breach of warranty of title, in addition to any other remedies the buyer may have under common law or against the auction house.

(4) Auction house's authenticity warranty or guarantee: At first glance it might seem that the question of whether or not an artwork is authentic is a straightforward one. It might be thought that if an artwork turns out not to be as described in the catalogue the buyer should be entitled to demand his or her money back from the auction house. The question is more complex than that for a number of reasons. First, not all the information about an artwork which appears in the catalogue can reasonably be expected to be guaranteed. Some aspects cannot be checked or verified by the auction house, some aspects are subjective and not intended to be relied upon, and some are not so fundamental that the buyer should be entitled to cancel the agreement.

The next consideration is that, as we have seen above, identifying the authorship, provenance or period of an artwork often involves a degree of detective work. It requires comparing the artwork to other known works, consulting academic texts, seeking expert opinions from scholars and using judgement. As a result, when the auction house expresses a view as to the authorship or period of an artwork it is not a statement of fact. It is a statement of opinion based on the state of academic and scholarly knowledge at the time of the sale. That opinion can only be as good as the state of knowledge about the artwork and the artist's oeuvre at that time. It is also common that, as the state of knowledge and scholarship develops, artworks which were previously thought to be authentic are deemed to be inauthentic and works which were thought to be inauthentic are rehabilitated as authentic. While it is perfectly fair to expect the auction house's opinion to be in line with the state of knowledge at the time of the sale, it would be unfair to expect the auction house to underwrite subsequent changes in the opinions of scholars.

The position is further complicated by the fact that when artworks are described in the catalogue there are gradations of authenticity. A work may be wholly or partly by the hand of the artist; it may be by the hand of a person from the artist's studio; it may be by the artist but with a signature added at a later date; it may be by the artist but added to at a later date. A list of some of the most common gradations is provided in the Glossary of Art Terms.

A further consideration is that the auction house is not actually the beneficiary of the proceeds of sale of an artwork which turns out to be a forgery or misattributed. The beneficiary is the seller. When a sale is unwound because an artwork turns out not to be authentic, the unwinding needs to result in the parties being put in the same position as they would have been in had they not entered into the sale transaction. The seller must return the proceeds of sale to the buyer; the auction house must return the buyer's premium made on the sale to the buyer and return any seller's commission it collected to the seller.

The conditions of sale of any auction house catalogue will usually take all of these considerations into account with a clause setting out a Warranty of Authenticity. This warranty is the guarantee to the buyer that the work he or she has bought is authentic. The circumstances in which a buyer can obtain a refund on grounds of authenticity are, however, carefully defined.

First, as we have already seen, they will make clear precisely which aspects of the catalogue description are warranted or guaranteed by the auction house and which are not. In most cases the authorship or the period will be guaranteed. Other aspects of the description will not. The conditions of sale will then define the time period within which a claim under the authenticity warranty may be made by the buyer. This is usually between one and five years after the sale. In order to make a claim the buyer must usually have remained the owner of the artwork and will be required to provide the auction house with evidence of inauthenticity. Any restoration work or physical alteration to the artwork will void the warranty.

(5) Withdrawal: Occasionally, works which are advertised to be offered for sale are withdrawn from sale – sometimes only immediately before the auction. This can be frustrating for bidders, who are disappointed and may have incurred cost in travelling to be at the auction. It is therefore sometimes made clear in the conditions of sale that the auction house has no liability to bidders in such circumstances.

(6) Written bids and internet and telephone bids: Today it is increasingly common for bidders not to attend the auction in person and instead to either leave written bidding instructions with the auction house, bid over the internet or request to bid on the telephone through an auction house employee. While this is usually just as effective as attending the auction, it leaves open the possibility that the bidder's bid is not executed due to human error or a technical problem such a dropped phone line or bad connection. The conditions of sale will therefore often make it clear that these arrangements must be made a minimum amount of time before the sale and that the auction house will not be liable if, for any reason, the bid is not executed.

(7) Bidding disputes and auctioneer's discretion: The conditions of sale will almost always give the auctioneer extremely wide discretion in deciding whether to refuse bids, how to advance the bidding, whether or not to go back in the bidding or whether to reopen the bidding after the fall of the hammer. In addition, where there is a dispute – for instance, where a bid has been missed, or the hammer brought down prematurely, or a bidder claims not to have bid – the conditions of sale will ordinarily confer on the auctioneer a wide power to determine who the successful buyer should be or whether to cancel the sale and reoffer the lot. This discretion will usually be upheld provided it is not exercised in an unreasonable manner. Allowing the auctioneer such latitude is important as many bidders adopt very tactical approaches to bidding which are designed to be confusing to their rival bidders but may end up confusing the auctioneer – or indeed the bidder him or herself. It is not uncommon for the auctioneer to have to remind bidders not to bid against themselves and to enquire whether or not a subtle gesture was intended to be a bid. Bidders are often indecisive and may also hold back from bidding until the hammer is just about to fall. In all these cases the scope for bidding disputes is significant and the auctioneer and auction house need the power to make the final decision as to who has won the lot.

3.2.2.2 Terms implied by law

While a readthrough of the auction house terms and conditions will provide a clear idea of the buyer's rights and obligations, it is also important to understand that the law implies certain terms into sale transactions – particularly with consumers. It is sometimes wrongly assumed that the laws which apply to our other daily transactions do not apply to auctions. In fact, this is often not the case. There are a number of terms which have historically been implied by law into auction sales by the Sale of Goods Act 1979, the Supply of Goods and Services Act 1982 and the Consumer Rights Act 2015. It is important to understand the interaction between these pieces of legislation. The Consumer Rights Act 2015 is the most recent piece of consumer protection legislation and, where there is a consumer sale, replaced many of the provisions contained in the Sale of Goods Act 1979 and the Supply of Goods and Services Act 1982. However, the Sale of Goods Act 1979 has not been repealed and still applies to contracts for the sale of goods and the supply of services in nonconsumer contracts. As we will see, this is important because among the contracts deemed to be nonconsumer sales – and therefore governed by the Sale of Goods Act 1979 rather than the Consumer Rights Act 2015 – are auction sales.

The function of these pieces of legislation is broadly to require the object sold to be accurately described, fit for purpose and free of claims or liens. Some of these implied terms can, in certain circumstances, be excluded or limited by terms in the conditions of sale, whereas others cannot.

(1) Correspondence with description: An auction sale of an artwork is a sale of goods by description. This is because the sale of the artwork is conducted on the basis of a description by or on behalf of the seller. Its physical characteristics are usually clearly described – often at considerable length – in the sale catalogue. The Sale of Goods Act 1979,[39] as a result, implies a term that the artwork will correspond with the description in the catalogue.[40] The consequences of the artwork not corresponding with the description are that the buyer will be entitled to reject the artwork and cancel the sale.

However, the right to cancel on grounds of noncorrespondence with description will not exist where the parties did not intend the purchaser to rely on the description. This can be established by the circumstances of the sale or by the express terms of the agreement as set out in the conditions of sale. For instance, in Harlingdon & Leinister Enterprises Ltd v Christopher Hull Fine Art Ltd,[41] the court found that a dealer who purchased a painting privately which was described by the seller as being by the German artist Munter had not as a matter of fact relied on the description of the artwork. Rather, he had formed his own view as to whether the work was by the hand of Munter or not. As a result he was not entitled to cancel the sale when the work subsequently turned out to be a forgery.

Equally, where the terms and conditions of the sale specifically limit or exclude the extent to which the description can be relied upon by the buyer, the buyer may not be entitled to reject the work. Typically the terms and conditions in the back of the auction catalogue will be very precise about which aspects of the description can be relied upon by the buyer and which cannot. While the catalogue and the condition reports will frequently describe the condition, history, provenance and authorship of an artwork extensively, the conditions of sale will usually contain a statement which significantly limits the ability of the buyer to cancel the sale should any aspect of that description prove incorrect. As we have seen, the conditions will usually provide that no warranty is given by the auction house in relation to any statement made to the buyer about the lot other than as set out in the authenticity warranty. The authenticity warranty will then set out which parts of the description are warranted and which are not.

While this may seem tough on buyers, it is important to remember that the artworks being sold at auction are not usually in pristine condition, that their history and authorship is not always known as a matter of fact, and that the buyer has usually had the opportunity to inspect the artwork him or herself. What this kind

[39] Section 13(1).
[40] Sale of Goods Act 1979, s 13(1A) added by the Sale of Goods and Supply of Services Act 1994, s 7(1), Schedule 2 paragraph 5(1), 4(b).
[41] [1990] 1 All ER 737.

of limitation seeks to do is to define exactly which aspects of the description the buyer can rely upon the auction house for and which aspects he or she needs to satisfy him or herself in relation to.

However, auction houses cannot simply exclude any liability for the description. Later in the chapter (see section 3.2.3, 'Exclusions and limits on liability'), we will see that exclusions of liability are subject to the test of reasonableness. This is a subjective test and will depend on the particular circumstances of the sale, the type of goods being sold and the identity of the parties.

(2) Satisfactory quality: Where goods are sold in the course of a business there is an implied term that the goods supplied under the contract are of 'satisfactory quality'.[42] When considering what 'satisfactory quality' means, it is worth bearing in mind that the Sale of Goods Act 1979 was primarily aimed at addressing the quality of brand new manufactured goods. It is more difficult to apply such a term to auctions of artworks which are in many cases very old and are not in pristine condition. Goods are deemed to be of satisfactory quality if, objectively, they meet the standard that a reasonable person would regard as satisfactory, taking account of any description of the goods; the price, if relevant; and all other relevant circumstances. This will include considerations such as whether or not the goods are fit for the purpose for which goods of the kind in question are commonly supplied, their appearance and finish, freedom from minor defects, safety, durability and – if the buyer is a consumer – any public statement made in the advertising or labelling of the goods. Many of these considerations will not be relevant where the goods being sold are artworks. Even where the consideration is relevant – such as in relation to the condition of the artwork – the implied term is also of limited assistance to buyers at auction. This is because a buyer cannot avail himself of this implied term in relation to any aspect of the goods which: (i) was drawn to the buyer's attention before the sale; (ii) would have been apparent on inspection of the goods where the buyer examined the goods.[43]

We have seen that auction catalogues tend to be very detailed in their description of the lots on offer. In addition, buyers tend to satisfy themselves of the condition of objects by requesting condition reports and inspecting artworks at the presale viewing. This alone makes it more difficult for a buyer to claim that an aspect of the artwork was not drawn to his or her attention, or would not have been apparent on inspection.

The possibility of reliance on this implied term is often further restricted by the provisions of the auction house's terms and conditions. These will usually empha-

[42] Sale of Goods Act 1979, s 14(2), substituted by the Supply of Goods and Services Act 1994, s 1(1).

[43] Supply of Goods and Services Act 1994, s 1(1)(2C).

sise that the artworks are, by their nature, not in perfect condition and that no warranty is given in relation to condition. Buyers are urged to inspect lots at the viewing and take advice if appropriate.

(3) Title, quiet possession and freedom from charges: Title claims are the most frequent source of disputes in the art world. These disputes can range from family disputes, to claims over stolen property, to more complex ethical claims such as Holocaust or cultural property restitution claims. In some ways this is not surprising, as most artworks have long histories in which they changed hands several times in many different circumstances. The difficulty with title claims is that they do not have to have legal merit in order to have dramatic consequences. The mere assertion of a claim over an artwork is sufficient to make it difficult or impossible to sell. In recognition of that importance, the law provides buyers with an implied guarantee from the seller that the sale will transfer ownership in the artwork to the buyer without any third party interests or claims.

The Sale of Goods Act 1979, s 12(5A) implies a term into contracts for the sale of goods that the seller has the right to sell the goods, that the goods are free of any encumbrance or charge not disclosed or known to the buyer and that the buyer will enjoy quiet possession of the goods. A seller can have the right to sell the property whether he or she is the owner of the property or if he or she is acting as agent selling for or on behalf of the owner. Quiet possession means the artwork can be owned with no interference or claims by any third party. Artworks can sometimes be used as security for loans, and such security arrangements are known as charges or encumbrances.

The right to sell a work is so fundamental to a sale transaction that it is rare that buyers will need to have recourse to arguing that this requirement is implied by the Sale of Goods Act 1979. In most cases the contract will contain a warranty from the seller that he or she is the owner and/or that he has the right to sell the artwork, and that the work will be free of charges or claims by third parties.

3.2.3 Exclusions and limits on liability

We have now established what terms will usually be either expressly or impliedly incorporated in the agency agreement and the conditions of sale. In many cases, however, these agreements will seek to limit or exclude liability for breach of those implied or express terms. The validity of such provisions will depend upon whether or not they comply with the various statutory laws designed to protect consumers against unfair contract terms.

3.2.3.1 Exclusions and limitation of liability in the conditions of sale

As noted earlier, the most recent source of consumer protection legislation, the Consumer Rights Act 2015, does not apply to sales by public auction. Section 2(5) of the Consumer Rights Act provides that for the purposes of the Consumer Rights Act 2015: 'a person is not a consumer in relation to a sales contract if—(a) the goods are second hand goods sold at public auction, and (b) individuals have the opportunity of attending the sale in person.'

As a result, the fairness of the contractual limits or exclusions in the conditions of sale will be determined by reference to the Unfair Contract Terms Act 1977 (UCTA). UCTA provides:

(1) Exclusion or restriction of liability for negligence (s 2 UCTA)

A person cannot by reference to any contract term or to a notice exclude or restrict his liability (i) for death or personal injury resulting from negligence or (ii) any other loss or damage resulting from negligence except in so far as the term or notice satisfies the requirement of reasonableness (s 2(2) UCTA).[44]

(2) Exclusion or restriction of liability for breach of contract (s 3 UCTA)

Where one party is a consumer and deals on the other's written standard terms of business the other cannot, as against the consumer, by reference to any contract term: (a) exclude or restrict any liability of his in respect of breach of contract; or (b) claim to be entitled to render either a contractual performance substantially different from that which was reasonably expected of him, or in respect of the whole or any part of his contractual obligation, to render no performance at all except in so far as the contract term satisfies the requirement of reasonableness (s 2(2) UCTA).[45]

(3) Exclusion or restriction of liability for misrepresentation (s 8 UCTA)

If a contract contains a term which would exclude or restrict any liability for misrepresentation made before the contract was made, or any remedy available to another party to the contract for misrepresentation, that term shall be of no effect except in so far as it satisfies the requirement of reasonableness.[46]

[44] UCTA, s 2(1).
[45] UCTA, s 3(1).
[46] UCTA, s 8(1).

In Avrora v Christie Manson & Woods Ltd,[47] the question of whether or not UCTA should apply to an auction house's conditions of sale restricting liability for negligence and misrepresentation was considered in detail. The judge concluded that UCTA did apply, and therefore such terms need to satisfy the test of reasonableness. The question then arose whether the restrictions were 'reasonable'. Section 11 of UCTA requires that the contractual term must be fair and reasonable having regard to the circumstances which were, or ought reasonably to have been, known to or in the contemplation of the parties at the time the contract was made. The onus is upon the person alleging that the term is reasonable to demonstrate that to be the case.

The concept of what is or is not fair and reasonable is therefore a somewhat fluid concept and shall be assessed on a case by case basis. Further assistance is provided by the nonexhaustive guidelines set out in UCTA Schedule 2, which states that regard must be had to:

• the strength of the bargaining positions of the parties relative to each other, taking into account (among other things) alternative means by which the customer's requirements could have been met;

• whether the customer received an inducement to agree to the term, or in accepting it had an opportunity of entering into a similar contract with other persons, but without having to accept a similar term;

• whether the customer knew or ought reasonably to have known of the existence and extent of the term (having regard, among other things, to any custom of the trade and any previous course of dealing between the parties);

• where the term excludes or restricts any relevant liability if some condition is not complied with, whether it was reasonable at the time of the contract to expect that compliance with that condition would be practicable.

In the Avrora case it was argued by the claimant that the exclusion by Christie's of liability for negligence and misrepresentation was unreasonable. It was suggested that this was, in part at least, because in Christie's contracts with buyers on standard terms, the buyer's bargaining position was weak. The judge, Newey J, found however that the buyer, who was a rich man, was under no economic imperative to deal with Christie's if he did not wish to. The buyer was also found to have had some familiarity with the terms provided by Christie's.[48] Perhaps more importantly, the judge found that the exclusion of liability for negligence did not leave the buyer without a remedy if the artwork he had purchased turned out to be a forgery. Christie's conditions of sale provided an authenticity warranty, giving the buyer a contractual right to cancel his purchase of the artwork and recover what it had paid without having to establish any fault on the part of Christie's.

[47] [2012] EWHC 2198 (Ch.).

[48] See also De Balkanay v Christie Manson & Woods Ltd [1995] Independent Law Reports, 19 January 1995.

Newey J added, however, that the exclusions would not protect an auction house from liability for fraud.

The judge in the Avrora case also made an important point on the fairness of the contractual exclusion from the auction house's perspective. The authenticity warranty rendered Christie's contractually liable to refund the purchase price to the buyer in the event that the artwork turned out to be a forgery. However, it also had a back to back contractual arrangement with the seller in which it was entitled to recover the purchase price from the seller in the event that it was called upon to make a refund to the buyer under the authenticity warranty. In this way all the parties would be put back in the same position as if the sale had not taken place. The judge noted, however, that the ability for the auction house to recover the purchase price from the seller would not be available to it in the event of a claim by the buyer for misrepresentation or negligence. The seller would then be unjustly enriched – having been paid in full for a forgery – while the auction house would be left to refund a purchase price it had never received in the first place. For this reason it was reasonable for the auction house to exclude liability for negligence or misrepresentation.

As I have said above, the question of reasonableness of exclusions of liability has to be considered in each individual case. Each auction house has its own distinct set of conditions of sale and buyers have different circumstances and levels of sophistication. However, the Avrora case is helpful in establishing that in authenticity disputes, exclusions of liability for negligence and misrepresentation are likely to be effective provided that an alternative contractual remedy is available.

3.2.3.2 Exclusions and limitation of liability in the agency agreement

In terms of exclusions and limitation of liability in the agency agreement, the Consumer Rights Act 2015 is the principal law dealing with the fairness of contract terms in consumer contracts. While, as we have seen, the 2015 Act does not apply to the conditions of sale applying to the auction, it will have some limited application to the agency agreement between the seller (where the seller is a consumer) and the auction house.

Where the agency agreement does not involve a seller who is a consumer, the fairness of the contractual terms in the agency agreement will be governed by UCTA, and any restriction on the agent's liability for breach of contract or negligence will need to satisfy the 'reasonableness' test in order to be enforceable.

The Consumer Rights Act 2015 applies (s 1(1))[49] where there is an agreement between a trader, such as an auction house, and a consumer for the trader to provide services. It will therefore apply in the context of an agency agreement where the auction house is being appointed by the consumer to sell an artwork at auction. A consumer for the purposes of the Consumer Rights Act 2015 is 'an individual acting for purposes that are wholly or mainly outside that individual's trade, business, craft or profession'.[50] To qualify, therefore, the seller must be an individual, that is, a natural person. He must also not be selling in pursuit of a business. This can sometimes be difficult to determine where prolific collectors are concerned, who buy and sell on a large scale – particularly where the primary motivation for sales is profit or investment.

Section 49(1) of the Consumer Rights Act 2015 implies a term into all service agreements between consumers and traders that the trader will perform the service with reasonable care and skill. Any term which seeks to exclude the trader's liability in this respect shall not be binding on the consumer.[51]

Section 50 of the Consumer Rights Act 2015 also provides that all such contracts to supply a service are to be treated as including as a term of the contract anything that is said or written to the consumer, by or on behalf of the trader, about the trader or the service, if what was said or written was taken into account by the consumer when deciding to enter into the contract or when making any decision about the service after entering into the contract. However, that obligation is subject to anything that was said or written to the consumer by the trader on the same occasion which qualified it, or which was subsequently otherwise agreed between the parties.

In addition, echoing the provisions of the Consumer Contracts Regulations 1999, s 62 of the Consumer Rights Act 2015 imposes a general requirement that contract terms and notices are to be fair by providing that 'an unfair term of a consumer contract or consumer notice is not binding on the consumer'. A term or notice is deemed to be unfair if, contrary to the requirement of good faith, it causes 'a significant imbalance in the parties' rights and obligations under the contract to the detriment of the consumer'. The fairness or otherwise of a term or notice is to be determined by '(a) taking into account the nature of the subject matter of the contract, and (b) by reference to all the circumstances existing when the term was agreed and to all of the other terms of the contract or of any other contract on which it depends'.

[49] Consumer Rights Act 2015, s 1(1).

[50] Consumer Rights Act 2015, s 2(3).

[51] Consumer Rights Act 2015, s 57.

Part 1 of Schedule 2 to the Consumer Rights Act 2015 provides, for guidance, a nonexhaustive list of the types of terms which are likely to be deemed to be unfair. To the extent that these are likely to be relevant to agency agreements between the seller and the auction house, they are:

- A term which has the object or effect of inappropriately excluding or limiting the legal rights of the consumer in relation to the trader or another party in the event of total or partial nonperformance or inadequate performance by the trader of any of the contractual obligations, including the option of offsetting a debt owed to the trader against any claim which the consumer may have against the trader.
- A term which has the object or effect of making an agreement binding on the consumer in a case where the provision of services by the trader is subject to a condition whose realisation depends on the trader's will alone.
- A term which has the object or effect of permitting the trader to retain sums paid by the consumer where the consumer decides not to conclude or perform the contract, without providing for the consumer to receive compensation of an equivalent amount from the trader where the trader is the party cancelling the contract.
- A term which has the object or effect of requiring that, where the consumer decides not to conclude or perform the contract, the consumer must pay the trader a disproportionately high sum in compensation or for services which have not been supplied.
- A term which has the object or effect of requiring a consumer who fails to fulfil his obligations under the contract to pay a disproportionately high sum in compensation.
- A term which has the object or effect of authorising the trader to dissolve the contract on a discretionary basis where the same facility is not granted to the consumer, or permitting the trader to retain the sums paid for services not yet supplied by the trader where it is the trader who dissolves the contract.
- A term which has the object or effect of enabling the trader to terminate a contract of indeterminate duration without reasonable notice except where there are serious grounds for doing so.
- A term which has the object or effect of automatically extending a contract of fixed duration where the consumer does not indicate otherwise, when the deadline fixed for the consumer to express a desire not to extend the contract is unreasonably early.

The most likely area of difficulty here is likely to be a provision which excludes or limits the legal rights of the seller in the event of the auction house's total or partial nonperformance or inadequate performance of any of its contractual obligations. In these cases it is likely that the test used by the courts to determine fairness will be similar to that adopted in the Avrora case to determine reasonableness (see above). However, because, unlike the conditions of sale, the terms of the agency

agreement are often negotiated – in some cases with the benefit of legal advice – it may well be more difficult for the consumer seller to succeed in demonstrating that a provision in the agency agreement restricting or limiting liability is unfair.

4 Auctions: financial arrangements

4.1 Advances, loans and credit arrangements

One of the advantages of the auction process is that it provides a speedy means of selling artwork where there is a requirement to raise money within a short period.

However, while the auction process is comparatively speedy, the period between consignment of the artwork to the auction house, the sale and the receipt of payment can stretch over several months. Some sellers cannot or do not wish to wait so long before receiving funds. For instance, the executors of an estate may incur a heavy tax liability shortly after the death of the deceased. That tax bill will need to be paid without delay – and long before the deceased's property can be taken in by the auction house, catalogued, offered for sale and sold. Recognising this need for immediate cash, auction houses are sometime prepared, in order to secure large or valuable consignments, to provide the seller with what is known as an advance. An advance is a payment to the seller in advance of the sale of the anticipated proceeds of sale of the artwork or artworks. It is in effect a loan of cash in advance of the sale.

Example

- Mr X, who is a collector of art, dies. His executor is required, shortly after Mr X's death, to pay a large inheritance tax bill of £35,000. Mr X's estate does not have the funds available to pay the bill. The executor therefore consigns one of Mr X's paintings, estimated at £70,000–£80,000, to an auction house for sale. In order to secure the consignment the auction house agrees to provide the executor with an immediate cash advance of £35,000 (50% of the low estimate of the painting). The cash is used by the executor to pay the inheritance tax bill. The painting is sold one month later for £70,000. When the buyer pays for the painting 30 days after the auction, the auction house deducts the advance money of £35,000 from the proceeds of sale and pays the remaining £35,000 to the executor.

4.1.1 Interest

The auction houses who offer this service are able to do so because they have in turn secured credit arrangements with their banks which provide the auction house with a line of credit. However, that line of credit comes at a cost to the auction house, and so the advance to the seller will usually carry interest to cover that cost. This is particularly the case where there is a long period of time between the advance and the date of the sale. The rate of interest charged will usually be highly competitive. However, the advance is designed to be a short term loan so, while a low interest rate will apply up to the date of the sale, a much higher default interest rate will usually apply in the event of nonrepayment by the due date.

4.1.2 Security

A loan given without taking security is known as an unsecured loan. The danger with an unsecured loan is that in the event that the person to whom the advance was paid is made bankrupt, the person who has made the loan has to line up for repayment with all the other creditors of the bankrupt person, with no guarantee of repayment in full or even in part. As a result, most prudent lenders seek security for the loan, known as a secured loan, making the lender a secured creditor. As a secured creditor the lender has the right to recover the loan money by selling the asset over which the lender has security.

Advances are therefore almost always secured loans, with the security being the artwork which has been consigned, and/or other property offered by the seller as security. As we have seen, the advance is usually repaid out of the proceeds of sale of the consigned artwork once it has been sold at auction, with any balance being paid to the seller. The purpose of the security is to cover the situation where the consigned artwork fails to sell at auction. In such cases the auction house will ask the seller to repay the advance in full; if the seller is unable to do that, the auction house, which will still be in possession of the artwork, has the ability to reoffer it for sale in order to use any proceeds of sale to repay the advance.

The legal arrangement which makes this possible is called a possessory pledge. The auction house acquires a security interest in the artwork through a possessory pledge over the artwork to be sold. Unlike many other forms of legal security, the attraction of a pledge is that it can come into being with very little legal formality or process. All that is required is that the auction house takes possession of the artwork. On its own, the pledge provides the pledgee (in this case the auction house) with a right to possession of the artwork but no automatic right of sale of the artwork in the event of a default by the pledgor (in this case the seller). However, an automatic right of sale will exist if it is expressly agreed to by the pledgor and pledgee – and that is usually a condition of the advance agreement. The advance agreement will therefore usually include a clause which records the

fact that the artwork is pledged as security, and also that the auction house has an automatic right to sell the artwork on such terms as it thinks fit if the advance is not repaid on time.

Possession by the pledgee is crucial to the effectiveness of a pledge, so it is important to consider what amounts to possession and how possession can be lost. Physical delivery of an artwork to the auction house is the clearest form of possession. However, possession can also be what is known as 'constructive possession'. For instance, where the artwork is held by the seller in a third party security vault or storage room the auction house can gain constructive possession of the artwork if the third party storage company agrees that it holds the artwork to the order of the auction house. In other words, it agrees that it will not allow anyone else, and in particular not the seller, access to the vault or storage room without the agreement of the auction house. A pledge can become ineffective if the auction house relinquishes possession of the artwork. In Bassano v Toft,[1] the court considered whether the pledge would become unenforceable if the pledgee parted with the pledged goods temporarily. The court held that where it did so in circumstances inconsistent with giving up the security interest in the pledged goods, then this did not endanger the validity of the pledge. So, for example, if the auction house released the artwork to the seller for a short period to show the artwork to a potential buyer or exhibit it in a museum, that would not endanger the pledge. However, any auction house releasing pledged artwork to a seller would be well advised to record in writing the fact that it is still asserting a pledge over the property – and, better still, require some other additional artwork to be pledged in the meantime as additional security.

There may be circumstances in which it is not possible for the auction house to take physical possession of the artwork. In these cases the artwork cannot be pledged because, as we have seen, physical possession is an essential requirement for a pledge. United Kingdom law, through the Bills of Sale Act 1878 (amended in 1892), provides for an alternative arrangement to cover such situations, called a bill of sale. The advantage of a bill of sale is that the artwork can remain in the possession of the person to whom the advance has been made. However, it also carries some major disadvantages, which has led to it being used only very rarely for advances and loans on artwork. First, the bill of sale is required to be in a very specific, and archaic, form. A failure to follow the required process and form will lead to the bill of sale being void and unenforceable. The bill of sale must also be executed as a deed, meaning that the signature of the bill of sale must be witnessed by a third party. Once signed, the bill of sale must then be registered at the High Court within a certain timeframe. It must then be reregistered every five years.

[1] [2014] EWHC 377 (QB).

Bills of sale can also only be used in relation to assets owned by individuals or partnerships.

The bill of sale is also difficult to use as there is little flexibility to allow for the kind of variables common in modernday financial arrangements. In particular, only a fixed sum determined at the time of the execution of the bill of sale can be secured. It is not therefore possible to use this arrangement to secure an overdraft or revolving credit arrangement. Interest on the loan must also be certain and must be expressed as a fixed rate. It is therefore not permissible to have an interest rate which goes up or down linked to the bank base rate. Interest also cannot be compounded or capitalised. Finally, the bill of sale must provide for a fixed time of repayment.

If the bill of sale is executed and registered in accordance with these requirements the lender will have a security interest in the artwork which overrides any other person's claim to the artwork – even a purchaser who has purchased the artwork in good faith and without notice of the security interest of the lender. In practice such a purchaser would be liable to the lender for any loss caused to the lender as a result of the purchase. The lender also has the right to seize the security in the event of a default by the borrower – although the lender cannot sell the security until five days have passed since the seizure.

The requirements for bills of sale however result in an extremely cumbersome process which usually makes such an arrangement unattractive as an option. Perhaps of more concern, though, is that, because it is so rarely used, the register at the High Court is rarely consulted by would-be lenders. As a result the system is potentially open to abuse by borrowers who seek to obtain credit from multiple lenders using the same artwork as security. This contrasts with the system in the United States, which has a well-publicised and highly organised central register of objects called the UCC register. This register, which is extensively consulted by lenders, lists all objects which are the subject of a security arrangement.

The current law on security over assets such as artworks is, in my view, not fit for purpose. While the pledge system works well, the UK should have a central register for charged assets along with a simple, modern procedure for recording security arrangements. Perhaps with this in mind, in 2015 the UK government launched a consultation with a view to reforming the UK law on bills of sale. It concluded that the current law is archaic and wholly unsuited to the 21st century. It recommended that the existing law on Bills of Sale should be repealed in its entirety and replaced with a new Good Mortgages Act to govern the way that individuals may use their existing goods as security for a loan. This was then followed by two further Law Commission consultations in 2017 and 2018. In 2018 however the government announced that it would not be bringing forward a new Goods Mortgages Bill. In February 2020 Lord Stevenson of Balmacara therefore took the

initiative by sponsoring the Goods Mortgages Bill as a private members bill starting in the House of Lords. At the time of writing Lord Stevenson's Bill is still in the early stages, having cleared only the first procedural hurdle for enactment. There is a long way to go before the Bill is brought into law. In the meantime we are stuck with a system which is generally acknowledged to be a relic of Victorian times.

4.1.3 Consumer credit regulations

It is worth noting that in the United Kingdom the grant of credit to consumers is regulated by the Financial Conduct Authority. This means that any lending activity, including lending on art, must in principle be authorised by the Financial Conduct Authority and the requirements of the Consumer Credit Act and the Financial Conduct Authority Handbook must be adhered to.

The Consumer Credit Act 1974 provides borrowers with a number of key protections. There is a requirement for the credit agreement to contain certain information, including:

- details of the type of credit agreement being proposed, for example, credit sale, hire purchase or conditional sale;
- the true cost of the credit, called the annual percentage rate (APR);
- the amount of each payment, when it is due to be paid, and how it is made up (loan, interest, administration charge);
- the borrower's cancellation rights and whether the borrower can pay off the loan early.

Auction houses tend to engage in secured lending only occasionally and then only as a means of securing consignments. As a result, they do not usually wish to engage in lending which is of a type that is required to be regulated by the Consumer Credit Act 1974. It is helpful therefore that the Financial Services and Markets Act 2000 (Regulated Activities) Order (Amendment) (No 2) Order 2013 (RAO) provides that there are some situations in which the Consumer Credit Act 1974 will not apply – and some such situations may be applicable in the context of art lending. They are as follows:

- where the lender is providing the borrower with credit exceeding £25,000 and the agreement is entered into wholly or predominantly for the purposes of a business carried on or intended to be carried on by the borrower (Article 60C RAO);
- where the borrower is borrowing more than £60,260, is a natural person and is of certified high net worth (definition in the Financial Services and Markets Act: 'high net worth' shall mean someone who has an annual income of not less than £150,000 or net assets of not less than £500,000) (Article 60C RAO);

- in the case of fixed sum credit repayable in not more than 12 instalments over a period of less than 12 months, without interest or other charges and not secured by a pledge (Article 60F RAO).

It is important to note that in order to take advantage of the high net worth exception the lender will be required to obtain from the borrower a declaration that the borrower will forgo the protection of a regulated credit agreement, together with a statement of the assets or income of the borrower from an accountant.

4.2 Guarantees and risk sharing arrangements

4.2.1 Guarantees

The attraction, for the seller, of an artwork being offered at auction is the possibility that competitive bidding will push the sale price up above the reserve, the low estimate or even the high estimate. It is this prospect of outperformance which contributes to the excitement of the auction process and makes it an attractive proposition for the seller. This potential brings with it a downside, however. It is equally possible that the artwork will not attract significant bidding and, as a result, that it will remain unsold. Quite aside from the disappointment of such a failure, the artwork may then – having publicly failed to sell – be 'burned'.[2] This will make it even more difficult to sell if it is reoffered for sale at a later date. There is therefore a demand from sellers for a mechanism which allows them to enjoy the possibility of outperformance while being protected from the possibility of underperformance. That mechanism is the minimum price guarantee.

The minimum price guarantee is an arrangement where the auction house agrees to guarantee to the seller that whatever the outcome of the auction, the seller will receive a minimum amount of money for the work. These arrangements are usually only available in international auction houses and are reserved for the most desirable and high value artworks, where securing the lot for sale is the subject of great competition between the auction houses.

Typically, the structure of minimum price guarantees is as follows:

If the lot sells for less than the minimum price guarantee, the auction house is obliged, in addition to the hammer price, to pay the seller the difference between the hammer price for which it sold at the auction and the minimum price guarantee.

[2] A term used to describe an artwork whose value is perceived by bidders to be reduced due to having recently been unsuccessfully offered for sale.

If the lot fails to sell at all, then the auction house will become the owner of the lot and is obliged to pay the seller the minimum price guarantee.

This arrangement, insuring the seller against the risk of a work of art failing to sell or selling below the minimum price, comes at a price to the seller. The auction house's reward for assuming that risk itself is a commitment from the seller that if the artwork sells for more than the minimum price, then the seller will share any excess with the auction house.

Example

- Mr Y owns a painting by Picasso. Recently a dealer approached Mr Y and offered £110,000 for the painting as a private sale. He was tempted to sell it to the dealer but was concerned that it might in fact be worth more than the £110,000 offered by the dealer. As a result he approaches an auction house to explore the possibility of an auction sale. Mr Y likes the idea of bidders competing, enabling the market to determine the true value of the painting – which he hopes will be much higher than £110,000. However, he is also worried by the possibility that it might not sell, or that it could sell for less than £110,000. He is also concerned that by the time of the sale, in two months, the art market may not be so buoyant. To convince Mr Y to consign to auction, the auction house therefore offers him a minimum price guarantee of £110,000. In doing so the auction house takes on the risk of a fall in the market or the bidding on the Picasso failing to meet expectations. The auction house agrees that it will pay Mr Y this £110,000 even if the Picasso is unsold at auction,[3] or if it sells for less than £110,000.[4] In return, Mr Y agrees that if the Picasso sells for more than £110,000 then Mr Y and the auction house will share any proceeds of sale of the Picasso in excess of £110,000 equally between them.

These are high risk arrangements for the auction house. Not only does the auction house have to be confident that the artwork will find a buyer at or above the guaranteed minimum amount, but it is betting ahead on the market conditions in a notoriously fickle market. Getting it wrong can be hugely costly. A great deal of pressure is placed by sellers on competing auction houses to offer high guarantees on artworks in order to secure them for sale. The skill for the auction house is to guarantee the work at a level which is high enough to secure the consignment but not so high that the lot is unsold and the auction house is forced to pay out the guarantee and become the owner of an artwork which will be difficult or impossible to sell other than at a significant discount.

[3] In which case the auction house becomes the owner of the Picasso.

[4] In which case the auction house will make up the difference between the price paid by the buyer and £110,000.

Guarantees have become a very important part of auction house business at the highest level.

A spectacular example of the risky nature of guarantees was provided in 2001 by Phillips. Phillips had recently been purchased by Bernard Arnault, whose ambition was to elevate that auction house to the level of Christie's and Sotheby's by offering guarantees to sellers at a very high level. Phillips was able to secure the prestigious Smooke collection by reputedly offering a staggering US$185,000,000 guarantee, which was far higher than the guarantees the other auction houses were prepared to offer. The problem was that the bidding for the collection did not reach anywhere near this figure. The total hammer price of the sale amounted to just US$86,000,000, leaving Philips with a loss of nearly US$100,000,000. A year later Arnault sold the company, having announced combined losses of US$400,000,000.

Phillips is not alone in having suffered losses as a result of guarantees. In 2008 the Lehman Brothers bank insolvency was the trigger for a sudden and significant loss of confidence in the art market. Bidder interest in Sotheby's and Christie's sales evaporated almost overnight. The problem was that both auction houses had committed to minimum price guarantees many months before, when nobody had anticipated such a dramatic change in market conditions. As a result, both auction houses ended up making major losses on the guaranteed lots in their sales. Sotheby's reputedly lost up to US$52,000,000 on guarantees in that sale season. Christie's had a similarly expensive outcome.

In 2015, Christie's and Sotheby's went head to head to secure the art collection of Sotheby's ex-chairman Alfred Taubman. Sotheby's saw this as 'must win' business and, in order to put it beyond Christie's reach, dramatically increased its initial US$350,000,000 guarantee offer to US$500,000,000. This proved to be a risk too far. The collection sold for significantly less than this amount, leaving Sotheby's with a US$12,000,000 loss for the last quarter of 2015.

From time to time – because of the risk – auction houses have sought to move away from guarantees. However, because these arrangements are so attractive to sellers, the auction houses have found themselves coming back to them in order to secure business. This has in turn led to a second structure designed to offset or lessen the risk to the auction house arising from the guarantee. This is known as the third party guarantee.

4.2.2 Risk sharing arrangements

As we have seen above, agreeing a minimum price guarantee with a seller means that the auction house is at risk of making a loss if the lot fails to sell. The auction house may however choose to dilute that risk by sharing it with a third party –

which may be an institution, an individual or another art market entity. In return for the third party agreeing to share that risk, the auction house agrees to pay the third party a fee, known as the financing fee, which is taken out of any income the auction house makes on the sale of the artwork. This arrangement is commonly referred to as a third party guarantee.

Typically, the risk of the loss is shared between the auction house and the third party by means of the third party agreeing, before the auction, to place an irrevocable bid on the lot at or around the level of the minimum price guarantee agreed between the auction house and the seller. The third party is therefore committed to bidding on the lot and, if there are no other bids, to buying the lot at the level of the irrevocable bid. In doing so, the third party rather than the auction house takes on the risk associated with the minimum price guarantee, and, in particular, of the lot not being sold.

The third party may also decide they wish to bid on the lot over and above their irrevocable written bid. In that situation, the auctioneer will make a saleroom announcement that the third party may be bidding, so that other bidders on that lot are aware that someone with a financial interest may be bidding on the lot.

Example

• Mr Y consigned his Picasso to an auction house for sale in May with a minimum price guarantee of £110,000. As part of the arrangement Mr Y has agreed to share any proceeds of sale over £110,000 with the auction house equally. There are two months to go until the auction and the auction house decides that it wishes to reduce its financial exposure on the Picasso. It therefore approaches Mr Z, who is a collector of artworks by Picasso. Mr Z is interested in bidding on the Picasso when it comes up for sale anyway and he also believes that it is likely to sell for £110,000 or more. He therefore agrees to act as a third party guarantor. The third party guarantor arrangement requires Mr Z to commit before the auction to buying the Picasso by placing an irrevocable written bid on it for £110,000. He also reserves the right to bid in the saleroom over this amount if he chooses to do so. As part of the arrangement, Mr Z also agrees that even if he is not the successful purchaser he will step in to buy the painting for this amount if the successful purchaser fails to pay for the lot. The auction house is now assured that the Picasso will sell for the minimum guaranteed amount and also has some protection against a defaulting buyer. There is also a possibility that, if there are other bidders for the Picasso, Mr Z will bid against them for it over £110,000. Its exposure in relation to the Picasso is therefore substantially reduced. However, in return for taking on the risk, Mr Z requires the auction house to pay him a share of its income on the sale as

a fee. The amount and structure of that fee is a matter for negotiation, but will dent the profitability of the sale of the Picasso for the auction house.

So why would such an arrangement be of interest to a third party? It may be of interest because the third party is confident that the lot will sell above his or her irrevocable bid, and that he or she will as a result receive a significant fee for what he or she considers to be a measured risk. It may also be of interest because, even if there are no other bidders and the third party acquires the lot at the irrevocable bid, the payment of the fee will result in a net discount to the purchase price.

The system of third party guarantees has been the subject of considerable comment and criticism. The principal concern was that these arrangements were complex and opaque from the perspective of other bidders. Auction houses have sought to address this by a number of measures. First, they seek to ensure that all bidders are aware of the existence of such arrangements, and works which are the subject of guarantees and third party guarantees are clearly identified in the catalogue. Second, the auction house websites often provide an explanation of how guarantees and third party guarantees work. Third, to avoid conflicts of interest, bidders who are bidding through or being advised by agents are encouraged to ask their agent whether they are a third party guarantor or have a financial interest in the lot they are recommending.

One particular concern around third party guarantees has been the perception that third party guarantors are receiving a discount on the price which is not available to other bidders. Critics would point out that where a third party guarantor acquired a lot, the sale price reported by the auction house would not take account of the financing fee paid to the third party guarantor by the auction house. Rather, they would report the price as the hammer price plus the buyer's premium, without mention of the financing fee. The auction houses argued that the third party guarantor was in a different position to other bidders only because he or she was taking a risk that other bidders in the room were not, and that this guarantee arrangement was in any event a separate transaction to the sale transaction. While that is certainly the case, it is also the case that where dealers acted as third party guarantors they were able, when reselling the lot, to exploit the fact that the net cost to them of purchasing the lot, after taking account of financing fees received, was often less than the reported price. This issue was, however, resolved by the intervention of the New York Department of Consumer Affairs, which in 2016 wrote to auction houses asking that where the lot was purchased by a third party the sale price should be reported as a net figure after deduction of any financing fees paid to the third party. While this outcome arguably does not reflect the complex risk/reward structure of the risksharing arrangement, it has nevertheless been adopted by auction houses.

There is also a worry that the prices achieved by lots which are the subject of third party guarantees are not 'real' prices. This argument is more difficult to sustain as the arrangement does require the successful bidders, whether the third party guarantor or a competing bidder, to pay for the artwork, and the amount paid (after deduction of any fees paid to the third party) is made public. However, it is certainly the case that the third party guarantee has the effect of, before the auction, setting a minimum threshold at which the artwork is certain to sell. This 'preselling' effect makes it very attractive to the auction house and the seller. It may be less attractive, however, for bidders who might have been hoping to acquire the lot significantly below the low estimate.

There is also a concern about conflicts of interest where the third party guarantor is an agent or dealer advising potential bidders. To counter this, auction houses legally require third parties to be transparent with their clients about their financial interest in lots and, on their websites, actively encourage bidders who are being advised to ask their agent or adviser if they have a financial interest in any lot they are being advised to bid on.

These types of financial arrangements undoubtedly introduce an element of complexity to auctions, and, rightly or wrongly, the public perception is that they may affect the underlying principle of auctions that all bidders are equal. It is also true, however, that these structures have developed in response to a very real and understandable demand from sellers. Auctions allow sellers to dream of the possibility of high prices but the nightmare downside is that an artwork's failure to sell in the public glare of an auction can dramatically affect its value. Understandably, given the huge sums which can be at stake, sellers are reluctant to gamble their valuable assets. They would rather have an insurance policy. Auction houses do not, on their own, have the financial means to take on all the risk of the insurance policy, and so that risk must be shared by third parties who are willing to share or reinsure the risk by committing in advance to stepping in and buying the artwork in the event that others are not prepared to bid. This is frowned upon by commentators because in a rising market the arrangement looks like a one-way profitable bet for the third party, but in a falling market the position may look very different. That is the nature of insurance.

5 Ownership and authenticity

In this book, we will deal with the questions of ownership and authenticity in two parts. In this chapter we will cover the principles and legal aspects of ownership and authenticity as they apply to art. Because title and ownership are the most common source of disputes in relation to artwork, later in the book[1] we will address the question of how such disputes are resolved in practice.

5.1 Title and ownership

Ownership or 'title' disputes are the most common area of litigation in the art world. Those disputes can range from marital disputes over ownership of artworks, to contractual disputes, to issues of stolen art and art looted in periods of conflict. The position is further complicated by the fact that there are often three parties to such disputes: the claimant, the defendant and the agent, such as a dealer or auction house in temporary possession of the artwork. We will cover these disputes in more detail in section 16.2, 'Title disputes'.

The difficulty from the point of view of justice is that the person in possession of the artwork is often a good faith purchaser of the artwork with no inkling of the fact that it is stolen or the subject of an ownership claim. Yet, because he or she is the person in possession of the object, he or she will be the obvious person for the claimant to sue in order to recover the artwork or to obtain damages.

It is also worth observing that defendants cannot really afford to ignore ownership claims – even if the claimant does not take the step of issuing legal proceedings. This is because there is a commercial reality that, however tenuous or questionable the ownership claim, an artwork cannot generally be sold on the open market unless and until that claim has been addressed and resolved. This is the case because buyers will not usually purchase objects where there is a risk of a title claim, however unmeritorious it may be.

For all these reasons, it is perhaps surprising that buyers of artworks pay relatively little attention to the question of ownership of the artwork at the time of purchase. Perhaps this is because it is often incorrectly assumed by buyers that as part of

[1] Sections 15.2 and 15.3.

their due diligence, auction houses and dealers have investigated and confirmed the legal ownership of the works they sell. In fact, this is not usually the case. While an auction house or dealer has the specialist knowledge to give assurances on authenticity and attribution, the issue of ownership is a question of fact and law of which the auction house or dealer does not have firsthand knowledge – and which it is not usually equipped to analyse or give a view on. That is not to say that auctioneers and dealers do not take the issue of ownership seriously. If the circumstances suggest that there may be a problem with the seller's right to sell or if the auctioneer or dealer has notice of a competing ownership claim, the auctioneer or dealer will not offer the work for sale without having investigated. Further, as a practical step, most reputable auctioneers and dealers will ask the Art Loss Register to check the lots they are proposing to offer for sale against the Art Loss Register's database of stolen property.[2]

Buyers at auction or from a dealer do also have some protection in the event that, following the sale, the object they have purchased is the subject of a claim. Before offering an artwork for sale, auction houses obtain from the seller a legally binding statement known as a warranty that the seller has good title and the right to sell the work. The legal benefit of this warranty is passed on to the buyer upon the sale of the object. Dealers will also usually provide buyers with a similar warranty. If it then transpires that the seller does not have good title or the right to sell the artwork, then the buyer will be able to rely on the warranty to recover the purchase price from the seller.

5.1.1 Title to stolen property

The starting point in United Kingdom law is that where goods are sold by a person who is not their owner and who does not have the authority or agreement of the owner to sell them, the buyer will acquire no better title to the goods than the seller had.[3] For example, if Mr X borrows a book from the library and then sells it to Mr Y, then because Mr X did not own the book, Mr Y cannot himself acquire title to the book. He may sue Mr X for a return of the purchase price but the book must be returned to the true owner – the library.

An exception to this, which can be relevant in the context of the art market, is where the actual owner of the goods has behaved in a way which would suggest to the buyer that the person selling the goods was doing so with the authority of the owner.[4] So, if the owner has allowed the seller to have the appearance of being

2 The Art Loss Register is a third party database established by the insurance industry in which lost and stolen artworks are listed.

3 Sale of Goods Act 1979, s 21(1).

4 Sale of Goods Act 1979, s 21(1).

empowered to sell the property – known as 'ostensible authority' – and the buyer has relied and acted upon that appearance, then the buyer acquires good title to the goods. To rely upon this exception the buyer will need to show more than a failure by the true owner to act. The owner must have positively done or said something which encouraged the buyer to believe that the seller was empowered to sell the artwork. For instance, if the true owner of a painting gives the work to a dealer and signs a contract with the dealer appointing him as his agent, a sale by the dealer will pass good title to a buyer even if the dealer exceeded his authority – for instance, by selling the painting for less than he was authorised to sell it for by the owner. However, that will not be the case if the buyer was aware that the dealer was exceeding his authority.

As we have seen above, a thief has no title to goods which he has stolen and where he is therefore unable to pass on good title to a buyer. This is because his title is void. However, where the seller has obtained the artwork by means of fraud, he obtains what is known as voidable title. This means, in practice, that the seller initially has good title to the artwork but the person he defrauded in order to obtain the artwork has the right to void that title, should he or she choose to do so. In such cases where, at the time of selling the artwork, the seller's title has not been voided by the defrauded owner, the buyer will in turn get good title to the artwork, provided he buys it in good faith and without notice of the fraud.[5] If, at the time of the sale, the defrauded person has voided the seller's title, however, then the seller will be in the same position as a thief and will therefore be unable to pass on good title to the buyer.

These rules can leave the innocent buyer without the artwork he or she purchased, and significantly out of pocket. However, where a significant amount of time has passed since the purchase, the law of limitation may come to his or her assistance. Section 2 of the Limitation Act 1980 provides that the limitation period for bringing an action in tort for conversion is six years from the date at which the cause of action accrued. After that period has expired, not only is the original owner unable to bring a claim against the innocent buyer, but the original owner's title to the object is automatically extinguished.[6] We will cover limitation periods in more detail later in this chapter.

5.1.2 Conversion

Conversion is the legal term for a claim in which the claimant is asserting that he or she is the true owner of the artwork and the defendant has dealt with the artwork in a way which is inconsistent with the rights of the true owner.

[5] Sale of Goods Act 1979, s 23.
[6] Limitation Act 1980, s 3(2).

Example

- Mr Smith gives his painting to Gallery A for safekeeping and Gallery A then sells it to Mr Williams. If Mr Williams then refuses to return it to Mr Smith, Mr Smith will have a claim for damages for conversion against Gallery A and Mr Williams. The claim against Gallery A will be on the basis that the gallery sold a painting without the consent of the owner, Mr Smith. The claim against Mr Williams will be on the basis that he refused to return the work to the true owner when asked to do so. Both are acts inconsistent with the ownership of the painting by Mr Smith.

To succeed in a claim for conversion, the claimant must show that he or she is the true owner of the artwork and that the defendant is either denying the owner's rights over the artwork or behaving in a way which is inconsistent with the rights of the true owner. Acts which are inconsistent with the rights of the owner could include delivering it to someone other than the owner, selling it without the consent of the owner or refusing to return it to the owner. The act must be deliberate and have the effect of denying the claimant the use or possession of his or her artwork.

The remedy sought by the claimant is usually damages equal to the value of the converted artwork, but, where the defendant holds the artwork, the court can order the return of the artwork to the owner.

Conversion is known as a strict liability tort.[7] This means that the state of mind, knowledge or intention of the defendant is not relevant. If the claimant can show that he or she is the true owner and that the defendant has dealt with the artwork in a manner inconsistent with the true owner's rights, then the defendant will be liable whatever his state of knowledge or his intention. This means that a dealer or auction house will be liable to the true owner for damages in conversion if it sells a stolen artwork, even where the dealer or auction house acted in good faith and did not know that the artwork was stolen.

Auction houses and dealers occasionally find themselves facing claims for conversion. While they may have been acting in good faith when converting an artwork, they are perceived as having deep pockets and it is often easier for claimants to sue the auction house or dealer rather than locate the thief or a subsequent owner. Another reason why the auction house or dealer may be preferred as the defendant in a claim for conversion is because the claimant is sometimes prevented from bringing a claim against the person who purchased the artwork from the dealer or auctioneer because the purchaser has legally acquired good title. Usually the

[7] Kuwait Airways Corp. v Iraqi Airways Co. (No 6) [2002] 2 AC 883 at 129.

purchaser does not acquire good title because, as we have seen (at section 5.1.1), it is a principle of United Kingdom law that where the seller does not own the property, the buyer of the property cannot himself become the owner. There are however some very limited exceptions to this rule. The main exceptions, some of which have been referred to earlier, are:

(i) where the owner has behaved in a way which has led the purchasers to believe that the person selling the artwork had the right to sell it. This is known as estoppel;[8]

(ii) where the artwork was sold before 2 January 1995 in Market Overt. Market Overt is an open, public and legally constituted market;[9]

(iii) where an artwork has been sold but the buyer allows the seller to remain in possession of it despite the sale. The original buyer will not be entitled to claim conversion against the second buyer if,[10] in this situation, the seller purports, despite the previous sale, to sell the artwork to another buyer who acts in good faith;[11]

(iv) where the seller has obtained the artwork by voidable title, such as by fraud. In these circumstances, until the owner has taken steps to avoid the seller's title, the seller will still be in a position to pass good title;[12]

(v) where a person having bought or agreed to buy the artwork obtains, with the consent of the seller, possession of the artwork or the documents of title to the artwork. In this case the delivery or transfer by that person, or by an agent acting for him, of the artwork or documents of title, under any sale or pledge, to any person receiving it in good faith and without notice of any lien or other right of the original seller in respect of the goods has the same effect as if the person making the delivery or transfer were acting as mercantile agent of the original seller in possession of the goods or documents of title with the consent of the owner. However, this exception does not apply where the original sale was a credit agreement or an agreement for payment by instalments where the owner retained title until all payments had been made.[13]

What acts, then, are capable of amounting to a conversion? Certainly a sale of an artwork without the consent of the true owner is an act of conversion. But what of acts which fall short of a sale? The case of Marcq v Christie Manson & Woods

[8] An example of this might be when the owner of an artwork entrusts the artwork to an agent and then a sale of that artwork by the agent to a purchaser can bind the owner, who will be prevented (estopped) from maintaining a claim in conversion against the purchaser.

[9] Section 22(1) of the Sale of Goods Act 1979, since repealed by the Sale of Goods (Amendment) Act 1994.

[10] Sale of Goods Act 1979, s 24.

[11] Although he will still have a claim for conversion against the vendor.

[12] Sale of Goods Act 1979, s 23.

[13] Sale of Goods Act 1979, s 25.

explored the question of whether,[14] when an auctioneer had attempted but failed to sell a stolen artwork, that unsuccessful attempt, and its subsequent redelivery back to the nonowner, could amount to a conversion. The court held that it could not. In the course of the judgment the court made it clear that taking the work in, seeking unsuccessfully to sell it and returning it to the consignor were 'ministerial' acts which did not qualify as conversion.

A wrongful refusal to deliver up an artwork to the true owner on demand, however, can be a conversion. Where this arises most frequently is in situations where an auctioneer or dealer is in possession of an object which is claimed by two or more parties. In such circumstances both the claiming parties will typically demand that the agent deliver up the artwork, and the agent is caught in the middle. He has the artwork but is unable to determine which of the parties has the best claim to ownership of the work and is therefore entitled to delivery up. Releasing to one or the other party will expose the agent to a claim for conversion from the other party. The agent will therefore retain the artwork pending the resolution of the ownership dispute. If the agent is sued by one or other of the parties it is open to the agent to apply to the United Kingdom courts for a determination of which of the parties has the best claim to title, and in such a case the agent will be permitted to drop out of the proceedings. This is called an 'interpleader'. However, to make such an application the agent must be able to show that he or she is strictly neutral and has no interest in the outcome.

5.1.3 Ownership of abandoned or lost property

One question which arises from time to time is that of ownership of property which has been abandoned by the owner and then found or recovered by a third party. This is particularly difficult in cases where the found object turns out to be valuable. Are these really cases of 'finders keepers'? Does the finder acquire good title or other rights over the object? For instance, if a painting is placed in a skip outside a house and picked up by a passerby, does the passerby acquire good title? If it turns out that the painting is valuable, can the owner who abandoned it claim it back? And what about an object left at a train station which is found and picked up by a fellow passenger? And what of an object which is abandoned but found on someone else's land?

The starting point was established in the case of Armory v Delamirie.[15] This case involved a chimney sweep's boy who found a jewel and offered it to a jeweller. The judge ruled 'that a finder of a jewel, though he does not by such finding acquire

[14] [2004] QB 286, [2003] EWCA Civ 731, [2003] 3 WLR 980.
[15] (1722) 5 Stra 505 [1558–1774] All ER 121.

an absolute property or ownership, yet he has such property as will enable him to keep it against all but the rightful owner'.

While it is settled law that the finder of a lost object has a better right to it than anyone apart from the true owner, are there circumstances where the finder of an object can have a better right to the object even than the previous owner? This will depend upon the intention of the true owner when he or she parted with the object. Was the object lost or forgotten by the owner or was it deliberately abandoned? That can only be determined by an analysis of the particular circumstances in which the owner came to be parted with the object. In Moffatt v Kazana,[16] the subject of the dispute was a biscuit tin containing banknotes which had been hidden in a chimney flue and forgotten there by the owner of the house. The house was sold and the biscuit tin was found many years afterwards. The judge held that the tin belonged to the executors of the previous owner of the house because an item which is forgotten cannot be considered to be abandoned. This is to be contrasted, on the other hand, with the position where an object is placed by the owner in a skip or rubbish dump. In these circumstances it may be possible to infer that the owner had abandoned any claim to ownership of the object, giving the finder good title. However, the courts tend to be reluctant to find in favour of abandonment for fear of depriving the original owner of his or her rights.

Parker v British Airways revolved around an item of jewellery found in a British Airways executive lounge.[17] The finder handed it in to the British Airways staff, asking them to return it to him if no one claimed it. Nobody came forward to claim it but instead of returning it, British Airways sold it and kept the proceeds. The finder sued the airline. The judge found in the finder's favour and in doing so established a number of principles:

(1) No rights are acquired by the finder of property unless (a) it has been abandoned or lost and (b) he takes it into his care and control.

(2) Where the finder acquires the object in bad faith or while trespassing, he will have only very limited rights over the object. Indeed, a finder has an obligation to take such measures as are reasonable in all the circumstances to let the true owner of the object know of the find and the current whereabouts of the object, and to care for it in the meantime.

(3) A finder does not acquire any absolute property or ownership in the found object, but has a better right to keep it as against all but (i) the true owner or (ii) any person who can show a prior right to keep the object at the time when the finder took the object into his care and control.

[16] [1969] 2 WLR 71.
[17] [1982] QB 1004.

(4) Unless otherwise agreed, any agent or employee who finds an object in the course of his employment or agency and takes it into his care and control does so on behalf of his employer or principal who in turn acquires a finder's rights.

Similar questions arise where the property is found on land or in a building which is not owned by the finder. Once again, Parker v British Airways established some helpful principles:

(1) Where the object which is found is attached to a building or land, the occupier of the land will have better title to the found object than the person who actually found it.

(2) Where the object is found in or on a building or land – but not attached to it – the occupier of the land will have better title to the found object than the person who actually found it, provided he or she has shown an intention to exercise control over the land or building and the things on or in it.

(3) Where the occupier acquires rights superior to those of the finder in this way he or she is under an obligation to take reasonable measures to inform the true owner of the find and to care for the object in the meantime.

5.1.4 Limitation periods

Most legal systems have a system of limitation of claims, designed to exclude legal claims after a certain period of time. Such claims are often referred to as 'time barred' or 'out of time'. The reason for excluding claims after a certain period is generally because claims being brought long after the cause of action arose carry a greater risk of injustice to the defendant. Also, as a practical matter, evidence becomes more difficult to unearth where the matters in dispute took place long ago. This is particularly true in the context of the ownership of art, where art is traded and handed from generation to generation, often without documentation or records.

In the United Kingdom the law on limitation periods is principally contained in the Limitation Act 1980. This Act sets out the rules on how long a claimant has to make his or her claim before it becomes time barred. For the purposes of this chapter we will look at the time periods applicable to ownership claims. As we have seen above, these are usually framed as claims in conversion. As conversion is a tort, the provisions of the Limitation Act 1980 relating to torts are the most relevant.

Under s 2 of the Limitation Act 1980, the normal limitation period for bringing an action in tort for conversion is six years from the date the cause of action accrued, which is the date of the conversion. After that period has expired, not only is the

claimant unable to bring a claim in conversion, but his or her title to the object is automatically extinguished.[18]

While the six-year time period will usually run from the date of the conversion, whether or not the claimant is aware of the conversion, there are some circumstances in which the time will begin to run at a later point. This happens in particular where the defendant or his agent has deliberately concealed a fact relevant to the claimant's claim, or where the claimant has parted with possession of the object as a result of a mistake or fraud. In such cases the six-year period will run from the date on which the claimant could reasonably have been expected to have discovered the concealment, fraud or mistake.[19] Where an artwork has been stolen from the claimant, the six-year period will begin to run only from the first conversion which is unrelated to the theft.[20] It is also important to remember that no limitation period applies where the claim is by a beneficiary against a trustee to recover trust property.[21]

Often, because an artwork goes through a number of hands, it is converted a number of times. In such cases the six-year limitation period does not start afresh with each conversion. Under s 3 of the Limitation Act, the limitation period starts from the date of the first conversion.

However, where an artwork has been stolen,[22] the right of the claimant to bring a claim relating to the theft is not affected by any limitation period. That principle is, however, subject to an important qualification. Where the claimant's title has been extinguished since the theft, the victim of the theft will have no right to bring a claim relating to the theft, other than against the thief. The victim's title can be extinguished because there has been a conversion unrelated to the theft which occurred after the theft, and the six-year limitation period since the conversion has expired. In such a case the claimant will be unable to bring a claim relating to the theft against the current possessor. There is a presumption that every act of conversion which follows a theft is related to the theft (Limitation Act 1980 s 4(2)). However, that presumption may be rebutted by evidence to the contrary that the act of conversion was in good faith and without knowledge of the theft (Limitation Act 1980 s 4(4)).

So, for instance: an artwork is stolen from Mr Smith in the year 2000 by Mr Williams. Mr Williams places the artwork into an auction in 2001 and it is sold to a good faith purchaser, Mr Jones. Mr Jones is unaware of the theft, so time will

[18] Limitation Act 1980, s 3(2).
[19] Limitation Act 1980, s 32(1)(b) and (c) as amended by the Consumer Protection Act 1987, Sched 1, para 5.
[20] Limitation Act 1980, s 4.
[21] Limitation Act 1980, s 21.
[22] Theft includes fraud and blackmail (Limitation Act 1980, s 4(5)(i)–(ii)).

run from the 2001 sale – which is a conversion. If Mr Smith fails to make a claim by 2007 then his claim to the artwork will be extinguished. He will therefore no longer be able to make a claim against the current possessor, Mr Jones. However, he will still have a claim against the thief, Mr Williams.

The claimant's title could also be extinguished if he or she has been paid damages or compensation in satisfaction for his interest in the artwork. So,[23] in the above example, if Mr Smith made a claim against Mr Jones within the six-year period and accepted a payment of damages from Mr Jones, then Mr Smith's title to the artwork would be extinguished and he could not pursue a claim against the thief.

It is also important to note that the six-year limitation period does not apply to actions for recovery of property under the Proceeds of Crime Act 2002. These are actions brought against convicted criminals for recovery of assets which are deemed to be proceeds of crime. Such actions can be brought by the Crown Prosecution Service at any time within 20 years after the cause of action arose.[24]

5.2 Authenticity and attribution

At the heart of the role of the auctioneer is the ability to confirm the authorship and authenticity of artworks. These issues are surprisingly complex. Artists often spend their lives producing artworks, preliminary sketches, designs, unfinished works and drafts, some of which are released to the public and some of which are not. Many artists do not achieve great recognition until later in life, and sometimes only after their death. The situation is further complicated by the fact that where artists are successful they have followers and imitators, both approved and unapproved, and both during their lives and after their deaths. The result is that there is often no coherent or comprehensive record of all an artist's works – and sometimes there is little or no record. The situation is further complicated by deterioration, changes or restoration suffered by the artwork over the years. Certainly, as time passes, the records tend to be less and less reliable. All of this means that the confirmation of authorship and authenticity – a process known as attribution – is more often than not an expression of opinion based on the current state of scholarship and research.

The auction house needs to take care over the attribution process because it owes duties both the seller and the buyer in this respect. In relation to the seller, we have seen[25] that there is a duty to act with care and skill. And in relation to the buyer,

[23] Torts (Interference with Goods) Act 1977, s 5(4).

[24] Limitation Act 1980, s 27A(2).

[25] Section 3.1.3.

the Conditions of Sale also provide contractual remedies where the artwork turns out to have been misattributed or inauthentic.[26]

5.2.1 The attribution process

It is worth delving into what lies behind those expressions of opinion. At its most straightforward, the auction house may have employees who are sufficiently expert in the work of an artist to be able to confirm with confidence that a work is by a particular artist.[27] That confidence may come from researching the recorded history of the artwork or because the work is one which has long been published and accepted as being by the hand of the artist. It may also come from research by the auction house specialist into the known work of the artist, including archives of past sales, exhibitions, scholarly articles and provenance.

In cases where the auction house specialist is not sufficiently confident of the attribution, or if there are doubts, the auction house may seek to confirm authenticity by obtaining the support of a third party expert in the work of the artist. These experts are often scholars who have developed a reputation and body of research which leads them to become an acknowledged authority on the artist. In some cases the experts may be the authors of a catalogue raisonné on the artist – a book listing and illustrating all the artworks known to have been produced by the artist.

In addition, many artists' oeuvres are protected and preserved by artists' foundations, which are established to preserve, protect and document the artist's body of work. Among the activities of such a foundation is often the determination of which artworks are by the hand of the artist and which are not. Typically foundations of this kind are composed of a committee of experts whose role it is to review and inspect artworks, giving the artwork the seal of approval where they consider it to be authentic, and rejecting the work where they do not consider it to be by the hand of the artist. As the arbiters of authenticity, foundations wield very significant power. Auction houses and dealers will not usually offer for sale without qualification a work which has been rejected as inauthentic by a respected foundation.

5.2.2 Certificates of authenticity

Authenticity certificates are formal documents, accompanying an artwork, which attest to the authenticity of an artwork. These play an important role in certifying authenticity and have particular weight and authority in the case of living or recently deceased artists, where the certificate is signed and issued by or on behalf

[26] Section 15.3.
[27] Known as 'specialists'.

of the artist. However, even where the artist is long deceased, such certificates may be issued by experts and foundations.

Certificates of authenticity do not however have a particular legal status in the United Kingdom beyond their evidential and commercial value. There is no law which determines who is entitled to issue certificates of authenticity. As a result, a certificate of authenticity may be very strong evidence of authenticity but – as with any other form of evidence – may be open to challenge, either on the grounds of the authenticity of the certificate itself or on the grounds of the underlying opinion expressed in it. Care should therefore be taken when evaluating a certificate of authenticity to ensure that it is original, that it is issued by an authority or person who is competent to confirm the authenticity of the artwork, that it relates to the artwork being transacted and that it is not expressed in terms which are unconditional and suitably unequivocal.

The ability of artists to provide confirmation of authorship is an important way of providing comfort to the buyer that a work is by the hand of the artist. There is no more powerful attestation of authorship than one which is issued by the artist. However, problems can arise where artists and their representatives use the power to issue authenticity certificates not as a means of confirming authorship but as a way of controlling the artist's brand, supply and commercial value. It is not uncommon to hear of certificates of authenticity being refused for reasons other than that the artist is not the author. For instance, artists may feel that the work was an early work which does not measure up to the quality of later works, or they may consider the work to be unfinished, or they may disapprove of the way the work has come into circulation, or they may not wish it to appear at auction. Legally, the artist is entitled to withhold a certificate of authenticity. There is no law which requires the artist to issue a certificate or express an opinion on authenticity. However, that refusal to issue a certificate does not render the artwork inauthentic or prevent a seller from attributing the authorship of the artwork to the artist.

The artist has a moral right not to have an artwork falsely attributed to him or her.[28] However, the attribution must actually be false and the person making the attribution must know it to be false. The moral right cannot therefore be invoked where the artwork is in fact by the hand of the artist (even if the work is half finished, is of poor quality or was not intended for sale). And even if it is not by the hand of the artist, the person attributing it to the artist has a complete defence if they honestly believed the attribution to be correct.

[28] CDPA 1988, s 84(a); see section 1.2.2.3.

There is also no reason why a seller cannot take the position that a work is by an artist even where the artist has refused to issue an authenticity certificate. However, the seller will want to be confident that the attribution is correct, to ensure that they do not face a claim from the buyer under s 13(1) of the Sale of Goods Act 1979 (correspondence with description)[29] or for misrepresentation.

Aside from the legal considerations, however, there may be commercial considerations which should be taken account of by buyers and sellers of artworks where the artist has declined to issue a certificate of authenticity. In the case of some artists whose work is frequently copied or forged, or where there is a high degree of uncertainty around the artist's oeuvre, the art market will not take the risk of transacting without a certificate of authenticity. In such cases the work may be difficult or impossible to sell without the requisite certificate.

5.2.3 The role and legal position of scholars, foundations and *catalogue raisonné* authors

The existence of foundations and experts is undoubtedly helpful in the determination of authenticity. Most operate on a not for profit basis and have a serious commitment to the scholarship and research necessary when determining authenticity. However, there are some major difficulties. The first problem is that there are no professional, scholarly or other qualification requirements to be satisfied in order to set oneself up as an expert or establish a foundation. Many foundations are run by friends or family of the artist. Nor is this field regulated. As a result, in principle, anyone can present themselves as an expert or set up a foundation. The second problem is that while in most cases the foundations and experts are driven by scholarly concern for the artist's oeuvre, the quality of expertise of an expert or foundation can sometimes vary. A further difficulty arises where more than one expert or foundation claims to be the authority on an artist. At best, this can mean that a work needs to have the blessing of more than one authority; at worst, where the authorities disagree with each other, the owner of the artwork can find him or herself in limbo – unable to sell the work, even though one leading expert believes it to be authentic. It is also important to remember that, other than in cases where the artist himself or herself is confirming authorship, authenticity and inauthenticity are often fluid concepts, dependent on the state of scholarly opinion at a particular time. Works which are fully accepted as authentic may quite suddenly be deemed inauthentic when the baton of expertise is passed to a new expert upon the death of the previously acknowledged expert, or on the establishment of a new foundation or the release of a new catalogue raisonné. A good example of this is the Rembrandt Research Project, which was established in 1968 to organise and categorise research on Rembrandt. Before the establishment of the

[29] See section 5.3.2 below.

Rembrandt Research Project the generally acknowledged expert on Rembrandt was Abraham Bredius, who had accepted 613 paintings as being by Rembrandt. The Rembrandt Research Project systematically investigated the works thought by Bredius to be authentic and, by the time the project was brought to an end in 2011, had revised this number down to 240, with a further 80 unresolved. This dramatic reassessment of the painter's body of work was highly controversial as it resulted in many paintings in museums and private collections being relegated to the status of copies, fakes or studio works. This illustrates how attributions can develop and change over time depending on the state of scholarship. Equally, works can be the subject of an attributional upgrade as a result of a development in scholarship or research. These downgrades and upgrades in attribution are common because the state of scholarship is constantly evolving.

It might be thought that attribution is a binary process. Either an artwork is by the hand of a named artist or it is not. Sometimes it is indeed that straightforward. However, in some fields where attribution is a more difficult exercise, the art world has developed a variety of gradations of attribution which are in many cases only subtly different, but which are intended to describe the proximity of association with the named artist. This is most frequently the case with older works of art, because the longer ago a work was created, the greater the potential for uncertainty as to who created it. That uncertainty is perhaps greatest in the field of Old Master painters, many of whom worked in a studio with assistance from other students, artists or followers. The most commercially successful works of famous artists were also replicated with and without their blessing or involvement, and this could happen both during their lives and afterwards. The result is that there are many gradations of attribution. At the upper level, an artwork may be fully attributed to a named artist. However, the description may also reflect a lesser level of involvement by the named artist – or, in some cases an absence of involvement by the named artist other than as a source of inspiration. A work may for instance be described as 'studio', which means that it is believed to have been made in the artist's studio but wholly or partially by the hand of another artist, possibly under the named artist's supervision. Equally, a work may be described as 'circle' of the named artist, which usually means that it was made by another artist but during the lifetime of the named artist. Or a work may be described as 'follower' of the named artist, which traditionally means that it was made by another artist but during or after the lifetime of the named artist. 'In the manner of' a named artist means the artwork was created by another artist in the manner of the named artist but after the lifetime of the named artist. Perhaps most confusing of all is the phrase 'attributed to', which – counterintuitively – means that there is uncertainty as to whether it is by the named artist or not. With such slight degrees of attribution, it is perhaps no wonder that the attribution of artworks is susceptible to adjustment and becomes stronger or weaker over time. And often, particularly in the field of Old Master paintings, those fluctuations are based upon the 'eye'

of the expert or the experts who are currently recognised by the art market as the person with the greatest authority and expertise on the artist in question. Experts and opinions can change – and with them, so do attributions.

Finally, where an expert – whether a person or a body – wields such power over the commercial value of artworks which are sometimes worth millions of pounds, there is inevitably great potential for conflicts of interest.

These difficulties, and the large sums of money at stake, have resulted in a great deal of pressure on foundations and experts. Because their stamp of approval carries so much weight, they find themselves being regularly invited to authenticate clever forgeries. In other cases they can find themselves being sued or pressurised by disgruntled owners of artworks which are rejected as inauthentic. Many foundations will agree to consider artworks only if the owner signs a document agreeing not to sue the foundation and indemnifying the foundation against claims by third parties arising from the foundation's decision. A number of foundations, such as the Keith Haring and Roy Lichtenstein foundations, have ceased altogether to authenticate artworks, in the face of mounting litigation. Paradoxically, this too has resulted in litigation in the United States, by owners who have non-authenticated artworks on which the foundations are no longer prepared to express a view.

In that context it is worth giving some thought to the liability under UK law of experts, foundations and authors of *catalogues raisonnés* for negligently expressed opinions.

5.2.3.1 Public policy considerations

Before examining the law, we should perhaps first consider the wider public policy question of the value and role of independent scholarship. It must be right that a scholar, who is genuinely independent and motivated only by a desire to create an accurate record of an artist's oeuvre, should be able to express an honestly held view without fear of liability. The bar for the liability of an expert or scholar should therefore accordingly be high. However, we also cannot lose sight of the fact that in the art world, opinions from respected sources can have direct and major financial consequences. In many cases there is only one scholar or expert on an artist whose view is considered by the art market to be determinative of authenticity. Often the expert takes that role upon themselves, and may also hold themselves out as the only authority. Where this happens the expert has extraordinary power – and, it might be argued, with great power must come great responsibility.

5.2.3.2 Liability for negligence

Turning to the law of negligence, in order to succeed in a negligence claim it would be necessary for the claimant to show that the expert, foundation or author owed the claimant a duty of care, that the expert negligently breached that duty and that the breach caused the claimant loss which was reasonably foreseeable.

5.2.3.3 Existence of a duty of care

Looking first at the question of the existence of a duty of care, such a duty can of course arise in the context of a contractual relationship in which the expert is employed or engaged by the owner of an artwork to research and provide an opinion on the authenticity of the artwork. In such a case a duty will arise to act with reasonable skill and care. That duty can of course be limited by the use of contractual provisions which exclude or limit the liability of the scholar or foundation. For this reason, as we have seen above, experts will typically express opinions on authenticity only if the person requesting the opinion signs a document absolving the foundation or scholar of any liability.

However, it is worth considering also whether a duty could also arise in tort in the absence of a contractual relationship.

The law will imply a duty of care in tort even where there is no contractual agreement, where a party seeks information or advice from someone possessing a special skill, where the person seeking the advice trusts that person to exercise due care and where that party knows that his or her advice is being relied upon.[30] So even where there is no contractual framework, an enquiry – even an informal enquiry – could in certain circumstances give rise to a duty. But is there an even wider duty owed by the expert, to the public at large or to certain persons who may be affected by an act or an omission by the expert? *Donoghue v Stevenson*[31] established the requirement to take reasonable care to avoid harm to those whom a reasonable person would have foreseen as likely to be adversely harmed by one's act or omission. *Caparo Industries v Dickman*[32] developed the thinking further:

> What emerges is that, in addition to the foreseeability of damage, necessary ingredients in any situation giving rise to a duty of care are that there should exist between the party owing the duty and the party to whom it is owed a relationship characterised by the law as one of 'proximity' or 'neighbourhood' and that the situation should be one in which the court considers it fair, just and reasonable that the law should impose a duty of a given scope upon the one party for the benefit of the other.

[30] *Hedley Byrne & Co v Heller & Partners Ltd* (1964) AC 465 (HL).

[31] [1932] AC 562.

[32] [1990] 2 AC 605.

With that in mind, could it perhaps be argued that the author of a *catalogue raisonné* might well anticipate that the owners of works by the artist which is the subject of the *catalogue raisonné* could be adversely affected by a negligent failure to include their work in the *catalogue raisonné*? Perhaps, but even if such a duty of care could be established, it seems likely that consideration of the need for freedom of expression for scholars would mean that the courts would not find it just or reasonable to impose such a duty on the scholar. Indeed, the courts have interpreted the test of justice and fairness to mean 'ordinary reason and common sense'[33] and it seems likely that in a case of this kind the common-sense outcome would be that a scholar should be entitled to express an honestly held view without fear of being sued.

5.2.3.4 The standard of skill and care

Even if a duty of care could be established, the refusal to authenticate the artwork or include it in the *catalogue raisonné* would only be actionable if, in doing so, the author or expert fell below the standard of skill and care to be expected in going about the exercise of his or her profession. The standard of care required is determined by reference to the expert's peers. In other words; did the work of the author, foundation or expert fall below the standard to be expected of an author of a *catalogue raisonné* or a person or organisation holding themselves out to be a leading expert in the oeuvre of the artist?[34]

As we saw in section 3.1.3, the question of whether the expert reached the correct conclusion is less relevant when examining whether or not the expert was negligent. The *catalogue raisonné* or the foundation or expert's opinion are all expressions of opinion and what is important, from a legal perspective, is whether the conclusion to include or exclude a work or to authenticate it or not was a reasonable one for a reasonably competent professional working in this field to reach.

Whether or not the opinion expressed was negligent will, in all cases, depend upon the facts of the particular case. It will involve an analysis of the research carried out by the expert, the reasoning behind the expert's conclusions and a comparison with the usual practices of the expert or foundation's peers. Ultimately the court will need to decide whether or not the opinion was one which could be reasonably held by the expert.

[33] *Minories Finance Ltd v Arthur Young (A Firm)* [1989] 2 All ER 105.

[34] To answer that question it might be helpful to look at the tests set out in the *Thwaytes* case, analysed in section 5.3.1 below.

5.2.3.5 *The loss and damage caused*

The final question – if the claimant has been able to overcome the twin hurdles of establishing a duty of care and a breach of that duty – is that of the loss suffered by the claimant. Here the issue of whether or not an artwork is in fact authentic may have greater relevance. The owner of an authentic artwork which has been negligently rejected as inauthentic may well have a claim for damages. If the artwork is however inauthentic then, regardless of whether or not the expert, the author or the foundation acted negligently, the owner of the artwork will not usually have suffered a loss and will not therefore be entitled to damages.

The question of proving that an artwork is in fact authentic could well be something of an evidential challenge in this context for a claimant. How can a claimant prove authenticity where there is only one acknowledged expert – and that expert is the defendant as a result of his or her finding that the artwork is inauthentic?

5.2.3.6 *Fraud*

An alternative cause of action may arise for fraud where an opinion of a foundation or expert is expressed knowing it to be false. In such a case, in order to succeed, the claimant would need to show that a false representation has been made knowingly, or without belief in its truth, or recklessly, careless as to whether it be true or false: *Derry v Peek*.[35] Alternatively, there may be a basis for a claim based on malicious falsehood or slander of goods, arising from false oral or written statements made maliciously with the intention of disparaging the claimant's goods.

5.2.4 Scientific testing

It is also worth commenting on the development of forensic and scientific testing as a means of determining authenticity and attribution. A number of laboratories have established themselves to offer state of the art scientific analysis of artworks. Sotheby's has even established its own in-house scientific testing facility. Techniques on offer range from ultra high definition photography, to X-ray analysis, to paint analysis. Such techniques instinctively feel more reliable and fact-based than reliance on the connoisseurship or expertise of the auction house specialist or scholar. However, while often very helpful, they are expensive and not always conclusive. In my experience I have found that where authenticity cases are litigated using scientific expert evidence, there is a tendency for judges to prefer to base their decision on scholarship and expert evidence rather than science. This is not to say that science does not have its place in the determination of authenticity

[35] [1886–90] All ER Rep 1 at p.22; (1889) 14 App Cas 337 at p.374), per Lord Herschell.

– it most certainly does. And in some cases it is of critical importance. But it does not always provide the certainty one might imagine it would.

5.3 The role and legal position of the auction house in relation to attribution

5.3.1 Underattribution – the sleeper

As we have emphasised at various points in this book, ascribing a work of art to an artist is an expression of opinion rather than a statement of fact. Underlying that expression of opinion is the 'eye' of the auction house specialist but also a degree of due diligence, the extent of which is dependent on the value of the artwork, the existence of any clues in the provenance or physical nature of the artwork and the state of scholarship. In the vast majority of cases, works are sold correctly attributed to the artist who created them. However, there are occasions when works are not correctly attributed. Just as unrecognised works can be discovered and sold for large sums having been attributed to great artists, so too can great works remain unrecognised and sold for less – and in many cases far less – than their true value. Such unrecognised works are known as 'sleepers'. While the purchase of a sleeper may be a windfall for the lucky buyer, the sale of the work at an undervalue represents a loss for the seller.

Typically a sleeper will be an Old Master painting in poor or dirty condition described in the auction catalogue without attribution to a specific artist or as being a copy by a follower of the artist. The work will be purchased, often by a dealer, who then cleans the work and carries out further research. If the purchaser is fortunate the cleaning and research will allow him or her to offer the artwork for sale as a new discovery with an attribution to a famous artist. If the work is successfully sold on that basis for much more than it was bought, and the sale comes to the attention of the original owner, the original owner may look to the auction house for compensation for the auction house's failure to correctly identify the artist.

We saw earlier in section 3.1.3, 'Duty to act with skill and care', that there is an implied duty of care and skill owned by the auction house to the seller.[36] The seller is entitled to expect that the auctioneer will not act negligently. If the seller intends to frame his or her claim as a claim for damages for negligence it will be necessary to demonstrate that the failure to recognise the importance of the artwork was negligent, that the owner suffered a loss as a result of that negligence, that the neg-

[36] Supply of Goods and Services Act 1982, s 13.

ligence claim is not excluded or limited by any provision in the agency agreement and that the claim is not time barred.

The leading case on 'sleepers' is Thwaytes v Sotheby's.[37] The judgment in this case is of great assistance in that it sets out in detail the duty of care expected of international auction houses in the field of authentication.

The claimant, Mr Thwaytes, had owned a painting similar to the well-known Caravaggio painting The Cardsharps, which is in the Kimbell Museum in Texas. Mr Thwaytes suspected that his painting could be a copy, also by the hand of Caravaggio, of the more famous painting. In 2006 Mr Thwaytes took his painting to the auction house Sotheby's with an instruction to research it. Sotheby's specialists formed the opinion that the painting was a copy and was not by Caravaggio – a view which was confirmed after X-rays were taken. The painting was therefore sold by Sotheby's at auction as a copy for £42,000, plus buyer's commission. After acquiring it at the Sotheby's auction, the purchaser carried out extensive investigations into the painting, including having it cleaned and restored, and in 2007 the buyer announced that the painting was an autograph replica of The Cardsharps, painted by Caravaggio himself. Mr Thwaytes issued proceedings against Sotheby's in negligence and for breach of contract. He claimed that the Sotheby's specialists had failed adequately to research the painting and had failed to notice certain features of it which should have indicated to them that it had 'Caravaggio potential', that is, that it might actually have been by Caravaggio, rather than a copy. Mr Thwaytes claimed that if Sotheby's had in fact performed its duties towards him properly, he could either have sold his painting for much more money or decided not to sell the painting and therefore own a work of art of much greater value than he received on its sale.

The first issue for determination by the court was the scope of Sotheby's duty of care. The second question was whether Sotheby's had breached that duty of care.

5.3.1.1 The scope of the auction house's duty of care

Mr Thwaytes had sought to suggest that, for three reasons, the particular circumstances of this case imposed on Sotheby's a higher duty of care than might ordinarily be the case.

First, it was alleged by Mr Thwaytes that the fact that he had given the painting to Sotheby's with an instruction to research and study it imposed a higher duty of care upon the auction house than if he had simply consigned it to the auction house for sale. The judge, Rose J, held however that in her view there was no basis

[37] [2016] 1 All ER 423.

for concluding that where a work is consigned to an auction house for research and assessment rather than for sale, that imposes on the auction house a duty to examine the work more carefully than if it is consigned for sale.

Mr Thwaytes alleged also that the fact that the picture came from a collection which was known to include important works of art should have made this painting worthy of special attention. This reasoning was also dismissed by the judge.

Finally, Mr Thwaytes argued that the fact that Sotheby's was aware that the painting was believed by his family to be by the hand of Caravaggio should have imposed on Sotheby's a higher degree of care in reaching its conclusions. Rose J also dismissed this argument, saying that 'an auction house must approach each painting on its merits regardless of the state of knowledge or expertise of the consignor'.

For these reasons, Rose J concluded that the duty undertaken by Sotheby's when the painting was consigned to it was the duty that arises generally when a painting is consigned to a leading international auction house, and that there were no special features in this case to extend that duty or make it more onerous.

The question then arose as to what that general duty of a leading international auction house was. Rose J found that:

(1) Those who consign their works to a leading auction house can expect that the painting will be assessed by highly qualified people – qualified in terms of their knowledge of art history, their familiarity with the styles and oeuvres of different artists, and in terms of their connoisseur's 'eye'.
(2) A leading auction house must give the work consigned to it a proper examination, devoting enough time to it to arrive at a firm view where that is possible.
(3) It would be much more difficult for a leading auction house to rely on the poor condition of a painting as a reason for failing to notice its potential.
(4) An art expert must know his or her own limitations and the decision as to when to bring in a third party expert would apply as much to Sotheby's as to a provincial auction house (bearing in mind that the bar for where that threshold is crossed is set at a much higher level in the case of an international auction house as opposed to a regional auction house).

Rose J made a clear distinction between the duties of care owed by a provincial auction house and an international auction house. She referred back to the case of Luxmoore-May v Messenger May Baverstock (a firm),[38] in which specialists in a provincial auction house had failed to spot that two dirty and overpainted

─────────────
38 [1990] 1 All ER 1067, [1990] 1 WLR 1009.

paintings of foxhounds might be the work of the famous English painter George Stubbs. In the Luxmoore case, when considering the duty of care owed by the auction house, the Court of Appeal had emphasised that the defendant in that case was a provincial auction house and not a leading auction house. An analogy was drawn with the distinction in the medical world between general practitioners and specialists. The judgment of Lord President Clyde in Hunter v Hanley was referred to:[39]

> In the realm of diagnosis and treatment there is ample scope for genuine difference of opinion and one man is clearly not negligent merely because his conclusion differs from that of other professional men … The true test for establishing negligence in diagnosis or treatment on the part of a doctor is whether he has been proved to be guilty of such failure as no doctor of ordinary skill would be guilty of it if acting with ordinary care.

A provincial auction house was therefore to be judged by the standard of 'general practitioners' rather than 'specialists'. A higher standard of care therefore applied to an international auction house.

Rose J, however, emphasised the very difficult task faced by the auction house specialist. In particular, she warned of the danger of applying hindsight. The fact that a work had not been correctly identified by the specialist did not necessarily mean that the specialist had been negligent:

> The valuation of pictures of which the artist is unknown, pre-eminently involves an exercise of opinion and judgment, most particularly in deciding whether an attribution to any particular artist should be made. Since it is not an exact science, the judgment in the very nature of things may be fallible, and may turn out to be wrong. Accordingly, provided that the valuer has done his job honestly and with due diligence, I think that the court should be cautious before convicting him of professional negligence merely because he has failed to be the first to spot a 'sleeper' or the potentiality of a 'sleeper'.

5.3.1.2 Auction house negligence

The judge considered whether, bearing in mind the duty of care of the international auction house, Sotheby's handling of Mr Thwaytes' painting was negligent. At the heart of this issue was whether Sotheby's was right to rely on its own expertise, whether in doing so it had been diligent in its research and whether the conclusions reached were reasonable. In other words, were the Sotheby's specialists sufficiently experienced in this field to make a judgement on attribution, were they careful in making that judgement, and was their judgement reasonable in the circumstances? Rose J concluded that Sotheby's was not negligent on the basis that:

39 1955 SLT 213 at 217.

(i) They were entitled to rely on the connoisseurship and expertise of their specialists in the OMP [Old Master Paintings] Department in assessing the quality of the Painting.

(ii) Those specialists were highly qualified and examined the Painting thoroughly ...

(iii) They reasonably came to the view on the basis of what they saw that the quality of the Painting was not sufficiently high to indicate that it might be by Caravaggio.

(iv) There were no features of the Painting visible ... (whether under ordinary or ultraviolet light) that should have put Sotheby's on notice that the Painting had Caravaggio features or non-copy features that should cause them to question their assessment based on quality.

(v) Sotheby's was entitled to rely on its specialists to examine the X-rays of the Painting to see if they provided any information which caused them to doubt their assessment of the Painting and those specialists reasonably came to the view that there was nothing in the X-rays that should cause them to question their assessment based on quality.

(vi) Sotheby's were not under any obligation either to carry out infrared analysis of the Painting or to advise Mr Thwaytes to arrange for that to be carried out. If they had carried out infrared analysis they would not have found anything in the infrared images that should cause them to question their assessment of the Painting.

(vii) Sotheby's were not negligent in failing to inform Mr Thwaytes about the [unusual] interest in the Painting ... [and if] they had informed him, I find that he would not have withdrawn the Painting from sale since he would have been informed that all the Sotheby's experts were certain that the Painting was a period copy and not by Caravaggio.

While the judge found there was nothing in the painting which should have triggered Sotheby's to seek outside specialist assistance from third party Caravaggio scholars, she went on to consider what would have happened had it done so. She found that while it may have found at least one expert who supported an attribution to Caravaggio, it would 'also have received a number of negative views of other eminent Caravaggio scholars saying it was a copy' and 'would have maintained their own very strong doubts about the autograph status of the Painting'. In these circumstances the judge considered that Sotheby's would not have been able to catalogue the painting as being 'by Caravaggio' or even as being 'attributed to Caravaggio'. Sotheby's would still have proposed to Mr Thwaytes that the painting be auctioned as by a follower of Caravaggio, with a mention in the catalogue that a one scholar believed it to be by the hand of Caravaggio. If that had happened, Rose J found, the painting would have sold for slightly more than the £42,000 it had sold for, but not a lot more.

The Thwaytes case was of course highly fact specific. However, there are some clear and helpful themes which have been established by the case.

First, the auction house must ensure that the specialist considering the work is appropriately qualified to do so. This is of course difficult, because it is in the nature of a 'sleeper' that the work is usually believed to be of low quality and value. The specialist assigned to catalogue the work may therefore be a junior member

of staff. One way of guarding against this is for the auction house to have in place some form of peer or departmental review process as a fallback.

Whether the specialist is senior or junior, or whether he or she is a specialist or a generalist, consideration should be given to the limitations of the auction house's inhouse expertise. At what point, if at all, should the auction house be asking itself whether it should seek the advice of one or more external scholars? The answer will depend in each case on the facts of the particular case. Are there signs apparent in an examination of the painting or its history which might suggest the possibility that the work is by the hand of a famous artist? Is there an acknowledged external source of expertise on the artist?

The level of research into the artwork that is carried out should be commensurate with its potential. Some works can safely be assessed by use of the 'eye' of the auction house specialist, or a reliance upon history and previous research. Even in these cases, the examination of the work should be carried out with appropriate care and in the correct conditions. For instance, the painting should be viewed under appropriate lighting conditions. However, where there are clear signs that the work could be of greater importance than was previously thought, the auction house should carry out further tests such as X-rays or viewing under infra-red light. While it would be impractical for these tests, or other scientific tests such as paint analysis, to be routinely carried out in all cases, there may be circumstances where it is appropriate to do so.

5.3.2 Overattribution

The inverse of the 'sleeper' is overattribution. In this case it is the buyer rather than seller who finds himself the victim. The buyer has bought an artwork believing it to be by a particular artist, or of a particular period, and finds that not to be the case. This can be because a work, while original, has been innocently but incorrectly identified by the seller or the auction house to be attributable to a particular artist or a period. It can also be because the artwork is a forgery. A forgery is an artwork which is not original and has been created with an intention to deceive as to its authorship, origin or period. In such cases, what options are open to the buyer?

The starting point for any claim against the seller or the auction house should be the sale contract. The sale contract will often provide specific contractual guarantees in the event that the artwork turns out to be misattributed or a forgery. However, such guarantees are likely to be subject to limits and conditions.

Auction houses will frequently provide guarantees to the buyer in their terms and conditions of sale. A buyer will be contractually entitled to a refund of the purchase price subject to certain stringent conditions. Every such set of terms and conditions will be different, but what follows is a description of the type of

structure often found in such guarantees. The auction house must usually be notified in writing of the misattribution or forgery within a limited time period after the sale, typically five years. It is of course not unusual in any field for guarantees to be limited in time. However, in this case there is another practical reason for imposing a time limit. When the auction house is called upon to refund the purchase price to the buyer in such circumstances it will usually make the refund out of its own funds and then in turn seek reimbursement from the seller – who was after all the recipient of the purchase price following the sale. The more time that has passed since the sale, the greater the risk that the seller will be untraceable or unable to reimburse the purchase price. Most terms and conditions will place the onus on the buyer to demonstrate to the auction house's satisfaction that the artwork was indeed misattributed or is a forgery. Because there can be diverging views on issues of authenticity, the most effective way of addressing this requirement is to find a third party expert acceptable to both the auction house and the buyer. However, even if evidence is provided that the work has been misattributed, the terms and conditions will often provide that the guarantee will only come into play if the description in the auction catalogue was out of line with the state of scholarship and opinion at the time of the sale. What this means in practice is that there will be no entitlement to a refund unless the opinion of the auction house at the time of the sale was at odds with the opinion of art world experts at the time of the sale. In this way the auction house ensures that it is responsible only for ensuring that its opinions are in line with the state of scholarship at the time of the sale, and that it is not underwriting subsequent changes in scholarship. The artwork must be returned to the auction house in the same condition, unrestored and undamaged, as it was at the time of the purchase. The thinking behind this requirement is that the cancellation of the sale must place all parties back in the same position they were in prior to the sale. This requires, of course, that the buyer is refunded the purchase price, but also that the seller is reunited with the returned artwork in the same condition it was in before it was sold. This can however present difficulties for the buyer where the misattribution or forgery has been discovered as a result of an invasive scientific test or as a result of cleaning or restoration, all of which will invalidate the guarantee. Finally, the buyer must, at all times since the sale, have remained the owner of the artwork. In other words, the guarantee is personal to the auction buyer and is not assignable to anyone who subsequently purchases or acquires the artwork.

If the buyer is unable to satisfy the requirements of the authenticity guarantee, what other options are available?

The law of mistake in common law will operate to void contracts where they are based on a mistake made by both parties to the contract on the existence of the subject matter of the contract or a sufficiently serious aspect of its quality. Where an artwork is sold, having been erroneously attributed to an artist or period, can

the law of mistake allow the buyer to cancel the contract? In practice, the ability to do this will be extremely limited. The law of mistake is intended to cover situations where the object itself is the subject of an error – not the qualities of the object. Because the qualities of the object – its authorship, age and condition – are usually covered in the contract, the courts are very reluctant to intervene to override the contractual intentions and commitments of the parties. This approach was confirmed in Leaf v International Galleries,[40] a case in which the purchaser of a painting entitled Cathedral of Salisbury by John Constable (1776–1837) sought rescission of the sale contract for mistake on the grounds that the work was a forgery. Denning LJ confirmed that recission for mistake was not available in such circumstances as the mistake related to the quality of the object rather than the object itself. Both parties wrongly believed the work to be by Constable. Denning LJ conceded that this was in a sense an essential and fundamental mistake. However, there was no mistake about the subject matter itself: this was a sale of a specific painting, Cathedral of Salisbury. The parties were agreed about the subject of the contract and the terms of its sale. That was sufficient to constitute a binding contract with which the court would not interfere.

In the absence of a contractual remedy for mistake, what other options may be open to the buyer of a misattributed or forged artwork?

As we saw earlier, an auction sale of an artwork is a sale of goods by description on the grounds that the sale of the artwork is conducted on the basis of a description by or on behalf of the Seller. The Sale of Goods Act 1979, s 13(1) (as amended by the Sale of Goods and Services Act 1994) therefore implies a term,[41] that the artwork will correspond with the description in the catalogue.[42] On that basis, if an artwork turns out not to be by the artist to which it is ascribed in the catalogue, can the buyer reject the artwork and cancel the sale on grounds of noncorrespondence with description? As we have seen, the right to cancel on grounds of noncorrespondence with description will not exist where the parties did not intend the purchaser to rely on the description. This can be where as a matter of fact the buyer did not in fact rely on the catalogue description.[43] More commonly, however, such claims will fail because the terms and conditions of the sale specifically limit or exclude the extent to which the description can be relied upon by the buyer. The conditions will, for instance, often provide that no warranty is given by the auction house in relation to any statement made to the buyer about the lot other than as set out in the authenticity warranty. The authenticity warranty will then set out what parts of the description are warranted and which are not. In such circumstances,

[40] [1950] 2 KB 86.

[41] Sale of Goods Act 1979, s 13(2).

[42] Sale of Goods Act 1979, s 13(1A) added by the Sale of Goods and Supply of Services Act 1994, s 7(1), Sched 2, para 5(1), 4(b).

[43] Harlingdon & Leinister Enterprises Ltd v Christopher Hull Fine Art Ltd [1990] 1 All ER 737.

provided the terms satisfy the requirement of reasonableness, the court is unlikely to allow a claim for noncorrespondence with description.

The buyer of a work which turns out not to be authentic may also wish to consider the possibility of a claim for misrepresentation under the Misrepresentation Act 1967. For a claim for damages or rescission of the contract of sale on grounds of misrepresentation to be successful, the statement made must be a statement of fact, which is false and which induced the person to enter into the contract. The statement may, depending on the circumstances, have been made fraudulently (knowing or believing it to be untrue or reckless as to its truth), negligently (carelessly or without reasonable grounds as to its truth) or innocently (neither fraudulently nor negligently).

Section 2(1) of the Misrepresentation Act 1967 excludes the possibility of a damages claim where the person who made the incorrect statement can show that he or she had reasonable grounds to believe that the statement was true. Damages are available if the statement was made fraudulently, or – if not made fraudulently – where the maker of the statement is unable to show that he or she had reasonable grounds to believe that the statement was true. However, even where damages are not available, it may nevertheless be open to the buyer to rescind the contract.

A buyer may seek to allege that a misrepresentation was made in the catalogue and that he replied upon that misrepresentation in purchasing the artwork. The auctioneer and seller will, however, be able to avoid liability if they are able to prove that they had reasonable grounds to describe the artwork in the terms they did, believing the description to be true, and not having formed that view carelessly. A further impediment to a misrepresentation claim will also arise where, as is often the case, the terms and conditions of sale include language which excludes or limits claims for misrepresentation. The courts will give effect to such provisions provided they satisfy the requirements of reasonableness.[44]

In conclusion, the courts have tended to recognise the freedom of the parties to contract. As a result, the remedies of a buyer of a work which has been incorrectly attributed or which turns out to be a forgery tend to be limited to those in the terms and conditions of sale, provided those terms satisfy the test of reasonableness.

5.3.3 The psychology of authenticity

While we have looked at how auction houses and experts go about correctly identifying authentic artworks, and the potential legal consequences of failing to do so,

[44] Misrepresentation Act 1967, s 3.

it is also interesting to consider why we place such value upon authenticity. While not a legal issue, the concept of authenticity is central to the mechanics of the art market and the value of artworks. Why do we react so dramatically differently to an artwork we are told is original as opposed to an artwork which we are told is not original? If the copy is of the same artistic quality and is otherwise identical in appearance to the original, why do we not value it equally to the original? It has been suggested that our preoccupation with attributing artworks to the hand of a named artist is a product of Western materialism linked perhaps to rarity and value, and that this preoccupation did not exist in the Eastern world to the same degree – where the artwork has traditionally been assessed on its own merits regardless of its authorship.[45]

Some scientific studies[46] suggest that there are certain clear elements which make up the notion of authenticity and play into our perception of value when we assess an artwork. First, and perhaps most importantly, when considering authenticity we assess an artwork as the end point of a unique creative performance. Authenticity and therefore value is therefore instinctively attributed to the original by virtue of the unique creative act we believe to have led to its creation. This is known as the 'performance effect'. A copy or forgery, which merely mimics that creative act, is not seen in this way. It lacks creativity and is not unique. Alongside that, authenticity is also often ascribed to an artwork according to the degree of proximity of the work to the creator or owner – known as the 'contagion' effect. This is why an ordinary article, even without any creative element, which belonged to a celebrity may be perceived to have value. For this reason, an Old Master painting which was created in part by the named artist and in part by assistants in his studio will have less contagion, and therefore be perceived as less authentic and valuable than a work which is entirely by the hand of the named artist. And a painting by a follower of a named artist which slavishly reproduces a work by the named artist is lacking not only in contagion but also in performance. Of course, there are other aspects which also contribute an expectation of value, but which are not part of the authenticity equation. For instance, scarcity and limited supply play a key role in perceptions of increased value – a factor which is seen in the world of prints and photographs which are issued by the artist as limited editions. It also appears that we instinctively attribute greater value to an artwork where the creative process has taken longer to complete – even where the appearance is identical to a work which has been produced more quickly.

[45] Abbing, Hans (2002). *Why Are Artists Poor? The Exceptional Economy of the Arts.* Amsterdam University Press.

[46] George E. Newman and Paul Bloom, 'Art and Authenticity: The Importance of Originals in Judgments of Value' (2011)141(3) *Journal of Experimental Psychology* 558–69.

5.3.4 Forgery risk

We have covered the challenges of attribution – the process of correctly identifying the author of an artwork. This is to be distinguished from the question of forgery. Wherever there is great art, there will also be forgeries. By 'forgery' we mean facsimile works which are created in order to deceive the viewer as to their authorship, period or origin. That is to be distinguished from artworks which are copies of or in the style of another work, but which are not intended to fool the viewer as to the authorship, period or origin. That forgery is a risk when buying art is tacitly acknowledged by dealers and auction houses in the form of the inauthenticity or forgery guarantees which are usually offered as part of the terms of sale. The extent of that risk is, however, difficult to identify, as there is necessarily a lack of hard data. There have been attempts to guess at the extent of the problem, most of which have tended to be hyperbolic and with an eye to creating headlines. The risk also varies to some extent depending upon the category of art and the ease with which the artwork can be replicated. While we can speculate about just how widespread forgery is, we can be in no doubt that it is one of the risk factors when purchasing art and that that risk needs to be understood and managed, both by the auction house or dealer and also by the collector. It is therefore worth analysing some of the more famous cases in order to understand the risks of forgery in the art business and how in practice they can be identified and managed. In particular, it will be seen that there are certain recurring themes which are worth looking out for.

Forgers have long recognised and taken advantage of our emotional responses to art in order to deceive us. While the technical act of creating a forgery which looks like the real thing is difficult, it is usually only one element of the act of deception. Sophisticated forgers spend as much time and care on creating the history of the work and strategising over the manner in which the forgery will be introduced into the market as they do on creating the work itself. As with any fraud, for the victim to be deceived the perpetrator needs to create a set of circumstances in which the victim's guard is lowered. This is usually achieved by creating a false, but believable, provenance. That history can be entirely invented but plausible, or it can be created by falsely linking the forged object to documented events or creating an object to match an object which existed but has since been lost.[47]

5.3.4.1 The Knoedler Gallery

In the United States in the 1990s, the famous Knoedler Gallery bought a series of important artworks by important painters including Mark Rothko and Jackson Pollock from a small-time, relatively unknown dealer called Glafira Rosales. The

[47] See the John Myatt forgery case described in section 2.2.6.

Knoedler Gallery sold these works on to its clients, including many sophisticated art collectors, for tens of millions of dollars.

The works bought from Rosales and sold by the Knoedler Gallery were later alleged to be clever forgeries. The forgeries had been created in a garage in Queens by Chinese artist Pei Shen Qian, a talented artist who was able to create convincing paintings in the style of Rothko, Robert Motherwell, Willem de Kooning and Franz Kline. His copies were then 'aged' using teabags and exposure to temperature fluctuations.

However, the creation of the forged works was only the first element of the forgery. In order for the works to be accepted, and to explain the sudden appearance of such important new works on the market, it was necessary to provide them with a convincing provenance or history. Rosales told the Knoedler Gallery that the works came from an anonymous collector based in Mexico and Zurich whose father had been introduced to these artists in their studios and bought works from them in cash before they had become famous. After the father's death the artworks had been inherited by his son and daughter, for whom Rosales was the authorised agent.

This mysterious, yet undocumented story was for a long time convincing enough to persuade those who came across the artworks of their authenticity. While this may appear surprising in retrospect, it should be remembered that many of the greatest collections were sourced by collectors directly from artists at the beginning of their careers. These collectors are admired and celebrated for their foresight, their taste and their 'eye'. The idea of a collector who is ahead of his or her time discovering artists before they are famous is widely embraced by the art world. What is however unusual is that such a collection would remain undiscovered and undocumented for so long. While this latter aspect should perhaps in retrospect have raised a red flag, the discovery of such a collection of this value is a commercial gold mine for a gallery – the kind of important discovery of which dealers and auction houses dream. A forger will know that when that dream appears to have come true there is sometimes a reluctance by agents in a highly competitive market to ask questions or probe in a way which might endanger their access to the collection and cause the owner of the collection to go to a competitor. The forger will therefore often take advantage of that reluctance by alluding to that possibility. For this reason, provided the artwork appears to be authentic and the story of the provenance is plausible, the forger will play on the fact that the information provided may often – at least initially – be accepted at face value. Another aspect of the Knoedler story which is often seen in forgery scams is the fact that the forger was not the salesperson – that role was left to Rosales.

The spell was broken by the Dedalus Foundation, which reversed an earlier decision to include a work by Robert Motherwell in the Motherwell *catalogue*

raisonné. The painting in question had originated from Rosales. The suspicions surrounding the origin of the works supplied by Rosales came to the attention of the FBI, which served a subpoena on the Knoedler Gallery. Other buyers began to question their purchases. A supposed Jackson Pollock was found, following scientific testing, to incorporate paints which had not been available until decades after Pollock's death. A painting 'by Mark Rothko' was submitted for scientific testing and the tests concluded that the materials and techniques used to create the painting were inconsistent with those used by Mark Rothko.

The Knoedler Gallery announced its closure in 2011 and a number of buyers sued, resulting in confidential settlements. Rosales was prosecuted and entered a guilty plea, agreeing to forfeit the US$33 million which she had earned through her dealings with the Knoedler Gallery. She was also ordered to pay restitution of US$81 million. Pei Shen Qian fled to China, where he remains today.

5.3.4.2 Wolfgang Beltracchi

A similar combination of artistic prowess and provenance invention was used in the Beltracchi case. Wolfgang Beltracchi was an extremely gifted German artist who discovered in the 1990s that he had a talent for creating convincing forgeries by Heinrich Campendonk, Max Ernst, Fernand Léger and André Derain. To ensure that his forgeries were believable he would research, identify and source the original pigments used by the artists and create his forgeries using existing old canvases and frames. He also consulted the *catalogue raisonné* of each of these artists in order to identify artworks which were listed, but not illustrated. This allowed him to create works to match the written descriptions of the works. As we will see, the use of the *catalogue raisonné* or art historical literature to identify works which have been lost, destroyed or not previously seen is a recurring theme in forgery. In common with many other forgers, Beltracchi became obsessed with his mission to create great fakes and sought to 'become the artist', creating works which these artists had never created but which he, Beltracchi, could create in their stead. The result was a series of paintings which not only fooled the experts, but were hailed as the best examples of work by the artists. But, as with the Knoedler forgeries, the creation of the forgery was only the first part of the deception. To ensure that rediscovered artworks were accepted by the experts, Beltracchi invented the myth of the Jaegers collection. Werner Jaegers was his wife Heléne's grandfather and, according to Beltracchi, an avid art collector who had bought much of his collection in the early part of the twentieth century from Alfred Flechtheim, a successful Jewish art dealer in Berlin. The fact that Flechtheim subsequently fled Germany following the rise of the Nazis provided an explanation for the lack of paperwork documenting Jaegers' purchases. To add greater authenticity the forged paintings bore a number of seemingly old labels, created by Beltracchi, including a woodcut label on the reverse depicting an image of Flechtheim and marked *Sammlung*

Flechtheim. Finally, to complete the picture, Beltracchi used a 1920s camera, old film and photographic paper to produce blurred black and white photographs of Heléne seated in a vintage dress, impersonating her grandmother Josefine Jaegers, in front of the forged works. In case anyone had any doubts about the provenance of the paintings, these photographs were used to prove that they had long been in Heléne's family. In fact, the only element of truth in this story was that Werner Jaegers was Heléne's grandfather. He was not, however, an art collector and had not known Flechtheim. And the paintings, while brilliantly executed, were all forgeries created by Beltracchi. As in the Knoedler case, the forger did not get involved in the sales of the forgeries. The role of salesperson was undertaken by Heléne. So convincing was the Beltracchi scheme that he was able to sell at least 14 works of art for a combined total of US$45m. In the course of doing so he was able to fool many of the greatest experts and authenticators. The scheme was uncovered only when scientific analysis of the paint used in one of the works was found to include titanium white, which was not available in 1914 when the painting was claimed to have been painted. Heléne and Wolfgang Beltracchi were arrested in 2010 and, after a trial in 2011, were sentenced to terms of imprisonment of four and six years respectively.

5.3.4.3 Ely Sakhai

One of the most audacious cases of forgery came to light only because of a chance discovery. Ely Sakhai was a New York art dealer who regularly attended Christie's and Sotheby's auction sales of impressionist and post-impressionist art. Bidding in person, Sakhai would buy at auction mid-priced artworks by Chagall, Monet, Renoir and Modigliani which had authenticity certificates. Having very publicly acquired the works, it is alleged that he arranged for identical copies of the works to be made by a talented team of Chinese painters based above his art gallery in New York. These copies were particularly convincing because they had been created side-by-side with the original authentic version. Just like Beltracchi and the Knoedler forgeries, the copies made use of materials and canvases which were consistent with those in use when the original paintings were created. In particular, many of the copies were painted over cheap old paintings which had been sourced from antique shops. It is alleged that Sakhai would then travel to Japan and sell the copy privately to Japanese collectors. The collectors believed they were buying the authentic work because they were supplied with the authenticity certificate, and Sakhai was able to show in each case that he had bought the work at auction. Meanwhile, in reality, Sakhi was said to have retained the original and the Japanese collector had bought a forgery. A few years later, it is said, Sakhai would sell the original too – doubling his money in doing so. A moment of bad luck would however prove to be his undoing. In May 2000 he consigned the original of Paul Gaugin's *Vase de Fleurs (Lilas)* to Sotheby's for sale. Coincidentally, Christie's spring sale catalogue also featured an identical Paul Gaugin's *Vase de Fleurs (Lilas)*.

The auction houses immediately knew that both could not be authentic. Both paintings were therefore sent to the Wildenstein Institute so that the acknowledged Gaugin expert could view them alongside each other. While the two were nearly impossible to tell apart from photographs, a physical comparison revealed that the Christie's version had a far fresher look than the Sotheby's version. The Christie's version was identified as a forgery and withdrawn from sale while the sale of the authentic painting went ahead, resulting in a sale price of US$300,000. Even at this point it was not realised that Sakhai was connected to the Christie's forgery. The FBI however traced the forgery back to a Japanese collector who, they discovered, had bought it from Sakhai. The FBI therefore made the connection and identified other similar cases where buyers of works from Sakhai discovered that an identical copy of the work they had purchased was being offered at auction. Sakhai was arrested and pleaded guilty. He was sentenced to return US$12.5m to his victims and serve 41 months in prison.

5.3.4.4 Shaun Greenhalgh

There is a tendency to think that forgers are highly specialised and tend to focus upon reproducing the work of a single or small number of artists. In many cases that is true, but some forgers are skilful enough to be able to turn their skills to create a variety of forms of artwork. Perhaps one of the most extraordinary examples of this was the work of Shaun Greenhalgh. Greenhalgh was a self-taught artist based in Bolton who, working with his father George and his mother Olive, created a wide variety or artworks including ancient Egyptian sculpture, eighteenth-century casts, ceramics and post-impressionist paintings. By consulting art books in his local library, Greenhalgh identified works which were recorded as having been lost or destroyed. He then set about recreating them. More extraordinarily still, these works were created by Shaun Greenhalgh in a garden shed using tools bought at a local do-it-yourself shop and using modern materials, which were then aged. The quality of the forgeries was such that they were believed by auction specialists, scholars and museums, including the British Museum, to be authentic and important. Perhaps the most famous of these was Greenhalgh's statue known as the Amarna Princess, which purported to be a 3,000-year-old representation of one of the daughters of the Pharaoh Akhenaten and Queen Nefertiti. Christie's was said to have valued the work at £500,000 and the British Museum was also persuaded of its authenticity and importance. It was therefore acquired by the Bolton Museum after a public appeal to raise funds for its purchase. In common with other sophisticated forgery operations, the Greenhalghs knew that the creation of the forgery itself was only the starting point. Shaun Greenhagh's aged father George took on the role of salesman of his son's forgeries and became adept at fabricating stories around the forgeries. These were invariably supported by convincing provenance information, usually linked to the artwork being passed down through the family having been originally acquired by an ancestor of the

Greenhalgh family. Often this information was supported by documents which were either forged or were original records of missing artworks which served as the source of inspiration for the creation of the forgery. In the case of the Amarna Princess, George was able to provide the Bolton Museum with an original auction sale catalogue from the 1890s at which, he said, he believed his grandfather had purchased a number of items, including this statue. Included in the catalogue were 'a draped figure of a female, five marble statuettes and eight Egyptian figures'. While the sale had indeed taken place, the draped figure was not the Amarna Princess, nor had the sale been attended by George's ancestor. But the story was convincing enough to persuade many of the leading experts that the statue was the real thing. And, to ensure that these experts were also under pressure not to dig too deeply, George used the tried and tested threat of competition to get buy-in by threatening to sell the statue at auction if the museums were unable to raise the money for its purchase. The purchase money followed swiftly. The scheme eventually unravelled when the Greenhalgh family tried their luck once too often – seeking to sell a forged Assyrian relief to the British Museum using similar provenance. The police arrested the family and, following a trial, Shaun Greenhalgh was sentenced to four years' imprisonment. His mother and father – who by that time were octogenarians – were given suspended sentences.

5.3.4.5 *Forgery rings – some common themes?*

One interesting aspect of all of these cases is that while the forgers' works were cleverly executed, many experts are surprised, with the benefit of hindsight, at their lack of sophistication. How is it possible, it is often wondered in retrospect, that scholars and experts can be duped by copies which on closer inspection contain obvious tell-tale signs of forgery? The answer seems to be that the aspect which is pivotal to the success of the deception is often not the fake itself, but the presentation of the fake.

Those outside the industry may also wonder why science is not used more routinely to identify and root out forgeries. Modern science has certainly enabled artworks to be subjected to pigment testing, thermoluminescence testing, infrared and x-ray. These tests have also often resulted in the discovery of forgeries. The difficulty is that scientific analysis is expensive, can be invasive and requires very specialised training and equipment. Scientific tests therefore tend to be carried out only when something has come to light which casts doubt on the authenticity or attribution of the artwork.

With this in mind, and taking account of some of the common threads in the cases above, it is perhaps possible to identify some warning signs which may assist in preventing being taken in by forgeries. First, the person first introducing the forgery into the market will usually be credible and unworldly – often purporting

to have no knowledge of art and frequently being an unlikely source of fine art. Second, there will be a believable back-story about how he or she came to own the artwork, often linked to an ancestor who was either a secretive collector with an eye for spotting talent or a lucky collector who was ignorant of the value of the artwork he or she had acquired. Forgers understand that provenance is always crucial to a successful forgery. Often the provenance documentation and known history of a forgery will be very incomplete but there will be some element of the story which is persuasively linked to truth. For instance, there is often a single document which, on its face, is very convincing and serves to allay any concerns the victim may have in relation to the work. In Sakhai's case it was the authenticity certificate, in Beltracchi's case it was the old photograph and in Greenhalgh's case it was the ancient auction catalogue. Sometimes reference will also be made to an ancestor who genuinely existed, or the work may be accompanied by a letter or document which purports to refers to the artwork – but not in sufficiently specific terms to positively identify it. Sometimes the forgery will match the description of an actual artwork which was thought to have been lost or destroyed. All these will add to the credibility of the artwork. The forgery itself will almost always be an exciting and important discovery – a story where luck and chance play a part in uncovering a work which was thought to be long-lost or which no one was aware of. The person presenting the forgery will often also add a deadline to the opportunity, such as the prospect of taking the artwork to a competitor. Finally, the presentation of the first newly discovered work will often be followed by further discoveries of other works – often by the same artist – acquired in similar circumstances. Indeed, a fresh supply of undiscovered works from the same source is perhaps the most significant warning flag of all. The problem with all these hallmarks is of course that none are, in themselves, necessarily unique to forgeries. The existence of some or all of these factors in no way renders the victim culpable, as they may just as well apply in the case of a genuine discovery. Hindsight is of course also a wonderful thing, and the reality is that even those who are expert and cautious can, through no fault of their own, be taken in, because the essence of a successful forger's work is to deceive and draw attention away from any flaws or red flags. However, it is notable that forgeries most often occur where all or many of these circumstances are present.

5.3.5 Authenticity and the blockchain

There has been much discussion in recent years about the extent to which blockchain technology can help to establish authenticity. That discussion has been accelerated by the arrival of NFTs as a means of selling digital art.[48] The blockchain is essentially a database which is replicated in a chain across many hundreds of computers. Because it exists in multiple copies, data in the database cannot there-

fore be easily altered, for instance by changing the database on one or a handful of the computers. Some of the excitement around blockchain has centred upon the idea that authentic works and transactions of art could be recorded via blockchain and in this way form an incorruptible record, which would allow people in the future to be sure of the provenance and authenticity of the artwork. Blockchain has been particularly popular for digital art and other easily reproduced – and therefore easily forged – art.

The main problem with blockchain recording is that, to be effective, the data in the blockchain record needs somehow to be inextricably linked to the artwork. So, for instance, if a painting is known to be authentic and its details are recorded in a blockchain, nobody can alter the data. However, it is difficult to be sure that the artwork itself is the one referred to in the database unless there is an equally incorruptible way of linking to artwork to the data. This can be done in relation to digital art because both theblockchain and the art exist in the virtual world and can be digitally linked. That is not however the case with physical artworks, which are more difficult to permanently match or link to a digital blockchain record. Some products have been developed, such as adhesive seals, which link the artwork in the physical world to the blockchain record. It remains to be seen whether these will be adopted by the market.

It is also difficult to see how blockchain can apply to noncontemporary artworks. In the field of Old Master paintings, for instance, where attributions can and do change regularly, blockchain is unlikely to be of assistance and may even be positively misleading.

Finally, there is the age old problem that the data on any database is only as good as the input data. There needs to be a good understanding of who is authorised to enter data and what their qualifications are to do so.

As yet, it is too early to tell whether these issues can be overcome. Only time will tell whether blockchain is going to revolutionise the art world from the perspective of authentication or whether it will be simply a passing phase.

6 Auctions: policing the saleroom

6.1 Mock auctions

The Mock Auctions Act 1961 was introduced to deal with 'rigged' auctions, which are designed to take money from unsuspecting consumers. Typically such auctions would take place in a busy thoroughfare where passersby would be encouraged to participate in an auction against other bidders who would be enthusiastically bidding and apparently winning items of significant value at low prices. Unbeknownst to the victim, the other bidders were in fact working with the auctioneer, encouraging the punter to bid large sums for objects which turned out to be of little value.

The Mock Auctions Act 1961 made it an offence punishable by a fine or imprisonment to promote, conduct or otherwise assist in a mock auction.

A mock auction is a sale of goods by competitive bidding where:[1]

(a) a lot is sold to a person bidding for it at a price lower than the amount of his higher bid for the lot, or part or the whole of the bid price is repaid or credited back to him – other than where the lot is defective; or

(b) the right to bid is restricted to people who have bought or agreed to buy one or more other articles; or

(c) any articles are given away or offered as gifts.

The Mock Auctions Act 1961 was, however, repealed by the Unfair Trading Regulations 2008, and therefore no longer applies. Instead, the Unfair Trading Regulations 2008 replaced the specific offence of conducting a mock auction with a more general prohibition on unfair and misleading commercial practices.

Under the Unfair Trading Regulations 2008, an auction or other sale will be unfair if it contravenes the requirements of professional diligence and it materially distorts or is likely to materially distort the economic behaviour of the average consumer.

[1] Mock Auctions Act 1961, s 1.

The Unfair Trading Regulations 2008 are designed to prevent highly misleading practices designed to confuse the consumer into a purchase.

It is likely that the sort of practices prohibited by the Mock Auctions Act 1961 – such as the undisclosed repayment or rebate of the purchase price in whole or in part to certain bidders – will also be found to be unfair or misleading under the Unfair Trading Regulations 2008. However, whereas the Mock Auctions Act 1961 prohibited these practices outright, the focus of the Unfair Trading Regulations tends to be on transparency. This means that in certain cases a practice may not be unfair, provided that the consumer is fully informed of its existence of the practice before deciding to make a purchase.

The practice of 'shill bidding', where the seller bids up his own lot in order to drive the price of the lot upwards, has been found to be unfair under the Unfair Trading Regulations 2008. However, this is to be distinguished from chandelier bidding, which is the practice of the auctioneer bidding on behalf of the seller below the reserve where he has made it clear that he is reserving the right to do so (see section 2.2.14, 'Bidding').

Other practices likely to be found misleading under the Unfair Trading Regulations are misleading statements or omissions made in respect of the sale of artworks relating to:

- the existence or nature of the artwork;
- the main characteristics of the artwork (composition, geographical origin, method and date of manufacture);
- price and manner in which the price is calculated;
- the existence of a specific price advantage.

It is important to remember that these Regulations are designed to prevent practices which are deliberately misleading. As a result, the most effective way in which dealers and auctioneers can guard against falling foul of these requirements is by exercising reasonable diligence to ensure that the descriptions of the artworks they sell are accurate.

6.2 Bidding agreements and auction rings

The principle of the auction sale is that of the level playing field. All bidders compete in a public and transparent way for an object. We have seen that the law in the UK has intervened to protect bidders from being unfairly induced to bid to higher levels than they would otherwise have done as a result of unfair practices. The law has also intervened to protect the auction house and the seller from unfair practices by bidders.

In the 1980s, a pub across the road from Christie's was particularly busy after auctions. It is said that if you were to listen carefully you would hear what appeared to be an auction taking place among the dealers. This was the auction ring in action. An auction ring typically works as follows. A group of potential bidders for a desirable object coming up for sale at an auction house agree between themselves that they shall not bid against each other for the object. Instead they agree that only one designated member of their group will bid for the object. In this way, the absence of competition is designed to ensure either that the object is sold for significantly less than might otherwise have been the case, or that it is unsold and then available for a private aftersale – again at a low price. If the designated member of the ring successfully acquires it in this way at a low price, the ring members then hold a separate private auction of the object among themselves. The amount by which the second auction price exceeds the first auction price is then divided up between the ring members. This practice has the effect of depriving the original seller of the true value of the object and depriving the auction house of all or part of the commission which would have been due on the sale of the object at its true value.

The Auctions (Bidding Agreements) Act 1927 was introduced to make auction rings illegal. The problem the Act has faced is twofold. First, it has needed to distinguish between auction rings and the legitimate practice of one or more dealers clubbing together to purchase an item. The second problem has been one of detection and enforcement.

The primary offence under the Act is offering an inducement to someone not to bid. The Act makes it illegal for any dealer to give or offer any gift or consideration to any other person as an inducement or reward for abstaining or for having abstained from bidding at a sale, either in relation to a particular lot or more generally.[2] The secondary offence is accepting or encouraging such an inducement. The Act makes it illegal for anyone to agree to accept, to accept, or to attempt to obtain an inducement in return for abstaining from bidding.[3]

In order to distinguish auction rings from bona fide joint purchases, the Act makes it clear that no offence will be committed where the dealer has, prior to the auction, entered into an agreement in writing with one or more persons to purchase goods on a joint account and has, prior to the agreement, deposited a copy of the agreement with the auctioneer.[4]

[2] Auction (Bidding Agreements) Act 1927, s 1(1).
[3] Auction (Bidding Agreements) Act 1927, s 1(1).
[4] Auction (Bidding Agreements) Act 1927, s 1(1).

The sanctions and potential consequences for breach of the provisions of the Act are serious. A conviction can result in imprisonment of up to two years, an order banning the convicted person from attending auctions and/or a fine.[5]

In addition, s 3 of the Auction (Bidding Agreements) Act 1969 provides that the seller of goods which are the subject of the illegal bidding agreement shall be entitled to avoid the sale contract. Where the contract cannot be avoided and the seller cannot recover the property, each of the participants in the auction ring shall be jointly and severally liable to the seller for any loss he or she has suffered as a result of the auctioning.

There have to date only been two successful prosecutions under the Auction (Bidding Agreements) Acts. This is because of the difficulty of detection. Such agreements are, of their nature, secret, and are rarely if ever recorded in writing. It is also telling that joint purchases agreements are very rarely deposited with auctioneers – despite the fact that dealers are known to regularly pool their resources. This situation cannot last and dealers who participate in agreements which contravene the Act are taking a major risk. Auction houses now regularly scrutinise suspicious bidding patterns and saleroom behaviour. It is only a matter of time before a ring is identified and the participants prosecuted. That likelihood of prosecution is increased by the arrival of more recent legislation in the form of the Enterprise Act 2002.

The Enterprise Act 2002 makes it a criminal offence to participate in a 'bid-rigging arrangement'.[6] Anyone doing so is liable to a fine and/or imprisonment of up to five years.[7]

A 'bid-rigging arrangement'[8] under the Act is an agreement among potential bidders to the effect that one or some of them will abstain from bidding or that they will bid in a certain way. While under the Enterprise Act the members of a 'bid-rigging arrangement' had to have been acting dishonestly to be convicted, the Enterprise and Regulatory Reform Act 2013 has since removed this requirement.

It is a defence to prosecution under the Enterprise Act if those involved in the arrangement informed the person requesting bids of the arrangement at or before the time a bid was made and provided that person with 'relevant information'[9] relating to the arrangement at or before the time the bid was made. 'Relevant

5 Auction (Bidding Agreements) Act 1969, ss 1(1), (2).

6 Enterprise Act 2002, s 188(2)(f).

7 Enterprise Act 2002, s 190.

8 Enterprise Act 2002, s 188(5).

9 Enterprise Act 2002, s 188A.

information' here means the names of the parties to the arrangement, a description of the arrangement and the relevant lots to which the arrangement relates.

6.3 Estimates and consumer pricing information

In October 2018 the Advertising Standards Authority (ASA) issued a ruling criticising Christie's in relation to its practice of publishing estimates in its sale catalogues, which the ASA deemed to be misleading.[10]

Christie's practice had been to provide, in relation to each lot entry, a guide to the likely range in which it expected the lot to sell – for instance, '£100,000–£120,000'. At the bottom of the same listing page, text in small font stated: 'Other fees apply in addition to the hammer price – see Section D of our Conditions of Sale at the back of this Catalogue.' A complaint was submitted to the ASA alleging that nonoptional fees and taxes, such as the buyer's premium and VAT, had not been made sufficiently clear, and that for these reasons the catalogue entry was a misleading advertisement.

The ASA ruling agreeing with the complaint can be summarised as follows:

(1) An estimate is a price: the ASA considered the auction estimate to be a 'price' for the purposes of the Advertising Codes.
(2) Detailed explanation of pricing at the back of the catalogue must be clearly signposted: the ASA acknowledged that it is legitimate, because there are so many variables, to have a detailed explanation of how the price is calculated in the back of the sale catalogue, but this must be well signposted.
(3) The estimate published in the lot entry must show the likely buyer's premium, VAT and fees and artist resale right charges.
(4) The ASA felt that because buyer's premium and VAT were material information necessary to allow customers to make an informed decision, the estimates should, within each individual catalogue entry, give an indication:
 (a) that nonoptional fees are payable;
 (b) of the 'likely percentage of buyer's premium charged';
 (c) of the rate of VAT applicable (even where it is not payable or recoverable by some clients);
 (d) of any other applicable fees (such as artist's resale royalty).
(5) General statements are not enough: it is insufficient to put in a general qualification such as 'Other fees apply in addition to the hammer price – see our conditions of sale at the back of this catalogue'.

[10] www.asa.org.uk/rulings/christie--manson---woods-ltd-a18-443340.html

(6) Buyer's premium rate guides must include VAT: in addition, the ASA found that when auction houses list buyer's premium rates in their catalogues and online, it is not enough to state that VAT may apply. The buyer's premium rates should be quoted inclusive of VAT.

The effect of the ASA ruling – if applied literally – was to require that when in the United Kingdom auction catalogues publish estimates, whether in advertising or in sale catalogues, the estimate might for instance look something like this:

Estimate: £100,000–150,000 (plus 30% BP*) ARR applies

Then in a footer notation: BP* – 'Buyer's Premium of 30% incl. VAT @ 20%. Lots marked ARR will be subject to an additional fee – please see table provided on page XX.'

When auction houses list their premium rates in UK sales catalogues and online, the ASA requires them to be expressed along the following lines:

> The buyer's premium is payable by the buyer as part of the total purchase price at the following rates: 30% (including VAT@20%) of the hammer price up to and including £180,000, 24% (including VAT@20%) of the portion of the hammer price above £180,000 up to and including £3,000,000 and 15% (including VAT@20%) of the portion of the hammer price above £3,000,000.

While this is one way of presenting the information, different auction houses have, however, addressed the ASA's requirements in different ways.

Phillips, for instance, states on each catalogue page:

> The amount of Buyer's Premium, VAT and, if applicable, Artist's Resale Royalty payable is dependent on the sale outcome. For full details see Calculating the Purchase Price in the Buyer's Guide Online or in the Catalogue. Buyer's Premium is payable at a maximum of 26%. VAT where applicable is payable at 20% on the Buyer's Premium.

As a general comment, there are real practical difficulties with the ASA's finding and the information now required to be displayed. First, the ASA's finding is based on the premise that an auction estimate is a price. An estimate, in my view, is not a price, but a statement of expectation as to the range in which the hammer is likely to fall. The price is the amount determined to be payable once the hammer does fall – which may or may not be within the estimate. Second, there are a number of variables which may apply when calculating the price payable. Those variables depend not just on the hammer price but on the VAT status of the property, the seller and the buyer, and whether artist's resale right applies and, if so, how much is payable and by whom. All of these factors make it difficult or impossible to determine, at the time the catalogue is printed, what the price ultimately payable

by the buyer will be. Any attempt to do so is at best going to be so vague and general as to be unhelpful, and at worst will be misleading.

7 Auctions: online auctions

The arrival of the internet and the success of online auction vehicles such as eBay initially encouraged the art industry to develop strategies around the sale of art online. As with many internet ventures, there were, over the following years, as many successes as there were failures, and progress was tentative at best. However, as the strategies and technical offerings became more sophisticated over time, online sales began, slowly, to become a part of auction houses' and dealers' business models. There remained a concern among auction houses, dealers and their traditional customers, though, that many of the most important aspects of traditional physical art auctions could not be replicated online. There was a pre-vailing view that beyond a certain price point, and outside of certain categories of art, buyers would not purchase art without having had an opportunity to view and inspect it in person. Auction houses and dealers also recognised that there is an important social aspect to collecting and trading in art and that the build-up to the sale, the social events surrounding the exhibition and the drama of the auction itself were essentially physical experiences which would be diminished in an online environment.

For all these reasons, until 2019 the growth in online sales of art had been steady but not stellar. While some buyers were becoming increasingly comfortable with spending large sums online for the purchase of art, by 2019 that sense of comfort was not yet widespread. In 2018 global online sales in the online art and antiques market accounted for 9% of total global sales and reached an estimated total of US$6 billion. This represented an increase of 11% over the previous year.[1] In 2019 online sales of art actually declined by 2%, to US$5.9 billion. While in other retail sectors e-commerce was increasingly becoming the most important sales channel, in the art market retail sales accounted for just 14% of sales in 2019.[2]

After years of peering over the abyss, the arrival of the Covid pandemic in 2020 would force the auction houses and dealers to throw caution to the wind and hurl themselves headlong and wholeheartedly into the online world. In March 2020 it became apparent that, due to health restrictions, physical exhibitions and auctions of art would, for the foreseeable future, no longer be possible. But auction houses could not simply mothball their businesses. The fixed overheads of such

[1] Dr Clare McAndrew, Art Basel and UBS report, *The Art Market 2019*.
[2] Dr Clare McAndrew, Art Basel and UBS report, *The Art Market 2020*.

large organisations as international auction houses simply could not sustain an extended period without sales. Their very survival was therefore at stake. Necessity is the mother of invention and over the course of a month, Sotheby's, Christie's and Phillips' staff worked furiously to perfect the technology, the processes and the visual formats required to sell art online at values and in quantities that had never been seen before. All three major houses developed virtual sales where one or more auctioneers conducted auction sales onscreen, taking bids on the internet or from staff manning the telephones in locations all over the world. Traditional sale schedules and venues were abandoned. Cinematic techniques, music and camera angles were used to create drama – and the results of these sales surpassed everyone's expectations. In addition to streamed virtual sales, the auction houses also embraced the time-based auction, offering works at a lower price point. Auctioneers discovered they could sell online and buyers responded with an appetite to buy online. The age of the internet art auction was truly born.

There remain, however, real challenges in the sale of art online, whether by private sale or by auction.

Foremost of these is the nature of art itself. Our response to art tends to be visual, emotional and tactile. We all know how different it is to view an image of a painting in a book and to view it in a museum. It is this need to experience an artwork firsthand which has allowed the traditional auction format to flourish over such a long period. Coupled with this is the ability, in most traditional auctions, for buyers to physically inspect artworks in order to ascertain for themselves the condition of the work. An opportunity to inspect and experience an artwork at first hand is often not available in online auctions, and this may lead in some cases to a reluctance on the part of buyers to participate in an online auction of art.

Art tends to be unique and, as such, its pricing has usually involved debate and haggling. Rightly or wrongly, there has been a feeling on the part of both buyers and sellers that advertising artworks online for private sale is less transparent in terms of pricing than traditional methods of private sale, or at least does not offer the same opportunities to haggle and agree a price. It is interesting in this context that in some ways, the events of 2020 and the move of private art sales online have in fact encouraged a greater degree of transparency in pricing than was previously the case. Dealers and auction houses realised quickly that marketing an artwork without being upfront about its asking price was a barrier to sales. The new online buyers wanted to know the price immediately, or they would move on. Attention spans online are notoriously fickle. A 2015 study by Microsoft[3] established that on average a consumer's attention online is limited to around eight seconds before moving on. And that attention span is falling dramatically each year. To seize

[3] Microsoft Attention Spans Research Report, *Microsoft Canada Consumer Insights*, 2015.

and hold the consumer's attention, the online seller needs to convey all the information necessary for a buying decision to be made in the space of a few seconds. Being coy about pricing therefore risks lost customers.

The anonymity offered by online transactions can also be a cause for concern for buyers, sellers and agents. All parties need to be reassured that their counterpart in the transaction is reputable and will honour the online sale. This is less easy in the world of online transactions, where identities can be misrepresented or hidden. The COVID crisis certainly brought with it a surge in reports of sophisticated online fraud in all industries by fraudsters who quickly identified and exploited the vulnerabilities inherent in transacting in cyberspace. The art world was no exception. The sometimes significant values involved in art transactions made the art business an attractive target for cybercriminals, using phishing emails, stolen credit cards and wire instruction interception.

There is also a perception that the risks for both buyers and sellers are greater in online transactions. Buyers are concerned about artworks being not as described; sellers are concerned about nonpayment. Perhaps for this reason, transactions have tended in the past to be at lower price points.

The COVID pandemic was however a dramatic and sudden inflection point for the art world. In 2020 the number of purely online auctions arranged by Sotheby's, Christie's and Phillips leapt by 214%, from just over 200 auctions in 2019 to almost 650 auctions in 2020. The revenue generated by those purely online auctions increased dramatically, by 475%, from US$165 million in 2019 to US$ 950 million in 2020.[4]

Dealers were also forced to move online in 2020 and the large art fairs made various attempts to put their offerings online. This met with some success but the sheer volume of art being advertised online was thought to have caused buyer fatigue. Despite this, galleries were able to increase the proportion of their online sales from 10% of total sales in 2019 to 37% of total sales in 2020.[5]

Through online sales, auction houses and dealers discovered a freedom which they had not previously enjoyed in the physical world. Online sales dramatically increased their ability to reach new audiences throughout the world; technology was able to bring the drama of the saleroom into their clients' homes; the location and timing of sales became less relevant; and – perhaps most importantly – it

4 Pi-Ex Public Auctions Report 2020.
5 Dr Clare McAndrew, Art Basel and UBS report The Impact of COVID-19 on the Gallery Sector – a 2020 Mid-year Report.

became clear that customers were prepared to buy some of the highest value artworks online.

The exponential growth of online sales in the space of a few months and the experimentation that was necessary as a result of the COVID restrictions changed the complexion of the art market. Because art is essentially a social activity there can be no doubt that as travel and meeting restrictions are relaxed there will be a resumption of the physical gatherings associated with the art market. But the online sale is here to stay. Virtual viewing and transacting will remain a very significant part of the art market because the internet provides an accessibility and customer reach well beyond traditional physical events, and because auction houses have discovered that their overheads can be significantly reduced by more effective use of online technology.

7.1 Forms of online auction

Online auctions exist in a number of different formats.

Perhaps the most well established and widely known is the eBay model. In this case the auction company simply provides a software platform through which the seller is able to put an object up for sale to potential buyers. It does not act as agent for the seller or the buyer and is merely a host for the sale. It assumes no liability for the seller's description and delivery of the property or for the buyer's obligation to make payment.

Traditional auction houses operate as agents for the seller and not merely as a platform. As such they have addressed the demand for online sales in two ways. First, they have enabled bidders to follow physical auctions online and bid through their computer against bidders who are in the saleroom or on the telephone. Second, they have introduced online only auctions, where bidders can bid only online in a time-limited auction.

7.1.1 Online bidding in physical auctions

Most auction houses, both large and small, now provide bidders with the ability to bid online in real time on lots offered for sale in physical auctions. This is often available with the ability for the bidder to view the auctioneer and the action in the saleroom. The legal position in relation to such bidding is the same as it would be for someone bidding in person or on the telephone.

The most frequent issue to arise in relation to online bidding in physical auctions is where a successful bidder claims either that he or she did not bid at all, or that

he or she bid mistakenly. When Christie's first launched its online bidding service in 2006, a successful bidder in its sale of Star Trek memorabilia claimed that his bid had been due to his cat walking across the computer keyboard. More recently the online purchaser of a vintage fairground carousel from Prestige Auctions for £245,000 sought to avoid the sale, claiming he had made a mistake. Auction houses now regularly have to deal with buyers claiming that they made a bid in error from their back pocket or that they unwittingly placed bids multiple times due to a software or internet time lag. The success of such arguments rests upon the particular circumstances of the case. For the buyer, proving that he or she was not in fact the bidder is difficult when auction sites require a password to login. An argument that someone bid without the account holder's authorisation would also be difficult to sustain where the account holder has, by allowing access to his or her login details, allowed someone to act on his or her behalf. As a practical matter, though, most auction houses will approach the issue in the same way as they would someone who bids in person in the sale room and then refuses to make payment. The auction house will seek to enforce the sale and, if that is not possible, will consider reoffering the lot or returning it to the seller.

We shall see[6] that online consumer buyers enjoy certain post-sale cancellation rights in relation to so-called distance sales, which includes purchases made online.[7] It is important to note that these cancellation rights do not apply in relation to auction sales which are conducted by an auctioneer and where consumers attend or are given an opportunity to attend the auction in person.[8] Online bidding in physical auctions does not therefore entitle buyers to exercise EU consumer cancellation rights.

7.1.2 The eBay model

eBay describes itself as a marketplace that allows users to offer, sell and buy objects. It emphasises that eBay does not have possession of anything listed or sold through it, and that it has no involvement in the transaction between buyers and sellers. The contract for the sale is directly between buyer and seller.

As with a traditional auction, objects are offered for sale, described and illustrated in detail. Bidders register bids online and, once a predefined period of time has passed, the object is sold to the bidder who has registered the highest bid.

Unlike traditional auctioneers, eBay assumes no responsibility for listings or content; these are prepared by its users. It emphasises in its 2022 User Agreement

6 Section 7.1.3.2 below.

7 The Consumer Contracts (Information, Cancellation and Additional Charges) Regulations 2013 S219(1).

8 The Consumer Contracts (Information, Cancellation and Additional Charges) Regulations 2013, s 5 (*Definition of Public Auction*) and s 28(g) (*Limits of Application: Circumstances Excluding Cancellation*).

that it 'has no control over and does not guarantee the existence, quality, safety or legality of items advertised; the truth or accuracy of users' content, listings or feedback; the ability of sellers to sell items; the ability of buyers to pay for items; or that a buyer or seller will actually complete a transaction or return an item'.

It does however impose upon its users certain obligations, including the obligation on buyers to pay for their purchases and on sellers to deliver goods purchased. Its user agreement includes prohibitions on:

- inappropriate categories or content;
- the sale of counterfeit items;
- content which is defamatory or infringes the intellectual property rights of third parties;
- transactions by minors;
- manipulation of bidding.

These obligations can be enforced by eBay, which has the ability to suspend or exclude users. However, in reality much of the enforcement occurs through users policing the eBay environment themselves. Users are encouraged to rate each other's behaviour and, while a good rating will encourage other users to transact, a poor rating will have the opposite effect. This is very different from the world of physical auctions where participants tend to look to the auction house to make judgements about the reliability of sellers and bidders.

Users of eBay are not, however, left entirely on their own. It provides a money back guarantee arrangement where items are not delivered or where the item delivered doesn't match the description. This comes into play when the users have been unable to resolve their differences amicably. In these cases eBay acts as an adjudicator and will refund the buyer if it determines that a purchase has not been delivered, or that the purchase does not match its description. Having reimbursed the purchase price, eBay then seeks to recover the purchase price from the seller.

Buyers and sellers on eBay are also provided certain contractual cancellation rights. EU consumers buying through eBay and other online auction platforms may also benefit from additional statutory cancellation rights. As we have seen above, the EU consumer cancellation rights do not permit EU buyers to unilaterally cancel their purchases where they buy online at a physical auction.[9] However, as eBay sales are not physical auctions and take place entirely online without the intervention of an auctioneer, the EU cancellation rights do apply to eBay sales – but only where the seller is a trader and the buyer is an EU consumer.

[9] The Consumer Contracts (Information, Cancellation and Additional Charges) Regulations 2013, s 5 (*Definition of Public Auction*) and s 28(g) (*Limits of Application: Circumstances Excluding Cancellation*).

Sotheby's has in the past attempted to use the eBay model and platform to hold online auctions of artwork. In 2002 eBay allowed Sothebys.com to appear within its own site and take advantage of its online auction technology. The partnership was shortlived and had been dissolved by 2003. One of the reasons this partnership may not have been as successful as was first hoped might be because buyers expected Sotheby's to occupy the traditional position of gatekeeper, ensuring the quality and accurate description of the works of art on the site. In fact, Sotheby's was, like eBay, assuming the role of platform host, allowing sellers to describe their artworks themselves without intervention by Sotheby's. When works were not accurately described or otherwise problematic, buyers were, one would imagine, unhappy not to be able to look to Sotheby's for solutions in the same way they could at Sotheby's physical auctions. Perhaps more concerning for Sotheby's was the fact that it had no control over the quality of artworks appearing on a platform carrying its name, potentially exposing its brand to damage. For all these reasons, Christie's, Phillips and Sotheby's have tended to avoid online auction models where they do not have control over the description of the works included in the sale.

7.1.3 The time limited online only auction

7.1.3.1 *Features of the time limited online only auction*

The favoured online auction model adopted by auction houses has been the time limited online auction model. A group of artworks is assembled – often along a theme – and made available by the auction house for online bidding over a limited period of time. The objects may or may not be available for physical inspection. Bidders place single bids or an electronic instruction to automatically bid in response to competing bids up to a maximum amount. On the expiry of the time period the winner is the person who has registered the highest bid. The fundamental difference between this model and the eBay model is that the lots on offer are sourced, described and presented for sale by the auction house rather than the seller. This ensures that the auction house has control over the description of the artworks on sale and allows it to assume the same basic responsibility for the sale and the description of the artwork sold as it does in a physical auction. In particular, most auction houses will offer the same authenticity warranties as they do in physical sales.

As we have seen, the major auction houses' use of timed online-only sales grew exponentially as a result of the COVID restrictions. This type of sale allowed the auction houses to achieve a steady turnover of sales despite the restrictions on holding physical sales. Looking ahead, the objective for auction houses is to use regular online-only auction sales to streamline and speed up the auction process. This would ensure that sellers are not restricted by the timing of the traditional sales calendar. Buyers would also welcome a regularly changing menu of artworks

on sale, and bidding online is a far less intimidating experience, which would spur competitive bidding and open the art market to new buyers. There is in my view no doubt that this is the future for art auctions in certain categories and at certain price levels. However there are also undoubtedly some challenges with this strategy. First, the inspection, photography, description and preparation of a lot for sale in an online-only auction sale is often no less a drain on resources than would be the case for a lot entered in a physical auction. Second, at the higher price points, auction houses seek to offer a personalised and bespoke service to their selling clients, and this is at odds with the one-size-fits-all approach necessary in order to streamline the selling process. Finally, the sheer volume of artworks being offered online has made it more difficult to capture the attention of potential buyers. These challenges will be overcome but it may take some time and will require some technological and commercial ingenuity.

One additional attraction of timed online sales for sellers and auction houses is the ability to quietly withdraw a lot midway through the sale where the lot is not attracting much interest or bidding. This is useful for a number of reasons. In non-timed physical auction sales taking place in real time, the level of interest in a lot can only be established with any degree of certainty in the minutes or seconds during which it is offered for sale by the auctioneer. Withdrawing the lot from sale at that point is not, in practice, an option. The auctioneer must plough on even if bidding is thin or non-existent. If the lot then fails to sell, it is publicly announced by the auctioneer as 'passed'. Sellers fear that such a public failure may well make the artwork more difficult to sell in future, affecting its value. Auction houses also dislike lots being 'passed' or 'bought-in' because it affects the auction house's 'sell-through' rates (the percentage of lots offered by the auction house for sale which are sold). Auction houses aim to have sell-through rates as close as possible to 100%, as such statistics are an important marketing tool for attracting consignments and a source of pride. Because online-only timed auctions take place over many days, the risks of a public failure are less. A seller can ask to withdraw his or her lot from the sale before the bidding deadline. Mid-sale withdrawal of lots which are not attracting bidding will often also suit the auction house, allowing it to ignore the withdrawn lot when it calculates and publicises its sell-through rate. There are three issues which arise from this approach. The first is whether the seller has the contractual right to withdraw – and this depends on the terms of the agreement between the auction house and the seller. In most cases sellers have the right to withdraw, but only if the auction house consents, and sometimes that consent will be conditional upon payment of a withdrawal fee. That fee may be waived or reduced by agreement where the auction house is also keen to have the work withdrawn. The second, which is more difficult, is what happens where bidding has exceeded the reserve. In those circumstances, can a bidder object to the withdrawal on the grounds that he or she has been deprived of the opportunity to buy the lot? Most auction house terms and conditions avoid this debate by

making it clear that until the hammer has fallen, the auction house retains the right, without liability to the buyer, to withdraw lots from sale. The third is a more general issue of transparency. While there is no duty on auction houses to take account of mid-sale withdrawals in their post-sale reports, it could be argued that this practice does not give a full picture of the outcome of the auction. An artwork which is unsold due to being prematurely withdrawn is arguably no different from an artwork which reaches the end of the auction but remains unsold due to a lack of bids.

One of the challenges of the time limited auction is that bidders tend to hold back for most of the time period and then become very active in the final minutes or seconds of the auction. This bidding strategy – known as 'sniping' – is intended to knock out competitive bids in the hope that the other bidders will not be sufficiently quick off the mark to outbid the last minute bidder. As sniping can result in the elimination of bidders who would bid higher but run out of time, some online auctions put in place an arrangement called 'popcorn bidding' or 'dynamic bidding'. Typically, for instance, if a bid is placed in the final five minutes of the auction, the time limit for the auction will be automatically extended by a further five minutes to allow other bidders to put in competitive bids. This process repeats until there are no further bids.

7.1.3.2 Time limited online only auctions and distance contracts

A time limited online only auction is likely to be a distance contract and therefore subject to cancellation and information rights under the Consumer Contracts (Information, Cancellation and Additional Charges) Regulations 2013 (CCR).[10] These regulations apply where the auction is an online sale without a live auctioneer and cannot be attended by the bidder or buyer in person.[11] In addition, for the regulations to apply, the seller must be a 'trader' and the buyer must be an EU-based 'consumer'. Under reg 4 of the CCR, 'consumer' is defined as an individual acting for purposes which are wholly or mainly outside that individual's trade, business, craft or profession. 'Trader' means 'a person acting for purposes relating to that person's trade, business, craft or profession, whether acting personally or through another person acting in the trader's name or on the trader's behalf'. Remember therefore that in the case where an auction house is acting as agent for the seller, it is the status of the seller which determines whether the CCR apply, not the status of the agent.

[10] See also section 3.1.4 for more about the Consumer Contracts (Information, Cancellation and Additional Charges) Regulations 2013.

[11] As a result they will not apply where the bidder is participating online in a public auction which is taking place in a physical saleroom.

As we have seen, the CCR require that in distance contracts where the seller is a trader and the buyer is an EU consumer, certain information must be provided, and that the successful bidder should have a right of cancellation of the sale.

7.1.3.2.1 Distance contracts: information to be provided

The website through which the online sale is taking place must provide certain information, including:

- the name of the business conducting the auction, its contact details and its address;
- a description of the property being offered for sale;
- details of how the price payable by the successful bidder is to be calculated, including all taxes;
- billing details and how a successful bidder can pay;
- delivery arrangements, costs and how long goods will take to arrive;
- how successful bidders can cancel and when they lose the right to cancel;
- what costs will be payable by the successful bidder who opts to cancel;
- a standard cancellation form, if they can cancel;
- details of any deposit or financial guarantees required from bidders;
- the cost of using phone lines or other communication to complete the contract, where it will cost more than the basic rate.

It is a requirement that the information must be provided in language and format that is easy to understand – either on paper or in an email in a format that can be saved for future use.

7.1.3.2.2 Distance contracts: cancellation rights

Bidders in online sales must be informed that if the seller is a trader and if they are an EU consumer they have a 14-day period after their order is delivered in which they can opt to cancel the sale without needing to provide a reason for cancelling.

Failure to inform the buyer of the right of cancellation will result in the buyer automatically having the right to cancel at any time at any time in the next 12 months. If during that extended period the buyer is belatedly informed of the cancellation right, they will have the right to cancel for 14 days thereafter. It is important to note, however, that under reg 19 CCR it is a criminal offence not to inform the buyer of the right to cancel, and a failure to do so can result in a fine.

A buyer wishing to cancel under the provisions of the CCR is required to notify the buyer of the intention to cancel the sale, and to return the purchase price, including the costs paid by the buyer for shipping, within 14 days of the goods being returned. If the auction conditions of sale provided that the costs of return shipping in the event of cancellation are to be covered by the buyer, then these must be paid by the buyer.

There are a number of practical issues which arise as a result of the regulations. The most fundamental of these is that it could be argued that a right of cancellation of this kind is at odds with the underlying philosophy of an auction. The point of an auction, and the reason for its efficiency, is that bids are irrevocable. Allowing buyers to cancel sales due to buyer's remorse could be argued to undermine the premise of an auction – and may be very detrimental to the seller.

The lengthy cancellation period opens up the possibility of a buyer making use of the purchased object for 14 days and then cancelling. This is a very real possibility where items such as jewellery or watches are concerned.

A further practical issue for sellers is to determine precisely when the cancellation period starts. The seller will know when the goods have been despatched, but it is not always easy to be able to say with certainty when the seller received the goods, triggering the start of the cancellation period. This is important because the online auctioneer needs to know when the cancellation period has ended, allowing the purchase price paid by the buyer to be safely released to the seller.

7.2 Sale location, applicable law and court jurisdiction

The fact that auction sales are increasingly taking place online raises complex questions of jurisdiction. Where has the sale actually taken place when it is organised by a London auction house, but the property being sold is located at the time of the sale in Luxembourg, the auctioneer is filmed conducting the sale in a TV studio in Geneva and bids are being taken on the telephone by staff in Hong Kong, London and New York?

The determination of applicable law and jurisdiction is a notoriously technical and complex area of the law, and each legal system has its own approach. This issue is covered in more detail in Chapter 15. For the purposes of this chapter it is perhaps sufficient to observe that online auctions will usually be covered by conditions of sale which will designate the applicable law and the court which is competent to hear disputes arising out of the online auction. Such clauses will generally be binding upon the parties. In consumer transactions, however, the consumer may in some cases have the ability to insist upon either suing or being sued in the courts and under the law of his or her country of domicile.

8 Auctions: negotiating agency agreements

8.1 Introduction

It can be difficult for a lawyer or seller presented with an auction house agency agreement to decide how to approach the negotiation. There is of course no right or wrong way, and each negotiation will be different. However, below are some thoughts and some advice which may be helpful.

The extent to which agency agreements are negotiable will depend upon the value of the consignment. If the property to be sold is desirable and there is competition between auction houses to secure the consignment, there will usually be a willingness to adapt the terms of the agreement to suit the seller.

Some consignors may ask themselves the question: do I need to negotiate the agreement at all? That decision is for the consignor to make. However, it is important to remember that, while they may be detailed and long, auction agency agreements are not designed or intended to be traps for the unwary. Even with agreements in their most standard unnegotiated form, sellers are unlikely to experience anything other than a smooth sale. Indeed, the standard agency agreement is designed to ensure a straightforward process by bringing certainty to situations where there might otherwise be ambiguity. There is, understandably, an instinct on the part of consignors to refer the agreement to a lawyer for review and negotiation. This is particularly the case with higher value consignments. The intervention of a lawyer will undoubtedly push the legal risks further towards the auction house, make the agreement more bespoke and provide peace of mind. However, it is also worth saying that, in my personal experience, there is usually little difference between the experience of a consignor on standard terms and that of a consignor whose agreement has been heavily negotiated.

If the decision has been taken to negotiate the agreement, a good negotiator will tend to take a 'less is more' approach. An effective negotiator will focus upon the issues which matter most. With that in mind, the following are the areas of the contract which may be worthy of attention.

8.2 Timing of the sale

Auction agency agreements will often commit to a date for the sale but have language which gives the auction house a wide discretion to move the date. This is not as alarming as it might at first appear. The clause is usually included in order to provide the auction house with some flexibility should events outside of its control result in the need to postpone or reschedule the sale. If this is a concern for the seller, the way to deal with it is to give the auction house the right to postpone, but, in the event that it exercises that right, or in the event that the postponement exceeds a certain timeframe, give the seller the right to withdraw the lot without penalty.

8.3 Marketing of the sale

Standard auction agency agreements will give the auction house absolute discretion in relation to how it goes about publicising the auction and the sale of the lot being consigned. This should not be problematic from the point of view of the seller. After all, auction houses have an interest in promoting their sales and presenting the lots in the sales in the most attractive way possible. However, it is also true that where major works are being consigned for sale, the auction house will often make specific marketing commitments – such as tours, exhibitions, dedicated promotional materials or advertising – in order to secure the consignment. Some sellers prefer to have those commitments enshrined in the agency agreement. Auction houses can be reluctant to do this where marketing commitments are dependent on external events, newspaper print deadlines or third parties. One way of addressing this concern is to include the marketing commitments but make them subject to events outside the control of the auction house.

8.4 Seller's warranties

At the core of the seller's agency agreement are the warranties provided by the seller in relation to the property being consigned. These will typically include warranties that the seller is the owner of the property and has the right to sell the property, that the property will be free of encumbrances and claims and that the property has been legally exported. Sellers will find it difficult to persuade the auction house to alter or qualify these clauses because these are crucial warranties which buyers expect when they purchase artworks at auction. The auction house cannot itself provide the warranties because they relate to matters which are not within the scope of knowledge of the auction house. The auction house therefore needs to rely upon the seller for their veracity. The question of ownership is a good example. Ownership can be acquired in a number of ways – sale, gift, donation,

exchange, inheritance. The effectiveness of the transfer of ownership which has happened in the past is a legal question which depends on the particular circumstances of the transaction and the law. The auction house is not in a position to assess those issues and therefore has to rely on the seller to provide a warranty, which is passed on to the buyer, that the seller is the true owner and has the right to sell the artwork. If the seller is unwilling to provide an unqualified warranty then the auction house cannot safely provide a matching warranty to the buyer.

8.5 Catalogue description

Auction agency agreements generally give the auction house wide discretion in relation to the drafting of the catalogue entry in which the artwork is described and any condition report or sale room announcement made in relation to the artwork. Instinctively, many sellers are nervous about this and often request a right of prior approval. Auction houses are reluctant to agree to such arrangements because the description of the artworks in the auction catalogue is an exercise of its professional judgement. Accuracy is crucial and, just as a lawyer would be rightly reluctant to allow a client to edit his or her legal advice, so too are auction houses nervous of sellers intervening in the cataloguing process. A compromise is often achieved by giving the seller the right of prior consultation rather than the right of prior approval.

8.6 Loss and damage to the artwork

Auction houses will always have blanket insurance policies in place to cover the artworks they handle. The auction agency agreement will contain provisions confirming this, and/or that the auction house will be liable to the seller for any damage to the artwork while it is in the hands of the auction house or its shippers. Some aspects of these provisions can sometimes be negotiated. Some sellers of valuable lots may request the comfort of a certificate from the auction house's insurer confirming that their artwork is covered. In addition, some standard agreements provide insurance cover for loss and damage up to the auction house's low or mid estimate. Sellers are sometimes able to secure cover up to the high estimate. As with any insurance cover, some types of loss and damage will be excluded. Some of the most common exclusions are changes in atmospheric conditions, war and terrorism. Sometimes these exclusions can be negotiated, although the auction house's ability to do so is often restricted by the exclusions under its own insurance policy. An important point for sellers to be aware of is that most claims under this clause do not arise from a total loss, where the artwork is completely destroyed or lost. The most common scenario is where the damage can be repaired. The question then to be determined is what loss the seller has suffered. This will be

quantified through a loss adjuster assessing the difference in value between the undamaged artwork and the artwork in its repaired state.

8.7 Aftersales

Most auction agency agreements include a provision which allows the auction house to offer artworks which are unsold at auction for private sale in the immediate aftermath of the auction. This should not be objectionable to the seller, provided that the agreement puts in place some limits on that right. Typically the auction house will agree not to sell the artwork privately unless the seller receives the same amount of money he or she would have received had the artwork sold at auction for the reserve. Another approach is to require that any such private sale should be subject to the prior agreement of the seller.

8.8 Payment

As we have seen, auction houses do not usually guarantee payment. In other words, the seller is paid by the auction house but only if and when the buyer pays for the artwork. There is sometimes some scope for negotiation of the timeframe of payments, but generally the auction house will not provide a guarantee of payment.

Sellers are often concerned to ensure that where a buyer is slow in making payment or fails to make payment at all, the auction house will pursue the buyer with vigour to recover the purchase price. As auction agency agreements usually do not contain provisions specifying what particular measures will be taken by the auction house in the event of nonpayment, sellers often seek to obtain commitments in advance from the auction house in this regard. For instance, the seller may seek a commitment that if payment is more than a certain number of days late the auction house will sue the defaulting buyer and/or cancel the sale. Such mandatory provisions are usually not helpful as each case of nonpayment is different and individual buyers react in different ways to different types of pressure. In some cases the chances of recovering payment are highly dependent on the approach which is taken. There are, sadly, some situations where there is no realistic prospect of recovering the money, whereas in others there is a prospect of payment but patience and a strategic approach are required. Judgement and discussion are also required. The best approach is therefore to include a provision which commits the auction house to regular and meaningful consultation with the seller in the event of nonpayment.

8.9 Withdrawal

Auction agency agreements usually permit the seller's withdrawal of the artwork from the auction in only very limited circumstances. This is because auction houses invest a great deal of time and resources in advertising the artwork and preparing the sale catalogue. The withdrawal of lots from a sale means wasted expenditure, lost income and disruption to the flow of the auction. Therefore the auction agency agreement will usually permit withdrawal by the seller only with the permission of the auction house and, even where permission is granted, the seller will be required to pay the auction house a withdrawal fee to compensate the auction house for its out of pocket expenses and lost profit. Sometimes auction houses are prepared to negotiate over these clauses but they will always insist upon a cost for withdrawal in order to ensure that the work cannot be withdrawn from sale in order to be sold privately or consigned to a competitor.

8.10 Cancellation of the sale

Auction houses always preserve the right to cancel sales of artworks which prove to have problems with authenticity or ownership, or where there has been a breach of any other warranty in relation to the property. Sellers, on the other hand, are naturally concerned to ensure that such rights of cancellation cannot be exercised arbitrarily, and therefore there is often a discussion to be had about the circumstances in which the cancellation right can be exercised. This is particularly important to sellers because the cancellation of the sale will necessitate the seller's return of the proceeds of sale. Some sellers question why, if the sale is cancelled due to authenticity, the seller – rather than the auction house – should be required to return the purchase price. After all, they argue, it is the auction house which held the artwork out to be authentic. The answer is that where the sale is cancelled due to a fundamental flaw in the artwork, the parties must be placed in the position they were in before the sale. The work must be returned to the seller, the seller must return the proceeds of sale and the auction house must return the premium and commission it received in relation to the sale. If the auction house has made a mistake and if that has caused the seller loss then that is a separate matter to be resolved between the seller and the auction house.

9 Private sales of art

9.1 Introduction

When we think of the sale and purchase of art there is a tendency to think of auction sales. In fact, most art sales are transacted privately and not by auction. A private sale is a sale between a buyer and a seller in which the artwork changes hands for an agreed price. Such transactions take place either directly between buyer and seller or through an agent. They are attractive to buyers and sellers for a number of reasons.

Buyers like private sale agreements because they do not have to compete with others to buy the work and the transaction is conducted discreetly out of public view. Sellers also like the discretion of private sale agreements. The main benefit to the seller, however, is the ability to put a price on the exclusivity sought by buyers. Unlike an auction, where the sale price is determined by competing bidders, the private sale price is not tested in the market and is instead determined by the seller's asking price and what the buyer is prepared to pay. This is why, when an object is rare and the buyer is prepared to pay for the rarity of the opportunity, private sale prices can often be higher than the price that would have been achieved at auction.

Private sales used to be the preserve of dealers, who would purchase works of art at auction, clean and restore them, and then offer the work to their clients, usually at a markup. Dealers would also take artworks on commission from the owner of the artwork, offering to find a buyer for the artwork.[1] Dealers no longer enjoy exclusivity in this regard, as auction houses have begun to offer their clients private sale services. Auction houses are well placed to provide these services because of the unrivalled intelligence they hold on their clients, their collections and the whereabouts of artworks throughout the world. This intelligence has been gathered by the houses' specialists and valuation departments over hundreds of years and enables the auction house to match buyers and sellers.

[1] We will cover the role of dealers in more detail in section 9.8.

Auctions and private sales are very different means of selling artworks but they share many of the same fundamental considerations. In particular, the legal position when considering issues of authenticity, attribution and title is very similar to the legal position where sales by auction are concerned. This chapter will therefore tend to focus upon aspects where private sales differ from auction sales or where there are special considerations which apply to private sales.

9.2 Structure and negotiation of a private sale agreement between buyer and seller

Private sale agreements concluded directly between the buyer and seller can be very simple documents. They are often short agreements; they may also take the form of standard terms and conditions printed on the back of an invoice from the seller or the seller's agent. Typically they will incorporate the following.

9.2.1 Parties

Where the sale is being concluded directly between the buyer and seller, the only parties to the agreement will be the buyer and the seller. Where the seller is represented by an agent the parties to the agreement will be the agent and the buyer, with the agent contracting on behalf of his or her principal, the seller. In such circumstances, while the contract will state that the agent is acting on behalf of the seller, often the seller is not named. The buyer may also be represented by an agent in the same way as the seller.

9.2.2 Price

The contract will set out the price that the buyer will pay for the artwork. Where the sale is directly between the buyer and the seller there will be no commission arrangements, so the price paid by the buyer is the amount the seller receives.

Where an agent is involved, a commission will usually be payable to the agent. Where the commission is charged to the buyer the price charged to the buyer can be expressed as a price inclusive of commission and VAT or it can be separated into the price, the agent's commission and any applicable VAT.

The contract will usually set out when the price is payable. Sometimes the price is payable in instalments. Where this happens it is also advisable to make some provision in the agreement for what happens in the event that the buyer pays some but not all of the instalments. Are the part payments nonrefundable, or are they refundable? In what circumstances?

Great care should be taken in private sale agreements over VAT, in particular import VAT. (See sections 11.9 and 11.10 on VAT.) When negotiating the price, careful account needs to be taken of any VAT which may apply as this can significantly affect the price payable by the buyer and/or the proceeds of sale received by the sellers.

9.2.3 Warranties

The contract will include warranties given to the buyer about the property.[2] A warranty is a contractual guarantee relating to an essential element of the artwork. These are typically aspects of the work or its history which the buyer is not able to investigate as part of his or her due diligence or which are so fundamental to the buyer's enjoyment of the artwork that they must be the subject of an explicit guarantee from the seller. The warranties are, from a legal perspective, the most important part of the sale agreement. A seller who breaches a warranty may be liable to damages for breach of warranty and/or cancellation of the sale agreement.

The most common warranty is a statement that the seller is the owner of the artwork and has the right to sell it. Warranties may however be given in relation to other aspects of the artwork. For instance warranties may be provided in relation to authenticity, condition, restoration work or compliance with export licensing requirements.

Unlike in auction sales, where artworks are sold on nonnegotiable standard terms, in private sale agreements warranties may be negotiated. Which warranties are included and the wording of the warranties are frequently a matter for negotiation between the parties. Even once the subject matter for the warranties has been agreed, there are often negotiations over their drafting. For instance, sellers will often seek to limit their effect by preceding the warranty with words like 'to the best of the seller's knowledge'. Buyers, conversely, will wish the warranty to be given in absolute terms.

9.2.4 Disclaimers of warranty

Just as it is important to be clear about what aspects of the artwork are warranted or guaranteed, it is also important to be clear about what is not warranted. This is for two reasons: first, because in the absence of a disclaimer, the law will imply terms into the contract of sale; second, because there will usually have been many conversations in the run-up to the contract.

[2] See also Chapters 3–8.

These may typically include statements of opinion, statements of belief or statements of fact. The buyer and seller should be clear about what statements – known as representations – the buyer is entitled to rely upon, and which representations are not intended to be relied upon. This is important because if a representation turns out to be incorrect it may allow the buyer to cancel the sale and claim damages on the grounds that he or she relied on the representation in deciding to purchase the artwork or to purchase it at the price and on the terms that he or she did. Achieving clarity on this point is done in two ways. First, the contract may make it clear that the seller gives no warranties and makes no representations other than as expressly set out in the contract of sale. Second, contracts often have a 'whole agreement' clause which makes it clear that this contract constitutes the entire agreement between the parties and there are no other understandings or agreements.

9.2.5 Condition

The seller will want as far as possible to place the onus upon the buyer to inspect the artwork. The contract may therefore often include a provision acknowledging that the buyer has inspected the artwork and has satisfied him or herself as to its condition, and/or that the buyer acknowledges that he or she is purchasing the artwork 'as is', that is, in whatever condition it is in at the time of the sale.

9.2.6 Passing of title

It is open to the parties to the agreement to determine at what point in time the buyer will become the owner of the property. Usually the contract will provide that ownership or title will not pass to the buyer until the price has been paid in full. It is possible to agree that ownership will pass at an earlier stage, but this carries risk for a seller, who will have parted with ownership of his or her artwork without having received full payment for it. That is a much weaker position than the seller who has not received full payment but nonetheless remains the owner of the artwork. If there is no provision in the contract concerning the passing of title, then title will be deemed to have passed at the time the contract is concluded between the parties.

9.2.7 Release of the artwork to the buyer

The contract will usually provide that the artwork will be released to the buyer only once payment in full has been received. It is possible to agree otherwise, so that the buyer is able to take possession of the artwork on making a part payment, but that is a risk for the seller. If the buyer then fails to pay the balance of the purchase price, the seller will be in a weaker position than if he or she had retained possession of the artwork.

9.2.8 Transfer of risk

It is also important that the contract should be clear about the precise point at which any loss or damage to the artwork transfers from the seller to the buyer.

9.2.9 Authenticity

Private sale contracts should be clear about what guarantees, if any, are provided in relation to the authenticity of the artwork. It is not usual to see contracts in which the seller provides no guarantee of authenticity. Equally, the contract may in some cases provide a guarantee which is limited in time. For instance, the buyer may be given a right to a refund if, at any time in the five years following the sale, he is able to demonstrate that the artwork is not by the artist and/or of the period.

9.2.10 Confidentiality

Because one of the advantages of private sales is discretion, such contracts will typically also have a confidentiality provision in which the parties agree to keep the transaction confidential.

9.2.11 Disputes

The contract will also state which court or arbitration body has jurisdiction to hear any disputes between the parties, and often includes a requirement that the parties enter into mediation before resorting to court action.

It is also important to state what law will govern the contract in the event of a dispute. The choice of law can be important, as different legal systems approach issues around ownership and authenticity very differently.

9.3 Structure and negotiation of private sale agreements using agents

A contract using an agent as an intermediary brings a little more complexity to the structure. In this case there will, before the contract of sale comes into being, be a separate agreement between the principal and the agent, authorising the agent to act on the principal's behalf and setting out the parameters and limits of the agent's authority. The agent will then be authorised to conclude a contract for the sale of the artwork on behalf of his or her principal. In some sale contracts only one party will be represented by an agent (typically the seller), but sometimes both buyer and seller instruct agents to act on their behalf.

The agreement between the seller and the agent will need to cover the following issues.

9.3.1 Purpose of the appointment

The agreement must make clear what it is that the agent is being instructed to do on behalf of the seller. Usually the agent's mission will be to sell an artwork or group of artworks privately.

9.3.2 The artworks to be sold

The artworks or artwork to be sold should be clearly described and identified by name, authorship, date, dimensions and ownership history so that there is no ambiguity.

9.3.3 Exclusivity

Is the agent the only agent being appointed to sell the artwork or is the seller reserving the right to appoint other persons to sell the artwork? If it is the former, then the agreement should state that the agent is being appointed as the exclusive agent. If it is the latter, the appointment should be characterised as nonexclusive.

Exclusive appointments are usually preferable, because they avoid the danger of confusion where a buyer has been identified but there is then an argument between agents over who identified the buyer. They also ensure that the artwork is not offered to potential buyers multiple times by different agents.

The agent will also want to make sure that the seller does not confuse or derail the sale process by offering the work for sale or entertaining offers for the artwork in parallel with the agent's efforts to sell the artwork. A clause will therefore usually be added in which the seller undertakes not to offer the work for sale him- or herself, and agrees to refer any unsolicited offers received to the agent.

9.3.4 Term

The parties will usually want to define a limited time period for the appointment. This ensures that the agent is under time pressure to sell the artwork and that the appointment comes to an end if the agent is unsuccessful in selling the work.

While the term of the appointment is a matter for negotiation, care needs to be taken in being clear about what needs to have been achieved during that time. Does the sale need to be completed, with payment made, within the term? Or does the agent merely need to have secured an offer which has been accepted by the time the term has expired?

In addition, the agent will want to include wording to ensure that he or she is not cut out of a transaction in the event that the seller concludes an agreement after the expiry of the term with a buyer introduced by the agent.

9.3.5 Price

Fundamental to any private sale agreement is the minimum price which the seller is prepared to accept. At the start of the process the seller will usually have a certain expectation in terms of price. The agent will aim for that price but will need to know how much flexibility he or she has around that price, and will need to know at what point he or she is authorised to conclude a sale. The buyer will also expect to be able to negotiate over the price.

There are various structures used to accommodate these requirements. The easiest, but most inflexible, is a fixed price structure where the agent is authorised to conclude a sale with a buyer at one price only unless otherwise agreed in writing with the seller. This gives the seller maximum control but has the disadvantage that the agent has no ability to negotiate over the price or conclude a sale other than if an offer is received at the price agreed with the seller. To overcome this, a slightly more flexible variation is where the contract states the price at which the agent shall offer the artwork for sale, but permits the agent to agree a lesser price down to a minimum price stipulated in the contract.

9.3.6 Agent's commission

As we have seen in section 3.1.1, 'Fiduciary duties', the agent owes his or her principal a duty of utmost good faith, known as a fiduciary duty. A key aspect of such a duty is that the agent must be transparent about the commission he or she is charging, and may not make what is known as a secret profit. As a result, the commission structure should be clearly set out in the agreement.

The most straightforward structure is one which states that the agent shall deduct and retain from the price paid by the buyer a predefined percentage of the price as a commission. The difficulty with this structure from the point of view of the seller is that the commission percentage will be the same whatever the price agreed with the buyer turns out to be. It could be said that the agent has a greater incentive to conclude a quick sale at a reasonable price than to push and hold out for a higher price. This is addressed in another commission structure commonly used in the art market, known as the 'net to you' structure. In this arrangement the seller and the agent agree the minimum net amount that the seller is prepared to receive in proceeds of sale from a sale of the artwork. This figure – the 'net to you' figure – is usually at the top end of the seller's expectations. The agent is then permitted to keep as a commission any excess over that minimum figure. The argument is that this incentivises the agent to seek a price which exceeds the seller's expectations

and to negotiate hard over that excess, as it represents the agent's commission. Where this construct is used sellers often require some protection in place in the contract to ensure that the commission retained is not excessive. They may therefore insist on a percentage cap to the commission the agent is able to retain – even if he or she is able to significantly exceed the minimum 'net to you' figure.

It is wise for sellers to include in the agreement a warranty from the agent that he or she shall not accept any commission other than as set out in the agreement. This ensures that the agent is not able to take two commissions on the same transaction – one from the seller and the other from the buyer.

9.3.7 Sale charges

It may be envisaged that the agent will incur out of pocket expenses in connection with the sale, for such matters as insurance, storage, restoration, shipping or authentication. The contract may provide that these costs shall be borne by the seller or by the agent.

9.3.8 Payment

Where the seller is represented by an agent, payment of the price is generally made by the buyer to the agent. In such circumstances the contract will usually provide that once payment is received by the agent, the agent will pay the proceeds of sale to the seller within a prescribed time period. Agents should be careful to make it clear that they will only be under an obligation to pay the seller if they have in turn been paid by the buyer. In this way the agent ensures that he or she is not liable if the buyer fails to pay.

9.3.9 Warranties

The agreement between the seller and his or her agent will also typically set out which warranties or guarantees the agent is authorised to give, on the seller's behalf, to the buyer. The agent needs to ensure that in the contract of sale which he or she eventually concludes with the buyer, he or she does not give the buyer warranties which he or she has not been expressly authorised by the seller to give. If he or she does, the agent will be liable to the seller if the seller is subsequently sued by the buyer on the basis of a warranty that the agent was not authorised by the seller to give.

Typically, the key warranties in a private sale of the artwork will be (see also section 3.2 onwards):

* that the seller is the legal owner of the artwork and has the right to sell;
* that the artwork is not subject to any liens, mortgages or charges;

- that the sale will transfer ownership to the buyer, free of any claims by third parties;
- that the seller has complied with all import and export requirements relating to the artwork;
- that the seller has disclosed all relevant information about the artwork's history, authenticity and condition.

Where the seller is not the owner of the work and is acting on behalf of the owner, the agent should be cautious to ensure that the owner is aware of and consents to the arrangements. One way of doing this is through the use of some additional warranties from the seller, as follows:

- that the seller has the permission of the owner to sell;
- that the seller is authorised to receive the proceeds of sale;
- that the owner is aware that the agent is being appointed and will be charging a commission;
- that if the seller is going to deduct a further commission from the proceeds of sale this will be disclosed to the owner;
- that the seller has conducted anti-money laundering due diligence into the owner and has obtained all appropriate 'know your client' evidence.

Other warranties may well be required depending on the circumstances or the negotiations of the parties.

9.3.10 Physical possession

It is always advisable for the agent to take physical possession of the artwork being sold. This ensures that the agent has control of which potential buyers the artwork is being shown to and guarantees that the artwork will be released when the buyer pays.

9.3.11 Insurance

If the agent is to have possession and control of the artwork, the contract should be clear about the insurance arrangements in place should the artwork be lost, stolen or damaged. Beware of being too vague about insurance cover. The maximum extent of cover should be clearly stated. Every insurance policy will also have exclusions and limits, and these should be identified in the contract to ensure that they are binding on the seller.

9.3.12 Transfer of ownership and risk

The contract should be clear about the agent's instructions in connection with the precise point at which ownership is to pass to the buyer under any contract of sale he or she concludes with the buyer. As we have said above, this will usually

be upon receipt of payment in full. The transfer of risk, being the moment the buyer becomes responsible for any loss of or damage to the artwork, should also be specified in the agreement. This will usually occur upon transfer of ownership and/or upon the buyer taking possession of the artwork. Particular care should be taken where shippers and packers are involved, to make it clear whether the transfer of risk happens at the moment of packing and collection or on delivery and unpacking.

9.3.13 Confidentiality

One of the reasons that the seller will appoint an agent to sell an artwork is to maintain confidentiality. As a result, just as with the sale contract, this agreement will usually also have a confidentiality provision in which the parties agree to keep the transaction confidential.

9.3.14 Disputes

As with the sale contract, the contract between the agent and the seller should also state which court or arbitration body has jurisdiction to hear any disputes between the parties and may include a requirement that the parties enter into mediation before resorting to court action. The governing law in the event of a dispute should also be stated.

9.4 Implied terms in private sales

In Chapter 3 we covered the rights and liabilities implied into auction sales contracts by the Sale of Goods Act 1979, the Supply of Goods and Services Act 1982, and the Consumer Rights Act 2015 (see section 3.2.2.2, 'Terms implied by law'). Because auctions tend to fall outside of the ambit of the Consumer Rights Act 2015, we saw that they tend to be regulated by the Sale of Goods Act 1979 whether or not they involve a consumer. Private sales, on the other hand, will – where they involve a consumer – tend to be regulated by the Consumer Rights Act 2015. Where they do not, they will usually be regulated by the Sale of Goods Act 1979.

9.4.1 Correspondence with description

A private sale of an artwork – just like a sale at auction – is a sale of goods by description. The sale contract will be on the basis of a description of the artwork which is the subject of the sale. Section 11(1) of the Consumer Rights Act 2015 and s 13(1) of the Sale of Goods Act 1979 both imply a term that an object such as an artwork sold by description will correspond with the description.

However, as with auctions, the right to cancel on grounds of noncorrespondence with description will not exist where the parties did not intend the purchaser to rely on the description. This may be the case where the buyer has not, as a matter of fact, relied on the description of the artwork. Also, where the terms and conditions of the sale specifically limit or exclude the extent to which the description can be relied upon by the buyer, the buyer may not be entitled to reject the work. However, any such terms will be subject, in consumer contracts, to the requirement of 'fairness' in s 62(1) of the Consumer Rights Act 2015 or 'reasonableness' in ss 2(1) and 8(1) of the Unfair Contract Terms Act 1977.

9.4.2 Satisfactory quality

We have seen that where goods are sold or supplied in the course of a business there is an implied term that the goods supplied under the contract are of 'satisfactory quality' (Consumer Rights Act 2015, s 9, Sale of Goods Act 1979, s 14(2), substituted by the Supply of Goods and Services Act 1994, s 1(1)).

Under s 9 of the Consumer Rights Act 2015, goods in sales to consumers are deemed to be of satisfactory quality if, objectively, they meet the standard that a reasonable person would regard as satisfactory, taking account of any description of the goods, the price, if relevant and all other relevant circumstances. This will include considerations such as whether or not the goods are fit for the purpose for which goods of the kind in question are commonly supplied, appearance and finish, freedom from minor defects, safety, durability and – if the buyer is a consumer – any public statement made in the advertising or labelling of the goods.

The Sale of Goods Act 1979 sets out similar requirements for sales to nonconsumers in s 14(2).

However, a buyer is unable to rely on these provisions in relation to any aspect of the goods:

- which was specifically drawn to the consumer's attention before the contract was made;
- where the buyer examines the goods before the contract is made, which that examination ought to reveal (Sale of Goods Act 1979, s 14(2C)(a) and (b); Consumer Rights Act 2015, s 9(4)).

9.4.3 Title, quiet possession and freedom from charges

The Sale of Goods Act 1979, s 12(5A) implies a term for nonconsumer sales on the part of the seller that in the case of a sale he or she has a right to sell the goods, and in the case of an agreement to sell he or she will have such a right at the time when the property is to pass.

The Consumer Rights Act 2015 provides that in a sale to a consumer by a trader, the trader must have the right to sell or transfer the goods at the time when ownership of the goods is to be transferred.

Both the Sale of Goods Act 1979 (s 12(5)) and the Consumer Rights Act 2015 (s 17(4)), however, make it clear that the implied term as to title will not apply – or will be limited – where the contract makes it clear that the seller is only transferring such title as he or she may have at the time of the sale.

It is rare that a buyer will be required to rely upon these provisions as in most cases the contract of sale will contain a warranty from the seller that he or she is the owner and/or that he has the right to sell the artwork, and that the work will be free of charges or claims by third parties (see above).

9.5 Exclusions and limits on liability in private sales agreements

We have now established what terms will usually be either expressly or impliedly incorporated in the agency agreement and the conditions of sale. In many cases, however, these agreements will seek to limit or exclude liability for breach of those implied or express terms. The validity of such provisions will depend upon whether or not they comply with the various statutory laws designed to protect consumers against unfair contract terms.

9.5.1 Exclusions and limitation of liability in the conditions of sale

The fairness of the contractual limits or exclusions in a private sale contract with a nonconsumer will be determined by reference to the Unfair Contract Terms Act 1977 (UCTA) and, for sales between a consumer and a trader, the Consumer Rights Act 2015.

9.5.1.1 Unfair terms and notices in consumer sales

The Consumer Rights Act 2015 provides in s 62(1) that an unfair term of a consumer contract or a consumer notice is not binding on the consumer. Section 62(4) of the Act defines an unfair term or notice as a term or notice which, contrary to the requirement of good faith, causes a significant imbalance in the parties' rights and obligations under the contract to the detriment of the consumer. Section 62(5) provides that fairness is to be determined, 'taking into account the nature of the subject matter of the contract, and ... by reference to all the circumstances existing when the term was agreed and to all of the other terms of the contract or of any other contract on which it depends'.

It is important to note, however, that under s 64(1)(a) the fairness test does not apply to terms which specify the main subject matter of the contract, provided that (s 64(2)) the term is transparent and prominent. 'Prominent' means presented in such a way that an average consumer would be aware of the term. The average consumer is defined (s 64(5)) as a consumer who is reasonably well informed, observant and circumspect. So terms relating, for instance, to the description of the artwork or the price must not be hidden in any small print, otherwise these terms are liable to be assessed for 'fairness'.

Part 1 of Schedule 2 to the Consumer Rights Act 2015 provides, for guidance, a nonexhaustive list of the types of terms which are likely to be deemed to be unfair.

Many of the examples given in Part 1 of Schedule 2 are unlikely to be relevant to a sale of artworks. The most relevant are:

> A term which has the object or effect of inappropriately excluding or limiting the legal rights of the consumer in relation to the trader or another party in the event of total or partial non-performance or inadequate performance by the trader of any of the contractual obligations.
> A term which has the object or effect of irrevocably binding the consumer to terms with which the consumer has had no real opportunity of becoming acquainted before the conclusion of the contract.
> A term which has the object or effect of excluding or hindering the consumer's right to take legal action or exercise any other legal remedy, in particular by—
> (a) requiring the consumer to take disputes exclusively to arbitration not covered by legal provisions,
> (b) unduly restricting the evidence available to the consumer, or
> (c) imposing on the consumer a burden of proof which, according to the applicable law, should lie with another party to the contract.

In addition to the requirement that terms in consumer contracts be fair, s 68 of the Consumer Rights Act 2015 imposes a requirement that the contract or notice be transparent. This means it should be in plain and intelligible language, and must be legible.

With this in mind, where exclusions and limitations of liability are intended to be relied on in a private sale agreement from a trader to a consumer, they should avoid 'legalese', reference to legal statutes, complex definitions and crossreferences. Plain English should be used, using short sentences and headings for each section. Any terms that could have a disadvantageous impact on the consumer should not be hidden away in the small print; they should be prominent.

9.5.1.2 Unfair terms under the Unfair Contract Terms Act 1977

On exclusion or restriction of liability for negligence, s 2(1) UCTA provides that, in nonconsumer contracts, a person cannot by reference to any contract term or to a notice exclude or restrict his liability (i) for death or personal injury resulting from negligence or (ii) for any other loss or damage resulting from negligence except in so far as the term or notice satisfies the requirement of reasonableness.

On exclusion or restriction of liability for misrepresentation, if a contract contains a term which would exclude or restrict any liability for misrepresentation made before the contract was made, or any remedy available to another party to the contract for misrepresentation, that term shall be of no effect except in so far as it satisfies the requirement of reasonableness (s 8(1) UCTA).

Guidance on reasonableness is provided by the nonexhaustive guidelines set out in UCTA Schedule 2, which states that regard must be had to:

- the strength of the bargaining positions of the parties relative to each other, taking into account (among other things) alternative means by which the customer's requirements could have been met;
- whether the customer received an inducement to agree to the term, or in accepting it had an opportunity of entering into a similar contract with other persons, but without having to accept a similar term;
- whether the customer knew or ought reasonably to have known of the existence and extent of the term (having regard, among other things, to any custom of the trade and any previous course of dealing between the parties);
- where the term excludes or restricts any relevant liability if some condition is not complied with, whether it was reasonable at the time of the contract to expect that compliance with that condition would be practicable.

On fraud and fraudulent misrepresentation, it is also a well-established principle of law that where a misrepresentation is fraudulent or the buyer is otherwise induced into the sale by fraud, no clause purporting to limit or exclude liability shall be valid: Thomas Witter Ltd v TBP Industries Ltd [1996] 2 All ER 573.

On restrictive covenants in private sale agreements, dealers and galleries representing artists are often concerned to maintain control over the pricing and value of the artist's work. Where works are sold exclusively through the dealer or gallery, that pricing can be controlled. The dealer sets the price and, by controlling the supply to maintain demand, ensures that this price level is maintained. However, once sold, the dealer or gallery is unable to control the price at which the artwork may be resold, either at auction or privately. If the resale price is made public – and is significantly lower than the artist's works on sale at the gallery or dealership – it makes it more difficult for the dealer or gallery to justify the price. As a result, dealers have sometimes sought to impose restrictions on the buyers of works

which prevent or restrict the buyer's ability to resell the artwork. Some sale contracts require any resale to be through the gallery or dealer, or to give the gallery or dealer first right of refusal to handle any such resale. Others impose a time limit on any resale or impose a prohibition on public sale by auction.

The extent to which these restrictions are enforceable depends on who the buyer is, and the reasonableness of the restriction.

Where the person buying from the dealer or gallery is a consumer as defined in s 2(3) of the Consumer Rights Act 2015,[3] to be binding on the consumer, the restriction must not be unfair. As we have seen, an unfair term or notice is a term or notice which, contrary to the requirement of good faith, causes a significant imbalance in the parties' rights and obligations under the contract to the detriment of the consumer (s 64(2) Consumer Rights Act 2015). With that in mind it seems likely that a term which seeks to severely restrict the consumer's right to resell the artwork and obtain full market value for it is likely to be deemed to be unfair.

Where the buyer is buying from the gallery or dealer in the course of a trade and is therefore not acting as a consumer, the likelihood is that such terms will be enforceable.

9.6 Consumer buyer cancellation rights

We saw in Chapter 7 that the Consumer Contract (Information, Cancellation and Additional Charges) Regulations 2013 (CCR) impose obligations where the buyer is a UK or EU consumer. While buyers at public auctions cannot avail themselves of those protections,[4] UK and EU consumer buyers in private sales of art from traders do benefit from CCR protection in two circumstances: (i) where the sale is a 'distance contract' in which the buyer and seller are not in each other's physical presence,[5] or (ii) where the sale is concluded 'off premises'.[6] In either of these two circumstances a UK or EU consumer buyer will be entitled to cancel the sale for any reason within 14 days of receipt of the artwork. This right applies regardless of where the trader they are contracting with is based.

3 'Consumer' for the purpose of the Consumer Rights Act 2015 means an individual acting for purposes that are wholly or mainly outside that individual's trade, business, craft or profession.

4 Consumer Contract (Information, Cancellation and Additional Charges) Regulations 2013, reg 28(g).

5 Consumer Contract (Information, Cancellation and Additional Charges) Regulations 2013, reg 28(g).

6 Consumer Contract (Information, Cancellation and Additional Charges) Regulations 2013, reg 28(g).

9.6.1 Definitions of consumers and traders

The CCR applies only to sales where the seller is a trader and the buyer is a UK or EU consumer. The first question is therefore to determine whether or not the buyer is a consumer and whether the seller is a trader for the purposes of the CCR.

A 'consumer' means 'an individual acting for purposes which are wholly or mainly outside that individual's trade, business, craft or profession' (reg 4 of the CCR). This means that, provided the purchase of art is not the buyer's sole or principal occupation, he or she will be a consumer. This is the case even where the buyer is experienced or a prolific collector of art, or if the buyer often buys and sells for profit.

Conversely, a 'trader' means a person acting for purposes relating to that person's trade, business, craft or profession, whether acting personally or through another person acting in the trader's name or on the trader's behalf (reg 4 of the CCR). In this case the person selling the artwork must be acting in the course of his or her trade, craft or profession but, unlike the consumer test, there is no requirement that this activity should be the trader's only business – or even his or her main business.

Having established that the sale is between a trader and a consumer, the next step is to determine whether the consumer has cancellation rights due to the sale either being a distance contract or an off-premises contract.

9.6.2 Cancellation rights in private sales of artworks by distance contract

The CCR define 'distance contract' as a contract concluded between a trader and a consumer under an organised distance sales or service provision scheme without the simultaneous physical presence of the trader and the consumer, with the exclusive use of one or more means of distance communication such as by phone, by post or over the internet, up to and including the time at which the contract is concluded.

As we saw earlier,[7] this provision appears to be intended to cover sales where there is a fixed process in which there is no physical contact between the consumer and the trader, involving template letters and forms sent out in sequence by post, telephone or internet leading to the conclusion of a binding agreement for services. To qualify as a distance contract the contract must also be *exclusively* negotiated and agreed by phone, by post or over the internet.

[7] See section 3.1.4.

With this in mind, the manner of the sale needs to be considered carefully in order to establish whether it qualifies as a distance sale and therefore allows the EU or UK consumer to cancel the sale. An artwork which can be viewed online and purchased by filling in an online order with payment details or a telephone transaction would seem to be covered by the CCR as a distance sale, as neither party are in each other's physical presence. However, if in between viewing the artwork online and purchasing it the buyer visited the trader's shop to view the artwork, that might well mean that the sale is not a distance contract and therefore falls outside of the ambit of the CCR.

9.6.3 Cancellation rights in private sales of artworks off-premises

Off-premises private sales of artworks also give rise to consumer cancellation rights under CCR (reg 5 of the CCR). Off-premises contracts are (i) contracts concluded in the physical presence of both the trader and the consumer, but not on the trader's premises; or (ii) where the consumer makes an offer to the trader to enter into an purchase contract, but not on the trader's premises; or (iii) where the consumer is approached by the trader outside the trader's premises and then the agreement is signed immediately thereafter on the trader's premises; or (iv) where the agreement is signed during an excursion organised by the trader with the aim of selling its services to the consumer.

Where a dealer has retail premises open by appointment or to passing trade, any transaction resulting from a visit to those premises by a consumer buyer is unlikely to be deemed to be an off-premises sale. However, dealers increasingly rely upon art fairs to sell their artworks and where sales are either agreed or concluded at the art fair they may be deemed to be off-premises contracts and therefore subject to a consumer cancellation right.

9.6.4 Information rights in consumer private sale contracts

The CCR also require certain information to be provided to consumers by the trader, depending on the nature of the contract.[8]

The information must be provided on paper or (with the consumer's agreement) on another durable medium. The information requirements are slightly different depending upon whether the contract is an on-premises contract or an off-premises contract. The information required is of a kind which would usually be expected to be provided in a private sale agreement and includes, in particular, the following:

[8] Schedules 1 and 2 of the Consumer Contracts (Information, Cancellation and Additional Charges) Regulations 2013.

(a) the main characteristics of the goods or services;
(b) the identity of the trader, his or her address and telephone number;
(c) the total price of the artwork inclusive of taxes;
(d) information relating to additional delivery charges;
(e) the arrangements and timing for payment, delivery, performance of the services;
(f) where applicable, the trader's complaint handling policy;
(g) where a right to cancel exists, the conditions, time limit and procedures for exercising that right;
(h) where applicable, that the consumer will have to bear the cost of returning the goods in case of cancellation;
(i) the existence and the conditions of any aftersales services and commercial guarantees.

Of these, the most important is the requirement to inform the consumer of his or her cancellation rights. A failure to do so is an offence under reg 19 CCR and operates under reg 31 CCR to automatically extend the buyer's right to cancel by up to 12 months after the date of the sale.

9.7 Agent's liability to the buyer and seller

In auction sales the auctioneer acts as agent for the seller. In private sales an agent can act either for the seller or the buyer. The obligations of an agent acting for the seller in a private sale transaction will be similar in many ways to those of the auctioneer acting for the seller in an auction. The agent will owe the seller a fiduciary obligation and is therefore precluded from acting for the buyer, as to do so would represent a conflict of interest. Where the agent is acting for the seller, the relationship will once again be of a fiduciary nature, and the agent cannot also act for the buyer.

As with the auction structure, the contract of sale is between the buyer and the seller. The agent is not liable on the contract of sale. However, an agent acting for a principal shall be deemed to give an implied warranty that he or she is empowered to act for his or her principal in connection with the sale. Where the agent acts outside of that authority – for example, by purporting to sell an artwork for less than he was permitted to sell it – the agent will be in breach of that warranty of authority, leaving him open to a claim for damages from the buyer.

It is also worth considering: where the agent acts outside the terms of his or her authority, is it open to the principal to challenge the validity of the sale? For instance, if the agent sells the principal's artwork for less than the price he or she was authorised to sell it for, is the sale binding on the principal? The answer depends upon whether the principal allowed the agent to appear to have authority

to sell on those terms. If the principal has deliberately or negligently allowed the agent to give the buyer the impression that he had the authority to conclude a sale on behalf of the seller on those terms, then the principal cannot then challenge the validity of the sale. This is known as the doctrine of 'apparent' or 'ostensible' authority. Ostensible authority was described by Denning J in Hely-Hutchinson v Brayhead Ltd [1967] 1 QB 549 as 'authority as it appears to others'. The case of Freeman & Lockyer (a Firm) v Buckhurst Park Properties (Mangal) Ltd and Another [1964] 2 QB 480; [1964] 2 WLR 618; [1964] 1 All ER 630, CA recognised that agents possess two types of authority: actual authority and apparent authority. Lord Diplock analysed the distinction between the two: 'Actual authority and apparent authority are quite independent of one another. Generally they co-exist and coincide but may exist without the other and their respective scope may be different.' He defined actual authority as 'a legal relationship between the principal and the agent created by consensual agreement to which they alone are parties'. Apparent or ostensible authority, however, is

> a legal relationship created between the principal and the contractor created by a representation, made by the principal to the third party, intended to be and in fact acted on by the third party, that the agent has the authority to enter on behalf of the principal into the contract of a kind writhing the scope of the apparent authority, so as to render the principal liable to perform any obligations imposed upon him by such contract.

Where there is a mismatch between the actual authority of the agent under the agency agreement with the seller and the agent's authority as it appears to the buyer, then, in order for the buyer to be able to rely on the agent's apparent authority and enforce the contract against the seller:

(i) the seller must have made a representation to the buyer that the agent had authority to enter into a contract on behalf of the seller of the type which the buyer is seeking to enforce. That representation can have been made by a written or oral statement or can have been implied through the seller's conduct or behaviour; and

(ii) the buyer must, relying on that representation, have been persuaded to enter into the contract.

Example

- A seller gives an artwork to a dealer with instructions to sell it for no less than £10,000. The agent therefore has actual authority to sell the work for no less than this amount. The seller allows the dealer to display the artwork in his gallery and offer it for sale to potential buyers. In permitting him to do so, the seller is giving the dealer apparent authority to sell on his behalf. Unless the seller or the agent communicates to potential buyers that the agent's authority

is limited in any way, then the agent's authority appears to others to be unlimited. If the agent then sells it to a buyer for £8,000 the seller cannot, having allowed the agent's authority to sell the artwork to appear to be unlimited, challenge the validity of the sale on the grounds that the agent exceeded his actual authority. Having, by his conduct, allowed the dealer to appear to the buyer as having that apparent authority, the law will not allow the seller to then prejudice the buyer by subsequently denying that authority. However, the position would be different if, prior to the sale, the buyer is aware or put on notice that the agent is not entitled to sell the work for less than £10,000. In that case the agent's apparent authority would be in line with his actual authority and the validity of the sale can be challenged by the seller if the sale took place outside the limits of the agent's authority.

Another situation which may arise is where the agent concludes a sale on the seller's behalf but fails to account to the seller for the proceeds of sale. In those circumstances, is the sale valid? Once again, if the agent had actual authority to sell the artwork or if the seller allowed the agent to have apparent or ostensible authority to sell the work, then the sale will be validly concluded when the buyer pays for the artwork. The buyer will be the owner of the artwork and the seller cannot avoid or cancel the sale on the grounds that the agent has not fulfilled his duties as agent to the seller. The seller's remedy is a claim against the agent for damages equal to the proceeds of sale of the artwork.

Where the agent in a private sale holds himself or herself out as being the seller or buyer, and does not reveal to the other party that he or she is in fact acting as agent for a third party, then the agent will be liable as if he or she was the principal (Saxon v Blake (1861) 29 Beav 438).

As in the case of auctions, where in the course of a sale of a specific artwork the agent reveals that he or she is acting as agent for the seller or buyer, but does not reveal the name of the seller or buyer, then it is unlikely that the agent will be liable under the contract of sale. However, in practice – as with auctions – the agent will tend to be sued in such cases because the other party does not usually know the identity of the principal. Suing the agent encourages the agent to reveal the identity of the principal and/or put pressure on the principal.

9.8 Transparency, secret commissions and the problems arising from subagency

It is not uncommon in the art market for an agent appointed by the seller to find a buyer for an artwork to enlist the help of other agents. Where this happens, and the subagent identifies a buyer, the subagent will want to be paid and the principal agent will also want to be remunerated for his or her part in the successful search.

This is an area of great danger for the agent and subagent, and one which must be navigated with care.

The agent and the subagent must ensure that the owner has full knowledge of the circumstances of the transaction, and in particular what deductions are made, and by whom, from the purchase price. If the owner is not aware of a commission or deduction, then that may render the commission a 'secret profit' (see section 3.1), which is a breach of fiduciary duty.

The issue of subagencies and secret profits was examined by the courts in the case of Accidia Foundation v Simon C. Dickinson Ltd. Accidia Foundation was the owner of an artwork by Leonardo da Vinci, Madonna and Child with St Anne and a Lamb. The foundation instructed the dealer Daniella Luxembourg to act as its exclusive agent to find a buyer for the painting. The arrangement was that Luxembourg would be entitled to charge a commission of 10% of the purchase price. Unknown to the foundation, Daniella Luxembourg engaged the dealer Simon Dickinson to assist in the search for a buyer. She agreed with Dickinson that if he was successful in finding a buyer he could keep, as a commission, any amount paid by the buyer in excess of US$6,000,000. Dickinson was successful and found a buyer who was prepared to pay US$7,000,000 for the painting. He therefore forwarded US$6,000,000 to Daniella Luxembourg and retained US$1,000,000 as a commission. Daniella Luxembourg in turn deducted US$500,000 as her commission and forwarded the remaining balance to Accidia Foundation. While she told Accidia Foundation of Dickinson's involvement (although it was suggested that he had acted as agent for the buyer), the foundation was left with the impression that the painting had been sold for US$6,000,000 and that the net proceeds of sale after deduction of the commission amounted to US$5,500,000. Later, the foundation discovered that the painting had in fact been sold for US$7,000,000 and therefore sued Dickinson. The basis for the foundation's claim was that Dickinson had in fact acted as the foundation's agent and that as such he owed the foundation a fiduciary duty. The retention of the US$1,000,000 was a secret profit and therefore a breach of that duty. The judge agreed and Dickinson was obliged to pay the US$1,000,000 to Accidia.

The lessons to be learned from this case are that agents and subagents must ensure that their principal is aware of and agrees to all deductions being made from the purchase price. A failure to do so can render the agent or subagent liable to repay the commission. The question arises: how can the subagent be sure that the main agent has made the principal aware of the subagency and any commission arrangements? And how can the subagent be sure what commission arrangements have been agreed between the seller and the main agent? Ideally the subagent should obtain these confirmations in writing from the principal. Where that is not

possible then the next best solution is for the subagent to obtain warranties from the agent that:

- the seller is aware of, and has consented to, the sub-agency and commission arrangements;
- if the seller is going to deduct a further commission from the proceeds of sale, this will be disclosed to the owner.

Similar issues have arisen in other cases, such as the Bouvier case. Yves Bouvier was the owner of Natural Le Coultre, a moving and storage company based in Geneva Freeport in Switzerland, which specialised in the storage and shipping of artworks. In this position Bouvier established close relationships with clients of Naturel Le Coultre, who were both dealers and collectors. Bouvier began to branch out, buying and selling artworks – in many cases leveraging the relationships and knowledge he had acquired in the course of his shipping and storage business. Bouvier was introduced to a Russian oligarch, Dimitiri Rybolovlev, by a mutual acquaintance, Tania Rappo. Rybolovlev wanted to buy expensive paintings and Bouvier was able to source those works using his knowledge of the art market. The arrangement was that the works would be bought by Rybolovlev from a Hong Kong corporate entity owned by Bouvier. Bouvier separately invoiced Rybolovlev a fee of 2% of the purchase price for his expenses associated with the purchase.

In this way, between 2003 and 2013, Rybolovlev bought 34 paintings through Bouvier at a cost of approximately US$2 billion. The method was the same in most cases. The owner of an artwork would be approached by an intermediary acting for Bouvier – often a dealer or an auction house – with an offer to purchase the artwork at a certain price. Once the seller was close to agreeing a price, Bouvier would offer it to Rybolovolev at a price which was usually much higher than the price agreed with the seller. Bouvier would then keep the difference between the two amounts. In a chance conversation, Rybolovlev discovered that a work by Modgliani which he had purchased through Bouvier for US$118,000,000 had been sold by the seller for US$83,500,000.

Rybolovolev instituted criminal proceedings in Monaco against Bouvier for fraud and money laundering on the grounds that he believed that Bouvier was advising him as agent and that the sums retained by Bouvier from these transactions were therefore unlawful secret commissions which he, as principal, was unaware of and would not have agreed to. Bouvier countered by claiming that he was never acting as Rybolovlev's agent, but rather was acquiring works of art for himself which he then sold on to Rybolovlev at a profit. In September 2021 the Swiss prosecutor in Geneva dismissed the criminal complaints against Bouvier. As with all such cases, the outcome in the Bouvier case turned on the particular facts. As a general point, however, the Bouvier case highlights the danger of ambiguity where intermediaries and agents are used to conclude private transactions. The appointment

of an agent or the creation of a set of circumstances which amount to an agency relationship will impose upon the agent a very high level of duty towards his or her principal. This duty necessarily requires full transparency, particularly where the agent's remuneration is concerned. That is very different from the relationship between a buyer and a seller, where a price is negotiated at arm's length, with the seller seeking the highest price possible and the buyer seeking the lowest price possible.

A common structure in private sale transaction chains is the 'back-to-back' sale. In this arrangement the intermediary presents himself to a potential buyer of an artwork as the owner of the artwork when in reality he has merely identified an opportunity to acquire an artwork owned by a third party, and the intermediary does not himself have the funds to acquire it. The intermediary will seek to get the seller to agree to sell to the intermediary while simultaneously getting the buyer to commit to buy the artwork from the intermediary at a higher price than the intermediary is paying the seller. The intermediary will then carry out two back-to-back transactions in rapid succession. First, he or she will agree to sell the artwork (that he or she does not yet own) to the buyer. In doing so he or she will obtain the purchase price from the buyer. Those funds will then immediately be used by the intermediary to buy the artwork from the seller himself or herself. Having paid the seller and taken possession of the artwork, the intermediary then completes the sale to the buyer by delivering the artwork to the buyer, keeping the difference between the price paid by the buyer and the price paid to the seller as profit. Such an arrangement has a number of potential legal problems. The first, and most obvious, is that at the point of agreeing to sell the work to the buyer and taking the buyer's money, the intermediary is selling an artwork he does not actually own. If the intermediary is knowingly and falsely presenting himself as the owner then there may in some circumstances be an argument that there has been a breach of warranty or that the buyer has been induced into buying by a fraudulent or negligent misrepresentation. The reason this does not arise in practice is that many such transactions are successfully concluded in this way without the buyer ever being aware of the intermediary's lack of title at the time of committing to the sale – and because by the time of the completion of the sale, the defect in title has been rectified. However, if for any reason the intermediary is not able to complete the purchase from the buyer, the intermediary will be left with a legal commitment to sell a work that he or she cannot deliver on. Even if the transaction is successfully concluded, however, there are risks around the differential between the price being paid by the intermediary to the seller and the price being paid to the intermediary by the buyer. If the differential is significant, the seller may – if he finds out about it – feel he or she could have got more for the artwork and the buyer may feel he or she could have bought the artwork for less. Does that matter? Probably not if the intermediary has been transparent and upfront with the parties about the arrangement. However, it may be a major problem if the intermediary

is not transparent and is presenting themselves as an advisor or agent to one or both parties. In those circumstances a fiduciary relationship may arise and, as we have seen,[9] such a relationship would prohibit a secret profit at the expense of the principal.

It is in the interests of all parties to spell out in a document in what capacity they are each acting and, where the intention is to create an agency relationship, for the document to set out precisely how the agent will be remunerated for the transaction. If you are acting as an intermediary and you are in doubt, it is worth remembering the mantra that 'transparency cures all' in agency relationships. If you are a principal it is wise to insist upon a warranty from the agent that the agent will not be remunerated directly or indirectly for the transaction other than as provided for in the agreement.

9.9 Resale restriction clauses

A growing phenomenon over the past decade is the use by artists and dealers in the primary art market of restrictive covenants. Artworks are sold, in private sales, to buyers with a legal clause, sometimes buried in the terms printed on the back of the invoice, which restricts the ability of the buyer to resell the work by auction or sometimes imposes a complete ban on any form of resale for a fixed period. Some include an obligation on the buyer to re-offer the artwork back to the original seller before reselling it. While there are many variants, the covenant will typically say something along the following lines:

For a period of 5 years from the date of the purchase the Buyer agrees not to offer the Artwork for sale at auction.

The justifications for such clauses include policing the ethical duties and responsibilities of purchasers towards the artwork and the artist, the need for price transparency, a wish to maintain control over the market in the artist's work and the desire to ensure that the artworks are sold to buyers who appreciate rather than speculate.

Interestingly, and perhaps also tellingly, the enforceability of these clauses has, at the time of writing, not yet been tested by the UK courts. Once they are tested we will know for sure whether or not they are enforceable, and in what circumstances. In the meantime, because this is a question which is increasingly raised in the art market, my view is that I do not believe these clauses are generally likely to be enforceable in the UK. This is particularly the case where consumers are involved.

[9] See section 3.1.1.

The reason for my conclusion is that such clauses seem in almost all cases to be for the overwhelming and sole benefit of the seller of the artwork, and, correspondingly, to the detriment of the buyer. Unless the buyer is getting a substantial concession in return for agreeing to such a restriction on his or her ownership rights, it seems to me that such clauses are at risk of being viewed by the courts in the UK as unfair. And this is particularly the case where the bargaining positions of the parties can be argued to be unequal.

9.9.1 If the buyer is a consumer

Restrictive covenants are unlikely to be enforceable against consumer buyers in consumer contracts because in the UK the Consumer Rights Act 2015 provides for the protection of consumers from unfair terms in 'consumer contracts'.

9.9.1.1 Is it a consumer contract?

The starting point is to establish whether the contract is a consumer contract, and therefore benefits from the protection of the Consumer Rights Act 2015 against unfair terms. A consumer contract is defined in the 2015 Act as a contract between a trader and a consumer.

'Trader' for the purposes of the 2015 Act means a person acting for purposes relating to that person's trade, business, craft or profession, whether acting personally or through another person acting in the trader's name or on the trader's behalf.

'Consumer' means an individual acting for purposes that are wholly or mainly outside that individual's trade, business, craft or profession.

A sale of a work of art between an art gallery, dealer or artist on the one hand and an amateur art collector on the other will therefore be a consumer contract. A sale between two amateur art collectors or between two art galleries, two dealers or an artist and an art gallery or dealer will not be a consumer contract. It is also worth noting that even experienced collectors who trade art will be consumers provided that trading art is not their trade, business or profession.

9.9.1.2 Is the restriction unfair?

If the contract is a consumer contract then the restriction must satisfy the test of 'fairness' under the 2015 Act to be enforceable. A term will be deemed to be unfair under the Act if, contrary to the requirement of good faith, it causes a significant imbalance in the parties' rights and obligations arising under the contract to the detriment of the consumer.

There will be significant imbalance if a term is so weighted in favour of the trader as to tilt the parties' rights and obligations under the contract significantly in the trader's favour by imposing (i) an onerous burden, risk or duty on the consumer, (ii) which is to the detriment of the consumer, and (iii) which is to the advantage of the trader.

When an artwork or indeed any asset is purchased, whether in the primary or secondary market, the buyer usually expects that, having paid the purchase price, he or she will be free to do with the asset what he or she wants. Indeed, the ability of the buyer to own his purchase free of all rights and claims is one of the key warranties expected by buyers in art purchases. In practice, also, where art is concerned it is in the nature of collections that collectors expect to be free to buy, sell and exchange as value, taste and interests fluctuate. So, on the face of it, a major restriction on that ability to sell or otherwise dispose of the artwork is likely to be a duty which is out of the ordinary and both onerous and potentially detrimental to the consumer. It is no small matter.

The greater the length and extent of the restriction, the greater the detriment.

But is it to the advantage of the trader? The fact that the trader has inserted it in the agreement means that it almost certainly will be. Unless the trader has made a very significant and genuine concession (significantly beyond the usual price discounts) to the consumer in return for the consumer's agreement to the restriction, it is likely that the advantage to the trader is simply at the expense of the consumer.

It is also easy to imagine that a court looking at such a clause will consider whether, objectively, the trader's justification for imposing the clause is reasonable, when balanced against the restriction of the consumer's rights.

The difficulties in enforcement increase further if there is room for the purchaser to argue that he or she was unwary or an inexperienced consumer and was taken advantage of. This will depend on the particular circumstances but relevant considerations will include the level of experience of the consumer; whether the consumer is able to purchase a similar artwork from another source; where the clause is prominent or buried in the small print, whether prior to the sale it was highlighted, drawn to the attention of and discussed with the consumer; whether the clause was added as a last minute afterthought – or even after completion of the transaction – and whether the restriction has been acknowledged in writing by the consumer.

With all this in mind, it seems to me that where consumers are concerned there is a risk and in many cases a likelihood of the courts concluding that the clause is unfair.

9.9.2 If the buyer is a trader

Contracts between traders or contracts between a consumer seller and a trade buyer which include a non-resale clause will not benefit from the protection of the Consumer Rights Act 2015. So, does this mean that in these non-consumer contracts such restrictive covenants will be enforceable? Only up to a point.

It should be said at the outset that the courts are generally reluctant to interfere in contractual relationships between businesses. However, there is also caselaw establishing that the UK courts will not generally enforce clauses which amount to an unfair restraint of trade.

Most cases over the enforceability of restrictive covenants arise in the context of employment relationships, where an employer seeks to prevent a departing employee from competing with his or her ex-employer. In such cases the person relying on the restrictive covenant will be required to satisfy the court (i) that they have legitimate business interests requiring protection and (ii) that the restriction is no wider than is reasonably necessary for the protection of those interests. The courts have acknowledged that the same underlying principles apply in business-to-business relationships: 'The mere fact that parties of equal bargaining power have reached agreement does not preclude the court from holding the agreement bad where the restraints are clearly unreasonable' (*Kores Manufacturing Co. Ltd v Kolok Manufacturing Co. Ltd* [1959]).

9.9.2.1 What are legitimate business interests?

Whether or not the seller is able to convince the court that the clause protects legitimate business interests will depend upon the particular circumstances in each case. Most examples of legitimate business interests are based on a need to prevent unfair competition. This includes the protection of trade secrets, prevention of poaching of customers or staff or unfair competition by ex-staff. It is therefore important to look at the motivation for the restriction in each case.

Restrictions which seek to prevent the resale of the work tend in many cases to be motivated by a desire on the part of the seller to have control over an artist's 'brand' through quality and supply control and pricing. This is a worry for artists and dealers who fear that a resale market or an auction market is outside of their control. There is also a concern that a work bought from a dealer may, possibly to the embarrassment of the dealer, be 'flipped' by a buyer who is able to resell the artwork at a much higher price. Conversely, artists may be unhappy that their works begin to change hands at price points which are unaffordable to their traditional client base. Or the artist may disapprove of their work being treated as a commodity. These may well be genuine and understandable concerns, but

from a legal perspective are they business interests which the courts will agree it is legitimate to protect by imposing legal restrictions?

We have seen earlier that such restrictive covenants are considered by the courts to be legitimate where used to prevent unfair competition. However, they may not be seen as legitimate where they seek to prevent any competition at all. Essentially, the person relying on the restriction must show that there is some aspect of their business that they own and that they are therefore entitled to protect from unfair use by a competitor. An example might for instance be a trade secret or a list of clients. It would be unfair for a competitor to make use of something which is confidential and proprietary, such as a client list, so it is legitimate to use a restrictive covenant to prevent such unfairness. With this in mind there is also a risk that non-resale clauses might fail to satisfy the legitimacy test as it could be argued that they are not designed to protect any proprietary interest but rather to prevent competition, particularly around pricing.

It is also worth bearing in mind that, when considering the legitimacy of a business interest, the courts may look at the negotiating positions of the parties. The courts are more sympathetic to such restrictions where the person agreeing to the restriction is receiving a concession from the person requiring the restriction in return. So, for instance, where the buyer of a business is prepared to pay a higher price for the business in return for the seller's agreement not to complete with the buyer, the courts would be likely to see this as a legitimate bargain. The reverse analogy might be where the buyer agrees to pay a genuinely and substantially discounted price in return for agreeing to restrictions on his right to resell.

9.9.2.2 *The extent of the limitation*

Even if the seller were to overcome the 'legitimate business interests' hurdle, the restriction would need to be drafted in a way which is no wider than is reasonably necessary for the protection of those interests. It would need to be limited in time and territory to a strict minimum. Clauses which seek to impose lengthy periods of restriction and/or which are not limited to a particular territory are more likely to fail the test.

9.9.3 A right against whom?

For those relying upon non-resale clauses it is important to remember that the restriction is a contractual right. So, even if it is enforceable, it can usually be enforced only against the buyer who was a party to the original sale. In other words, it is not generally enforceable against an auction house or a dealer handling the resale – or against the buyer in the resale. It is of course open to the person relying on the clause to sue the original buyer and apply to the court for an injunc-

tion to prevent the breach of the clause by stopping the resale, but such injunctions are as difficult to obtain as they are expensive to apply for.

It is sometimes suggested that the auction house or dealer handling the resale could, in doing so, be liable to the original seller for inducing a breach of contract by the original buyer. Such claims, while superficially attractive to the original seller seeking to bring pressure to bear in order to stop a resale, are unlikely to have any legal merit, for a host of reasons. The most important of these is that such a claim is dependent on the enforceability and validity of the restriction, which, as we have seen, is itself highly doubtful. Second, they require proof of actual knowledge by the reselling agent or auction house of the restriction – which is rarely the case. Third, there needs to be deliberate intent on the part of the reselling agent or auction house to encourage the original buyer to breach the restriction. This is a major problem because if the reselling agent or auction house reasonably believes the contractual term to be ineffective there can, by extension, be no such intent. Finally, as we will see below, the original seller is also likely to encounter problems in demonstrating that he or she has suffered loss as a result of the breach. For all these reasons, such claims of inducement to breach of contract do not usually stand up to close scrutiny.

9.9.4 What is the damage?

The challenges for the person seeking to enforce the non-resale clause do not end there. As the usual remedy for a breach of contract is a right to damages, the person relying upon the non-resale clause will need to demonstrate that he or she has in fact sustained a quantifiable financial loss as a result of the breach of the restriction. That may also be difficult.

If the work is resold for more than it was originally sold for, then that serves only to increase the value of the artist's work – which can only be to the financial benefit or the artist and anyone owning works by the artist. If on the other hand the work is resold for less than the original price or fails to sell, then that is likely to suggest only that the price paid by the original buyer to the seller was more than the actual market value of the artist's work.

Every case is different and, as I have said above, the courts have not yet expressed a view on this question. Until that happens we cannot say for certain whether these clauses are enforceable, and if so under what conditions. However, there are so many reasons why such clauses are problematic that it seems there is a significant risk that the UK courts will not enforce such clauses – particularly if the person agreeing to them is a consumer.

9.10 The art dealer

9.10.1 Introduction

The art dealer is a retailer of art, selling art to the public by private sale rather than auction. Private sales of art through dealers represent a very significant portion of total global art sales. In 2018 they were estimated to have reached US$35.9 billion, up 7% on 2017.[10] In common with other retailers, many art dealers have a shopfront, also known as a 'gallery', displaying the art on sale. Customers can walk in, agree a price, pay for and leave with the artwork they purchase. However, beneath this seemingly simple commercial structure the dealer's activity can include a variety of more complex activities, including but not limited to representing artists, advising collectors or purchasing at auction or privately for resale at a profit.

Broadly speaking, the sale and purchase of art through a dealer acting as an agent for the seller will be covered by the same principles as the sale and purchase of art through an auctioneer acting as agent for the seller. The art dealer will be appointed as agent for the seller to sell the artwork. There will therefore be an agency agreement between the dealer and the seller setting out the terms on which the agent is authorised to sell the artwork on behalf of the seller. Once a buyer has been identified, the work will be sold under a contract of sale between the buyer and the dealer as agent for the seller. The agency contract and the sale agreement will contain similar provisions to those covered in section 3.1.5 on the auction agency agreement.

9.10.2 Stock sales

While dealers take artwork on consignment from sellers as agent (see below), they will also often, just like any retailer, need to stock their business with artworks available for purchase. This stock is acquired and owned by the dealer. The acquisition and sale of artworks as stock is perhaps the most traditional form of art dealer activity. The dealer uses his or her own funds to acquire artworks, either privately or at auction, with a view to reselling them privately at a profit. To achieve a profit, the dealer relies on a number of factors. First, the dealer will often have a list of actual or potential clients in mind who might be interested in the artwork at the time he or she acquires it. Second, he or she will wish to display the artworks attractively in the shopfront or gallery. He or she may also restore or repair the artwork before putting it on sale so that it is more desirable upon resale. Dealers also seek to make a profit by using their knowledge and instincts to identify value which others have failed to spot. A successful acquisition and

[10] Dr Clare McAndrew, Art Basel and UBS report, The Art Market 2019.

sale will result in a profit for the dealer – sometimes substantial. A less successful acquisition can lead to the artwork languishing in the dealer's showroom or stock room and having to be disposed of eventually at a loss or without profit.

These methods have, to some degree, been under pressure for a number of reasons. On the one hand, auction salerooms, which were the traditional source of dealer stock, are increasingly frequented by private individuals and collectors. Dealers are therefore at risk of finding themselves competing for works at auction against the very people they would, in past times, have hoped to sell the works to. Second, the ready availability of auction sale data means that the price at which the dealer acquired an artwork at auction is in the public domain and therefore known to potential buyers who are then offered the artwork by the dealer. This makes it difficult for the dealer to sell a work acquired at auction for a materially higher price than the price at which it was acquired. As a result, many dealers prefer to buy their stock artworks privately rather than at auction. Third, auction houses now have departments and staff able to conduct private sales, which were previously the preserve of dealers.

However, there are also many aspects which favour the dealer. Many buyers prefer to buy from dealers rather than at auction because of the less public nature of dealer transactions. Dealer transactions are less hurried and avoid the competition inherent in auction sale rooms. Many dealers also act as trusted advisers to collectors, providing advice on building a collection and sourcing new artworks.

9.10.3 Agency sales

Dealers will also take artworks belonging to their clients on consignment for private sale. In this structure the dealer acts as agent for the owner and, unlike the stock sales structure, is not putting his or her own money at risk. Instead the dealer's client remains the owner and if a successful sale is concluded by the agent, the agent is entitled to a commission. The amount of the commission is negotiated between the seller and the dealer.

As we have seen, the commission may be expressed as a fixed amount. Alternatively it may be agreed to be a percentage of the sale price charged to the buyer. It may also be expressed as a percentage of the sale price, but capped at a maximum amount. In some cases the seller will agree that he or she wants a minimum net amount for the sale and permit the agent to keep any 'upside' over this amount as a commission. This arrangement can be problematic where the upside is significant and/or where the agent is not transparent with the seller about the sale price and upside achieved. If such an arrangement is adopted it is recommended that the parties agree a maximum cap on the amount of upside.

Dealers entrusted with artworks for private sale as agent for the owner sometimes enlist the help of other dealers or auction houses to assist in the search for a buyer. The creation of a subagency arrangement of this kind can cause difficulties if not handled carefully. This is covered in more detail in section 9.7, 'Transparency, secret commissions and the problems arising from subagency'.

9.10.4 Sales on behalf of the artist

One of the key areas where auction houses have not yet made inroads into the dealers' territory is the primary market – the sale of artworks sourced directly from the artist. In return for the right to exclusive or nonexclusive representation of the artist, the dealer undertakes to showcase, promote and sell the artist's work. Successful dealers approach this as a form of brand management. Central to this exercise is the control of the market value of the artist's work. This is achieved, first of all, by pricing the works at the right level when they are offered by the dealer for sale. In addition, to maintain the prices, dealers will carefully control supply of the artist's work so as to maintain demand. Dealers will also regularly bid upon and buy their artist's works when they appear at auction. Doing this ensures that the value of the artist's work on the secondary auction market remains high. Pricing is, however, only one part of the brand. Buyers of art – particularly contemporary art – want their purchases to say something about them. The dealer will therefore seek to build a story around the artist's work. Sometimes the personality of the artist himself or herself becomes a key part of the brand. Artists such as Pablo Picasso, Jeff Koons, Andy Warhol and Salvador Dali are all examples of artists who recognised the importance of building and promoting themselves as a brand. It is the dealer's job, using sponsorship, exhibitions, social media and the press, to promote and protect the brand of the artists he or she represents.

9.10.5 Agreements between dealers and artists

The legal basis of the relationship between the dealer and the artist is the agreement under which the dealer agrees to act as the artist's agent. The following are some of the issues which will usually be addressed in such agreements.

9.10.5.1 Agency

The contract will designate the dealer as the agent for the artist, empowered to negotiate and conclude sales on the artist's behalf, in return for a share of the proceeds of sale. As with the relationship between the seller and the auction house, this agency relationship is fiduciary in nature, obliging the dealer to act at all times in the interests of the artist.

9.10.5.2 Term

The artist and dealer will need to agree the period for which they intend to work together. If this is a new and untested artist, the term is likely to be shorter so that the parties can test the market. For a more established artist the parties may envisage a longer-term commitment.

9.10.5.3 Exclusivity

Exclusivity lies at the heart of the dealer's relationship with the artist. In order to develop the artist's brand and pricing, the dealer will ideally want sole control of the artist's oeuvre. However, there may be situations where the artist is happy to designate more than one dealer to act on his or her behalf, making the arrangement nonexclusive. The artist should consider whether any exclusivity should be limited to a particular geography or whether it should be worldwide.

9.10.5.4 Supply of artworks

The contract should specify the commitments the artists is making to supply the dealer with artworks to sell. A minimum number of artworks should be specified. Where the dealer is selling the artist's entire oeuvre it should also be made clear that all of the artist's output during the term of the agreement will be provided to the dealer.

9.10.5.5 Promotions and exhibitions

The artist will want to secure a concrete commitment from the dealer to showcase his or her work through exhibitions or other promotional activities. The contract will often specify how many exhibitions of the artist's work will take place and whether the exhibition will be exclusively devoted to the artist or to the works of a number of artists.

9.10.5.6 Artist control

It is often wise for the artist to seek some kind of artistic control over the presentation, reproduction and marketing of his or her artworks.

9.10.5.7 Pricing

Setting the prices for the artworks is the responsibility of the dealer, who will set the price level according to the likely market for the artist. However, the artist may wish to insert a provision which stipulates a maximum discount from the asking price that the dealer can agree to.

9.10.5.8 Costs and expenses

In most cases the dealer will take on the costs of handling and selling the artist's works. This will include insurance, storage and marketing costs.

9.10.5.9 Financial arrangements

The dealer and the artist usually agree to split the proceeds of any sale of the artist's work which is negotiated by the dealer. The split of proceeds will depend upon the balance of power between the dealer and the artist, but it is commonly an equal 50/50 split. Often the costs and expenses incurred by the dealer will be deducted from the sale proceeds first before the net proceeds of sale are divided up. The contract should oblige the dealer to provide the artist with a regular update on completed sales, prices achieved and division of proceeds of sale. If the proceeds of sale are to be held for any period in the dealer's account, it may be prudent for the artist to require that they be held in a separate account or even an escrow account.

9.10.5.10 Title

The contract should usually provide that title in the artwork will remain with the artist until the moment of completion of the sale by the dealer to a buyer. The contract may well include a provision that the dealer may not release the artwork to a buyer until the buyer has made payment in full.

9.10.5.11 Sales otherwise than through the dealer

The agreement should also deal with the question of sales or commercial transactions relating to the artist's work which are not conducted through the dealer. These might include sales directly by the artist from the artist's studio or commissioned artworks. These may be prohibited, or they may be permissible subject to the dealer's prior consent, or they may be permitted subject to the dealer being paid a proportion of any income received by the artist in relation to any such transactions.

9.10.5.12 Purchases of works by the dealer

The dealer may also wish to retain the option of purchasing the artist's work outright. Such agreements will usually be the subject of separate negotiations on a case by case basis between the artist and the dealer. In such cases it is important to remember that artist's resale right is payable.

9.10.5.13 *Intellectual property*

An important part of brand management is the management of the reproduction rights of the artist's works. It is open to the artist to assign those rights to the dealer but a better approach is for the artist to retain all intellectual property rights and simply grant the dealer a licence to reproduce the artworks as may be necessary in order to market and sell the artworks.

9.10.5.14 *Early termination*

One of the thorniest issues surrounds the right of early termination. The artist will want to ensure that if the dealer is unsuccessful in selling the artworks the artist has the possibility of bringing the arrangement to an end early. The dealer, on the other hand, will want to ensure that, after their investment of time and money in developing the artist's brand, that artist cannot simply walk away and sign up with another dealer. Most agreements will allow the parties to terminate where one is in breach of contract, but if the agreement does allow for early termination for reasons other than a breach of contract, such termination will usually be subject to a long notice period.

10 Ethics, public policy and art

10.1 Holocaust restitution claims

10.1.1 Holocaust confiscation and looting

In order to understand the phenomenon of Holocaust restitution claims it is important to understand the historical context. The Nazi movement in Germany had strong views not only on political matters but also on cultural issues. Following the First World War, under the liberal German Weimar government of the 1920s, Germany became a major centre for avant-garde art. This modern art was despised by Hitler and the Nazi party. In 1933 Hitler became Chancellor and immediately put in place measures to take control of the museums, dismissing museum directors and staff who did not share the Nazi view of what they considered to be 'degenerate' modern art. In 1937 propaganda minister Joseph Goebbels began preparations for an exhibition of post-1910 German 'degenerate art'. Nearly 16,000 works, both owned by and loaned to museums, were selected and confiscated from existing museum collections and a government decree was passed declaring that the government would not pay compensation for confiscated art. A selection of the confiscated works was exhibited alongside descriptions, slogans and commentary ridiculing the art and attacking the artists. Following the exhibition, a commission for the exploitation of degenerate art was formed and sales of degenerate art were held in Germany and in Switzerland, with the proceeds of sale going to the Nazi party. This, however, was only the first phase in what was to become Hitler's cultural war.

After German troops arrived in Austria in 1938 there was an outbreak of vicious antisemitism and looting of Jewish businesses and property. The art collections of prominent Jewish collectors were systematically confiscated by German troops. Some Jews were allowed to leave Austria over the following months and years, but on condition of paying significant sums or forfeiting their assets in order to obtain an exit visa.

One year later, the invasion of Czechoslovakia resulted in similar waves of confiscation and looting of artworks – aimed not just at Jews but also at the libraries, museums and palaces of Prague. This pattern of confiscation and looting

was repeated as Hitler's troops invaded other countries, including Poland, the Netherlands, France and the Soviet Union.

Within Germany itself Jews were subjected to increasing levels of persecution, looting and confiscation. Those that fled were usually able to do so only in exchange for forfeiting their assets, enduring forced sales of their property or paying large tax demands.

These confiscations and forfeitures were unusually well documented. The Nazis were meticulous recordkeepers and, in an effort to give these confiscations a veneer of legality, the actions of the Nazi party were carefully recorded in every detail.

The thefts were, however, only part of the story. It has to be remembered that these confiscations were accompanied by unprecedented violence, humiliation and cruelty, including the mass deportation of Jews to concentration camps where entire families faced death through torture, starvation or execution as part of what Hitler called his 'total solution of the Jewish question'.

The vast quantities of art confiscated as a result of these terrible acts were sorted by the Gestapo, with the best art retained for Hitler, Goebbels and German museums. The remainder was earmarked for sale to dealers and by auction. In this way the confiscated art was effectively distributed into the art market.

10.1.2 Postwar restitution efforts

Immediately following the end of the war in 1945, various attempts were made to reunite victims of the looting and confiscation with their stolen property. While this effort was in many cases successful, the sheer number of objects in circulation and the number of victims, both deceased and living, meant that in many cases restitution was not possible.

In order to assist this process, in 1943 the allied forces introduced the Inter-Allied Declaration against Acts of Dispossession Committed in Territories under Enemy Occupation or Control. This declaration permitted countries to declare invalid any sales, purchases or dealings in property which had been situated in territories or which belonged to residents of those territories. Property obtained by looting, duress or sham transactions included writing in its ambit. While undoubtedly helpful, the effect of the declaration remains doubtful. It is a nonbinding declaration and was in any event intended to regulate relationships between States rather than individuals. The declaration required States to enact its provisions in national legislation, and in most cases this never happened.

There then followed a long period of relative inactivity in the efforts to identify and restitute art looted during the Holocaust, during which many fewer claims were advanced. This period of inactivity, which stretched over many decades, would prove to be highly significant as it was during this time that the vast numbers of stolen but unrestituted artworks were freely traded in domestic and international art markets. As these artworks changed hands, their connection with the terrible events of 1933–45 faded and eventually disappeared.

However, from the mid-1990s onward there was revived interest in and awareness of Holocaust restitution claims. This was prompted in part by the publication in 1994 of Lynn Nichols' The Rape of Europa, a detailed account of the fate of Europe's treasures in the Third Reich and the Second World War. Nichols' book was followed in 1998 by the public release of the archive of the Einsatzstab Reichsleiter Rosenberg (ERR), the 'Special Task Force' headed by Alfred Rosenberg. The ERR was one of the main Nazi agencies engaged in looting cultural valuables in Nazi-occupied countries during the Second World War and its archives provided meticulous records of the stolen artworks, the victims of the thefts and the perpetrators.

10.1.3 The 1998 Washington Conference

Also in 1998, the United States hosted the Washington Conference on Holocaust Era Assets. The aim of the conference was to discuss Jewish wartime losses. It included representatives of 44 governments and 13 international nongovernmental organisations. The Washington Conference reached agreement on 11 principles:[1]

(1) Art that had been confiscated by the Nazis and not subsequently restituted should be identified.

(2) Relevant records and archives should be open and accessible to researchers, in accordance with the guidelines of the International Council on Archives.

(3) Resources and personnel should be made available to facilitate the identification of all art that had been confiscated by the Nazis and not subsequently restituted.

(4) In establishing that a work of art had been confiscated by the Nazis and not subsequently restituted, consideration should be given to unavoidable gaps or ambiguities in the provenance in light of the passage of time and the circumstances of the Holocaust era.

(5) Every effort should be made to publicise art that is found to have been confiscated by the Nazis and not subsequently restituted in order to locate its pre-War owners or their heirs.

[1] www.state.gov/p/eur/rt/hlcst/270431.htm

(6) Efforts should be made to establish a central registry of such information.

(7) Pre-War owners and their heirs should be encouraged to come forward and make known their claims to art that was confiscated by the Nazis and not subsequently restituted.

(8) If the pre-War owners of art that is found to have been confiscated by the Nazis and not subsequently restituted, or their heirs, can be identified, steps should be taken expeditiously to achieve a just and fair solution, recognising that this may vary according to the facts and circumstances surrounding a specific case.

(9) If the pre-War owners of art that is found to have been confiscated by the Nazis, or their heirs, cannot be identified, steps should be taken expeditiously to achieve a just and fair solution.

(10) Commissions or other bodies established to identify art that was confiscated by the Nazis and to assist in addressing ownership issues should have a balanced membership.

(11) Nations are encouraged to develop national processes to implement these principles, particularly as they relate to alternative dispute resolution mechanisms for resolving ownership issues.

These principles do not have force of law but set a direction of travel which the 44 countries represented at the conference intended to follow. More importantly, the principles provided a wakeup call to the art market, to museums and to collectors that they had a responsibility to educate themselves about the issue, that Holocaust restitution claims were to be taken seriously and that solutions were to be found.

10.1.4 Holocaust restitution claims in the United Kingdom

It is interesting that despite the declarations following the Washington Conference in 1998, very few countries in fact went on to alter their laws to facilitate Holocaust restitution claims. Most governments left it to museums and art market players to find their own pragmatic solutions to the issue – which did not involve recourse to the law.

Indeed, the fact that the law in the United Kingdom in general makes little special provision for Holocaust claims may explain why Holocaust restitution claims are so rarely litigated in the United Kingdom. In addition, litigation over such claims is discouraged by the complexity of the variables. Even if a claimant is able to demonstrate that an artwork was stolen or obtained under duress in the 1933–45 period, it is not unusual for the artwork to have since changed hands many times, in many different jurisdictions. Good title may or may not pass during these transactions depending on the state of knowledge of the person acquiring the object and depending on the law on the country in which the transaction took place. In some jurisdictions a purchase by a good faith buyer will transfer good title to the buyer. In others, the buyer cannot acquire good title to a stolen work regardless of

his state of knowledge. The answer to these questions requires in each case a very detailed investigation and consideration by the parties and the court of the facts and the law. The cost and uncertainty of such an exercise, and the risk of being the losing party and having to bear the winning party's legal costs, is sufficient to put both claimants and defendants off litigation.

The result has been a growth in informal dispute resolution. Typically, pragmatic owners who are faced with a claim realise that they need to resolve the claim in order to be able to sell their artwork. Pragmatic claimants also want to avoid litigation, recognising that the legal hurdles to a claim are significant. The fact that claimants and owners are usually both prepared to see the work sold makes resolution easier in many cases because the dispute can be confined to an equitable division of the proceeds of sale of the artwork. Of course, it is also fair to point out that these are highly complex and emotionally-charged disputes, and so not all claims are amicably resolved in this way. Auction houses have however tended to lead the way in acting as facilitators of this kind of dispute resolution. This is in part out of necessity. Where a work consigned for sale is found to have a problematic provenance, the auction house holding the artwork will find itself in the middle of a dispute, and will therefore often be well placed to act as a mediator or facilitator. As a result of this, a number of the leading auction houses have established restitution departments which specialise in researching the provenance of works and, should a problem or dispute arise, finding a negotiated solution.

While it could be argued that the law has a limited role to play in such disputes, it is nevertheless worth analysing the principal legal hurdles to claims. They are important because, whether or not the claim falls to be decided by the law, they may well be factors in determining the terms on which a claim can be resolved.

10.1.4.1 Ownership

The starting point for any claim lies in proving that the owner in the period 1933–45 was the owner of the artwork. This is not always straightforward, given the passage of time and, in many cases, the absence of records. Paintings were often recorded in prewar inventories and purchase records using generic titles such as 'Nude' or 'Landscape' or 'Flowers in a Vase'. Where artists produced several works which might match these descriptions there is often scope for doubt when seeking to demonstrate, for instance, that a work hanging in a museum today is the same work as one which was in a Jewish collection prior to the war. In some rare cases identification is possible because prewar photographs of rooms incidentally include images of paintings hanging in the room. In other cases the date of the work, its dimensions, its published exhibition history or its known provenance allow it to be identified.

10.1.4.2 Wrongful dispossession

Having established that an artwork was in the possession of a particular collector prior to the war, the next question to be determined is how the collector came to be parted with the artwork. For a restitution claim to be successful it must be demonstrated that the owner was wrongfully dispossessed of it, as a victim of a theft or confiscation. This question may be tragically clear, such as in the cases where families were deported to concentration camps and the family house emptied of its contents by the Gestapo. However, the Nazi regime also had many other ways of dressing up confiscations and thefts to give the appearance of legitimate transactions. The Nazi regime was frequently at pains to create bureaucratic structures, processes and records to legitimise these transactions. Victims were issued with large tax demands which could only be paid by the victim selling off his or her assets. In other cases victims were promised the right to leave the country in return for leaving their assets to the State or making a large payment which could only be raised through the sale of assets. Against this background the question to be determined in relation to any transaction in Germany or occupied territories during the 1933–45 period is whether the transaction was legitimate or whether it was in truth a transaction conducted under threat. Each situation raises the question of whether the owner experienced a threat or oppression, and, if he or she did, whether or not the owner's decision to sell was prompted or caused by that threat or oppression. A forced confiscation of an art collection by the Gestapo is unlikely to be anything other than theft. However, other situations require greater analysis. For instance, where a wartime victim of oppression is able successfully to leave Germany with his artworks and settles in Switzerland, living off the proceeds of sale of the artworks, what is the status of such sales? Where a German bank, which is owed money by a Jewish collector, enforces its security rights during the war by selling the collector's artworks, is that a forced sale? The answer in each case depends on the facts and the evidence. One cannot of course assume that all wartime transactions were illegitimate, and it is right that all claims should be scrutinised. However, there is also a risk that in analysing these transactions we fail to really appreciate the extent of the confusion, horror and hostility of wartime Europe, and the behaviour that can be, and was, triggered by such an environment.

10.1.4.3 Subsequent transactions

One feature of Holocaust restitution claims is that the artworks which are the subject of the claim are rarely in the possession of the original wrongdoer. This is because confiscated works were often immediately sold by auction, or sold, inherited or given away privately. Then, over the decades which followed, these artworks continued to be traded and added to private and public collections – often travelling across borders. As time went on it became increasingly likely that the buyer or seller in these transactions would be in good faith and unaware of the wartime history of the work. This is important from a legal perspective because the

validity of a purported transfer of ownership is in many jurisdictions dependent on the state of knowledge of the buyer. In other words: was the buyer acting in good faith? The majority of civil law jurisdictions – including in Western Europe – accord a degree of protection to the good faith purchaser of a stolen work. This is different to common law systems of law, such as that in the United Kingdom, where the general rule is that a thief cannot give a buyer good title, regardless of whether the buyer is in good faith or not. This is known as the Nemo dat rule[2] – the legal principle that the purchase of something from someone who has no ownership right cannot confer any ownership title on the purchaser (see also section 5.1 'Title and ownership'). English law therefore prefers the rights of the innocent victim of theft over those of the innocent purchaser of the stolen property. In civil law systems, on the other hand, the rights of the good faith purchaser tend to be preferred over those of the victim of theft. The result is that the ownership rights of the victim of a theft can be very different depending upon which law is applied. It is important in this context to note that under English law, where there are disputes over title to a moveable object, the law to be applied to determine whether title has been acquired in a transaction is the lex citus, that is, the law of the country in which the property was located at the time of the transaction.[3] With that in mind, an illustration of how a transaction outside the United Kingdom can defeat a claim by the dispossessed owner can be found in the case of Winckworth v Christie Manson & Woods Ltd.[4]

Japanese artworks were stolen from an English collector and transported to Italy, where they were sold. When the buyer brought the works back to the United Kingdom in order to sell them, the original owner issued legal proceedings in the United Kingdom in order to assert his ownership over the works and secure their return. The United Kingdom court had to determine whether the ownership in the artworks had remained with the victim of the theft or whether the buyer had acquired valid ownership as a result of the sale in Italy. To do this the court decided that it should apply Italian law as this was the law applicable to the sale under which ownership had purported to be transferred. Under Italian law, because the buyer was in good faith and unaware that the artworks had been stolen, he had acquired good title to the artworks – and therefore superior title to that of the person from whom they had been stolen. Had the sale transaction taken place in England, the outcome would have been just the opposite. Ownership would have remained with the victim of the theft under the Nemo dat rule.

Given the international nature of the art market, and the inevitable chaos of the postwar period, it is not unusual to find that an artwork which was confiscated in

[2] The rule is affirmed by the Sale of Goods Act 1979, s 21(1).
[3] Islamic Republic of Iran v Berend [2007] EWHC 132 (QB).
[4] [1980] 1 All ER 1121.

wartime Germany has subsequently been bought and sold many times in many different jurisdictions. A claimant will need to demonstrate that, despite each of these transactions, he or she still has better ownership rights than the current owner of the artwork. This will involve a complex analysis, in relation to each transaction, of the applicable law and the state of mind of the seller and purchaser.

10.1.4.4 Limitation

As we have seen (in section 5.1, 'Title and ownership'), limitation rules exist because the more time elapses, the greater the risk of injustice. This is particularly relevant where thefts of property are concerned. While few would argue with the right of a victim of theft to sue the thief or a person who knowingly handled stolen goods for conversion, the position is more difficult where the person facing a claim is someone who paid full price for an object he or she had no reason to believe was stolen. It becomes more difficult still when that unsuspecting owner is only the latest in a line of innocent owners and the original victim of the theft is long dead. It is this risk of injustice which has led legal systems all over the world to adopt rules which exclude claims once a certain period has elapsed. However, there is also an argument – which appears to have been accepted by governments and the public – that the events of the Holocaust were so exceptionally horrific that justice demands the rules on limitation be set aside where Holocaust restitution claims are concerned. The difficulty is that, despite having recognised this, governments have been slow to enact legislation which specifically excludes or extends limitation periods where Holocaust claims are concerned. In the absence of a steer from the law, it has been left to the claimants and the owners of works stolen between 1933 and 1945 to work out compromise solutions themselves. It is tempting therefore to conclude that limitation periods do not play a large part in the negotiations. In fact, they do. While they are rarely openly relied upon as a reason not to return the work, both parties negotiate knowing that the claimant's ability to mount a successful legal claim if negotiations fail may be severely compromised by the rules of limitation.

As a result, it is worth considering the laws in relation to limitation periods (see section 5.1, 'Title and ownership'). While we will cover the limitation rules under United Kingdom law below, it is important to remember that each country has different rules of limitation. The rules applicable in each case will depend upon the location and circumstances of the transactions involving the property in question.

In the United Kingdom, s 4 of the Limitation Act provides that the right of any person from whom a chattel is stolen to bring an action in respect of the theft is not subject to any limitation period. In principle, therefore, the victim of the theft can sue the thief for the return of the stolen object regardless of the time that has

elapsed since the theft.[5] However, as mentioned above, where Holocaust restitution claims are concerned, the person in possession of a stolen artwork will almost never be the thief. Rather, the current owner of the property is likely to be the latest in a series of owners since the original theft. A claim against such an owner will be based upon the tort of conversion, which is the legal term for a claim in which the claimant is asserting that he or she is the true owner of the artwork and the defendant has dealt with the artwork in a way which is inconsistent with the rights of the true owner. In the United Kingdom, s 2 of the Limitation Act 1980 provides a limitation period on ownership claims based on conversion of six years from the date of the conversion (see section 5.1, 'Title and ownership'). Further, not only will the claimant be prevented from bringing a claim in conversion after the expiry of that period, but unless he or she has recovered possession of the object within that six-year period, his or her ownership of the artwork will be deemed to be extinguished.[6]

The first conversion after the theft of an artwork takes place at the point that the thief sells,[7] or transfers, the stolen artwork to a third party who is in good faith without notice of the theft. The six-year limitation period will therefore start running at that point. Each subsequent transfer of ownership thereafter is a further successive conversion.[8] Section 2 of the Limitation Act 1980 provides that where there are successive acts of conversion the limitation period will not restart with each act of conversion; rather, it will run from the date of the original first conversion. So, in the case of a theft, once the thief has sold the artwork to a buyer in good faith, the victim of the theft will have six years from first conversion to sue the buyer. If he or she fails to do so within that time, the right to sue any of those who successively convert the artwork will be lost and the victim's title to the artwork will be extinguished.

As we have also seen, however, where Holocaust claims are concerned, the theft and subsequent conversions are unlikely all to have occurred in the United Kingdom. The law to be applied to resolve the question of ownership is therefore likely to be that of one or more foreign jurisdictions. Section 1(1) of the Foreign Limitation Periods Act 1984 established the principle that where, in any United Kingdom legal action, the law of any other country is to be applied in determining the substantive dispute – such as an ownership dispute – the limitation laws of

[5] Section 4(2) makes it clear that any conversion related to the theft will be considered as part of the theft. So the conversion which occurs when the thief sells an object to someone who knows the object is stolen will be considered to be a part of the original theft.

[6] Section 3(2) of the Limitation Act 1980.

[7] Or someone who acquired the artwork in a transaction connected with the theft.

[8] Under s 4(2) of the Limitation Act 1980, a conversion following the theft where the new owner acquires the object in bad faith will be considered to be part of the original theft. This means that the six-year period will run from the next conversion thereafter which is in good faith.

that country will also be applied in determining any limitation issues. As a result, if a United Kingdom court decides that German law is applicable to the analysis of the legal effect of a transaction which occurred in Germany in 1945, then the German law of limitation shall also be applied to determine whether a claim relating to that transaction is time barred or not. There are some very limited circumstances where the United Kingdom court will not apply the foreign limitation period. The most relevant of these is where it is contrary to a clearly identifiable fundamental principle of justice or where it would cause undue hardship to one of the parties.[9] However, English courts should not invoke the public policy exception unless foreign law is manifestly incompatible with public policy.[10]

The complexity of the legal issues around ownership, dispossession, successive crossborder transactions and limitation periods surrounding Holocaust restitution claims was illustrated by an early restitution case, City of Gotha and Federal Republic of Germany v Sotheby's and Cobert Finance S.A.[11] The case related to a painting by the Dutch painter Joachim Wtewael, which was believed to have been confiscated from the collection of the Ducal family of Saxe-Coburg-Gotha in the city of Gotha during the Second World War. The painting resurfaced in the 1980s when it was smuggled from Moscow to Berlin by the wife of the Togo Ambassador in Moscow. She did not deliver it to the intended recipient; instead it ended up in the possession of a man named Rohde. The painting was then acquired from Rohde in 1988 by someone known as Mina Breslav and consigned to Sotheby's for sale. The painting was offered for sale in March 1989 and bought by Cobert Finance S.A. Sotheby's was sued by the City of Gotha and Cobert Finance S.A. was sued by the Federal Republic of Germany. The issues considered by the court were whether the Federal Republic of Germany had a valid ownership claim to the painting and whether or not that claim was time barred under German limitation laws. The court had to untangle a complex factual web, tracing the painting from the point of its confiscation, via Russia, and back to Germany. To establish a chain of title the transaction had to be analysed to determine the nature of each transaction, the national law applicable to the transaction, the state of mind of the parties involved in the transaction and the effect of the transaction on title. Then the court had to consider a complex issue of conflicts of law to resolve the question of whether the German or United Kingdom law of limitation would apply. We will not cover the detailed arguments and findings of the court in this book, as they were specific to the particular facts of that case. However, the length and complexity of the case and the judgment serve as an illustration of why

9 Section 2(2) of the Foreign Limitation Periods Act 1984.
10 City of Gotha and Federal Republic of Germany v Sotheby's and Cobert Finance S.A., Times Law Reports, 9 October 1998.
11 Times Law Reports 9 October 1998.

neither claimants nor defendants in restitution disputes tend to look to the courts to resolve their differences.

10.1.5 The Spoliation Advisory Panel

In February 2000 the United Kingdom government established the Spoliation Advisory Panel (SAP) to mediate claims from any person or their descendants who had lost possession of a cultural object during the period 1933–45, where the object is (i) now in the possession of a UK national collection, or (ii) in the possession of another UK museum or gallery established for the public benefit. While primarily established to consider claims relating to objects in museums, the SAP can also be called upon to advise on claims relating to objects in private collections, but only in cases where it is jointly requested to do so by both the claimant and the owner.

The SAP is intended to operate as a form of dispute resolution forum and its proceedings provide the parties with an alternative to litigation. Its recommendations are not legally binding on the parties, but in the event that its recommendations are accepted by the claimant, the claim will be deemed to be fully and finally settled from a legal perspective.

A claimant making a claim will need to present a statement of case, setting out full details, together with supporting evidence of the object, its current location, its provenance, the circumstances in which it was lost between 1933 and 1945 and the basis on which the claimant is entitled to make the claim. The institution or owner of the object will need to present its case, setting out, together with supporting evidence, the provenance of the object and the circumstances in which it acquired it.

10.1.5.1 Spoliation Advisory Panel reports

The dearth of caselaw in the United Kingdom relating to Holocaust restitution claims makes it helpful to analyse the decisions and reports of the SAP. While the SAP is intended to operate as an alternative dispute resolution vehicle rather than a court of law, it is interesting to review the findings it has made over the years, as there are some themes which emerge.

The first claim to be considered by the SPA, in 2001, related to the painting A View of Hampton Court Palace by Jan Griffier the Elder, held at the Tate Gallery. The SAP found that the claimant's mother had lost the painting in circumstances tantamount to a forced sale for an undervalue. The SAP recommended an ex gratia payment of £125,000 to the claimant and that the Tate Gallery should display, alongside the painting, an account of its history and provenance during and since the Nazi era, with special reference to the claimant and his family.

Three years elapsed before the second case was referred to the SPA. That case related to a still life painting, formerly attributed to the eighteenth-century artist Chardin, which had been seized from an auction house by the Nazis in 1936 and was acquired in good faith by the Burrell collection eight years later. The painting was then donated to the Corporation of the City of Glasgow by Sir William Burrell and his wife in 1944. Having reviewed the evidence, the SAP recommended that Glasgow City Council (the successor to the Corporation of the City of Glasgow) should return the work to the claimants, who wished to remain anonymous.

The third claim to be considered raised a difficult question of law which needed a change in United Kingdom legislation to be overcome. The claimant in this case was the Metropolitan Chapter of the Cathedral City of Benevento in Southern Italy. Its claim was for the return of the Beneventan Missal, a twelfth-century manuscript. When the claim was first presented in 2005 the SPA decided that it was likely that the Missal had been looted during the Allied bombing of Benevento in 1943 and was then sold in 1944 by a Naples bookseller to a British soldier, prior to its acquisition by the British Museum in 1947 and transfer to the British Library in 1973. The problem, however, was that the British Library Act 1972 legally prevented the British Library from removing the Missal from its collection. A change in the law was going to be necessary in order for the Missal to be permanently returned to the claimant. The SAP therefore recommended that the Missal be loaned to Benevento and that in the meantime the government should consider changing the law to allow the library to restitute objects lost during the Nazi era. This led to the Holocaust (Return of Cultural Objects) Act 2009, which allows 17 United Kingdom collections to return items lost during the Nazi era where this is recommended by the SAP. Once the new legislation was in force the Missal claim was referred back to the SAP, which recommended in 2010 that the Missal be permanently returned to the claimant.

In 2006 the heirs of the late Dr Arthur Feldman referred the matter of four drawings acquired by the British Museum in the 1940s to the SAP. The SAP concluded that the evidence showed that these four drawings were in all probability in Dr Feldman's possession at the time of the confiscation of his collection by the Gestapo in 1939. While the SAP acknowledged that the claimants had no legal basis for a claim to compensation, they had a moral claim, which should be recognised in an ex gratia payment by the government of £175,000.

Also in 2006, the SAP for the first time recommended the rejection of a claim. The claim was by the heirs of Jakob Goldschmidt to a painting (Portrait of a Young Girl in a Bow Window, attributed to Nikolaus Alexander Mair von Landshut) in the Ashmolean Museum in Oxford. Jakob Goldschmidt had been a well-known German banker and art collector in the 1920s and 1930s. The heirs had claimed that the von Landshut painting was one of many sold under duress by Goldschmidt during 1933. The SPA concluded that Goldschmidt had indeed

sold his assets, but that this was because the bank that he had been in charge of had collapsed. The sale of the painting had occurred because Goldschmidt was personally liable for the bank's debts, and not as a result of persecution by the Nazi regime. The SPA concluded that the moral force of the claimant's case was weak and that no moral obligation rested on the Ashmolean. It therefore recommended rejection of the claim.

This was then followed in 2007 by a further rejection recommendation, this time in relation to a claim by the granddaughter of the late Franz W. Koenigs in respect of three paintings in the possession of the Courtauld Institute of Art. In 1940 the paintings had been on loan to a museum, but were also collateral for a loan. When her grandfather's bank went into liquidation the paintings were sold, in order to repay the bank's debts, to a collector, Count Antoine Seilern, who subsequently bequeathed them to the Home House Society (the predecessor of the Samuel Courtauld Trust) in 1978. The granddaughter argued that the paintings were sold for less than their true value as a result of a conspiracy by two persons connected with the museum, and that the sale must have been made under duress. The SAP recommended rejection of the claim on the basis that the Koenigs family were not deprived of the paintings by theft, by forced sale or by sale at an undervalue.

2008 brought a claim by the heir of Heinrich Rothberger concerning two pieces of porcelain which were said to have been seized from him by the Gestapo in Vienna in 1938. The pieces of porcelain were in the British Museum, London and the Fitzwilliam Museum, Cambridge. The SAP concluded that the claimant had a strong moral claim to the items. As the Holocaust (Return of Cultural Objects) Act 2009 was not yet in force, the piece in the British Museum could not be restituted due to a deaccessioning prohibition in the British Museum Act 1963. As a result the SPA recommended that the government make an ex gratia payment of £18,000 and that the British Museum should acknowledge the history of the piece whenever it is published or exhibited. The piece in the Fitzwilliam Museum was not subject to the British Museum Act 1963 prohibition, so the SAP recommended that it should be returned to the claimant.

In 2009 the SAP considered a claim by the heirs to the late Professor Dr Curt Glaser to eight drawings in the collection of the Courtauld Institute of Art in London. The SAP took the view that the Courtauld had good legal title to the drawings as any claim by Professor Dr Curt Glaser would be time barred under the Limitation Act. The SAP then considered whether, even in the absence of a legal claim, Dr Curt Glaser might have a moral claim. It concluded that while the predominant reason for Professor Dr Curt Glaser's sale of the drawings in 1933 was Nazi oppression, the sale of the works was conducted by Dr Glaser himself, and that the prices he had achieved suggested that the sale was not at an undervalue. The moral claim was therefore insufficiently strong to warrant the restitution of the drawings. The SAP recommended, however, that whenever any of the drawings were on

show, the Courtauld should display alongside it a brief account of its history and provenance during and since the Nazi era, with special reference to the claimants' relationship with and historical interest in the drawings.

2010 brought a further rejection. On this occasion the claimants were the heirs to Herbert Gutmann, a prominent German banker and art collector who sold The Coronation of the Virgin in 1934 to pay off business debts. The painting is now in the possession of the Samuel Courtauld Trust. It was argued by the claimants that some of Gutmann's debts were fabricated by the Nazis and others were the result of Nazi persecution in his business affairs. This was rejected by the SAP, which concluded that, while there was some evidence that Gutmann had suffered from antisemitic persecution under the Nazi regime, it was only a subsidiary and causally insignificant factor in his decision to sell his collection. The SAP also found that he achieved a fair price for the sale of the painting. The SAP concluded that the claimants' moral case was therefore weak and that the painting should not be restituted to the claimant.

2014 proved to be a busy year for the SAP. In March 2014 it issued a decision in relation to a painting by John Constable, Beaching a Boat, Brighton, which was in the possession of the Tate Gallery. The SAP concluded it was likely that the painting belonged to a Hungarian art collector in 1944, at the time when German forces invaded Hungary, and that it was consequently looted by the occupying forces. The recommendation of the SAP, therefore, was that the Tate should return the painting to the heirs of the art collector (who wished to remain anonymous). This recommendation was reviewed by the SAP in 2015 following the discovery of further information, and the 2014 decision was upheld.

Also in 2014, the SAP published reports on a number of claims by the heirs of the art collector Emma Budge for the return of objects from various United Kingdom museums. The heirs claimed restitution of three Meissen figures from the collection of the Victoria and Albert Museum, a silver-gilt renaissance salt in the possession of the Ashmolean Museum, a tapestry fragment in the collection of the Burrell Collection in Glasgow and four Nymphenberg figures from the Cecil Higgins Gallery in Bedford. The SAP confirmed that after the death of Mrs Budge in 1937, her art collection had been sold by the auction house of Paul Graupe, and, crucially, that her family had been deprived of the proceeds of the sale of the collection. The SAP recommended that in the circumstances, the Victoria and Albert Museum and the Cecil Higgins Gallery should offer to return the figures claimed from their collections, and the Ashmolean Museum should return the salt to the estate of Mrs Budge. However, the SAP noted that Mrs Budge had expressed the wish that, following her death, some or all of her art collection should go to museums in Germany or abroad. As a result, the SAP suggested that the executor of Mrs Budge's estate give consideration to the possibility of one of the Meissen figures remaining in the possession of the Victoria and Albert Museum. In rela-

tion to the tapestry fragment in the Burrell Collection, the SAP recommended that the Burrell Collection should make an ex gratia settlement payment to the estate reflecting the current market value of the tapestry.

In the same month, the SAP ruled in relation to another sale through the Paul Graupe auction house. This time the object in question was a painted wooden tablet, the Biccherna SPA, in the collection of the British Library. The SAP reached the view that the Biccherna SPA had been owned by a Munich art gallery, itself owned by Jewish shareholders. It believed that the wartime sale by the Graupe auction house was a forced sale, having been triggered by an extortionate tax demand from the Nazis. The SAP concluded that the Biccherna SPA should be returned to the heirs of the shareholders of the gallery.

In 2015 the SAP considered a claim on behalf of Margraf & Co GmbH, a company owned by Jakob and Rosa Oppenheimer and liquidated by the Nazis in the late 1930s. The claim related to an oil painting by Pierre-Auguste Renoir entitled Cros de Cagnes, Mer, Montagnes, which was now in the possession of Bristol City Council. On this occasion the SAP rejected the restitution claim, concluding that while the loss of the painting amounted to a forced sale, it was not as a result of Nazi persecution but rather as a direct result of Margraf's bankers' legitimate exercise of their commercial rights over the painting in order to ensure repayment of a significant debt accrued by the Margraf group. That debt had arisen before the Nazis had come to power. The SAP recommended, however, that the Oppenheimers' connection with the painting should be incorporated into its narrative history when on display.

In 2016 the SAP considered a claim for a gothic ivory relief showing a man and woman playing chess, originally from the collection of Max Silberberg, a German Jewish businessman and art collector. The ivory was in the possession of the Ashmolean Museum. The claim was based on the fact that in 1933, Max Silberberg and his family were forced to sell their house and subsequently their artwork at auction in Berlin in 1935 and 1936. The SPA concluded that Max Silberberg was in financial difficulty which was unconnected with the Nazis, and the Berlin sales were neither forced sales nor sales at an undervalue. The SPA also concluded that Max Silberberg had received the proceeds of the sale at the time. The SPA therefore rejected the claim.

The SPA has over the years been extremely successful in resolving many of the claims before it. It has done so without applying the complex legal rules applicable to such cases and has instead approached each case with an eye to resolving claims in an equitable manner. The diversity of the findings suggest that it has done so without allowing itself to be pressured, either by the museums or by the claimants. However, at the time of writing the SPA has not made a recommendation on a case since 2016. Perhaps the SPA has fulfilled its role in connection with public collec-

tions. It will therefore be interesting to see whether in future it will have the opportunity to consider claims which do not relate to artworks in museum collections.

10.1.6 Holocaust (Return of Objects) Act 2009

As explained above, this legislation was introduced when it was discovered that where the SAP recommended the return of an object to the claimant, national institutions were forbidden by legislation from deaccessioning items, even where they were judged to have been stolen. The Holocaust (Return of Objects) Act 2009 changed that anomaly, allowing national institutions to return treasures to claimants if the SPA recommended the return and the government agreed.

10.1.7 Immunity from seizure in the United Kingdom

Part 6 of the Tribunals, Courts and Enforcements Act 2007 provides immunity from seizure for cultural objects loaned from overseas to temporary public exhibitions in approved museums or galleries in the United Kingdom.

This legislative initiative followed a controversial seizure in 2005, when 54 paintings were seized by customs officers in Martigny, Switzerland. The pictures had been loaned to the Pierre Gianadda Foundation by the Pushkin State Museum of Fine Arts in Russia. They were impounded by the Swiss authorities after they had left Martigny following the three-month loan. The seizure was ordered by the Swiss court at the request of a Swiss import and export firm, Noga SA, who claimed that the Russian government owed it several million dollars in unpaid debts. This gave rise to a concern on the part of cultural institutions in the United Kingdom that cultural objects on loan from foreign countries in British museums could be similarly seized – and that this possibility could discourage foreign countries and institutions from lending artworks to United Kingdom museums. It was therefore decided to introduce antiseizure legislation in the form of the Tribunals, Courts and Enforcements Act 2007. The Act provides immunity from seizure for qualifying cultural objects. To qualify for immunity:[12]

- the object must usually be kept outside the United Kingdom;
- the object must not be owned by a person who is resident in the United Kingdom;
- the import of the object must not be in breach of any law;
- the object must be brought into the United Kingdom for the purpose of a temporary public exhibition at an approved museum or gallery;
- the museum or gallery must have published information about the object where required to do so by regulations.

[12] Section 134(1) and (2) Tribunals, Courts and Enforcements Act 2007.

An approved institution will be an institution considered by the United Kingdom government to have adequate procedures for establishing the provenance and ownership of objects. The institution is also required to publish information relating to the objects on loan, including the name and address of the lender or his agent, a description of the object(s) for which immunity is being sought, details of the object's provenance and information concerning the exhibition. More specific information must be disclosed to potential claimants on request, unless the request is unreasonable. This information requirement is designed to ensure that, even if claimants are unable to seize the object while it isn't in the United Kingdom, they have the necessary information to do so once the artwork has returned to its country of origin. The information must be published for a minimum of four weeks before the date on which the object enters the UK and for an additional period of at least 12 weeks or until the exhibition closes, whichever is the longer.

If protected by this legislation,[13] the object is protected from any civil or criminal measures or investigations in the United Kingdom against the artwork, the owner, the museum or gallery or any other person. This means that claims by creditors of the lender, or ownership claims – including Holocaust restitution claims – cannot be pursued in the UK courts where they are intended to result in the seizure of the artwork. There is an exception to this rule, however. A protected object can be seized where the United Kingdom court is obliged to make a seizure order as a result of an EU obligation or any international treaty. As a result, there would be no immunity if a request was made by another EU Member State for the return of an object under the 1993 EU Directive on the Return of Illegally Removed Cultural Property or pursuant to a claim from a signatory State to the 1970 UNESCO Convention or the 1954 Hague Convention for the Protection of Cultural Property in the Event of Armed Conflict.

This legislation was controversial among organisations representing Holocaust victims as it was thought to be likely to prevent victims taking action to recover works looted from them during the period 1933–45.

10.1.8 US court jurisdiction and Holocaust claims

We have seen that Holocaust claims tend not to be litigated due to the cost and legal uncertainty. Where they are litigated, however, the choice of court is often critical to the success or failure of the claim. Claimants are often keen to bring claims before US courts, perhaps because there is a perception that US courts will be more sympathetic to such claims or perhaps because there is a fear that the courts of the country in which the alleged confiscation happened are likely to be less sympathetic. While this book is focused on UK law, it is relevant on this point

[13] Section 135 Tribunals, Courts and Enforcements Act 2007.

to look at US law because the question of whether the US courts have jurisdiction over Holocaust restitution claims is a recurring theme and relevant to the pursuit of restitution claims.

One of the first cases in which the parties battled hard over the question of jurisdiction was the claim by Maria Altmann against the Austrian State for the return of a number of works by Gustav Klimt which had belonged to her Jewish ancestor Adele Bloch-Bauer and her husband Ferdinand. These works were in the Austrian Gallery in Vienna and it was alleged by Altmann that they were there because they had been wrongly taken by the Austrian State during the 1930s from Ferdinand Bloch-Bauer. When the Austrian Restitution Commission turned down Altmann's claim on the grounds that the paintings had been gifted to the Austrian State in her will by Adele Bloch-Bauer, Altmann was left contemplating having to start a legal claim in Austria. A claim before the Austrian courts faced great legal and financial obstacles – not least the requirement of payment of a bond of US$2,000,000 as a precondition to issuing proceedings. Altmann's lawyer therefore decided instead to try to litigate the case and sue the Austrian State before the US courts. He believed that he would have a greater chance of success before a US jury and that the commencement of proceedings would not involve the payment of the bond. The difficulty he faced was that since 1976 the US Foreign Sovereign Immunities Act (FSIA) had provided sovereign states immunity from prosecution in the United States Courts. Austria argued that this law prevented the US court accepting jurisdiction. The fact that the events complained of had occurred before 1976 was not an issue, Austria contended, because the FSIA was in effect retrospective. Austria contended that the FSIA had established a principle that claims against sovereign states should be pursued in the court of the state in question. Altmann's case was that the law applied only to events after 1976, that the FSIA did not therefore apply to her claim and that she should as a result be permitted to pursue her case before the US courts. The case went to the US Supreme Court which ruled, in 2004, in Altmann's favour. The ruling did not overturn the FSIA principle that foreign sovereign nations are immune from litigation in US courts. It also agreed with Austria that the FSIA was retrospective. However, the Court found that the principle did not apply where the complainant was not a national of the state in which the events complained of had occurred. In this case Ferdinand Bloch-Bauer was a Czech national and not a national of Austria, and his descendants were therefore not bound to pursue their claim in Austria. From a tactical perspective the Supreme Court's decision tipped the balance heavily in Altmann's favour. Austria knew that if it litigated in the US it risked losing. Altmann however also knew that the litigation could last years. The parties therefore agreed to a one-day binding arbitration hearing in Austria. The arbitration took place in 2006 and the arbitration court's decision was that the instruction in Adele Bloch-Bauer's will to her husband to donate the paintings to the Austrian State had been a non-binding expression of wish and that this wish could not be binding in this case because the

paintings were owned by Adele's husband. The paintings were therefore returned by the Austrian State to Altmann, who sold them privately and at auction.

There was an expectation, following the Altmann case, that US courts might accept jurisdiction for restitution claims by victims of the Holocaust. In fact, that did not turn out to be the case and the US courts have remained cautious about accepting jurisdiction in cases where the case would ordinarily be litigated in the country where the alleged wrong occurred. This was illustrated in the 2021 case of *Federal Republic of Germany v Philipp* relating to the Guelph Treasure. The Guelph Treasure is a medieval treasure said to be worth €200m, which is on display at the Kunstgewerbemuseum in Berlin. It had been alleged by the descendants of a group of Jewish collectors that the collectors had been forced to sell the treasure to the Nazis in the 1930s. The claimants argued that the immunity afforded by the FSIA to foreign states should not apply as the taking of the property in this case amounted to a violation of international law. The Supreme Court however refused to accept jurisdiction for the claim, deciding that the taking of property by the state from its citizens was a matter of domestic rather than international law. It therefore unanimously rejected the argument that the German State could be sued in the US for taking art from German citizens.

10.1.9 Holocaust looted art databases

The release in the mid-1990s of government information and archives, and the huge amount of research which has since been carried out into the extent of the wartime thefts, has led to the establishment and development of a number of online databases. These databases are consulted by those involved in the art market in order to determine whether an artwork is recorded as being lost or confiscated during the period 1933–45, or whether there is anything in the known provenance of the artwork which might suggest that the work may have been looted. Typically, these databases will include lists of stolen works and/or names of victims of looting or persons or organisations involved in the looting.

The key databases used for this purpose are:

- Lost Art – www.lostart.de
- ERR Database – www.errproject.org/jeudepaume/
- Art Loss Register – www.artloss.com
- Central Registry – www.lootedart.com
- Munich Central Collecting Point – www.dhm.de/datenbank/ccp/dhm_ccp .php?seite=
- Sonderauftrag Linz (Hitler's Museum) – www.dhm.de/datenbank/linzdb/ indexe.html
- Goering Collection – www.dhm.de/datenbank/goering/dhmgoering.php?seite =9

- Getty Research Institute German Sales – www.getty.edu/research/tools/provenance/german_sales.html
- UB Heidelberg Auktionskatalogs (Drouot) – http://digi.ub.uni-heidelberg.de/de/sammlungen artsales.html
- Freie Universitat Forschungstelle Entartete Kunst database – http://emuseum.campus.fu-berlin.de/eMuseumPlus?service=ExternalInterface&lang=de
- Fold 3 Historical Military Records Holocaust Collection – www.fold3.com

One of the difficulties with databases of this kind is that it is sometimes relatively straightforward for a claimant to secure the inclusion of an artwork on a database of stolen art. Databases will usually agree to the inclusion if the claimant is able to put forward a plausible argument that an artwork was stolen or that such a possibility cannot be ruled out. This can lead to disputes where the current owner of the artwork believes the claim to be misconceived or legally unjustified. Databases argue that they serve simply as notice of the existence of a claim rather than confirmation of the claim's validity. However, the difficulty is that the inclusion of an artwork on a database of stolen art means, in practice, that the artwork cannot be sold. This is a powerful tool in negotiations over title disputes – particularly where the law is not an option for the claimant due, for example, to lack of conclusive evidence, expiry of limitation periods or intervening good faith purchases. Databases are conscious of this and do therefore tend to exercise some judgement in determining what works should and should not be listed. The exercise of that judgement, however, can be controversial. The German database lostart.de removed 63 artworks by Egon Schiele at the request of three dealers. The artworks had been claimed by the heirs of the Jewish collector Fritz Grünbaum, who died in the Dachau concentration camp. The heirs argued, without success, that the works should be relisted on the basis that it was not for lostart.de to determine the validity of restitution claims – merely to note the existence of the claim. In a separate 2020 case, a German court ruled that the current owner of an artwork did not have the right to prevent a claimant, the heirs of the Jewish art dealer Max Stern, from registering the claimed artwork on lostart.de. The Court took the view that the inclusion of the artwork on the database did not constitute a claim. This is certainly consistent with the approach taken by most databases but it does not address the consideration that deciding whether or not to include a work on a database carries significant responsibility, as the effect of doing so is to render the artwork unsaleable. There is no caselaw on this point in the UK courts but it is likely that the courts would agree that the database is not required to require the claimant to prove ownership, but rather that he or she has a *bona fide* claim which has some evidential basis. The court might also look closely at the motivation of the claimant. A listing based on a good faith claim is unlikely to be objectionable, but a malicious or false claim which has no evidential support and is intended only as a device to bring the owner to the negotiating table and/or deliberately disparage the title of the person who owns the artwork may in some cases be actionable (see section 15.2.6 Slander of Goods and Title).

10.2 Cultural property and heritage

Today the art market is global as never before. However, moveable art – just like culture and language – has never been static. While it may be easier now to purchase a work of art in New York and then fly it to Beijing, the movement of art across cultures, time and territories is no new phenomenon. The drivers for this movement are and always have been varied.

The primary, and by far the largest, driver for the movement of art and crafts has always been trade. Since man first began to travel along trade routes, artworks and crafts have been exchanged and traded alongside commodities. This trade benefited artists and craftsmen and had the effect of spreading artistic and cultural influence. This transfer of art from one person to another across territories and time has since the beginning of time brought pleasure, education and cultural exchange. The appreciation of art, its study and its conservation has also in large part been responsible for the survival of artworks that might otherwise have deteriorated or been destroyed. In this context the movement of art through trade is unambiguously a force for good.

However, there have historically been, and in some cases continue to be, other, more controversial drivers for the movement of art. And it is these more controversial drivers which have fuelled a debate today over the ownership of cultural property and ancient art. That debate is sparked by the countries claiming repatriation of lost cultural property, which, for the purposes of this chapter, we shall call 'source countries'.

Art has long been seized as the prize of conquest in wartime. Pillage has often been considered, by the victor at least, to be the entitlement of the conqueror and the destruction and theft of artwork is a recurring theme in wars waged over time all over the world. While the primary motivation for the confiscation of a nation's artworks is the enrichment of the victor, the removal of a country's cultural and artistic expression also serves as an attack on the identity of the subjugated people. This is no recent phenomenon. In 455 ad the Vandals invaded and extensively looted Rome; in 870 the Byzantine city of Mdiona in Malta was sacked by the Aghlabids; and between 1000 and 1027 the Indian cities of Somnath, Mathura and Kannauj were repeatedly plundered. In 1204 the riches of Constantinople were brought back to Italy by the crusaders after the siege of the city. Between 1804 and 1814 Napoleon Bonaparte engaged in systematic looting throughout Europe and Africa. In 1860, the Yuan Ming Yuan Summer Palace in Beijing was plundered, and in 1900 Beijing was pillaged when European forces invaded China to put down the Boxer uprising. More recently, between 1933 and 1945 Germany and Japan engaged in extensive looting of the countries they occupied, with Hitler and Goering vying with each other to build the most impressive art collection.

Destruction and looting of treasures remains a tragic feature of war and conflict – as we have seen most recently in Afghanistan, Iraq and Syria.

Colonialism also provided the opportunity for the colonial power to acquire works of art from sometimes unwilling, sometimes merely compliant indigenous populations. Modern state colonialism began in the fifteenth century with the Portuguese and Spanish led age of discovery. That period was characterised by widespread looting of arts and crafts which incorporated gold and silver. The colonialists felt a moral obligation to bring Christianity to South America and an ambitious project of this kind required extensive financing. Memorably, King Ferdinand of Spain instructed his conquistadors to 'get gold, humanely, if you can, but at all hazards, get gold'. The conquistador Cortes conquered the Aztec king Montezuma in order to acquire the Aztecs' vast stores of gold. Attention then turned to the Incas in Peru, defeated by Francesco Pizzaro. The gold treasures of the Incas were also confiscated. Finally, it was Colombia's turn, and this time it was Gonzalo Jiménez de Quesada who oversaw the looting of the goldhoarding civilisation known as the Muisca. The Spanish and Portuguese colonisation of South America was the starting point for a trend of colonialism by other states throughout Africa, America and Asia between the fifteenth century and 1914. The Belgian, British, Danish, Dutch, French, German, Italian, Portuguese, Russian, Spanish and Swedish empires all established colonies across large areas. Japan, the Ottoman Empire, China and the United States also became colonial powers. While there were some benefits for the colonised country, such as trade and investment in infrastructure, there were also negative consequences, which could include the subjugation of inhabitants, the removal of resources and the acquisition of artwork and treasures.

Exploration and tourism have also provided an opportunity for art to be acquired and transported out of the source country. While today the acquisition and export of artworks are more strictly regulated, in many countries export restrictions are a relatively recent development. Explorers and tourists in the nineteenth and early twentieth centuries were often free to bring back the ancient objects they found or bought in the countries they visited.

Academic interest and the desire to populate museums have also fuelled excavations, often with the consent of the source country at the time of the excavation. Such excavations have undoubtedly revealed buildings and ancient artworks which might otherwise never have seen the light of day, contributing to our understanding of ancient cultures. However, they have also resulted in large quantities of cultural property being taken abroad to be displayed in museums. Museums argue that their function is the education of mankind in the culture and history of mankind. They say that they fulfil the functions of preserving the object while educating the public and providing wide access to important objects – none of which would happen if the works were left in the source country. They also point

out that many of these objects would not have survived had they remained in their countries of origin, without the stewardship of collectors and museums.

Poverty and conflict are other powerful drivers in the movement of art. In countries affected by poverty and conflict, desperate inhabitants are led to excavate sites of historical interest, seeking to sell whatever they find in order to make ends meet. Aerial photographs of historic sites all over the world show the same landscapes pockmarked with hundreds of holes where local residents armed with pickaxes and shovels have dug pits in search of archaeological remains to sell on to middlemen.

Because these drivers raise questions over the manner in which art moved from the source country, there has, since the 1970s, been a growing argument that antiquities should be returned to the source countries in which they were found, on the grounds that they were wrongly taken in the first place. This argument is fuelled by a sense of injustice over the past and a sense that the repatriation of culture is critical to the identity and self-esteem of the source country. The argument is based on the premise that objects of cultural, artistic or historical significance belong to the territory or population where they were created. The central theme to the argument, from an artistic and academic perspective, is the contention that, outside of the context in which it was created, an ancient object loses its historical, artistic and educational value.

There are also strong political aspects to the argument. The fact that antiquities are to be found in collections and museums outside the source countries is often seen by those countries seeking restitution as evidence of the imbalance of power between the first and third world countries. Added to this, the existence of important artworks outside a source country is often a painful reminder to that country of humiliating or tragic historical events. This sense of injustice is strong even in circumstances where artworks were acquired in conditions which at the time were lawful. For this reason, the issue of repatriation and ownership of ancient art is as political as it is ethical.

Example

- Easter Island is famous for its mysterious massive statues. Each of the 887 figures on the island are thought to represent tribal leaders or deified ancestors.
- In 1868 the British frigate HMS Topaze visited the islands and the crew found a two and a half metre high statue, known by the islanders as 'Hoa Hakananai'a', buried in the earth up to its shoulders. The crew excavated the sculpture and pulled it along the ground on a sledge for three miles, floating it out to their ship on a raft made with empty casks. On its return to Britain the statue was presented to Queen Victoria; since then it has been on display in

the British Museum in London. Hoa Hakananai'a is one of the best examples of the Easter Island sculptures, but it is not the only one outside of the island. There are examples in Chile, Belgium, the United States, France and New Zealand.

- At the time of writing, Easter Island has been pressurising the British Museum, through the press and political channels, to return Hoa Hakananai'a. The basis of the claim is that it was removed 150 years ago without the permission of the Easter Islanders and that the island is now missing a crucial part of its cultural heritage.

- The question with which the museum, archaeologists, politicians and the public are wrestling is whether an object of this importance can justifiably be held in a museum, far away from its cultural context. This is far from a unique case. Questions of this kind are being asked of museums and collectors all over the world and the answers are not obvious. In this case, for instance, visiting Easter Island is an impossibility for most people. If examples of such works are not available in museums they will remain largely unseen. There are also many examples remaining on the island. Does the absence of one example materially lessen the island's cultural heritage? The removal may not have been authorised, but it could be argued that it happened a long time ago, at a time when there were no legal restrictions on the removal of cultural property from the island. The museum is no doubt also concerned that agreeing to return the statue would set a precedent and open the floodgates to demands for the return of objects throughout its collection. On the other side of the argument, it is argued, with some justification, that the statue was removed without permission, and in an act of colonial dominance. The statue is also one of the best examples of its kind and would not be at any risk of damage if it were returned to its original site. What is its educational value or artistic impact when, rather than sitting majestically on the island staring out to sea, it sits in the sterile museum environment? Perhaps most importantly, the islanders say it has an important spiritual and ancestral connection for them. This is just one example of the complex questions that now surround ancient art.

Against this background of both legitimately and illegitimately sourced ancient art, the debate over what is or is not licit, and what it is ethical to own or trade, is extremely complex. There is a wide spectrum of views, ranging from those who believe that all antiquities should be freely traded to those who believe that all antiquities should be returned to their source country. Even among those with less polarised views there is little agreement on what is licit and illicit. Faced with this wide divergence in perspectives, it is not surprising that international law on the subject of cultural property has tended to be a compromise which has satisfied neither side of the debate. In what follows, we will first analyse the relevant international conventions and then examine national United Kingdom law.

10.2.1 International conventions on cultural property protection

10.2.1.1 1954 Convention for the Protection of Cultural Property in the Event of Armed Conflict

The Convention for the Protection of Cultural Property in the Event of Armed Conflict 1954 was the first international treaty with a worldwide ambit designed to protect cultural heritage in the event of armed conflict.[14] Its provisions included:

- peacetime measures designed to safeguard cultural property, including the preparation of inventories and emergency planning measures, including plans for the removal or protection of cultural property;
- measures to ensure that cultural property is not exposed to or targeted for destruction or damage in the event of armed conflict;
- proposals for the creation of an international register of cultural property under special protection;
- marking of certain important buildings and monuments with an emblem to indicate protected status;
- establishment of special units within military forces to be responsible for the protection of cultural property.

Signatory states to the 1954 Hague Convention were required to enact national legislation to make unlawful certain acts in relation to cultural property, including:

- attacking or targeting cultural property under enhanced protection;
- using cultural property under enhanced protection or its immediate surroundings in connection with military action;
- destruction or appropriation of protected cultural property;
- theft, pillage, misappropriation or vandalism directed against protected cultural property.

In large measure as a result of the conflicts in Syria and Iraq, the United Kingdom acceded to and ratified the 1954 Convention for the Protection of Cultural Property in the Event of Armed Conflict. Its accession took place in 2017 – more than 50 years after the Convention came into being. The domestic legislation in which the 1954 Convention was enacted is the Cultural Property (Armed Conflicts) Act 2017 (see section 10.2.2.4).

[14] Often referred to as the 1954 Hague Convention.

10.2.1.2 *1970 UNESCO Convention on the Means of Prohibiting and Preventing the Illicit Import, Export and Transfer of Ownership of Cultural Property[15]*

The 1970 UNESCO Convention was an instrument born of compromise. The first draft tabled required all parties to impose export controls on cultural property and prohibit imports of any item without an export licence from the source country. This was rejected by the United States as unworkable. The compromise was a more targeted but far less revolutionary convention.

The effect of the UNESCO Convention, as it was eventually agreed and implemented, is to encourage signatory States to introduce national laws in their countries to support the three main objectives of the Convention. These are:

1. preventative measures to impede the illicit import and export of cultural property from their territory;
2. measures to recover and return cultural property illicitly stolen from other signatory States and imported after the entry into force of the convention; and
3. a commitment to cooperate between signatory States and provide assistance through the creation of export and import controls.

It is important to note that the UNESCO Convention leaves it to the signatory States to decide for themselves how their national laws will be framed to achieve these objectives. The national law introduced in the United Kingdom to implement the objectives of the UNESCO Convention is the Dealing in Cultural Objects (Offences) Act 2003.[16] Other countries, such as the United States and Switzerland, chose, instead of introducing local legislation, to implement the UNESCO Convention requirements by entering into targeted bilateral agreements with individual countries.

The UNESCO Convention was eventually signed by 129 Member States. However, that process took place over many decades. It was only ratified by the United States in 1983, and by the United Kingdom in 2002. That delay is important because neither the Convention nor the national legislation introduced in the United Kingdom and the United States are retroactive.

It is often incorrectly thought that the UNESCO Convention date of 1970 is a threshold date with legal force. It has been suggested that any cultural property in open circulation outside of its country of origin prior to that date is licit, whereas anything taken from a source country after that date is illicit. That is certainly not the legal position, as the UNESCO Convention only has effect in its

[15] Often known as the 1970 UNESCO Convention.
[16] See section 10.2.2.1 below.

signatory countries when and to the extent that the signatory country introduces national legislation pursuant to the UNESCO Convention requirements.[17] Many source countries also object to the notion of 1970 as a threshold date, as they argue that to do so implicitly legitimises objects illicitly removed from source countries prior to 1970.

10.2.1.3 1995 UNIDROIT Convention on Stolen or Illegally Exported Cultural Objects

Source countries soon became frustrated with what they felt to be the limitations in the 1970 UNESCO Convention, and sought to redress its perceived shortcomings through a further convention – the 1995 UNIDROIT Convention on Stolen or Illegally Exported Cultural Objects.[18] The provisions of this convention are weighted in favour of the source country seeking restitution of cultural property. One of the frustrations of those seeking restitution of cultural property following the 1970 UNESCO Convention was the continuing need for the claimant to prove that the claimed object had been stolen and that the claimant had legal title. How and when objects were acquired or discovered and then left their country of origin is usually difficult or impossible to prove – particularly in cases of clandestine excavations. The UNIDROIT Convention seeks to address this by creating a uniform law which requires the return of an object without the need for the claimant to provide proof of the actual theft.

Source countries have also long argued that noncompliance with export requirements should form a valid basis for a restitution claim. The suggestion has been that the absence of a valid export licence should constitute proof of illicit origin. This has been resisted by many countries on the basis that border control is the responsibility of source countries and that it is not for other countries to enforce the source country export controls, particularly where the border controls have not proved effective. There are many practical considerations which complicate this argument on both sides. Export controls on cultural property are a relatively recent phenomenon, and, when introduced, tend to introduce blanket prohibitions on the export of ancient cultural property. Export documentation is often lost, not retained or kept by the country issuing the licence. As a result, it is rare to find ancient objects accompanied by an export licence – either because they left the country prior to the existence of export controls or because the blanket prohibition encouraged smuggling out of the country or nonenforcement. Source countries point to the lack of export licences as proof of the scale of illicit trafficking, while critics argue that it merely reflects overregulation by source countries, together with a lack of enforcement. The UNIDROIT Convention sought to settle

[17] See Jeddi v Sotheby's & Ors. [2018] EWHC 1491.
[18] Also known as the 1995 UNIDROIT Convention.

the argument by giving claimants a right to claim restitution on the grounds of illegal export (Article 1).

Unlike the 1970 UNESCO Convention, which merely established the right of a signatory State to ask another signatory State to restitute an object, UNIDROIT creates a right of legal action which can be initiated by private individuals. UNIDROIT also provides that even if the current possessor acquired the object in good faith, he or she will not have good title and will be obliged to return it. Compensation will be paid, but only if the current possessor can show that he or she acquired it in good faith and exercised due diligence prior to acquiring it (Article 6).

Finally, the UNIDROIT Convention sought to surmount another obstacle to restitution claims: periods of limitation. The UNIDROIT Convention provides that any claim for restitution shall be brought within a period of three years from the time when the claimant knew the location of the cultural object and the identity of its possessor. The Convention also provides for a backstop, ruling out claims after the expiry of 50 years from the time of the theft (Article 3.3). However, this backstop does not apply to cultural objects that form an integral part of an identified monument or archaeological site, or which belong to a public collection (Article 3.4). In addition, a Contracting State may declare in the case of certain objects that an extended time limit of 75 years or longer should apply, if this is required under its national law (Article 3.5).

All of these measures were designed to tip the balance back towards those making ownership claims, and place the burden of disproving the ownership claim on the person in possession of the object. These requirements were felt by the countries with art markets to be unfair to owners of ancient objects, and as a result only 29 countries have signed the convention. The United Kingdom is not a signatory and is not therefore bound by the UNIDROIT Convention.

10.2.1.4 European Directive on the return of cultural objects unlawfully removed from the territory of a Member State

The European Union has, since 1993, legislated for the physical return of cultural objects that have been unlawfully removed from EU countries' territory. This legislation aims to balance the EU's principle of free movement of goods with the protection of national treasures. This legislation is applicable to the European Economic Area countries.

The central purpose of the 1993 Directive was to establish a procedure for the return of cultural objects unlawfully removed from one EU Member State to another. To qualify for return under the Directive, a cultural object must be identified by the source country as a national treasure possessing artistic, historic or

archaeological value under national legislation. Member States are required under the 1993 Directive to cooperate in locating, identifying and securing the return of unlawfully removed cultural objects.

There are time limits for bringing court proceedings for the return of qualifying objects. Proceedings must be brought within three years of discovering their location and the identity of the person holding them. There is in most cases a backstop limitation period of 30 years from the date the object was removed from the source country, after which no proceedings can be brought, regardless of when the location of the object or identity of the holder is discovered.

Compensation is available to the owner of an object restituted pursuant to the 1993 Directive only if the owner proved that he or she exercised 'due care and attention' in acquiring it.

As with most legislation relating to cultural property, the 1993 Directive is not retrospective. It therefore applies only to cultural objects unlawfully removed from a Member State on or after 1 January 1993.

10.2.2 United Kingdom cultural property protection legislation

Those handling cultural property in the United Kingdom need to be aware of a number of different laws, most of which are inspired or required by the international conventions referred to above.

Of general application is the Dealing in Cultural Objects (Offences) Act 2003, which relates to all tainted cultural objects which left their country of origin before 2003. The Iraq Sanctions Order and the Syria Sanctions Order apply to cultural property illegally removed from Iraq and Syria since 1990 and 2011 respectively. The Cultural Property (Armed Conflicts) Act 2016 applies to cultural property from occupied countries since 1954.

Anyone buying, selling, importing or exporting ancient cultural property – particularly of an archaeological or architectural type – should ensure that they have satisfied themselves that the object they are handling does not fall within the prohibitions set out in these acts and orders. The consequences of ignoring a warning sign or failing to carry out due diligence are extremely serious – even for those acting in good faith.

10.2.2.1 *Dealing in Cultural Objects (Offences) Act 2003*

The Dealing in Cultural Objects (Offences) Act 2003 is the legislation introduced following a 2000 recommendation from the Ministerial Advisory Panel on Illicit Trade, chaired by Norman Palmer QC. The recommendation was that the United

Kingdom should accede to the 1970 UNESCO Convention. The 1970 UNESCO Convention required signatory countries to introduce legislation at national level to combat the illicit trade in cultural property (see section 10.2.1.2). The Ministerial Advisory Panel advised that United Kingdom law as it stood was sufficient to meet that requirement, provided the criminal law was changed to include a criminal offence of trading in cultural property which had been stolen, illegally excavated or illegally exported. The Dealing in Cultural Objects (Offences) Act 2003 was therefore enacted and is now the central piece of United Kingdom legislation relating to the prevention of illicit trade in cultural property.

The central objective of the legislation is to combat the traffic in cultural objects which have been unlawfully removed from buildings, monuments or wrecks, or excavated from historic sites within or outside the United Kingdom, whether on land, underground or underwater. At its heart is the criminal offence of dishonestly dealing in a tainted cultural object, knowing or believing that the object is tainted (s 1). The offence carries a maximum prison sentence of seven years and/ or an unlimited fine (s 1(3)).

A 'cultural object' is very broadly defined as an object of historical, architectural or archaeological interest (s 2). It is 'tainted' if after 20 December 2003 it is removed from a building, structure or monument (including caves or wrecks) of historical, architectural or archaeological interest or is excavated, and the removal or excavation was a criminal offence at the time it was done either in the United Kingdom or the country in which the removal or excavation took place (ss 2(2) and 2(3)).

To commit an offence, a person must have committed a prohibited act in relation to the tainted object (s 3(1)). He or she will have to import or export the tainted cultural object, or acquire or dispose of it. However, he or she must also have committed the act in bad faith, both knowing or believing that the object was tainted and acting dishonestly (s 1(1)). It is also for the prosecuting authority to prove that the person committing the act was acting in bad faith, showing that he or she was aware of the tainted status of the object and that he or she was acting dishonestly. It is important to note that the law does not require a person handling the object to carry out due diligence. However, if a person deliberately closes their eyes to facts or signs which would suggest that an object is tainted, dishonesty may be inferred.

Where the offence is committed by a company or an organisation and a director or manager of the company can be shown to have consented, participated in or negligently allowed the commission of the offence, both the company and the director or manager will be liable to prosecution (s 5(1)).

It is important to note that this offence is not retrospective. While this UK law was introduced in order to comply with the obligations under the 1970 UNESCO Convention, it applies only to objects which were removed from their source

country after 30 June 2003. In practice this means that dealers and auctioneers can be confident that they are not at risk of prosecution under the 2003 Act if they can satisfy themselves that the object was out of the source country by 30 December 2003. It is for this reason that many auction houses and dealers insist – as a minimum requirement – on contemporaneous evidence such as an invoice dated earlier than 30 December 2003.

10.2.2.2 Iraq (United Nations) Sanctions Order 2003

The Iraq (United Nations Sanctions) Order 2003 was introduced into United Kingdom legislation as a result of a United Nations resolution. The order has the effect of prohibiting the import or export of illegally removed Iraqi cultural property (art 8(1)). Any person dealing in illegally removed Iraqi property is guilty of an offence unless that person proves that he did not know and had no reason to suppose that the item was illegally removed Iraqi cultural property (art 8(3)). Anyone holding or controlling illegally removed Iraqi cultural property is required to hand it to the police and will be guilty of an offence if he or she fails to do so unless he or she is able to prove that he or she did not know and had no reason to suppose that the item was illegally removed Iraqi cultural property (art 8(2)).

For the purposes of the order, 'illegally removed Iraqi cultural property' means Iraqi cultural property and any other item of archaeological, historical, cultural, rare scientific or religious importance illegally removed from any location in Iraq since 6 August 1990 (art 8(4)).

What is interesting about this piece of legislation is that it reverses the burden of proof. Whereas the accused in a criminal prosecution is usually presumed innocent until proven guilty, a person found in possession of or dealing in illegally removed Iraqi cultural property is in this case required to prove that they did not know and had no reason to suppose that the item was illegally removed Iraqi cultural property.

The practical effect of the order is that dealers and auctioneers have ceased to handle Iraqi objects unless the object is accompanied by concrete evidence that it was outside of Iraq before 6 August 1990.

10.2.2.3 Syria Sanctions Order 2014

The Export Control (Syria Sanctions) (Amendment) Order 2014 was enacted in August 2014. and created new offences and penalties for their breach. The order brought into force in the United Kingdom the provisions of a European Union Regulation prohibiting throughout the EU the import, export, transfer or provision of brokering services for the import, export or transfer of Syrian cultural

property where there are reasonable grounds to suspect they have been removed illegally or without the consent of their owner. The prohibition does not, however, apply if it is demonstrated that either: (i) the goods were exported from Syria prior to 15 March 2011; (ii) the goods are being safely returned to their legitimate owners in Syria.

10.2.2.4 Cultural Property (Armed Conflicts) Act 2017

In 2015 the so-called Islamic State forces in Syria began to release images of the deliberate destruction of the ancient historic site of Palmyra. Aerial photography indicated that sites all over Syria and Iraq were being excavated and anecdotal stories emerged of an organised trade in ancient objects unearthed in this way. It was thought that these objects were transported to Turkey, where they would be eventually released into the European art market. While there was no evidence of the objects having reached the European art market, governments in Europe were under pressure to be seen to take action. While the United Kingdom had legislation in place in the form of the Dealing in Cultural Objects (Offences) Act 2003 and the Iraq and Syria sanctions orders, the government wanted to be seen to react. A decision was therefore taken to ratify the Convention for the Protection of Cultural Property in the Event of Armed Conflict 1954 and incorporate its provisions into United Kingdom law by enacting the Cultural Property (Armed Conflicts) Act 2017.

The key provisions of the Cultural Property (Armed Conflicts) Act 2017, as far as the art market is concerned, can be found in Section 17 of the Act: 'It is an offence for a person to deal in unlawfully exported cultural property, knowing or having reason to suspect that it has been unlawfully exported' (s 17(1)).

A person guilty of an offence under this section in England and Wales is liable to imprisonment for up to seven years or a fine (or both) (s 17(6)).

This provision is particularly interesting because most criminal offences require dishonest intent for an offence to be committed. Under s 17(1), however, a person acting in good faith without dishonest intent can be guilty of an offence because it is found that he had 'reason to suspect'. The government's justification for this approach was grounded in the fact that there had been few successful prosecutions under the Dealing in Cultural Objects (Offences) Act 2003. It was argued by the government that this was due to the requirement to prove dishonest intent under the 2003 Act. Their solution was therefore to introduce legislation which permits the prosecution even in the absence of dishonest intent.

The practical problem with this approach is that when reviewing the provenance of any artwork, it is rare that the object will have a complete documented history. Such information as there is may have gaps or may conflict with other informa-

tion, or may be unreliable. It may also be the subject of assertions of ownership by source countries which may or may not be well founded. The person handling it therefore has to assess and weigh up the information available in the round and make a judgement as to whether the object is of licit or illicit origin. Under the Cultural Objects (Offences) Act 2003 that judgement could be made without fear of prosecution, provided it was made honestly and in good faith. Under this new s 17(1) offence the judgement can later be reviewed with the benefit of hindsight, and if it is found that the person exercising the judgement 'had reason to suspect' that the object was of illicit origin he or she may be convicted of a criminal offence even if he or she acted honestly and in good faith.

The potentially draconian effects of the Cultural Property (Armed Conflicts) Art 2017 are, however, mitigated and limited by two facts: (i) the offence applies only to property imported into the United Kingdom after the Act came into force; (ii) property is 'unlawfully exported cultural property' if, at any time since 1954, it has been unlawfully exported from a territory which at the time was occupied by another state that was a party to the Convention.

The Cultural Property (Armed Conflicts) Act 2017 unfortunately – and presumably for reasons of political sensitivity – does not identify the territories which qualify as 'occupied', but a list of these can be found on Wikipedia: https://en.m .wikipedia.org/wiki/List_of_military_occupations.

One of the hallmarks of domestic and international legislation on the protection of cultural property is that it is either born of such compromise that it is ineffective in the fight against the illicit trade, or it is so uncompromising as to make handling even licit cultural property risky. The Cultural Property (Armed Conflicts) Act 2017 is an example of the latter situation. It is, unfortunately, the product of a government seeking, for political reasons, to address a complex and nuanced issue by means of blunt and ill-conceived legislation. The result is that risks of dealing in ancient art – whether licit or illicit – have increased appreciably.

10.2.2.5 The Treasure Act 1996

The Treasure Act 1996 is a law relating to the discovery of ancient objects in England, Wales and Northern Ireland. The purpose of the law is to impose an obligation on those who discover such objects to report the find to the authorities. If it is then determined to be 'treasure' within the definition of the 1996 Act, the owner is then obliged to offer the object for sale to a museum at a price set by a panel of experts. If the museum does not wish to purchase the object or does not have the funds to do so, the owner may keep the object or sell it on the open market.

This Act is of particular interest to metal detector enthusiasts or landowners who allow metal detecting on their land. England is one of the few European countries

in which searching for ancient objects using a metal detector is permitted for private individuals. Under English law, the owner of the land on which an archaeological artefact is found is the sole owner of the artefact. However, it is usual for metal detecting enthusiasts to reach an agreement with the landowner that they will share any treasure or the proceeds of any treasure which is found.

'Treasure' tends to be determined by the extent to which the object contains gold or silver. It is defined (s 1) as:

- All coins found in the same hoard. A 'hoard' is two or more coins which are more than 300 years old when they are found. However, if the coins contain less than 10% gold or silver there must be ten or more coins to qualify as a hoard.
- Two or more prehistoric base metal objects in association with another.
- Any individual find (other than coins) that is at least 300 years old and contains at least 10% gold or silver.
- Objects substantially made from gold or silver which are less than 300 years old and have been deliberately hidden with the intention of recovery, but the owners or heirs are unknown.

An example of the operation of the Treasure Act was the discovery of a 3,000-year-old Bronze Age pendant, known as a 'Bulla', which was found by a metal detectorist in 2018 in Shropshire. The find was reported to the local Finds Liaison Officer for Shropshire & Herefordshire. It was determined by the coroner to fall within the definition of treasure on the basis that it was an individual find of more than 300 years old and contained more than 10% gold. The independent Treasure Valuation Committee recommended a value of £250,000. The British Museum was able to raise the £250,000 purchase price with the help of funding from the Art Fund and the American Friends of the British Museum.

It will be seen that the definition of treasure is very narrow and largely confined to gold and silver. This was highlighted when an intact and unique copper alloy Roman helmet was discovered in a field in Cumbria in 2010. The helmet was known as the Crosby Garrett helmet and remains one of the most extraordinary ancient objects found in recent times. Despite its importance from an artistic and historical perspective, the fact that it was made of copper alloy meant that it did not qualify as 'treasure'. The founder was therefore free to offer it for sale at Christie's, where it sold for £2,300,000 to an unknown private buyer. In January 2019 the government launched a review of the law to establish whether the definition of 'treasure' should be extended to encompass objects of historical importance regardless of the material from which they are made. In December 2020 the UK government confirmed that a new and wider definition of 'treasure' is to be introduced into the Treasure Act legislation to ensure that major finds can

be designated as treasure if they are historically or culturally significant, regardless of the material from which they are made.

10.2.3 Codes of conduct

As we have seen, attempts to legislate in relation to the complex issue of cultural property have met with mixed success. Legislation and international conventions have tended to serve a political rather than a practical purpose. Most importantly, they do not appear to have dampened the illicit trade in cultural property. It is therefore worth analysing the extent to which the art market itself has addressed the issue through codes and self-regulation.

10.2.3.1 Code of Practice for the Control of International Trading in Works of Art

In 1985 a number of bodies in the UK art trade signed up to a voluntary code of practice known as the Code of Practice for the Control of International Trading in Works of Art. Those organisations included:

- Christie's
- Sotheby's
- British Antique Dealers' Association
- Society of Fine Art Auctioneers
- Fine Art Trade Guild
- Society of London Art Dealers
- Incorporated Society of Valuers and Auctioneers
- British Association of Removers
- Antiquarian Booksellers' Association
- Antiquities Dealers' Association
- Royal Institution of Chartered Surveyors

The Code came into being as a result of concerns over trafficking in stolen antiques and works of art and the illegal export of such objects. Through the Code, the subscribing bodies undertook:

> to the best of their ability, not to import, export or transfer the ownership of such objects where they have reasonable cause to believe:
> (a) The seller has not established good title to the object under the laws of the UK, i.e. whether it has been stolen or otherwise illicitly handled or acquired;
> (b) That an imported object has been acquired in or exported from its country of export in violation of that country's laws; and
> (c) That an imported object was acquired dishonestly or illegally from an official excavation site or monument or originated from an illegal, clandestine or otherwise unofficial site.

There is no doubt that the objectives of this Code were a step in the right direction, particularly in the 1980s, when awareness of the issue was less acute than

it is today. The legitimate art trade has no difficulty agreeing with the principle that objects which have been stolen or sourced illegally should not find their way into the legitimate art market. There are, however, a number of areas of practical difficulty.

As we have seen, it is a fact that artworks have since time immemorial been traded and collected across borders. It is a reality that the circumstances in which objects left their original source country are often unknown or clouded by the passing of time. The question therefore arises as to what should constitute 'reasonable cause' to believe an object to be illegally exported. Some source countries will argue that the absence of an export licence should lead to a presumption of illegality. However, it is also argued that the requirement to document and evidence export compliance is relatively recent, and that as a result it is not reasonable to expect export documents to be available where objects left their country of origin a long time ago. Further, even where export procedures were in place at the time of the object leaving its country of origin, paperwork and records may not be available for perfectly legitimate reasons, such as having been lost or destroyed. It may also be that the object was exported otherwise than through the formal export process, with the consent or agreement of the source country.

The Code suggests that there is an obligation on the seller to establish good title under UK law. The difficulty with this approach lies in the fact that artworks rarely have ownership documentation. The question of who owns an object is a legal question which depends on the law and the history of the object – which the art dealer or auction house is often not in a position to investigate or assess. As a result, in practice, significant reliance is placed on the seller's assertion that he or she is the legal owner of the artwork and has title to it. The correct and practical interpretation of the Code should be that the art dealer or auction house should be entitled to rely on the seller's assertion that he or she has good title unless there are reasons to doubt that assertion, in which case there is a positive obligation to delve further into the question of title and, if the results of that investigation are unsat-isfactory, to refuse to handle the artwork. Even then, in the author's view, the art dealer or auction house must be permitted to assess the strength of the evidence and take a view, provided that view is taken in good faith.

The Code does not include timeframes. There is a great deal of debate around the relevance of timeframes. Many source countries argue that the date when an object which was taken out of a country is irrelevant. An object taken by a nineteenth-century tourist should, they argue, be returned to the source country in the same way as an object excavated last year and exported from a conflict zone. Then there are those who seek to compromise by suggesting a blanket date after which objects taken from countries should be treated as illicit. In some quarters, 1970 has been adopted as the line in the sand. This is controversial for countries that do not want to legitimise pre-1970 illicit activity. Finally, there are those that

argue that the parameters of licit and illicit behaviour can only be dictated by the laws in force today in the country in which the artworks are currently to be found, many of which include limitation periods and other evidential and procedural obstacles to enforcement. While this debate remains unresolved, the fundamental problem is that it is unclear what objects are to be considered licit and illicit.

The Code is also controversial in that it asks subscribers to undertake to recognise and enforce the export laws of countries outside the UK. This is something which UK law has traditionally avoided doing, preferring instead to enforce ownership rights of countries which claim to have acquired ownership. That position has however now been changed by the Cultural Property (Armed Conflicts) Act 2017, which is in line with the provisions of the Code.

Where illicit activity is suspected, the Code imposes certain duties on its subscribers:

(I) Members also undertake not to exhibit, describe, attribute, appraise or retain any object with the intention to promote or fail to prevent its illicit transfer or export; and

(II) Where a member of the UK fine art and antiques trade comes into possession of an object that can be demonstrated beyond reasonable doubt to have been illegally exported from its country of export and the country of export seeks its return within a reasonable period, that member, if legally free to do so, will take responsible steps to co-operate in the return of that object to the country of export. Where the code has been breached unintentionally, satisfactory reimbursement should be agreed between the parties.

The requirement that illegal export must be demonstrated 'beyond reasonable doubt' greatly tempers the effect of the Code. 'Beyond reasonable doubt' is the very high standard of proof required to secure a conviction in criminal law. That standard is far higher than the standard of proof required in civil cases, 'on the balance of probabilities'. An explanation of what is meant in UK law by the expression 'beyond reasonable doubt' was provided in Miller v Minister of Pensions,[19] in which Denning J said:

> That degree is well settled. It need not reach certainty, but it must carry a high degree of probability. Proof beyond reasonable doubt does not mean proof beyond the shadow of a doubt. The law would fail to protect the community if it admitted fanciful possibilities to deflect the course of justice. If the evidence is so strong against a man as to leave only a remote possibility in his favour, which can be dismissed with the sentence 'of course it is possible but not in the least probable' the case is beyond reasonable doubt, but nothing short of that will suffice.[20]

[19] [1947] 2 All ER 372.
[20] At pp. 373–4.

The burden of proof to be satisfied is therefore extremely heavy. It is doubtful, for instance, that, on its own, the absence of an export licence would be sufficient to prove illegal export beyond reasonable doubt. Evidence would need to be brought to positively prove that the illegal act had taken place.

Further, in criminal law, the onus is on the prosecution to prove guilt beyond reasonable doubt. That suggests that in the case of the Code it is for the person asserting illicit activity to prove the illegal export, not for the person handling the object or the seller to prove that it was legally exported.

Finally, the Code provides that 'violations of this code of practice will be rigorously investigated'. It does not specify by whom, or what the consequences will be. In conclusion, while the Code may be helpful in setting out the objective of preventing the sale of illicit sourced objects, its effectiveness is undermined by its lack of specificity and the standard of proof required.

10.2.3.2 The Antiquities Dealers Association Code

The Antiquities Dealers Association (ADA) is the principal trade association for dealers in antiquities within the United Kingdom. In 2015 it updated its code of conduct for ADA members.

The code of conduct requires ADA members to 'comply with all applicable laws, regulations and restrictions in the import or export of art, cultural objects, property, services, information or technology, wherever they operate in the world'. Specifically, it requires ADA members 'engaged in the shipping of antiquities … to abide by export laws of the country from which the antiquities will be shipped'. It also requires ADA members to 'ensure compliance with all other national laws affecting the movement of goods – including (but not limited to) rules governing the movement of cultural heritage and other culturally sensitive materials, and the movement of items to, from, or originating in countries subject to trade embargoes or sanctions'.

It is notable that the focus of the code of conduct is upon compliance by ADA members where they are involved in shipping objects, rather than historical compliance with export laws prior to the ADA member's involvement. Historical compliance is, however, covered to some degree by the requirement that before offering property for sale, ADA members must 'be satisfied that they have conducted the level of Due Diligence required to establish that the property they are handling is authentic and that there are no known legal obstacles to selling and passing title'.

The ADA code of conduct also contains provisions to deal with the increasing need to document and record transactions – seen as central to the fight against the

illicit trade. It requires that ADA members should record each transaction with diligence and keep records for a minimum of six years. The identity of the source of the object is also recorded, requiring that 'unless the vendor is well known to the dealer, where an item is worth over £3,000 the member should request photographic identification and if practical take and retain a copy of it'.

Members are required to obtain in writing the name and address of the vendor; a warranty that the vendor has good title to the objects; confirmation of where, when and how the vendor obtained the objects, to the extent that this can be provided by the vendor; where the vendor acquired the objects outside the United Kingdom, confirmation that the item has been exported or imported in conformity with local laws; and, where available, evidence of the latter. In addition, wherever possible, members are required to arrange payment by a method that leaves an audit trail.

10.2.3.3 The trickledown effect

Perhaps the most interesting phenomenon has been the influence of market forces. In 2011 UNESCO's Edouard Planche contacted Christie's with the proposal that, for the first time, a major international auction house should attend UNESCO's annual conference in Paris to speak about its due diligence procedures in relation to ancient cultural property. This was revolutionary – auction houses had traditionally not been part of the dialogue at UNESCO, which viewed the art market as part of the problem rather than the solution. This was, however, to be the beginning of an important dialogue and collaboration between the art market and UNESCO. The results of that collaboration were a greater awareness by the auction houses of the ethical issues surrounding cultural property and a significant tightening of due diligence procedures and evidential requirements in the major auction houses. From UNESCO's side there was a realisation that the art market was prepared to work as a partner in combating the illicit trade. This was welcome, but, perhaps most importantly, major auction houses began to demand more evidence from sellers of provenance. This in turn led to collectors and dealers being equally demanding when purchasing ancient art in order to protect the value of their investment. Purchasers began to insist on proof of provenance for ancient art. As a result, at the time of writing, the demand for unprovenanced items has fallen. Ancient art which has good documented provenance stretching back before 1970 commands strong prices, whereas art with lesser or undocumented provenance is very much less in demand. Ancient art without provenance is unsaleable on the legitimate market.

10.2.4 Civil remedies

The argument commonly used in restitution claims is that an object was stolen or exported contrary to the laws of the country of origin. Many cases brought on this basis by source countries were unsuccessful because of the principle that a United Kingdom court will not enforce the laws of a third party state.

Because the United Kingdom will not enforce the laws of a third party state, many restitution cases are instead framed to ask the United Kingdom court to recognise the ownership rights of the claimant state rather than enforce its export laws. Typically the claimant state will seek to argue that the act of illegal export confers title upon the claimant state and that, as a civil matter, the object should be returned to its owner. An example of this approach was the case of *Attorney-General of New Zealand v Ortiz*[21] [ChD 1984]. In that case the New Zealand government was seeking to prevent the sale by a London auction house of a Maori pair of carved door panels on the grounds that the doors had been illegally exported from New Zealand. The New Zealand government claimed that it was the owner of the doors by virtue of New Zealand legislation. The House of Lords considered the New Zealand legislation and determined, however, that on the true construction of the New Zealand law, the State of New Zealand had not in fact acquired title. The law provided that this would only happen if the doors were seized, and title did not pass automatically upon unauthorised export. As the doors had not been seized, the New Zealand State had not acquired title, and its claim for restitution therefore failed.

The *Ortiz* case was based on a strategy adopted in an earlier case – a claim by the Republic of Iran, for restitution of a group of objects in the hands of the Barakat gallery in London. In that case Iraq was, successful because it argued that it was not asking the United Kingdom to enforce Iranian laws, but was asking the United Kingdom courts to enforce its rights as owner of the object – ownership having been conferred on the State by Iranian law.[22]

Those dealing in cultural property therefore need also to bear in mind that, irrespective of the legislation specific to cultural property, it is open to States to make a civil claim for restitution of an object if they can prove that ownership in the object lies with the State. States are able to assert ownership of objects where they can demonstrate that their national legislation gives the State legal title to the object and they have evidence that the object satisfies the requirements to become State property.

21 [1984] AC 1; [1984] 2 WLR 809; [1983] 2 All ER 93; [1983] 2 Lloyd's Rep 265.
22 Government of the Islamic Republic of Iran v The Barakat Galleries Limited 2007 EWCA Civ 1374.

It is as a result of the Barakat Galleries case, and the similar case in the United States of United States v Schultz,[23] that many source countries have now introduced provisions in their cultural property protection laws which automatically render the source country the owner of certain classes of ancient object, whether discovered or undiscovered. This is intended to allow the country of origin to bring a civil claim for restitution abroad on the grounds that it is the owner of the work. This sounds straightforward but is in practice difficult for the source country. First, the onus is on the source country to prove that the object came from the source country. Second, laws of this kind are not retrospective, so a source country would also need to prove that the object it is claiming was in the source country after the enactment of the law. This is difficult unless the object was recorded in a photograph or inventory in the source country at a date after the enactment of the law.

A further complication lies in the fact that even where the source country acquired title to an object under its national legislation, subsequent good faith transactions or limitation periods can defeat the claim.[24]

In the absence of a right to ownership under the national legislation of the source country, is there a right to restitution on grounds of theft and conversion? In a well-argued article entitled *Inherited Guilt and Inherited Grievance: Prescription, limitation and Ownership of the Past*,[25] Gilead Cooper QC questions the legal standing of claims based on theft and conversion for restitution of cultural artefacts – focusing in particular upon the legal merits of the claim by the Nigerian government for the return of the Benin bronzes. Cooper identifies a number of major difficulties which would be faced were the claim to be litigated in the United Kingdom. Those would include establishing the relevant *mens rea* of those who took the bronzes, whether the taking of the bronzes actually constituted an offence under English law at the time they were taken, whether the Kingdom of Nigeria – which only came into existence in 1960 – had *locus standi* to make a claim and whether any claim would in any event be excluded by the Limitation Act. Cooper also argues that such legal considerations are relevant as the ethical justification of righting historic wrongs runs into difficulty where the owner is innocent of any wrongdoing and faces a claim by a claimant who has no right in law to its return. While acknowledging that limitation periods can be arbitrary, he asks: 'how far back shall we look?'

Such claims are however rarely tested in court. Indeed, one major difficulty for auction houses and dealers lies in the fact that source countries will often assert

[23] 333 F 3d 393 (2d Cir. 2003).

[24] Islamic Republic of Iran v Berend [2007] EWHC 132.

[25] Gilead Cooper QC (2019). *Inherited Guilt and Inherited Grievance: Prescription, Limitation and Ownership of the Past*. Wolters Kluwer.

ownership claims – sometimes via the press – without actually formally pursuing the claim through legal channels. This is perhaps because the cost of pursuing the claims through the courts is prohibitive for the source country, or it may be because of the difficulty of finding evidence of a legal basis for a legal claim. It may however also be because the assertion of a claim is often sufficient in itself to disrupt the sale and put bidders off bidding on the claimed object. The problem with this approach is that artworks which are the subject of such claims can remain in a state of limbo. They can sometimes not be sold as they are the subject of an ownership claim, and yet there is no evidence to support the claim, so there is no basis for their return to the claimant country.

10.2.4.1 The Stargazer case

- As we have seen, it is rare that cultural property claims find their way into the civil courts and reach a conclusion in which important legal principles are established. The Guennol Stargazer case, however, did just that.
- In 2016 Christie's offered for sale a tiny Anatolian statue known as 'the Guennol Stargazer', from 3000–2200 bc. The origin of the statue and how and when it had left its source country were unknown but there was clear evidence that it had been in the United States since at least 1966, and probably much before then. It had therefore left its source country long before the 1970 UNESCO Convention. Turkey however laid claim to the Stargazer on the grounds that it had been illegally exported under its 1906 antiquities law. Turkey was unable to provide any concrete evidence as to when and how it had been removed from Turkey, or indeed whether it had ever been in Turkey. It applied to the court for an order to stop the sale,[26] but was unsuccessful. The court refused the application but stipulated that Christie's should undertake not to release the object for 60 days after the sale to enable Turkey time to put forward any evidence it had of illegal export. The problem Christie's then faced was a practical one. It was free to go ahead with the sale but unless Turkey formally abandoned its claim there was a real danger that bidders would be put off bidding for the Stargazer. Christie's solution was to make an announcement prior to the sale to the effect that anyone who successfully bid on the Stargazer would be entitled to cancel the sale and would not be required to make payment in the event that, after the 60-day period, Turkey's claim was successful. The tactic appeared to work as bidders competed with each other for the lot, resulting in a sale price of US$12.7m. However, the case was not resolved after the 60-day period and the sale was not consummated after Turkey filed a claim against Christie's in the Southern District of New York in

[26] Republic of Turkey v Christie's Inc., No. 1:17-cv-03086 (AJN) (SDA), 2018 BL 170526 (S.D.N.Y. 14 May 2018).

2017. The auction house counterclaimed, alleging tortious interference with sale contract and prospective economic interference.

• In 2021, after many years of argument, the US District Court handed down judgment in the Stargazer case (*Republic of Turkey v Christies Inc and Others*). The court emphatically rejected Turkey's claim to the Stargazer on the basis that it did not meet the burden of proof in establishing its ownership claim and that, even if it had met that burden, the claim would have failed as Turkey had not acted promptly and had slept on its rights. This was a landmark case which offered some helpful signposts on how the courts in the US – and perhaps outside the US – will approach cultural property restitution cases. It also provided some guidance for museums, collectors and countries seeking restitution of cultural property.

10.2.4.1.1 The application of the law to restitution claims
It is sometimes assumed that, because of the complex ethical, political and historical issues which surround them, cultural restitution claims are not subject to the same evidential requirements and rules of justice which apply to other claims, or at least that these rules should be applied less rigidly. The Stargazer ruling illustrated that this will not be the approach where the parties bring their dispute before the US courts. It confirmed that, in common with any ordinary civil ownership dispute, a party claiming restitution must, if it hopes to prevail in a US court of law, be able to satisfy the evidential burden of proving the facts necessary to establish ownership in accordance with the requirements of the law.

10.2.4.1.2 Presumption of wrongdoing or illegality
It is not uncommon for the parties on either side of the debate in cultural property restitution cases to assume or allege bad faith and wrongdoing. The Turkish government followed a line of argument which is commonly used in cultural restitution cases – that an antiquity outside of its country of origin without evidence of how it came to leave that country should be treated by collectors as a red flag and that there is a presumption of illegal export or excavation which arises in such circumstances. There was also an argument advanced that those who had owned the Stargazer in recent times had closed their eyes to the possibility of illicit origin and therefore had 'unclean hands'. As an alternative, Turkey argued that even good faith purchasers have a duty to carry out extensive due diligence before making a purchase. The Court rejected this. It was satisfied that an antiquity was capable of leaving its country of origin in licit as well as illicit circumstances. It also found that the owner of the idol had acquired it in good faith, and that in any event a private collector was not required to exercise the same levels of due diligence as a dealer when acquiring an antiquity.

10.2.4.1.3 The burden of proof

The Court made it clear that, in the absence of evidence of illegality, the burden of proving ownership fell squarely upon the country claiming restitution – and that satisfying this burden was a requirement for success. 'Turkey bears the burden of proof of establishing by a preponderance of evidence that it has an ownership claim to the Idol.' It is also clear from the judgment that this can only be achieved where the claimant is able to identify and provide evidence of the particular circumstances in which the object which is the subject of the claim was found and left its country of origin. In this case Turkey had to demonstrate that this particular idol had left Turkey after 1906. The Court concluded that Turkey had failed to satisfy that burden. In practice this will prove to be a high bar for claimants in future cases, particularly where decades, or hundreds or even thousands of years, may since have passed.

10.2.4.1.4 The global art trade in the ancient world

A fascinating aspect of this case was the argument over the extent to which ancient artworks such as the Stargazer were traded across borders. Just as the trade in art is a global business today, so too was the trade in art in ancient times. The Court accepted the defendants' argument that trade in and exchange of artworks such as the Stargazer was common, both at the time they were being made and subsequently. Art has always been traded. It found that the Stargazer could well have left its country of origin in licit circumstances and long before Turkish cultural property protection laws were brought in in 1906.

10.2.4.1.5 Limitation periods apply in restitution cases

The Court found that the Turkish government had 'slept on its rights' and had been guilty of 'inexcusable delay' in asserting its rights over the Stargazer. Its existence and whereabouts were very publicly advertised over many decades when it was exhibited at the Metropolitan Museum in New York between 1968 and 1993. It was only when the Stargazer was offered for sale by Christie's in 2017 that the Turkish government chose to act. The Court found that the Turkish government either did know or should have known about the Stargazer long before 2017, and any claim was therefore time-barred under the equitable doctrine of laches. It is of course tempting to dismiss limitation periods as a technical defence. However, the reality is that limitation periods are an important and equitable element of almost all systems of justice, which are necessary in order to prevent injustices. The takeaway for those involved in restitution claims is that to bring a successful claim, claimants must act promptly, and any failure to do so will be fatal to the claim. At a practical level it is difficult to see how in future any cultural property restitution claim can be successful where the object has, as in this case, been exhibited in a museum and written about over a long period of time.

10.2.4.1.6 Turkey's 1906 cultural patrimony law does confer ownership rights

In a finding which was helpful for Turkey, the judgment recognised that had the Turkish government been able to demonstrate that the Stargazer had left Turkey after 1906, the 1906 Turkish Cultural Patrimony law would have conferred title in the Stargazer upon Turkey, and the US Court would have recognised its ownership rights. This may be relied upon by Turkey in future restitution claims.

The Stargazer judgment which so firmly rejected Turkey's claim needs to be seen in the context of an earlier 2020 case in which Sotheby's had been rebuffed by the Courts when it had taken a different, and more aggressive, approach in relation to an ancient statuette of a horse, dating from the eighth century bc. The horse, which had previously been sold at auction in Switzerland in 1967 to dealer Robin Symes, had been acquired by the sellers in 1973. It was due to be sold at Sotheby's in New York in 2018, with an estimate of US$150,000–US$250,000. Immediately before the sale, Sotheby's was contacted by the Greek government, alleging that the horse had been illegally exported from Greece. As with the Stargazer case, a central element of the claim was that Greece had no record of an export licence having been granted. In contrast to the Stargazer case, however, the Greek government took no steps to advance its claim through the court. Instead Sotheby's decided to withdraw the horse from sale on the grounds that the publicity surrounding the Greek claim would damage its saleability. Rather than leaving matters at that, Sotheby's and the owners of the horse issued proceedings in the US court against Greece seeking a declaration that the owners had good title to the horse. The purpose of the claim was, it said, to protect the owners of ancient art against baseless claims. In 2020 the US Court of Appeals ruled that Sotheby's was not entitled to sue the Greek government. The Court decided that the Greek government's protests against the sale had been motivated by sovereign concerns rather than commercial interests, and that it was therefore immune from prosecution under the US Foreign Sovereign Immunities Act.

The strategic lessons from the Stargazer case and the Sotheby's Horse case seem to be that governments are entitled to raise reasonable objections, without fear of prosecution, to sales of items they consider to be of sovereign interest. However, if they propose to actively pursue a civil ownership claim, the evidential bar for a successful claim is high enough that such claims will succeed only where the illegal act complained of can be identified and proved with specificity. Even then, the claim will fail if the claimant did not act immediately.

10.2.5 The future

It is understandable and, in many cases, entirely justifiable for the countries who have been denuded of their cultural heritage and artworks over centuries to aspire to and demand the return of those objects – particularly where the objects are

reminders of tragic historical events. At the same time, it must also be recognised that there are real practical, humanitarian and ethical difficulties with the idea that an entire category of art should be returned to its country of origin. And it is also fair to ask: how far back does one go in seeking to right the wrongs of the past?

There is, without doubt, a compelling argument that many antiquities have great – and, in most cases, the greatest – value in the context of their original surroundings. It is also the case, however, that not all antiquities regardless of type or quality fall into this category. Many antiquities do have a different – and considerable – value outside of the context of their original surroundings. An antiquity in the British Museum, for instance, has educational value and context when displayed and juxtaposed against other works of art from other periods or cultures. However, that is not a justification where the country of origin has few or no examples of important antiquities in context. The starting point, in my view, must be that source countries should be rich in examples of the art that their culture has created. However, that is not inconsistent with the principle of wide-spread access to important artworks outside of the country of origin in museums and collections, in order to educate and inform the many millions of people who might otherwise not have the ability to visit the source country and access the art-works. In short, there must be a balance – and the overriding priority at all times must be the preservation of the object.

Collectors, dealers, auction houses and museums are sometimes characterised by countries of origin and critics of the antiquities trade as acting in bad faith or as handlers of stolen property. That is unfortunate, as it makes finding equitable and practical solutions very much more difficult. Collectors and museums are usually driven by the same passion for the historical and aesthetic significance of the object as archaeologists and scholars. In arguing for the return of these ancient objects it is important to acknowledge that, even where the circumstances of the artwork leaving its country of origin are unacceptable or questionable by today's standards, collectors and museums have played and continue to play an important role in the study and preservation of these objects. While many of the objects would have been perfectly safe – and, indeed, more beautiful and meaningful – had they been left in situ in the source countries, it is also the fact that, in some cases, the objects which are in private collections and museums might not have survived, or would have suffered damage, had they been left in situ. Is that a justification for their removal? No, particularly as the risk of damage or loss applies, of course, wherever valuable objects are stored – whether in museums or collectors' homes or in the source country. However, where examples of the artworks are to be found in many different countries, the risk is undoubtedly spread. Certainly, protection from loss or damage should not generally be advanced as a justification for the wrongful removal of the objects. It is usually only justified where the removal is with the consent of the source country.

Conversely, there is a tendency to criticise countries of origin for failing to protect or value their heritage. This is not a fair criticism. Source countries often have modern and sophisticated museum facilities which are capable of housing and protecting cultural property. As for historic sites over and underground, these are extremely difficult to protect – even in wealthy countries during peacetime. That task becomes impossible in countries where resources are scarce or where there is conflict. Imposing that responsibility solely on the country of origin is also inconsistent with the view that the preservation and ownership of our cultural heritage is a responsibility shared among us all.

Example

- In Cambodia, in cases where statues looted from the country's hundreds of temples are returned, there is no question of reinstalling the statue in the temple it was taken from. The statue would very quickly be looted again. This is not due to a lack of vigilance or care on the part of the Cambodian government. It is a logical consequence of the sheer number and remoteness of historic sites. They cannot all be policed all of the time. So instead, restituted statues are placed in the national museum, where they can be protected.

In the attempt to fight illicit trade, there is a tendency for source countries to define very widely what constitutes important cultural property. It is not uncommon, for instance, for countries to designate all artworks over a certain age as cultural property of importance. In reality the question of what is culturally important or not is far more complex. There are some artworks which are arguably fundamental and important examples of a nation's culture, where there could be a strong argument for their return. However, these need to be distinguished from the vast majority of objects, which are decorative and interesting but perhaps not important in the wider context. In my view, making such a distinction is in the interests of the country of origin, because the failure to do so significantly weakens the arguments in favour of restitution. It is also, ironically, in countries where the laws on export and ownership of cultural property are most restrictive that the illicit trade is most rampant. I would suggest that a more nuanced approach to the issue is likely, in the end, to be more effective for countries seeking the repatriation of items of cultural heritage.

It is undoubtedly the case that the circumstances in which many antiquities left their countries of origin were tragic or at least questionable by today's standards – and, indeed, often also by yesterday's standards. The passing of time should not make the events any less tragic or questionable. Anyone who owns or holds an object cannot ignore such events. This is in part because of the ethical considerations which arise from them, but also because those events are an important part of the history of the object. However, in practical terms it is also true that

the passing of time does make it more difficult to unwind or rectify the position without causing serious injustice. It is for this reason that the laws in most countries incorporate a form of limitation period after which claims cannot be brought for ownership claims. Claimants in restitution cases criticise limitation periods, but the reason they exist is that most legal systems recognise that it will often be inequitable to allow claimants to pursue claims against people who are unconnected with the events on which the claim is based – particularly where the events took place long ago. If the rights to restitution of the country of origin are to be recognised, then so too should the rights of a good faith owner of the object.

It will be difficult to resolve this issue as long as it is defined in terms of ownership. Museums and collectors argue that they own objects because the law in their country confers ownership upon them and because they have often parted with large sums of money to acquire them. Countries of origin claim ownership because of laws awarding the State automatic ownership of all ancient objects of cultural or artistic value. This is an impasse which cannot, in my view, be resolved by looking to the law. The ownership argument is also difficult because it renders compromise difficult. Countries and museums that advance their respective ownership arguments in absolute terms find it politically difficult to then countenance the possibility of a loan or shared ownership, because that would be inconsistent with the narrative of ownership.

In recent years, however, many museums and governments are in many cases beginning to take a radically different approach, accepting that something needs to be done to address the question of cultural property claims. Much of this change in approach reflects a reassessment of the historical behaviour of countries in conflict and colonial times. This includes a recognition that many of the world's greatest museums were supplied with artworks and relics which had been obtained in unacceptable and often violent circumstances. A number of states and museums have decided in principle and in practice to voluntarily return objects of cultural importance to their source countries in cases where it is thought appropriate due to the circumstances in which they left the source country. That is a pragmatic and thoughtful approach which will rightly be applauded by many. However, it does raise many very difficult questions about what the parameters of such decisions should be and how, in practical terms, a museum can repatriate an object in one case while refusing to do so in another case.

My personal view – and it is a personal view – is that while we can and should now introduce laws, security measures and codes of practice aimed at protecting existing sites, we will have little success if we look to the law or international conventions to find equitable solutions for past injustices. The solution to past injustices, just as with Holocaust restitution (see section 10.1 'Holocaust restitution claims'), is to be found in dialogue which recognises that these issues cannot be righted without significant compromise on all sides, and on a case by case basis.

Countries of origin need to be far more selective in identifying the objects which are genuinely critical to their culture and history, and should seek the return of those objects only. This is of course difficult because it requires an acceptance that objects which are not critical to the nation's culture and history may remain in circulation even where there are questions over the circumstances of the object's removal. However, by being more targeted, it is more likely that restitution claims will be successful. On the other side of the argument, collectors and museums should also recognise that many of these objects were removed in sometimes terrible circumstances which would not be acceptable by today's standards. There should also be an acknowledgment that while collectors and museums should be free to own and display examples of ancient art from around the world, the underlying aim should be for all countries to be rich in the finest examples of their own cultural heritage. They should be encouraged to be open to reaching pragmatic solutions involving exchanges, restitutions and loans. Any lack of trust can be overcome by governments guaranteeing and underwriting the obligations of their museums.

An example of how this can be achieved was the agreement negotiated by the Benin Dialogue Group, a group comprising European Museum representatives and representatives of Nigerian local and national government. Under the agreement, Nigeria agreed to build a museum in Benin City to house the most iconic Benin bronzes which had been looted by British troops in Benin in 1897 during a violent so-called punitive expedition. The European museums in which these bronzes are now to be found agreed to lend, and in some cases unconditionally restitute, their Benin bronzes to the new Nigerian museum on a rotating basis, and to provide advice on the design of the museum and to cooperate with Nigeria in training and funding. In reaching this agreement the Nigerian government was emphatically not dropping its ownership claim over the bronzes and the museums were also not conceding their entitlement to retain and display the bronzes, but both sides were putting to one side the question of ownership in order to find a way of ensuring that Nigeria was able to display and celebrate its heritage in context. This has in turn led to a sequence of voluntary returns of Benin bronzes from museums and institutions all over the world. It was also the inspiration for the decision, in February 2022, by the Belgian government to announce its intention to consider the negotiated return of thousands of Congolese artworks taken from the Congo – often in violent circumstances – when it was a Belgian colony. Bearing in mind the formidable legal hurdles to restitution outlined by Gilead Cooper QC in his article, it is interesting to see that the Benin bronze issue is leading the way in terms of finding political solutions.

Perhaps one way of addressing the issue and facilitating the dialogue might be the establishment of an independent panel similar to the Spoliation Advisory Panel (see section 10.1.5) tasked with finding equitable solutions to claims by source

countries. Such a panel would not be tasked with resolving issues of ownership but instead would encourage loan deals and exchange programmes designed to ensure that the most important ancient artworks could be exhibited in context and also made available in the museums of the world for the education of those who are unable to travel to the source country.

There is also, I believe, considerable scope for organisations such as UNESCO to take a more interventionist role in finding solutions. Over the past decade the organisation has made huge strides in engaging with the art trade and the results of that engagement have been extremely encouraging. The trade has become far more aware of its responsibilities with regard to provenance research and there has been a genuine debate over what should and should not be sold. There is, however, still a tendency for UNESCO to be inward looking, and I would suggest that the next most effective step would be to establish a permanent art trade committee within the auspices of UNESCO.

10.2.6 Guidance for the collector

Collectors of ancient art need to be very aware of the provenance of the objects which they acquire. Greater awareness of the issues surrounding the illicit trade have led to increasing scrutiny of the history of ancient objects and objects which, five or ten years ago, were freely traded. Certainly, an ancient archaeological or architectural object without recent provenance is likely to be difficult or impossible to sell in the legitimate art market. Its value will, however, increase where it has a long and documented provenance.

As a minimum, therefore, the responsible collector needs to ensure that there is clear evidence that the artwork was not recently underground or attached to a building in the source country. Many auction houses use 1 January 2000 as the threshold date for these purposes. This date is, to some extent, random. The point is that it is a date sufficiently far back in the past that a recently excavated object cannot satisfy the requirement. The hope is that a message is sent to those considering getting involved in the illicit trade that there is no commercial value in the objects they may find and traffic because there will be no evidence of pre-2000 provenance. The responsible collector should therefore satisfy himself that there is documentary or photographic evidence that the artwork was outside the country of origin at least prior to 1 January 2000.

That, however, is the minimum threshold. The responsible collector should also look at the known history of the object between 1970 – which is the year of the UNESCO Convention – and 1 January 2000. If there is any reason to suppose or suspect that the object was looted from a source country during this period then the responsible course of action would be not to purchase the object.

European law has now imposed new and significant restrictions on the import into the European Union of cultural property (see section 12.2).[27] In particular, for antiquities over 250 years old being imported into the European Union, it will be necessary to show that they were lawfully exported from their source country, unless they can be shown to have left the source country before 24 April 1972. While it may be 2025 before these changes are introduced, this will render the import of ancient objects into the European Union extremely difficult. It is worth noting too that, following Brexit, the UK government has ensured that these European import restrictions do not apply to imports into the UK.

10.3 Listed building protection

10.3.1 Introduction

The United Kingdom has a fairly extensive regime designed to protect buildings considered by the government to be of special architectural or historic interest. Buildings of this kind are included in a list of protected historic buildings, in a system known as 'listing'. Details of the regime are set out in the Planning (Listed Buildings and Conservation Areas) Act 1990, maintained by Historic England.

The regime is designed to protect many categories of historic building, ranging in importance from historically significant buildings to relatively ordinary buildings which display aspects of historical interest. Listed buildings are classified into three grades: Grade I buildings are of exceptional interest; Grade II* buildings are particularly important buildings of more than special interest; Grade II buildings are of special interest, warranting every effort to preserve them. (The vast majority of listed buildings fall into this category.)

Section 7 of the Planning (Listed Buildings and Conservation Areas) Act 1990 states that no person shall execute or cause to be executed any works for the demolition of a listed building or for its alteration or extension in any manner which would affect its character as a building of special architectural or historic interest, unless the works are authorised.

This protection regime is important because the protection extends not only to the building itself, but to buildings or objects within the immediate surroundings of the protected building as well as the building's fixtures and fittings. A fixture is an object which, while it has its own identity, has been attached to the building in such a way as to become a part of that building. An object to which this protection extends – such as a fireplace, a statue, a built in panel or other fitting – cannot

27 Regulation of the European Parliament and of the Council on the Introduction and Import of Cultural Goods.

usually therefore be detached from the building and sold without consent, and a failure to obtain consent can result in criminal and civil sanctions. It is therefore important to be clear about whether or not the circumstances are such that an object is protected by the listing, and therefore cannot be detached and/or removed from the building.

It is also to be noted that objects, such a garden statuary, which might not otherwise be considered to be buildings can themselves have listed building status.[28] In *Skerritts of Nottingham v Secretary of State for the Environment Transport and Regions* [2000] JPL 1025 a three-fold test to determine whether or not an object is a building was adopted, considering size, permanence and degree of physical attachment of the structure.

10.3.2 Fixtures and fittings

In general, an object which is fixed to a listed building will be protected by the listing if it is a 'fixture'. This is because it is considered to have become part of the building itself. Whether or not an object is a fixture or fitting is dependent on the particular facts of the case. The key considerations in determining this are:

- The method through which the object is attached or affixed to the building, and the ease with which it can be removed, including the damage caused to the structure or object by its removal.
- The objective and purpose for which the object was affixed to the building. Was it for the improvement of the building or for the enjoyment of the object itself?

The starting point is that where a chattel (an item of personal property) is physically attached to the property, this will be an indication that it is a fixture. For instance, in the case of Holland v Hodgson (1872) LR 7 CP 328 looms were attached, using nails, by the tenant of a mill to the floor of the property. It was held that as a result of the attachment the looms became a fixture of the property. Blackburn J said, 'an article which is affixed to the land even slightly is to be considered as part of the land, unless the circumstances are such as to show that it was intended to all along continue a chattel, the onus lying on those who contend that it is a chattel'.

To determine such intention, the question is whether the chattel was attached to the land to enable the object to be better enjoyed as an object, or for the more convenient use or improvement of the land.

Blackburn J gave the example of blocks of stone placed one on the top of another without any mortar or cement for the purpose of forming a dry stone wall. These

[28] *Dill v The Secretary of State for Communities and Local Government & Ors* [2020] UKSC 20.

would become part of the land and therefore fixtures. However, the same stones, if deposited in a builder's yard and stacked on the top of each other for convenience's sake in the form of a wall, would remain chattels rather than a fixture.

While physical attachment is an indicator of a fixture, it is not necessarily conclusive. Account must also be taken of the extent of the attachment and the object of annexation. In Leigh v Taylor [1902] AC 157 it was held that valuable tapestries stretched on to hard board and affixed by the tenant of the property to the walls by nails were chattels rather than fixtures. The court held that it was

> evident from the very nature of the attachment, the extent and degree of which was as slight as the nature of the thing attached would admit of ... that this thing, put up for ornamentation and for the enjoyment of the person while occupying the house, is not under such circumstances as these part of the house. That is the problem one has to solve in each of these cases. If it is not part of the house, it falls under the rule now laid down for some centuries, that it is a sort of ornamental fixture, and can be removed by whoever has the right to the chattel.

Conversely, in D'Eyncourt v Gregory,[29] a case which also revolved in part around tapestries, the court reached a different conclusion. The tapestries were held to be fixtures as they were integral to the decoration of the room where they were attached as wallpaper or frescos. So too were a statue of lions, garden seats and vases, as they were all deemed to form part of the overall architectural design of the building. Lord Romilly MR said:

> I think it does not depend on whether any cement is used for fixing these articles, or whether they rest on their own weight, but upon this – whether they are strictly and properly part of the architectural design for the hall and staircase itself and put in there as such, as distinguished from mere ornaments to be afterwards added.

In Berkley v Poulett,[30] the objects under discussion were a number of valuable paintings which were set into oak panelling in the building, a large marble statue of a Greek athlete which weighed half a tonne and rested on its own weight on a stone plinth on the west lawn, and a large sundial also resting on its own weight outside the building. In that case the items were found by the court to be chattels rather than fixtures. Scarman LJ was of the view that the object of annexation has greater significance than the degree of annexation. He found that the paintings were affixed for the better enjoyment of them as paintings and the statue and sundials were also placed for the better enjoyment as chattels. The position would presumably have been different, however, if the paintings, statue and sundial had been found by the court to be part of the original design for the building.

[29] (1866) LR 3 Eq 382.
[30] [1976] EWCA Civ 1 Court of Appeals.

It can be seen, therefore, that the question of whether an object is a fixture or not is dependent on the circumstances, and in particular the purpose for which it was attached, the moment in time at which it was attached, the manner of its attachment and the degree of its attachment. In many cases the answer will be obvious. A fireplace which was part of the original design of a protected building will be protected on the basis that it was included for the improvement of the building, and because it is built into the fabric of the listed building. The issue becomes more complicated, however, when the object in question is free standing, is hanging from a hook or was added long after the building was originally designed and built.

10.3.3 Objects and buildings within the curtilage of a listed building

Buildings and other structures, such as sculptures, are to be treated as part of the listed building where they:

(i) pre-date July 1948; and
(ii) are within the 'curtilage' of a listed building.[31]

A curtilage is a building or piece of land attached to the listed building and forming 'one enclosure with it'.[32] The question of whether a building or structure is within the curtilage of the listed building depends on the particular circumstances of the case. In Methuen-Campbell v Walters,[33] the curtilage of a house was held to be narrowly confined to the area surrounding it and, in that case, did not extend to a paddock.

There are three key factors to be taken into account in assessing whether a structure or object is within the curtilage of a listed building.[34]

These are:

(i) the physical layout of the listed building and the structure;
(ii) their ownership, both historically and at the date of listing; and
(iii) the use or function of the relevant buildings, again both historically and at the date of listing.

[31] Section 1(5) of the Planning (Listed Buildings and Conservation Areas) Act 1990 says that the listed building also includes any ancillary object or structure within the curtilage of the building, which forms part of the land and has done so since before 1 July 1948.

[32] Lowe v Secretary of State [2003] EWHC 537.

[33] [1978] CA 2 EGLR 58.

[34] Attorney-General ex rel. Sutcliffe and Others v Calderdale BC, 1982 and Debenhams plc v Westminster CC, 1987.

10.4 Endangered species

Because art is so often a representation of the artist's immediate environment, man has frequently looked to his natural surroundings when creating it. Early art forms and many traditional craftworks today include carvings made out of animal bones or wood, leather and animal skins. More sophisticated antique artworks such as furniture also frequently incorporate bone and ivory inlay. Even today, contemporary artists such as Damien Hirst continue to make frequent use of animal parts and plants.

10.4.1 The CITES Convention

As the human population has expanded, the numbers of many species of animals and plants have dwindled. This is in part due to habit loss, but also due to trade in animals and plants – including artworks which incorporate animal parts and plants. By the 1960s governments began to realise that, in order to protect these species, concerted international action was needed. This realisation led to the creation in 1973 of an international convention called CITES (the Convention on International Trade in Endangered Species of Wild Fauna and Flora).

The CITES Convention, to which 183 States have signed up, makes the international trade in specimens of certain designated species in those States subject to a licensing system. A licence is required for the import and export of the species covered by the Convention.

The Convention is given effect in Europe and the United Kingdom by EC Council and Commission Regulations.[35] The enforcement provisions are contained in a Statutory Instrument called the Control of Trade in Endangered Species (Enforcement) Regulations 1997 No 1372 (COTES). It is to be noted that whereas until recently artworks containing protected species could move freely between the United Kingdom and other EU countries, this is no longer possible due to Brexit. Exports and imports between the United Kingdom and Europe are subject to CITES controls.

10.4.2 The protected species

The species covered by CITES are listed in three appendices, according to the level of protection required. Approximately 5,600 species of animals and 30,000 species of plants are protected by being listed in the CITES Convention Appendices.

[35] Council Regulations (EC) No. 338/97 and (EC) No. 939/97.

Appendix I includes species threatened with extinction. Trade in specimens of these species is permitted only in exceptional circumstances.

Appendix II includes species not necessarily threatened with extinction, but in which trade must be controlled to ensure their survival.

Appendix III contains species that are protected in at least one country, which has asked other CITES Parties for help in controlling the trade.

The countries which are parties to the convention have all agreed that any CITES-listed specimen can be imported into or exported from their country only if a licence has been obtained and presented for clearance on exit or entry to the country.

10.4.3 CITES licences required

The circumstances in which licences will be granted or not are dependent on the appendix in which they are listed. It is important to note that the status of animals and plants is under constant review, meaning that a species can move from one appendix to another depending on the level of threat to its survival. The CITES website http://checklist.cites.org provides a useful search engine which has details of whether a species is listed in one of the appendices, the history of its listing and which of the appendices it currently sits in.

Appendix-I specimens
1. A CITES import permit from the State of import is required, and will be issued only if the specimen is (a) not to be used for primarily commercial purposes and (b) if the import will be for purposes that are not detrimental to the survival of the species.
2. A CITES export or re-export permit issued by the State of export or re-export is also required. An export permit will be issued only if (a) the specimen was legally obtained; and (b) the trade will not be detrimental to the survival of the species; and (c) an import permit has already been issued.
3. A CITES re-export certificate may be issued only if the specimen was imported in accordance with the provisions of the Convention.

Appendix-II specimens
1. A CITES export permit or re-export certificate issued by the State of export or re-export is required.
2. A CITES export permit may be issued only if the specimen was (a) legally obtained and if the export will not be detrimental to the survival of the species.
3. A CITES re-export certificate may be issued only if the specimen was imported in accordance with the Convention.
4. No import permit is needed unless required by national law.

Appendix-III specimens
1. In the case of trade from a State that included the species in Appendix III, a CITES export permit issued by that State is required. This may be issued only if the specimen was legally obtained.

2. In the case of export from any other State, a certificate of origin issued by its CITES Management Authority is required.
3. In the case of re-export, a CITES re-export certificate issued by the State of re-export is required.

10.4.4 Exceptions

Parties may make certain exceptions to the above in the following cases, although a permit or certificate may still be required:

1. where the specimens are in transit or being transhipped;
2. in relation to specimens that were acquired before CITES provisions applied to them (known as pre-Convention specimens);
3. for specimens that are personal or household effects;
4. for animals that were 'bred in captivity';
5. for plants that were 'artificially propagated';
6. for specimens that are destined for scientific research;
7. for animals or plants forming part of a travelling collection or exhibition, such as a circus.

CITES also provides an important exemption for antiques. An item shall be exempt from normal CITES sales controls if it (i) was acquired prior to June 1947 and (ii) has been 'worked' – meaning significantly altered from its natural raw state for jewellery, adornment, art, utility or musical instrument.

Previously there was some question over whether, for instance, a tusk could be considered to be 'worked' if it was not carved but was polished and permanently mounted on a decorative stand or plinth. Guidelines provided by the government on the interpretation of 'worked' have put that debate to rest. For ivory tusks or sections of tusks to be considered worked, they need to be fully carved across 'the whole surface'. A tusk will not therefore be considered to be worked if it is merely polished and permanently mounted.

It is also worth remembering that a pre-1947 object which is repaired or restored must, in order to fall within the exemption, be shown to be repaired or restored using post-1947 'worked ivory'.

10.4.5 Enforcement

In the United Kingdom, Customs and Excise are responsible for the enforcement of CITES controls at the border, while enforcement within the United Kingdom is the responsibility of the police with help from DEFRA. The offences and sanctions for breach are set out in CITES.

The CITES system depends on a reliable permit system. This system requires the applicant to inform him or herself on the status of the species he or she is handling and to apply for permits in an honest and open manner. It is therefore an offence to apply for a permit based on information which the applicant knew or should have known was false. Specifically, it is an offence, for the purpose of obtaining the issue of a permit or certificate, to knowingly or recklessly make a materially false statement or representation, or to knowingly or recklessly provide a document or information which is materially false. It is also an offence to knowingly falsify or alter any permit or certificate or recklessly use or provide a false, falsified or invalid permit or certificate or one which has been altered without authorisation.

Where a permit has been granted for a particular purpose, or subject to particular conditions, it is an offence to use the specimen for another, nonauthorised purpose or to breach the conditions.

Under CITES it is an offence to purchase, or acquire for commercial purposes, or sell any specimen classified as an Annex A specimen. These are specimens of any species which is either threatened with extinction or so rare that any level of trade would imperil its survival.

It is also an offence to purchase or acquire for commercial purposes, or sell, and so on, any unlawfully obtained or imported Annex B specimen. An Annex B specimen is a specimen of a species the trade in which might not be compatible with its global survival, or with the survival of populations in certain countries.

In order for a prosecution to take place the specimen involved must be clearly identified. Often the only way of doing this is on the basis of expert zoological or botanical evidence from a person who is both academically qualified and practically experienced.

The offences carry a punishment of a fine and/or up to two years' imprisonment, depending on the seriousness of the breach, whether the person prosecuted is a repeat offender and whether the offender was acting as part of a wider group.

It is a defence to the offence to prove that at the time a specimen first came into a person's possession he or she made such enquiries as in the circumstances were reasonable to ascertain whether it was imported or acquired unlawfully, and that at the time the alleged offence was committed he or she had no reason to believe that the specimen was imported or acquired unlawfully.

Just as serious are the consequences for the artwork seized. In most cases, artworks which are seized as a result of offences committed under the CITES regulations are retained by the authorities without compensation. They are rarely if ever returned to the owner, regardless of the value of the object. For this reason it is essential for

collectors, dealers and auction houses to be alert to whether an artwork object or item of furniture incorporates material from a species protected under the CITES convention. Failure to do so and failure to apply for the correct licences can lead to criminal prosecution and permanent seizure of the work.

10.4.6 Ivory and rhino horn

We have seen above that the international system imposing restrictions on the trade in animal parts is to be found in the CITES Convention, implemented in the UK through the Endangered Species (Import & Export) Act 1976 and the UK Control of Trade in Endangered Species (Enforcement) Regulations 1997. While this legislation covers a host of endangered species, few of these have been as emotive as ivory from elephants and rhino horn. These have been difficult from the perspective of the art market because many ancient and antique objects and artworks, which play no part in the poaching of elephants and rhinos and the illicit market, were crafted in whole or in part using ivory and rhino horn. This was recognised in the UK legislation which permitted the trade in ivory provided the artwork or object in question had been (i) 'worked' (for example, carved) and (ii) completed before 1947. There was much criticism of this exception on the grounds that it is difficult in many cases to state with certainty that a work of ivory – particularly a minor unrecorded work – has come into existence before 1947.

In 2017 the government announced plans to impose a blanket ban on the trade in all elephant ivory, subject to some very limited exceptions. The exceptions, contained in the Ivory Act 2018, are as follows:

- Any antique (to be defined as an artwork produced before 1918) containing ivory, so long as it is assessed as being (i) of 'outstandingly high artistic, cultural, or historical value' and (ii) an example of 'one of the rarest and most important item of their type'.[36] The determination of value, importance and rarity will be made by selected museums.
- Any object containing less than 10% of its volume in ivory and made pre-1947 (known as the de minimis rule).[37]
- Musical instruments containing a maximum ivory volume of 20% and made pre-1975.[38]
- Portrait miniatures, which are often painted directly onto ivory, will be exempted if they were made before 1918 and have a surface area of no more than 320cm².[39]

[36] Ivory Act 2018, s 2.
[37] Ivory Act 2018, s 7.
[38] Ivory Act 2018, s 8.
[39] Ivory Act 2018, s 6.

Museums will remain free to buy, borrow or exchange objects containing ivory provided they are accredited and the acquisitions are consistent with their acquisitions and ethical policies.

Anyone wishing to sell an item under the exemptions will be obliged to register their items online using a system managed by the Animal and Plant Health Agency (APHA). A fee will be charged. Where the exemption in question is the 'rarest and most important item of its type' exemption, before issuing a permit the APHA will obtain advice from a suitably quailed institution to decide whether the item meets the requirements of the exemption. It seems likely that this exemption may only be granted where the object is of 'museum quality'.

The dating of the ivory plays a significant role in determining whether or not an item falls within the exemptions. Dating may be possible through either: (i) evidence of the item's provenance; (ii) age verification by an expert; or (iii) radiocarbon dating.

The Act, which is expected to come into law in 2022, envisages criminal sanctions for selling ivory in breach of the law. This will include a prison sentence of up to five years and an unlimited fine.

Items which do not fall within the legal list of exemptions and cannot be registered cannot be dealt in, but can be kept for personal use, given away as a gift, bequeathed in a will or loaned provided that no payment, exchange or barter is involved.

In relation to rhino horn, the sale of 'worked' items of rhino horn acquired or prepared prior to 1947 is still permitted. Uncarved rhino horn cannot be sold regardless of its age. In March 2012 the European Union imposed restrictions on the export of rhino horn from countries within the European Union regardless of whether or not they have been 'worked'. Export licences will now only be granted for rhino horn works of art in limited circumstances.[40] The result is that while pre-1947 worked rhino horn works of art can be sold in the UK, they are unlikely to be granted licences to be sent overseas.

The European Union is also considering measures to restrict the trade in ivory. At the date of writing, the EU was considering legislation which would:

- suspend the import of raw ivory into the EU for commercial purposes and any trade in raw ivory within the EU for commercial purposes. There is however an exception, where trade within the EU is concerned, for the repair of musical

40 http://apha.defra.gov.uk/documents/cites/cites-news061014-info.pdf

instruments. Exceptions will be made on a case-by-case basis and will require authorisation in the form of a certificate from a national authority;

- suspend the trade for commercial purposes in worked ivory acquired in the EU between 1975 and 1990 within the EU trade;
- require a certificate in order to trade within the EU in pre-1975 worked items. Such certificates will be issued only in respect of pre-1975 musical instruments and pre-1947 'antique' items;
- suspend the re-export out of the EU or import into the EU of in pre-1975 worked items except in the case of pre-1975 musical instruments;
- permit exceptions to these rules in the case of a genuine exchange of cultural goods between reputable institutions, the export or import of an heirloom moving as part of a family relocation, or where the item is moved for enforcement, scientific or educational purposes.

The UK government is now also considering extending the elephant ivory ban in the UK to non-elephant ivory such as hippopotamus, walrus and narwhal ivory.[41]

10.5 Freedom of expression

10.5.1 Introduction

In the United Kingdom the right to freedom of expression is enshrined in the Human Rights Act. The Human Rights Act incorporates into United Kingdom law the provisions of the European Convention on Human Rights. Article 10 of the European Convention on Human Rights provides:

1. Everyone has the right to freedom of expression. This right shall include freedom to hold opinions and to receive and impart information and ideas without interference by public authority and regardless of frontiers.
2. The exercise of these freedoms, since it carries with it duties and responsibilities, may be subject to such formalities, conditions, restrictions or penalties as are prescribed by law and are necessary in a democratic society, in the interests of national security, territorial integrity or public safety, for the prevention of disorder or crime, for the protection of health or morals, for the protection of the reputation or rights of others, for preventing the disclosure of information received in confidence, or for maintaining the authority and impartiality of the judiciary.

In this way, the right to freedom of expression is a qualified right, which is subject to certain limits.

The right to freedom of expression is of particular importance to artists who seek, with their work, to challenge the status quo and question accepted views.

[41] DEFRA 2021 consultation on extending the Ivory Act to other species.

Contemporary art in particular seeks to be provocative, disturbing, eccentric and sometimes offensive. So the question arises – at what point is the limit of freedom of expression reached? The three areas where this question most frequently arises are sex, race and religion. We will explore each of these in turn.

10.5.2 Obscenity and sex

Original art is often intended to challenge perceptions of artistic value and break down boundaries. This was never more so than in the Royal Academy show 'Sensation' in 1997, which showcased the work of a new breed of British artists whose work was intended to shock and challenge. The works on display included Sarah Lucas's explicitly sexual images and sculptures, and installations by Jake and Dinos Chapman involving child mannequins with noses replaced by penises and mouths in the form of anuses. Contemporary artists were deliberately pushing the boundaries of art using explicit sexual and violent imagery which was, in part, designed to lead us to question the boundaries between art and obscenity.

'Sensation' caused considerable discussion over the limits of freedom of expression. In particular, concern was expressed over an image of the child murderer Myra Hindley and an image of the Virgin Mary by Chris Ofili which incorporated elephant dung. When the exhibition travelled to the Brooklyn Museum in New York, Mayor Giuliani sought to withdraw funding for the exhibition on the grounds that it was 'sick stuff'. In many ways the artists and the exhibition thrived on the resulting notoriety and this in turn has encouraged other artists to explore the limits of freedom of expression using 'shock art'. Artists creating works including challenging sexual imagery and galleries seeking to display such works need, however, to be aware of the legal boundaries in the United Kingdom.

10.5.2.1 The Obscene Publications Act 1959

The Obscene Publications Act 1959 provides the starting point for an analysis of the law in this area. The Act makes it an offence to publish any article that has a 'tendency to deprave and corrupt' persons who are likely in the circumstances to read, see or hear the contents of the article.[42] The question of whether or not an article is obscene is one for the jury, and not for expert witnesses. This formulation – while bringing uncertainty to the question of what is obscene – has had the advantage of ensuring that the test of what is obscene is rooted in the mores and standards of ordinary citizens today, rather than those of the public in the 1950s.

[42] Section 1 of the Obscene Publications Act 1959.

Some guidance can be found in the Crown Prosecution Service Guidance on prosecution policy.[43] Whereas until January 2019 the prosecution guidance enumerated various acts likely to be considered to be obscene, this has now been replaced by some tests centred on consent. As a result, prosecutions under the Act are unlikely provided that:

The act depicted is consensual, no serious harm is caused and it is not otherwise inextricably linked with other criminality (so as to encourage emulation or fuelling interest or normalisation of criminality). The likely audience for the depiction must also not be under 18 (having particular regard to where measures have been taken to ensure that the audience is not under 18) or otherwise vulnerable (as a result of their physical or mental health, the circumstances in which they may come to view the material, the circumstances which may cause the subject matter to have a particular impact or resonance or any other relevant circumstance).[44]

However, even where the imagery is of a kind that might be considered obscene, the Act does allow for a defence for artistic works which is not available in any other obscenity legislation. Section 4 of the Act states that

a person shall not be convicted of an offence ... if it is proved that the publication of the article in question is justified as being for the public good on the grounds that it is in the interests of science, literature, art and learning, or other objects of general concern.

For artists and galleries this is an important exception, but care should nevertheless be taken. The fact that an object is labelled as art does not provide automatic immunity. The defence will fail if the judgment of the court is that the object is so lacking in artistic merit that it does not meet the 'public good' test.

However, the existence of the 'public good' exception for artistic works has tended to deter the police from prosecuting artists and galleries using the Obscene Publications Act 1959. Attempts have instead been made by the prosecuting authorities to circumvent the artistic 'public good' defence by looking instead to other offences where the defence is not available. In 1990, in the cases of R v Gibson and R v Sylveire, the prosecution successfully prosecuted the artist who created and the gallery owner who displayed an art exhibit consisting of a pair of earrings made of real freeze-dried foetuses. The prosecution was based upon the ancient common law offence of 'outraging public decency'. The Obscene Publications Act was not invoked, presumably as it would have allowed a defence to have been mounted on the grounds of artistic merit – a defence which was not available in a prosecution for outraging public decency. This approach is no longer possible as the offence of outraging public decency was abolished in 2009. The

[43] www.cps.gov.uk/legal-guidance/obscene-publications
[44] CPS Prosecution Guidance Obscene Publications, revised January 2019.

authorities have therefore looked to other legislation since then when considering prosecutions under obscenity and indecency law. The four key areas in which such prosecutions are possible are under the Protection of Children Act 1978; s 160 of the Criminal Justice Act 1988; Part 5, ss 63 to 67 of the Criminal Justice and Immigration Act 2008; and the Indecent Displays (Control) Act 1981.

10.5.2.2 The Protection of Children Act 1978

When considering the question of indecency, particular care needs to be taken where the subject of an image is a child. The focus of the police and prosecuting authorities has moved over the years from the protection of public morals to the protection of children. The Protection of Children Act 1978 makes it an offence to take, make, distribute, show or possess with a view to distributing any indecent image of a child. A child is defined as a person under the age of 18. The sensitivity over imagery of children should not be underestimated. It is important to note that the Protection of Children Act 1978 does not provide for a defence of artistic justification or public good, as in the Obscene Publications Act.

10.5.2.3 Section 160 Criminal Justice Act 1988 (possession of an indecent photograph of a child)

Section 160 makes it an offence for a person to have any indecent photograph or pseudo-photograph of a child in his possession. Just as with the Protection of Children Act, there is no Obscene Publications Act defence of artistic justification or public good.

10.5.2.4 Part 5, ss 63–67 of the Criminal Justice and Immigration Act 2008 (possession of extreme pornographic images)

Sections 63 to 67 of Part 5 of the Criminal Justice and Immigration Act 2008 make it an offence to possess pornographic images that depict acts which threaten a person's life; acts which result in or are likely to result in serious injury to sexual organs; bestiality; or necrophilia.

Section 63(6) of the Act makes it clear, however, that the extreme image must be not only explicit, but realistic. This requirement was introduced to avoid artworks such as paintings depicting the Greek myth of Leda and the Swan being caught by the offence, because the depiction of bestiality is neither explicit nor realistic.

10.5.2.5 The Indecent Displays (Control) Act 1981

In 1981 the Indecent Displays (Control) Act was introduced. This Act provided that if any indecent matter is publicly displayed, the person making the display

and any person causing or permitting the display shall be guilty of an offence. The Act however made it clear that this did not apply to any matter included in the display of an art gallery and visible only from within the museum or art gallery.[45] It is also worth noting that a work is not deemed to be 'publicly displayed' if either

(a) visitors have to pay to access the place where the work is displayed; or
(b) where persons under the age of 18 are not permitted to enter while the display is continuing and this is enforced by a warning notice stating

> WARNING Persons passing beyond this notice will find material on display which they may consider indecent. No admittance to persons under 18 years of age.[46]

In 2001 images by the photographer Tierney Gieron of her children seminaked on a beach wearing masks were on exhibition at the Saatchi Gallery in London. The police visited the gallery and sought advice from the Crown Prosecution Service on the possibility of a prosecution under the Protection of Children Act 1978. Tierney Giron said that the images had 'wholesome innocent intentions'. The police intervention led to a major debate in the media over censorship. The Crown Prosecution Service eventually announced that it would not be prosecuting the matter as there was no realistic prospect of a conviction. The spokesman added that '[i]n reaching this decision the CPS considered whether the photographs in question were indecent and the likely defence of the gallery, i.e. whether the gallery had a legitimate reason for showing them.'

A similar situation arose in 2009 when the Tate Gallery was planning to exhibit a work called Spiritual America in its Pop Life exhibition. This work was a photograph by the US artist Richard Prince of actress Brooke Shields standing naked in a bath when she was 12 years old. The image was in fact a photograph of a photograph which appeared in the Playboy publication Sugar n' Spice in 1976. It was described in the exhibition catalogue notes as an image of a 'bath damp and decidedly underage Brooke Shields'. The police visited the Tate Gallery and, it is said, threatened to prosecute if the work was not taken off display. The Tate Gallery duly complied.

10.5.2.6 Some practical guidance for artists, museums, auction houses and galleries

The first consideration is: is the subject matter of the art likely to be considered indecent? Generally, even the explicit depiction of consensual sex between adults is unlikely to be considered indecent. This is particularly the case where, when exhibiting the work, an effort is made to exclude minors and warn the public of the

[45] Indecent Displays (Control) Act 1981, s 4(b).
[46] Indecent Displays (Control) Act 1981, s 6(a).

graphic nature of the works exhibited. Where problems will arise is in connection with realistic depictions of nonconsensual sex involving violence, degradation or bondage. In these cases the police may prosecute if they feel the material is sufficiently indecent that the artist or exhibitor will be unsuccessful in claiming that the artistic value of the work is a defence to the prosecution.

The second consideration is the realism of the depiction of the subject matter. Old Master paintings and nineteenth-century paintings and drawings, for instance, frequently include depictions of rape. These, however, are almost certainly not problematic from the perspective of indecency law because they are clearly imaginary and stylised depictions. That is different from a modernday photograph in which the appearance is given of a real act of sexual violence taking place.

Any depiction of a child – someone who is or appears to be under 18 years of age – in a context which is sexually suggestive is likely to be problematic. This is particularly the case where the child is naked or in a state of undress.

A further consideration is the public nature of the display. Challenging material displayed in a window which can be viewed by passersby is more likely to be problematic than material on display in a private gallery.

A degree of protection can be gained from taking precautions to warn the audience in advance of the explicit nature of the material on display. This then provides the audience with a choice.

Finally, the importance of context needs to be borne in mind. A photograph of a child in a swimsuit displayed on its own may raise no questions of indecency. However, if that image is displayed alongside works of a sexual nature, the context – while not rendering the image indecent – could cause offence.

10.5.3 Art, religion and race

When we think of challenging art, we tend to think of art which is challenging from the perspective of sexual mores. However, in seeking to challenge perceptions art is also capable of causing controversy in other ways. In particular, questions can be raised where the subject matter of art is a controversial treatment of race or religion.

10.5.3.1 Religion

In the United Kingdom blasphemy laws were abolished in 2008. Section 1 of the Racial and Religious Hatred Act 2006 creates the offence of stirring up religious

hatred.[47] The offence is committed if a person uses threatening words or behaviour, or displays any written material which is threatening, if he intends thereby to stir up religious hatred. 'Religious hatred' means hatred against a group of persons defined by reference to a religious belief or lack of religious belief.[48]

It should be noted that the offence relates only to words, behaviour and written material. It does not, therefore, cover images, but will cover performance art or artworks which contain written words.

The effect of the law is further limited by the fact that the words, behaviour or written material must be threatening. Abusive or insulting writing, words or behaviour are not sufficient to secure a conviction.

There is also a requirement of intent on the part of the defendant. He or she must intend to stir up religious hatred.[49] It is not enough that the artist was reckless. Part 3A s 29J goes on to confirm that nothing in the Act 'prohibits or restricts discussion, criticism or expressions of antipathy, dislike, ridicule, insult, or abuse of particular religions, or the beliefs or practices of its adherents'.

For all these reasons it is extremely difficult to object to an artwork on the grounds that it is offensive to a religious group under the Racial and Religious Hatred Act 2006.

10.5.3.2 Race

The position in relation to works which cause racial offence is rather less restricted than that of religion. The offence of incitement to racial hatred under s 18 of the Public Order Act 1986 means that artists, producers and presenters of written material, public performances or video or audio recordings may be guilty of an offence if their art involves threatening, abusive or insulting words, images or actions that are intended to – or, having regard to all the circumstances, are likely to – stir up racial hatred against a group defined under s 17 as persons defined by reference to colour, race, nationality (including citizenship) or ethnic or national origins. As with the Racial and Religious Hatred Act 2006, the offence relates only to words, behaviour and written material. It does not therefore cover images, but will cover recordings, performance art or artworks which contain written words.

[47] Which in Part 3A amends the Public Order Act 1986 to include offences of hatred against persons on religious grounds.

[48] Part 3A Racial and Religious Hatred Act 2006.

[49] Part 3A Racial and Religious Hatred Act 2006.

Anyone accused of this offence has a defence if they are able to show that the work was not intended to be threatening, abusive or insulting and/or the accused was not aware that it would be interpreted in that way.[50]

Public sensitivity also plays a part, and the fact that a work is not illegal does not mean that the work will be tolerated in the court of public opinion. In 2004 the Barbican exhibited an art installation called Exhibit B created by South African artist Bill Bailey. The installation featured black actors in chains and was intended as a critique of ethnographic displays that showed Africans as objects of scientific curiosity in the nineteenth and early twentieth centuries. After a public outcry, the Barbican took the decision to voluntarily withdraw the installation from exhibition.

10.6 Furniture and Furnishings Fire Safety Regulations

The Furniture and Furnishings (Fire Safety) Regulations 1988 (as amended in 1989, 1993 and 2010) are designed to ensure that furniture and upholstery sold in the United Kingdom meet specified fire ignition resistance levels and are suitably labelled. This is an important set of rules for those trading in antique or second-hand furniture.

The main elements contained within the Regulations are:

• Filling materials must meet specified ignition requirements.
• Upholstery composites must be cigarette resistant.
• Covers must be match resistant.
• A permanent label and display label must be fitted to every item of new furniture.

The maximum penalty is a fine and six months' imprisonment. Further, where a product causes personal injury or property damage, the supplier could be liable to pay damages.

While these regulations are very sensible for sales of new furniture, they would be unworkable in relation to the sale of secondhand furniture dating back to times when fire safety was not the concern that it is today. As a result, under reg 4 of the Furniture and Furnishings (Fire Safety) Regulations 1988, the following are excluded from these requirements:

• the supply of any goods manufactured before 1 January 1950;

[50] Section 18(5) Public Order Act 1986.

- the supply of furnishing and upholstery materials when the person supplying them knows or has reasonable cause to believe that they will be used for recovering or reupholstering furniture manufactured before 1 January 1950; or
- in any case where the person supplying goods to which those requirements relate knows or has reasonable cause to believe that the goods will not be used in the United Kingdom.

However, the requirements will apply in relation to secondhand furniture which was made after 1 January 1950 unless the goods are supplied to be used outside the United Kingdom.[51]

For this reason, auctioneers and dealers selling secondhand post-1950 furniture will often include in their catalogues a provision stating that the furniture sold is being supplied as a work of art, and is not for use in a private home without first being reupholstered and treated with fire retardant chemicals.

[51] Regulation 4 of the Furniture and Furnishings (Fire Safety) Regulations 1988, SI 1988/1324.

11 Art and taxation

11.1 Tax and art

11.1.1 Capital gains tax

Capital gains tax (also commonly referred to as CGT) is the tax payable when an asset such as an artwork is disposed of at a higher value than at its acquisition. Tax is paid on the increase in value. So, a painting bought for £50,000 and sold five years later for £70,000 will generate a taxable gain of £20,000 (£70,000 minus £50,000).

Capital gains tax is only payable once your total gains in a tax year exceed your tax free allowance (Annual Exempt Amount). The Annual Exempt Amount for the year to 5 April 2022 was £12,300, and £6,150 for trusts. If total gains in the tax year fall below this amount no tax is payable.

11.1.1.1 When capital gains tax is triggered

Capital gains tax is triggered by the disposal of the asset. 'Disposing of an asset' for the purposes of capital gains tax includes selling it; giving it away as a gift or transferring it to someone or some entity, such as a company or trust; swapping it for something else; or getting compensation for it, such as payment by an insurance company following theft or destruction.

There are two general exemptions where capital gains tax is not payable: gifts to a spouse or civil partner, and gifts to a charity. There are also some specific exemptions for transactions involving artworks and objects, such as sales or gifts of chattels when the proceeds or deemed proceeds are £6,000 or less, and disposals of mechanical instruments (such as clocks) or objects with an expected useful life of 50 years or less. It is also possible to defer the tax on artworks and objects in some circumstances (see 11.2.1). Capital gains tax is not payable on gifts to a spouse or civil partner provided the partners are not separated and lived together in the tax year of the gift.[1] However, when the spouse or civil partner disposes of the gift,

[1] Excluding gifts which are made to the spouse or civil partner for their business to sell on.

capital gains tax will be payable. The starting point for the calculation of the gain in such cases will be the value at the date the asset was acquired by the donor, as the donee spouse or civil partner is deemed to have acquired it on the same date.

A gift to a charity will not attract capital gains tax. However, if you sell an artwork to a charity for more than you paid for it you will trigger a capital gain. If you sell an artwork for less than the market value to a charity, the gain will only be calculated on the money you receive, unless you have another connection with the charity.

11.1.1.2 Calculating the gain

On the disposal of an artwork, the values to be used when working out the rise in value are easily identified. The purchase price or acquisition value is the starting point and the sale price or disposal value is the other part of the equation. It is more difficult, though, where the artwork is acquired or disposed at an under-value, or otherwise than by a purchase or sale: in those circumstances the relationship between the buyer or donee and the seller or donor will be considered. If the buyer/donee and seller/donor are deemed to be connected, then the actual amount paid or received is ignored and an open market value is used instead. For instance, if the artwork was inherited, or a gift, from a family member, or if it was sold to someone related to the seller for less than it was worth to help the buyer, then the open market value will be used instead of the money paid or received. In these circumstances, the figure to be used is the open market value, and ascertaining that open market value requires the object to be valued.

If the artwork was owned by the seller/donor on or before 31 March 1982, the purchase price or value at the date of acquisition is ignored and the gain is calculated as the rise in value over the open market value as at 31 March 1982.

Certain costs incurred during ownership of the artwork and connected with the sale can also be deducted from the proceeds to calculate the gain. These include acquisition costs (for example, fees paid in addition to the cost of the artwork), restoration, photography, marketing and advertising of the sale, fees and transport for the sale. It is not possible to deduct interest payments on a loan used to purchase the artwork.

Disposal of artworks for deemed or actual proceeds of £6,000 or less is exempt from capital gains tax. There is a formula which provides some relief from capital gains tax where the proceeds are only slightly over £6,000.

11.1.1.3 Tax payable

In the tax year 2021/22 higher rate income taxpayers will pay 20% on gains. Basic rate income taxpayers will pay either 10% or 20% depending on the size of the gain and how much of their basic rate income tax band is available.

Trustees and personal representatives for the estate of a person who has died (the deceased) pay 20% capital gains tax on sale of the assets of the trust or estate at a profit. In the tax year of death and for the following two years post death, the personal representatives are entitled to deduct the deceased's annual exempt amount from any capital gains.

11.1.2 Inheritance tax

Inheritance tax (commonly known as IHT) is the tax payable on the assets owned by certain trusts and the estate of a deceased person, if the values are above a certain threshold. Currently IHT is payable on the value of the estate or trust assets, where they exceed £325,000. IHT frequently affects estates of persons who owned artworks or who gifted artworks to others in the seven years prior to their death.

The IHT rate is 40% on death and is applied to the value of the estate over £325,000, reduced to 36% if more than 10% of the estate is gifted in the deceased person's will to a UK or EEA registered charity.

IHT is payable by the personal representatives handling the estate and is paid from funds in estate. IHT must be paid by the end of the sixth month after the month of death of the person whose estate is being taxed or, in other circumstances, the end of the sixth month following the month of the event triggering the IHT liability.

IHT may also be payable where an asset, such as an artwork, was gifted by the deceased to someone less than seven years before his or her death and the total value of the estate exceeds £325,000. In this case IHT is payable by the recipient of the gift. Tax is payable at 40% of the value of the gift for gifts made within three years of the date of death of the person who made the gift. If the gift was made between three and seven years from the date of death, the rate of tax payable is on a sliding scale known as tapering relief. The scale is as in the table below.

Years between the date of death and the gift	Rate
3 to 4	32%
4 to 5	24%
5 to 6	16%
6 to 7	8%

11.1.3 Estate duty and capital transfer tax

Estate duty and capital transfer tax are the forerunners of IHT. Estate duty applied to the assets owned by the deceased on death, whereas capital transfer tax, applied to lifetime transfers and to the estate on death. Capital transfer tax was introduced in 1974 to replace estate duty and IHT has many similarities to the capital transfer tax rules. However, capital transfer tax was superseded and replaced by IHT in 1986 (see section 11.1.2).

11.1.4 Domestic VAT

Domestic value added tax (VAT) is a United Kingdom consumption tax which is levied and accounted for by the seller in relation to sales of most goods, including art, and services. The default VAT rate is 20%. Sales between private individuals are not liable to VAT.

VAT is not payable in relation to goods which are exported from the European Union or to someone who is registered for VAT purposes in another EU country.

11.1.5 Import VAT

Goods entering the United Kingdom from abroad are liable to a tax known as import VAT at the point at which they enter the EU. This is not to be confused with domestic VAT, which may apply on any sale transaction (see above). While the standard rate of import VAT is 20%, works of art, antiques more than 100 years old and certain collectables benefit from a reduced rate of import VAT of 5%.

11.2 Tax efficient arrangements

There are a number of ways in which owners of important artworks can structure their affairs in a tax efficient way or settle tax liabilities using artworks. These are essentially as follows.

11.2.1 Conditional exemption

Conditional exemption is a way to defer payment of capital gains tax or IHT when an artwork which meets certain criteria (see 11.3) is passed to a new owner either by inheritance or as a gift. It is the only scheme in which the artwork can remain in the ownership of an individual or a family trust.

In return for the deferral of tax liability the new owner of the artwork provides 'undertakings' to retain and take care of the object, make it available for the public

to view and keep it in the United Kingdom. Owners are also requested, but not obliged, to give notice of an intention to sell an artwork which is conditionally exempt from tax.

If these undertakings are breached or if the object is sold, this is known as a 'chargeable event' and the exemption is withdrawn and the deferral comes to an end. Consequently, the tax must be paid. In the absence of a chargeable event the deferral will continue until the owner dies or the trust is wound up and either the new owner pays the tax or agrees to abide by new undertakings.

11.2.2 Sales to the nation

The sale of conditionally exempted artworks or those which would qualify for conditional exemption (see 11.3) triggers the deferred IHT and/or capital gains tax. However, sale to certain public bodies listed in Schedule 3 to the Inheritance Tax Act 1984 (see 11.4) can be arranged in a way which results in these tax charges being waived. In practice the benefit of the waiver is shared between the seller and the buyer. The effect is that the seller receives a larger net amount than he or she would have done on an open market and the buyer pays less than the open market value.

11.2.3 Acceptance in lieu

The acceptance in lieu scheme is a mechanism by which certain artworks considered to be preeminent are given by the owner to a public institution in satisfaction of all or part of the owner's inheritance tax liability. The combined total value of the tax reduction available in a year under the acceptance in lieu scheme and the cultural gifts scheme (see 11.4 below) is £40 million.

11.2.4 Cultural gifts scheme

The cultural gifts scheme, which bears many similarities to the acceptance in lieu scheme, is designed to encourage philanthropic donations of preeminent artworks to public museums and institutions for display. The incentive for the donor is a tax reduction in income tax, capital gains tax or corporation tax based on a percentage of the value of the artwork donated. Only individuals or companies can use this scheme; notably, jointly owned works of art cannot be offered under the cultural gifts scheme.

11.2.5 Lifetime gifts

An owner of an artwork can, in order to avoid or mitigate IHT on his or her death, gift the artwork to an individual during his or her lifetime. IHT will not apply provided the person making the gift dies more than seven years after the gift. If

the death occurs between three and seven years after the gift was made, a reduced rate of inheritance tax will be payable under the tapering relief scheme (see section 11.1.2). A gift which is not to an individual will almost certainly be a chargeable transfer at an initial rate of 20% with a further 20% payable on the death of the donor unless they survive for seven years longer, with taper relief available if they survive more than three but less than seven years.

11.3 Conditional exemption

Some works of art can be exempted from IHT and or capital gains tax when they are passed to a new owner either by inheritance or as a gift. This is a deferral of the tax payable.

To be considered for exemption the object or objects must be preeminent for their national, scientific, historic or artistic interest, either individually or as part of a qualifying group or collection of objects, or have a connection with a building of outstanding historic or architectural interest. The Arts Council advises HMRC whether an object satisfies any of these criteria.

It is a condition of the arrangement that the person to whom the work has been gifted, or who inherits it, provides 'undertakings' to retain and take care of the object, make it available for the public to view and keep it in the United Kingdom.

If these undertakings are breached, for example if the object is sold, this is known as a 'chargeable event' and the exemption is withdrawn and the tax must be paid Notably, the tax is calculated on the basis of the object's value on the date of the breach.

Of all the undertakings, it is the requirement to make the object available for public viewing which is the subject of most discussion and negotiation. Previously it was possible to limit access to a system of viewing 'by appointment' only. Since 1998, the requirement has been that access for artworks with a new exemption should be without an appointment. This usually involves giving the public access to the artwork for at least 28 days a year in England and 25 days in other parts of the UK. The availability of public access to the artwork must also be publicised and full details are published on HMRC's website. When not available for viewing without an appointment, the artwork must still be available for interested members of the public by appointment at other times.

If public access of this kind is problematic or impractical for the owner, one alternative is to provide public access to the artwork by lending it to a public institution such as a museum or gallery. This can be done with an agreement to

lend the artwork for a certain number of days each year or for a longer period every few years, such as three months every three years. While this would seem to be an attractive solution, museums and galleries are not always keen to accept responsibility for loans unless the artwork fits their needs. Moving the artwork also presents risks of damage or theft.

A chargeable event which triggers the withdrawal of the tax concession can be one of the following:

- A material breach of one of the undertakings. For instance, the work is found to have been mishandled or damaged by neglect, the public have not been given access or the artwork has been shipped out of the United Kingdom.
- A sale or disposal of the conditionally exempted work. However, a sale to a museum or body listed in Schedule 3 of the Inheritance Tax Act 1984 is not a chargeable event (see section 11.4, 'Sales to the nation').
- A transfer of ownership of the conditionally exempt artwork following the death of the owner, unless the new owner reapplies successfully for conditional exemption.

11.4 Sales to the nation

A sale of an artwork to a museum or other body listed in Schedule 3 of the Inheritance Act 1984 can be tax efficient, particularly so where the artwork is conditionally exempt.

The bodies listed in Schedule 3 of the Inheritance Tax Act 1984 include a wide selection of national museums and institutions, together with museums and libraries maintained by local authorities and universities.

As explained in section 11.2.1, 'Conditional exemption', under the conditional exemption scheme inheritance tax and capital gains taxes can be deferred in exchange for 'undertakings' to take care of the object, make it available for the public to view and keep it in the United Kingdom. The difficulty with this arrangement is that the deferred inheritance tax or capital gains tax is triggered if the artwork is subsequently sold on the open market. The result is that the net proceeds of sale received by the seller are substantially reduced. However, the sale of artwork to a Schedule 3 body will allow the seller to receive a larger portion of the sale proceeds. Such sales are also free of VAT on the artwork.

An administrative arrangement has therefore been developed to allow the seller and the Schedule 3 body to negotiate a price. The key feature of the arrangement is that the benefits of the tax free sale can be shared between the seller and buyer. As a sale to a Schedule 3 body results in the seller receiving a greater net sum than

in an open market sale, the Schedule 3 body will seek to negotiate a price which is substantially less than the open market value. By sharing the benefits of the tax free sale, the seller receives more than he or she would have obtained on the open market and the Schedule 3 body pays less than it would have had to pay to acquire the artwork on the open market. Consequently, the benefit of the tax exemption is shared between the seller, who usually receives 25% of the tax he would have had to pay on an open market sale of the artwork, and the buyer, who pays a smaller sum for the purchase. For the buyer the reduction in price is 75% of the tax which would have been due on an open market sale. The government does not intervene in this process in any way.

A key part of the negotiation process is the agreement of the open market value of the artwork. That value is then used to calculate the 'special price'. Although the special price is a matter for negotiation and depends on the circumstances, a typical example of the calculation would be as follows:

Open market value of the artwork	£100,000
LESS: Notional IHT and capital gains taxes payable by seller on an open market sale of the artwork as follows:	
– CGT at 20% on the gain in value since acquisition (say £40,000):	
	£8,000
– deferred IHT payable on previous conditionally exempt transfer: 40% of £92,000 (open market value of £100,000 less £8,000 CGT)	
	£36,800

Total tax	£44,800
Open market value less total tax	£55,200
PLUS 'Douceur' of 25% of total tax (£44,800):	£11,200
Price payable by the Schedule 3 body:	£66,400
Price received by the seller	£66,400

In the above example, had the sale been on the open market for £100,000, the seller would have received net proceeds of £55,200 after deduction of CGT and IHT. However, because the sale is to a Schedule 3 body, HMRC writes off the tax it would have received on an open market sale and the seller receives £66,400. The Schedule 3 body also acquires an artwork worth an open market value of £100,000 for £66,400.

11.5 Lifetime gifts

An owner of an artwork can, in order to avoid IHT on his or her death, gift the artwork to an individual during his or her lifetime. This usually gives rise to a potentially exempt transfer. It is potentially exempt because its effectiveness in avoiding IHT depends on the donor surviving the gift by seven years. If the death occurs between three and seven years after the gift was made, a reduced rate of IHT will be payable under the tapering relief rules (see section 11.1.2). Not all gifts are potentially exempt for IHT. Capital gains tax may also come into play.

The gift cannot, however, be illusory. The object cannot physically remain in the donor's possession as this will mean that the donor has retained the benefit of enjoying the artwork and HMRC will consider that the gift is ineffective for IHT purposes only. Consequently, the donor must effectively deliver the artwork to the person to whom it is gifted and the donor cannot reserve any benefit in the artwork or be deemed to have reserved a benefit. This is sometimes addressed by arrangements where, following the gift, the person to whom it has been gifted leases it back to the donor. Where that happens, in order to extinguish a possible inheritance tax liability, the donor must give full consideration for their continued enjoyment of the artwork, frequently in the form of a rent. The issue then to be determined is what a market rate would be for such a leasing arrangement. This is an area frequently challenged by HMRC.

11.6 Acceptance in lieu

As noted in section 11.2.3, the acceptance in lieu scheme is a mechanism by which certain artworks, considered to be pre-eminent, are offered by the owner (usually personal representatives or trustees) to HMRC in satisfaction of all or part of the owner's IHT liability. It cannot be used in satisfaction of a capital gains tax liability. It is particularly useful to executors or personal representatives of estates or trustees where there is a significant IHT charge. As with sales to the nation (see 11.4) there is an incentive to pursue this as the douceur is available, reducing the tax payable on the artwork by 25%.

11.6.1 Who may benefit from the scheme?

Individuals, trustees or executors or personal representatives who have a liability to IHT.

11.6.2 The Acceptance in Lieu Panel

Applications under the acceptance in lieu scheme are made to the Acquisitions, Exports, Loans and Collections Unit at Arts Council England. The application is considered by the Acceptance in Lieu Panel. This is a panel of experts with art world experience, including museum curators, conservators and dealers.

The application must contain full details of the object, including its history and provenance, a valuation and data such as comparable sales justifying the value, evidence of title and provenance, images of the work, a statement setting out why the work is believed to satisfy the criteria for the scheme and details of the donor's tax status, the tax event giving rise to the liability and the institution to which the donor would prefer to see the object allocated.

11.6.3 Objects which may be considered

The categories of artwork eligible for the acceptance in lieu scheme are objects including works of art, heritage objects, pictures, manuscripts and archives or scientific object which in the opinion of the Acceptance in Lieu Panel are of pre-eminent quality either alone or as a collection or group. There is no guidance in the law on what pre-eminent means but the Acceptance in Lieu Panel uses the four criteria below as a framework of reference in their decision making:

- Does the object have an especially close association with the United Kingdom's history and national life?
- Is the object of special artistic or art historical interest?
- Is the object of special importance for the study of some particular form of art, learning or history?
- Does the object have an especially close association with a particular historical setting?

An object need not satisfy all of the criteria and the Acceptance in Lieu Panel will, in addition to these criteria, also take into account whether the object has a significant connection with a particular place in the United Kingdom. Consequently an object might be considered preeminent, and so qualify for the scheme, in one part of the United Kingdom but not in another.

Alternatively, the object must be or have been kept in a building of architectural or historic interest where the artwork forms a significant element, alone or with other objects, of the internal decoration and plays an important role in the understanding of the building or the people who have occupied it.

11.6.4 Value and condition

The value of the work has a direct effect on the extent of the tax benefit and is considered by the Panel. The object's value is based on the price the object could reasonably be expected to fetch if it were offered for sale on the open market. The Panel considers the proposed valuation, bearing in mind the object and its condition. The intention is to be fair to all parties and the Panel have been known to increase the open market value of the object if they think that the offer price suggested is too low.

11.6.5 Acceptance in Lieu Panel decision

If the Panel does not consider that an object is pre-eminent or associated with a historic building, the application will be declined. If the object is accepted as meeting the criteria and the open market value has been agreed by the Panel, the Panel will make a recommendation to the Secretary of State for Culture, Media and Sport.[2] If the Secretary of State agrees with the recommendation, the donor will be informed by Arts Council England and a Memorandum of Acceptance will be drawn up by HMRC. The Memorandum is the contract which exchanges the artwork in satisfaction of the IHT liability. The artwork is then transferred into the ownership of a suitable public body.

11.6.6 Advantages for the owner

This is best illustrated by an example. The executors of an estate have an inheritance tax bill of £70,000 to pay and own an artwork worth £100,000. The executors could settle that tax liability by selling the artwork belonging to the estate on the open market for £100,000. By doing this the executors would, after payment of the inheritance tax attributable to that object, have disposed of an object worth £100,000 and be left with net proceeds of £60,000. The executors would also need another £10,000 of cash to pay the £70,000 tax due. Alternatively, by offering the artwork worth £100,000 to an institution via the acceptance in lieu scheme, the executors could receive a tax credit equal to the net amount after the inheritance tax has been deducted (£60,000) and an incentive of 25% of the inheritance tax bill of £40,000 – in this case £10,000. The executors will therefore have paid off the inheritance tax liability of £70,000 (£60,000 plus the incentive of £10,000), leaving them with more cash in the estate.

There may be circumstances where, due to the value of the artwork donated, the credit which is generated by the arrangement is greater than the seller's tax liability. In those cases, HMRC will not 'give change' equal to the excess. However, in

2 Or, if appropriate, the Welsh Ministers, Scottish Ministers or Northern Ireland Department for Culture Arts and Leisure.

some circumstances where this happens, the public body acquiring the object may be prepared to pay the difference to the seller. This is known as a 'hybrid offer'.

11.7 Cultural gifts scheme

Until 2011, a donor of an object to a United Kingdom museum would receive nothing more than gratitude. Unlike in many other countries, where donations of art to museums are encouraged through tax incentives, there was, surprisingly, no similar scheme in the United Kingdom. That changed in 2011 when the Chancellor of the Exchequer finally answered calls by introducing the cultural gifts scheme, which is designed to encourage donations of artworks to public museums and institutions for display, for the benefit of the public and nation. The incentive for the donor is a tax reduction in income tax, capital gains tax or corporation tax based on a percentage of the value of the artwork donated. The impact of the scheme has been constrained by the fairly limited extent of the tax reduction and also by the annual limit on the value of the tax concessions available.

The cultural gifts scheme is very similar in structure and process to the acceptance in lieu scheme. The acceptance in lieu scheme (see sections 11.2.3 and 11.6) is a mechanism where the owner can pay an IHT liability in whole or in part by transferring an object to a national institution. The cultural gifts scheme is a means by which individuals can receive an income tax reduction and companies a corporation tax reduction in return for donating an object to the nation.

11.7.1 Who may benefit from the scheme?

Individuals with a liability to UK income tax or capital gains tax and companies with a liability to UK corporation tax. Living artists may also offer their own work under the scheme.

11.7.2 The Acceptance in Lieu Panel

As with the acceptance in lieu scheme, applications under the cultural gifts scheme are made to the Acquisitions, Exports, Loans and Collections Unit at the Arts Council England and the application is considered by the Acceptance in Lieu Panel.

Just as with the acceptance in lieu scheme, the application must contain full details of the object including its history and provenance, a valuation and data such as comparable sales justifying the value, evidence of title and provenance, images of the work and a statement setting out why the work is believed to satisfy the criteria

for the scheme, details of the donor's tax status and the institution to which the donor would prefer to see the object allocated.

11.7.3 Objects which may be considered

To qualify, the object must be of particular historical, artistic, scientific or local significance and be accepted by the Acceptance in Lieu Panel as being pre-eminent either individually or collectively or associated with a building in public ownership, such as a National Trust property, giving access to the public for at least 100 days a year. The framework of reference provides four criteria used under the acceptance in lieu scheme to assist in the decision making process (see 11.6.3).

As with the acceptance in lieu scheme, an object does not need to satisfy all of the criteria.

11.7.4 Value and condition

The value of the work will also be reviewed by the Panel. The object's value is based on the price the object could reasonably be expected to fetch if it were offered for sale on the open market. The Panel will consider the proposed valuation, bearing in mind the object and its condition.

11.7.5 Acceptance in Lieu Panel decision

If the Panel considers that an object is not pre-eminent the application will be declined. If the Panel considers that the object is pre-eminent and it has agreed the open market value and considers that the object should be donated for the benefit of the nation, the Panel will make a recommendation to the Secretary of State for Culture, Media and Sport.[3] If the Secretary of State agrees with the recommendation, the donor will be informed by Arts Council England and will receive a letter with the agreed valuation and a schedule of how the tax reductions will be applied. The donor has 30 days to accept the offer.

11.7.6 Tax reduction

The amount of the tax reduction available to the donor under the cultural gifts scheme is:

> 30% of the agreed value of the object in the case of capital gains tax and income tax;
> 20% of the agreed value of the object in the case of corporation tax.

[3] Or, if appropriate, the Welsh Ministers, Scottish Ministers or Northern Ireland Department for Culture, Arts and Leisure.

The donor can specify which tax the relief should be applied to, and in what order.

Care needs to be taken by the donor to ensure that the tax liability is at least as large as the tax reduction, as HMRC will not give credit for any excess unused tax reduction and once agreed, the tax reduction schedule cannot be varied.

However, if the donor is an individual he is entitled to spread the tax reduction he receives over five years from the year the offer is registered. That is not possible if the donor is a company, in which case the tax credit can be applied only to the accounting year in which the offer is registered.

11.7.7 Limits on the scheme

The cultural gifts scheme is run on a first come, first served basis. This is important because the annual joint budget for tax waived in the acceptance in lieu and cultural gifts schemes has an annual limit of £40 million.

11.7.8 Rules for the institution to which the object is given

The institution to which the work is entrusted can be a museum, an art gallery, a library or similar institution. It will own the object and it will be a condition of the donation that the institution shall at its own expense maintain the object in good condition and keep it in a place with appropriate security and environmental conditions. The object must be made available to the public and be on open public display for a minimum of 100 days per annum.[4]

The object may not be sold nor, without ministerial consent, be transferred to another institution other than for short periods.

11.8 Resident non-domiciliaries

Residents of the United Kingdom who have their permanent home and closest connections outside the United Kingdom are commonly known as 'non-doms' and have a slightly different tax regime to permanent residents. Non-doms are able to elect not to be taxed on foreign income and gains provided these were not brought into or used in the United Kingdom during the relevant tax year. This is called being taxed on a remittance basis. This can have great benefits because it means that artworks owned by the non-dom and held outside the UK can be sold or inherited without generating a UK tax liability.

4 Or an agreed lesser period if it is thought that 100 days' display would be detrimental to the long-term preservation of the object.

Since April 2017, however, once an individual has been resident in the United Kingdom for more than 15 years, he or she is deemed to be domiciled in the United Kingdom and cannot rely on non-dom status to avoid liabilities for income tax, capital gains tax and IHT on all foreign income and gains as they arise or on foreign assets on death.

In addition, UK residents with their current permanent home outside the United Kingdom, who were born and originally domiciled in the United Kingdom, are no longer able to be taxed on a remittance basis while they are resident in the United Kingdom.

Even where the art owning non-dom qualifies for the tax treatment under the remittance regime, he or she needs to take care not to inadvertently trigger a tax charge by bringing the artwork into the United Kingdom. In such cases a tax charge can apply on any foreign income that was used to fund the purchase of the artwork unless the owner is able to show that those funds had already been taxed in the United Kingdom. It is important to note that the tax charge applies to the funds used to purchase the artwork rather than the value of the art itself. Capital gains tax will of course also apply on any profit made if the art is sold.

There are some exceptions. Art can be brought into the United Kingdom temporarily for up to 275 days, or it can be brought in for restoration, repair or public display without triggering a charge. Nor will a charge be triggered if the artwork is brought into the United Kingdom for sale provided the proceeds of sale are taken offshore within 45 days of being released to the seller.

11.9 Domestic VAT

Domestic Value Added Tax (VAT) is a United Kingdom consumption tax which is levied most goods and services. The default VAT rate is 20%. Some items such as books do not attract VAT – these are known as zero rated items. Sales between private individuals also do not attract VAT.

VAT is invoiced by the seller of the goods or services to the consumer, and it is the seller who is responsible for accounting to the UK tax authorities for the VAT paid by the consumer.

VAT is not payable in relation to goods which are exported from the European Union or to someone who is registered for VAT purposes in another EU country. In both cases it is necessary to show evidence of export of the goods from the UK within three months of the transaction. In the case of sales to someone who is

registered for VAT purposes in another EU country, the VAT registration number of the buyer must also be shown on the sales invoice.

11.9.1 Normal VAT rules

Only sellers who are registered for VAT purposes can sell under normal VAT rules. Where this happens in a private sale transaction, VAT at 20% will be added to the purchase price.

In some cases the seller of an artwork will be an individual who is not VAT registered, who is selling through an agent, who is VAT registered. The question then arises: can the buyer of the artwork be charged VAT? The answer depends on whether the agent is acting as a 'disclosed' or 'undisclosed' agent for the seller. The agent will be a disclosed agent where he or she discloses to the buyer the name of the seller he or she is acting for. An undisclosed agent is an agent who does not reveal the seller's identity to the buyer or does not reveal that he or she is acting as agent at all. In the case of a disclosed agent the invoice will be from the seller and, because the seller is not VAT registered, will not include VAT. Where the agent is an undisclosed agent, however, the buyer will be dealing with the agent as if he or she was the seller, and so VAT will be charged.

11.9.2 Second-hand goods margin scheme

In most cases, however, it will not be attractive to the seller to charge VAT at 20% on the purchase price. This is because a large VAT bill may put buyers off. It would also be difficult for traders who purchase second-hand goods for resale to the public to impose upon them a VAT liability based upon the full value of the goods. These concerns can thankfully be addressed as the VAT rules provide a special optional regime for second-hand goods, works of art, antiques and collector's items under which VAT is not levied on the purchase price but instead on the trader's profit margin, that is, the difference between the price for which the goods were purchased and the amount for which they were resold. If the goods are resold at a loss, no VAT is payable. This is known as the margin scheme arrangement. The invoice from the trader to the buyer under a margin scheme sale will not include a VAT element and the buyer may not reclaim VAT on a margin scheme purchase. If the buyer wants to reclaim VAT the sale must be processed under normal VAT rules outside the margin scheme.

11.9.3 Auctioneer's margin scheme

There is also a further variation on the margin scheme available for auction sales only. This is known as the auctioneer's margin scheme and is to be distinguished from the second-hand goods margin scheme. Under this arrangement the auctioneer does not have to account for VAT on the hammer price of goods sold at

auction. Instead the auctioneer accounts for VAT on the value of the auctioneering service supplied to the buyer and the seller. In other words, rather than VAT being charged on the goods being sold, VAT is charged on the buyer's premium and seller's commission charged by the auctioneer. The buyer's premium and seller's commission are invoiced to the buyer and seller respectively inclusive of VAT. The vast majority of auction sales in the United Kingdom take advantage of this scheme as it results in a significantly lower VAT charge than would be the case if VAT was charged on the hammer price.

The auctioneer's margin scheme requires that the invoicing should be carried out in a specific way.

The invoice to the seller must include the seller's and auctioneer's name and address, date, invoice number, stock number, transaction date, lot description, hammer price, commission charges to the seller (without showing a separate amount for VAT) and the net amount due to the seller.

The invoice to the buyer must include the seller's and auctioneer's name address and VAT number, date, invoice number, stock number, transaction date, lot description, hammer price, buyer's premium (without showing a separate amount for VAT) and the total amount payable by the buyer. If the buyer intends to resell the purchased lot using the second-hand goods margin scheme the amount shown on this invoice will be deemed to be the purchase price for the purposes of calculating the margin on the resale.

Where the auctioneer's margin scheme is used, the buyer cannot reclaim the VAT. In addition, for the auctioneer's margin scheme to apply, certain conditions must be satisfied. The most important of these are that the person selling the lot must not be registered for VAT and must not have acquired the lot in circumstances where VAT was paid and could then be claimed back on the purchase.

While the default position in UK auctions is usually that the artworks are sold under the auctioneer's margin scheme, auction catalogues will also – using a system of symbols – identify lots which are being sold otherwise than through the auctioneer's margin scheme. This includes:

- lots sold under normal VAT rules, where VAT is charged at 20% on both the hammer price and the buyer's premium;
- lots, such as books, which are zero rated for VAT purposes.

11.10 Import VAT

In order to protect the UK economy, goods entering the UK are liable to import VAT at the point at which they enter the UK. This is separate from any domestic VAT which may apply on any sale transaction (see above). Goods exported out of the UK are normally free of any UK import VAT. While the standard rate of import VAT is 20% for works of art, antiques more than 100 years old and certain collectables benefit from a reduced rate of import VAT of 5%.

When artworks are brought into the UK from abroad to be sold, they can be imported on the basis of a temporary admission authorisation (TA). This arrangement – which is only available to persons or organisations authorised by the UK tax authorities – allows the payment of import VAT to be suspended for up to two years until the goods are sold to a buyer, who is then treated as the importer. Any import VAT due will be charged to the buyer by the auction house. If the goods are sold to a buyer outside of the UK and exported out of the UK, no import VAT will be payable; if they are sold to a buyer who keeps them in the UK, import VAT will be payable.

Artworks which have been imported from outside the UK on the basis of a temporary import authorisation are identified in the auction catalogue with a symbol. If the work is bought by a buyer in the UK, the buyer will then be invoiced: (a) the hammer price plus 5% import VAT, and (b) buyer's premium, including 20% VAT, which is not shown separately.

The most significant effect of Brexit upon the art market was the fact that, following Brexit, imports of artworks from the European Union would attract import VAT. Further, where an artwork was brought into the United Kingdom from the European Union on temporary import for sale, and then bought by an EU buyer the artwork would attract import VAT charged by the EU country upon re-entry into the European Union.

12 Shipping, export and insurance of art

Until 2021, a two-track process existed for the shipping of artworks – one for shipping art to and from European Union countries, and the other for movements of art to and from non-European Union Countries. Now that the United Kingdom has left the European Union there is a single process which applies to all exports of artworks out of the United Kingdom.

12.1 Export of cultural property

The export licensing regime from the United Kingdom for cultural goods, including those classified as national treasures, is administered by the Arts Council England's Export Licensing Unit. The export licensing is less restrictive than in many other European countries. The purpose of the licensing system is not to prevent the export of cultural property but to provide an opportunity for the United Kingdom to retain cultural property within the United Kingdom where it is felt to be of outstanding national importance. However, the right to retain the property is conditional upon the owner being compensated by being paid the full value of the artwork.

As a general rule, an object which has been in the United Kingdom for less than 50 years will be granted an export licence. However, while the United Kingdom has the power to determine whether or not to grant an export licence for objects in the United Kingdom, it cannot, following Brexit, grant EU export licences. Therefore, where a licence is sought from the United Kingdom authorities for the export from the United Kingdom to a non-EU country of an object which has entered the United Kingdom from another EU country, the United Kingdom licensing authorities will want to be satisfied that the object left the EU country or countries legally.

Many export licence applications are made by overseas buyers of works bought at auction or by dealers in the United Kingdom. In more complex cases involving national treasures, the licence application process can take a considerable amount of time. In such cases the question arises whether the buyer is obliged to pay for his or her purchase pending the outcome of the export licence application. Auction houses usually include in their conditions of sale a provision which makes it clear

that it is the responsibility of the buyer to obtain all necessary export licences and that the grant or refusal of the licence does not affect the buyer's obligation to pay for the artwork. In practice, however, this obligation can be the subject of negotiation. Sellers and auction houses will frequently not insist on enforcing the payment obligation if it means they can secure a high bid for a lot from an overseas seller. The licence application following the sale must however be made by the owner of the property (or the auction house or dealer as agent for the owner). Whether the seller or the buyer is the owner will depend on whether payment has been made by the buyer at that point. As we will see below, there can be advantages to having control of the licence application process, and this may be an incentive for the buyer to make payment in full even before the application for an export licence is made.

12.1.1 No export licence required

Certain categories of object are the subject of a standing arrangement where the exporter is not required to obtain an individual export licence. These are:

- the Open General Export Licence (Objects of Cultural Interest) (OGEL);
- the Open Individual Export Licence (OIEL).

The OGEL is a licensing system which is available to all exporters, and is designed to ensure that artworks of lower value are not subject to the need for a formal export licence application. The OGEL enables the exporter to export the artwork to any destination (subject to any trade embargoes) provided its value is less than a certain threshold specified from time to time by the Secretary of State for each category of artwork.[1] (Because the list of OGEL items and their values change periodically, it is always important to consult the Arts Council England website for the latest version.) The OGEL system also permits the export for up to six months of some common temporary exports, and the reexport of some common temporary imports. There is no formality required other than notification to the customs at the port or airport on the export declaration that the goods are being exported under the OGEL scheme.

An OIEL is a licence granted to a named individual, company or institution, to permit either the permanent or temporary export of specified objects within a limited timeframe (usually three years). To qualify for an OIEL the exporter

[1] Open General Export Licence (Objects of Cultural Interest) dated 1st January 2021: £180,000 or less for any painting in an oil or tempera medium (excluding any portrait of a British historical personage); £10,000 or less for any photograph or group of photographs; £10,000 or less for any (non-photographic) portrait of a British historical personage, any other artworks with a value below £65,000 (other than oil or tempura paintings, photographs or groups of photographs, portraits of British historical personages, documents, any items excavated from land or sea in the territory of the United Kingdom in the past 50 years and any documents, manuscripts or archives).

will need to demonstrate a track record of export compliance and membership of a professional body. This system is intended to ensure that works which have entered the United Kingdom in the past 50 years, and therefore do not have a strong connection with the United Kingdom, can be freely exported without the need for a formal export licence. The OIEL scheme is also the system used by exporters and museums who wish to export objects for exhibition within the European Union. It is particularly useful for museums loaning artworks to museums in other European Union countries as it allows, without the need for an export licence application, for the temporary export of the artwork to another European Union country for a period of up to three years.

12.1.2 Individual export licence required

If the artwork cannot be exported under the OIEL or OGEL scheme or under the Specific Open Licence Scheme, for example because it is above the OGEL value threshold and/or has been in the United Kingdom for longer than 50 years, it will require an individual export licence. Exporters can apply either for a permanent or a temporary export licence, which is usually limited to a period of three years. Temporary export licence applications are processed in the same way as permanent licence applications except that, because the artwork will be returning to the United Kingdom, they are not scrutinised for national importance.

The export licence application process itself is shortly to become a digital rather than paper-based application process. The application requires the completion of an application form including a full description of the artwork to be exported, together with high resolution colour photographs, detailed provenance and value. If the artwork has entered the United Kingdom in the past 50 years the application should be accompanied by evidence of how and when it entered the United Kingdom. It is a criminal offence[2] to deliberately or recklessly provide false information on a licence application.

12.1.3 Referral to the Reviewing Committee on the Export of Works of Art and Objects of Cultural Interest

The United Kingdom has a relatively liberal system of export control where national treasures are concerned. Whereas many countries define national treasures very widely, the United Kingdom assesses the importance of artworks by reference to a limited set of criteria. Even in the relatively small number of cases where the object is found to be a national treasure, the export licence will then only be refused where United Kingdom-based museums or individuals are able, within a limited time period, to offer to purchase the artwork for its actual market value.

2 Section 4 of the Objects of Cultural Interest (Control) Act 2003.

Export licence applications are reviewed by an expert adviser. If the expert adviser believes that the artwork satisfies one or more of the so-called Waverley Criteria (see below), the expert adviser will object to the grant of an export licence. The application will then be referred to the Reviewing Committee on the Export of Works of Art and Objects of Cultural Interest (the Reviewing Committee). This happens only rarely – in between 25 and 50 cases out of applications for 31,000 objects every year. In 2014–15 only 17 cases were referred to the Reviewing Committee. If, as is ordinarily the case, the expert adviser does not object to the export, then the application will simply be granted.

The Reviewing Committee is an expert body formed to consider whether an object is of sufficient importance to constitute a national treasure. An object will be considered to be a national treasure if the Reviewing Committee considers that its departure from the United Kingdom would be a misfortune on one or more of the following grounds, known as the Waverley Criteria.

- Criteria 1: History – Is it so closely connected with our history and national life that its departure would be a misfortune?
- Criteria 2: Aesthetics – Is it of outstanding aesthetic importance?
- Criteria 3: Scholarship – Is it of outstanding significance for the study of some particular branch of art, learning or history?

The first criteria of connection with United Kingdom history and national life can be satisfied by an object having been created in the United Kingdom, or abroad, provided it has acquired national importance by association with a person, a location or an event in the United Kingdom.

The second criteria is a subjective judgement on the quality of the object. Is it a particularly fine example of its type?

The third criteria – scholarship – assesses the value of the object to learning. Is the object of particular importance either as an object or as a result of its connection with a person, place, event, archive, collection or assemblage?

The Reviewing Committee consists of eight permanent members, each with expertise in a particular area. The Reviewing Committee is assisted in each case by up to three independent assessors with expertise in the category of artwork under consideration.

The person applying for the export licence or their agent will be invited to submit evidence to the Reviewing Committee setting out why the applicant believes the artwork does not satisfy any of the Waverley Criteria. The expert adviser will also submit a report in which he or she explains why the artwork does satisfy one or more of the Waverley Criteria. Usually the person applying for the export licence

is not the overseas buyer of the object, but the United Kingdom-based seller of the object. This is because the overseas buyer is generally not inclined to pay for the work until the export licence application is successfully completed. However, as we will see below, some overseas buyers are willing to pay for the work prior to the export licence application as it may provide them with some strategic advantages.

At a hearing, the Reviewing Committee will consider the reports of the applicant and the expert adviser and hear oral submissions in response to any questions the Reviewing Committee may have.

The Reviewing Committee then advises the Secretary of State for Culture, Media and Sport as to whether or not it believes that the artwork satisfies any of the Waverley Criteria.

If it does not believe that the artwork satisfies any of the Waverley Criteria, it will recommend that the export licence should be granted. This is a rare occurrence, as in practice most artworks referred to the Reviewing Committee are ultimately found to satisfy one or more of the Waverley Criteria.

If, as is more commonly the case, the Reviewing Committee considers that the artwork does satisfy one or more of the Waverley Criteria, it will recommend to the minister that the decision on whether or not a licence should be granted should be deferred for a defined period of time. That period is separated into two parts – the first deferral period and the second deferral period. The first deferral period is intended to give museums or United Kingdom-based third parties an opportunity to make a 'matching offer' to purchase the artwork from the applicant so that the work can remain in the United Kingdom. The second deferral period is an opportunity for the offeror to raise funds in order to complete the purchase. Typically the total deferral period is between four and nine months, depending on the importance of the artwork. However, the Reviewing Committee can recommend one or more extensions of the deferral period if it believes it appropriate to do so.

In order to ensure that the applicant is not out of pocket, the amount of the matching offer required will usually be equal to the price at which the object was sold, including any commissions due to the auction house or agent who sold it.

In some circumstances, however, a museum will not in practice need to raise cash equal to the matching offer. This occurs where the applicant is United Kingdom-based and has a tax liability because the artwork has been conditionally exempted (see section 11.3, 'Conditional exemption'). In such cases the minister may give a credit against the matching offer equal to the tax liability, or a part of it. This is a source of frustration for overseas buyers who have bought an artwork for a significant sum and then see a museum being able to prevent the export and

acquire the work by raising a lesser cash sum. As a result, some overseas buyers pay for the object in full prior to the application for an export licence. This makes the buyer both the owner of the artwork and the applicant for the licence. This has the advantage for the overseas buyer of giving the buyer control of the export licence application and also preventing the museum from taking advantage of the tax liability of the original United Kingdom-based seller. As a result the museum will have to raise the full cash amount of the matching offer if it is to prevent the grant of an export licence.

If a matching offer is made, the applicant was until recently not obliged to accept it. However, following a consultation the United Kingdom government introduced a change to the rules to provide certainty for museums seeking to raise the funds for a matching offer. Under the new rules, if, at the end of a first deferral period, a serious expression of interest is received from an offeror making an offer to purchase the artwork, the owner will then be required to enter into an option agreement prior to a second deferral period during which the offeror will have the opportunity to raise the necessary funds. The option agreement will give the offeror the legal right to purchase the artwork provided it is able to raise the necessary funds within the second deferral period. The owner will be bound to complete the sale in those circumstances. The second deferral period would not begin unless and until the owner had entered into a binding option agreement in a prescribed form. A refusal by the owner to enter into the option agreement will result in the export licence application being refused. But the licence will usually be granted if, having entered into the option agreement, the offeror is unable to raise the necessary funds to complete the purchase or if the offeror backs out of the offer.

12.1.4 Temporary admission import scheme

The temporary admission scheme is frequently used in order to admit artworks temporarily, for a period of up to two years, into the United Kingdom for auction or exhibition. Items admitted in this way are not subject to duty or import VAT (see below). The import VAT will however become payable upon the expiry of the two years or if the artworks are sold or released into free circulation in the United Kingdom by the importer and not re-exported out of the United Kingdom. The temporary admission scheme is very commonly used by auction houses or dealers in the United Kingdom who want to offer artworks from abroad for sale in the United Kingdom. It provides a means of suspending the import VAT liability until it is known for certain whether import VAT is payable or not.

The temporary admission scheme does however require the provision of a guarantee to cover the full amount of the import VAT liability that may become due if the temporary admission procedure is not correctly discharged. This of course impacts cashflow. One way to address this is for the importer to apply for a full temporary admission authorisation from HMRC. This regime requires the

importer to demonstrate to HMRC's satisfaction that it has a good compliance record, is financially solvent, has good recordkeeping systems and has processes in place to identify and correct any errors found. Auction houses, galleries and dealers who are granted a full temporary admission authorisation benefit from a waiver which means they do not have to put up the guarantee of the full amount of import VAT liability.

12.1.5 ATA carnet scheme

The ATA carnet scheme may be used to permit the artwork to travel across borders outside of the United Kingdom. The ATA carnet is an international customs document, purchased from the local chamber of commerce, that can be used to cover temporary movement of an artwork or defined group of artworks across borders without payment of customs charges. It simplifies customs clearance of goods by replacing customs documents that would normally be required and provides financial security for any customs charges potentially due on the goods. The ATA carnet must accompany the artwork during its transport and be presented and stamped at each border.

ATA carnet holders must provide a financial guarantee in the form of security related to the value of the goods being temporarily exported. This security is to ensure that any customs claims, if made, are financially covered. It can be provided in the form of a banker's draft or cash, a bank guarantee or security under the Carnet Security Scheme, a service which allows the carnet user to arrange for the security to be provided without having to supply either banker's draft, cash or bank guarantee. A failure to return the artwork to the country of origin will lead to the financial guarantee being forfeited.

12.1.6 Bonded warehousing

A bonded warehouse or 'bond' is a physical space or building in which goods, including artworks, which would otherwise be subject to customs duties upon import into the United Kingdom, may be stored without payment of duties. Artworks temporarily stored in bond in the United Kingdom are deemed to be in a sort of duty free area outside the United Kingdom market. The advantage of such an arrangement is that the importer can defer the payment of import VAT and customs duties until the moment the goods come out of bond and enter the United Kingdom market, or avoid import VAT and duties completely if the goods come out of bond to be taken out of the United Kingdom. Running a customs warehouse requires authorisation and the provision of a financial guarantee.

In the past, dealers and galleries made extensive use of bonded warehousing in order to import artworks into the United Kingdom and then remove them temporarily for sales exhibition, returning them to the warehouse to conclude any sales

resulting from the exhibition. This is no longer possible as HMRC now insist that artworks taken temporarily out of bond for exhibition or sale are imported into the United Kingdom under the temporary admission scheme (see above). The disadvantage of this for dealers and galleries is that the temporary admission scheme requires the provision of a guarantee to cover the full amount of the import VAT liability that may become due if the temporary admission procedure is not correctly discharged. This of course impacts cashflow. One way to address this is for the dealer or gallery to apply for a full temporary admission authorisation from HMRC (see above).

12.1.7 UK import VAT and duties

Artworks which are brought into the United Kingdom from any other country attract import VAT at the rate of 5% of the purchase price plus, in the case of watches, jewellery, lighting and ceramics, duty at rates of between 2 and 8% of the purchase price. The major change brought about by Brexit is that import VAT and, where applicable, duty are now also payable where the artwork is brought into the United Kingdom from the European Union. So, where a work which has been shipped into the United Kingdom from a European country is sold to a United Kingdom buyer, that buyer will – in addition to the purchase price, be required to pay import tax and, where applicable, duty.

12.2 Import of artworks into the European Union

12.2.1 Import VAT for imports into the European Union

As the United Kingdom is now no longer within the European Union imports of artworks into the European Union from the United Kingdom will attract import VAT – charged by the European Union country into which the property is imported. The import VAT rates are, at the date of writing, as follows:

France	5.5%
Germany	7%
Italy	10%
Spain	10%
Netherlands	9%

This means in practice that European Union buyers who purchase artworks in the United Kingdom now face an additional cost which they did not face before Brexit.

12.2.2 EU cultural property import licences

The European Union has now introduced import licensing requirements for cultural property entering European Union countries.[3] The motivation for doing so is principally to address concerns over the illicit trafficking of cultural property. However, because of a concern over the potential effects of these measures on the legitimate art trade, the United Kingdom passed legislation to ensure that these import licensing requirements did not apply to imports of cultural property into the United Kingdom.[4]

The regulation prohibits the import into the European Union of cultural goods, including antiquities which are more than 100 years old, which were removed from a non-European Union source country in breach of the laws and regulations of that source country.[5] It does not cover cultural property which was created or discovered in the European Union territories.

In addition, archaeological objects or elements of historical sites or buildings which are more than 250 years old will, regardless of value, require an import licence, granted only where the importer is able to provide supporting documents and evidence to show that either (i) the cultural goods in question have been exported in accordance with the laws and regulations of the source country in which they were created or discovered, or (ii) they were removed from the source country at a time when such laws and regulations did not exist.[6] However, an important exception to this rule is where the source country cannot be determined or where the cultural goods left the source country before 24 April 1972. In such cases it will be sufficient for the importer to prove – by means of an export licence – that the cultural goods were lawfully exported from the last country in which they were located for more than five years.[7]

Finally antiquities (other than those caught by Article 4(4)), manuscripts, books, paintings and objects of artistic interest which are more than 200 years old and worth more than €18,000 require an importer statement, which states that either (i) the cultural goods have been lawfully exported from their source country, or

3 Regulation of the European Parliament and of the Council on the Introduction and Import of Cultural Goods (17 April 2019).
4 The Introduction and the Import of Cultural Goods (Revocation) Regulations 2021. This legislation was necessary because the EU Regulation came into effect in the United Kingdom three days before the United Kingdom left the European Union.
5 Regulation of the European Parliament and of the Council on the Introduction and Import of Cultural Goods (17 April 2019), Art. 3.
6 Regulation of the European Parliament and of the Council on the Introduction and Import of Cultural Goods (17 April 2019), Art. 4(4).
7 Regulation of the European Parliament and of the Council on the Introduction and Import of Cultural Goods (17 April 2019).

(ii) where the source country cannot be determined or the cultural goods left the source country before 24 April 1972, the cultural goods were lawfully exported from the last country in which they were located for more than five years.[8]

The process of applying for import licences, making declarations and submitting evidence will take place through an electronic licensing system which has yet to be developed and is unlikely to be in place until 2025.

When they are implemented, these requirements are likely to severely restrict the ability of art dealers and collectors to import antiquities into the European Union. In practice only antiquities which can be shown to have left their source country before 24 April 1972 will be able to be imported. This is because antiquities which left their source country after 24 April 1972, or cannot be shown to have left the source country before 24 April 1972, are unlikely to have been accompanied by an export licence issued by the source country. The impact on other forms of cultural property over 200 years old and valued at over €18,000 should not be as great, but there will now be an additional administrative burden involved in submitting importer statements of lawful export.

12.3 Insurance of art

As art becomes widely exhibited, traded and transported, the risks of damage or loss become more significant. In addition, the level of financial exposure to these risks increases in line with the increase in artworks' value. It has become common for artworks worth tens of millions of pounds to be taken on tour by auction houses to Asia, the United States, the Middle East, Russia and Asia. Museums also loan important artworks to each other and solicit loans from private collectors. However much care is taken to protect the artworks against damage in transit or theft, the risks involved in such arrangements are high. Even where art is not on the move, there are significant risks associated with fire, flood or theft. The consequences of loss or damage are also very significant and insurance cover is needed to limit exposure to any such loss.

12.3.1 Loss and damage

Artworks are high risk from an insurance perspective. Artworks have always been targets for theft and many works, both ancient and modern, are extremely delicate – sensitive not just to sudden movement but also to minor variations in temperature, humidity and light.

[8] Regulation of the European Parliament and of the Council on the Introduction and Import of Cultural Goods (17 April 2019), Art. 5(2).

Insurance is available for loss and damage of artworks and, as with any other insurance market, the terms on offer are dependent upon the underwriter's assessment of the risks to which the artwork is being exposed. Insurers will wish to be reassured about storage conditions, fire prevention, security arrangements and access. Further consideration is required where the artwork is being moved or transported, as this is where the vast majority of claims arise.

In many other fields the main insured cost is the cost of replacement or repair. In the art world the cost of repair is not usually the most significant consideration. Rather, the principal consideration is the diminution in value of the artwork as a result of the damage. Replacement in the case of a total loss is also not often an option where unique artworks are concerned, so in some cases, compensation on a total loss basis is the only possible outcome. In cases of diminution in value and compensation for total loss, the major issue is the valuation of the lost or damaged artwork. Value is always a matter for negotiation with insurers, so at the time of taking out insurance cover, the insured should seek to agree a 'total loss' value. If that cannot be done the insured should ensure that the artwork is independently valued. In both cases the value should be reviewed regularly. Detailed condition reports and images of the artwork should also be regularly prepared and updated, particularly where the artwork is moved.

As with any insurance policy, the detail is important. It is therefore worth analysing some of the most common pitfalls and excluded risks. While common, these are by no means universal, and in many cases are of course subject to negotiation.

12.3.2 Inherent vice

Artworks are often made of materials and components which are themselves inherently likely to deteriorate over time, as opposed to deterioration caused by external forces. A good example of this is Damien Hirst's 1991 work The Physical Impossibility of Death in the Mind of Someone Living – a 14-foot tiger shark suspended in a tank of formaldehyde. In 2006 it was reported that the shark carcass may be deteriorating, and that as a result the artist was considering replacing the formaldehyde and possibly the shark itself. If this report is correct, this is an example of damage due to inherent vice – where the materials inherent in the artwork deteriorate without an external catalyst. Most insurance policies will seek to exclude any claims for loss or damage to an artwork caused by inherent vice.

12.3.3 Terrorism cover

The growth of international terrorism since the attacks on the US in September 2011 has made insurers cautious about this risk where artworks are concerned. Many policies will exclude terrorism cover altogether, or limit claims to acts of terrorism while the artwork is in transit.

12.3.4 War and confiscation

As we have seen in other chapters, history has shown that artwork can often be one of the first casualties of war and civil unrest. As a result, many policies seek to exclude any loss or damage caused in these circumstances. Even outside of war, there are many examples of artworks being seized or confiscated by governments on many pretexts. This can happen for political reasons, or as a result of title claims, or as a result of civil disputes with the owner of the art. Losses arising from such seizures and confiscations are also often excluded from insurance policies.

12.3.5 Moth, vermin and woodworm damage

Artworks can be damaged by insects and vermin ranging from woodworm to rats and mice. Such damage can often occur unnoticed while art is in storage. As a result some insurers will seek to exclude this risk.

12.3.6 Wear and tear

Deterioration or damage which occurs naturally as a result of aging and normal use of the object is usually an excluded risk.

12.3.7 Atmospheric change

Loss and damage caused by changes in atmospheric conditions may, in some circumstances, not be covered under some policies.

12.3.8 Insufficiency in packing

Insurers will often not cover losses where these are caused by the artwork being shipped in inappropriate or insufficient packing materials.

A further consideration for the insured is the level of the deductible, which is the first part of any claim which is payable by the insured in the event of loss or damage to the artwork. For example, if the claim is for £10,000 and the policy carries a 10% deductible per claim, then the insured will pay the first £1,000 and the insurer will cover the balance of £9,000. The higher the deductible, the lower the cost of the policy.

It may come as some surprise to know that some owners of valuable artworks choose not to insure their artworks at all. This often happens where the value of the artwork is so significant that the cost of insuring it is prohibitive.

12.3.9 Title insurance

Ownership and title claims remain the single most common source of disputes in the art world. These claims range from Holocaust restitution claims to claims based on allegations of illegal excavation and export, theft and security interests, and, of course, ordinary civil disputes. These claims are extremely hard to anticipate because they depend upon the ownership history and legal chain of title of the artwork – something which is not always known to or understood by the buyer of a work of art. Such claims, whether well founded or not, can make it impossible to sell the artwork and/or result in significant legal costs or losses to the owner. As a result, there is a growing interest in what is known as title insurance – a policy designed to provide financial protection to the owner of an artwork in the event of a claim being made. Premiums for such cover will vary depending on the level of risk involved. One key consideration is a concern that title insurance is often requested only in cases where there is a higher risk of a claim than might usually be the case – for instance, where an artwork has no recorded wartime provenance.

13 Museums

13.1 Introduction

The establishment, management and financing of museums is a topic for a separate book. As the purpose of this book is to analyse the art business we will confine ourselves, in these chapters, to an analysis of those museum activities which touch upon the art business – namely, the acquisition, lending, borrowing and disposal of artworks by museums.

13.2 Museum accreditation and ethics

In the United Kingdom the Arts Council manages an accreditation scheme designed to set and promote nationally agreed standards for museums. The objective of the accreditation scheme is to define good practice and professional standards. Most importantly, the scheme provides guidance to museums on effective planning, responsible collections management and community engagement. Currently approximately 1,700 museums in the United Kingdom are accredited under the scheme.

In addition, the Museums Association, which is a nongovernmental independent association of museum institutions and museum professionals, provides a code of ethics for its members. This code of ethics underpins the Arts Council accreditation scheme. Many of the provisions of the code of ethics address issues relating to the management and purpose of museums and collections which, as we have said, are beyond the scope of this book. It is, however, worth reviewing those parts of the code of ethics which relate to acquisitions, loans, borrowing and disposals, and therefore touch upon the commercial aspects of art.

13.2.1 Due diligence

As we saw in Chapter 10, ethical and legal questions over the ownership of certain categories of artworks have increasingly been raised. The principal categories in which such claims have been made are:

• artworks suspected of having being spoliated or wrongfully confiscated during the period 1933–45 in Europe;
• ancient art which is alleged to have been wrongfully removed from its country of origin.

Public awareness of these claims and questions has led to museums, in common with others in the art market, reviewing their due diligence procedures. The Museums Association code of ethics currently provides that museums should 'conduct due diligence to verify the ownership of any item prior to purchase or loan, and that the current holder is legitimately able to transfer title or to lend. Apply the same strict criteria to gifts and bequests'[1] and

> Reject any item for purchase, loan or donation if there is any suspicion that it was wrongfully taken during a time of conflict, stolen, illicitly exported or illicitly traded, unless explicitly allowed by the existing collections treaties or other agreements, or where the museum is co-operating with attempts to establish the identity of the rightful owner(s) of an item.[2]

Of particular interest in this context is the additional guidance provided in the Museums Association code of ethics urging museums to reject any item if there is any suspicion that, since 1970,[3] the artwork or object may have been stolen, illegally excavated, removed from a monument, site or wreck contrary to local law or otherwise acquired in or exported from its country of origin (including the United Kingdom), or any intermediate country, in violation of that country's laws or any national or international treaties, unless the museum is able to obtain permission from authorities with the requisite jurisdiction in the country of origin. As a result of this requirement, museums have tended not to purchase or acquire antiquities or fragments unless the item has provenance which goes back to 1970 or earlier.

13.2.2 Disposal and deaccessioning

The disposal and deaccessioning of artworks from museum collections can sometimes be a necessary part of the functioning of museums. The Museum Association code of ethics seeks to ensure that such disposals are responsibly

[1] Principle 2.4 of the Museum Association Code of Ethics 2015.
[2] Principle 2.5 of the Museum Association Code of Ethics 2015.
[3] 1970 is the date of the agreement of the UNESCO Convention on the Means of Prohibiting and Preventing the Illicit Import, Export and Transfer of Ownership of Cultural Property.

undertaken as part of a museum's long-term collections development policy, the starting point for which should be a curatorial review. The code of ethics recommends transparency and openness, according to unambiguous, generally accepted procedures.[4]

As government funding is tending to decline and as competition for private funding increases, there is inevitably financial pressure on museums. The code of ethics emphasises, however, that collections should not normally be regarded as financially negotiable assets and that financially motivated disposal risks damaging public confidence in museums.[5] Such disposals should therefore not be undertaken principally for financial reasons, except where it will significantly improve the long-term public benefit derived from the remaining collection. The code states that this will require demonstrating that:

- the item under consideration lies outside the museum's established core collection as defined in the collections development policy;
- extensive prior consultation with sector bodies and the public has been undertaken and considered;
- it is not to generate short-term revenue (for example to meet a budget deficit);
- it is as a last resort after other sources of funding have been thoroughly explored.

Nor should museums be tempted to mortgage collections or offer them as security for a loan. Indeed, museums are urged by the code to 'resist placing a commercial value on the collections unless there is a compelling reason to do so, and for collections management purposes only'.[6]

13.2.3 Conflicts of interest and commercial relationships

One area of sensitivity is that of links between individual museum staff and the commercial world. Museum curators can play an extremely important part in the authentication of artworks and due diligence around the provenance of artworks. However, any such assistance must be provided keeping in mind the Museum Association's code of ethics principle that they should refuse to place a value on items belonging to the public.[7] Museum staff should also ensure that they 'avoid any private activity or pursuit of a personal interest that may conflict or be perceived to conflict with the public interest'.[8]

[4] Principle 2.8 of the Museum Association Code of Ethics 2015.
[5] Principle 2.9 of the Museum Association Code of Ethics 2015.
[6] Principle 2.10 of the Museum Association Code of Ethics 2015.
[7] Principle 3.4 of the Museum Association Code of Ethics 2015.
[8] Principle 3.1 of the Museum Association Code of Ethics 2015.

Modern museums have been very effective at developing links with the commercial world which benefit the museum and the public. However, the museum world continues to be sensitive around such relationships, to avoid a risk, or perceived risk, of compromising the museum's principles. The Museums Association code therefore recommends that museums consider offers of financial support from commercial organisations with care and 'seek support from organisations whose ethical values are consistent with those of the museum. Exercise due diligence in understanding the ethical standards of commercial partners with a view to maintaining public trust and integrity in all museum activities.'[9]

These principles are relevant as auction houses and dealers – as well as other commercial organisations – are eager to associate themselves with museums. In the case of the commercial art world such associations are, in part at least, intended to lend support to the argument that auction houses and dealers are not merely sales outlets but play an important role in the study, preservation and appreciation of art. These associations traditionally take the form of offers of complimentary valuations and of sponsorships and events. In addition to these more obvious forms of association, however, dealers and auction houses are increasingly curating their exhibitions with a level of sophistication and professionalism which tends to blur the line between museums and the commercial world. It is of course possible to be cynical about this approach, but it is a genuine reaction to the demand from clients that auction houses and dealers should be trusted advisers, sharing in their enthusiasm and intellectual curiosity, rather than mere salesmen. Museums are also aware of the power of implicit endorsement in relation to specific works of art. The exhibition of a loaned artwork in a museum lends credibility to the work and adds value. The expression 'museum quality' is widely used in the art world to describe artworks of exceptional quality, and, of course, value. With this in mind, museums are still cautious about these links and behaviours, but there is also far more pragmatism about the relationships than was previously the case.

13.3 Purchases and acquisitions by museums

The acquisition of artworks and objects for museum collections tends to be rarer today. While in the United States generous tax subsidies have been used to encourage legacies and gifts to museums, such incentives are very much more limited in the United Kingdom (see Chapter 11). In this time of austerity, government funding is also very restricted. As a result, museums' acquisition strategies are selective and limited.

[9] Principle 3.6 of the Museum Association Code of Ethics 2015.

13.3.1 Outright purchase by the museum from museum funds

It is extremely rare today for a United Kingdom museum to participate as a bidder in an auction to acquire an artwork. This is largely because United Kingdom museums do not have funds available with which to add to their collections. According to the Tate Gallery, for instance, only around £1,000,000 of its general funds are spent on acquisitions each year[10] – and many museums will not have anything like that to spend. Where museums do have the funds, the strong preference is to acquire artworks by private sale. Such a sale not only provides the comfort of an exclusive negotiation; also, the sale of a conditionally exempt artwork to certain national museums and institutions can result in the seller receiving a greater net sum than he would on the open market (see section 11.3, 'Conditional exemption'). This allows the museum to seek to negotiate a price substantially less than the open market value.

13.3.2 Donation

Many museums are heavily dependent upon the generosity of donors who gift or leave artworks or even collections to the museum. While this is often done without financial benefit to the donor, there are also incentives to encourage the donation of objects to UK museums.

The cultural gifts scheme is intended to provide the donor of the object with a reduction in income tax, capital gains tax or corporation tax based on a percentage of the value of the artwork donated (see section 11.7). Unfortunately, the impact of the scheme is limited by the limited extent of the tax reduction, and also by the annual limit on the value of the tax concessions available.

As we saw in section 11.6, the United Kingdom also operates an acceptance in lieu scheme, which allows the owner of an object to pay an inheritance tax bill in whole or in part by donating an object to a national institution. As with the cultural gifts scheme, the impact of this incentive is limited by the annual financial limit on the tax concessions available.

Each year approximately 30 objects are donated to museums as a result of the cultural gifts and acceptance in lieu schemes. In 2016 the total value of these objects was £47,200,000.

[10] Tate Gallery Website.

13.3.3 Acquisition with assistance from the Art Fund, government and National Lottery Fund grants

The Art Fund was established in 1903 and was known at that time as the National Art Collections Fund. It was established by a group of artists and patrons as a reaction to inadequate government funding of museums. In 1905 the Fund organised a public appeal to raise funds to secure Whistler's Nocturne in Blue and Gold (Old Battersea Bridge). That first success was followed a year later when it purchased Velazquez's Rokeby Venus and presented the painting to the National Gallery. Since then the Art Fund has raised funds and provided grants to secure many of the most important works in United Kingdom national collections, including the Wilton Dyptych, Botticielli's Virgin Adoring the Sleeping Christ Child, Turner's Blue Rigi and Raphael's Madonna of the Pinks. These purchases are sometimes funded in part by the Art Fund's own resources, but at the higher values the Art Fund's principal contribution is as a fundraiser. Often the fundraising campaigns are triggered by an application to export an artwork from the United Kingdom, where the Reviewing Committee on the Export of Works of Art and Objects of Cultural Interest (see section 12.1.3) has temporarily suspended the export application to allow museums the opportunity to make a 'matching offer' to purchase the artwork.

The National Lottery Heritage Fund has been another important source of grants to museums and cultural institutions. It claims to have awarded several billion pounds in grants to more than 1,100 museums and galleries in the United Kingdom since 1994.[11]

13.3.4 Long- and short-term loans

The cost of insuring, protecting and conserving important artworks means that in some cases owners prefer to allow museums to keep individual artworks on long-term loan. This ensures that the owner remains the legal owner of the artwork, while the costs associated with the ownership of the artwork are borne by the museum. This can be an important source of exhibits for museums. Equally, loans between museums are becoming ever more frequent as a means of broadening access and breathing life into established museum collections. In addition, museums which do not usually charge for access to their permanent collections are able to do so for admission to special exhibitions of objects on short-term loan. Not only is this an important source of income for museums but it can serve to encourage new visitors to a museum, expanding its appeal and even changing the visitor demographics.

[11] www.heritagefund.org.uk/hub/museums-libraries-and-archives

13.4 Loans to and by museums

13.4.1 Loan agreement

Museums' ability to make and accept loans of artworks is of increasing impor-
tance, not just within the United Kingdom, but also worldwide.

Primarily, such loans are important to ensure that artworks are made available to
a wider audience, enhancing understanding, enjoyment and learning. The cura-
tion by museums and galleries of so-called blockbuster exhibitions has become an
essential tool for generating high levels of public interest in artists or categories
of art. A regular theme and key attraction of such exhibitions is that works of art
which would otherwise not be seen together are assembled in one single venue for
a short period of time. Such exhibitions are largely dependent on loans of artworks
from private and institutional lenders throughout the world. They can only exist
with a sophisticated level of logistical planning designed to ensure that lenders can
lend their artworks with confidence, knowing that their artworks are safe in the
hands of the museum, both in transit and on display.

Such loans are also increasingly important as a means of addressing the very diffi-
cult question of ownership of cultural heritage. As we saw in section 10.2, 'Cultural
property and heritage', many countries are increasingly seeking to assert claims for
the restitution of artworks and historical objects which originated in the claimant
countries and are now to be found in the world's museums. The museums counter
that these objects are owned by humanity as a whole rather than a State. They
argue that these objects should be made available for study and appreciation
throughout the world rather than returned to their source, where they will be seen
and appreciated by only a fraction of the number of people who visit museums.
There is force in both arguments and perhaps because of this, it is unlikely that the
debate can be easily – or indeed even ever – resolved. However, one major area
of opportunity in finding a pragmatic solution to the debate lies in the ability and
willingness of museums, and collectors, to make and receive loans of artworks.
This could allow museums to continue their role of educating and informing the
public while also giving the public in the source country to which the object is
loaned the opportunity to see, understand and enjoy their own heritage.

The benefits of such loans have to be weighed against the safety of the object
being loaned, and – perhaps most importantly – the museum being satisfied that
the artwork will be returned at the end of the loan period. For instance, s 4 of the
British Museum Act of 1963 provides that:

> The British Museum may lend for public exhibition (whether in the United Kingdom
> or elsewhere) any object comprised in the collections of the Museum: provided that in
> deciding whether or not to lend any such object, and in determining the time for which,

and the conditions subject to which, any such object is to be lent, the British Museum shall have regard to the interests of students and other persons visiting the Museum, to the physical condition and degree of rarity of the object in question, and to any risks to which it is likely to be exposed.

However, there are also many other considerations in deciding whether or not to loan an object and most United Kingdom museums have detailed loan policies setting out the circumstances in which they will or will not agree to loans. Most such policies require a scholarly justification for the loan and assurances that the exhibition in question will not contain objects stolen or illegally excavated or acquired as defined in the UNESCO Convention on the Means of Prohibiting and Preventing the Illicit Import, Export and Transfer of Ownership of Cultural Property, 1970.

13.4.2 Structure and negotiation of the loan agreement

Loan agreements will vary in form and content from museum to museum; however, the following key issues will need to be covered.

13.4.2.1 Term of the agreement

The term will usually be a fixed term from one date to another. This provides the lender with certainty as to the return date. If necessary, the provision can include the possibility of an extension of the term by mutual agreement.

13.4.2.2 Costs

In most cases the lender can expect the borrower to cover the costs associated with the loan, such as valuation, packing, shipping, inspection and security.

13.4.2.3 Care

The primary concern of any lender will be the conditions in which the artwork is kept. This may be dealt with by a catchall provision in which the borrower agrees that it will take the same care of the loaned artwork as it does of other objects in its collection. Alternatively, if the artwork on loan requires special atmospheric, climatic or light conditions, these can be included in the contract as requirements. It may also be sensible to include a requirement as to the precise location where the artwork will be exhibited and stored pending exhibition. Minimum security requirements may also be desirable.

As an example of more specific stipulations, some contracts will stipulate:

• Maximum light levels or light hours (in lux) to which artwork will be exposed.

- Temperature range within which the artwork will be kept.
- Relative humidity levels within which the artwork will be kept.
- Requirement for constant or regular surveillance while on exhibition.
- Requirement for a barrier to be erected to keep the artwork out of reach of the public.
- No consumption of food or drink to be permitted in the vicinity of the artwork.

Another approach is to adopt the care and transport requirements of the Government Indemnity Scheme, which tend to be the highest industry standards. This can be achieved through a clause which states that the borrower will abide by the Government Indemnity Scheme: Security and Environmental Conditions and the Government Indemnity Scheme: Transport Conditions.

The contract may also include a provision stating that in the event of damage the lender will be informed immediately and any repair or restoration work shall be carried out subject to prior written consent from the lender.

13.4.2.4 Transport and packing

The moments of greatest risk for any artwork on loan are packing, transportation and unpacking. The loan agreement should therefore specify who will undertake the packing, shipping and unpacking, and should where appropriate impose clear minimum standards and requirements for the packing materials and the manner of shipping.

13.4.2.5 Condition reports

The loan agreement should provide for inspections and written and/or photographic condition reports at each point before and after the artwork is shipped or moved. In the case of longer-term loans such reports should be carried out at least annually.

13.4.2.6 Insurance

The lender will need to be reassured that the artwork will be covered by adequate insurance at all times. There are a number of ways in which this can be achieved. If the loan is to a United Kingdom museum or gallery it is likely to be covered by the government indemnity scheme (see below). In other cases commercial insurance cover will be required and the contract should be careful to require that insurance should be on a 'nail to nail' basis, that is, coverage from the moment it is removed from the lender to the moment it is returned. Evidence of insurance cover should also be required as a precondition to the loan, preferably with the lender named as the insured in the event of loss or damage. The lender should also take care to review the exclusions in any proposed insurance policy. Many such policies will

exclude certain risks such as terrorism or war. Finally, it is also possible for the partners to agree to noninsurance. Where this is agreed, one of the parties – the lender or the borrower – undertakes to take on the full risk of loss or damage to the artwork.

13.4.2.7 Seizure

The rise in repatriation claims arising from cultural heritage issues and wartime confiscation has led to an increased risk that artworks lent to museums or institutions for exhibition may be the subject of court seizure orders obtained by claimants. To some extent that risk has been reduced by the Tribunals, Courts and Enforcements Act 2007, which was introduced to provide immunity from seizure for cultural objects loaned from overseas to temporary public exhibitions in approved museums or galleries in the United Kingdom. However, this is a real consideration and the agreement should include provisions requiring the borrower to make the lender aware of any threat of seizure – and to defend the lender's interests.

13.4.2.8 Exhibition

The borrower will usually wish to retain absolute discretion over how the borrowed artwork is exhibited, the accompanying text and the method of display. Lenders may be happy with this or can seek to limit that discretion so that, for instance, these issues are to be discussed, notified or agreed with the lender. More specifically, lenders who prefer anonymity will be concerned to ensure that the loan agreement takes account of their confidentiality concerns where the accompanying text or catalogue refers to the lender or to the ownership of the artwork. The phrase 'from a private collection' is often used in this context.

13.4.2.9 Photography and copyright

In the case of borrowing by a museum or gallery, the contract will usually state that the museum or gallery will retain the copyright in any images which it creates of the artwork. One reason is that the merchandising of such images as postcards, posters, tea shirts, bags and fridge magnets can be an important source of revenue. Such merchandising also performs a valuable function in promoting the museum brand. It is a matter for negotiation whether the lender is prepared to agree to this or to restrict the ability of the museum to make use of the image – and, if so, on what terms.

Regardless of what is agreed in the contract, however, if the artwork itself is still in copyright (see section 1.1) then the museum will need to secure consent from the

copyright owner – the artist or his descendants or assignees – to make use of any reproduction of the image of the artwork.

Separately, the contract may also deal with the question of whether the visiting public will be permitted to photograph works in the exhibition.

13.4.2.10 Termination

Museums will usually wish to ensure that they have as firm a commitment as possible for the loan of the artwork and that the commitment can be withdrawn only upon the lender giving a reasonable period of notice – and usually not while the loaned work forms part of a fixed-term exhibition. The contract will therefore usually contain a provision that either party can terminate the loan agreement, but only on giving the other party a certain number of months' notice. The loan document should also provide a right of immediate termination by the lender in the event that the borrower has not complied with the terms of the agreement.

13.4.2.11 Prohibition on marketing loaned artworks

The appearance of an artwork in a museum exhibition can add significantly to its recognition, and therefore also its value. Museums are aware of this and will often include in the loan agreement a clause in which the person loaning the artwork agrees not to market the work for sale while it is on exhibition at the museum.

13.4.3 Government indemnity scheme

The key concern for anyone lending an artwork to a museum for exhibition is insurance against loss, theft or damage to the work. The cost to museums of purchasing such insurance on the commercial market is in most cases prohibitive, so the government has, pursuant to the National Heritage Act 1980 (s 16(1)), put in place the government indemnity scheme to provide cover for objects loaned to museums by private lenders. The scheme facilitates the underwriting of risk in relation to artworks loaned to museums, galleries, libraries and other bodies, such as the National Trust, as well as loans between these bodies. It provides a form of insurance cover for artworks on loan during transit to and from the borrowing museum or institution, storage, setting up, display and dismantling. The advantage to museums of the government taking on the risk of loss or damage to objects on loan to museums is that the scheme is free of charge, resulting in an estimated saving to museums of around £15,000,000 per year.[12]

[12] www.gov.uk/guidance/government-indemnity-scheme

The scheme ensures that the lender will be indemnified by the government if the artwork is lost, stolen or damaged during the period of cover. In this case indemnification means a commitment to put the owner in the same financial position as if the damage, loss or theft had not happened.

Applications for cover under the government indemnity scheme are made by the institution to which the loan is being made. Whether a proposed loan of this kind qualifies for cover under the government indemnity scheme is determined on a case by case basis by the Secretary of State. In making that determination a key question for the Secretary of State is that of the public benefit stemming from the loan. The Secretary of State will not approve an undertaking unless he or she considers that the loan will facilitate public access to the object in question or contribute materially to public understanding or appreciation of it. The Secretary of State will also need to be satisfied that the institution has carried out appropriate due diligence into the origin of the loaned artwork, and of the adequacy of the security and environmental conditions (light, temperature, humidity, and so on) in which the artwork is to be kept.

The beneficiary of the indemnity is the person or institution having legal title to the loaned artwork. A change in ownership while the artwork is on display will invalidate the indemnity, necessitating a fresh application to the Secretary of State for an indemnity.

The government is aware that the loan of an artwork to a museum collection can increase the value of the object. It wishes to avoid lenders seeking to lend artworks in order that the exhibition can be used as a platform or showcase for a sale of the artwork. As a result, the indemnity cover may be withdrawn if the Secretary of State becomes aware that a loaned artwork is being offered for sale on the open market. In such circumstances the lender will be required to seek commercial insurance cover.

One key area for negotiation and discussion in the context of the government indemnity scheme is value. The value of the object should be agreed at a level which represents a fair estimate of the value that the object might sell for if sold on the open market at the time of the loan. Inevitably there will be a discussion between the owner and the borrower over what that value might be. If agreement on valuation cannot be reached between the borrower and the lender, the Secretary of State may seek the views of an independent assessor or may decide to provide indemnity cover for part rather than all of the proposed valuation. In either case, however, if he or she is unhappy with the proposed valuation, it is always open to the borrower to decide not to lend the artwork.

As with all insurance policies, there are some risks which are excluded. The default position is that loss of, or damage to, the object arising or flowing from war, hos-

tilities or warlike operations is an excluded risk. It is important to note, however, that loss or damage resulting from acts of terrorism, riot, civil commotion, piracy and hijacking are not excluded. The second standard exclusion relates to acts of negligence by the owner or persons acting on behalf of the owner. The final exclusion relates to loss or damage caused by the condition of the object at the time it is loaned, including 'inherent vice'.[13] Inherent vice is loss or damage caused by something which is intrinsic to the object itself – for instance, if the paint on the artwork causes a chemical reaction which damages or degrades the object. With this in mind, it is also a requirement of the grant of an indemnity that the artwork should be fit to travel and should not be at risk of being damaged or degraded if moved.

13.5 Deaccessioning and disposal of artworks by museums

Largely due to the more difficult economic climate, attempts by museums and local authorities to deaccession works from their collections have become more frequent. Such decisions are inherently controversial, particularly where they are motivated by funding gaps.

Example

- In 2012, Tower Hamlets mayor Lutfur Rahman threatened to sell a 1957 sculpture which had been gifted to the borough by Henry Moore. The work had originally been sited on a housing estate in Stepney but was moved to the Yorkshire Sculpture Park in the late 1990s for safekeeping. Rahman's argument was that the sale of the statue was essential to help address a major council budgetary deficit. The sale would address not only the financial needs of the borough, but also Rahman's political aim to highlight the lack of local council funding. In the event, perhaps in large part due to the controversy around it, the sale never happened.
- The Northampton Museum is a museum largely devoted to the history of footwear. It boasts the largest collection of shoes in the world. In addition to its footwear themed exhibits the museum has over the years acquired other artworks, including oriental ceramics and Italian art. Among its collection was an Egyptian statue known as Sekhemka. The statue had been donated to the museum by son of the Second Marquess of Northampton in the nineteenth century. Northampton Borough Council were told during a routine insurance valuation that the statue, which was felt not to be central to the museum's collection, was of great value. The Council therefore took the decision to sell the statue at auction in 2012 in order to fund restoration work to the museum.

[13] Similar exclusions for inherent vice are found in most commercial insurance policies.

The sale was successful, resulting in a hammer price of £15.76m. However, the Council's decision to sell proved to be highly controversial and led to the Arts Council removing Northampton Museum's accreditation, rendering the museum ineligible for future grants and funding.

13.5.1 Museums Association deaccessioning guidelines

The Museums Association provides detailed guidance for museums considering deaccessioning. The Museums Association states that it supports the responsible disposal of items from museum collections provided the disposal is legal and ethical. Ethical disposal is defined as being undertaken when:

- the disposal is within the framework of a clearly defined collections development policy
- it is on the advice of a range of staff (not an individual) and is agreed by the governing body
- it is done with the intention that wherever possible items remain within the public domain
- it is unlikely to damage public trust in museums
- it is likely to increase the public benefit derived from museum collections. (Museums Association Disposal Toolkit Guidelines for Museums)

The Museums Association guidance is also strongly focused on the reasons for the disposal. These include:

- improved care for the item
- improved access to the item; increased enjoyment of and engagement with the item by the public
- improved context for the item
- continued retention of the item within public museum collections or the wider public domain
- removal of any hazard posed by an item (e.g. through contamination).

The Museums Association illustrates a number of acceptable outcomes, but only where they are incidental outcomes of a curatorially motivated disposal:

- resources freed up to better care for and utilise other parts of the collection
- creating or optimising space (in order to assist the improved care and continued acquisition of collections).[14]

[14] Museums Association Disposal Toolkit Guidelines for Museums.

According to the Museums Association, the following are unacceptable reasons to dispose of an item:

- for financial reasons (unless in exceptional circumstances)
- on an ad hoc basis (i.e. other than as part of an approved collections development policy)
- without considering advice from someone with specialist knowledge of this type of item
- if the disposal would adversely affect the public reputation of museums
- if the disposal would not be in the long-term public interest
- outside the public domain, except in exceptional circumstances.[15]

13.5.2 Legislative provisions on deaccessioning

The Museums and Galleries Act 1992 sets out the circumstances in which certain national museums and galleries – the Tate Gallery, the National Gallery, the National Portrait Gallery and the Wallace Collection – are permitted to dispose of artworks from their collections. These are slightly different for each of the institutions concerned.

The Tate may dispose of artworks only by way of:

- sale, transfer or gift to another national museum which the board of trustees believes to be a more appropriate place for the work to be housed;
- disposal of an object which is unsuitable for retention and can be disposed of without detriment to the interests of students or other members of the public;
- disposal of an object which has become useless by reason of damage, physical deterioration or infestation.

The National Gallery may not dispose of any object unless it is a sale, transfer or gift to another body or institution specified in the Museums and Galleries Act.

The National Portrait Gallery shall not dispose of any artwork unless:

- it is a sale, transfer or gift to another body or institution specified in the Museums and Galleries Act;
- the object to be disposed of is a duplicate of another object in the collection;
- the disposal is of a portrait of a person and the trustees are satisfied that there has been an error in the identification of the subject of the portrait;
- the disposal is of an object which has become useless by reason of damage, physical deterioration or infestation.

[15] Museums Association Disposal Toolkit Guidelines for Museums.

The Wallace Collection is not permitted to dispose of (or add to) its collection in any circumstances.

Any money raised by a disposal by these museums is required to be used in the acquisition of other objects for the collection.

The British Museum Act 1963 provides that the circumstances in which objects from the British Museum's collection can be deaccessioned are very limited. The starting point for any such decision is a strong presumption against disposal. The Museum will not dispose of objects donated to the Museum where to do so is contrary to the wishes of the donor. Further, the trustees will not agree to a disposal unless:

- the object is a duplicate of another object held in the collection; or
- the object is unfit for retention and can be disposed of without detriment to the interests of scholars or other members of the public; or
- the object has become useless by reason of damage, physical deterioration or infestation.

In addition to the statutory restrictions on deaccession of artworks, there may also be other legal restrictions, such as the conditions or terms under which the work was donated to the museum.

Equally, there are ethical considerations. A significant and growing part of the Museums Association code of ethics is devoted to the question of deaccessioning and disposal. In particular, the code encourages museums to recognise the principle that collections should not be regarded as financially negotiable assets and that financially motivated disposal risks damaging public confidence in museums. The code recognises, however, that there may be circumstances where a disposal may be justified in view of the long-term public benefit which will be derived from the remaining collection. This will, however, require demonstrating that the item lies outside the museum's core collection, that the museum has consulted with museum sector bodies and the public, that the disposal is not to generate short-term revenue (such as to address a budget deficit) and that it is a last resort. Such is the sensitivity of this issue that the code includes two separate appendices providing additional guidance on financially and curatorially motivated disposals.

14 Art funds

14.1 Introduction

A popular piece of advice in the art market is that you should never buy purely for investment. Buy what you like and consider yourself lucky if it increases in value. Despite this, there has been a significant growth in the treatment of art as an asset class.

There are many reasons for the popularity of art as an investment. First, the very successful marketing campaigns of auction houses highlight ever growing prices for a select group of popular artists. Because of the wider availability of historical auction data, it is also possible for journalists to compare the prices at which artworks were last sold and their current sale price. Where there is a substantial increase in value – particularly over a short period of time – the resulting media reporting then sparks interest from collectors of works by the artist whose works are enjoying a rise in value. These collectors then consign works to auction with similar expectations of high returns on their investment. Second, and perhaps most importantly, art is an asset which can provide tangible and aesthetic enjoyment. This makes it a far more enjoyable asset to own than, say, stocks and shares. Third, there is an aura of connoisseurship around art and the value of art which lends itself to speculation. Collectors like the idea of having the foresight and taste to invest in an unknown artist whose works subsequently become more valuable. Finally, the art market does not necessarily follow the wider economic downturns and can indeed be seen as a safe or stable haven for investment in turbulent times.

A group of researchers at Stanford University conducted a study in 2013 in which they concluded that the perceived returns of 10% per annum on purchases of fine art between 1972 and 2010 had been significantly overestimated by the art sales indexes.[1] This was because the art indexes tend to track only those artists successful enough to be sold at auction, ignoring those who turn out not to be successful. This meant that not only were the investment return calculations based on a self-selected group of high performing artworks, but the downside risk of

[1] *Does It Pay to Invest in Art? A Selection-Corrected Returns Perspective* by Arthur G. Korteweg, Roman Kräussl and Patrick Verwijmerenof.

buying a work by an artist who did not ultimately prove to be successful was being ignored by the art index figures.

The attraction of looking at art as an asset class has however led to the establishment of what are known as art funds. Art funds are generally investment funds established to generate a profit for their investors through the buying and selling of works of art. These funds are managed by a team which is remunerated by a management fee and, in most cases, a share of any returns delivered by the fund.

Art funds are popular with individual investors but also with wealth managers seeking to allocate a specific portion of a client's investment portfolio to a diversified investment with lower correlation to traditional financial markets. Well managed art investment funds look to satisfy that demand. Such funds also appeal to asset managers who are looking for 'new asset classes' which offer interesting alternatives to more traditional investment opportunities. The interest value of such an offering can attract and keep clients.

The term 'art fund' can cover a multitude of different arrangements. After all, an investment fund is simply the pooling of capital of more than one person or entity, with a mutually agreed investment strategy. Such art funds can range from 'friends and family' funds to professionally managed art investment funds with a wider pool of investors. There are no stock market listed art funds in the United Kingdom, so all are private funds.

The returns are achieved through the identification of opportunities for the purchase of artworks which the fund manager believes can be sold at a later date for a profit. The investment strategies, including the types of works invested in, the value of the works, the sourcing and disposal strategies and the duration of the investment, vary from fund to fund. They are attractive to investors for two reasons: first, because the art fund managers position themselves as having a depth of knowledge of the art market and investment opportunities which ordinary collectors do not; second, because the investor's risk is reduced through diversification.

Art fund managers believe that they are able to realise gains through a variety of different approaches. Different artists and types of artwork enjoy varying degrees of popularity in different parts of the world. A work which can be purchased at an affordable price in one country may be sold in another country at an increased price. Another strategy may be the identification of and investment in emerging artists. This could mean unknown young artists or more established artists whose works are becoming more fashionable and therefore expensive. Art funds are also able to secure additional funding for purchases leveraged against their existing holdings. A more recent development has been the emergence of art fund managers who are willing to partner with auction houses in offering minimum price

guarantees to auction sellers in return for a share of the profits if the work exceeds the minimum guarantee.

14.2 Choosing an art fund

Because such funds vary so much in structure and strategy, there are some basic questions which anyone considering investing in an art fund should consider before doing so.

14.2.1 The art fund manager

The investor should consider who the physical person is who is managing the art fund. What is their track record? What art market or art valuations experience is held by the key individuals at the fund manager? A professional fund manager should be able to point to data which illustrates a track record in investing in art and/or buying and selling art.

14.2.2 Asset acquisition due diligence

The acquisition of art is not, as we have seen elsewhere in this book, without risk. The value of art can be severely impacted by authenticity, attribution, provenance, title and condition issues. A professional art fund manager should be able to provide potential investors with details of the due diligence process that is under-taken prior to acquiring an asset.

14.2.3 Market sector

The art market is made up of different categories of art. Each provides different levels of risk and opportunity, requiring a different investment strategy. The investor needs to know what sector of the art market the fund is investing in, what the investment strategy is and whether there is a particular market opportunity that the fund manager is capable of accessing. In practice, this means an ability to source investment grade works at the right price. This requires valuation expertise but also market access and connections.

14.2.4 Liquidity

Good art investment funds tend not to be liquid and they are intended to take a longer-term view, usually of between five and ten years.

14.2.5 Return objective

Investors should ensure that the art fund has a clear investment return objective. Generally, the objectives are (i) preservation of capital and protection against inflation and (ii) capital appreciation, as opposed to dividend yields.

14.2.6 Fee structure

The fund should have a clear fee structure, which will usually be based upon a management fee combined with a performance fee once a target hurdle return has been achieved by the manager.

14.2.7 Ticket size

Most funds will have a minimum investment threshold in order to invest in the fund. Generally, the lower the threshold, the more caution is required, as the opportunities in art investment tend to arise at the upper value points in the art market. While it is not always the case, as a rule, the lower the value point of the art being purchased, the lower the likelihood of a significant return – and the greater the risk of the investment value remaining static or falling.

14.3 Investors and risk appetite

As with any investment vehicle, different types of investors will be seeking a different balance of risk and return. Investors in art funds tend to fit into three categories: (i) high net worth individuals; (ii) asset managers and institutional funds; (iii) pension fund managers. Pension funds tend to seek very low risk investments and are willing to accept a lower potential return as a consequence. High net worth individuals, on the other hand, tend to prefer greater risk in the hope of a higher return. The investor's appetite for risk will be reflected in the approach taken by the fund in relation to acquisitions and disposals.

14.4 Valuation and audit

Investors in art funds should ensure that the fund is audited annually by reputable auditors. As the value of the art held by the fund is critical to the monitoring of the performance of the fund, investors will also wish to satisfy themselves as to the valuation arrangements and ensure that valuations are carried out on a regular basis. Funds are generally valued by reference to net asset value, which is a combination of the cash and the art held by the fund.

15 Art disputes

15.1 Disputes and court proceedings

15.1.1 Introduction

As a cursory review of the Art Newspaper will reveal, the art industry is no stranger to legal disputes. The value of the artworks, both financial and emotional, together with the potential for uncertainty around ownership, authorship and authenticity all combine to make the art world a frequent source of disputes. However, while disputes are common, it is relatively rare, in the United Kingdom at least, for disputes to reach the law courts, let alone to reach trial. The primary reason for this is in all likelihood the value which the art industry has traditionally attached to discretion and confidentiality. The prospect of having disputes played out in court in the public eye is usually highly unappealing for all parties. Another reason may be a view that the courts will not understand the unusual commercial landscape of the art world.

However, disputes continue to be a feature of the art world whether or not they reach the courtroom, and in this chapter we will look at how best to address and resolve them.

15.1.2 Making a claim

We will deal later in this chapter with the particular types of claim which are commonly made in the context of the purchase and sale of art. First, however, we will look at the more general considerations applicable to claims, regardless of the type of claim.

In ordinary circumstances the first step should be to make the other party aware of the existence of the claim. This should be done promptly and in writing, with full details of the facts and legal arguments in support of the claim. The person to whom the claim is addressed should be given a reasonable opportunity to respond to the claim in writing. This should, in ordinary circumstances, be a period of no less than 14 days, and in complex cases it may be more. This notification process is not merely a formality. A failure to take this step before issuing proceedings can lead to the claimant being penalised in costs.

The recipient of the claim must then respond in writing to the claim, indicating whether the claim is accepted and, if not, the reasons why it is not accepted.

Even if the claim is rejected, the claimant is not free to rush into issuing legal proceedings. The United Kingdom courts expect litigation to be used as a last resort. As a result, the courts require the parties, before issuing legal proceedings, to have given serious consideration to whether negotiation or some other form of alternative dispute resolution (ADR) might enable them to settle their dispute without commencing proceedings. This is a continuing obligation on the parties, who are required to continue giving consideration to the possibility of reaching a settlement at all times, including after proceedings have been started. Once again, failure to explore settlement options can have serious consequences for both or either of the parties once the case goes to trial.

15.1.3 Legal costs

A major consideration for claimants and defendants in litigation is exposure to legal costs. This is because the general rule in United Kingdom litigation is that the unsuccessful party will be required by the court to pay not only his own legal costs but also those of the successful party. Those costs can be very significant, and in some cases even outweigh the sums in dispute. This is an important consideration because parties to litigation are rarely conscious at the outset of the litigation of the extent to which litigation is a gamble. Claimants and defendants routinely overestimate the strength of their hand to start with. There is often talk at the outset of 'an issue of principle' and 'my day in court'. The outcome of litigation, however, depends on a great number of factors which are unpredictable at the beginning of the process. These include the question of documents that will come to light in the runup to trial, how the witnesses will perform when crossexamined, the quality of the expert evidence and, of course, the attitude of the judge. These factors render any claim, to a lesser or greater extent, a gamble. Understanding this is important because the consequences of losing the gamble, from the point of view of liability for legal costs, are so serious. Claimants would therefore be well advised to exercise great caution before issuing proceedings. Defendants should also aim to be equally realistic about their prospects of success. The approach of the trial is often accompanied by a growing sense of realism on the part of the parties of the weaknesses of their case, and therefore a greater openness to a negotiated settlement. The problem is that by this time the legal costs have also grown to the point where settlement becomes more difficult or uneconomic due to the sums in issue.

One tactical step which can reduce the potential exposure to costs for either side to a dispute is a mechanism known as a Part 36 offer.[1] A Part 36 offer is a formal

[1] Civil Procedure Rules Part 36, rr 36.1–36.30.

offer of settlement which, unless withdrawn, remains open for acceptance until trial or such lesser period as is specified in the offer. If the offer is accepted, the claim is settled on the terms of the offer. If the offer is not accepted and the legal proceedings continue, the party who refused the offer will be at risk of having to pay the offering party's legal costs from the date the Part 36 offer was made if the amount awarded by the court is equal to or better than the Part 36 offer made by the offering party.

Example

- In the absence of a Part 36 offer, if the claimant is claiming damages of £10,000 and is successful, the defendant will, regardless of the amount of damages awarded, in the ordinary course of events be expected to pay the claimant's costs as well as his own costs and the damages awarded by the court. However, if the defendant makes a valid Part 36 offer of, say, £8,000 which is not accepted by the claimant within 21 days of the offer, then, even if the claimant is successful, the defendant will only have to pay the claimant's costs if the damages awarded by the court exceed the defendant's rejected £8,000 Part 36 offer. The decision to reject or accept a Part 36 offer is therefore a critical one for the recipient.

However, the form and terms of a Part 36 offer are strictly prescribed if the offer is to be deemed valid and effective. The offer must:

- be in writing;
- be stated to be made pursuant to Part 36;
- specify a period for which the offer is open for acceptance (21 days or more if made 21 or more days before trial);
- be clear about whether the offer relates to the whole or part of the claim, and whether it takes account of any counterclaim by the other party.

Part 36 offers are not disclosed to the Court until after the trial, when the judge is considering what orders to make in relation to costs.

Once made, if the recipient of the offer chooses to accept it, the rule is that the defendant to the proceedings is required to pay the claimant's costs up to the date of acceptance of the Part 36 offer.

15.1.4 Alternative dispute resolution

Litigation is an extremely expensive and often destructive way of resolving disputes. A great deal of energy has therefore been devoted in the past 20 years to the development of alternative dispute resolution (ADR) mechanisms outside the law courts. The advantages of ADR over court proceedings include privacy, a simpli-

fied and more informal procedure, and lower costs. See section 15.8 for a more detailed analysis of ADR and how it may be used in art disputes.

15.1.5 Legal proceedings

Once the claim has been outlined and responded to, and the possibility of a nego-tiated settlement or ADR unsuccessfully explored, the claimant may issue court proceedings. This is the formal step required to start the litigation. It takes the form of two documents, known as a 'claim form' and 'particulars of claim'. These documents set out the basic facts of the case and the legal basis of the claimant's legal claim against the defendant. Once issued by the court, these documents are served upon the defendant,[2] who then indicates whether he or she accepts or rejects the claim. If the latter, he or she must respond with a 'defence' – a formal document setting out the facts and legal grounds on which the claimant's claim is rejected. Further documents may be exchanged in order to clarify the parties' respective cases.

A major part of any litigation is the disclosure of documentary evidence. Unlike in some other countries, United Kingdom law requires the parties to disclose all relevant or potentially relevant documents, emails, correspondence and records in the party's possession or control, whether or not they are helpful to the party disclosing them. This can be an extremely onerous and time-consuming task.

The other significant task is the preparation of witness evidence. Each party will interview the witnesses it intends to call to testify to issues of fact in support of its case. In each case a written witness statement will be prepared and signed by the witness. Witness statements are then exchanged between the parties in the months before the trial.

In cases which require technical evidence the parties will also involve expert wit-nesses. These are independent witnesses whose function is to advise the court of technical or specialist matters. In authenticity cases, for instance, the parties will often call upon scholars specialising in the artist in question and upon scientists to testify on issues such as pigment analysis. Expert witnesses will prepare expert reports which will then be exchanged some time before trial. The experts on both sides will then be required to meet in order to determine what, if any, issues can be agreed between them before the trial.

The trial usually takes place around 12–18 months after the issue of proceedings. Civil cases do not involve a jury and the trial will be determined by a single judge. The judge will have read the particulars of claim, the defence, the witness

[2] The documents are sometimes referred to as court proceedings.

statements and the key parts of the evidence. The trial consists of the barrister for each party making oral submissions and drawing the judge's attention to the key parts of the evidence. The witnesses will then be called for crossexamination. Crossexamination is carried out by the opposing barrister, although the judge will often also have questions for the witness. The trial ends with a summing up by the barristers for each side. The judge will then retire to make a decision.

15.1.6 Injunctions

An injunction is a temporary court order obtained to preserve and regulate the position between two parties to a dispute before the trial takes place to resolve the dispute. It is designed to ensure that nothing can happen prior to trial which will cause irretrievable loss to one or other of the parties to the dispute. Usually an application for an injunction is made immediately prior to the issue of legal proceedings. Injunctions can be mandatory, requiring a party to do something; alternatively, they can be prohibitory, restraining a party from doing something. In the context of the art world, injunctions are most frequently used as a means of seeking to prevent the sale or disposal of an artwork which is the subject of an ownership dispute. They have, however, also been used by sellers who have consigned a work to an agent for sale, but wish to prevent the sale due to a breach of contract by the agent. In Elidor Investments SA v Christies, Manson Woods Ltd,[3] the seller successfully applied to the court for an injunction preventing the auction from taking place on the grounds that while Christie's had, under the terms of the agency agreement, complete discretion in relation to the cataloguing of the sale, that discretion was subject to the test of reasonableness. The judge held that in the particular circumstances of the case the discretion had been exercised unreasonably, as the approach taken by Christie's in the catalogue descriptions was inconsistent throughout the catalogue and also not in line with its stated practice.

Where an injunction is issued by the court, it is crucial that anyone served with the injunction abides by it to the letter. This is because a breach of the terms of an injunction can lead to proceedings for contempt of court, and imprisonment.

The courts do not issue injunctions lightly. Many injunction applications are made on very short notice, and in urgent cases on the basis of evidence from only one party to the dispute. Because the consequences of an injunction can be very significant, the courts are at pains to balance the rights of the parties to the dispute as fairly as possible. To assist them in this they have developed some principles to determine whether or not a case is appropriate for an injunction; these are known

3 [2009] EWHC 3600 (QB) 2009 WL 5641047.

as the American Cyanamid principles, as expressed in the House of Lords case of American Cyanamid v Ethicon.[4] The guidelines are as follows:

- Is there a serious question to be tried? The person applying for the injunction will need to show, by reference to evidence, that there is a serious legal issue to be resolved. It must not be a frivolous or vexatious case and the application must not be intended to simply put pressure on the other party.
- Would damages be an adequate remedy? The court must ask itself whether, if it fails to issue an injunction and allows the threatened behaviour to go ahead, the applicant for the injunction can be adequately compensated in damages. If so, then the injunction will not usually be granted. As an example, a person who is seeking an injunction to prevent the sale of a unique artwork which he wants to return to his family home, from which it was stolen, might argue that if the sale were to go ahead he would not be adequately compensated by an award of damages. His interest is in the artwork itself rather than the proceeds of sale of the artwork. However, a dealer who claims ownership of a financial share in a painting which is to be sold could probably be adequately compensated by damages if the painting is sold.
- Where does the balance of convenience lie? An assessment of the balance of convenience will depend upon the facts of each individual case. The test applied by the court is whether it would do greater damage to the applicant if the injunction were wrongly refused than it would do to the respondent if the injunction were wrongly granted. This is sometimes referred to as 'the balance of the risk of doing an injustice'.[5] Looking at the test once again in the context of an injunction to prevent the sale of an item at auction, the court will need to weigh the loss to the applicant if the claimed artwork is sold against the loss to the current owner who will lose this opportunity to sell his work and potentially suffer loss if the value of the work is diminished by reason of its withdrawal from sale.
- Are there any special factors? The court will also consider whether, even if some of the other American Cyanamid tests are not satisfied, there are other factors which would make it just to grant the injunction. Once again this will depend on the particular facts of the case but, by way of example, it has been held that where it is clear that the proposed course of action would be a clear breach of a contractual obligation, the court should simply grant the injunction.[6]

There are also important further considerations for the applicant prior to applying for an injunction. First, injunctions do not exist in a legal vacuum. They are an interim measure requiring the issuing of legal proceedings aimed at a trial to

4 [1975] AC 396.
5 Cayne v Global Natural Resources [1984] 1 All ER 225.
6 Doherty v Allman [1878] 3 App. Cas. 709.

determine the validity of the applicant's case. As I have mentioned above, the issue of proceedings carries a potential liability for costs. That potential liability will be significantly increased by the injunction application – which is invariably very costly due to the amount of evidence to be gathered in support of the application, and the urgency. In addition, the applicant will be required to demonstrate that he or she has the means to compensate the defendant for any losses suffered if it turns out that the injunction should not have been granted. This is called a crossundertaking in damages. The court may order that the applicant deposit a sum in court as security for the undertaking or provide some other security for the undertaking.

It is worth also giving thought to the position where an injunction to halt a sale on grounds of an ownership challenge is applied for by the claimant and refused by the court. In such circumstances the seller is faced with a difficult choice. While the injunction application has been refused, the artwork remains the subject of continuing legal proceedings. In those circumstances the seller has a choice: continue with the sale, knowing that the continuing litigation may discourage bidders, or withdraw the item from sale to allow the litigation to resolve itself.

Example

- In 2014 Christie's was asked by a Portuguese nationalised bank to sell a collection of paintings by Joan Miro valued at US$30,000,000. The sale was highly controversial and political in Portugal and the opposition socialist party in Portugal made an application to the Portuguese courts for an injunction. The grounds of the application were that the works had been exported from Portugal without complying with the necessary export formalities and therefore belonged to the State of Portugal. The injunction application was unsuccessful and Christie's was therefore free, in theory, to proceed with the sale. However, with the prospect of continuing litigation in Portugal over the ownership of the works, Christie's took the position that it would not proceed with the sale on the grounds that it could not place its buyers in the position of acquiring works of art which were the subject of a continuing ownership claim.

15.2 Sale location, applicable law and court jurisdiction

The determination of applicable law and jurisdiction for resolving disputes is a notoriously technical and complex area of the law, and each legal system has its own approach. For the purposes of this book we will look at how the Courts in the UK and in the EU will approach the question in the context of contractual disputes.

15.2.1 Applicable law

In the UK the provisions of Retained Regulation (EC) 593/2008 (more commonly known as 'Retained Rome I') have encapsulated the courts' approach to identifying the applicable law in contracts entered into on or after 1 January 2021. The provisions of Retained Rome I are broadly the same as the provisions of EU Regulation (EC) 593/2008 ('Rome I'), which apply to the EU, so the approach taken to applicable law clauses by EU countries and the UK is broadly the same.

15.2.1.1 Choice of law clauses

Article 3(1) of Rome I sets out the overriding principle that the parties to a contract have the freedom to choose which law should apply to the contract.

Most auctions and agreements relating to the sale and purchase of art will be subject to written terms and conditions, which will usually include a provision stating which law is to govern the transaction. This will therefore usually be the law applied in the event of a dispute, as Rome I will usually give effect to such a provision.

The general principle giving the parties to a contract freedom to choose the applicable law is however subject to a qualification, designed to ensure that parties cannot sidestep a country's laws by simply selecting the law of a country which has laws which are convenient for one or both parties but which has no connection with the transaction. Article 3(4) of Rome I makes it clear that such choice will not be given effect where the parties have chosen the law of a country which has no connection at all with the transaction and has been chosen in order to circumvent the law of a country whose law would otherwise have been applicable to the contract. In other words, in the context of the sale of an artwork, to ensure that a choice of law clause is binding the law chosen by the parties should generally either be that of the seller, the auction house/agent, the buyer or the location of the artwork being sold. With this in mind, most sales of art conducted online will, in their conditions of business, identify as the applicable law the law of the country in which the auction house/agent offering the property for sale is located.

Under Article 6(1) of Rome I a contractual provision choosing the applicable law will also be binding in a consumer contract. A consumer contract is a contract between a consumer (defined as a natural person acting for a purpose which can be regarded as being outside his trade or profession) and a professional (someone acting in the exercise of his trade or profession). However, under Article 6(2) of Rome I this is subject to an important qualification. The choice of law will not be binding if the choice has the result of depriving the consumer of mandatory

consumer protection laws he would otherwise have enjoyed the benefit of in his country of habitual residence.[7]

This means that even if an applicable law has been agreed upon, and even if the chosen law has a strong connection to the transaction, it may still be challenged by a consumer if that consumer is deprived of a mandatory right or remedy that he or she would have enjoyed in his country of habitual residence in the absence of that choice of law clause.

It is important to bear in mind when considering whether or not a contract is a consumer contract that the parties to the contract of sale are the seller and the buyer, and for the purposes of the contract of sale the professional status of the agent (in this case the auctioneer) is not part of the equation. The ability for a consumer buyer to claim the benefit of the consumer contract exception is therefore limited to circumstances where the seller who has consigned the work to the auction house or agent for sale is a professional acting in the course of his or her trade. They will not apply – even where the buyer is a consumer – where the consignor is not selling the artwork in the course of a business.

15.2.1.2 No choice of law clause

It is less common that an auction agreement or other art-related contract would not include terms and conditions with an express choice of law clause, but if that were the case the following considerations would apply in determining the correct choice of law.

15.2.1.2.1 Non-consumer contracts

Article 4(1)(a) of Rome I establishes the principle that in the absence of a choice of law provision, a contract for the sale of goods shall be governed by the law of the country where the seller has his habitual residence. So, in a private sale of an artwork, the applicable law shall be that of the habitual residence of the seller of the artwork.

Rome I however has a dedicated provision to deal with the choice of law where goods are sold by auction. Article 4(1)(g) of Rome I provides that if the parties have not contractually chosen a law, the governing law shall be the place where the auction takes place, if such a place can be determined. In the case of an auction conducted by a London auction house, therefore, the applicable law would, in the absence of a choice of law provision, be United Kingdom law.

[7] Habitual residence is taken as the person's residence at the time of concluding the contract.

However, Rome I goes on to provide two so-called escape provisions where the place of the auction cannot be determined or where the outcome of applying Article 4(1)(g) would result in an absurd outcome. First, Article 3(3) provides that where it is clear from all the circumstances of the case that the contract is manifestly more closely connected with a country other than that indicated in paragraph 4(1)(g), the law of that other country shall apply. Second, Article 4(4) of Rome I provides that the contract shall be governed by the law of the country with which it is most closely connected. The combined effect of these escape provisions is to provide a common-sense fall-back to ensure that where the rules result in a counterintuitive outcome the contract shall be deemed to be governed by the law of the country which is most closely related to the transaction.

15.2.1.2.2 Consumer contracts
However, the rules in Article 4 of Rome I do not apply in consumer contracts concluded between a consumer (defined, as we have seen above, as a natural person acting for a purpose which can be regarded as being outside his trade or profession) and a professional (someone acting in the exercise of his trade or profession). In these cases, in the absence of a choice of law clause in the conditions of business the contract shall be governed by the law of the country where the consumer has his habitual residence, provided that the professional pursues or directs his commercial or professional activities in the country where the consumer has his habitual residence. In practice this means that the professional must have some kind of commercial presence in the consumer's country of residence, such as an office or a branch. It would probably also apply if the professional was selling art in the consumer's country of residence at an art fair.

15.2.2 Court jurisdiction

Until Brexit, the position with regard to choice of jurisdiction clauses as between litigants in EU Member States was determined in the UK and in the EU by the Regulation (EU) 1215/2102, known as 'Brussels I (recast)'.

The general rule in Article 4 of Brussels I (recast) is that persons domiciled in an EU Member State should be sued in the EU Member State in which they are domiciled regardless of their nationality. In the absence of the parties to the contract having agreed upon which court is to have jurisdiction, therefore, the principle is that the auction house should sue an EU buyer in the courts where the buyer is domiciled. Conversely, the buyer should sue an EU-based auction house in the auction house's place of domicile or an EU seller in the seller's place of domicile.

However, as we have noted above, in most cases the conditions of business of auctions will contain a choice of jurisdiction clause. Article 25 of Brussels I (recast) will usually give effect to such clauses and any such agreement will be assumed to

be intended to give the chosen court exclusive jurisdiction unless otherwise stated by the parties.

However, as with Rome I, Brussels I (recast) provides for an important exception where the contract is a consumer contract:

Under Article 17(1)(c) a consumer contract for these purposes is a contract which has been concluded by a consumer, acting outside of his or her trade or profession, with a person who pursues commercial or professional activities in the Member State of the consumer's domicile or, by any means, directs such activities to that Member State.

In such cases, Article 18 of Brussels I (recast) states: 'A consumer may bring proceedings against the other party to a contract either in the courts of the Member State in which that party is domiciled or, regardless of the domicile of the other party, in the courts for the place where the consumer is domiciled.'

In practice, therefore, where the buyer is an EU-domiciled consumer, Brussels I (recast) permits the buyer to sue the auction house and the seller in the place of domicile of the EU consumer regardless of whether or not the conditions of business of the auction confer jurisdiction on another court and regardless of whether or not the auction house or seller are domiciled in an EU Member State.

Where the consumer is being sued, Article 18(2) goes on to provide that proceedings may be brought against an EU-domiciled consumer by the other party to the contract only in the courts of the Member State in which the consumer is domiciled.

Brussels I continues to be used by EU courts to determine which EU court has jurisdiction over contractual disputes. Following Brexit, however, Brussels I is no longer applied by the UK courts. This is because it is an EU regulation which applied directly to the United Kingdom while it was a member of the EU, but ceased to apply as soon as it ceased to be a member. Further, because the United Kingdom is no longer a member of the EU, the courts of EU countries are not bound to apply the Brussels I (recast) rules when faced with a contract where there is a choice of jurisdiction clause in a contract which selects the United Kingdom courts. Both the UK courts and the EU Member State courts will instead look to their domestic law when deciding whether to give effect to such a clause.

The UK is however a party to the 2005 Hague Convention on Choice of Court, which is an international agreement pursuant to which contracting states (which include the United States, the UK, EU Member States and China) agree to uphold contractual agreements designating a contracting state's courts as having exclusive

jurisdiction. However, under Article 2(1), the Hague Convention on Choice of Court does not apply to contracts where one party is a consumer.

Where the Hague Convention does not apply – either because one party is not from a Hague Convention state or because one party is a consumer – the UK common law rules will apply. Those rules provide that the English courts will have jurisdiction if: (i) proceedings are permitted to be served on the defendant; or (ii) the defendant submits to the jurisdiction of the English courts. Proceedings can be served on the defendant abroad without the need for permission from the English court if the dispute relates to a contract which contains a clause designating the English courts as having jurisdiction. Otherwise permission is required, and will generally be granted where the dispute relates to a contract made in England or governed by English law.

15.3 Title disputes

Title disputes, also known as ownership disputes, are the most common form of dispute encountered in the sale and purchase of art. This is perhaps not surprising given the cocktail of factors and circumstances inherent in the ownership of artworks, which provide fertile ground for disputes. Artworks change hands frequently, in many different circumstances and in transactions which are often not documented or recorded. Because artworks are handed down or transacted from generation to generation, the mists of time can frequently obscure their ownership or provenance history. The emotional, historical, political and financial value and significance of artworks is also in constant flux. Because of these factors, artworks are frequently the subject of completing claims. Those claims are varied in nature. They can range from domestic disputes between divorcing couples through to claims arising from contractual disputes, recovery of stolen property, Holocaust restitution claims and claims by sovereign states over archaeological objects.

While the circumstances of such claims are many and varied, there are some common overall considerations which need to be borne in mind when evaluating the claim. Because these claims arise most frequently in the context of sales of artworks – and in particular, auction sales – we will focus on disputes against that background. For an analysis of the legal basis of title and conversion claims see section 5.1, 'Title and ownership'.

In practice, when faced with competing claims of ownership over an artwork, what are the key issues to bear in mind?

15.3.1 Commercial considerations for sellers

Leaving aside for a moment the legal questions, the existence of a dispute over ownership raises a practical problem for anyone seeking to sell the artwork which is the subject of the ownership claim by a third party. That practical problem is that buyers of artworks – and indeed any other object – expect, as a minimum, to be able to enjoy the artwork without interference or claims from third parties. In other words, they want to acquire artworks without fear of any claims – whether justified or otherwise – on the artwork by third parties. Therefore, unless the owner is able to successfully challenge the ownership claim, potential buyers of the artwork may well be put off buying the artwork. Faced with that commercial reality, if the owner of the work wants to sell the artwork he or she will either have to eliminate the claim – usually through the courts – or reach a negotiated settlement with the claimant. In many cases, even where the competing claim is of dubious merit, the owner will prefer to seek a negotiated settlement rather than incur the uncertainty, delay and cost of legal proceedings. It is fair to say that this commercial reality is one which claimants are aware of, and on occasion use to their advantage. Of course, if the owner is happy to keep the artwork and not inclined to sell it, these considerations are of less importance.

15.3.2 Burden of proof of ownership

It is generally for the person who is challenging the owner's ownership of the artwork to prove that he or she has better title than the owner. This needs to be done by reference to evidence such as records or documents. It is not for the owner to prove that he is the lawful owner, as there is a presumption that if he is in possession of the artwork, he is the lawful owner. However, if the person making the claim is able to raise sufficient evidence to cast doubt on the owner's claim to title, then the burden of proof will fall back on the owner. The owner will then be required to provide some evidence, in the form of records or documents, to refute the evidence of the claimant.

However, the standard of evidence required to displace the presumption that the possessor is not the lawful owner should not be underestimated. *Hilden Developments Limited v Phillips Auctioneers and Ors*[8] related to a painting by Damien Hirst consigned to Phillips by the collector Robert Tibbles. Robert Tibbles' position was that he had bought the painting from White Cube in 1998 and that it had been in his possession ever since. The claimant, an offshore company controlled by Tibbles' family members, challenged the consignor's ownership, principally on the basis of a White Cube invoice addressed to the claimant, Hilden Developments. The claimant argued that this invoice amounted to con-

[8] 2022 EWHC 54 (QB).

clusive evidence of ownership, and indeed had repeatedly demanded that Phillips hand over the painting to Hilden Developments on the basis of this document. Phillips declined to do so, taking the position that the ownership of the painting was a matter for the court to determine on the basis of all the evidence. This proved to be the correct approach as, having heard the witnesses and examined the surrounding facts, the court found in favour of Robert Tibbles. It found that the painting had indeed been purchased by Robert Tibbles, despite the invoice being addressed, on Robert Tibbles' instructions, to Hilden Developments and despite the purchase being partly financed by a loan from Robert's father which the court believed was subsequently repaid. While the case turned on the particular facts of the case and the testimony of the witnesses, it provides a useful reminder that the presumption of ownership in favour of the possessor is not easily displaced.

15.3.3 Consequences of a claim where artwork is in the agent's hands

Ownership claims often emerge when artworks appear on public view, such as in auctions or exhibitions. In those circumstances the artwork is often in the hands of the owner's agent rather than the owner. The owner's reaction to such claims is often to instruct the agent to immediately return the artwork. It is open to the agent to agree to do this but he or she should be aware that in doing so he or she may be exposing him or herself to a claim for damages in conversion, should it subsequently transpire that the third party claim was in fact justified. Agents therefore tend to be cautious and will usually refuse a request by the owner to return an artwork which is the subject of a claim. (Similarly, agents are reluctant to agree to requests – as in the Hilden case above – by third party claimants to deliver up claimed artworks). This is intended to ensure that the agent does not become a party to the dispute. To ensure that there can be no question of the agent's right to retain the artwork in such circumstances, agents will frequently include a clause in their agreement with the owner that in the event of a third party claim the agent shall be entitled to retain the artwork for a reasonable period to allow the parties time to resolve the dispute.

Owners may also insist that the agent continue with the sale of the artwork, arguing that the third party claim is without merit. If the agent is sufficiently confident that the claim has no merit, it is open to the agent to continue with the sale. However, just as with the release of the artwork back to the owner, the agent should be aware that in doing so he or she may be exposing him or herself to a claim for damages in conversion, should it subsequently transpire that the third party claim was justified. The buyer may also be unhappy to discover that he has bought an artwork which is the subject of a claim, and seek to cancel the sale. To avoid the agent being placed in a difficult position, the agreement between the owner and the seller therefore usually provides that in the event of a title claim the

agent is entitled to withdraw the property from sale or, if the sale has already taken place, to cancel the sale.

15.3.4 The commercial consequences of a claim

An ownership claim can have a very negative effect on the value of the artwork. This is particularly the case where high-profile auctions are concerned. High profile lots which are fresh to the art market can generate greater interest from bidders. Conversely, a lot which is withdrawn from sale and then reentered at a later date runs the risk of fetching a lower price than it might otherwise have done. This is known as a lot being 'burnt'. Just as bidders value freshness to the market, they are likely to be sceptical about any lot which has had to be abruptly withdrawn from sale and is now being put up for sale again. This can be because they are concerned that the lot may have authenticity, condition or legal issues. In the case of high value lots the agent will also have invested time and money in marketing the lot for sale. Those costs can sometimes be very significant. It is not unusual for important artworks sold on the international art market to be shipped for exhibition to London, New York, Hong Kong and Russia prior to the sale. For this reason, withdrawal from sale is a step that the auction house and the seller will want to avoid. Such a withdrawal involves real costs and, of course, loss of credibility for the agent. Claimants are acutely aware of that concern and in some cases will seek to use it to their advantage.

15.3.5 Timing of the claim

With this in mind, where auctions are concerned, there is undoubtedly a temptation for claimants to signal their claim as close as possible to the auction date. The thinking behind such tactics is to place the owner and the agent in a difficult position. Because time does not permit a detailed analysis of the claim, the owner has a choice: either reach a financial settlement with the claimant or face having to withdraw the lot from sale rather than risk it being unsold due to bidders being put off by the claim. The 'eleventh hour claim' tactic can, however, backfire. A last minute notification forces the auction house and the owner to make a snap judgement over the seriousness of the claim. That may end in the decision to withdraw the lot, but it may just as easily end in the decision to press ahead with the sale. Courts also tend to be unsympathetic to – and may even penalise – claimants who do not put forward their claims at the first opportunity. The advice to claimants is therefore to notify the owner of a claim as soon as possible. Delay in making the claim is unfair to the owner and may also prejudice the claimant's case.

15.3.6 Slander of goods and title

As indicated above, claimants should also be aware that putting forward a claim which the claimant knows to be false or is unable to justify in order to disrupt the

sale of an artwork or force the owner to the negotiating table can lead to a claim by the owner for damages for slander of title or goods. A claim for slander of title or goods lies against anyone who maliciously and falsely disparages the title of the owner of personal property, causing special damage to the owner. Disparagement means making an allegation that the owner is not the owner or has limited ownership rights, and/or that the owner has no right or a limited right to sell or deal with the property.

15.3.7 Settlement options

Where the claimant's interest is in the financial value of the artwork rather than the return of the artwork itself, an effective and frequently used device for negotiated settlements over title claims is a tripartite agreement between the claimant, the owner and the agent that the sale of the artwork may go ahead, with good title being passed to the buyer – but with either (i) the proceeds of sale being divided between the claimant and the owner in agreed proportions, or (ii) the proceeds of sale being retained by the agent pending resolution of the dispute between the claimant and the owner.

15.4 Authenticity disputes

Authenticity disputes are the type of dispute which usually spring to mind first when thinking about art disputes. While authenticity disputes are less common than disputes over title, they retain a high profile. Perhaps this is in part due to media interest. The story of a discovery of a valuable artwork bought for very little money carries the same excitement value as the story of a lottery win. Equally, the purchase of an expensive work which turns out to be worthless carries a similar level of outrage value. Whatever the reason, authenticity disputes are an ever present risk in the art world. This is because art has always been imitated and copied – sometimes out of homage and sometimes with more base motives. The passage of time has also made the correct identification of the authorship of works more difficult, which is why authenticity disputes are more prevalent in the field of Old Master paintings. The waters are further muddied in this field by the establishment of schools of pupils whose function it was to emulate or complete the work of the master. Contemporary artists are not immune from such disputes either.

Where there is a forgery or a misattribution of an artwork there is often someone who has lost money as a result. In the case of an unrecognised masterpiece acquired for very little (known as a 'sleeper'), the seller will lose out. In the case of the masterpiece purchased at full price and then discovered to not be by the hand

of the master, the buyer will lose out. In either case the victim is likely to seek redress.

15.4.1 Forgery and misattribution

To begin with, it is important to understand the difference between a forgery and a misattribution. A forgery is an artwork which has been created with the deliberate intention of deceiving as to its age, its origin or its authorship. A misattribution, on the other hand, is a work whose age, origin or authorship has been incorrectly identified. This distinction is important because contractual guarantees of authenticity in art sales are sometimes limited to forgeries rather than misattributions.

15.4.2 Claims by buyers of inauthentic or misattributed artworks

It is common today in commercial art transactions for art to be sold with the benefit of an authenticity guarantee. In the event of an authenticity dispute, therefore, the contract of sale is the starting point for the buyer. Does the contract contain a provision which gives the buyer a money back guarantee in the event that it turns out that the artwork he or she has bought turns out not to be by the artist it has been ascribed to in the contract? Such guarantees provide a great deal of peace of mind for buyers but they are nonetheless often subject to limits and conditions. As we saw in section 3.2, 'The auction house and the buyer', auction houses and dealers will frequently provide such guarantees in their terms and conditions of sale. Typically, however, in order to be able to rely on the guarantee, the buyer will need to notify the auction house in writing of the misattribution or forgery within a limited time period after the sale – typically five years. Most terms and conditions will place the onus on the buyer to demonstrate to the auction house's satisfaction that the artwork was indeed misattributed or is a forgery. This may not be straightforward in the absence of conclusive scientific proof. In such cases, one way of addressing this requirement is to find multiple experts who agree that the work is not authentic or a single third party expert who is acceptable both to the auction house and to the buyer. However, even if evidence is provided that the artwork has been misattributed, the terms and conditions will often provide that the guarantee will only come into play if the description in the sale contract or auction catalogue was out of line with the state of scholarship and opinion at the time of the sale. What this means in practice is that a refund is not payable unless the opinion of the auction house or dealer at the time of the sale was at odds with the opinion of art world experts at the time of the sale. Such a provision ensures that the dealer or auction house is responsible only for ensuring that its opinions are in line with the state of scholarship at the time of the sale. It will not, however, underwrite subsequent changes in scholarship. The artwork must also usually be returned to the auction house or dealer in the same condition, unrestored and undamaged, as it was at the time of the purchase. As we saw in section 3.2, the thinking behind this requirement is that the cancellation of the sale must place all

parties back in the same position they were in prior to the sale. The buyer obtains a refund of the purchase price but the seller is also reunited with the returned artwork in the same condition as it was before it was sold. This requirement can present difficulties for the buyer where the misattribution or forgery has been discovered as a result of an invasive scientific test or as a result of cleaning or restoration, all of which may invalidate the guarantee. Finally, such guarantees are usually personal to the buyer. He or she must, at all times since the sale, have remained the owner of the artwork. The guarantee is not assignable to anyone who subsequently purchases or acquires the artwork.

If the buyer is unable to satisfy the requirements of the authenticity guarantee, what other options are available? In some circumstances it may be that the buyer could have a claim under the Sale of Goods Act 1979 (s 13(1)) and the Sale of Goods and Services Act 1994 (s 3(2)), which imply a term that the artwork will correspond with the description in the sale contract. However, the term will only be implied in the absence of a contrary intention in the contract. The contract will often include terms which provide such a contrary intention. They may, for instance, limit or exclude the extent to which the description can be relied upon by the buyer, stating that no warranty is given by the auction house in relation to any statement made to the buyer about the lot other than as set out in the authenticity warranty. Finally, the buyer may wish to consider a claim in misrepresentation under s 2(1) of the Misrepresentation Act 1967, which provides:

> Where a person has entered into a contract after a misrepresentation has been made to him by another party thereto and as a result thereof he has suffered loss, then, if the person making the misrepresentation would be liable to damages in respect thereof had the misrepresentation been made fraudulently, that person shall be so liable notwithstanding that the misrepresentation was not made fraudulently, unless he proves that he had reasonable ground to believe and did believe up to the time the contract was made the facts represented were true.

A buyer may seek to allege that a misrepresentation was made in the sale contract or auction catalogue and that he or she relied upon that misrepresentation in purchasing the artwork. The seller and/or the seller's agent will however be able to avoid liability if they are able to prove that they had reasonable grounds to describe the artwork in the terms they did, believing the description to be true and not having formed that view carelessly. A further difficulty with a misrepresentation claim will also arise where the terms and conditions of sale include language which excludes or limits claims for misrepresentation. The courts will give effect to such provisions provided they satisfy the requirements of reasonableness (Misrepresentation Act 1967, s 3).

15.4.3 Claims by sellers of underattributed artworks

Where the seller has him or herself sold a work to a buyer without recognising its true value, the most obvious remedy will be to seek to void the contract on grounds of mistake. As we saw in section 5.2.2, 'Overattribution', the law of mistake in common law and equity will operate to void contracts where they are based on a mistake made by both parties to the contract on the existence of the subject matter of the contract or a sufficiently serious aspect of its quality. The doctrine of mistake is, however, intended to cover situations where the object itself, not the qualities of the object, is the subject of an error. Because the qualities of the object – its authorship, age and condition – are usually covered in the contract, the courts are very reluctant to intervene to override the contractual intentions and commitments of the parties. In Leaf v International Galleries,[9] the purchaser of a painting entitled Cathedral of Salisbury by John Constable (1776–1837) sought rescission of the sale contract for mistake on the grounds that the work was a forgery. Denning LJ confirmed that rescission for mistake was not available in such circumstances as the mistake related to the quality of the object rather than the object itself. Both parties wrongly believed the work to be by Constable. Denning LJ accepted that this was an essential and fundamental mistake. However, there was no mistake about the subject matter itself. This was a sale of a specific painting, Cathedral of Salisbury. The parties were agreed about the subject of the contract and the terms of its sale. That was sufficient to constitute a binding contract with which the court would not interfere. Where only the seller, rather than both the buyer and the seller, has been under a misapprehension, there are also no grounds for avoiding the contract, even where the buyer knew of the seller's mistake (Smith v Hughes (1871) LR 6 QB 597 at 607 per Blackburn). The only exception to this is where the buyer has actively misled the mistaken seller. In such case, a failure to disabuse the seller could amount to equitable fraud.

More options may be open to the seller where he or she is represented by an agent such as a dealer or an auction house who has expressed a view on attribution. There is an implied duty of care and skill owned by the agent to the seller (Supply of Goods and Services Act 1982, s 13). The seller is entitled to expect that the agent will not act negligently. An agent who negligently fails to identify an artwork as a valuable work may be liable to his or her principal for any loss caused to the principal as a result. The loss will usually be the difference between what it was sold for and its value had it been correctly described. The case of Thwaytes v Sotheby's [2015] 1 All ER 423 sets out in some detail the standard of care to be expected of an international auction house in the field of attribution and authentication. Rose J found that:

[9] [1950] 2 KB 86.

(i) 'Those who consign their works to a leading auction house can expect that the painting will be assessed by highly qualified people – qualified in terms of their knowledge of art history; their familiarity with the styles and oeuvres of different artists; and in terms of their connoisseur's "eye".'

(ii) 'A leading auction house must give the work consigned to it a proper examination devoting enough time to it to arrive at a firm view where that is possible.'

(iii) 'It would be much more difficult for a leading auction house to rely on the poor condition of a painting as a reason for failing to notice its potential.'

(iv) 'An art expert must know his or her own limitations and when to bring in a third party expert would apply as much to Sotheby's as to a provincial auction house albeit, of course, that the bar for where that threshold is crossed is set at a much higher level in Sotheby's case [than in that of a regional auction house].'

However, in the Thwaytes v Sotheby's case Rose J made a clear distinction between the duties of care owed by a provincial auction house and by an international auction house. Equally, the same distinction could be made between the duties of an international art dealer and a sole practitioner dealer. Regard must be had to the resources available to the agent and his or her knowledge of the field. The fact that a work had not been correctly identified by the agent does not necessarily mean that the agent has been negligent: the critical issue for any art specialist reviewing a work of art is to make appropriate use of the resources available to him or her – both external and internal – and to act upon any signs which could raise questions about his or her assessment of the work. In the Thwaytes v Sotheby's case Rose J concluded that Sotheby's was not negligent, on the basis that:

(i) 'They were entitled to rely on the connoisseurship and expertise of their specialists in the OMP [Old Master Paintings] Department in assessing the quality of the Painting.'

(ii) 'Those specialists were highly qualified and examined the Painting thoroughly.'

(iii) 'They reasonably came to the view on the basis of what they saw that the quality of the Painting was not sufficiently high to indicate that it might be by Caravaggio.'

(iv) 'There were no features of the Painting visible … (whether under ordinary or ultraviolet light) that should have put Sotheby's on notice that the Painting had Caravaggio features or non-copy features that should cause them to question their assessment based on quality.'

(v) 'Sotheby's was entitled to rely on its specialists to examine the X-rays of the Painting to see if they provided any information which caused them to doubt their assessment of the Painting and those specialists reasonably came to the view that there was nothing in the X-rays that should cause them to question their assessment based on quality.'

(vi) 'Sotheby's were not under any obligation either to carry out infrared analysis of the Painting or to advise Mr Thwaytes to arrange for that to be carried out. If they had carried out infrared analysis they would not have found anything in the infrared images that should cause them to question their assessment of the Painting.'

(vii) 'Sotheby's were not negligent in failing to inform Mr Thwaytes about the [unusual] interest in the Painting ... [and if] they had informed him, I find that he would not have withdrawn the Painting from sale since he would have been informed that all the Sotheby's experts were certain that the Painting was a period copy and not by Caravaggio.'

The themes emerging from the Thwaytes v Sotheby's case which are relevant to claims by sellers in relation to 'sleepers' are therefore:

• The agent should satisfy him or herself that he or the person considering the work is appropriately qualified to do so.

• Consideration should be given by the agent to the limitations of his or her expertise. Are there signs apparent in an examination of the artwork or its history, which might suggest the possibility that the work is by the hand of a famous artist? Is there an acknowledged external source of expertise on the artist? Should the advice of one or more external scholars be sought?

• The level of research and testing carried out into the artwork should be commensurate with its potential. But in all cases the examination of the work should be carried out with appropriate care and in the correct conditions.

15.5 Condition disputes

Many artworks offered for sale are by their nature not in pristine condition. They are often old, have changed hands many times, have travelled great distances and have been kept in a variety of conditions. In addition, many will have been restored, repaired or altered. All of these factors will affect the condition of the artwork, and therefore often its value. As a result, a key concern for buyers of artworks is that the condition of the work should be acceptable. Often a simple physical inspection of the artwork will suffice, but in many cases damage to the artwork becomes apparent only on a more detailed inspection – sometimes necessitating specialist techniques, knowledge or equipment.

The need for such an inspection is greatest where auctions are concerned. Artworks are usually displayed for inspection only shortly before the sale and most auction houses include in their terms of business an express disclaimer of liability for defects in the condition of the artworks sold. While auction houses will guarantee the authenticity of the works they sell, they will usually not guarantee the condition of the works. This is because condition issues can often only be

discovered through invasive tests and are often not apparent on a simple physical examination. Christie's terms are typical:

> Prospective buyers are strongly advised to examine personally any property in which they are interested, before the auction takes place. Condition reports are usually available on request. Neither Christie's nor the seller provides any guarantee in relation to the nature of the property apart from the Limited [Authenticity] Warranty ... The property is otherwise sold 'as is' ... Buyers are responsible for satisfying themselves concerning the condition of the property and the matters referred to in the catalogue entry.

Auction houses will, on request, usually provide potential bidders with a 'condition report'. This is a short document listing any obvious or known issues affecting the condition of the artwork. However, such condition reports are usually accompanied by heavy disclaimers reminding that bidder that they must satisfy themselves of the condition of any lots upon which they intend to bid.

Disputes over the condition of artworks purchased are common. Usually, the condition defects are revealed when the successful bidder sends his new purchase to the restorer for cleaning or repair. Such work can reveal hidden defects. In such circumstances the buyer of the work may, depending on the severity of the issue, seek to cancel the sale, recover the costs of repair or obtain compensation for diminution in value due to the condition issue. Auction houses will, however, seek to rely upon the exclusions of liability in their conditions of sale.

15.6 Saleroom disputes

The speed with which sales by auctions move, the reliance upon the personal interaction between bidders and the auctioneer, the variety of sources of bids and the tactics employed by bidders make saleroom disputes a not uncommon occurrence.

A good auctioneer will make the process of auctioneering seem straightforward. The reality, however, is that there can be few more taxing roles. The auctioneer's job is to generate excitement and momentum in the room. To do this, he or she needs to anticipate exactly where in the room the bids are likely to come from, recognise the often subtle gestures of bidders, decide which bids to accept first, move swiftly from bid to bid and know at what point in the bidding he or she is permitted to sell the artwork. A lapse in concentration or a misunderstanding can interrupt momentum and quickly deflate a sale. To cover this possibility, most auction houses include a provision in their terms and conditions which give the auctioneer discretion to accept or reject bids, to determine who the winning bidder is and to reopen the bidding even after the fall of the hammer. That discre-

tion must be reasonably exercised but beyond that is unfettered. This will cover the most common disputes, some of which are listed in what follows.

15.6.1 Missed bids

It is rare that the auctioneer fails to notice a bidder. The auctioneer is usually assisted by a spotter, the auctioneer's clerk, who sits next to him scanning the room for bids. If the auctioneer or clerk is unaware of a bidder, auction house staff in the auction room may also shout 'Bidding Sir!' while pointing at the bidder. However, a missed bid can happen where the bidder waits to place a bid until the last moment before the hammer falls. In such cases the hammer can fall without the auctioneer noticing the bid. In these circumstances the auctioneer has the discretion to reopen the bidding and take the bid, or he or she can refuse the bid. Whichever option is chosen, someone is going to be disappointed. If the bidding is not reopened, the bidder whose bid has been missed will be unhappy at losing a chance to win the lot. If it is reopened, the bidder to whom the lot was sold will be unhappy at having had his purchase cancelled and having to bid more in order to acquire the artwork. The more time has elapsed since the fall of the hammer, the more awkward the position becomes. While many auctioneers' terms and conditions allow the auctioneer discretion to reopen the bidding at any point, even later in the sale, the exercise of that discretion to reopen the bidding may – depending on the circumstances – become more difficult to justify once the auction has moved on to the next lot.

While it is a rare occurrence, the legal status of a missed bid is of interest. The question was considered in the case of Richard v Phillips.[10] In that case the auctioneer was unaware of any of the bids made by one of the bidders, Mr A, who was bidding in a particularly languid way. The missed bids had however been seen by the auctioneer's clerk and so, despite the lot having been knocked down to Mr B, the auctioneer took the decision to reopen the bidding. This was on the grounds that the terms and conditions of the auction provided that the bidding could be reopened 'if any dispute arises respecting a bid'. The bidding for the lot was reopened and Mr B was again the successful bidder, but this time at a higher hammer price. Mr B therefore sued for the difference between the higher and lower hammer price, claiming that because Mr A's bids had not been brought to the auctioneer's attention they were not effective as bids. It followed, Mr B argued, that in the absence of a bid there was no 'dispute over a bid' – and therefore the auctioneer had no right to reopen the bidding. The court held that Mr A's bids had in fact been communicated because the auctioneer's clerk had been aware of them, and that there was therefore a dispute over a bid which entitled the auctioneer

[10] [1969] 1Ch. 39 CA.

to reopen the bidding. However, the Court of Appeal also endorsed the point of principle made by the first instance judge, who said:

> It is competent for a bidder to make his bids by signals but he can only make an effective bid by communicating it to the auctioneer, and if his signal fails to register through no fault of the auctioneer's he has, I think, simply failed to make a bid in any relevant sense.[11]

The case therefore helps to clarify two points in relation to missed bids. First, a bid that is not communicated to the auctioneer is not a bid at all. Second, a bid that is missed by the auctioneer but spotted by the auctioneer's clerk is deemed to be a bid communicated to the auctioneer.

A separate, and unfortunately regular, source of disputes revolves around written or telephone bids which fail to be communicated to the auctioneer. This can be because the auction house is unsuccessful in contacting the telephone bidder, because the telephone line drops in the middle of the bidding, because written bids are not recorded due to an administrative error or because the telephone bidder is too slow in making up his or her mind whether or not to bid. The legal position, as we have seen from Richard v Phillips, is that in these circumstances the bidder is not deemed to have made an effective bid. However, in all of these cases the bidder is understandably upset at having lost the opportunity to bid and may seek to argue that the auction house is responsible for his or her lost opportunity. The legal question in such cases is usually addressed in the terms and conditions of sale of the auction house, which typically include provisions which exclude liability on the part of the auction house for failing to execute written bids or errors in connection with telephone bidding.

15.6.2 Nonbidders

Just as the auctioneer can occasionally miss bids, so too can the auctioneer misconstrue a gesture as a bid. (A Christie's auctioneer was reputed to have once mistakenly taken bids from a statue with a raised arm at a packed Christie's house sale.) In such circumstances, the auctioneer will hopefully identify the error before the hammer is brought down and, exercising his or her auctioneer's discretion, reopen the bidding at the last 'real' bid. The position is more difficult where the hammer has been brought down and the error is identified at a later stage. In such circumstances the auctioneer may opt to insist on the validity of the sale, but a determined refusal by the buyer to pay presents a practical problem. In most such circumstances – while it is under no duty to do so – the auctioneer will opt to pay out the seller from its own pocket, cancel the sale to the buyer and reoffer the lot in the hope that it can recoup its losses.

[11] [1967] All ER 876 at 881.

Another very unusual, but problematic, issue surrounds the successful bidder who seeks to argue that he or she is not responsible for his or her bids on grounds of insanity. In such cases, to be successful the bidder must prove his or her mental incapacity by reference to medical evidence and – crucially – demonstrate that the auctioneer was or should reasonably have known of the incapacity of the bidder.[12]

Equally, auction houses must take care to vet bidders as, where a successful bidder is under the age of 18, the sale contract, unless it is for necessaries – such as clothing or food – is voidable at the option of the minor.

15.6.3 Bidding sequences

Given the variety of bidding methods auctioneers have had to develop a system of priorities to avoid confusion. While it is a matter for the auctioneer, it is common to start with written or 'absentee' bids, then take bids from bidders in the saleroom, then take telephone bids and finally online bidders.

15.6.4 Refusal to accept bids

Most auctioneers' conditions of sale will include a right in the auctioneer's absolute discretion to accept or reject bids. This becomes an issue in two situations. The first is where the auctioneer is concerned about the ability or willingness of the bidder to make payment. This is a big decision by the auctioneer, as a refusal in a public auction to accept a bid from a bidder is very likely to damage the commercial relationship between the auction house and the bidder. The second is where the bidder does not accept the auctioneer's invitation to bid at the next natural increment, offering instead to bid at a lower amount. This is known as 'splitting the bid' – a practice which is generally frowned upon by auctioneers as it can slow down the progress and rhythm of the bidding. In these circumstances the auctioneer will assess whether accepting the split bid is likely to progress the bidding or whether it will be detrimental to the momentum of the bidding. Usually split bids are more likely to be accepted at the upper end of the bidding.

15.7 Payment disputes

The sale of artwork is no different from the sale of any other object in that the seller will be concerned to receive payment in full. Some of the common strategies to ensure that full payment is received follow.

12 Molton v Camroux 1948 2 Exch 487.

15.7.1 Passing of title on payment in full

The parties to a sale are free to decide in their contract when ownership in the artwork will pass to the buyer. Unless there are compelling reasons to do otherwise, prudent sellers will usually include a provision in the sale agreement that ownership will not pass to the buyer until payment in full cleared funds has been received by the seller.

15.7.2 Retaining possession of the artwork

In most circumstances, the best way for the seller to protect his or her position against nonpayment is by retaining the artwork until payment in full has been received. However, even with this approach there is a drawback. A sale price agreed at auction or private sale may not be achievable again if another buyer cannot be found at the same price level once the original buyer has dropped out. In those circumstances the seller will still have the artwork but the artwork will have suffered a loss in value as a result of the buyer's failure to pay. It is of course open to the seller in such a situation to sue the defaulting buyer for any such loss, but that requires the extent of the loss to be quantified – and this can only be reliably done if the artwork has been successfully resold to another buyer.

15.7.3 Securing a deposit or part payment

It is common practice in the art market to permit buyers to make payment in instalments. Some such arrangements will provide that the seller will retain the artwork until payment in full has been received. Others will permit the buyer to take possession of the artwork upon part payment. The latter arrangement will require, to some degree, a leap of faith on the part of the seller, who will need to consider what his or her options are – whether or not he or she has parted with possession of the artwork – if the balance due is not then received.

The parties need to address what happens to any part payments or deposits which have been made if the buyer fails to pay in full. Sellers often assume that in the event of nonpayment they can simply retain any part payment. That may be correct if the sale agreement gives them that right by specifically stating that any part payment can be retained. But in the absence of such a provision, the seller can only justify retaining part payments to the extent of the loss suffered as a result of the buyer's nonpayment. Usually the loss will be the difference between the sale price agreed with the defaulting buyer and the sale price the seller is able to agree with a new buyer plus interest.

As we have seen above, in principle the parties are free to provide in the contract for the seller to be entitled to retain any part payment in the event of nonpayment by the buyer. However, that is subject to an important qualification. Such clauses,

known as liquidated damages clauses, are enforceable under United Kingdom law only to the extent that they are proportionate to the innocent party's legitimate interest in enforcing the defaulting party's obligations under the contract (Cavendish Square Holding BV v Talal El Makdessi; Parkingeye Limited v Beavis).[13]

Example

- If the sale price for a painting is £10,000 and the deposit paid by the buyer is £7,000, a clause allowing the seller to keep the painting and the £7,000 in the event of late or nonpayment of the second instalment of £3,000 is in danger of being unenforceable. This is because in ordinary circumstances the seller's loss due to cancellation of the sale is very unlikely to be 70% of the value of the painting. It could be argued that a provision is out of proportion to the innocent party's legitimate interest in enforcing the defaulting party's obligations under the contract, and therefore unenforceable. The seller's loss is likely to be the difference between the £10,000 and the price he is able to obtain if he sells the painting to a different buyer, plus any wasted costs of the cancelled sale plus interest. With that in mind, a clause providing for retention of, say, 20% of the value of the painting is more likely to be enforceable.

Where the artwork is released to the buyer upon part payment or payment of a deposit, the agreement should also state that ownership in the artwork will not pass to the buyer until payment in full. It should also provide that until that time the buyer will hold to the order of the seller, will retain possession of it and will not sell the work, advertise it for sale or mortgage or charge it.

Care should also be taken to ensure that if the artwork is released to the buyer prior to payment in full, the buyer agrees to insure it for the sale price and, if possible, that the seller is named as a payee on the insurance policy.

15.7.4 Interest

Any sale contract should include a provision for interest to be payable on any sums which are due and unpaid. The interest rate should be sufficiently high to provide a positive incentive to the buyer to make payment on time.

[13] [2015] UKSC 67.

15.7.5 Legal proceedings

Ultimately, if the buyer refuses to make payment, it is open to the seller to sue for damages for breach of contact. However, before going down this avenue the seller should give thought to some key questions.

First, is there any easier way to rectify the situation? For instance, can the first sale be cancelled and the artwork sold to another buyer? If it is sold at the same or a higher price, the seller's losses as a result of the cancelled first sale will be covered. Even if it is sold to the second buyer for less than the original sale price, the seller's losses will be limited to the difference between the two prices and can form the basis of a claim for damages against the first buyer.

Second, are the costs of pursuing the claim likely to outweigh the amount claimed? The fee for issuing proceedings in the High Court is 5% of the amount of the claim for claims between £10,000 and £200,000, and a fixed fee of £10,000 for claims in excess of £200,000. Depending on the amount of the claim, fees for issuing proceedings in the County Court vary between around £200 and £2,500. In addition, the claimant will incur the often substantial costs of legal representation. These costs will be recoverable, if he or she is successful, from the claimant in High Court proceedings. In the County Court, however, such costs may not be recoverable or may be limited in small claims or fast track cases.

Third, is there a way, short of issuing court proceedings, that the debt can be recovered from the buyer? One method, for instance, is through the use of a statutory demand. A statutory demand is a formal written demand, in a specified form, served on the debtor for payment of a debt within 21 days. The purpose of the demand is to establish that the debtor is insolvent and unable to pay his debts. Failure to pay the debt within 21 days entitles the creditor to commence bankruptcy or insolvency proceedings. This method is far cheaper than court proceedings and places immediate pressure on the debtor to pay. However, it is only appropriate where there is no defence to the claim. If the debtor is able to show that there is a genuine dispute or defence to the claim, he will be able to set aside the statutory demand.

Finally, what is the likelihood of successful enforcement against the debtor if the legal proceedings are successful and result in a judgment against the debt? Is the debtor likely to be able to pay? Does he or she have assets in the United Kingdom jurisdiction which can be seized to enforce the judgment? A judgment obtained against a defendant who is unable to pay is of questionable value.

If, having considered these issues, the seller believes that it is worthwhile pursuing the defaulting buyer in court he or she can issue proceedings claiming damages for breach of contract. While this court process is broadly outlined in section 15.1,

'Disputes and court proceedings', when discussing strategy for debt recovery it is worth considering the process of summary judgment.

Summary judgment is a process in which, at an early stage in the process, the claimant can seek to obtain an expedited decision from the court on the grounds that the defendant has no defence to the claim, or has a defence which has no real prospect of success at trial. This is particularly useful in claims for debts where the defendant is refusing to pay without legal justification. However, while summary judgment applications are an attractive option for claimants seeking a quick resolution of the issue, they are not without risk. First, the preparation of a summary judgment application involves a great deal of work – and, therefore, cost. This is because the application for summary judgment must be supported by detailed evidence and legal argument. Second, to defeat a summary judgment application the defendant need only show that he or she has an arguable defence. He or she need not show that the defence will succeed or is likely to succeed – merely that it is arguable. A summary judgment application may also be refused where the disputed issues of fact can only be determined at a full trial, or because the case is complex and the defendant needs more time to investigate the position. Third, the cost consequences of a rejected application for summary judgment can be serious for the claimant, who may be required to pay not only his or her costs of the application, but also those of the defendant. A successful summary judgment application, however, will provide the claimant with an enforceable judgment against the defendant at a far earlier stage than if the claim had gone to trial, saving both cost and time.

In most circumstances, despite the fact that the contract of sale is between the buyer and the seller, where legal action is taken against a defaulting buyer the plaintiff is the auction house. This is because the case of Chelmsford Auctions Ltd v Poole [1973] 1 QB 542 decided that auctioneers can sue a purchaser in their own name, not merely for the amount of their commission and other charges but for the whole of the purchase price. However, in Fordham and another v Christie, Manson & Woods Ltd,[14] it was established that there is no obligation on auctioneers to sue. Most agency agreements between the seller and the auction house also make it clear that the auction house is not under any such obligation, and indeed has complete discretion as to whether or how to pursue defaulting buyers. In circumstances where the auctioneer declines to take action it remains open, however, to the seller to take legal action against the buyer. The difficulty is that because of the auction house's duty of confidentiality, the seller will not know the identity of the buyer. In such circumstances the auction house will often voluntarily disclose the name and address of the defaulting buyer to the seller. The justification for doing so is that the buyer is in breach and therefore cannot rely on the auctioneer's

14 [1977] 2 EGLR 9.

duty of confidentiality to protect him or her from the consequences of the breach. However, if the auction house refuses to voluntarily disclose the name and address of the buyer it is open to the seller to apply to the court for preaction discovery, compelling the auction house to reveal the buyer's name and address. Such an action is based on the rule that a claimant may seek preaction disclosure against a person where he lacks the information necessary to commence an action.[15]

15.7.6 Publicity

The power of negative publicity is often underestimated. When Christie's and Sotheby's sales in Hong Kong first began to attract wealthy bidders from mainland China, there was a concern that it would be difficult to pursue bidders who failed to pay. This was due to the fact that many bidders were new bidders, unknown to the auction houses, and also to worries over navigating the unfamiliar Chinese legal system in order to enforce any court judgment. It was quickly apparent, however, that these bidders were often far more concerned about negative publicity and any suggestion of impecuniosity than about court proceedings. As a result, the auction houses took the unusual step of issuing a press release when they issued proceedings against nonpayers. This proved to be an extremely effective means of recovering payment.

15.8 Alternative dispute resolution

Alternative dispute resolution (ADR) is a generic term applied to the many different mechanisms available to parties to settle their dispute outside of the courtroom. In the United Kingdom the courts have sought to actively encourage these methods as an alternative to litigation, to the point where the parties will, by the time they reach trial, be required to demonstrate that they have made serious efforts to resolve the dispute by alternative dispute resolution.

Alternative dispute resolution can take whatever form the parties agree upon. There is no prescribed format. Some forms of ADR are designed to explore compromise financial settlement solutions in which both parties offer concessions without necessarily digging deeply into the relative merits of each party's position. This is a form of settlement negotiation. Others are designed, to a greater or lesser extent, to address the merits of each party's case. This is not a negotiation, but a form of minitrial. What all formats have in common is that they are designed to offer an alternative to the cost and publicity of a court trial. Some of the most commonly used formats are set out in what follows.

[15] Senior Courts Act 1981, s 33(2); CPR, r 31.15.

15.8.1 Mediation

Mediation is a process by which the parties invite a mutually agreed neutral third party to explore and facilitate negotiations between the parties. Typically, the parties will spend a day or more in the same building, but in different rooms, with the mediator shuttling between the rooms. The mediator's role is to act as a facilitator to get each side to realistically evaluate the strengths and weaknesses of their respective cases and to guide them towards settlement. This is by far the most common form of alternative dispute resolution.

15.8.2 Early neutral evaluation (ENE)

ENE is a process where a neutral third party with expertise in the field is asked by the parties to evaluate the parties' cases and offer an expert view on all the issues or certain of the issues in dispute. Unlike in mediation, the third party is taking a position and offers a view, but the view is not binding. The expert view simply serves to narrow the issues in dispute and will form the basis for a subsequent negotiation.

15.8.3 Expert determination

An expert determination is a means of ADR in which an expert is invited to consider the technical and legal issues in dispute and make a binding decision, like a judge. The parties agree in advance that the expert's decision will be enforceable between them.

15.8.4 Arbitration

Arbitration is best described as a form of private judicial process. The parties to the dispute agree to submit their dispute to one or more mutually agreed arbitrators, who make a binding decision on the dispute as an alternative to court proceedings. The form the arbitration shall take is a matter for agreement between the parties; however, arbitrations usually involve a detailed consideration of the merits of the case. Their key advantage over court proceedings is confidentiality, together with a more bespoke and streamlined process.

Where the art industry is concerned, there is a major advantage to using ADR over court proceedings. The practices and commercial operations of the art industry are often extremely unusual. For instance, the considerations around issues as complex as Holocaust restitution, authenticity and title claims to antiquities are not of a type with which the courts regularly find themselves confronted. This is not in any way to question the professionalism and judgement of judges, who are experienced in bringing themselves up to speed on issues with which they were not previously familiar. However, a lack of familiarity with the art business has

in some cases led to some surprising findings. An example of a surprising finding in court proceedings occurred at first instance in the case of Thomson v Christie Masons & Woods Limited (see also section 3.1.1, 'Fiduciary duties').

Canadian heiress Taylor Thomson brought her High Court claim against Christie's in 2004 in relation to a pair of eighteenth-century urns which she had bought, and which she believed to be later, nineteenth-century copies. The judge at first instance, Mr Justice Jack, ruled in the High Court that, having heard the expert evidence, he considered that on balance there was a 70% probability that the urns were eighteenth-century originals, and that this should have been made clear to Taylor Thomson as a special client. Mr Justice Jack's judgment was overturned on appeal, with the appeal judges ruling that Mr Justice Jack had been wrong to place himself in the position of an art expert adjudicating over whether or not the work was eighteenth- or nineteenth-century. The test he should have applied was to consider whether Christie's conclusion that the urns were eighteenth-century was a conclusion that a reasonably competent international auctioneer could have reached at the time of the auction. The court of appeal found that Christie's opinion was a reasonable one to have held. A similarly surprising finding was made by Mr Justice Vos in Accidia Foundation v Simon C. Dickinson Ltd.[16] In that case one of the witnesses, a dealer, had given evidence that it was common practice in the art market for dealers to be instructed by sellers to sell artworks on the basis of a net return agreement. In other words, the parties would agree that the dealer should find a buyer at a sale price which resulted in net proceeds of no less than a specified amount being paid to the seller. If the dealer was able to sell the artwork for more than that amount, he would be permitted to keep as a commission any excess. In his judgment, Mr Justice Vos said:

> I do not think any such arrangement is common or usual, certainly not when an individual owner is the ultimate seller … I am, therefore, not satisfied that any custom or practice exists whereby art dealers agree with principals or their agents for a return price on the basis that the dealer may sell the piece at any price without informing the principal or his agent of that ultimate price or of the level of commission the dealer thereby receives after passing on only the return price. Such arrangements may exceptionally have occurred, but they cannot be described on the evidence I have heard as usual practice or the way in which valuable paintings are usually sold, even dealer to dealer, in the London art market. Moreover, such arrangements would be objectionable as being unreasonable and unlawful, unless they were concluded with the fully informed consent of the principal seller or the dealer accounted to that principal for the secret profit secured.

In fact, this custom and practice was indeed very common in the art market at the time. While the judge's comments about importance of transparency in such

16 [2010] EWHC 3058 (Ch).

arrangements were well made, the finding that no such custom or practice existed in the market was incorrect.

It is against this background that it is argued by some that there are advantages in selecting a mediator or arbitrator with experience of the art market to assist in the resolution of art market disputes.

It is also worth adding that the ADR process is not a panacea. It is fair to say that in some cases parties do not approach ADR with a genuine desire to settle the dispute. This may be because they are determined not to compromise and want their day in court. Or they may be using it as an opportunity to find out more about the other side's case. However, even in such cases, the fact of opening a channel of communication and the initiation of a discussion about settlement can serve to break through any instinctive reluctance on the part of the parties and their legal advisers to face up to the possibility of compromise.

My personal view is that ADR is not sufficiently widely used in resolving art disputes. Litigation is an expensive and uncertain way of resolving the many delicate and difficult issues which arise. My experience is that whether or not parties are invested in the idea of settlement, a 24-hour period spent in a nonbinding mediation is rarely time wasted. In many cases it will provide the key to unlocking settlement, and even where it does not, it will provide a platform for settlement at a later date. My personal preference – certainly as far as mediations are concerned – is to limit to a minimum the involvement of lawyers in the process. This may sound surprising, but the reason is that lawyers are trained to fight disputes and therefore tend to be less inclined than their clients to offer concessions. There is also often a reluctance among lawyers to be the first to suggest settlement or offer up a compromise solution as, from a tactical perspective, this is felt to be a sign of weakness in litigation. Their art industry clients however tend in general to be more comfortable with ADR, as they are used to the give and take involved in commercial deals as well as the importance of maintaining relationships.

16 Anti-money laundering and sanctions compliance

16.1 Anti-money laundering legislation in the United Kingdom

As awareness and understanding of terrorist financing and criminal activity has grown, so too has a realisation that the sale and purchase of artworks is open to abuse by criminals as a means of laundering dirty money. 'Money laundering' is the phrase used to describe the process by which 'dirty money' – the profits of crime and corruption – is converted into apparently legitimate assets.

Critics have often speculated that the art market is vulnerable to being used for tax evasion and money laundering. They argue in favour of regulation of the art industry on the grounds that the size of the transactions, the culture of confidentiality and the portability of artworks leave it open to abuse by criminals seeking to launder money. This was underlined in 2020 when the United Kingdom National Risk Assessment (NRA) 2020 concluded that art market practitioners were high risk for money laundering.

The NRA reported the art market to be attractive for money laundering because of 'the ability to conceal the art's beneficial owners, the final destination of art, the wide-ranging values involved, and the size and international nature of the market'.[1]

In a no doubt connected development, the United Kingdom government announced that it would be introducing a levy against a range of businesses which are thought to be at risk of money laundering and economic crimes. That list includes art market participants. The levy, which will be used to raise money for government oversight and enforcement, will first be charged for the financial year from 1 April 2022 to 31 March 2023.

[1] National risk assessment of money laundering and terrorist financing 2020, p.138. This was a controversial finding as it was criticised by art market representatives on the grounds that this conclusion was not to supported by the underlying data.

The amount of the levy is as follows:

- Medium-sized regulated entities (£10.2m–£36m UK revenue): annual levy of £10,000.
- Large regulated entities (£36m–£1bn UK revenue): annual levy of £36,000.
- Very large regulated entities (over £1bn UK revenue): annual levy of £250,000.

Whether or not art has in fact been used to launder money is a matter for debate and speculation. Indeed, there are at the time of writing very few instances of anyone being convicted of money laundering using art. It is certainly the case that much of the media and law enforcement commentary on the subject is largely speculative and/or based on a more general concern aroused by the high prices achieved for art at auction. However, there is no doubt that there is a genuine and well-founded concern at the possibility of the art market being exposed to money laundering, which those involved in the art industry cannot ignore. The art industry needs to be aware of the risks of money laundering and take steps to ensure that it protects itself against that risk. The consequences of failure to do so – both legal and reputational – are serious.

In common with many other jurisdictions, the United Kingdom has two sets of legislation aimed at curbing money laundering. One is aimed at the population at large, whereas the other is specific to certain regulated industries. The first, the Proceeds of Crime Act 2002, is a general prohibition on knowingly handling criminal property. The second, the Money Laundering, Terrorist Financing and Transfer of Funds (Information on the Payer) Regulations 2007, is aimed at creating a regulatory framework for certain United Kingdom businesses, now including the art business, which are considered to be potentially exposed to money laundering.

16.1.1 Proceeds of Crime Act 2002

Criminal law makes it an offence to be involved in money laundering. The main legislation aimed at the public and the corporate world in general relating to money laundering offences in the United Kingdom is the Proceeds of Crime Act 2002 (POCA 2002). POCA 2002 makes it an offence to conceal (s 327), arrange (s 328), acquire or possess (s 329) criminal property. Even those who handle criminal property innocently are at risk, as dishonesty is not required to commit one of these offences. However, an essential ingredient for a conviction is that the person accused of committing the offence knew or suspected that the property was derived from criminal conduct. No offence is committed if the alleged offender does not know or suspect that the property involved is the proceeds of criminal conduct. A conviction for a money laundering offence under POCA 2002 carries a prison sentence of up to 14 years. These sanctions can apply to individuals, directors, employees and officers.

16.1.2 The Money Laundering Regulations 2007

Until recently the art industry was subject only to the requirements of POCA 2002. This was in contrast to the banking, legal, accounting, trust services, casino and real estate industries, which were thought to be at greatest risk of money laundering and were therefore made subject to regulation for money laundering purposes through the provisions of the Money Laundering Regulations 2007. The Money Laundering Regulations 2007 require that firms in these regulated sectors carry out identity checks on potential customers, keep records of transactions with clients, train staff to recognise potential money laundering activity and suspicious transactions and put in place reporting procedures for suspicious transactions. Failure to comply with these requirements can lead to criminal penalties including fines and imprisonment.

16.1.3 Money Laundering, Terrorist Financing and Transfer of Funds (Information on the Payer) Regulations 2017

In 2017 the Money Laundering Regulations 2007 were updated and replaced by the Money Laundering, Terrorist Financing and Transfer of Funds (Information on the Payer) Regulations 2017. The update was primarily to incorporate the requirements of the EU's 'Fourth Money Laundering Directive'.

The 2017 legislation was initially focused upon the same regulated sectors as the 2007 legislation – the banking, legal, accounting, trust services, casino and real estate industries. However, concerns about money laundering in the art market led the European Parliament in 2016 to vote to extend the anti-money laundering regime to include intermediaries in the art market, such as dealers and auction houses.

Under this directive, known as the 'Fifth Anti-Money Laundering Directive', art intermediaries such as auction houses and dealers in Europe were required from 10 January 2020 to undertake customer due diligence, by identifying and verifying the identity of clients and ultimate beneficial owners buying and selling artworks. They were also expected to register with the regulator, be subject to audits of their anti-money laundering compliance systems, carry out training and keep records.

The Fifth Anti-Money Laundering Directive was transposed into United Kingdom law by amending the Money Laundering, Terrorist Financing and Transfer of Funds (Information on the Payer) Regulations 2017, known as the 2017 Regulations.

The 2017 Regulations represented a greater change for some parts of the art market than others. The risk that art could be used for money laundering purposes had been recognised by the major auction houses from around 2010 onwards.

In response to that risk, the auction houses had themselves implemented 'know your client' procedures and set up compliance departments trained in spotting the signs of money laundering activity. These procedures and structures were set up to mirror those in the regulated sector and became, over time, increasingly sophisticated. As a rule, however, the smaller players in the art industry tended to be reluctant to invest in and implement such measures without being required to do so by law. From 2020, however, all of that was to change and most United Kingdom dealers and auction houses would find themselves required by law to take anti-money laundering measures.

16.2 Practical challenges of the new regulatory framework

16.2.1 The tension between confidentiality and transparency

Bringing the art market into the regulated sector was straightforward from a legislative perspective. What was far more complex was determining how the laws should be applied in practice. It was recognised from the outset that the implementation of the new 2017 Regulations would be difficult due to the peculiarities of the art market's structure and operation. In particular, the distinguishing feature of the art market – that of client confidentiality – was at first glance difficult to square with the transparency requirements of the new 2017 Regulations. The heart of this very real problem was that for agents and auction houses, the 2017 Regulations could require the disclosure to a competitor of the name and address of a client. This is a significant problem because the most valuable commodity for an auction house or a dealer is the relationship with the client. As we have seen elsewhere in this book, these relationships are vigorously pursued, carefully nurtured and jealously guarded because they form the bedrock of the agent's income. An agent advising a wealthy active collector can expect commission income from advising on the collector's purchases of art and on any sales of art from the collection – particularly where the agent is the collector's only advisor. The fear for the agent is that this lucrative relationship risks being lost if the agent has to disclose to another dealer or an auction house details which will give the competitor direct access to the collector.

In addition, many clients use agents specifically because they value discretion and do not want to publicise their art transactions. While this desire for privacy can sometimes be viewed by people outside the art market with suspicion, the reasons for it are usually understandable and mundane. We will see later (Chapter 18.1) that many of the traditional triggers for the sale of art, such as debt, divorce and death, are matters which sellers wish not to publicise. And security conscious buyers – particularly those in the public eye – are often equally uncomfortable with the idea of details of their purchases being made available to others.

16.2.2 The complexity of multiple agency

The problem of disclosure was also magnified by the fact that many art trans-actions involve multiple agents and a long chain. For instance, a painting can be consigned to an auction house by a dealer who represents the seller and the painting might be bought by a buyer who is also represented by an agent. A simple transaction of this kind involves five parties. The question, then, is: who discloses what information to whom?

16.2.3 Industry-wide guidelines

In order to address these problems of interpretation and the practical challenges of implementation, the British Art Market Federation was tasked by the government with producing a guidance document for United Kingdom art Market Participants, known as 'AMPs' (the art market entities governed by the 2017 Regulations). This document would be approved by the United Kingdom government's Treasury department and serve as the 'bible' for the art market and AMPs on the interpretation of the 2017 Regulations and on anti-money laundering practice. (The guidance document is available at https://tbamf.org.uk.) The sheer size of the document is an indicator of the complexity of the task of marrying up the regulatory regime with the art market, but it is an extremely useful document for anyone seeking to understand how the 2017 Regulations should be applied in practice. I will summarise the salient points from the guidance in this chapter but for detailed guidance the BAMF guidelines should be the first port of call.

16.3 Application of the 2017 Regulations

The 2017 Regulations apply to what are described as 'art market participants' or 'AMPs' carrying on business in the United Kingdom,[2] trading or storing works of art where the value of the transaction amounts to €10,000 or more.

In plain language, an AMP means a commercial trader in works of art (or freeport operator storing works of art) in the United Kingdom who transacts beyond a certain financial threshold.

16.3.1 Art market participants

More specifically, the 2017 Regulations define an AMP as 'a firm or sole practitioner who

[2] BAMF Guidance on Anti Money Laundering for United Kingdom Art Market Participants, 30 June 2022, Part I ss 8 and 9.

(i) by way of business trades in, or acts as an intermediary in the sale or purchase of, works of art and the value of the transaction, or a series of linked transactions, amounts to 10,000 euros or more; or

(ii) is the operator of a freeport when it, or any other firm or sole practitioner, by way of business stores works of art in the freeport and the value of the works of art so stored for a person, or a series of linked persons, amounts to 10,000 euros or more.'

Individual buyers and sellers of art will not therefore be considered to be AMPs unless the extent of their trading can be described as a business.

The term 'intermediary' is intended to identify someone who, by way of business, actively transacts in the sale or purchase of works of art on behalf of a seller or buyer under whose authority they act.[3] While the meaning of 'actively transacts' is not defined, my view is that the key element of the intermediary role is therefore that the intermediary must have the legal authority to transact in the purchase or sale of artworks on their principal's behalf. An intermediary could therefore be an agent or an art dealer, which could include an art gallery, auction house or an online sales platform. An intermediary could themselves be such an entity, or might simply be a person or entity paid by the seller or buyer for whom they act.[4]

It is important to note that under the BAMF Guidance an online sales platform selling artworks will be an intermediary if the platform is conducting relevant activity in the United Kingdom and receives commission in relation to transactions (sales or purchases of works of art) taking place on their platform. In other words, an online sales platform which is physically based outside the United Kingdom but acts as an intermediary for their United Kingdom customers will be caught by the regulations.[5] The full force of HMRC's supervisory regime will therefore apply to businesses such as Artsy, 1stDibs, Platformart, Artspace and the like. insofar as they conduct relevant activity in the UK, no matter where their physical presence may be.

The BAMF Guidance makes it clear, however, that those on the periphery of art transactions, such as framers, shippers, or other persons just providing contact information, will not be within the scope of the regulations provided they do not actively participate in purchase/sale transactions and are not therefore acting as intermediaries.[6]

[3] BAMF Guidance on Anti Money Laundering for United Kingdom Art Market Participants, 30 June 2022, Part I s 12A.

[4] BAMF Guidance on Anti Money Laundering for United Kingdom Art Market Participants, 30 June 2022, Part I s 12B.

[5] BAMF Guidance on Anti Money Laundering for United Kingdom Art Market Participants 30 June 2022 Part I s 12C.

[6] BAMF Guidance on Anti Money Laundering for United Kingdom Art Market Participants, 30 June 2022, Part I s 12D.

A role which is sometimes played by those involved in the art business is that of introducer. A party will introduce a potential buyer or seller to another party who will conduct a transaction. The introducer will often be remunerated for making the introduction but is not usually otherwise involved in the transaction itself. The BAMF guidance provides that introducers performing this function will not be within the scope of the regulations provided they are not actively participating in the sale or purchase transaction. In other words, an introducer will not fall within the regulations if they are simply paid for the introduction. But they will be deemed to be an intermediary if they are remunerated for their active participation in the transaction of the work of art.[7]

Artists selling their own work, whether as an individual/sole practitioner or through a business they own, are not within the scope of the Regulations, and so are not required to register as an AMP. This extends to sales of an artist's own work through their business which only sells their work (but not for sales of other artists' work if also sold through their business). Similarly, sales out of an artist's estate, or sales of an artist's work by someone employed by the artist, or the artist's business, to sell the artist's work, are not within scope of the Regulations.[8]

16.3.2 Carrying on business in the United Kingdom

It is to be noted that for the 2017 Regulations it is not necessary that the AMP be a UK-registered entity or UK-resident person. Rather, they need to be acting in the course of business being carried on by them in the United Kingdom.[9] The regulations define this to include AMPs who would not otherwise be regarded as carrying on business in the United Kingdom but who have a registered or head office in the United Kingdom.[10]

As we have seen, the art business is global in nature. Art fairs attract dealers from all of the world, allowing them to buy and sell paintings worldwide. One concern therefore is whether an AMP who is based abroad could be caught by the regulations by virtue of a single transaction or series of transactions in the United Kingdom. Overseas-based AMPs who transact in the United Kingdom will be caught by the regulations. This would also seem to be the logical outcome to prevent UK-based AMPs being at a disadvantage to their overseas competitors

[7] BAMF Guidance on Anti Money Laundering for United Kingdom Art Market Participants 30 June 2022 Part I s 12E.

[8] BAMF Guidance on Anti Money Laundering for United Kingdom Art Market Participants 30 June 2022 Part I s 12F.

[9] The Money Laundering, Terrorist Financing and Transfer of Funds (Information on the Payer) Regulations 2017 s 9.

[10] The Money Laundering, Terrorist Financing and Transfer of Funds (Information on the Payer) Regulations 2017 s 9.

when doing business in the United Kingdom. However, the registration system and the mechanics of the regulatory oversight do not at the time of writing seem to be geared towards foreign-based AMPs. A foreign-based AMP transacting in the United Kingdom should therefore seek to comply as far as is practically possible with the requirements of the 2017 Regulations, just as if he or she were a UK-registered business.

The 2017 Regulations also impose upon United Kingdom AMPs a requirement not only to comply with the requirements of the 2017 Regulations but to impose the United Kingdom standards upon any of its foreign subsidiaries or branches. So, in practice, a United Kingdom auction house or dealer with branches in Hong Kong and New York is obliged to have a global policy which is compliant with the United Kingdom 2017 Regulations, even if the requirements of Hong Kong and New York law are less onerous.[11]

16.3.3 Works of art

To be an AMP, the items being traded or stored must be 'works of art'. As we know, art can mean many things to different people, so it was important to define in the Guidelines what is meant, for the purposes of the 2017 Regulations, by a 'work of art'. Rather than reinvent, the wheel it was decided to adopt a definition of 'work of art' which had been used in pre-existing legislation – s 21 of the Value Added Tax Act 1994. As a result, the following are considered 'works of art' for the purposes of the 2017 Regulations:

(a) any **painting, drawing, collage, decorative plaque or similar picture** executed by hand;

(b) any unique or limited edition **original engraving, lithograph or print** produced by an individual from plates executed by hand;

(c) any **original sculpture or statuary**;

(d) any unique or limited edition[12] **sculpture cast** produced by or under the supervision of the artist (or following the artist's death under the supervision of the owners of the artist's moral rights);

(e) any unique or limited edition[13] **tapestry** or other hanging which was made by hand from an original design;

(f) any **ceramic** executed and signed by an individual;

(g) any unique or limited edition[14] hand-made **enamel on copper** signed by the artist or the studio where it was made. (However, this will not include items where the

[11] The Money Laundering, Terrorist Financing and Transfer of Funds (Information on the Payer) Regulations 2017 s 20.

[12] To qualify as a limited edition the total number of sculpture casts must not, subject to certain very limited exceptions, exceed eight.

[13] To qualify as a limited edition the total number of tapestries must not exceed eight.

[14] To qualify as a limited edition the total number of enamels produced from the same design must not exceed eight and each of the enamels must be numbered and signed.

enamel is incorporated into an item of jewellery or an item produced by goldsmiths or silversmiths);

(h) any unique or limited edition[15] **photograph** which is signed by the photographer and printed by the photographer or under the photographer's supervision.

It is interesting to note that there are many items which are not included in this definition, including:

(a) furniture
(b) technical drawings, maps or plans
(c) jewellery and watches
(d) automobiles
(e) coins
(f) stamps
(g) antiquities

Inevitably, given that definition used comes from an Act introduced in 1994, the definition does not explicitly include digital art and non-fungible tokens.

16.3.4 The 10,000-euro limit

To be regulated as an AMP the financial value of the transaction or series of linked transactions by the trader must be 10,000 euros or more. This means that a single transaction can carry a trader out of the unregulated market into the regulated market.

To calculate the value of a work for the purposes of the 10,000-euro threshold the final invoiced price should be used for non-auction sales, including taxes, commissions and ancillary costs. Where a work is sold at auction the value should be calculated based on the hammer price, plus commission, taxes and ancillary costs.[16]

One of the problems has been the interpretation of what is meant by 'linked transactions' in a market where buyers and sellers can be repeat customers. The Guidelines suggest that this is not intended to capture separate unrelated transactions, but rather a transaction or series of related transactions which are broken down deliberately with the intention of circumventing the 10,000-euro threshold. And for these purposes a single invoice covering multiple transactions will be

[15] To qualify as a limited edition the photograph prints must be individually signed and numbered and must not exceed 30.

[16] BAMF Guidance on Anti Money Laundering for United Kingdom Art Market Participants 30 June 2022 Part I paragraph 21.

considered to be linked.[17] A classic example would be a customer who purchases a number of artworks at an auction or privately on a single visit. While each transaction is separate, the group of transactions would be seen as linked, whether they appeared on separate invoices or a single invoice. They would also be linked even if invoiced separately over a longer time span. If on the other hand these separate transactions occurred on separate occasions over a period of six months and were invoiced separately, it seems less likely that these would be seen as linked transactions.

16.4 Obligations of art market participants under the 2017 Regulations

A trader who qualifies for regulation will need to register with the Regulator, Her Majesty's Revenue and Customs (HMRC), as an AMP and will be required to take a number of steps in order to be compliant with the 2017 Regulations. The regulatory framework is both mandatory and prescriptive as to the compliance measures which must be taken and recorded as having been taken by AMPs.

16.4.1 Registration requirement

Traders are required to register with HMRC immediately upon qualification as an AMP. This can be done online.[18] As part of the application process the beneficial owners and the senior management of the applicant are reviewed by HMRC to ensure that they are appropriate people to undertake their responsibilities.

A trader can proceed with transactions pending the approval of the registration application, but must in the meantime implement and satisfy all the other requirements of the 2017 Regulations.[19]

It is important to note, as we have seen earlier, that overseas dealers coming to the United Kingdom to do business in the United Kingdom are likely to be considered subject to the 2017 Regulations and therefore required to register with HMRC. While this may at first blush seem surprising, the aim of the 2017 Regulations is to ensure that all art transactions in the United Kingdom are subject to anti-money laundering safeguards. It would make little sense to allow overseas dealers who

[17] BAMF Guidance on Anti Money Laundering for United Kingdom Art Market Participants 30 June 2022 Part I paragraph 22.

[18] www.gov.uk/guidance/register-or-renew-your-money-laundering-supervision-with-hmrc

[19] BAMF Guidance on Anti Money Laundering for United Kingdom Art Market Participants 30 June 2022 Part I paragraph 24.

trade in the United Kingdom – even on an occasional basis – to ignore those safeguards.

16.4.2 Annual risk assessment requirement

AMPs need to carry out a formal risk assessment at least once every year, assessing the exposure of the business to money laundering and terrorist financing. This will involve an analysis of the AMP's client base, safeguards and transaction types. Aspects to consider include the value of transactions, whether the types of artworks sold are susceptible to being used for money laundering purposes, the extent to which transactions are in-person and whether the AMP deals with clients who are PEPs[20] or based in jurisdictions considered to be high risk for money laundering purposes. There is no prescribed format for the risk assessment but its conclusions, the safeguards put in place and the recommendations for the future should be documented and may be reviewed at any time by HMRC.[21]

16.4.3 Requirement to appoint a nominated officer

The AMP must appoint a senior person based in the United Kingdom within the AMP's organisation whose role is to ensure that the organisation's policy and procedures are compliant with Anti-Money Laundering 2017 Regulations, receive reports of suspicious activity from staff and decide whether the suspicions should be reported to the National Crime Agency.[22]

16.4.4 Requirement for an anti-money laundering policy and procedure

The 2017 Regulations require that AMPs put in place a written anti-money laundering policy setting out a policy statement, controls and procedures. Once again there is no prescribed format for the policy, but the Guidance states that it should include:[23]

- The risks of money laundering or terrorist financing identified in the risk assessment
- The responsibilities of senior management and all employees in relation to anti-money laundering compliance

[20] Politically exposed persons.
[21] BAMF Guidance on Anti Money Laundering for United Kingdom Art Market Participants 30 June 2022 Part I paragraph 30.
[22] BAMF Guidance on Anti Money Laundering for United Kingdom Art Market Participants 30 June 2022 Part I paragraph 34-38.
[23] BAMF Guidance on Anti Money Laundering for United Kingdom Art Market Participants 30 June 2022 Part I paragraph 40.

- Customer due diligence measures – including identification and verification requirements
- Identification of customers or beneficial owners who are politically exposed persons (PEPs) or family members or close associates of PEPs
- Timing of customer due diligence and the exercise of discretion on risk-based aspects
- Suspicious activity reporting procedures
- Internal control procedures, including cash and third-party payment handling
- Use of reliance or outsourcing arrangements
- Ongoing monitoring activities

16.4.5 Requirement for training

AMPs are required to train employees so that they are familiar with the AMP's anti-money laundering policies and procedures and are able to identify red flags and areas of risk. The training should be regularly repeated to ensure that memories are refreshed and that new staff are trained. Training may be face-to-face, online or via seminars and conferences but should be appropriate to the risks faced by the AMP's business, and the focus may vary depending upon the roles and duties of the persons being trained. AMPs should keep a record of attendance at training sessions as this may be required by HMRC. Training should be carried out at all levels of seniority throughout the organisation.

16.4.6 Requirement for customer due diligence

At the heart of the 2017 Regulations is the requirement for AMPs to carry out due diligence in relation to their customers, known as customer ID and verification checks, CDD or customer due diligence. In other words, AMPs need to establish the identity of the physical person with whom they are transacting and obtain documentation to verify that information. They also need to have an understanding of their customer's source of funds and take appropriate action if they come across any red flags or warning signs. This is not only the most important area of the 2017 Regulations – it is also the area of greatest complexity. Who should be carrying out the checks? Who is the AMP's customer for the purposes of the checks? When should the checks be carried out? What form should the checks take? I will try below to break these questions down and provide some guidance.

16.5 Customer due diligence requirements under the 2017 Regulations

If an AMP has determined that he or she is subject to the due diligence obligations of the 2017 Regulations, the next step is to establish (i) who or what the due diligence should relate to and (ii) what constitutes due diligence.

16.5.1 Identifying the AMP's customer for due diligence purposes

As we have seen, the duty to carry out customer due diligence arises in relation to 'customers' of the AMP where the AMP is acting as an intermediary. As a result, the starting point for the AMP is establishing whether or not the AMP is acting as an intermediary in the transaction.[24]

If the AMP is acting as an intermediary the next step is to identify who is the intermediary's customer, and by extension who he or she is meant to be checking.

In a straightforward retail scenario, the owner of a shop selling art will know that his customer is the buyer who comes into the shop off the street and decides to buy an artwork.

However, if the shop owner acquired the painting as stock beforehand from a seller, or if the shop owner is acting as an agent for a seller, then the seller may also be the shop owner's customer.

If one were then to add a layer of complexity and imagine that the seller is represented by an agent, then the shop owner might potentially have three customers: the seller, the seller's agent and the buyer.

Similarly, in an auction scenario, while the auction house acts as agent for the seller, the auction house's customers will include not only the seller but also the buyer and any agent acting for either the buyer or seller.

Where matters get more complicated is in determining who is the customer of the parties at the other ends of the chain. So, for instance, where the seller is represented by an agent who is consigning an artwork on the seller's behalf to an auction house for sale, who is the seller's agent's customer? Is it just the seller? Or is it the seller and the auction house? Or is it the seller, the auction house and the buyer? Equally, where an auction buyer is represented by an agent who is the buyer's agent's customer? Is it just the buyer? Or is it the buyer and the auction house? Or is it the buyer, the auction house and the seller?

[24] See section 16.3.1 above.

When the 2017 Regulations were first introduced there was considerable confusion over this question, which led to unnecessary and duplicative requests for documents and information – largely out of an abundance of caution.

With the Regulator's blessing, the guidelines have now been clarified to state that an AMP's customer will depend on the role played by those involved in a particular transaction.

The BAMF guidelines now state that the customer of an AMP who is selling or acting as an intermediary in the sale or purchase of a work of art will be whoever is paying the AMP for the artwork, or for the AMP's services in relation to the transaction.[25] The BAMF guidelines go on to provide a series of helpful practical examples.[26]

Where, for example, the AMP is an auction house, the auction house's customers will be:

- the seller of a work of art, or other AMP, who has paid the auction house to auction the artwork;[27]
- the purchaser, or other AMP, who pays the auction house for the work of art.

The AMP auction house is therefore required by the regulations to carry out customer due diligence in relation to the person or entity who is actually paying the AMP auction house. It is important to note however that where the person or entity paying the AMP auction house is himself or herself an AMP acting as agent for a buyer or seller, the AMP auction house is obliged under the 2017 Regulations only to carry out customer due diligence on the AMP agent who is making payment, not the principal on whose behalf the agent is acting. However, the position is different if the agent is not an AMP. If the agent is not an AMP then the AMP auction house will need to carry out customer due diligence on the agent and also on the agent's principal.

While this may be acceptable from the United Kingdom regulator's point of view under the 2017 Regulations, it does present some difficulties from the point of view of sanctions legislation. The auction house needs to know who the agent is acting for in case the agent is acting for a sanctioned individual. Equally, the auction house will also have obligations under POCA 2002 to ensure that they have no reasonable suspicion that they are handling or facilitating a sale of a work of art which itself represents the proceeds of crime. To meet POCA 2002 and sanctions compliance obligations, therefore, it may be appropriate (as determined on

[25] The Money Laundering, Terrorist Financing and Transfer of Funds (Information on the Payer) Regulations 2017 s 47A.

[26] The Money Laundering, Terrorist Financing and Transfer of Funds (Information on the Payer) Regulations 2017 Table 5.19.

a risk-based approach) for an AMP auction house to carry out further checks on the seller or consignor of a work of art, to ensure that they are not handling stolen works of art or otherwise facilitating use of the proceeds of crime.[28] Such further checks are likely to involve knowing the identity of the ultimate customer.

Examples

The BAMF guidelines provide a series of helpful examples[29] to illustrate who is responsible for customer due diligence and in what circumstances.

Example 1: An AMP is selling art to their customer, a buyer.

In this situation the person paying the AMP is the AMP's customer, the buyer. As the buyer is paying the AMP in order to buy the art, the AMP needs to conduct customer ID and verification checks on the buyer.

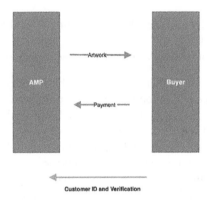

Example 2. An AMP is facilitating the sale of art between its customers, a seller and a buyer.

Here, the AMP is in the middle of the transaction. Both the seller and the buyer are the AMP's customers. The seller is paying the AMP to sell the art and the buyer is paying the AMP for the art or for the AMP's services. The AMP therefore needs to conduct customer ID and verification checks on both the seller and the buyer.

There may be a question in this scenario where the AMP is not charging the seller to sell the work but is deducting and keeping a sum from the purchase price paid

28 BAMF Guidance on Anti Money Laundering for United Kingdom Art Market Participants 30 June 2022 Part I paragraph 49.

29 BAMF Guidance on Anti Money Laundering for United Kingdom Art Market Participants 30 June 2022 Part II paragraph 5.21.

by the buyer, or is charging the buyer a commission or premium on top of, or included in, the purchase price. In such a case I believe that such an arrangement is tantamount to the AMP charging the seller for his or her services, and the seller is the AMP's customer regardless or whether or not the seller actually makes a payment to the AMP for the AMP's services. The only scenario of this kind where, in my view, the AMP could argue that the seller is not the AMP's customer is if the AMP takes no payment at all for brokering the transaction.

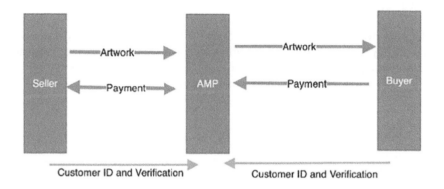

Example 3. An AMP is facilitating the sale of art between its customers, a seller and a buyer. The customers are each beneficially owned by another person.

Here the seller and the buyer are the AMP's customers, when the seller is paying the AMP to sell the art or for the AMP's services and when the buyer is paying the AMP for the art or for the AMP's services.

The AMP needs to conduct customer ID and verification checks on both the seller and the buyer. In addition, the AMP needs to identify and verify the beneficial owner of both the buyer and the seller.

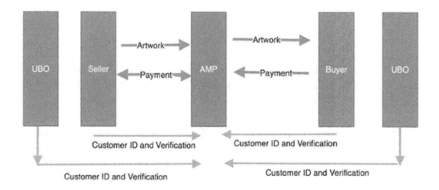

Example 4. An AMP is facilitating the sale of art between its customers, a seller and a buyer, both of whom are being separately advised.

The seller is using the services of an agent or advisor to provide advice on where best to sell the art. The agent or advisor is not involved with the actual sale.

The buyer is also using the services of an agent or advisor to provide advice on the maximum amount to pay for the art. The agent or advisor is not involved with the actual purchase.

The AMP needs to conduct customer ID and verification checks on both the seller and the buyer. The advisors are not sufficiently involved in the purchase or sale to be facilitating the sale or purchase. The AMP does not therefore need to conduct customer ID and verification checks on the agents or advisors.

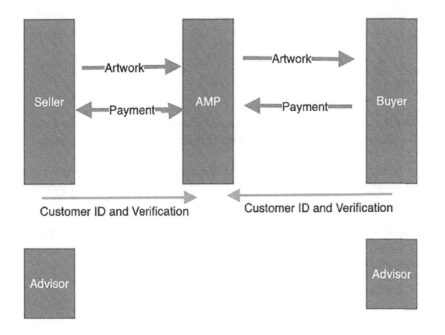

Example 5. An AMP is facilitating the sale of art between its customers, a seller and a buyer. The seller is using a person, the agent, to act on their behalf. The agent is not an AMP but is actively involved with the sale of the art.

Here the AMP needs to conduct customer ID and verification checks on both the seller and the buyer. The AMP also needs to verify that the agent is authorised to act on behalf of the seller or buyer, and to identify and verify the agent.

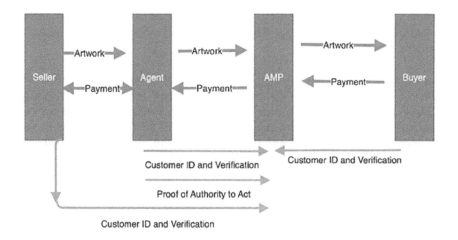

Example 6. Three AMPs are facilitating the sale of art in a transaction between a seller and a buyer. They are each paid for the art of their services by their customers in the chain.

AMP 1 is paid for his or her services by the seller and for the art by AMP 2. AMP 2 sells the art to AMP 3 on behalf of AMP 1 and is paid for his or her services by AMP 1 and for the art by AMP 3. AMP 3 is paid for the art and his or her services by the buyer.

Each AMP must conduct customer ID and verification checks on his or her customers. The AMP's customer for these purposes is the person who is paying the AMP for the art or services in relation to the transaction. AMP 1 needs to conduct customer ID and verification checks on the seller and on AMP 2; AMP 2 needs to conduct customer ID and verification checks on AMP 1 and AMP 3; AMP 3 needs to conduct customer ID and verification checks on the buyer.

It will be noted that in this example, and in contrast to example 5, the BAMF guidelines are not requiring AMP 2 to obtain customer ID and verification in relation to the ultimate buyer and seller. That is the responsibility of the AMPs acting as agents for the buyer and seller.

In practice this therefore means that an auction house to whom an AMP agent consigns a work on behalf of a seller is not under an obligation under the 2017 Regulations to carry our customer ID and verification in relation to the seller. That

is the duty of the AMP agent, not the auction house.[30] However, if the consigning agent is not an AMP the position is different, and the auction house would be required to carry our customer ID and verification both in relation to the agent and the seller.

However, while this may at first sight appear to be welcome news to AMP agents who are anxious to protect the confidentiality of their principals, it may not in fact obviate the need for disclosure by AMP agents of their principal's identity to the auction house or the other AMP at the centre of the transaction. While not required in order to comply with the 2017 Regulations, such disclosure will still, in many circumstances, be necessary in order to reassure the AMP at the centre of the transaction that the principal is not a sanctioned individual and/or that the artwork or the purchase price are not the proceeds of crime.

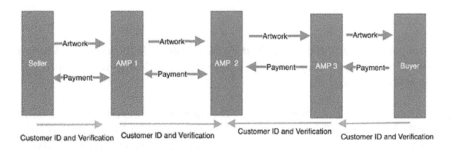

16.5.2 Relying on others to do due diligence

The art market has traditionally operated, perhaps to a greater degree than other markets, on trust. The 2017 Regulations recognise this,[31] making it clear that it is perfectly acceptable, in order to avoid duplication and/or problems with confidentiality, for an AMP to rely upon another AMP to carry out customer ID and verification checks.

This should be done through the use of a 'reliance letter' in which the AMP carrying out the customer ID and verification checks sets out what checks he or she will carry out on the customer, with a view to the other AMP accepting the assurances

30 This is different from the scenario in which one AMP 2 might choose to rely upon AMP 1 under the 'reliance provisions' of the 2017 Regulations (see section 16.5.2 below). In example 6 there is no question of reliance as the duty falls on AMP 1 to carry out the identity checks on his principal and AMP 2's duty is limited to checking and verifying the identity of AMP 1.

31 BAMF Guidance on Anti Money Laundering for United Kingdom Art Market Participants 30 June 2022 Part I paragraph 52, The Money Laundering, Terrorist Financing and Transfer of Funds (Information on the Payer) Regulations 2017 s 39.

in the reliance letter in lieu of carrying out his own customer ID and verification checks.

In practice, the AMP relying on the confirmation of a third party needs to have in writing:[32]

- the identity of the customer or beneficial owner whose identity is being verified;
- the level of customer ID and verification checks that have been carried out; and
- confirmation of the third party's understanding of his obligation to make available, on request, copies of the verification data, documents or other information.

This is not however the panacea that it might at first seem, as it comes with a sting in the tail. The 2017 Regulations provide that where AMP1 is relying on AMP2 to do AMP1's due diligence, then AMP1 will still be liable for any failure by AMP2 in carrying out the due diligence.[33] Given the potentially serious consequences of sloppy or non-existent due diligence it is a brave AMP who is prepared to rely on another AMP to carry out his due diligence for him. Further, such reliance letters cannot be used as a means to avoid AMP1 revealing the identity of his customer to AMP2, as the guidance makes it clear that this element must be revealed in the reliance letter.

We have seen above[34] that an AMP who is being paid by an agent AMP who is acting on behalf of the principal is not under an obligation, under the Regulations, to identify and verify the identity of the principal. That is the responsibility of the agent AMP. But at the same time, the AMP being paid by the agent AMP may want reassurance that the principal is not a sanctioned individual or that the artwork or purchase price are not the proceeds of sale. This is where the reliance provisions may play an important role. The agent AMP could for instance provide his or her counterpart AMP with a reliance letter revealing the identity of the principal, the types of ID checks undertaken, confirmation that there are no red flags and an undertaking to provide copies of documents if required. The counterpart AMP will therefore be able to check that the principal is not sanctioned, and will have some comfort that there are no red flags.

[32] BAMF Guidance on Anti Money Laundering for United Kingdom Art Market Participants 30 June 2022 Part I paragraph 5.202, The Money Laundering, Terrorist Financing and Transfer of Funds (Information on the Payer) Regulations 2017 s 39.

[33] The Money Laundering, Terrorist Financing and Transfer of Funds (Information on the Payer) Regulations 2017 s 39(1).

[34] Section 16.5.1 Example 6.

16.5.3 When should customer ID and verification checks information be obtained?

In general, customer ID and verification checks must be carried out prior to completion of the transaction. In practice this means that customer ID and verification checks on a seller by an auction house or dealer should be completed before the work is offered for sale and customer ID and verification checks on the buyer should be completed before the purchased property is released to the buyer – and certainly before any proceeds of sale are released to the seller.[35] Bidders in a saleroom are not transacting unless they are successful so there is no obligation to obtain customer ID and verification information as a precondition of bidding. However, where possible it is good practice for auction houses to ask for customer ID and verification information from bidders – if only to avoid delays later on if they are successful.

16.5.4 What constitutes customer due diligence under the 2017 Regulations?

Obtaining customer ID and verification information is a two-part process. The first is to identify the customer by establishing who the physical person is that the AMP is dealing with. The second – and often more difficult – part is verifying that information.

16.5.4.1 Identification

What information needs to be obtained in order to identify a customer?

16.5.4.1.1 Identification of individuals
If the customer is an individual, the AMP should obtain the following information:

- Full name
- Residential address
- Date of birth

16.5.4.1.2 Identification of corporations
For corporate customers the AMP should obtain the following:

- Name of the company, registered number and principal place of business
- List of directors
- Senior management
- The law to which it is subject

[35] BAMF Guidance on Anti Money Laundering for United Kingdom Art Market Participants 30 June 2022 Part I paragraph 54.

- Its Articles of Association or other governing documents
- Its legal and beneficial owners

16.5.4.1.3 *Identification of beneficial ownership*

Perhaps one of the most important aspects of the new regulatory regime is the requirement to look behind entities in order to identify the physical person or persons controlling the entity. Trusts and companies, whether based in the United Kingdom or in overseas jurisdictions, are sometimes used in the purchase and sale of artworks. While there are legitimate reasons for such arrangements, there is widespread public concern that these ownership structures could be used to hide the true beneficial ownership of the artwork, or worse, to assist with wrongdoing or laundering money. That perception was to some degree fuelled by the leak of documents to journalists from the Panamanian law firm Mossack Fonseca, which became known as the 'Panama Papers'. This was followed more recently by the Paradise Papers leaks. While the disclosures which followed these leaks arguably did not reveal widespread illegality, they did show a number of prominent sports, business and political personalities as beneficial owners of offshore companies, and the purpose of those offshore arrangements was in most cases to avoid or hinder identification of ownership. The impression given was one of a lack of transparency and there were therefore calls for that opacity to be addressed.

The European Union is intending to create registers of the beneficial owners of companies and trusts operating within the European Union. In addition, in 2016 the United Kingdom government introduced a register for United Kingdom companies, known as the PSC (People with Significant Control) register. This register sets out, in relation to each United Kingdom-registered company, the people with ownership or control of the company. This information is publicly available for every United Kingdom company registered at Companies House.[36] For the purposes of the PSC, a person with significant control is:

(i) an individual who owns more than 25% of the shares of a company;
(ii) an individual who owns more than 25% of the voting rights of a company;
(iii) an individual who holds the right to exercise or actually exercises the right to appoint or remove the majority of the board of directors of a company;
(iv) in some circumstances an individual who does not satisfy (i), (ii) or (iii) but has the right to exercise or does exercise significant influence or control over the company or trust.

The United Kingdom government is also planning to require British overseas territories to make public the ultimate beneficial owners of all their registered companies by the end of 2023.

[36] www.gov.uk/get-information-about-a-company

The 2017 Regulations impose upon AMPs a requirement, where they are dealing with unlisted companies or trusts, to find out who the physical person is who controls the company or trust. For private and unlisted companies, the 2017 Regulations require that the AMP should know the names of all individual beneficial owners owning or controlling more than 25% of the company's shares or voting rights (even where these interests are held indirectly) or who otherwise exercise control over the management of the company.[37]

The 2017 Regulations also require AMPs to take reasonable measures to verify the identity of those individuals.[38] This means that not only should the AMP obtain the name of the ultimate beneficial owner, but he or she should also verify that person's identity – for instance by obtaining photo ID.

The 2017 Regulations acknowledge the possibility that in some cases it simply may not be possible to find out who the ultimate beneficial owner of a corporate customer is. In these cases, provided the AMP has exhausted all possible means of identifying the beneficial owner, the AMP satisfies the customer due diligence requirements under the 2017 Regulations by instead taking reasonable measures to verify the identity of the senior person in the body corporate responsible for managing it. In such cases, however, the AMP must keep records in writing of: (a) all the actions it has taken to identify the beneficial owner of the body corporate; and (b) all the actions it has taken in verifying the identifying the senior person in the body corporate; and (c) any difficulties the AMP has encountered in doing so.[39]

Unhelpfully, the Regulations expressly provide[40] that AMPs do not satisfy their obligations in relation to identifying and verifying ultimate beneficial owners by relying upon the European or Companies House PSC registers. This very odd provision raises two questions. First, what is the point of creating the PSC registers if they cannot be relied upon? Second, what then is a reliable means of identifying and verifying ultimate beneficial owners? The 2017 Regulations are silent on both points. The reality is that AMPs are to a significant degree reliant upon what they are told by the customer.

[37] The Money Laundering, Terrorist Financing and Transfer of Funds (Information on the Payer) Regulations 2017 s 28(4)(a).

[38] The Money Laundering, Terrorist Financing and Transfer of Funds (Information on the Payer) Regulations 2017 s 28(4)(b).

[39] The Money Laundering, Terrorist Financing and Transfer of Funds (Information on the Payer) Regulations 2017 s 28(7) and (8).

[40] The Money Laundering, Terrorist Financing and Transfer of Funds (Information on the Payer) Regulations 2017 s 28(9).

16.5.4.2 Verification

The 2017 Regulations require the AMP not only to identify the customer but also to verify the identity of the customer. The 2017 Regulations provide[41] that 'verify' means verify on the basis of documents or information obtained from a reliable source which is independent of the person whose identity is being verified.

The most obvious way of verifying information in relation to individuals is the use of photographic ID documents. There is no obligation for these to be produced in original form or that they should be notarised copies. A copy of the original document is sufficient.

There are occasions where the customer is reluctant, for privacy reasons, to provide a copy of an ID document. In such circumstances the Guidance acknowledges that there are other ways to become comfortable. The example given in the Guidance is a written assurance from a trustworthy person, such as a bank, who is independent of the customer and who has dealt with the customer for some time.[42] But there may be further ways to address this. For example, it may be possible for the AMP to be shown the original or a copy of the passport and make a note of the passport number without retaining a copy.[43]

Verification information is also often available by consulting online resources and databases. This is particularly the case for corporate entities which are listed on company registers. The Guidance suggests that checking such registers is acceptable as a form of verification provided AMPs are satisfied as to the reliability and independence of the source. However, rather unhelpfully, the 2017 Regulations provide that, when verifying the identity of the ultimate beneficial owners of a company, the register of people with significant control of a company held by the company or by the company register cannot be relied upon as a means of verification. As mentioned above, given that the very purpose of such information being recorded and made publicly available is to allow the ultimate beneficial owner to be easily identified, it is difficult to understand the thinking behind this provision.

The 2017 Regulations are not prescriptive about the documents required in order to verify customer identity and acknowledge that the requirements will vary

[41] The Money Laundering, Terrorist Financing and Transfer of Funds (Information on the Payer) Regulations 2017 s 28(18).

[42] BAMF Guidance on Anti Money Laundering for United Kingdom Art Market Participants 30 June 2022 Annexe II paragraph 5.31.

[43] Bear in mind however the requirement that the AMP keep records and be able to produce copies of the CDD if required during an audit or investigation. One solution might be to have a copy deposited with an independent third party such as a solicitor who provides a written undertaking that the document will be produced on demand in the event of audit or investigation.

depending upon the type of client and the level of risk involved in the transaction.[44] However, an appropriate record should be taken of the steps taken and copies of or references to the evidence obtained to identify the customer must be kept.[45]

The following is a summary guide:

Client Type	Basic Information Needed	ID Type
Private individual	Name	**Photo ID** (passport; national ID card; driving licence)
	Address	**Proof of Permanent Residence** (recent bank or credit card statement; utility bill; tax authority letter)
Private company	Company name Registered address Registered number Directors' names Shareholders' names Ultimate beneficial owner (UBO)	**Certificate of Incorporation** **Copy of shareholders' register** **Copy of register of directors** **Photo ID of UBO**
Trust	Trust name Trustee name(s) Settlor name Beneficiaries' names Nature and purpose of the trust	**Photo ID of trustees** **Trust deed** (can be redacted if sensitive)
Estate	Deceased's name and prior address Date of death Executors'/administrators' names	**Copy of will** (and any codicils) OR **Grant of probate/Letters of administration** **Photo ID** for executors/ administrators

If the customer refuses to provide customer ID and verification information the AMP should not transact with the customer and should consider whether the circumstances are sufficiently suspicious as to require a Suspicious Activity Report.[46]

[44] The Money Laundering, Terrorist Financing and Transfer of Funds (Information on the Payer) Regulations 2017 s 28(120).

[45] BAMF Guidance on Anti Money Laundering for United Kingdom Art Market Participants 30 June 2022 Annexe II paragraph 5.35.

[46] The Money Laundering, Terrorist Financing and Transfer of Funds (Information on the Payer) Regulations 2017 s 31.

16.5.4.3 *Verification and agents*

The 2017 Regulations provide that where the AMP is contracting with a party who is known by the AMP to be acting as an agent for another party, the AMP must verify that the agent is authorised to act for the principal. As we have seen earlier, if the agent is not an AMP, the AMP must also identify the principal and verify the principal's identity by refence to documents or information from a reliable independent source.[47] We have also seen that if, however, the agent is an AMP then the 2017 Regulations do not require the AMP being paid by the AMP agent to identify the principal and verify the principal's identity. That task becomes the responsibility of the AMP agent. As I have said above, however, even in such cases the AMP agent will need to disclose the identity of the principal in order to satisfy the counterparty AMP that the principal is not a sanctioned person.

The disclosure by an agent of the identity of his or her principal is in many ways the most controversial of the provisions in the 2017 Regulations for the art market. This is because client relationships are the life-blood of many art intermediaries, such as dealers, auction houses and art advisors. Disclosing this information to competitors – even for compliance purposes – is at best counterintuitive. As a result many art market intermediaries have changed their approach, choosing to act as principals in transactions rather than on behalf of clients. Where this is not possible the most common way of ensuring that the information is not misused by competitors is to disclose the information under a non-disclosure agreement, and/ or to a trusted compliance officer or lawyer employed by the competitor.

16.5.5 Evaluating and reacting to due diligence results

16.5.5.1 *Red flags*

Gathering information identifying the customer and verifying the customer's identity is, however, only one part of the exercise. Based on the information received and the surrounding circumstances of the transaction, the AMP must assess the risks from a money laundering perspective of entering into a transaction with the customer. This means looking for any red flags or reasons for caution. Typical red flags include:

- Cash payments
- Third party payments
- Client with no obvious source of wealth
- Buyers and sellers closely connected
- Transactions which don't make commercial sense
- Offshore companies

[47] The Money Laundering, Terrorist Financing and Transfer of Funds (Information on the Payer) Regulations 2017 s 28(10).

- Excessive secrecy
- Refusal to provide customer ID and verification information
- Client is based in a high-risk jurisdiction

A red flag is not necessarily a reason not to enter into a transaction, but it may well be a reason for further consideration of the risks and for asking further questions.

16.5.5.2 Politically exposed persons (PEPs)

A politically exposed person, more commonly referred to as a 'PEP', is defined as an individual who is entrusted with prominent public functions, other than as a middle-ranking or more junior official. This includes:[48]

- heads of state, heads of government, ministers and deputy or assistant ministers;
- members of supreme courts, of constitutional courts or of other high-level judicial bodies the decisions of which are not subject to further appeal, except in exceptional circumstances;
- ambassadors, charges d'affaires and high-ranking officers in the armed forces (other than in respect of relevant positions at Community and international level);
- members of the administrative, management or supervisory boards of State-owned enterprises; and
- directors, deputy directors and members of the board or equivalent function of an international organisation.

AMPs are required[49] to have in place measures to identify PEPs as they trigger a requirement for enhanced due diligence (see below).

16.5.5.3 Enhanced due diligence

There are certain circumstances where the AMP is required to apply what are known as 'enhanced due diligence' measures.[50] Broadly, this is where there are circumstances, such as red flags, which would indicate a higher risk. Examples are:

- any business relationship with a person established in a high risk third country or in relation to any relevant transaction where either of the parties are established in a high risk third country (see further below);

[48] BAMF Guidance on Anti Money Laundering for United Kingdom Art Market Participants 30 June 2022 Annexe II paragraph 5.168.

[49] The Money Laundering, Terrorist Financing and Transfer of Funds (Information on the Payer) Regulations 2017 s 35(1) and (5).

[50] The Money Laundering, Terrorist Financing and Transfer of Funds (Information on the Payer) Regulations 2017 Section 33.

- where the AMP has determined that a customer or potential customer, is a PEP, or a family member or known close associate of a PEP;
- any case where the AMP discovers that a customer has provided false or stolen identification documentation, and the AMP proposes to continue to deal with that customer;
- any case where a transaction is complex or unusually large; and
- any case identified as one where there is a high risk of money laundering or terrorist financing, either by the AMP or in information made available to the AMP by the authorities.

The Financial Action Task Force (FATF), the EU, HM Treasury and other non-governmental organisations publish lists of high-risk countries and risk perception indices. As per the updated list of EU High Risk Countries which came into force on 1 October 2020 and the current FATF high risk jurisdictions, EU list countries are Afghanistan, Iraq, Trinidad and Tobago, Mongolia and Vanuatu; Albania is on the FATF list; countries that appear on both EU and FATF lists are the Bahamas, Barbados, Botswana, Cambodia, Ghana, Jamaica, Mauritius, Myanmar/Burma, Nicaragua, Pakistan, Panama, Syria, Uganda, Yemen and Zimbabwe; and blacklisted countries are Iran and North Korea (DPRK).

One set of circumstances which is not specified is where a payment is made by cryptocurrency. I would suggest that a prudent AMP should carry out enhanced due diligence in relation to any payment received in cryptocurrency.

Enhanced due diligence means that the AMP should, as far as is reasonably possible, examine the background and purpose of the transaction and increase the degree and nature of monitoring of the customer's activity in order to determine whether these transactions or activities appear unusual or suspicious.[51] This includes obtaining more information about the customer and beneficial owner and the reasons for the transaction, and increasing the monitoring of the business relationship.[52]

Examples of enhanced due diligence include:

- obtaining, and where appropriate verifying, additional information on the customer and any beneficial owner;
- obtaining information on the source of funds or source of wealth of the customer;
- obtaining the approval of senior management to undertake the transaction;

[51] BAMF Guidance on Anti Money Laundering for United Kingdom Art Market Participants 30 June 2022 Annexe II paragraph 5.31.

[52] The Money Laundering, Terrorist Financing and Transfer of Funds (Information on the Payer) Regulations 2017 s 33(3A).

- requiring settlement to be carried out through an account in the customer's name via a bank subject to similar due diligence requirements to the AMP.

In deciding when to apply enhanced due diligence and considering the extent of the additional enquiries or controls, it is important to bear in mind that such decisions should be informed by an assessment of the risks of the particular circumstances. A good example is that of PEPs. PEPs can and often do purchase artworks. The fact that someone is a PEP should not, on its own, cause the AMP to reject the transaction or even treat it with undue suspicion. Rather, the AMP should, for instance, consider whether the transaction is unusually high value given what is known about the PEP's likely remuneration, and run an internet search to see if there is any adverse media reporting suggesting financial misconduct. It should also be remembered that the purpose of these measures is to identify potential money laundering and links with terrorism. In the course of due diligence it is always possible that the AMP will discover past misdemeanours which fall into different categories. If that happens the AMP has the discretion to decide whether or not to deal with the customer but the provisions of the Anti-Money Laundering Regulations 2017 are not generally a part of that decision. Another common issue is where a customer is identified as having been convicted of an offence or financial misdemeanour for which he or she has served out a sentence or paid a fine. In such circumstances the AMP must decide what the level of risk is in dealing with the customer. Does the customer still present a risk of money laundering? This will depend on the particular circumstances.

16.5.5.4 Simplified due diligence

Just as there are circumstances which require a higher level of due diligence, the guidance recognises that there are there are also situations where a lesser standard of due diligence is acceptable.[53] The AMP may in certain circumstances conclude, on the basis of what he or she knows about the client, that there is a low risk of money laundering. Typically, this will be in situations where the customer is a long-term client of the AMP, but it may also be where the customer is a public administration, is a listed company or is subject to supervision under the money laundering directive.

Where the AMP considers a simplified due diligence process to be applicable it can adjust the extent, timing or type of due diligence measures otherwise required under s 28 of the 2017 Regulations.

[53] The Money Laundering, Terrorist Financing and Transfer of Funds (Information on the Payer) Regulations 2017 s 37.

16.5.5.5 Source of funds

Reference is sometimes made in the legislation and the guidance to the need to understand a client's source of funds. This is of particular relevance in situations where enhanced due diligence is required, such as where the customer is a PEP or the circumstances suggest that there may be a risk of money laundering. There is however little guidance as to the extent of the enquiry required or the form that such due diligence should take. I would suggest that this is principally an exercise in establishing whether what you know about the customer from the customer themselves or from public sources is consistent with the source of funds. If it is consistent and there are no other high risk factors or red flags then no further enquiry should usually be necessary. If it is not consistent, if the transaction is higher risk or if there are other reasons to be concerned it may be prudent to delve deeper and ask for supporting documentation or other evidence.

16.6 Suspicious activity reporting obligations

There is a very real danger that following the due diligence procedures outlined above can provide a false sense of security. AMPs carrying out the checks need not only to carry out the checks, but also, in doing so, to look critically at the results of the checks and the surrounding circumstances. Is there something about the circumstances of the transaction or the person which is unusual or suspicious?

It is a defence to a prosecution under POCA 2002 for the defendant to show that he or she reported the suspicious transaction to the anti-money laundering authorities and obtained consent for the transaction to proceed. Such reports are made to the National Crime Agency (NCA) using the Suspicious Activity Report (SAR) procedure, details of which are to be found on the National Crime Agency's website (www.nationalcrimeagency.gov.uk). Suspicious Activity Reports can be filed online, by fax or by post. When in doubt, faced with an unusual or suspicious transaction, it is always prudent to report the matter to the NCA.

Once a SAR seeking consent has been filed, the person filing the report must not proceed with the transaction without obtaining NCA consent. The NCA will respond within seven days of their receipt of the SAR. However, where the NCA fails to respond within seven days the transaction can go ahead, because NCA consent is automatically assumed in law in such circumstances. Usually, the NCA will consent to the transaction proceeding. However, where consent is refused the NCA has 31 days to take action. If no action is taken within 31 days, consent to the transaction proceeding is again assumed in law.

Filing a SAR may feel like a significant step but in practice the NCA's role is primarily information gathering and observation. The subject of the SAR will in

almost all cases be unaware of the SAR filing, and the risk of criminal sanctions for not filing a SAR should far outweigh any concerns over client relationships.

One of the practical difficulties with filing a SAR is that it is also an offence to 'tip off' the subject of the SAR that the report has been filed or that the transaction is being investigated. Tipping off – or making a disclosure likely to prejudice a money laundering investigation – carries a penalty of five years' imprisonment under s 333 of POCA 2002. Extreme care should therefore be taken to avoid giving the subject of the SAR any hint of the SAR's existence or of any investigation into their affairs.

16.7 Sanctions compliance

16.7.1 Introduction

As we have seen, the business of art has become ever more international in nature. In conducting business throughout the world, however, art businesses need to be extremely careful to ensure that they do not breach restrictions, known as 'sanctions', imposed by governments or international bodies on other states or individuals. Sanctions are bans or restrictions on trade designed to punish or prevent behaviour which is felt to be unacceptable. Sanctions can apply to individuals, governments, government bodies and terrorists or terrorist groups. Often such bans are focused upon trade associated with weapons or petroleum, or financing arrangements which could assist terrorism. However, some sanctions are wider in nature and can extend to the trade in art and cultural property. For this reason, those trading in art internationally need to be aware of and comply with sanctions legislation.

16.7.2 Sanctions in place in the United Kingdom

Russia's invasion of Ukraine in 2022 triggered a raft of sanctions worldwide against Russia, the Russian government and individuals and companies thought to be linked to the Russian political elite. This underlined how quickly sanctions legislation can change and how much care should be taken to check the up-to-date position, which will certainly have changed since the publication of this book. The up-to-date position can be found at https:www.gov.uk/government/publications/the-uk-sanctions-list.

What follows applies to transactions in the United Kingdom. Transactions involving or taking place in countries outside the United Kingdom may be subject to other restrictions and sanctions. Of particular importance and relevance in the context of international art sales are sanctions imposed by the United States. A list of these (known as the SDN list) can be found on the United States

Treasury Department website at https://home.treasury.gov/policy-issues/financial
-sanctions/specially-designated-nationals-and-blocked-persons-list-sdn-human
-readable-lists.

At the time of writing, the following regimes are subject to United Kingdom
sanctions: Afghanistan, ISIL and Al-Qaida organisations, Belarus, Central African
Republic, Democratic Republic of the Congo, Egypt, Eritrea, Federal Republic of
Yugoslavia & Serbia, Iran, Iraq, Ivory Coast, Lebanon, Liberia, Libya, Mali, North
Korea, Republic of Guinea, Republic of Guinea-Bissau, Somalia, Sudan, Syria,
Tunisia, Ukraine, Venezuela, Yemen and Zimbabwe. There are also, as mentioned
above, extensive sanctions in place against Russia, Russian individuals and entities
and Russian banks.

The sanctions against these countries and groups prohibit or restrict dealings in
the funds or assets, including artworks, of the persons or countries which are the
subject of the sanctions – defined as a 'designated person'.

In the United Kingdom a person commits an offence if they know or have reason-
able cause to believe that the funds or assets they deal with belong to a designated
person. Sanctions, ranging from fines to imprisonment, are set out in the Policing
and Crime Act 2017.

16.7.3 Trade sanctions

In addition to financial sanctions, sanctions may also be applied to the import and
export of designated goods to and from certain countries. Up to date guidance
on current United Kingdom restrictions on imports from particular countries is
available at www.gov.uk/government/publications/do-i-need-an-import-licence.

In section 10.2.2.2 we covered the ban on the handling, importation and expor-
tation of any item of illegally removed Iraqi cultural property illegally removed
from Iraq since 6 August 1990. Similar restrictions apply to Syria as a result of the
Export Control (Syria Sanctions) (Amendment) Order 2014, which prohibits the
import, export, transfer or provision of brokering services for the import, export
or transfer of Syrian cultural property where there are reasonable grounds to
suspect they have been removed illegally or without the consent of their owner
after 15 March 2011.

16.7.4 Penalties for breaching sanctions

Sanctions compliance should be scrupulously observed, as the punishments for
failure to do so are serious. Breaching sanctions is a criminal matter and any
person or corporate body which breaches sanction measures commits a criminal

offence which can lead to imprisonment and/or a fine. Officers of companies may be personally liable if the offence is committed with their consent.

While much of the focus of 'know your client' compliance has been on anti-money laundering legislation, it is in the field of sanctions compliance that companies – in particular international companies – are arguably most exposed. This is because some sanctions legislation, particularly in the United States, imposes an absolute obligation not to deal with sanctioned individuals or entities, and in those cases it is often no defence to show that you did not know that the individual was sanctioned or that you took all reasonable steps to avoid dealing with a sanctioned individual or entity. In an industry where agents are able to present themselves as principals or as agents acting for undisclosed principals, there is a real risk that an auction house or dealer can find themselves having unwittingly transacted with a sanctioned person or entity. This was highlighted when in 2020, after a two-year investigation, the US Senate Permanent Subcommittee on Investigations issued a report entitled 'The Art Industry and US Policies that Undermine Sanctions'. The committee concluded that sanctioned Russian oligarchs had manged to circumvent US sanctions by purchasing and selling art through an intermediary agent who had alternately presented himself as the principal customer and/or an agent acting on behalf of an undisclosed principal. All three major auction houses had found themselves, to varying extents, exposed to prosecution under sanctions legislation as a result. The report suggested that this situation could have been avoided by means of more robust anti-money laundering and 'know your client' procedures. While it is certainly true that such procedures limit the risk, the difficulty remains that such procedures only work when the information provided by the agent is truthful. They will not work when the agent falsely claims, as in this case, to be acting as principal or where the information provided about the principal is false.

16.8 Facilitation of tax evasion

Under United Kingdom law it is an offence to facilitate tax evasion.

In September 2017, through the Criminal Finances Act 2017, the United Kingdom introduced two new corporate criminal offences,[54] which make United Kingdom and non-United Kingdom companies criminally liable for failure to prevent the facilitation of tax evasion by an employee, agent or anyone else acting for or on behalf of the company.

[54] Criminal Finances Act 2017 Part 3, ss 45 and 46.

The effect of the legislation is to make companies criminally responsible where their employees, their agents or someone acting on their behalf assist a taxpayer in avoiding United Kingdom or non-United Kingdom tax. Assisting someone to avoid tax means aiding, abetting, counselling or procuring the tax evasion. If found liable, the company can face an unlimited fine. Tax evasion is defined as cheating the public revenue or any offence consisting of being knowingly concerned in or taking steps with a view to the fraudulent evasion of tax.

It is a defence to a prosecution under the Act for the company to show that it had in place 'reasonable prevention procedures' to prevent the facilitation of tax evasion.[55] In practice, this means that companies should show that they have conducted a risk assessment and put in place practical measures to prevent facilitation of tax evasion.

For the offence to be committed, the third party must have criminally evaded tax and there must have been a deliberate and dishonest act or failure to act amounting to facilitation.[56]

This offence is of particular relevance for auction houses and dealers who work with clients with complex tax affairs and are asked to structure transactions in certain ways in order to be tax efficient. The difficulty is that the line between tax efficiency, which is legal, and tax avoidance, which is illegal, is not always obvious. If in doubt, advice should be taken from a tax specialist to ensure that what is being proposed is not illegal.

[55] Criminal Finances Act 2017, s 45(2).

[56] Criminal Finances Act 2017, s 45(5).

17 The Bribery Act

17.1 Introduction

The challenge for art market players is to be in the right place at the right time in order to move quickly when an opportunity arises for the acquisition or sale of an artwork or collection of artworks. This can be done through developing close relationships with owners of artworks, keeping careful records of the whereabouts of artworks, providing regular valuations and creating opportunities such as special sales. In many cases, however, where there is no preexisting connection with the owner of the art, the most valuable information about potential opportunities may come from family members, friends or advisers to the owner of the artwork. Where such opportunities are introduced to dealers or to auction houses the family member, friend or adviser may well request or expect to be financially rewarded in return for the introduction. This is known as 'introductory commission' or 'IC'. While payments of introductory commission can, in certain circumstances, be acceptable, they can in many cases expose both the person paying the commission and the person receiving it to criminal sanctions.

The Bribery Act 2010 was introduced in the United Kingdom in order to address instances of bribery both within and outside the United Kingdom. The Act contains two general offences, covering the offering, promising or giving of a bribe (active bribery) (s 1 of the Bribery Act 2010) and the requesting, agreeing to receive or accepting of a bribe (passive bribery) (s 2 of the Bribery Act 2010).

17.2 Active and passive bribery

An active bribery offence is committed where someone (the offeror) offers, promises or gives a financial or other advantage to another person either where:

(i) the advantage is intended by the offeror to bring about the improper performance by another person of a relevant function or activity or to reward such improper performance; or

(ii) the offeror knows or believes that the acceptance of the advantage offered, promised or given in itself constitutes the improper performance of a relevant function or activity.

Passive bribery is committed where a person directly or indirectly:

(i) requests, agrees to receive or accepts a financial or other advantage intending that, in consequence, a function or activity should be performed improperly;
(ii) requests, agrees to receive or accepts a financial or other advantage, and such request, agreement or acceptance itself constitutes the improper performance of a function or activity;
(iii) requests, agrees to receive or accepts a financial or other advantage as a reward for the improper performance of a function or activity; or
(iv) in anticipation of or in consequence of a recipient or potential recipient requesting, agreeing to receive or accepting a financial or other advantage, a function or activity is performed improperly.

17.3 Improper performance

'Improper performance' means performance which amounts to a breach of an expectation that a person will act in good faith, impartially or in accordance with a position of trust.[1] For example, an art adviser, lawyer or financial adviser advising his or her principal, the owner of an artwork, is likely to be in a position of trust in relation to the principal and there will be an expectation on the part of the principal that the adviser is acting in good faith and providing impartial advice. A payment or promise of payment by an auction house or dealer to the adviser or friend is a bribe if it is intended to encourage behaviour in the adviser which is not impartial or is in bad faith. Whether that was in fact the intention is to be determined on the particular facts of the case. For the purposes of deciding whether a function or activity has been performed improperly, the test of what is expected is a test of what a reasonable person in the UK would expect in relation to the performance of that function or activity. It is very important to note that it is not a valid defence or justification to argue, in the case of payments made abroad, that the making of such payments is in line with custom or practice in the country in which it is made – unless it is expressly permitted under the laws of that country.

In cases where the offeror knows or believes that the adviser is not as a matter of principle permitted to accept a financial advantage, the question of the intent and the performance of the function or activity is not relevant. The offence is committed by offering or making the financial inducement.

[1] Bribery Act 2010, ss 3, 4 and 5.

17.4 Bribery of a foreign public official

Section 6 of the Bribery Act 2010 creates a separate offence of bribery of a foreign public official. The offence is committed where the offeror offers, promises or gives a financial or other advantage to a foreign public official with the intention of influencing the official in the performance of his or her official functions.

A 'foreign public official' includes officials, whether elected or appointed, who hold a legislative, administrative or judicial position of any kind of a country or territory outside the United Kingdom. It also includes any person who performs public functions in any branch of the national, local or municipal government of such a country or territory or who exercises a public function for any public agency or public enterprise of such a country or territory, and officers exercising public functions in state-owned enterprises.

Unlike an offence under ss 1 and 2, the offence under s 6 does not require proof that the offeror intended to induce 'improper performance'. It is sufficient for the offence to be committed that the offeror's intention was simply to influence the official.

17.5 Transparency and disclosure

Any payment made by the offeror to an adviser or other person acting in a position of trust in relation to his or her principal is at very high risk of being deemed to be a bribe if the payment is secret or undisclosed to the principal.

We have seen (in section 3.1.1) that advisers usually owe their principals a fiduciary duty, which is a highest duty of good faith. Fiduciaries cannot, without breaching that duty, accept secret payments. Where this happens they will be required to account to their principal for any such payment.

In addition, and more seriously, such secrecy and lack of disclosure around a financial payment will put both the offeror and the adviser at risk of prosecution for bribery. This is because the secrecy raises a presumption that the intention behind the payment is to encourage improper performance or influence a public official, or that the acceptance of the payment is or would have been prohibited.

For this reason, any offer or payment of an introductory commission should be accompanied by positive steps on the part of the offeror and the recipient of the payment to ensure that the principal is aware of the payment. For the recipient this should take the form of a clear, preferably written, statement or notice to the principal that the recipient is being remunerated by a payment from the offeror.

The offeror will also wish to protect him or herself against the possibility that such a disclosure has not been made by the recipient or that the principal has somehow not been made aware of the payment. The best practice is for the offeror to actively check with the principal that he or she is aware of the payment. If that is not possible – for instance because the adviser is acting for an undisclosed principal – a notice that the introductory payment is being made to the recipient should be included in the contract. Confirmation that the principal is aware of the payment should be sought in writing from the recipient. The manner of the disclosure will vary in each case but offerors of payments should be very careful where the recipient of the payment appears uncomfortable or evasive concerning the disclosure of the payment to the principal.

17.6 Corporate failure to prevent bribery

Section 7 of the Bribery Act 2010 creates corporate liability for failing to prevent bribery on behalf of a commercial organisation. This provision is designed to ensure that commercial organisations put in place antibribery training and systems. A commercial organisation which does this will have a full defence to a prosecution under s 7 of the Act if it can show that the instance of bribery in question occurred despite the organisation having adequate procedures in place to prevent its employees or persons associated with it from engaging in bribery.[2]

The guidance notes accompanying the Bribery Act 2010 contain some very specific requirements concerning the steps which corporate bodies need to take in order to be considered to have adequate procedures in place.[3] These should be studied carefully, as they are onerous and a failure to have the necessary procedures, monitoring and training in place can leave the company open to prosecution under s 7.

17.7 Penalties

The penalties for offences under the Bribery Act 2010 are serious. Under s 11 of the Act, an individual guilty of an offence of active or passive bribery, or of bribing a public official, is liable for a maximum ten-year term of imprisonment, or to a fine, or both. An organisation guilty of an offence under s 7 (failure of commercial organisations to prevent bribery) is liable to a fine.

[2] Bribery Act 2010, s 7(2).

[3] Ministry of Justice publication 'The Bribery Act 2010' available at www.justice.gov.uk/downloads/legislation/bribery-act-2010-guidance.pdf

17.8 Practical guidance

Where payments are being requested or made to intermediaries, advisers or influencers in order to secure a transaction, regardless of structure or name, great care must be taken. While such a payment is not problematic where all parties are aware of it, there is a real risk that it could be deemed to be a bribe where it is not disclosed.

Auction houses and dealers should make introductory commission payments to an introducer only where they are satisfied that the person being introduced knows that the payment is being made. Ideally they should disclose it themselves to the person being introduced, in writing if possible. The payment should also be conditional upon an undertaking from the introducer that he or she will inform the person being introduced of the payment.

It is also essential for companies in the art world to ensure that they have in place antibribery policies and training for staff. This provides a full defence for the company and its directors in the event that a staff member engages in an act of bribery.

18 Confidentiality and data protection

18.1 Confidentiality

It is a well-established and longstanding feature of the art world that the identities of sellers and buyers are not made public, and are treated as highly confidential by auction houses and dealers. Phrases such as 'property of a distinguished European collector' are, even today, commonly used in auction catalogues. Within auction houses and dealerships the confidentiality of client information is treated as paramount. This tradition of confidentiality arises in large part because of the three most common catalysts for art sales, discussed previously, known as the 'three Ds': death, debt and divorce. None of these are circumstances which sellers wish to advertise. Artworks are, aside from real estate, the most visible signs of wealth. As a result, where death, debt or divorce require a disposal of assets, sellers tend to want to do so as discreetly as possible. Buyers too usually want discretion. Advertising valuable acquisitions can make buyers a target for crime and even put them in physical danger.

But the focus on confidentiality is not only driven by buyers and sellers. Knowledge of where artworks are and who owns them is of great commercial value, and information of this kind is closely guarded by auction houses, dealers and agents. Dealers and agents are particularly protective of the relationships they have established with their principals. In order to protect those relationships, art advisers and intermediaries will often insist upon nondisclosure agreements before negotiations over valuable lots can even start.

Occasionally, of course, it may be to the seller's advantage to be open about his or her identity. For instance, certain collections command a significant premium precisely because of their association with the seller.

Buyers too are frequently concerned about confidentiality. Bidders in auctions sometimes go to great lengths to hide the fact that they are bidding on lots. At its most basic level this can involve the bidder conveying his or her bids via an auction house employee on the telephone or bidding by written bid. Arrangements can however be more elaborate, with the bidder being in the room and giving a secret

sign to someone else in the room to bid or stop bidding on his behalf. Or the bid may be conveyed from the bidder on the telephone to the bidder's agent on the telephone, and then again by telephone to the auction house employee. Usually these arrangements are born of a belief that hiding the bidder's identity will provide a tactical advantage against competing bidders. However, they can also arise out of a desire for privacy and a concern to ensure that the bidder's purchases do not become a subject for public discussion. Equally, there are some buyers who enjoy bidding very prominently in the sale room and have no difficulty with the publicity which comes with being the successful bidder on a sought after work of art. However, a desire for publicity is the exception rather than the rule. Most sellers and buyers prefer not to make their art transactions public and the tradition of discretion and confidentiality is deeply entrenched in the art world.

This culture of confidentiality – or, some would say, secrecy – can give rise to criticism and suspicion. This is in some ways surprising. After all, we would not be surprised if a bank refused to publicly disclose details of a customer's transactions. The concern is, however, also understandable in the context of the threat of money laundering and tax evasion.

It is also important to deal with a few myths and realities concerning confidentiality.

It is sometimes suggested that the duty of confidentiality is not in fact a legal duty. This is unlikely to be correct. Certainly, where the contract between the auction house or dealer and the buyer or seller contains an express contractual provision in which the auction house or dealer agrees to keep the seller's identity confidential, that provision will impose a binding legal duty of confidentiality upon the auction house or dealer. Even where there is no express contractual provision, a legally binding duty of confidentiality is likely to be implied by the fact that custom and practice in the art market leads to an expectation on the part of clients that their identity will be kept confidential. The ability of the law to imply a term into a contract as a result of custom and usage has been recognised by the courts,[1] and, in the art industry, there is certainly a tradition of discretion and confidentiality. Therefore, in the absence of evidence that the parties had agreed otherwise, it would seem likely in many cases that – even where the contract is silent on confidentiality – the court would be prepared to imply a term that the seller's and/ or the buyer's identity would be kept confidential. It is also worth noting that data protection obligations in the United Kingdom impose obligations upon auction houses to handle the personal data of their clients carefully and responsibly (see section 18.2, 'Data protection').

[1] Hutton v Warren (1836) 1 M & W 466.

There is a common misapprehension that where the auction catalogue does not disclose the identity of a seller, this suggests that the identity of the seller is not known to the auction house. In fact, this is not the case. While the auction catalogue will not usually disclose the name of the seller to the public, 'know your client' (KYC) obligations require the auction house or dealer to satisfy themselves as to the identity of the seller (see chapter 16, 'Anti-money laundering and sanctions compliance'). The auction house will therefore always have details of the seller on file.

The fact that confidential information is not disclosed publicly does not mean it is not made available where the law requires it. For instance, if the authorities are investigating a crime such as theft, tax evasion or money laundering, the dealer or auction house will be obliged to provide the confidential details to the investigating authorities provided they have followed the correct procedures. Equally, the civil courts have the right to order the disclosure of confidential information where it is appropriate to do so – and auction houses and agents will comply with an order from a competent court for disclosure of this information.

It is sometimes suggested that there should be no confidentiality surrounding the sale and purchase of art and the parties to all transactions should be recorded and made publicly available. There is much to be said for transparency as it is an effective means of ensuring that confidentiality is not used as a means of hiding illegal activity. However, the fact that this information is available to law enforcement, tax authorities and civil claimants should be sufficient to prevent illegality. A line needs to be drawn where the degree of transparency is such that those involved in the market are unnecessarily exposed to public comment and scrutiny beyond that which is necessary to prevent wrongdoing. Certainly, if lists of buyers and sellers were made publicly available, the art market would be the only market in which the acquisition or disposal of a valuable personal asset would be available for public consumption.

One area of concern is the use of intermediaries and agents. An intermediary or agent is able to present himself or herself as the principal. The auction house or dealer may never know that the agent or intermediary is in fact acting for another party. This situation has become less common in the United Kingdom with the advent of the new anti-money laundering regulations, which increasingly encourage transparency while discouraging the use of intermediaries to protect the identity of principals.

18.2 Data protection

18.2.1 European General Data Protection Regulation

It is the business of auction houses and dealers to know their clients and the artworks their clients own. This is a question not just of collecting data, but also of the development of close, sometimes even very personal, relationships of trust between the client and the dealer, auction house or art adviser. This necessarily also involves recording often quite personal and confidential information about the client and the client's transactions on a client database. We have seen that from a contractual perspective confidentiality is a cornerstone of the art world, but there are, in addition to those contractual obligations, obligations imposed more generally upon those who hold personal data regulating how that personal data is gathered and used. Those obligations were until recently imposed by the Data Protection Act 1998. However, the growth of data gathering through social media and other means – along with the consequences of data breaches – has required a substantial update of the law in this respect. The Data Protection Act 1998 has been replaced by a Data Protection Bill which enacted the European General Data Protection Regulation (GDPR). The effects of the GDPR will be widely felt because they will apply not only to companies operating within the European Union, but also to all businesses that market to or do business with European Union Member States, regardless of where in the world that business is located.

Brexit has meant that the United Kingdom is no longer subject to European GDPR legislation and is considered to be a 'third country' for the purposes of sending personal data from EU countries to the United Kingdom. However, in practice nothing substantive has changed from the pre-Brexit framework, for two reasons. First, the United Kingdom has enacted European law in the form of the 2018 Data Protection Act (as amended by the Data Protection, Privacy and Electronic Communications (Amendments etc) (EU Exit) Regulations 2019). Second, transfers of personal data from the EU to the United Kingdom are authorised by the EU following the EU decision in June 2021 that personal data was adequately protected in the United Kingdom. This will ensure that personal data can flow between the EU and UK until June 2025.

18.2.2 The five GDPR principles for handling personal data

Detailed guidance on compliance with the obligations under the GPDR is provided by the Information Commissioner's Office (www.ico.org), but the basic

requirements for compliance likely to be relevant to an art market business are as follows:

1. Personal data shall be processed lawfully, fairly and in a transparent manner in relation to the data subject.
2. Personal data shall be collected for specified, explicit and legitimate purposes and not further processed in a manner that is incompatible with those purposes.
3. Personal data shall be adequate, relevant and limited to what is necessary in relation to the purposes for which they are processed.
4. Personal data shall be accurate and, where necessary, kept up to date.
5. Personal data shall be kept in a form which permits identification of data subjects for no longer than is necessary for the purposes for which the personal data are processed.
6. Personal data shall be processed in a manner that ensures appropriate security of the personal data, including protection against unauthorised or unlawful processing and against accidental loss, destruction or damage, using appropriate technical or organisational measures.
7. The person controlling the data shall be responsible for, and be able to demonstrate compliance with the GDPR.

While these principles may seem general, the requirements they impose are onerous for those who hold personal data. The days when personal information such as email addresses and contact details could be gathered without the subject's knowledge are over. Nor will it be possible to put the gathered data to multiple uses or share it with others. With the mass harvesting of data by social media and tech companies and the major data breaches suffered by companies at the hands of hackers has come a realisation that those holding the data have a significant responsibility to ensure that they do so only with the informed consent of the data subject and that there is a duty of care in such cases to ensure that the data is not abused. This is highly relevant to the art industry, where building personal relationships and servicing those relationships has necessitated the building of sophisticated databases of confidential personal information.

18.2.3 Lawful, fair and transparent collection and processing of data

The first principle – that of lawfulness, fairness and transparency – is the starting point. This means that in practice the person providing the data needs to be made aware, at the time of providing the personal data, of the fact that his or her personal data is being recorded, who it is being recorded by and the specific purposes for which it is going to be used. The purpose or purposes need to be clearly and narrowly defined. The client needs to have given 'informed consent' to the collection and processing of the data. This gives rise to the question of what is or is not informed consent. For instance, it is not sufficient for the consent to be a blanket

consent for the use of the data for 'any purposes'. Nor is it informed consent where the client is told that unless he or she objects the data will be retained and used. Article 4(11) of the GDPR provides that consent of the data subject means 'any freely given, specific, informed and unambiguous indication of the data subject's wishes by which he or she, by a statement or by a clear affirmative action, signifies agreement to the processing of personal data relating to him or her'.

There therefore needs to be a positive indication of acceptance by the person providing the data. The person requesting the data cannot rely on inaction or the failure of the data subject to object to, or rely upon, preticked boxes. There should also be a genuine choice on the part of the data subject. It would not, for instance, be acceptable to make the performance of a contract conditional upon the provision of data which is not necessary for the transaction. Nor is it likely to be acceptable to seek to obtain blanket consent for a series of separate uses of the data. Consent should be sought separately for each use. Data subjects must be informed of their right to withdraw consent at any time prior to giving consent (GDPR Article 7(3)). Articles 12–18 of the GDPR also set out the specific information that must be given to the data subject to ensure fair and transparent processing.

The requirement of transparency referred to in the first principle has tended in the past to be covered by means of a 'privacy notice' included in contracts or on a website. These have usually been lengthy and provide the data processor with quite extensive rights in relation to the use of the user's data. While such notices continue to be acceptable in principle if they are readily understandable, the recommendation from the Information Commissioner's Office is that in more complex cases other methods are adopted – such as a privacy dashboard – giving the user genuine control and choice over the use and control of their data.[2]

18.2.4 Use of personal data

The second principle is designed to ensure that those processing personal data collect only such data as is strictly necessary for the purposes of the transaction and use the data only for those purposes.

18.2.5 Accuracy of personal data

The third, fourth and fifth principles impose upon the person holding the data an ongoing obligation to ensure that the data is accurate, is up to date and is not held longer than is necessary for the purposes for which consent was given. This will mean putting in place systems to regularly update data and to ensure that old data is deleted.

[2] https://ico.org.uk/for-organisations/guide-to-data-protection/privacy-notices-transparency-and-control/

18.2.6 Protection of personal data

The sixth principle – requiring the data user to keep the data safe from misuse or accidental destruction – is potentially the most serious. As we will see later, the GDPR imposes major sanctions on companies who allow their data to be hacked. As a result, those processing personal data are expected to take organisational and technical measures which are proportional to the risk of a data breach, bearing in mind the likelihood of a breach occurring and the consequences in the event of a breach. The sort of measures one might see are firewalls, encryption of data, limiting staff access to data on a need to know basis and password protection. Consideration also needs to be given to the ability to restore availability and access to the data promptly in the event of a problem.

The seventh principle imposes a duty of accountability. It is not enough to be processing data fairly and in accordance with the principles – data controllers need to be able to demonstrate that they have done so by reference to records.

18.2.7 Data breach reporting obligations

The GDPR also introduces a series of reporting obligations where a breach of personal data occurs. Article 33 requires personal data breaches to be reported to the Information Commissioner's Office without undue delay and, where feasible, not later than 72 hours after becoming aware of it. The only exception to this is where the personal data breach is unlikely to result in a risk to the rights and freedoms of data subjects. The notification must include at least:

- a description of the nature of the breach, including, where possible, the categories and approximate number of data subjects and personal data records concerned;
- the name and contact details of the relevant Data Protection Officer or contact point;
- the likely consequences of the data breach;
- measures taken or proposed by the data controller to address the breach and/ or mitigate its effects.

Article 34 of the GDPR requires, in addition, that breaches of personal data should be reported to the person or persons whose data has been breached where the data breach is likely to result in a high risk to the rights and freedoms of a data subject. This must be done by the data controller without undue delay. The notification must include, in clear and plain language, the nature of the breach and the same details as are required for a breach notification to the information commissioner's

office under Article 33 (see above). However, no such notification to the data subject is necessary where any of the following conditions have been met:

- the personal data is in a form which will makes it unintelligible to unauthorised persons (for example, where it is encrypted);
- the controller has taken steps to ensure the originally high risk is no longer likely to materialise; or
- individual notification of each data subject would involve disproportionate effort (in which case a public communication will need to be used).

The importance attached to these obligations is reflected in the sanctions for failure to comply with them. Serious failures can attract fines of up to 2% of the annual global turnover of the data controller or 10 million euros, whichever is higher.

18.2.8 Data subject right to information

It is important for those holding data to remember that all individuals have the right to know what personal information is held about them on a database. They can request that information and the person or organisation operating the database is required to respond within 40 days. A fee of up to £10 can be charged for providing the information. As a result, database holders would be well advised to include on databases only information about clients which will not cause embarrassment or legal risk were it to be revealed to the client.

Transfers of personal data to countries outside the European Union presents a particular problem in a global market such as the art market. Articles 44–50 of the GDPR provide that such transfers can only take place where:

- the European Commission has decided that the third country in question provides an adequate level of protection; or
- the person handling the data has provided appropriate and enforceable safeguards including:
 - binding corporate rules, which reflect the GDPR principles and provide the data subject with the same rights as he or she would enjoy under the GDPR;
 - standard data protection clauses, to be determined by the European Commission or the UK information commissioner;
 - an approved code of conduct together with binding and enforceable commitments of the controller or processor in the third country to apply the appropriate safeguards, including as regards data subjects' rights; or
 - an approved certification mechanism pursuant to Article 42 together with binding and enforceable commitments of the controller or processor in

the third country to apply the appropriate safeguards, including as regards data subjects' rights; or

♦ contractual clauses approved by the UK information commissioner between the data controller and the recipient of the personal data in the third country.

Most international art market companies with subsidiaries or offices outside the EU are likely to rely upon establishing binding corporate rules and/or contractual clauses in order to ensure that data can be held and transferred regardless of territory.

Index